The Aesthetic Experience

The Aesthetic Experience

An Anthropologist Looks at the Visual Arts

JACQUES MAQUET

Yale University Press

NEW HAVEN AND LONDON

Designed by James J. Johnson
and set in Palatino Roman type.
Printed in the United States of America by
Murray Printing Company, Westford, Massachusetts.

Library of Congress Cataloging in Publication Data

Maquet, Jacques Jérôme Pierre, 1919–
 The aesthetic experience.

 Bibliography: p.
 Includes index.
 1. Aesthetics. I. Title.
BH39.M39 1986 701'.1'7 85–8232
ISBNs 0–300–04134–9 (pbk.)
0–300–03342–7 (cloth)

*The paper in this book meets the guidelines for
permanence and durability of the Committee on
Production Guidelines for Book Longevity of
the Council on Library Resources.*

10 9 8 7 6 5

Contents

List of Illustrations ... vii
Preface ... xi
1. *The Reality Anthropologists Build* ... 1

PART I: ART IN HUMAN EXPERIENCE

2. *Art in Everyday Reality* ... 13
3. *The Aesthetic Vision* ... 25
4. *The Significance of Form* ... 35
5. *Aesthetic Vision as Contemplative* ... 51
6. *Aesthetic Experience in Other Cultures* ... 59
7. *Art in Other Cultures* ... 65

PART II: THE AESTHETIC OBJECT
AS SYMBOLIC

8. *Meanings in Aesthetic Objects* ... 79
9. *Visual Forms as Signs* ... 93
10. *Visual Forms as Symbols* ... 103
11. *The Aesthetic Quality* ... 119
12. *Preferences in Art* ... 141
13. *Between Creators and Beholders* ... 151

14. *Aesthetic Vision, a Selfless Experience* ... 161

PART III: THE AESTHETIC OBJECT
AS CULTURAL

15. *The Cultural Component in
 Aesthetic Objects* ... 169
16. *The Aesthetic Segment of a Culture* ... 179
17. *Techniques of Production and
 Aesthetic Forms* ... 185
18. *Societal Networks and Aesthetic Forms* ... 201
19. *Aesthetic Forms and Other
 Ideational Configurations* ... 223
Conclusion: The Individual Nexus ... 241
*Appendix: Aesthetic Anthropology as
 Critical Knowledge* ... 243
Notes ... 252
Works Cited ... 256
Analytical Table of Contents ... 261
Index of Proper Names ... 266
Index of Topics ... 269

Illustrations

Ritual headdress (*bamana chi wara*).
 Bambara, West Africa. 2
Mask. Senufo, Ivory Coast. 2
Ritual figurine. Teke, Congo. 6
Cup. Kuba, Zaire. 7
Hamba in a basket. Cokwe, Zaire. 14
Willem de Kooning. *Woman, II*. 1952. 15
East Building interior courtyard.
 National Gallery of Art,
 Washington, D.C. 16
Paul de Lamerie. Silver dish and bowl.
 c. 1725. 18
Thonet Brothers. Rocking chair. 1860. 19
A Thonet rocking chair in a private
 residence. Les Issambres, Var, France. 19
Marcello Nizzoli. Olivetti typewriter. 1949. 19
Charles Pollock. Knoll armchair and
 side chair. 1965. 19
Virgin and Child. Auvergne, France.
 12th century. 20
Reclining couple on sarcophagus.
 c. 520 B.C. 21
Nana Kraus. *Portrait of Erwin Broner,
 Architect*. 1984. 21
Royal headdress worn by King
 Rudahigwa in a public ceremony.
 Nyanza, Rwanda. 1955. 23

Royal headdress. Rwanda. 23
Robert Graham. *Dance Column I*, detail.
 1978. 26
Sorel Etrog. *Mother and Child*. 1964. 27
Alexander Calder. *Les Renforts
 (The Reinforcements)*. 1963. 28
Ivan Albright. *Into the World Came
 a Soul Called Ida*. 1929–30. 34
Gustave Courbet. *La Rencontre
 (The Encounter)*. 1854. 36
Edward Hopper. *Nighthawks*. 1942. 37
Sandro Botticelli. *Birth of Venus*. c. 1482. 37
Ceremonial mask (*kanaga*). Dogon, Mali. 38
Vajrasattva in union with his Śakti.
 Rough brass figurine. Tibet.
 20th century. 39
Robert Rauschenberg. *Booster*. 1967 40
Gold mask. Asante, Ghana. 41
Georges Braque. *Le Portugais
 (The Portuguese)*. 1911. 44
Pablo Picasso. *Portrait of Daniel-Henry
 Kahnweiler*. 1910. 44
Andy Warhol. *Marilyn Diptych*. 1962. 45
Jackson Pollock. *Autumn Rhythm*. 1950. 46
Head of the Buddha. Mathurā, India.
 5th century. 47
Utamaro Kitagawa. Polychrome print

(*nishiki-e*) of a lovemaking scene.
c. 1800. 48

Edvard Munch. *The Scream*. 1894. 49

Adolph Gottlieb. *Blast, I*. 1957. 50

David Alfaro Siqueiros. *Echo of a Scream*.
1937. 50

Carved wooden bowl. Trobriand Islands. 61

Ardagh chalice. Ireland. 8th century. 61

Asante chief's carved wooden stool.
Ghana. 63

Two Asante chiefs' stools carried in
procession. Kumasi, Ghana. 64

Diego Velázquez. *Prince Philip Prosper
of Spain*. c. 1660. 66

Thomas Shields. Silver sauceboat.
c. 1780. 66

Rwanda traditional basket. 67

Rwanda traditional tray. 67

Tutsi woman weaving a basket. Nyanza,
Rwanda. 1955. 68

Four male Wodaabe dancers. West Africa. 69

Three stages in the stylization of a bird
and crocodile representation. Massim
district, New Guinea. 72

"Cubist" mask. Grebo, Ivory Coast. 73

Piet Mondrian. *Broadway Boogie Woogie*.
1942–43. 78

Jackson Pollock. *Number 1, 1948*. 1948. 81

Mark Tobey. *Edge of August*. 1953. 83

Roy Lichtenstein. *Blonde Waiting*. 1964. 84

Jean Ingres. *The Source*. 1856. 87

Mel Ramos. *Ode to Ang*. 1972. 87

Amedeo Modigliani. *Reclining Female
Nude*. 1917. 88

Mel Ramos. *You Get More Salami with
Modigliani No 14*. 1978. 89

Paul Delvaux. *The Blue Sofa*. 1967. 90

Tom Wesselmann. *Great American Nude
No. 92*. 1967. 91

Titian. *The Rape of Europa*. c. 1560. 91

El Greco. *Portrait of a Cardinal*, probably
Cardinal Don Fernando Niño de
Guevara. c. 1600. 95

Māyā's dream. Bhārhut, Madhya Pradesh.
2d century B.C. 99

A Buddha's hand with the long fingers
mark, in the gesture of bestowing
fearlessness (*abhaya mudrā*). Thai.
20th century. 100

El Greco. *The Agony in the
Garden of Gethsemane*. c. 1580. 101

El Greco. *Assumption of the Virgin*. 1577. 102

Ludovico Visconti. Napoleon's tomb.
1861. 105

Gustave Klimt. *The Kiss*. 1908. 107

Francis Bacon. *Painting 1946*. 1946. 111

Buddha in *samādhi*. Anurādhapura,
Sri Lanka. 3d or 4th century. 113

Schema of the Anurādhapura Buddha. 114

Anurādhapura Buddha: frontal triangle,
lateral triangles, frontal obliques,
frontal horizontals, frontal verticals,
frontal ovals, frontal rectangle,
balance of forces. 114–15

Henry Moore. *Three Rings*. Red
travertine marble. 1966. 118

Mask. Tikar, Cameroon. 120

Georges Braque. *Castle at La Roche-Guyon*.
1909. 121

Richard Hunt. *Why?* 1974. 122

Aldo Casanova. *Artemis of Ephesus*.
1966. 122

Casanova. *Artemis of Ephesus*, detail. 122

Jean Arp. *Ptolemy III*. 1961. 122

Arp. *Ptolemy III*, another view. 123

Dame Barbara Hepworth. *Pelagos*. 1946. 124

Bruce Beasley. *Dione*. 1964. 124

Antoine Pevsner. *Developable Column*.
1942. 125

Kasimir Malevich. *Woman with Water
Pails: Dynamic Arrangement*. 1912. 126

Cloister of the Saint-Michel-du-Cuxa
monastery. France. 12th century. 126

Abbey of Sénanque. Provence.
12th century. 127

Cloister of Santa Giuliana. Perugia.
13th century. 127

Gothic windows of Sainte Chapelle.
Paris. 13th century. 127

Pablo Picasso. *Guernica*. 1937. 128

Robert Capa. Death of a Republican
 volunteer, Spain. 1938. 129
Eddie Adams. Murder of a Vietcong by
 Saigon police chief. 1968. 131
Malanggan open work. New Ireland,
 Micronesia. 132
Cast bronze head surmounted by
 vultures. Benin, Nigeria. 18th century. 132
Stone carving of Quetzalcóatl. Aztec. 133
Head. Nok, Nigeria. c. 250 B.C. 133
Sculpted head on top of a *nimba* mask.
 Baga, Guinea. 133
Trophy head. Costa Rica. c. 1000–1300. 134
Attributed to Li Ch'eng. *A Solitary Temple
 amid Clearing Peaks.* Song (Sung)
 dynasty, 10th century. 136
Lovers (*mithuna*). Madhya Pradesh,
 India. 11th century. 139
Parthenon. Athens. 447–432 B.C. 143
Notre Dame. Paris. 1163–1250. 143
Taj Mahal. Agra. 1634. 143
Mikhail Larionov. *Glass.* 1912. 147
Natalia Goncharova. *Cats.* 1913. 147
Adolf Wissel. *Kahlenberg Farm Family.*
 c. 1939. 148
Constantin Brancusi. *Adam and Eve.*
 1916–21. 150
Chief's stool, village of Buli.
 Luba, Zaire. 153
Constantin Brancusi. *Male Torso.* 1917. 153
Constantin Brancusi. *Caryatid II.* 1915. 154
Mark Rothko. *Black on Grey.* 1970. 160
Attributed to Calamis. *Zeus of Artemision.*
 c. 460 B.C. 170
Head of the Buddha. Gandhāra,
 Pakistan. 4th century. 171
Church of Chapaize. Saône-et-Loire,
 France. 173
Abbey of Saint-Martin-du-Canigou.
 Pyrénées Orientales, France.
 11th century. 173
Bodhisattva Avalokiteśvara. East India.
 12th century. 173
Jan Vermeer. *Woman Reading a Letter.*
 c. 1662–64. 175

Han Van Meegeren. *Disciples at Emmaüs.*
 c. 1936. 175
Shield being carved from a tree trunk.
 Rwanda. 1955. 184
Woman pounding in a mortar;
 figurine carved in one piece of wood.
 Lwena, Zaire. 184
Lineage ancestor figurine. Bembe, Zaire. 184
Kongo figurine carved in soft stone
 (*mintadi*). Angola. 184
Bronze plaque showing an official holding
 a box. Benin, Nigeria. Early 17th
 century. 187
Bronze plaque showing two officials,
 one carrying an ivory gong. Benin,
 Nigeria. Late 17th century. 187
Bronze head. Benin, Nigeria.
 Late 17th century. 187
Gustave Eiffel. Eiffel Tower under
 construction in 1889. Paris. 188
Joseph Paxton. Aerial view of the
 Crystal Palace. Hyde Park,
 London. 1851. 189
Paxton. Interior of the Crystal Palace. 189
Eero Saarinen. TWA terminal. 1956–62.
 JFK International Airport, New York. 189
George Wyman. The Bradbury Building.
 Los Angeles. 1893. 190
Morris Louis. *Alpha-Pi.* 1960. 191
Kenneth Noland. *Song.* 1958. 191
Richard Diebenkorn. *Ocean Park
 No. 94.* 1976. 192
Funerary figures. Ekoi, Nigeria. 194
Tusk on head. Benin, Nigeria. Late 17th
 or 18th century. 195
Victor Vasarely. *Kara.* 1956. 197
Ludwig Mies van der Rohe. Toronto-
 Dominion Center. Toronto, Canada.
 1969. 200
Harold E. Edgerton. Stroboscopic photo
 of a bouncing golf ball. 1959. 203
Marcel Breuer. Cesca side chair,
 manufactured by Thonet Brothers.
 1928. 206
The Abramtsevo church, designed and

built on the Mamontov estate. 1882. 207

Natalia Goncharova. *Haycutting.*
1910. 209

Ernst Kirchner. *Two Against the World.*
1924. 211

André Derain. *The Old Tree.* 1905. 211

Wassily Kandinsky. *Black Lines.* 1913. 211

Vladimir Tatlin. Model for the *Monument
to the Third International.* 1920. 213

Aleksandr Rodchenko. *Hanging
Construction.* 1920. 214

Kasimir Malevich. Cup and teapot.
c. 1920. 214

Alexandrovich Deyneka.
The Tractor Driver. 1956. 215

Alexandrovich Deyneka. *The Defense of
Sebastopol.* 1942. 215

M. Savitsky. *Partisan Madonna.* 1967. 216

Arkady Alexandrovich Plastov. *Spring.
At the Bathhouse.* 1954. 217

Josef Thorak. *Comradeship.* 1937. 218

Walter Hoeck. *Young Germany*
(adapted by Beatrice Fassell). 219

Ivo Saliger. *Diana at Rest.* 219

Dome of the Church at Chora.
Constantinople. 13th–15th century. 222

Mosaic of Christ as Pantocrator. Hagia

Sophia basilica. Constantinople.
11th century. 224

Anthemios and Isidoros. Hagia Sophia
basilica. Constantinople. 532–537. 226

Hagia Sophia basilica, ground plan. 226

Pol de Limbourg. A plan of Rome from
the illuminated *Très Riches Heures du
Duc de Berry.* c. 1414. 227

Andrea Mantegna. *Saint Sebastian.*
c. 1472. 228

Mantegna. *Saint Sebastian,* detail:
a view of Rome in the background. 229

Hubert and Jan van Eyck.
Adoration of the Lamb. c. 1432. 231

Raphael (Raffaello Sanzio).
The School of Athens. c. 1509. 231

Door. Senufo, Ivory Coast. 233

High relief in clay. Abomey, Dahomey. 234

In the royal enclosure of Abomey,
building with clay high reliefs.
Dahomey. 234

Bronze plaque showing the sacrifice
of a bull. Benin, Nigeria. 235

Ancestors' figures. Dogon, Mali. 237

Edvard Munch. *Workers Returning Home.*
1913. 239

Preface

This book presents, in outline, a system of interpretation of the visual arts in an anthropologist's perspective. It does not offer a survey of what has been written on the visual experience of art. Discussions are limited to the sources of this system and to what is of immediate relevance to it. Consequently several important contributions by anthropologists to the study of art and the related subjects of symbols and metaphors are not mentioned. More anthropologists than the ones here discussed have indeed described artifacts, analyzed styles, elaborated concepts, proposed classifications, and constructed theories on the functions and significations of symbolic thinking. At this initial point, situating my system in relation to other perspectives of interpretation is not necessary. It would even be somewhat presumptuous.

The idea of this book slowly matured in seminars held over two decades, first in Paris, at the Ecole des Hautes Etudes en Sciences sociales and the Musée de l'Homme, and later in Los Angeles, at the University of California, in the Department of Anthropology. Many stimulating discussions were generated by colleagues and students who attended these seminars.

A Wenner-Gren Foundation grant aided me in starting my art slides collection. Several grants from the UCLA Academic Senate provided me with research assistance.

Dawn Chatty, Barbara Mathieu, Marjorie Dickenson, and Martin Cohen participated with sagacity and alacrity in the early stages of the manuscript preparation. David Blundell cheerfully and generously put his talent and expertise at my disposal in the selection and production of photographs. Nancy Daniels performed with discrimination and endurance the exacting task of meticulously editing the final version of the entire manuscript and diligently assisted me in the carrying out of the author's responsibilities during the publishing process.

Ellen Graham, editor at Yale University Press, thanks to her enthusiasm and rigor, efficiently fulfilled her difficult role of encouraging and prodding the author.

My wife Gisèle patiently shared with me the inevitable yet unpredictable vicissitudes of book making. As beneficial as her forbearance was her active collaboration, from discussing incipient thoughts and tentative concepts to advising on practical matters.

Finally, I wish to thank the artists and their copyright holders, museums, art galleries, private collectors, photographers, and photographic agencies for their cooperation with the illustrations.

xi

The Aesthetic Experience

CHAPTER ONE

The Reality Anthropologists Build

IN THIS BOOK, AN ANTHROPOLOGIST LOOKS AT THE VISUAL ARTS. THIS IS NOT A STRIKING
first line. Yet I cannot find a better description of the approach that is developed here.

An *anthropologist's* views are not anthropology. The inclusion of one anthropologist's
contribution to that body of knowledge we call anthropology depends on the consensus
of other anthropologists. The process of inclusion is unpredictable, nonformalized, and
takes some time. Thus I do not claim that what is attempted here is, or will be, recognized
as a portion of mainstream anthropology.

Also, like my fellow anthropologists, I am not *only* an anthropologist. Most of us
have been seriously involved in other intellectual disciplines. For me, these have been
law, philosophy, and sociology, particularly the sociology of knowledge.[1] All of us have
been exposed to, and have responded to, some of the great intellectual stimulations of
this century such as Marxism and Freudianism, existentialism and phenomenology,
surrealism and structuralism, counterculture and consciousness movements. And, of
course, all of us have been molded by some affective encounters or spiritual commit-
ments. When researching or writing, however, we sometimes try to act as if we were only
anthropologists. In this book, I have not attempted to do so: not only my anthropological
persona has written the pages that follow. The person I have become by having lived
through the excitements and disappointments of the intellectual and emotional turbu-
lences of the twentieth century has also written them. I see no virtue in refusing to take
experiential resources into account because they do not fit in the traditional framework of
one's discipline. Anything that is relevant should be taken into account.

Of course, such things should be dealt with in a manner appropriate to a work of
knowledge. Observations should be validly made, and conclusions should be supported
by the kind of evidence and the type of argumentation used in scholarly discourse. This is
what I have attempted to do. As I will make clear in several discussions, an epistemologi-
cal concern has been constantly present during the preparation of this study.

1

Ritual headdress *(bamana chi wara)*. Bambara, West Africa. Museum of Cultural History, University of California, Los Angeles. Photo by Richard Todd.

Mask. Senufo, Ivory Coast. Private collection, Los Angeles. Photo by Jacques Maquet.

Aesthetic anthropology may not be mainstream anthropology, but my idea of it originated, years ago, from research on a typically anthropological matter: the visual arts of traditional Black Africa. The questions I had in mind were typically anthropological too. What were the functions of the stunning Baga headdresses, the elegant Baule figurines, or the impressive Dogon statues in the societies in which they had been carved? Were they only perceived as ceremonial objects by the members of these societies, or were they also considered art objects by the users? Why were the Bambara and Senufo styles of sculpture different when Bambara and Senufo, both millet farmers, lived in similar environments and in the same region? I approached African artifacts as cultural phenomena, and it proved to be a fruitful perspective.[2]

It seemed warranted to extend the scope of the inquiry and to keep the same perspective. I became interested in anthropology of art, art and culture, cross-cultural aesthetics, and related matters treated under such headings in university courses and scholarly books. These titles connoted an anthropological approach to art.

Art has been mainly "built" by art historians as a fairly autonomous domain in which chronology and the sequence of schools and styles are the main issues. For some philosophers, art is a contingent manifestation of a transcendental beauty. For art critics, the visual objects express the intentions and skills of an individual artist. For experimen-

tal psychologists, art is a stimulus generating responses whose variations may be measured. Psychiatrists see in art a sublimation of repressed impulses, and art dealers see a source of market commodities. What can anthropologists add to this series of—here oversimplified—"constructions" of art by different groups of specialists?

The reality anthropologists build is not fragmented. It is a whole in which man's activities and creations are not considered each apart from the others. Our studies still validate Tylor's more than century-old definition of culture as "that complex whole which includes knowledge, belief, art, law, morals, custom, and any other capabilities and habits acquired by man as a member of society."[3] Walter Goldschmidt reaffirms the centrality of the concept of culture as an integrated whole in anthropology. "Man does not live leisure on Saturday, religion on Sunday, and economics the other five days of the week; what he believes, what he does, and how he feels are all of a piece."[4] His detailed ethnography of the Sebei, an African people, is a convincing demonstration that a culture is a whole, "not merely in the sense of interconnection, but on a much deeper level."[5]

In an anthropological perspective, art is not reduced to an ideational configuration of forms; it is situated among other systems such as philosophies, religious beliefs, and political doctrines. It is not separated from the societal organizations that support it (academies, art schools, museum and commercial galleries), nor from the institutional-ized networks of the total society (government, castes and classes, economic agencies, and private corporations). It is related to the system of production which constitutes the material basis of the society. A first contribution of anthropology is the construction of art within an encompassing reality.

A second is a cross-cultural scope. Anthropology began as an ethnology of nonliter-ate societies, and it has been comparative ever since its origin. Many other social sciences are comparative, but none has such a wide range of comparison, from the small-scale societies of hunters and gatherers to the enormous contemporary industrial states. Difference in size would invalidate any comparison if the fundamental unity of human-kind were not recognized as a basic element of our reality. Because the human organism, particularly the nervous system, is practically identical among all living populations, we may assume that its main functions, such as acting, thinking, contemplating, being affected by feelings and emotions, are not limited to some human populations. As creation and appreciation of art are mental processes, it is not unwarranted to look for their manifestations in the whole gamut of cultures. We do not know if art phenom-ena are universal, and we do not a priori claim that they should be. We just say that they could be.

Probing into these "anthropology of art" questions, I was soon treading ground not mapped by mainstream anthropology. I had to consider problems new for anthropol-ogists. How are art objects distinguished from other man-made things? Is there a specific perception of the artistic quality? Is there a contemplative mode of consciousness to be distinguished from cognition and affectivity? Since anthropology did not provide me with the conceptual tools needed for approaching these questions, I looked for them in other disciplines of knowledge. The first results of this query were published in my *Introduction to Aesthetic Anthropology*.[6]

The *Introduction*, limited by the constraints of the series in which it was first pub-lished, touched many points too briefly; in the present book they receive the more extended treatment they deserve. Also, the exploration of the aesthetic experience was

left unfinished in the *Introduction*. I did not consider its symbolic dimension and the implications of symbolism. Yet it is only through the symbolic character of art that we can clarify some fundamental questions: the basis for preferences in art, the assessment of the aesthetic quality, and the relevance of communication and emotion to the analysis of art. These matters, which were beyond the scope of the *Introduction*, are discussed here.

When I wrote the *Introduction*, I shared with phenomenologists the assumption that art is not an independent entity, either in the world out there or in the realm of essences and ideas, but a mental construction agreed upon by a group of people. This was for me an important philosophical position, but without significant consequences for empirical research. Now, I better appreciate the methodological implications of this theoretical standpoint.

I suggested above that art history, psychology, anthropology, and other disciplines of knowledge "build" art, whereas it is more usual to say that they "observe" art. Social sciences, as well as the humanities, use the common language of a society (except for a few so-called technical terms), and the common language indeed implies that there is a world of things out there (rocks, tables, paintings, sculptures, etc.) as well as a world of nonmaterial entities (love, prestige, beauty, the past, etc.). It further implies that these material or ideal things have an existence of their own, and that they can be observed and known. For example, the prestige of the current president may be measured and compared to the prestige of past presidents. To know things is to say in words what they are. If what is said about a thing—or, more precisely, an *object*—corresponds to what it is, this bit of knowledge is true; if not, it is false. The language we use in everyday life, as well as in the social sciences, constantly reiterates the implicit belief in an external world of observable objects. It also reiterates the notion that truth is conformity of what is stated about an object with what the object is.

If we, social scientists, live in the world implied by the language we speak, then we approach art as an external entity. This suggests to us certain questions such as, How can we define art with objectivity? and, Is there true art in this or that society? If, on the contrary, we consider art as a collective construction, we are led to ask other questions such as, Has this particular society built in *its* reality something similar to what is called art in *our* reality? and, What is implied in what they say and do when they look at this carving? In this perspective, we do not compare a collective view with its object but with another collective reality, constructed either by a community of scholars or by our own society. In this approach, one does not claim that a particular view, even the observer's critical view, is a closer approximation to a part of an external world than another view; one does not compare two representations of the same object, to the object; one compares two realities.

Why use the term *reality*? Does it not denote what is usually called *world view*, *Weltanschauung*, *image du monde*: ideational configurations in which a society expresses its outlook on the total environment in which its members live? Indeed, reality refers to such an ideational system, but it makes clear that these systems are not images of a reality but the reality itself. When I see a painting as artistic, a ceremony as religious, an act as political, a transaction as economic, I perceive these qualities as "real" in the sense that they exist independently from my views of them. To me, they are neither imaginary nor arbitrary. When I attend a Catholic mass, I do not feel free to call it an economic

transaction; it is a religious ritual, whatever I may think of it, because it is considered that way by the members of my society. The term *reality* connotes this independence from the subject's mind. This is why we prefer it. It reminds us of the firmness and solidity of the collective constructions.

We prefer it for a second reason. World *views* and similar terms again suggest a reference to external objects. They imply that they are *views* of the world, *images, reflections* of something which is beyond them. The word reality implies no further reference to an external object; it excludes being an image of something else, thus being either true or false. The real simply is.

A reality, independent from an individual subject as well as from an object beyond itself, is the mental construction of a group. It is a "socially constructed reality," to use the terminology of Berger and Luckmann.[7] Its validity is based on the consensus of the total society or of one of its specialized groups. The French men and women of the thirteenth century agreed on, and lived in, a reality that included an earth-centered universe, a humankind damned by an original sin and redeemed by a divine savior, and a social order dominated by a king and a nobility. The French people of the twentieth century have constructed, and are living in, a completely different reality. The reality built by the physicists of today bears no resemblance to the reality of the physicists of one century ago. Each of these realities was, or is, validated by the consensus of the contemporaries, be they the common men and women of a society or the specialists in a certain field.

We should not forget that this book deals with socially constructed realities and not with a world of external entities, material or nonmaterial. This phenomenological position should imbue every step of our study. It makes indeed a difference even at the level of the concrete development of a research.

It is hoped that this study will be a modest contribution to knowledge. In the phenomenological perspective, previously outlined, how can one contribute to knowledge? By extending or modifying the reality built by precedent anthropologists and other social scientists. Scholarly realities are in constant process: each new book or article changes them a little or, sometimes, very much. In order to be included in a disciplinary reality, a contribution must fit in the preexisting construction. As with material buildings designed by architects, it is a matter of continuity in materials (a stone wall should not be extended with bricks), in techniques (a standard mass-produced door should not be put next to a handcrafted one), and in styles (a Gothic steeple should not surmount a neoclassic church). Similarly, the kind of data, the methods of research, and the type of discourse usual in a branch of knowledge should also be found in any new contribution. Some revolutionary changes in the paradigms of a science might also happen, as we have been made aware by Kuhn, but continuity is more frequent.[8]

In the Western tradition of critical knowledge, there is only one model for acceptable cognition. The starting point is a *theory*, a carefully worked out reality, usually expressed in a well-defined system. For instance, the cultural materialist theory, which states that in a culture the source of dynamism is primarily located in the productive process. The visual forms of artifacts are thus expected to be influenced by this process and to reflect the differences in the systems of production.

From the theory, *hypotheses* are generated. For instance, one may deduce from

Ritual figurine. Teke, Congo. Private collection,
Los Angeles. Photo by Jacques Maquet.

cultural materialism that the forms of artifacts made in the African equatorial forest societies will display folk-style characteristics because on the subsistence level of production there is no division of labor and no specialization of craftsmen. The savanna kingdoms, which produce a surplus, on the other hand, will develop court, or elite, art forms in their artifacts. The difference between a theory and a hypothesis is that the theory cannot be directly confronted with facts whereas a hypothesis can be tested.

This testing, under the form of *empirical observation*, is the third step of our paradigm of critical knowledge. In our example, it is possible to observe the artifacts made in forest societies and in savanna kingdoms and see if there is a folk/elite difference in their forms.

Because the three steps of the paradigm—theory, hypothesis, and observation—are emphasized differently in the physical sciences, the social sciences, and the humanities, the complete model may not be apparent in some research, and an analysis may be needed to reveal it. Later we shall come back to this matter. I mention this well-known paradigm of critical knowledge here because it does not seem to fit in a phenomenological perspective. It appears to imply that theory and hypothesis are mental representations of something external, and that observation is a comparison between that something external and its image.

Certainly, this is usually how it is understood. Yet it need not be so. What we observe is also a built reality. In our example, the two pairs of variables, *subsistence production/ surplus production* and *folk style/court style*, are concepts defined by the observers. For instance, subsistence and surplus may be defined with reference to individual families or to the whole societal unit. A society may have no surplus to export although its individual

Cup. Kuba, Zaire. Royal Museum of Central Africa, Section of Ethnography, Tervuren, Belgium.

farmers produce more than their families need. The other pair of variables is also defined by the observers. They may decide that abundant ornamentation, glossy finish, and professional-like expertise are the criteria of an elite style; or they may choose other features. It is the observer who selects the criteria and who defines each of them. In other terms, the facts are not out there, they are made-up.

We have been trained to regard *facts* as external touchstones of our knowledge. "A hypothesis is proved if supported by facts" because, it is usually understood, the intellectually anticipated relationship can be observed in the world out there. "Confirmation by facts" can be better described as the fit of a newly constructed extension of reality (the hypothesis) into a previously built system (the facts). Ironically, the word *fact*, which connotes independent entities for most of us, comes from the Latin *factum*, which means *made*.

In the present study, when using the paradigm of valid knowledge—theory, hypothesis, observation—we remain aware that the facts we observe are themselves parts of a socially constructed reality. This does not deprive them of their confirming value, but it does qualify it.

Art is a part of a socially constructed reality. Our first task is to apprehend that part of reality and to describe it.

There are as many realities as there are long-lived and stable groups of interacting people engaged in related activities. Each of them creates its reality. In a plural society (which includes several ethnic or religious groups, or a stratification of classes or castes) and in any large and complex society (which comprises specialized occupations), there are several realities. Cattle owners and land tillers in Rwanda, Brahmin and Sudra in India, upper-class New Yorkers and Lower East Side dwellers, nuclear scientists and monks, bankers and janitors live in different "worlds," as it is often stated. Yet each of these pairs lives in the same encompassing society during the same period. When members of the two groups within the pair meet, they interact and talk with each other. Their common ground is what phenomenologists call the "everyday reality."

All members of plural and complex societies, in fact, spend a large part of their lives in everyday reality. The philosopher's proverbial man in the street is every one of us, most of the time. It is only when we explicitly act as members of a group or a profession that we switch to a specialized reality. For the physicist in the laboratory, matter is constituted of electrically charged subatomic particles in motion, but outside the laboratory, bricks and timber are as solid, massive, and inert for physicists as for the man in the street. In the classroom, the teacher explains that colors are not properties of things, but characteristics of reflected light: they are electromagnetic radiations which have a certain wavelength range; but when the class is over, teacher and students continue to speak of red apples and yellow grapefruit. The yogi, who while sitting in meditation has experienced a state of egolessness, still uses the ordinary pronouns *I* and *me* in conversation. The reality constructed from everyday living is an unavoidable one for us all, most of the time.

For this reason, it seems to me that a good research procedure is first to consider art in terms of the everyday reality, rather than in those of the more specialized realities of philosophers, critics, and even artists.

Another reason is that the reality common to all the members of a society is more similar to another common societal reality than the particular realities of specialized

groups. All over the world, everyday realities reflect some universal human experiences: using the environment for collective survival, coping with the unfolding of the life cycle, and communicating for the sake of cooperation. The principal values sought for in the mainstream social life seem to be the same everywhere: power and prestige, affluence and pleasure. These quasi-universal experiences generate similarities in everyday realities.

The ordinary language spoken by all the members of a society creates a set of assumptions shared by its users. For instance, the grammatical organization of the English language makes its users speak in sentences consisting of at least a subject and a predicate. "This tree is beautiful" and "Carol is tall." There is no practical way to speak English without attributing predicates to subjects. The implied assumption is that we live among substantial beings, like Carol and the tree, which keep their identities as long as they exist, and to which we attribute qualities, like tallness and beauty. This grammatical structure "builds" qualities as separate from the subject: tallness does not belong to the core identity of Carol, neither does beauty belong to the tree. Indeed if I say "Carol is beautiful" and "This tree is tall" I do not imply that Carol and the tree are substantially affected by the new predicates; the same subjects simply support other qualities. The subject-predicate structure, though, is not limited to English: it exists in most languages, as do certain other linguistic features. This is another reason for anticipating convergences in the everyday realities of many societies.

Anthropologists are, and have always been, concerned with intercultural comparisons. Comparing requires some similarities between the things to be compared. Art objects and experiences should be first considered within everyday realities because this is where similarities may be expected.

Art should exist as an explicit category in the common language of the ordinary people of the society we wish to consider first. The word *art*, or its correspondent in the language spoken by the whole society, should be understood and occasionally used by everybody. It should make sense to all who hear it in conversation or on the radio and who read it in a newspaper. The ability to understand words and to use them meaningfully is, of course, different from the capability to define them. Everyday language, an instrument for living, does not include many verbal definitions. I cannot define electronics, but I can competently use my pocket electronic calculator. And, when I buy one, I can clearly indicate to the salesperson the features I want it to have. When a man says "I love you" to a woman, this statement makes sense to them, and to somebody who happens to overhear it; it is meaningful and does not require a discussion of the concept of love. Defining words and concepts in common use is the specialized task of those who compile dictionaries; it is not a skill necessary for everyday communication and interaction.

The presence or absence of the word *art* in everyday vocabulary is a matter I raise here because anthropologists have found out that a corresponding word does not exist in most of the languages of the nonliterate societies they used to study exclusively. This may appear surprising, since anthropologists have written articles and books on the arts of these societies, and in chapter 7 I shall discuss at length the implications of the paradox. A brief comment can be made here. It is the American and European observers of nonliterate cultures who have designated some objects made in these societies as *primitive*

art. Carvings representing men, women, or animals, colorful ornaments, decorated panels, and similar objects were said to be "art." They were analogous to some of the objects Western artists had produced for centuries: figurative sculptures and paintings, adornments and embellishments of surfaces, and decorative patterns.

Lest this observation seem too simplistic, I wish to add here that this process of assimilating into the art category objects imported from faraway and dominated countries is ancient and recurrent in history. Often the makers of the objects called "artistic" did not have the word *art* in their vocabulary. The conquerors attributed this quality to these objects. Victorious armies incorporated into the artistic reality of their homeland the looted pieces brought back from the defeated countries.

In terms of scholarly strategy, it would not be advisable to start our study in a culture which does not possess in its language a word that could translate the English term *art*. Of course, at a later stage, we shall consider what conclusions we may draw for aesthetic anthropology from the fact that some societies do not have a word for art in their common language.

Contemporary industrial societies explicitly include art as a word in their common languages and as a part of their everyday realities. As I happen to live in Los Angeles, I refer to its metropolitan culture as the everyday reality in which to start the investigation of art. Yet, as the focus of our study is not what is specific to the Los Angeles cultural scene, we could begin our inquiry in any large urban area of the contemporary world, make similar observations, and draw similar conclusions. Paraphrasing the ancient philosophers' dictum "In any man, the same nature," we can say "In any city of our age, the same everyday."

It could be objected that by beginning anthropology at home we are guilty of ethnocentrism, one of the anthropologist's capital sins. The sin is to take one's collective reality for an external and independent world, which then becomes the absolute criterion of correctness for other cultural views. If we were to consider that art, as implied and expressed in the Los Angeles language and practice, is what art is 'in itself', and what it should be, we would be ethnocentric. Here, we are aware that our "home definition" of art is simply *our* reality and not a standard for others.

Another objection is that there is the difficulty of maintaining an objective stance when concerned with one's own society. It is assumed that the observers' biases, interests, and emotional involvements are almost insuperable when observers are immersed, as members, in the societies they study.

One should realize, however, that observers are *also* involved when they study societies foreign to them. On the surface, involvement may be less apparent and less directly identifiable. But, at a deeper level, involvement is strong: when one decides to share the life of an alien society for one year and often for a longer period, the stakes are high for the ego. If involvement is deemed an obstacle to objectivity, it is not limited to "home anthropology."

But is this an obstacle? In the conventional paradigm of the validity of knowledge, as conformity to an external object, certainly involvement is an obstacle. In our phenomenological perspective, however, involvement may be turned into an asset, particularly at the descriptive stage of our inquiry. At this point, what we need is an understanding of *art in everyday reality* in the culture of a contemporary urban area of the industrialized world. Having an insider's access to that reality will be an aid to understanding it.

Art in Human Experience

CHAPTER TWO

Art in Everyday Reality

TO THE WORD ART, THERE CORRESPOND SEVERAL CONCEPTS, MEANINGS, OR INTELLECTUAL representations. We would like to know what art means for the men and women of today who live and work in a large city. To ask them, or a representative sample of them, the direct question, What does art mean? would provide idiosyncratic answers and many instances of "I don't know." The culture of everyday life includes very few definitions of concepts, and certainly no definition of art. Yet a concept of art may be inferred from our daily behaviors and categories. Though working in our own society, we have to use the same approaches as an anthropologist in an unfamiliar culture. One of these approaches, the one we choose here, is to start from the *insiders'* categories.

From the insiders' point of view, the word *art* does not primarily point to a notion, but to a category of material objects. In its daily use, it serves for designating a class of things, for distinguishing them from other things. When anthropologist Mesquitela Lima was among the Cokwe of Angola, he noticed that the word *hamba* referred to an important concept in the Cokwe system of beliefs concerning spirits, and that a variety of things—such as small carved figurines, stones, and plain pieces of wood—were designated by the same term, *hamba*. He began his research by delimiting the class of objects called *hamba*.[1] Let us begin by exploring the sets of objects subsumed under the category of art for the people living in Los Angeles.

A good survey of what is put into this category in our culture may be found in the classified telephone directory of Los Angeles. The alphabetical entries, from "Art Galleries, Dealers & Consultants" to "Art Schools," cover most of the institutions, occupations, and societal networks recognized as being associated with art objects. We are informed on where to go if we want to buy paintings, graphics, sculpture, drawings, prints, weavings, and silk screens. Or if we want to rent them or sell them, to have them cleaned, restored, appraised, packed, and shipped. Some galleries are specialized in ancient and primitive art, others in French Impressionists and Fauves, and others in etchings from Chagall, Picasso, and Miró. Folk art collections are offered by other dealers.

Information is also provided on making art objects, with schools for learning painting, drawing, sculpturing, industrial design, photography, and ceramics, and shops where the necessary art supplies can be purchased. The area's art museums, where art objects are on exhibition, are also mentioned.

The focus of all these directory entries is the *art object*. On the basis of the knowledge held in common by all members of our society (or, at least made available to them in the general dictionaries of our language), we may infer that art objects are these items made by the classical techniques of painting, drawing, and sculpturing, plus a few related techniques like photography, weaving, and pottery. Art, as used in the directory, does not include all the fine arts recognized in the nineteenth-century academic classification: what is related to architecture, literature, drama, music, and dance is not cross-referred.

Classified directories are meant for consumers; they are exclusively business-oriented. The art entries tell us that, among all the commodities on the market, there is a commercially recognized category of art objects. Unlike concepts, market categories do not overlap; they are exclusive in the sense that items of the same type are not sold under more than one category. Market categories have a high degree of stability, for they reflect the specialization of commercial enterprises. This absence of ambiguity is very fortunate—and unusual—as it makes it possible for the observer to identify the extension of a class of phenomena from the point of view of the society that is studied. What an anthropologist wants to study—for example, religious phenomena—often does not correspond to an inside category embodied in a class of material objects. In such a case, the anthropologist is left wondering if, for instance, a given ceremony is religious, magic, or political.

The art object category is not only commercially based. It is also recognized as a focal category in some educational institutions: art museums and art schools. A large number of specialized persons (curators, teachers, administrators, librarians, technicians, guides, and museum attendants), an imposing architectural complex of buildings (exhibition

Hamba in a basket. Cokwe, Zaire. Instituto de Investigação Cientifica Angola, Luanda. Photo from Lima 1971.

WILLEM DE KOONING. *Woman, II.* 1952. Collection, The Museum of Modern Art, New York. Gift of Mrs. John D. Rockefeller 3rd.

halls, maintenance workshops, storage rooms, lecture halls, classrooms, studios, restaurants, and kitchens), a multiple organization of services (audiovisual production, research, conservation, teaching, public relations, fund raising, and security) supported by public and private funds are related to and have developed around these movable items called art objects.

All this is common knowledge in our society. According to the usual expression, "everybody knows" that among the material things around us, there is a distinct class of things known as art objects, and "everybody knows" where to find them: in museums and galleries. This is a part of the everyday reality in which we live, not only in Los Angeles, but in any large city of the contemporary industrialized world.

Our daily reality provides us with a first, and unambiguous, indicator for identifying art objects: objects exhibited in museums and sold in galleries are art objects.

In addition to social categories used for practical classification, the everyday reality is expressed by what people say in informal conversations. Talking with the man in the street, remembering some comments we heard or made ourselves (the man in the street, after all, is our everyday self), we become aware that some art objects in galleries and museums are considered by some people as not "really" art. At the Museum of Modern Art in New York, I overheard angry visitors saying "This is not art," when they were

looking at a painting of the *Woman* series by Willem de Kooning or at an Andy Warhol *Campbell's Soup* picture.

In daily speech, art also connotes a positive value. "A bad painting is not art, and should not be hung on the walls of a museum" is a summary of many comments. A piece, to be really art, should have a certain "artistic" value. The everyday reality seems thus to offer two criteria for identifying art objects: location in a museum or gallery and something called artistic value.

The two criteria are complementary rather than contradictory. The "artistic value" is the reason an object should be exhibited in a museum or offered for sale in a gallery. Museum and gallery objects are presumed to have an artistic value, and when it is lacking we feel deceived in our expectations. When our response to an object is "This is not art," we express disappointment.

At this point in our study, the criterion of artistic value cannot replace the criterion of location as an indicator. We do not yet know how to recognize the artistic value of an object, whereas it is fairly easy to identify art objects by their belonging to the museum-gallery network. We shall thus continue to use it, but we note that in the common reality of our culture the still mysterious artistic value is a positive attribute that should characterize exhibited objects.

Let us now proceed to museums and galleries, and observe the behavior of the people around us, as well as our own. Behaviors indirectly reveal, too, what reality a society has built, and is still building—for reality construction is an ongoing process.

Museum visitors walk slowly from one painting to another, from a statue to a vase, from an eighteenth-century armchair to a showcase with a few pieces of china. They stop in front of the objects and look at them; they read the short notices on the labels and look back at the objects. In front of a painting, they move back and forth until they have found a spot at the right distance and angle from where they feel it best seen. Sometimes a docent gives an explanation, or a visitor makes a comment for the benefit of another; what is said refers to what they are looking at. It is appropriate to speak softly so as not to disturb other viewers. One should refrain from touching anything and from sitting on the exhibited chairs. One may sit on benches set up in relation to the things to be seen, and not in a manner favoring conversation as in a living room or a hotel lobby.

Such is the museum behavior generally expected. It is different from the behavioral patterns appropriate in a church, in an airport waiting hall, or at a cocktail party. Museum behavior clearly expresses that visitors are there for looking at the objects on display.

Similar patterns of conduct are in order wherever items recognized as art objects are presented: in galleries, in sculpture gardens, in the homes of art collectors, or in the halls or on the grounds of private corporations and public buildings. In the latter places, which have other functions than to house art objects, one pays attention to them only occasionally; when one does, it is by silently looking at them.

From these socially expected behaviors, we immediately may infer another facet of the social reality of art objects: to be beheld is their proper and only use. Paintings are hung on walls, sculptures are erected in gardens, murals are applied on plastered surfaces just to be looked at. This is an immediate inference: it does not have to be proved by reasoning. It carries its own evidence in everyday knowledge. What else could be done with a painting, a drawing, a mural, a statue, a photograph but to look at them? They were made for that purpose: they are visual objects by destination.

East Building interior courtyard. National Gallery
of Art, Washington, D.C.

PAUL DE LAMERIE. Silver dish and bowl. c. 1725.
Los Angeles County Museum of Art.
The Mr. and Mrs. Arthur Gilbert Collection.

But what about the eighteenth-century armchairs, the silverware, the tables and desks that are exhibited in our fine arts museums? They were made to be used for sitting, eating, serving a cup of tea, or writing upon, and in fact they were used that way. And what about the industrially made objects on display at the Museum of Modern Art, such as a Thonet rocking chair, a Braun coffee grinder, an Olivetti typewriter? And what about the furniture on display at the Musée du Louvre during the 1972 temporary exhibition devoted to Knoll International? These objects were designed for specific uses and are still performing their intended functions in many kitchens and living rooms, offices and conference rooms. They were not destined to be visual objects.

Yet in museum settings they were metamorphosed into art objects to be looked at. As mentioned in my *Introduction*, the distinction between "art by destination" and "art by metamorphosis" is useful.[2] Originally made by André Malraux in his *Museum Without Walls*, it brings a welcome clarity to the reason for such a variety of objects in fine art museums.[3]

When visiting a museum, one can assign each art object to either one of the two categories. Belonging to the category of art by destination are landscapes and still lifes, narrative and genre pictures, nudes and mythological characters, abstractions and nonfigurations. Such two- or three-dimensional objects certainly were drawn or painted, carved or cast in order to be art objects. On the contrary, classified as art by metamorphosis are those objects, hand crafted or industrially produced, which originally belonged to

THONET BROTHERS. Rocking chair. 1860. Collection, The Museum of Modern Art, New York. Gift of Café Nicholson.

A Thonet rocking chair in a private residence. Les Issambres, Var, France. Photo by Jacques Maquet.

MARCELLO NIZZOLI. Olivetti typewriter. 1949. Collection, The Museum of Modern Art, New York. Gift of the Olivetti Corporation of America.

CHARLES POLLOCK. Knoll armchair and side chair. 1965. Photo by Herbert Matter (Knoll 1971).

Virgin and Child. Auvergne, France. 12th century.
The Metropolitan Museum of Art, New York. Gift
of J. Pierpont Morgan, 1916 (16.32.194).

Reclining couple on sarcophagus. c. 520 B.C.
Museo Nazionale di Villa Giulia, Rome.
Photo by Brogi.

NANA KRAUS. *Portrait of Erwin Broner, Architect.*
1984. Artist's collection, Los Angeles. Photo by
Jacques Maquet.

contexts other than art, but later on were included in the network of galleries and museums.

A "context other than art" is not restricted to the world of utilitarian objects, the only ones we have mentioned so far. It also includes objects made for use in religious ritual, government ceremonial, and family memorial. A statue of the Virgin and Child carved from wood during the twelfth century to be placed in a church in Auvergne became a work of art eight centuries later when displayed in a New York museum, The Cloisters.

An Etruscan terracotta representing a reclining couple is a stunning piece that may be seen at the Museo Nazionale di Villa Giulia, in Rome. This sculpture was made twenty-five centuries ago as the lid of a sarcophagus, in the context of cult homage to the family forebears. It became "art" when it was excavated.

Among the statues sheltered in our museums, some originally were erected on public squares to glorify national heroes, and among the paintings, there are many portraits which were intended to be memorials of personalities important to their country, their city, or just their family. Now, heroes and personalities have been forgotten. For the museum visitor, the portraits are identified as "a Greco," "a Frans Hals," and "a Picasso"—not as Brother Paravicino, Pieter van den Broecke, and Kahnweiler, who were the persons represented. In the museum context, the images of these individuals were metamorphosed into art.

"Primitive art" covers another large group of artifacts that were metamorphosed into art objects. In the societies where they were created, the masks of traditional Black Africa were worn by dancers in order to provide spirits with embodiments through which they could express emotions and feelings and communicate requests and demands. In European and American museums, masks were separated from dances and from the rest of the costumes. They were put in a showcase, and they became motionless carvings.[4]

In their traditional setting, the ancestral statues carved in the societies of the equatorial forest of Africa evoked the continuity of the kinship group and the solidarity of all the descendants of a common ancestor, the lineage founder. Offerings were brought to them in the family compound where they were kept.

In the kingdoms of West Africa, as well as in those of the savanna south of the equatorial forest, royal headdresses, ornated scepters, and ceremonial stools represented the glory and the power of kings and paramount chiefs, and they were revered as signs of authority. When separated from their cultures of origin and physically removed to very different societies, such objects can no longer operate as they used to do in their primary contexts. In the new environments, there are no spirits in search of a body who could dwell in these particular masks, no lineage reaffirming its unity, and no ruler requiring his subjects' homage in the forms which were prescribed in faraway kingdoms.

A metamorphosis is unavoidable: a new reality has to be constructed for these objects so that they make sense for the people living in the society into which they have been introduced. The metamorphosis is not always into an art object. It may be into a curiosity, something strange which reveals how "different from us" are those who made these objects, or into an artifact of material culture in the collection of an ethnographic museum, or even into a "fetish," an "idol," a false god—all demonstrating the superiority of our own gods.

The visitor to an art museum who pays attention to the distinction between the two categories of art object—by destination and by metamorphosis—will discover how numerous are the items that were not made for display only. In fact, few art objects by destination were ever made in pre-Renaissance Europe or in nonliterate societies.

Royal headdress. Rwanda. Royal Museum of
Central Africa, Section of Ethnography,
Tervuren, Belgium.

Royal headdress worn by King Rudahigwa in a
public ceremony. Nyanza, Rwanda. 1955.
Photo by Jacques Maquet.

In our everyday reality, art is first approached as an action-oriented or practical
category. Everyday knowledge is more concerned with where to find art and how to deal
with it than with what it is. The everyday category of art first includes those man-made
objects which are exhibited in museums and transacted about in galleries. The objects
thus identified as art objects are at the center of a specialized network of educational
institutions, professional associations, and commercial enterprises. This approach to the
art phenomenon evokes the famous "definition" of a Jew as somebody regarded as a
Jew by self and others. The statement is not a definition, it does not tell what Jewishness
is but merely provides an indicator of identification. It is only a first step.

The everyday reality further provides us with a behavioral model for our encounters
with art objects: we are expected to look at them. Their only use is visual, even when their
acquisition was motivated solely by the buyer's search for social prestige. Observing art
objects, we notice that some of them were made only to be looked at (there are no other
possible uses that we can discover), whereas many had other functions outside the art
context (such as utilitarian, religious, or political). This distinction is not explicitly stated

in the everyday culture; it is an observer's interpretation founded on general historical knowledge.

Finally, the everyday reality of art includes the notion of artistic value. Museum and gallery objects are expected to show evidence of an undefined quality (that we simply call artistic for lack of any more precision at this point). It is perceived as essential: objects wanting in it should not be displayed, in fact should not even be called "art."

CHAPTER THREE

The Aesthetic Vision

ART OBJECTS—SOCIALLY IDENTIFIED AS SUCH—ARE ON DISPLAY IN MUSEUMS AND HOMES, IN gardens and palaces only to be looked at. This is strange. We spend almost all our waking hours with open eyes, looking at things and people. The urban environment is almost entirely man-made, and we have to be visually aware of it all the time. Why should more objects be made only to be looked at?

The adverb *only* suggests that we may look at things not just for looking at them, but for ulterior reasons. When I look at a traffic light, it is not only to receive a visual impression of red, green, or yellow, but to conform my driving to the directions given by the lights. When walking on the street, I look around me in order not to get lost, not to bump into somebody, and to recognize a friend if, perchance, one comes by. In a library, I do not just look at a book, but I read the text in order to understand what the author wrote.

These are different ways to look at something: the quick and precise glance at the traffic light distinguished among all the lights of a downtown business street, the scanning and panoramic look when moving in a crowd, and the focusing of the reader's eyes on the words of the book. Is there another way of looking when in the presence of art objects?

There is a way of looking at art objects which is different from the ways just illustrated. This visual relationship between a viewer and an art object is a specific mental phenomenon.

Social scientists do not feel comfortable when they have to describe and analyze inner processes. They believe that they should not trust their own introspection, as it is subjective; that they should not accept informants' introspections if they do not have behavioral correlates; and that observations of mental states cannot be independently repeated by several observers. These methodological doubts and objections rest on a certain conception of objectivity that has evolved from the scientific study of physical phenomena. The criteria applied in that field cannot simply be transferred to the study of mental phenomena. A field of investigation should not be closed on the grounds that the research methods of another are not applicable. In each area of phenomena, such as

ROBERT GRAHAM. *Dance Column I,* detail. 1978.
Franklin D. Murphy Sculpture Garden, University
of California, Los Angeles. Photo by Jacques
Maquet.

physical, biological, social, and mental, there are strategies which permit attainment of
critical knowledge. Called "science" in the physical and biological areas, and "scholar-
ship" in the humanities, critical knowledge is systematically built with a primary concern
for cognitive validity.

Critical knowledge can be opposed to ordinary knowledge where such a concern is
not of overriding importance. But critical knowledge is rooted in the commonsense
methods of everyday knowledge. In ordinary life we have to take into account the mental
states of others and thus try to understand them. We use, quite reasonably, different
approaches.

The first approach is to refer the mental experience of somebody else to an analo-
gous experience we have had. You tell me that you have a strange guilt feeling since your
father passed away last month, though you know you have no responsibility in his death
due to cancer, and in fact you loved him very much. I can understand what you feel.
Twenty years ago, I heard on the news that the flight to London on which my brother was
booked had ended in a crash. To my surprise, I was overwhelmed with guilt more than
grief.

Because we can refer to an accumulation of experiences kept in memory, we can
understand analogous feelings, emotions, and processes occurring in others' minds. In
fact, even in scientific studies, we refer to our accumulated experience more than we like

SOREL ETROG. *Mother and Child.* 1964. Franklin D.
Murphy Sculpture Garden, University of
California, Los Angeles. Photo by Jacques Maquet.

to admit. Commenting on a theory of perception, the philosopher Frits Staal notes that "our personal knowledge of perception is vast and is taken for granted. When we study reports on perception or theories of perception, we make constant use of this repository." He concludes that "without the vast experience of perception which we all have accumulated from early childhood," the scientific literature on perception could not have been written, nor would it be intelligible.[1]

Let us call this first approach to inner phenomena *experiential reference*. In order to understand what "looking at an art object" is, let us remember what we experienced when looking at a work of art, or let us go to a museum and look at one.

I very vividly remember my encounter with the large Calder stabile in the garden of the Museum of the Maeght Foundation in Saint-Paul-de-Vence a few years ago. Wandering through the outdoor museum with two friends, I first saw the stabile from a distance. It is erected among trees with a light-colored foliage—silver birches, I believe. There stood huge, nonfigurative forms in black steel plates, very much in contrast to the green and sunny environment. Their presence imposed on my attention. Moving closer, I stopped where I could best see the stabile and I looked at it for some time, not being aware if the time was short or long. Later, I did not remember if I was standing or sitting: I was just looking. The image of the stabile is very clear in my mind; I still see the general shape as well as some details of the metal surface. Though I was looking with intensity, I did not try to analyze the different shapes of the plates, nor to figure out the height or the weight of the stabile. In fact, I did not think at all while I was looking, nor did I pay any attention to my companions. I did enjoy the experience, but I became aware of the enjoyment only later, after the actual encounter was over. During the experience, I was not in an introspective mood, and I did not even notice my affective state: pleasure or absence of pleasure. In fact, "I," my usual self, was not in the foreground of my awareness; the visual experience of that sculpture was filling all my consciousness.

Later, when discussing with my companions what we had seen at the museum, I had little to say about the stabile. I told them that my visual experience had been intense, that for a time it somehow had put me outside of my usual stream of thoughts, worries, and feelings. When asked what Calder meant by the sculpture, all I could say, after some reflection, was that the stabile meant for me a powerful, but latent and contained, energy. It was a force that was not threatening, but friendly and even reassuring; it was ready to flow in harmony with the trees around, it was not going to explode and destroy.* I had no comments to offer on the place of that piece in the evolution of Calder's artistic career, nor on its possible importance in the trends of contemporary sculpture.

This is the kind of experience we can refer to when, as anthropologists, we want to analyze the particular way one looks at art objects. A comparative reflection, remaining very close to experience, reveals differences in our ways of looking at things. I look at a map of sixteenth-century London in order to discover how the city space was organized. I analyze the distribution of the different areas: the King's palace, the nobility's residences, the merchants' establishments, the markets, the port. I am thinking and reasoning all the time; I jot down some notes and make rapid sketches in order to better grasp the essential characteristics of that space. It is an analytical observation aimed at intellectual understanding, very different from the way I looked at the Calder stabile.

*Years later, when preparing this book, I discovered that the name of this stabile was *Les Renforts*, "the reinforcements" (Fondation Maeght 1967: plate 48).

ALEXANDER CALDER. *Les Renforts* (The Reinforcements). 1963. Fondation Maeght, Saint-Paul, Alpes Maritimes, France. Photo by Jacques Maquet. © ADAGP, Paris / VAGA, New York, 1985.

An old postcard with a view of the Taos pueblo is on my desk; recently I found it with other souvenirs in a closet. I look at it and I remember the lovely trip made years ago in the American Southwest, and the friend who was traveling with me; I wonder where she is now. My look at the postcard is a rapid glance that triggers an affective state of nostalgia, pleasant and sad at the same time. In fact, it is for enjoying the bittersweet taste of personal remembrances that I look at old pictures.

In front of me is the city map of Los Angeles. I look at it to find the place where I will have to be later today and the best way to get there. I am not concerned now with the organization of space in Los Angeles, nor with the street names that might conjure nostalgic memories. And I do not look at the grid of the map as if it were a kind of geometrical graphic. I look only for useful indications that will help me get to my appointment.

By referring to one's personal repository of art experiences, one may capture the specificity of looking at art objects, and by a phenomenological analysis, one may express in everyday language some characteristics of the visual relationship to art. The object is seen as a whole, in its totality; its different parts may be perceived as distinct, but are not analyzed separately. The looking is "only looking"; there is no further aim. One does not look at the stabile to find out what welding techniques were used, or as a starting point for daydreaming. It is a visual presentation with nothing behind or beyond it. The art object appears to "dominate" the viewer, in the sense that the latter's importance is not as strongly felt as in ordinary life: it is the object that matters. In other terms, the distinction subject-object becomes less sharp. The awareness of the object has priority over the self-awareness of the subject. As in our preceding analyses, the explicit elucidation of these characteristics—object perceived as a whole, vision not a means to another goal, predominance of the object—is based on direct inferences and remains very close to the beholder's experience.

Experiential reference, the first approach to the inner response to an art object, may be supported by a second approach: the common language and what it implies. Do we find the reality constructed by and revealed through the ordinary language to be congruent with the personal experiences just described?

In the English language which we use everyday, and which everybody understands, there are several simple words that denote, in a rudimentary but clear manner, purely visual responses to things or persons: *beautiful, nice, pretty, handsome,* and their antonyms *ugly, unattractive, inelegant, ungainly.* Certainly these words have other connotations than 'good to look at' (or the opposite), but they have only a visual meaning in many cases. Within the context of a sentence (and when we speak or write, words are always understood to be in sentences), there is no ambiguity: "This tree is beautiful" refers to the tree's visual aspect whereas "Peter is a beautiful person" refers to his moral qualities.

That the meaning 'good to look at' is familiar even to children is illustrated by a study made in 1970 by the psychologist Grace F. Brody. She wanted to assess the preferences among abstract visual forms of over five hundred children ages three to seven. The figures used were the circle, the rectangle, the diamond, and the horizontally and vertically bisected square. The children were shown a perfectly regular rendering and a slightly distorted one of the same figure, and were asked to point to the drawing that looked "nicest."[2]

A significant majority of the children found the regular renderings "nicer" than the distorted ones. These results are not directly relevant to the question we discuss here: what matters is that the children understood the question and that one austere nonrepresentational geometrical form could appear "nicer" to them than another one. They could consider the visual quality as such, and look at the figures in the way characteristic of a pure vision (the experiment had been designed in such a way as to make it impossible to look at the figures as images or as conventional signs). These children had already internalized what is meant by "nice." Certainly they had already often heard comments such as "This coat is very nice, but is not warm" which indicate that the visual aspect of something can be separated from the others and can have a different value. The visual aspect may be positive, and the others, negative.

It may seem strange that these ordinary words repeated by each of us so often every day are associated with the much less frequent visual experience of a work of art. Certainly an engrossing experience of art and the fleeting look at so many things we term "nice" and "pretty" are different experiences, yet they are on a continuum. The word *beautiful* summarizes a positive visual response to an art object: it is indicative of a state of mind rather than descriptive of the object.

When I say "Calder's stabile is beautiful," I mean that when I looked at it, my visual experience was fine. This trite and commonplace statement is, in fact, most appropriate. The experience of "only looking" is not analytical; in retrospect, a description and an analysis of the experience may be attempted if needed for some specific purpose such as giving a lecture about it. But in the normal course of life, it is sufficient simply to take note of the experience, and the hackneyed sentence "This Calder is beautiful" does just that: it indicates that this stabile triggered an appreciative response in the beholder. When applied to a dress, a hairstyle, or a pair of shoes, *nice, pretty,* and *beautiful* are also indicators of a viewer's positive response. But the depth of the experience, though expressed by the same word, is commensurate with the object (a monumental Henry Moore reclining figure, or a necktie) and the circumstances (a coffee grinder in the skillfully lit glass case of a quiet museum gallery, or on the cluttered shelf of a noisy and crowded hardware store).

Some very ordinary words of our everyday language point out the variable quality of visual experiences. This assessment is part of our common reality that "everybody knows." This second approach to mental states through what the common language implies confirms our personal inner experience that we referred to in the first approach.

A third approach is to take cognizance of what the experts say. I understand my friend's guilt regarding his father's death by remembering an analogous experience of mine when I thought that my brother had perished in an airliner accident. But I cannot explain why my friend and I felt guilty about misfortunes for which we were not at all responsible. Reading some psychoanalytic literature, I learn that unconscious hostility and repressed hatred are frequent in a son toward his father, and among rival siblings; that often hostility generates an unconscious wish that father or sibling were dead; and that when father or sibling happens to die, one feels responsibility and remorse for the event. This opinion of the experts provides me with an explanation for mental processes my friend and I experienced.

What are the views of the experts on the visual relationship between beholder and

art object? By experts I mean those who specialize in art history or art criticism, in philosophy or psychology of art, and the connoisseurs and curators who have reflected upon their visual familiarity with art.

Specialists use the term *aesthetic* for denoting the specific quality of the perception and experience of art objects as such. The eighteenth-century German philosopher Alexander Baumgarten is credited with being the first to select the Greek term *aisthetikos*, which originally meant 'pertaining to sense perception', and give it its modern meaning. During the nineteenth and twentieth centuries, the term was widely adopted by specialists and even by ordinary users of the language. The invention, and the widespread adoption, of a new word to designate the response to art indicates that in our reality, there is a specific way to look at works of art.

There is also a consensus of experts on some of the essential characteristics of the aesthetic experience. As a lineage of British thinkers—from Archibald Alison to Clive Bell, Roger Fry, Herbert Read, Edward Bullough, and Harold Osborne—have situated the aesthetic experience at the center of their studies, they have developed a detailed and complex knowledge of it. In *The Art of Appreciation*, Osborne discusses the features that have been regarded as characteristic of the aesthetic attitude.[3] He describes eight such features; his ten-page account is so illuminating that I will summarize it here.

A first feature of the aesthetic perception is that it separates, "frames apart," the object from its visual environment in order to favor the concentration of attention. Second, the context of the object—historical, sociological, and stylistic—so important for the historian, is irrelevant for the aesthetic beholder. "The intellectual interest in knowing all that can be known *about* a work of art may be ancillary to, but is not identical with, the aesthetic interest. The two interests are related but distinct."[4] Third, a complex object is perceived as complex, but it is not analyzed into an assemblage of "parts standing in such and such relations to each other."[5]

Fourth, aesthetic experience is "here and now." Our practical concerns that make the future and the past implicit in all our everyday life are put into abeyance; consequently "the characteristic emotional color" of the aesthetic experience is made of serenity and detachment.[6] Fifth, "those meditative musings and plays of the imagination in which poetic sensibility delights to indulge are also foreign to an aesthetic engrossment," because they interfere with concentration on the visual object.[7]

Sixth, aesthetic perception is concerned with the object as seen, thus with its appearance, not with its existence. Kant associated indifference to the existence of the object with the disinterested approach to it he deemed necessary for the aesthetic perception. What matters is the object as visible, not its existence which makes ownership of it possible. Seventh, when aesthetic absorption is achieved, there is a loss of the sense of time, place, and bodily consciousness. The beholder becomes identified with the object, though a residual awareness of self as distinct is retained. Eighth, aesthetic attention may be directed to anything, but it cannot be maintained beyond what the object can sustain.

This description of what several specialists consider characteristic of aesthetic perceptions certainly confirms that our mental responses to works of art are not idiosyncratic or exceptional.

Our inner experiences concur with the experts' analyses on the specificity of our visual relationship to art objects. Beholding art requires attention. One is, and needs to

be, fully aware of the object; one's concentrated attention may reach the level of absorption when one becomes so engrossed in the object as to be only dimly aware of self. Beholding art requires silencing discursive activities; it is not compatible with an analytical attitude. The object is seen as a totality, and if there is an attempt at analysis, the specific perception recedes in a mental background or disappears. Beholding art requires disinterestedness. A desire to own the object in order to enjoy its exclusive possession, or a vicarious sensual satisfaction generated by the view of the object, is experienced as, and recognized as, an obstacle to the vision of works of art.

These three specific traits of the "only looking" attitude—attention, nondiscursiveness, and disinterestedness—are not explicit in the common language. Yet they are congruent with the ordinary words conveying the meaning of 'good to look at ', such as *nice* and *beautiful*. And, as they exclude the consideration of practical concerns ("This coat is beautiful, but expensive and made of delicate fabric"), these words suggest an absence of material interests, which is a part of being disinterested.

From the particular way we look at art objects, a new concept, *aesthetic object*, is suggested. It is defined as an object stimulating and sustaining in the beholder an attentive, nondiscursive, and disinterested vision. With the introduction of this new concept, we can clarify some questions left unanswered at the end of the preceding chapter.

From observing an urban society in its everyday life, we discovered that the reality referred to by the term *art* included a category of commodities that are found in a specialized segment of the market and that have a specific use. Further, we observed that the same term *art* also expressed a positive quality ("Really, this painting is art"), and that the denotations of the two meanings were not coextensive: all the art objects were not art, and all the objects with an "art quality" were not art objects. Now we can say that the mysterious "art quality" is the aesthetic quality.

The two concepts can be clearly defined and distinguished. *Art objects* are man-made items designed (art by destination) or selected (art by metamorphosis) for display. *Aesthetic objects*, man-made or natural, stimulate a total disinterested vision.

The two classes of objects are related. In an ideal world—where what is intended is realized—art objects would be a subclass of the class of aesthetic objects. In fact, they are two classes which partly overlap.

The distinction between *art* and *aesthetic*, as presented here, does not belong to the reality of the everyday language. Yet it makes explicit what everybody says about a painting that is "not art."

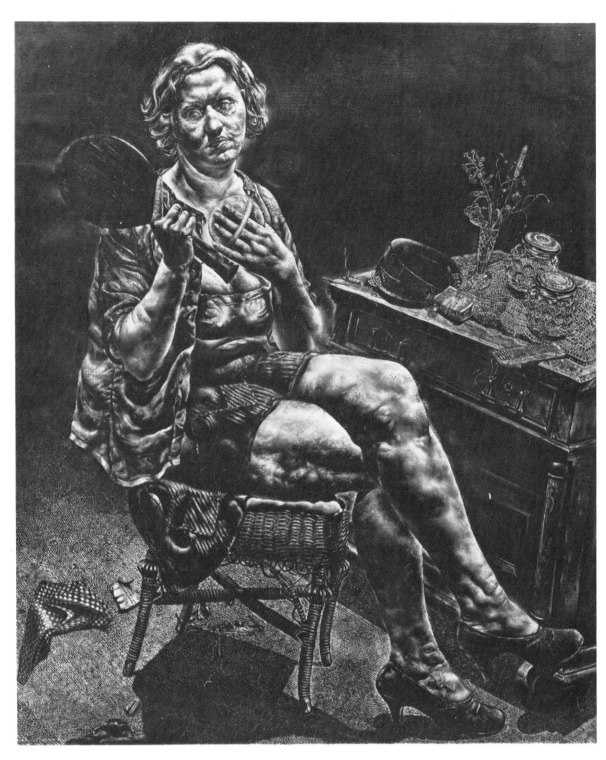

IVAN ALBRIGHT. *Into the World Came a Soul Called Ida*. 1929–30. Courtesy of The Art Institute of Chicago.

CHAPTER FOUR

The Significance of Form

WE HAVE SAID THAT AESTHETIC OBJECTS STIMULATE AND SUSTAIN THE BEHOLDER'S UN-divided, whole, and disinterested visual attention. But we have to go further in our analysis and delve more precisely into what aspect, or aspects, of the object is, or are, aesthetically significant.

It is not the question of the aesthetic evaluation of an object that we want to raise here, nor the question of artistic preferences. We want to find out in what area, as it were, the aesthetic relevance is located. Is it in the representational dimension of the aesthetic object, as in an image depicting beautiful persons, lovely flowers, and dramatic sunsets? Or is it in the craftsmanship dimension, as in a work effectively executed? Or is it in the basic material from which the object has been molded or carved?

In these last decades of the twentieth century, few would pause over these questions. However, less than a century ago, the answers would have been different for the majority of the public. These old attitudes still bear influence today, at a subliminal level. Let us briefly review them here.

If anthropologists are asked whether the society they study produces visual art, chances are that they will add to their answers a reference to images: "yes, they do carve or engrave, paint or draw humans and animals"; or, "no, they do not make pictures." We still tend to equate visual art with representations. There are good reasons for this continuing association.

Since the Renaissance, three of the four visual fine arts—painting, drawing, sculpture, and architecture—have been representational and have remained so until the first nonfigurative paintings, such as those composed by Kandinsky around 1910. During these centuries of figurative art, nonrepresentation was confined to decorative patterns and other ornamentations considered as minor and auxiliary works. Even if the absolute dominance of nonfigurative painting during the 1950s and 1960s is over, the painting of those decades established that representation by itself has no aesthetic relevance.

When paintings, drawings, and sculptures represent recognizable entities of our

GUSTAVE COURBET. *La Rencontre* (The Encounter).
1854. Musée Fabre, Montpellier. Photo by Claude
O'Sughrue.

experience or imagination, do the persons and things depicted matter? In our museums
are represented many attractive young women and handsome young men, elegantly
attired or in the nude; middle-aged men are kings and courtiers, warriors and aristocrats,
displayed with the noble bearing befitting their elevated status; older men are vigorous
and wise, at the peak of a life of intellectual or spiritual achievements. Landscapes are
sunny and inviting, mountains and lakes appear in their pristine freshness, and storms at
sea are more grandiose than frightening. In these images, persons and things are
endowed with more attractive qualities than are people and environments in our daily
lives. Is this "improvement" aesthetically necessary?

A noble and beautiful subject matter was indeed considered essential to art during
the centuries such paintings were made, mostly from the Renaissance to the nineteenth
century. In 1855, when Gustave Courbet proclaimed that artists should set their easels
where peasants live and work rather than in studios, he was regarded as a revolutionary
and called "leader of the School of the Ugly."

Yet even before Courbet's time there were works of art that did not represent
beautiful people and pleasant landscapes. Velázquez's dwarfs and mental defectives and
Goya's beggars and war victims were, and are, regarded as masterpieces. Again,
twentieth-century art makes it clear: subjects as deteriorated as Ivan Albright's middle-
aged and middle-class men and women, as depressed as Edward Hopper's characters,
and as uninviting as Yves Tanguy's landscapes hang on the walls of our museums.
Museum collections implicitly tell us what art theorists and critics explicitly say and

EDWARD HOPPER. *Nighthawks*. 1942. Courtesy of The Art Institute of Chicago.

SANDRO BOTTICELLI. *Birth of Venus*. c. 1482. Uffizi Gallery, Florence.

repeat: that the aesthetic quality of a work of art does not depend upon the attractiveness of what is represented. If Botticelli's *Birth of Venus* is a masterpiece, it is not because there is in the center a lovely young woman.

The painter as a virtuoso imitator of nature has always been fascinating. From the famous story of Zeuxis's grapes, so lifelike that birds were trying to peck them, to the illusionistic perspectives on Baroque ceilings to the contemporary more-than-photo-like images of the hyperrealists, perfect verisimilitude has always been admired as a feat of extraordinary skill. The earliest experience of art appreciation that I remember occurred during a sightseeing tour of Ghent with my mother. We were shown the *Adoration of the Lamb* retable by Hubert and Jan van Eyck. It is a masterpiece, we were informed by the guide, because each blade of grass had been separately painted in order to give the impression that it is a real meadow. Today, we still overhear "Look at the cat, it is so well painted that I could stroke it!" But our contemporaries agree that an illusionistic rendering, though certainly difficult, is not relevant to the aesthetic value of the piece.

Neither is superior craftsmanship, which is attested by a perfect execution of the

Ceremonial mask *(kanaga)*. Dogon, Mali. Museum
of Cultural History, University of California,
Los Angeles.

object: straight lines are really straight, curves are regular, colors are uniformly applied,
surfaces are polished and shiny, and right angles have exactly ninety degrees. From the
impressive Dogon carvings, recognized as masterpieces by the Western public and
critics, to George Segal's plaster figures and to Rauschenberg's mixed-media assem-
blages, many of our museum pieces do not reveal superior craftsmanship or a concern for
it.

The material from which the object is made is likewise irrelevant to the aesthetic
value of a piece. Certainly there are noble materials—such as gold, ivory, pre-
cious stones, and rare timber—which, in the past, were regarded as the only appropriate
ones for certain objects used in Christian ritual or at the king's court. We have since
metamorphosed them into art, but certainly not because they were made in rare and
expensive materials.

We do not say that the areas we have reviewed—representation, subject matter,
mastery in resemblance and perspective, skillful execution, and material—are not noticed
in the aesthetic perception. We only say that these are not the crucial areas that stimulate
and support the aesthetic experience. It is not because it represents Aphrodite and is
carved by a skillful sculptor from a block of rare marble that a statue will trigger and
sustain the beholder's aesthetic interest.

After this process of elimination, the same question remains: what area of the object
does carry aesthetic significance?

Vajrasattva in union with his Śakti. Rough brass
figurine. Tibet. 20th century. Private collection,
Los Angeles. Photo by Jacques Maquet.

Gold mask. Asante, Ghana. Wallace Collection,
London.

The answer is, in fact, implied in what we said about the way we look at something in
an aesthetic mode. When we just look at the object as a whole, without analyzing it, and
without associating with it memories and projects, thoughts and feelings, gossip and
erudition, we, as beholders, pay attention to the visual appearance of the object: what is
visible and only what is visible. As the painter Maurice Denis expressed it in an often-
quoted sentence written in a manifesto published in 1890: "A picture, before being a war
horse, a nude woman, or some anecdote, is essentially a flat surface covered by colors
arranged in a certain order."[1] It is that flat surface covered by colors arranged in a certain
order which is the area of aesthetic significance.

What is first visible is the outline, the border line that separates the object from the
surrounding space. For a painting, a drawing, a photograph, the frame marks the outline
and is usually a rectangle or a square. For a three-dimensional object, the outline is the
visual contour of the sculpture which makes it distinct from the environment: air, space,
background, and foreground.

Then, within the border line of a painting, there are the "colors arranged in a certain
order": the areas established by different colors, the shapes formed by closed lines or by
contrasts of light and dark. In sculpture, there are the three-dimensional volumes
revealed by reflected light, and the areas delimited by differences in texture, smooth and
rough, which absorb and reflect light in varied manners. Without touching, we "see"
that the feel of the surfaces is different.

All these visual elements—outline and lines, shapes and colors, light and texture—
constitute the *form* of the object. It is this area of the form that is aesthetically significant; it
is in this aspect of the object that we have to look for what stimulates and sustains the
holistic and disinterested attention of a beholder.

To realize that the aesthetic significance of an object is on the side of its form is an
important step, but not the last one. Every man-made thing (as well as every natural
thing, of course) has a visual form, but not necessarily one that can support an aesthetic
vision. Some configurations of visual elements appear to be better than others in stimulat-

ROBERT RAUSCHENBERG. *Booster*. 1967. Los Angeles
County Museum of Art. Gift of The Times Mirror
Company.

ing a perception in the aesthetic mode. This raises the question of what makes the form of some objects aesthetic. This question shall be addressed later; at this point we should further discuss the implications of the conclusion just reached: the aesthetic relevance of visible things lies in the area of their form.

Since Kant, *content* is usually opposed to form in the sense that what is said is opposed to the way it is said. If we transpose content to the visual field, it can denote what is represented, but this denotation (or this meaning) is not applicable to nonfigurative artworks, neither to metamorphosed utilitarian objects, nor to the other nonformal elements we have just reviewed—verisimilitude, superior execution, and the matter from which the object is made. To keep clear of these difficulties, I have suggested *substance* as the term to be opposed to form in the visual field.[2] Without forcing its meaning, substance has a broad denotation that can accommodate all the nonformal elements, from what it represents (if applicable) to the stuff of which it is made.

The boundary visually separating the formal area—the flat surface of the painting or drawing, the combined volumes of the sculpture—from its surroundings is of particular importance. It is often emphasized by a frame which clearly bestows another quality to the surface or the space that it encloses. Even perception is influenced by the frame.

In the late afternoon of a summer day, a friend is sitting in a garden, under a tree; she is reading. Her dress is light blue; she wears a wide-brimmed straw hat. She is partly under the shade of the tree and partly in the sunshine. However, I see the dress as uniformly blue, and her lovely tan as even, on her forehead under the brim of the hat and on her chin which is in the sun. I take a photograph of her. In the print, I see that the dress is greenish in the shade, and flat white in the sunlight, without gradations and modeling. The upper part of her face is in a bluish shadow which strongly contrasts with the highlighted lower part.

I saw the local color of the dress, light blue, as uniform in sunlight and shade because I knew it was its "true" color, and I did not make the perceptual effort to pay attention to the differently lit areas of the dress. This is a usual and well-known phenomenon. The camera recorded the optical colors, the colors as they appear in specific light conditions, as it was designed to do. But why did I not also "see" the local colors on the photographic print? When I looked at the photograph I knew as well as I did in the garden that the whole dress was blue. What made the difference is the frame: it separates the picture from its environment and makes me see it as a surface covered with different colors. Looking at the picture as an area of forms, I perceive the colors "as they are," as optical colors. This change of perspective occurs without any decision, effort, or even consciousness on my part; it is imposed on me, as it were, by the frame. I still perceive the configuration of colors and shapes as representing my friend, but I have become aware of the colors as forms.

An analogous experience may be made with music. Suppose you listen to a concert performed outdoors, on a summer night. There are the sounds of the musical instruments; and also, there are low-level noises: muffled coughing, the drone of traffic on a distant freeway, the rising and falling hum of a car passing on a nearby road and of an aircraft flying over the area, the barking of a dog. You are dimly aware of these noises, and actually they do not bother you much as they are outside the auditive frame of the musical performance. If you pay attention to the music, they are framed out.

If, immediately after the concert, you listen to a tape recording made during the performance, those same noises become a part of what you listen to, and you cannot avoid hearing them. They are now included within the auditive frame of the tape. The only noises you can frame out during the playback are the low-level interferences coming from other sources than the tape deck. You perceive the sounds on the tape "as they are" on it, and "as they were" during the performance.

The unexpected effect of the frame on our sensory perceptions, as revealed in the cases of the photographic print and the tape recording, stresses the significance of the aesthetic object as offering a visual or auditive area separated from the everyday continuum of sensory stimulants for the eye and the ear. But are we attuned to the perception of forms as forms, that is, do we see shapes, colors, and lights as shapes, colors, and light? Do we in fact see the visible?

We do. But if we want to be fully alert to the aesthetic forms whenever they are present in our field of vision, we have to prepare ourselves, to train ourselves. There is nothing unusual in this. All our potentialities—to memorize, to reason, to apply our attention to action—are actualized by precept and practice. Instruction and exercise began early in our life and were an important part of the long process of education, even though we may have been unaware of this.

But we were not trained to look systematically at what we saw. On the contrary, we were conditioned to give priority to other uses of vision, particularly to develop the rapid and precise glance which *recognized* a danger to be avoided or an opportunity to be grasped. From the dark clouds perceived as omen of a coming storm, to the smile on a stranger's face which promised a friendly disposition, to the blinking light indicating that a car was about to change lanes, we were trained to promptly identify visual cues for an immediate response.

Sometimes the conditioning is so strong that it operates when we visit a museum. Because we have so often seen postcards and other reproductions of *Mona Lisa,* a quick look is sufficient for us to recognize the original painting at the Louvre Museum, and we move on to the next room. How often are we unable to tell the color of the suit or the dress of a person we have spent the whole day with at work?

Stress on conceptual knowledge, another feature of our education, leads us to give more weight to what we know than to what we see. We know that the carpet was made in a uniform beige, and we "see" it uniformly beige near the windows, under the table, and in the corner of the room where an electric lamp is lit. If we put what we know between brackets, we see that the carpet is not uniform in color: it is lighter near the window, darker under the table, and yellowish near the lamp.

The very language we speak operates as a screen: we "see" the world through it. The Bureau of Standards has a system of designating colors that permits us to name 267 colors; and some art schools use a system starting with six primary colors (blue, green, red, yellow, magenta, and cyan) that can be combined by addition and subtraction to divide the circular spectrum into twelve, twenty-four, or more separated segments.[3] In ordinary language, we use perhaps a dozen names for distinguishing colors; the parts of the spectrum that are not separately designated by names are not "seen"; more exactly, they are lumped with the adjacent parts that have a name.

Training ourselves to see consists in a deconditioning. Forms are not simply convenient pointers indicating threats and opportunities. And forms are not to be hidden, as it

GEORGES BRAQUE. *Le Portugais* (The Portuguese).
1911. Oeffentliche Kunstsammlung,
Kunstmuseum, Basel. © ADAGP, Paris / VAGA,
New York, 1985.

PABLO PICASSO. *Portrait of Daniel-Henry Kahnweiler*.
1910. Courtesy of The Art Institute of Chicago.

were, behind a screen of useful conceptual simplifications. Our preparation consists in setting aside and temporarily removing the functions of indication and conceptual simplification which obscure the visual encounter with the forms. We need to turn our attention away from distracting concerns.

Elimination of competing concerns accounts for the recognized importance of nondiscursiveness and disinterestedness in the aesthetic experience.

Visiting the Kunstmuseum in Basel, I look at Braque's Cubist painting *The Portuguese*. I remember having seen a similar one, *Kahnweiler* by Picasso. I wonder who has influenced the other; the date of *The Portuguese* is on the museum label, 1911. I do not remember the date of the Picasso portrait, but it must be about the same time, certainly after *Les demoiselles d'Avignon*, which is not as analytically cubist as *Kahnweiler*, and the year of *Les demoiselles* is 1907, for sure. I have to check the date of *Kahnweiler*. In the museum bookstore, they certainly have books on Picasso, and I can quickly check the date when leaving the museum. But, after all, does it matter which painting came first? Around 1910, Picasso and Braque were close friends, and together they were experimenting with Cubist techniques . . .

These speculations, relevant to art history, had completely removed my attention

ANDY WARHOL. *Marilyn Diptych*. 1962. The Tate
Gallery, London.

from *The Portuguese*. Though I continued to look at it while thinking, this stream of
thought has obstructed the development of an aesthetic vision. My mind was not open to
it; my attention was occupied with information about the painting and could not be
focused on the painting itself.

The famous *Marilyn Diptych* silkscreen painting by Andy Warhol, made of an
enlarged photograph of Marilyn Monroe's head repeated twenty-five times on the
canvas, was exhibited in a New York gallery in the early sixties. I saw it there a few
months after her suicide. I remembered her last film, *The Misfits*, and how convincingly
she played her part. Did she see herself as a misfit in life despite her successful career
and her immense popularity? May this have had more to do with her suicide than the
solitude mentioned in magazine articles? . . . And so went my thoughts; they were about
the person represented. I barely looked at "the flat surface covered by colors arranged in a
certain order." It may well be that the forms on the canvas were not that arresting; in any
case, my stream of thoughts distracted me from them.

To take an art object as a stimulant for imagination has been "one of the most popular
trends of art criticism from the earliest times until the present day," wrote Osborne.[4] Yet
imagining what are the emotions and thoughts of the persons depicted, or commenting
upon the moral message of the artist one "reads" in the work, or letting the stream of
associations run, stands in the way of looking at the forms as forms.

In this section discursive thinking has been understood in its broadest sense. It
includes not only the logical reasoning proceeding from premises to conclusions, but any
activity of the mind moving, even by association, from one idea to the other. This is true
to the word's etymology: the Latin *discursus* comes from *currere* 'to run', and *dis-* 'in
different directions'. This evokes the image of a very active mind going back and forth
from one mental content to another and, by doing so, establishing relationships between
ideas.

JACKSON POLLOCK. *Autumn Rhythm*. 1950. The
Metropolitan Museum of Art, New York.
George A. Hearn Fund.

To be disinterested seems to have a moral connotation unexpected in the field of art
appreciation. In fact, it is a prerequisite here not as a moral virtue, but as a condition of
total attention to the object as a configuration of forms.

Our common language, embodied in general dictionaries, distinguishes *uninterested*
from *disinterested*. To be uninterested in something is to have no interest in it, to be
indifferent to it. I am not interested in sailboats; I am indifferent to them; I am uninter-
ested in buying one, possessing one, and sailing on one. Uninterested conveys the
meaning of a lack of interest in something. Disinterested concerns the self: it is to be free
of self-interest and ego-involvement. To be self-interested is to be centered on the pursuit
of personal advantages: pleasure and affluence, power and status, prestige and recogni-
tion. To be ego-involved is to be absorbed in oneself and one's own advancement.

Looking at Jackson Pollock's *Autumn Rhythm*, an action painting which captures the
vitality of the New York School of abstract expressionism in the years immediately
following World War II, I am reminded of New York at that time and how exhilarating my
discovery of it was. Pollock was a part of that discovery. The painting I am looking at is
the pretext for, and the trigger of, a flow of personal reminiscences: what I was doing and
thinking and expecting during that period, the projects I realized, and those I gave up.
Self-interest dominates my consciousness; I still look at the painting, but I do not pay any
attention to it.

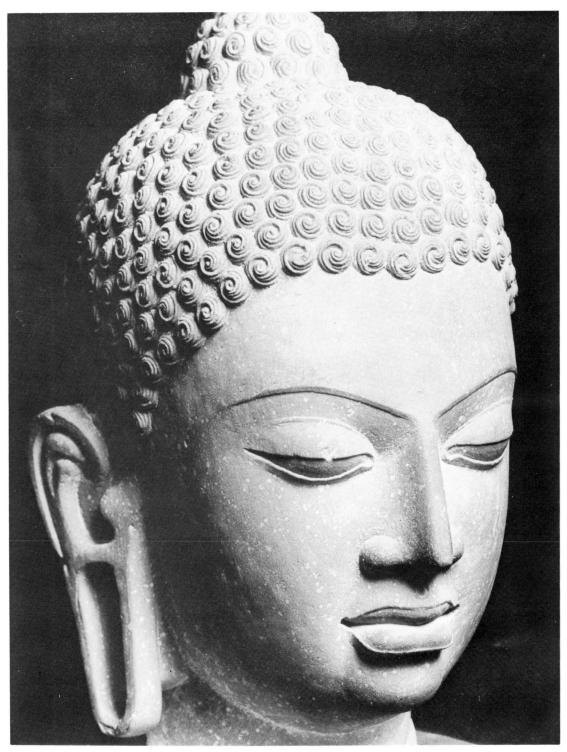

Head of the Buddha. Mathurā, India. 5th century.
Archaeological Museum, Mathurā. Photo from
Snellgrove 1978, by kind permission of Kodansha
International, Tokyo.

At a dealer's in ancient art, I see the head of a Buddha image in stone. It is a fifth-century Indian statue. The modeling is soft, the eyes closed, and the smile barely perceptible. My full attention is focused on the head; time stops. The dealer tells me the price, and I am back in time and place. I want to own that head, to bring it home, and to enjoy myself in looking at it whenever I want. But I cannot possibly afford it. The dealer has stepped aside, and I keep on looking at it, yet I cannot recapture the aesthetic stance: the desire of possession is too strong. My passionate interest in the statue is, in fact, a passionate self-interest. I shall miss the joy, the pride, and the prestige of ownership; this is what upsets me and distracts my attention from the Buddha's head.

Self-disinterest may be expressed, when the picture is representational, in terms of distance between the beholder and what is depicted. I look at a *nishiki-e*, a polychrome print by Utamaro, a delightful image of a lovemaking scene. I am aware of the harmony of colors, the visual balance of the two bodies, the grace of the curving lines, the unity of the composition focused on three points on an invisible ascending line from lower left to upper right: the penetration, the man nibbling at the nipple of the woman, and the half-open mouth of the woman. I aesthetically perceive the picture as long as my attention is kept on the image, within the frame of the picture, at a distance from the same scene imagined as actual. If mental images of the pleasures of "unframed" intercourse move to the foreground of my awareness, my attention to the forms disappears. The aesthetic experience yields to an erotic reverie. Self-disinterest is replaced by self-indulgence.

UTAMARO KITAGAWA. Polychrome print *(nishiki-e)* of a lovemaking scene. c. 1800.

EDVARD MUNCH. *The Scream.* 1894. Munch
Museum, Oslo.

The connection between self-indulgence and eroticism is obvious, but the beholder's
ego may be equally involved in other emotions and feelings. *The Scream* by Edvard Munch
is an impressive composition. The oblique straight lines indicate a descending direction—
though they represent a horizontal bridge—and unstable curves dominate the upper
part of the picture. The screaming person is terrified by something which is behind and
slightly to the left of the beholder, and which seems to threaten the beholder as much as
the screamer. It is death and suffering, inseparable from the human condition. At this
point, the beholder's attention may be diverted from the flat surface of the picture and
replaced by personal anxiety or even self-pity.

Adolph Gottlieb's *Blast, I* is a powerful nonfigurative painting. The title suggests a
nuclear explosion, and the confused shape in the lower part of the painting may refer to
the earth after an atomic war. The floating disk above, the sun, remains unaffected by
mankind's destruction of its own habitat. Again, the beholders' attention may be deflected
from the vision of the painting to fear for themselves and anger at the governments'
irresponsibility.

Emotions always have a self-interested aspect, even if they seem purely altruistic. In
the Museum of Modern Art, in New York, *Echo of a Scream* by Siqueiros has such an
emotional impact that it is difficult to confine one's attention to the forms assembled on
the canvas. In the ugly backyard of industrial civilization, which threatens to cover the
whole world, a child is loudly screaming, and the echo of his scream fills the world, as
indicated by an enlarged duplicate of his head which fills the upper part of the picture and
dominates the pictorial space. The beholder who becomes emotionally involved will
probably identify with the child, who represents the victims of the profit incentive on
which our economic system is based.

ADOLPH GOTTLIEB. *Blast, I.* 1957. Collection, The Museum of Modern Art, New York. Philip Johnson Fund.

DAVID ALFARO SIQUEIROS. *Echo of a Scream.* 1937. Collection, The Museum of Modern Art, New York. Gift of Edward M. M. Warburg.

The aesthetic experience results from an encounter between a subject, the beholder, and an object whose forms are aesthetically significant. We have established that the necessary disposition of the beholder is an attitude of nonanalytical and disinterested attention, and we have identified the configuration of visible forms as the area of the object on which the beholder's attention is focused.

Still, we are at the threshold of the aesthetic encounter. On the side of the beholder, concentrated attention, nonanalysis, and no self-interest are only preliminary conditions. On the side of the object, the visible forms simply delimit the area.

We must now consider further the beholder's mental apprehension of aesthetic forms.

CHAPTER FIVE

Aesthetic Vision as Contemplative

THE BEHOLDER'S MENTAL PREPARATION FOR AN AESTHETIC ENCOUNTER, AS JUST DESCRIBED,
appears to be similar, in fact almost identical, to the preparation recommended to
meditators in some classical Eastern traditions. Is it a superficial resemblance mainly due
to the limited vocabulary available for the description of mental phenomena, or is there a
deep convergence of the two experiences?

This matter deserves to be carefully considered. If there is a significant parallelism at
the experiential level, the aesthetic vision, so far studied in isolation, would be placed
within a broader framework, and the specificity of the aesthetic vision could be better
explained.

What is called in the West "the Eastern traditions" refers to several bodies of
doctrines and practices so immense as to defy any attempt to use them as manageable
terms of comparison. We will restrict our comparison to two major literary sources,
Patañjali's *Yoga Sūtra* (Aphorisms) and Buddhaghosa's *Visuddhimagga* (The Path of
Purification).[1] We take them as important works respectively representing the Hindu
system of Yoga (Sk. *yoga darśana*)* and the Theravāda Buddhist system of meditation.

These texts, written by two Indian scholars, probably during the fifth century A.D.,
were at that time epitomes of long traditions: the Buddhist was about one thousand
years old, and the Yoga still more ancient. They also were starting points of new phases of
these traditions, and they still are used for meditational practice. The *Yoga Sūtra*, a
collection of 195 short aphorisms to be memorized, requires commentaries (a sūtra is
a thread on which to string the beads of commentaries), and commentaries were written
by Vyāsa (between the 7th and the 9th centuries), by Vāchaspatimiśra (9th century),
by King Bhoja (11th century), and by Vijnānabhikshu (16th century).[2] Recent authors
continue to offer new translations and new commentaries of Patañjali's *Yoga Sūtra*.[3] The
Visuddhimagga, a long treatise of more than seven hundred pages in the Pali Text Society

*In this passage "Sk." indicates a Sanskrit word, and "P." indicates a Pāli word.

51

edition, is considered the basic work of reference by many contemporary meditation teachers in Theravāda countries (mainly Sri Lanka, Burma, and Thailand). *Yoga Sūtra* and *Visuddhimagga*, far from being little-known marginal sources, are alive and important texts on meditation.

Concentrating one's attention on the visible object is the first condition for an aesthetic perception. The first of the *Yoga Sūtra*'s four books is devoted to concentration (Sk. *samādhi*). In the second aphorism, yoga, as a mental discipline, is defined as the elimination of the distractions that prevent concentration. In Wood's translation, it is the "suppression of mental fluctuations."[4]

In the third chapter of the *Visuddhimagga*, also devoted to concentration (P. *samādhi*), it is stated that concentration is the "centering of consciousness . . . on a single object," with "non-distraction as its characteristic." The object on which one concentrates may be water in a bowl, colors perceived in flowers spread on a tray, an artifact such as a disk made of clay, a bodily activity such as breathing, a mental image such as a decaying corpse, or a virtue such as compassion. The frame, as a device for isolating the object and facilitating visual concentration on it, was recommended to Buddhist meditators. He who chooses to concentrate on a fire "should make a hole, a span and four fingers wide, in a rush mat, a piece of leather, or a cloth, and, after hanging it in front of the fire . . . should sit down" and look at the fire so framed.[5]

The aesthetic attention should be nondiscursive. Patañjali, in the concise style of his aphorisms, mentions several kinds of intellectual fluctuations of a discursive nature that the yogi must suppress: cognitions, whether true or false, imaginations, and memories.[6]

The Path of Purification considers the case of some mental objects that may be approached either through discursive reflection or through nondiscursive meditation. The former approach is found to be unwise as it may generate distracting thoughts and emotions. For instance, reflecting about death, "if (one) exercises one's attention unwisely in recollecting the death of an agreeable person, sorrow arises, as in a mother on recollecting the death of her beloved child she bore; and gladness arises in recollecting the death of a disagreeable person, as (an) enemy." On the other hand, one can meditate on death in a nondiscursive manner by mentally repeating "Death will take place," or even more simply "Death, death."[7]

It is widely recognized that the aesthetic vision is disinterested, characterized by detachment, as Harold Osborne reminded us.[8] The term *detachment* is also used by teachers of meditation: affective fluctuations of emotions, feelings, and desires make concentration impossible if they are left uncontrolled. Patañjali's yogi control their affective fluctuations by dispassion, (Sk.) *vairāgya*, which is translated by Woods as nonattachment, "the consciousness of mastery of desires."[9]

The Buddhist meditator has to overcome "greed, craving, and clinging." This effort is called virtue (P. *sīla*), and the first two chapters of *The Path of Purification* are devoted to virtue. Virtue, described as nonattachment, is considered by masters of meditation and aestheticians alike from the same standpoint: not as an achievement to be attained primarily for the sake of social morality, but as a requirement for mental concentration.

When the usual mental stream of thoughts and feelings, regrets and anxieties, fears and hopes, futilities and incongruities has slowed down or stopped, attention is stabilized on the visible object. This state is described by metaphors. One is *absorption* of the subject into the object, as if the subject's consciousness, having penetrated into the object, finally

disappears in it. Another metaphor, antithetical to the absorption image, is the *invasion* of the field of consciousness by the object, as if the vision made by the object penetrates and fills the viewer's mind. A third metaphor is that of *nonduality*, suggesting that object and subject become one.

Harold Osborne and other aestheticians observe that when the aesthetic encounter is successful, "we are no longer fully conscious of ourselves as persons sitting in a concert hall or standing before a canvas in a picture gallery . . . we become identified with the aesthetic object by which our attention is gripped and held."[10]

Meditators also are said to achieve states of absorption (Sk. *dhyāna*; P. *jhāna*). In fact, this part of the theory of meditation is considerably developed in the Theravāda tradition. *The Path of Purification* distinguishes eight levels of absorption. The first level is not unlike the absorption described by aestheticians: the usual flow of thoughts and feelings is broken, the mind is undistracted, steadily fixed on the object of meditation as on one point. This is called "one-pointedness of mind" (P. *citta ekaggatā*).[11] There may be a deepening of the aesthetic absorption that could be described in terms of the other levels of meditative absorption, at least to the fourth level. We do not know, because aesthetic experiences have not been described and analyzed with the careful observation and the sophisticated conceptualization characteristic of the texts found in the Eastern meditational traditions. At any rate, there could be no parallelism between the higher levels of meditation—namely, the fifth to the eighth—and mental states characteristic of the aesthetic vision. Indeed, these levels are no longer associated with any sensory perceptions, which are essential in the apprehension of the visible.

In both traditions, the term *samādhi*, concentration, denotes a state of deep and quiet meditation where the subject experiences oneness with the object. Mental absorption is favorable to a nonverbal understanding of the object. Absorption, in fact, is usually sought for the insights it provides rather than for its own sake. Insights, intuitions, illuminations—all immediate apprehensions of the object—give access to the object "as it is." This expression *the object as it is*, so frequent in writings on meditation, may be misleading. It does not mean the object *as it is in itself*, independent from any subject (something logically contradictory as there is no object without a subject), but the object *as it is nonverbally*, freed from the conceptual conditioning that acts as a screen between an experience and the consciousness of it. The insights (Sk. *vipaśyanā*; P. *vipassanā*) of the meditator in the Theravāda tradition correspond to the beholder's intuition.

These Sanskrit and Pāli texts deal with mental states which are not part of the usual repository of experiences of twentieth-century Western men and women. However, experiential references are available to Westerners, and accessible to anthropologists. During four trips in South and Southeast Asia, I practiced meditation in the Buddhist Theravāda tradition as a resident trainee in four monasteries in Sri Lanka, Thailand, and Burma for about four months altogether.*

In one exercise I was to focus my attention on abdominal breathing. I was to be aware of each upward movement of inhalation and of each downward movement of exhalation,

*The monasteries were the Vipassanā Bhāvanā Centre in Kanduboda, Sri Lanka; the Samnak Vipassanā Vivek Asom in Chonburi, Thailand; the Thathana Yeiktha in Rangoon, Burma; and the Tapovanaya in Angoda, Sri Lanka. My meditation teachers were respectively the late Ven. Seevali Thero, Ven. Acharn Thawee Bhalathammo, Ven. Sayadaw U Javana, and Ven. D. Chandrasiri Maha Thera, to whom I am deeply grateful.

and mentally—not verbally—take notice of them. Trying to do so, one rapidly becomes aware of the tremendous force of the stream of mental phenomena, and of its resistance to the meditator's attempts at controlling its fluctuations. These fluctuations are perceived as obstacles to the exercise of concentrated attention.

Memories, images, daydreams, and expectations are immediately recognizable, but discursive thinking is tricky for the apprentice meditator to discern. For instance, I was ruminating and comparing the ups and downs of breathing to the waves of the sea, wondering if there was a kind of rhythmic pattern common to the physical world and myself, if this could be considered a pantheistic view, and so on. In this manner, my attention moved away from the object on which I wanted to concentrate, abdominal breathing. It took me some time and the guidance of my teacher to be able to distinguish discursive thinking from insight.

Another day, I was reflecting on the monotony of our secluded life in the monastery, and how few were the items it provided for remembering; from there, I began to build a hypothesis on the relationship between unique events and memory. On another occasion, I was trying to express a clear conceptual distinction between detachment and indifference. These analyses were taking me away from the meditative state of consciousness.

The training was intensive: about eight hours of sitting meditation and four hours of walking meditation a day, complete silence except for the daily private interview with the teacher, no reading, and writing kept to a few notes in the field diary. It was effective. Slowly, the flow of fluctuations decreased; concentration could be maintained for longer periods of time and became deeper; and some insights on life's limitation, impermanence, and insubstantiality flashed through my mind.[12]

This experiential reference to meditation—as limited as it was—confirms the analogy of meditation with aesthetic absorption. What can be read in Patañjali's *Aphorisms* and in Buddhaghosa's *Path of Purification* remained opaque to me until I had had a beginner's experience of meditation. But should an individual's mental experience be taken into account in the scholarly search for critical knowledge? Earlier we used the experiential reference approach to clarify what is meant by "looking at an art object." In that case we could refer to an experience common to many, if not all, of our contemporaries living in the industrial world; at present we refer to the meditative experience, which is not a part of the cultural stock of every Western person.

The reporting of inner phenomena by an individual observer should meet the standards of validity and reliability considered acceptable for fieldwork observations. This matter is discussed in the Appendix. Suffice it to say here that the reliability of my observations can be checked; other observers may go to the monasteries where I have been, and the conceptual framework I have used is presented in this book. Just as hundreds of Sinhalese, Thai, and Burmese and a few Westerners have done and still do, other observers may undertake intensive meditational training and compare their observations with mine.

Their validity may be assessed too. Social scientists rightly are suspicious of the validity of what an informant may say about his mental experiences if there is no way to check the informant's perceptivity and veracity. Fortunately, in traditions where certain mental skills are taught, and have been taught for centuries, there is an indirect control: the teacher knows how these skills should be acquired—as there is a mapped progression—and what the indicators of the progression are. A teacher is not easily

fooled by a trainee's illusion or deception. A disciple's assertion accepted by a discerning teacher is as valid as a good informant's statement reported by a perceptive anthropologist.

Two main Eastern traditions, represented by two of their fundamental texts, and interpreted in their experiential context, attest that there is a parallelism between aesthetic vision and meditative absorption. From the analogy of the two processes, it may be inferred that aesthetic perception and meditation reveal the same mode of consciousness, a mode different from cognition and emotion, which we may call the mode of contemplation.

In order to grasp what the contemplative mode is in relation to the others, let us consider the Western construction of the human psyche from a phenomenological perspective. The distinction between what I refer to as 'me' and as 'the world' around me is basic to this construction. If somebody were to deny, in everyday life, the soundness of this distinction, he could not use the common language, he could not take part in social interactions, and he soon would be committed to psychiatric care. Certainly, in other realities than the everyday one, for instance in the reality built by philosophers, the distinction between the empirical 'ego' and 'the world' can be questioned without social disapproval; but in the transactions of the practical life and the communications of the common language, the duality 'I' and 'the world' is a basic assumption.

The world is everything that is outside of my body: the natural and man-made environment, the other sentient beings, and particularly the other human beings. The *I* is my body, or more precisely the consciousness of my body. I perceive it differently from the way I perceive other bodies, from inside, as it were. My body may be deprived of consciousness for a certain time; for instance, after a severe shock, I may lie unconscious, and then regain consciousness. The opposite, a consciousness deprived of body, is not a part of the Western reality in the twentieth century. *Mind*, a synonym of consciousness, does not primarily suggest awareness; it evokes the continuous functions of the brain, such as thought, will, and perception, and includes the unconscious processes of the brain.

Consciousness may be described as the totality of the mental processes of which I am aware at a certain time. In addition to this meaning of consciousness as awareness, consciousness is also, in our common language, an accumulation of records of these mental contents of which I have been aware during the life of my body; it is a bank in which memories are kept. What is in my mind at any time may come either directly from the world (after having been processed by my sensory organs) or from my store of records.

As consciousness, I am constantly in transaction with the world. Because I have different intentions regarding the world, I approach it in different ways. We have an everyday experience of three of these fundamental approaches: acting, knowing, and feeling. We approach the world in an active mode when we seek to change it by modifying the environment, by obtaining something from somebody by persuasion, pressure, or exchange, or by planning ahead toward a sequence of acts that eventually will produce some results. *Knowing* is the cognitive mode of consciousness. Here we want to observe something without changing it, just to understand how it works. It may be something trivial and speculative (such as, Why has this candidate lost the election?),

or something studied by rigorous scholarly methods (such as a historical reconstruction of the diffusion of Bantu languages in sub-Saharan Africa). *Feeling* here indicates the affective mode of consciousness. The subject's mind is dominated by an emotional state (such as anger, love, hatred, or admiration) usually accompanied by pleasantness or unpleasantness.

Aesthetic vision and meditative attention do not fit into any of these three modes of consciousness. They are not active, as they are not oriented toward changing the world; they are not cognitive, as they are characterized by nondiscursiveness, nonverbality, and holism; and they are not affective, as they exclude self-interest. They are contemplative.

Though not as noticeable as the other modes of consciousness, contemplative moments are many in everyday life. Each time we become aware of the visual quality of a dress or a tree, a billboard or a way to walk, the sky at sundown or the lights of the city, there is an aesthetic repose of a few seconds or a few minutes. During these fleeting encounters with things perceived as good to look at, the contemplative mode dominates our consciousness.

In the countries where everybody knows that "meditation is *the* essential practice of exemplary Buddhists," meditation in its full extent is practiced only by a small minority, a spiritual elite.[13] But short periods of time spent in a meditative mood are fairly popular. In Sri Lanka, children are encouraged to begin the day by sitting for a few minutes in the meditation posture and wishing all sentient beings to be free from suffering and to attain enlightenment; they are to repeat the words mentally in the quiet mood of lovingkindness (P. *mettā*). Some Sinhalese keep that practice all their lives. Laymen and laywomen are invited to meditate in the temple during the full-moon day of each month and during other celebrations, and many do. In the West, it is likely that some repetitive prayers and chanting weaken the flow of mental fluctuations and generate a contemplative attention.

Before making decisions in the course of ordinary life, we often do not have the time or the inclination to proceed with a discursive analysis of the situation, and we rely upon a total and immediate apprehension of a problem or a personality: an intuition. Usually it is by intuition that we perceive a person as trustworthy or not, and an undertaking as dangerous or not.

Intuition is not restricted to what occurs in everyday life. It has eminent apologists in philosophy and science. For Descartes, Locke, and Leibniz, fundamental truths were reached by intuition, and rational processes were later used for proof and explanation. Poincaré and Einstein, we are often reminded, stressed the importance of intuition in their scientific discoveries.

Intuitions, flowers that blossom in the silent and one-pointed mind, cannot be forced. But mental concentration stimulates their appearance or, more probably, permits the undistracted subject to become aware of their presence. Because of that, and because of their immediacy and totality, intuitions belong to the contemplative mode of consciousness.

As ideas and images, feelings and sensations arise and disappear in the mental field, so do modes of consciousness. These modes of consciousness after all are only conceptual categories into which we class mental fluctuations having some attributes in common. For instance, anger and love, being emotions of the subject, are classed under "affective mode."

Looking at the striking shape of a sports car, I find it beautiful; for a few seconds, visually overwhelmed, I am fully in the contemplative mode. Then I become aware of how that vision affects me: in fact, I am envious of the owner of the car, and envy belongs to the affective mode. A few seconds later, I wonder why this form is so arresting, and I begin to analyze it in the cognitive mode. Finally, the idea that perhaps I could afford such a car flashes into my mind; in the active mode, I begin to make some practical plans to find out first what is the price of the car, and what would be the trade-in value of my present car. This is a sequence of modes of consciousness following one another very rapidly, but at each moment, one mode is dominant.

In the common reality of our society, the contemplative mode is largely ignored; at the least, it is not as clearly recognized as the others. Its importance is less evident, and sometimes it appears mysterious. Why is this so?

From the standpoint of the individual, the other modes are, for most of us, more rewarding because they accord well with the mainstream values of our society.[14] Action offers the usual access to power, affluence, security, and prestige. Cognition, as such, may bring some prestige and some affluence but is most often a preparation for action. Affectivity is closely associated with pleasure; positive emotions, such as love, gratitude, and admiration, are pleasant to experience; and negative emotions, such as pity, anger, and contempt, may enhance self-esteem through others' recognition of one's generosity, self-satisfaction regarding one's virtues, and the self-righteousness of one's indignation. These are strong inducements to relate to the world through these approaches. Contemplation, on the other hand, is low-keyed, requires the effort of mental preparation—even for the aesthetic vision—and has little utility in the enhancement of self-interest.

At the collective level, contemplation has been of secondary importance in the evolutionary process. In order to survive, and to progress in the domination of the environment, action and cognition have been the most effective ways to deal with the world. It should not surprise us, then, that the Western tradition, the tradition most clearly committed to the domination of nature, did not develop methods for cultivating contemplative skills. However, in the present predicament of the highly industrialized societies—overpopulated, overpolluted, and depleting the earth's resources—the contemplative approach may become more attractive: it may become the most effective way of relating to the world to survive and progress.

Beginning in the 1960s, important new developments took place in the neurological study of the two hemispheres of the brain. On the basis of research on the lateralization of the brain conducted by R. W. Sperry and his associates M. S. Gazzaniga and J. E. Bogen, and from a survey of other research dating back to 1864, Joseph Bogen has proposed to localize in the left hemisphere the *propositional* capacity of the brain, and in the right what he calls its *appositional* capacity. Propositional refers to the use of words in forming propositions, and appositional refers to apposing or comparing, for example, perceptions and schemas. Appositional is admittedly vague because of the "difficulty in characterizing the ability of the right hemisphere [which] arises largely from our ignorance."[15]

According to Bogen's report on the dichotomies suggested by researchers who preceded him, the left-right lateralization of the brain has been associated with at least fourteen dualities since the 1860s. Here are five of these pairs (in which the first term is

always localized in the left hemisphere): (1) linguistic versus visual or kinesthetic; (2) symbolic or propositional versus visual or imaginative; (3) verbal versus perceptual or nonverbal; (4) verbal versus visuospatial; and (5) logical or analytic versus synthetic perceptual.[*]

Bogen states that "the original and hardly arguable fact [is that] the left hemisphere is better than the right for language, . . . 'verbal activity' or 'linguistic thought'; [and that] in contrast . . . the right hemisphere excels in 'non-language' or 'non-verbal' function."[16] With a typical Western bias, the left hemisphere is called the *dominant* hemisphere.

The characteristics of what we have called here the contemplative mode—nonanalytical, visual, receptive, perceiving totalities, and nonverbal—certainly belong to the right hemisphere. That the contemplative mode of consciousness is, according to these neuropsychological works, located in a certain area of the brain, is of little consequence for our own studies, except in one important connection. Separate organic rootings for cognition and contemplation provide a strong confirmation that they are distinct and irreducible mental functions.

At the beginning of this chapter, the aesthetic vision, so far considered in isolation, seemed to be a particular and somewhat narrow visual approach to tangible objects. I have attempted to put it in its broadest framework. As meditation, aesthetic vision apprehends its object in a contemplative mode of consciousness, which is one of the primary ways through which the subject relates to the world.

In moving from art as an everyday category to the aesthetic vision as a contemplative approach, I have tried to develop a conceptual framework that will enable us to make meaningful cross-cultural comparisons. That a fundamental mode of human consciousness is manifested in the aesthetic vision suggests that the aesthetic quality and its appreciation are likely to be found in many, if not all, cultural traditions.

[*]Bogen 1973:111. In the second dichotomy, the term *symbolic* has not the same acceptation as in this book (see chapter 10), where symbolic processes are seen as nondiscursive, nonanalytical, and nonverbal. They are associated with the functions of the right hemisphere.

CHAPTER SIX

Aesthetic Experience in Other Cultures

IF AESTHETIC VISION IS A MANIFESTATION OF CONTEMPLATION, AND IF CONTEMPLATION IS A basic mode of consciousness, we may conclude that the aesthetic perception is, at least potentially, universal. Any society may develop an aesthetic approach to natural and man-made things. But do many societies outside the urban centers of the contemporary industrial world recognize and actualize this human potentiality?

This question cannot be answered a priori. And, as we are dealing with an inner experience, direct observation of behaviors will not produce conclusive results. We will have to proceed in an indirect manner, and try to find indicators, as we did for our own culture—with the added difficulty that we are at a distance from other cultures.

Language provides us with precious indicators. Does the everyday language of the society we consider include words which denote a positive response to a purely visual stimulus? Does it possess words having the simple meaning of 'good to look at', as do the English terms *beautiful, handsome,* and *pretty*?

Words conveying such meanings were reported in some nonwritten languages of Africa by Leiris and Delange. Summarizing studies made on a dozen West and Central African languages, these French Africanists concluded that the distinction between 'good' and 'beautiful' was made in most of them. They particularly mentioned the languages of the Wolof of Senegal, the Bambara of Mali, the Susu of Guinea, the Daza of Central Sahara, the Bulu of southern Cameroon, and the Cokwe of Angola.[1] The words denoting 'nice to look at' in these African languages have slightly different connotations—as do *beautiful, handsome,* and *pretty*—but their core meaning is the same. As any anthropologist who has carried out research in Africa knows, the meaning 'nice to look at' is easily expressed in the language of the observed group. And, as any tourist having bargained in an African market knows, a message such as "I prefer this because it looks nicer than that" can easily be conveyed with a minimal linguistic competence of the two parties.

In the written language of the great traditions of Asia, the vocabulary pertaining to the different responses of a beholder is rich and subtle. And, as Thomas Munro makes

59

clear in his survey of Oriental aesthetics, there is an abundant literature in the classical languages of India, China, and Japan which is devoted to analysis, explanation, and theory of the aesthetic experience.[2] *Rasa*, the central concept of Sanskrit aesthetics, finds its origin in the *Nātyaśāstra*, a collection of texts probably written during the fourth or fifth century A.D., and its highest development in the work of the tenth-century philosopher Abhinavagupta, according to contemporary Indian specialists in aesthetics such as S. K. De, K. C. Pandey, and Y. S. Walimbe.[3]

The presence, in a language, of ordinary words referring to visual quality, and of intellectual reflections on the aesthetic experience, indicates that the aesthetic potentiality has indeed been developed in many societies, literate and nonliterate, simple and complex, ancient and modern.

There are silent cultures, those of societies which, linguistically, are dead: no speaker of their language remains, and there are no extant written archives. We only have a collection of their artifacts. Is it possible to find in the objects left some clues to the mental attitudes of their makers regarding the vision of forms?

Many artifacts are utilitarian. They are tools—knives and spears, pots and jugs, axes and hammers—worked by hand, used to perform simple tasks. They are instruments whose utilization is obvious. They do not require any explanation beyond themselves. Their purpose lies in directly or indirectly maintaining bodily survival. It is their evident and primary context.

These artifacts have formal characteristics of shape, color, and texture required for their proper operation in their usual context. These aspects constitute the instrumental form of the object. The knife's blade and its handle are shaped in a form that insures the most effective utilization of the knife for cutting meat or carving wood; the form is fully instrumental. The form may additionally have a visual quality which stimulates in us an aesthetic perception of it. Even if the contemporary observer has such a visual response, one cannot assume that the aesthetic form was a concern of the craftsman who made the knife or of the members of that group. But, if contemporary observers detect in the knife some formal aspects which were not needed for its efficacy as a cutting or carving tool, may we not assume that these noninstrumental forms reveal an aesthetic concern? Perfect regularity or smoothness of the handle, ornamental engravings, or application of a colored coating go beyond what is necessary for the proper use of the knife. These noninstrumental forms indicate an aesthetic interest within that society.

Elsewhere, I have posited the case of a wooden bowl discovered with other artifacts from an extinct culture.[4] Its context was everyday life; it was used to serve food. Its shape is circular, its rim rounded, its bottom flat. These formal characteristics are instrumental: circular shape and rounded edge made cleansing easier, and flat bottom prevented the vessel from being overturned. We also notice that the rim of the bowl is a perfect circle, which is not easy to achieve for a carver working with only adz and knife, and that some engraved patterns are repeated with regularity and symmetry. These latter formal characteristics are not instrumental: they do not enhance the utility of the bowl as a container for food. This constructed example was given substance by E. Adamson Hoebel who, quoting it, published a picture of a carved Trobriand Islands wooden bowl illustrating it.[*]

*Hoebel 1972:624. Discussing the same case, Richard L. Anderson notes that "roundness is highly desirable because it maximizes the strength and capacity of a vessel while minimizing its weight" (Anderson 1979:13n).

The criterion of noninstrumentality is applicable in our contemporary cultures as well as in distant and little-known societies. A sporting gun is made to fire on a certain type of game; silver engravings on the butt do not enhance its killing effectiveness. In the Canadian winter, a fur coat is a garment primarily made to keep its wearer warm; this goal is attained whether or not the pelts are perfectly matched in size and color. These formal aspects, not necessary for the proper use of the object in its context, have been added for their visual appeal.

Formal instrumentality is not confined to utilitarian contexts. For objects used in a religious context, there is also a ritual instrumentality. Let us assume that the chalice used in the rite of the Eucharist should be marked by a cross if the rite is to be efficacious. Thus the cross engraved in the metal is not decorative but instrumental. In the same way, some marks engraved on a wooden bowl used for food offerings to the ancestors may be

Carved wooden bowl. Trobriand Islands. Private collection. Photo by Don Breneman (Hoebel 1972).

Ardagh chalice. Ireland. 8th century. National Museum, Dublin.

magical signs that keep the evil spirits away, and not ornamental patterns. This, however, does not exclude noninstrumental forms; the way the cross and the magical signs are engraved may disclose a concern for balanced lines and shapes, for contrasting colors, or for the visual enhancement given by precious and semiprecious stones. These features are not necessary for the ritual effectiveness of the religious or magical rites.

At this point a question may be raised. In the case of a silent culture, known only by a set of artifacts, is it possible for the contemporary scholar to determine if a feature is instrumental or not? For instance, how do we determine if the artifact had its primary meaning in a ritual context? Certainly the criterion of noninstrumentality requires an interpretation based on a general knowledge of similar cultures of the same area, of objects of the same kind that we know more about, and about the ritual context. Such general knowledge is currently available for practically any set of artifacts. What if, as could happen, a new set were discovered in isolation, and could not be related to anything we know? In this case, an interpretation would be impossible, and only risky speculations could be presented. But such discoveries become increasingly unlikely. In the usual ethnographic or archaeological situation, comparisons are possible, and the noninstrumentality of forms may be ascertained.

Another objection should be discussed. Is it legitimate to infer a concern for aesthetic vision from an interpretation of some forms as noninstrumental? This inference is based on the fact that, indeed, an aesthetic intention is the only explanation for producing forms not necessary to the tool's fulfillment of its function. Why would craftsmen ornament the surface of an object with a decorative pattern if making it nice to look at had no meaning for themselves and other members of the society? Why would a carver take the trouble of making a perfectly circular bowl when an imperfect shape would not impair the use of the bowl? This interpretation of artifacts from silent cultures—those with no written texts and no members alive—is confirmed by the expressions of verbal cultures, which speak orally or textually: it is the concern for visual quality that prompts the creators of objects to go beyond the forms required by the instrumentality of the object.

The aesthetic intention in the makers of artifacts and the aesthetic appreciation in the users are not limited to the utilitarian and ritual instruments.

Another context in which objects have a conspicuous aesthetic dimension is the political. Scepters of chiefs, seats of kings, insignia of authority carried by attendants when the ruler appears before his subjects, and ornate vestments worn by the courtiers were, and still are, instruments of power. They expressed and strengthened the domination of the rulers over the subjects. In some cases these objects *were* power: the material possession of the crown or the throne gave legitimacy to the king. Among the contenders for the supreme power of the Asante, the one who could control the golden stool was recognized as the Asantehene. Such instruments of power most often are endowed to a high degree with aesthetic ornamentation.[5]

Social hierarchy is another context for objects with a strong aesthetic component. The large groups—castes or classes—into which a stratified society is divided express differences and ranks in status through objects used as distinctive marks. Insignia characteristic of aristocracies and upper classes, high initiation grades and prestigious professions, nobilities and other privileged minorities are illustrated by the gold-plated fly whisks of the Baule notables, the ivory figurines of the high initiates among the Lega, or the rank sculptures of New Hebrides.[6]

Asante chief's carved wooden stool. Ghana. Mu-
seum of Cultural History, University of California,
Los Angeles.

The instrumentality of artifacts associated with government and hierarchy is to make
evident the structures of societal relationships and thereby to reinforce them. The objects
should express that there is a difference between rulers and subjects, superiors and
inferiors, and that rulers and superiors should be admired, respected, and feared "because
they are better" and thus deserve their privileges. The political and hierarchical function
of these objects is more limited and, at the same time, more general than the utilitarian or
ritual functions of the objects discussed above. The instrumentality of a knife (that it cuts
or carves certain materials) provides the craftsman with more constraints in terms of size
and shape of blade and handle, for instance, than the instrumentality of a scepter
(through which the power and legitimacy of the king is manifested), which allows for a
wide variety of sizes, shapes, and materials. The maker of a scepter has more opportuni-
ties to incorporate noninstrumental forms in the artifact than the maker of a knife. It is in
this sense that hierarchical and political contexts are more favorable to aesthetic forms
than are ritual contexts (limited by a particular ceremonial or myth) or utilitarian contexts
(limited by the specific use of the tool).

The contexts we discussed—life-maintenance and ritual, government and stratifi-
cation—are not the only ones in which artifacts display noninstrumental forms. Family is
another: from the forebears' emblems to the parents-and-children pictures, there are

Two Asante chiefs' stools carried in procession.
Kumasi, Ghana. Photo: Ghana Information
Services.

numerous memorabilia whose instrumentality is to keep alive the memory of those with whom the living generations of the family may identify. This fosters solidarity among them and encourages them to cooperate with one another. Again, these artifacts make it possible for sculptors and painters to develop noninstrumental forms to a rather high degree.

The present discussion may give the impression that the beauty of an object, its aesthetic quality, is something *added* to the instrumentality of the object, as an accretion upon the surface of the artifact, as it were, if there is room for it. This is not what is meant. The aesthetic quality is not conceived as an ornament added to the object. But in our search for objective clues of aesthetic concern in other cultures, what clearly is an embellishment to the object is an unambiguous indicator of aesthetic intention. It is nothing more. The beauty of the knife is likely to be in its instrumental form, as the beauty of an aircraft propeller, and not in some decorative pattern on the handle. Yet, at this point, we cannot assume that the maker had an aesthetic intention when he shaped the blade; neither can we assume that the engineer who designed the propeller had such an intention. On the contrary, aesthetic intention may be inferred from noninstrumental adornments on the handle, even if they do not at all contribute to the "beauty" of the knife.

By distinguishing the aesthetic concern for a society from its aesthetic achievements, we can positively answer the question raised at the outset of this chapter. Yes, many societies—all the known societies, I dare say—recognize and actualize the human potentiality for aesthetic perception and appreciation. This answer is based on modest but indisputable indications provided by languages and artifacts. It is not dependent upon the aesthetic judgment of the observer.

CHAPTER SEVEN

Art in Other Cultures

AMONG THE DIFFERENT CONTEXTS IN WHICH WE HAVE DISCOVERED OBJECTS REVEALING AN aesthetic intention, a special context, the art context—in which the only function of the object is to be looked at—has so far not been mentioned; yet we may expect to find a large number of aesthetic objects in this context if it were as important in other cultures as it is in contemporary industrial societies. We discovered this context at the beginning of our exploration of the categories under which the visual forms are subsumed in the collective reality of our society. Is there such a context in other cultures? Do their carvers, painters, and craftsmen make objects only to be looked at? Do their beholders select such objects? In other words, do they produce and recognize art?

It seems the answer should be yes. Those in charge of the focal art institutions of our society—museums and galleries, art magazines and books—collect, exhibit, write about, report on, and sell artifacts produced in other societies that are labeled "art" of pre-Columbian America, of Oceania, of Africa, and more succinctly "primitive art." Clearly, these works meet the criteria developed in our second chapter: "displayed only to be looked at." They are works of art.

They are art *for us*. If we briefly examine them, we notice that practically all of them were produced and used in their societies of origin as weapons, kitchen utensils, regalia, insignia of rank, magical instruments, sacred objects, and ceremonial garments. They had particular instrumental uses in specific contexts; their primary function was not exclusively visual. They were not meant to be art objects by destination.

Neither were they, in their cultures of origin, metamorphosed into art objects after being no longer used in their primary contexts. In our culture we do this regularly, when we exhibit in an art museum a religious statue carved in the thirteenth century to be placed on a church's altar, a portrait of a young Spanish prince painted by Velázquez in the seventeenth century to be hung on a wall in his parents' castle, or a silver sauceboat produced by Thomas Shields in the eighteenth century to be placed on the dinner table of wealthy Philadelphians. Traditional masks and statues of Africa were discarded after their ceremonial use was over and simply left to decay; this was a rapid process for wood and other organic materials in hot, humid climates.[1]

65

THOMAS SHIELDS. Silver sauceboat. c. 1780. Los Angeles County Museum of Art. Purchased with funds provided by the Decorative Arts Council.

DIEGO VELÁZQUEZ. *Prince Philip Prosper of Spain*. c. 1660. Kunsthistorisches Museum, Vienna.

Objects we have labeled "primitive art" were not art for those who made them. Did they make other objects with no other use than visual enjoyment? Yes, but they were few and of minor importance. Such were the small brass figurines forged by the Mossi and Dahomean smiths, the miniature baskets woven by the Tutsi women of Rwanda, the wooden cups elaborately carved in the shape of human heads by the Kuba craftsmen for the nobility, and the golden pendants hammered by Asante and other Akan artisans for the affluent.[2] Leiris and Delange call them trinkets and are understandably reluctant to recognize on the basis of these "worthless trifles" an African category of art.[3]

In the reality constructed by the men and women of the nonliterate world, art was neither a linguistic category nor a social practice.

The absence of art is not restricted to the societies without writing. In the civilization of the European Middle Ages, which belongs to the ancestry of the contemporary urban societies of the Western world, very few objects were made exclusively to be contemplated. Open an art history book devoted to the Middle Ages, and look at the photographs. Most of the pictures are of objects which were instrumental either in the Christian ritual, in the royal government, in the feudal hierarchy, or in the everyday life in castles and walled towns. Some artifacts certainly had solely visual relevance—tapestry wall hangings representing hunting scenes, for example—but they were few. No historian would think of restricting a study of the art of the Middle Ages to these objects.

Rwanda traditional basket. Photo by Jacques
Maquet.

Rwanda traditional tray. Photo by Jacques
Maquet.

Tutsi woman weaving a basket. Nyanza, Rwanda.
1955. Photo by Jacques Maquet.

Classical antiquity, which covers another set of cultures antecedent to our own in the Western tradition, did not produce many exclusively visual artifacts either. The same approximate but significant test of the illustrated art history book certainly would provide us with a higher ratio of purely visual objects than would a book on the Middle Ages, from the small and elegant Tanagra figurines in clay and the bronze statuettes, small-scale replicas of large public statues for home display on what might be considered the second-century B.C. equivalents of the Victorian mantelpiece, to the mosaic coverings and the frescoes of the opulent Roman *villae*. Yet an art historian of the antiquity taking into account only these and similar art objects would miss what are considered to be the most significant aesthetic creations of Greece and Rome: the statues of the gods, temples and public buildings, and ornamented vessels for ceremonial or home uses.

If I may venture a generalization on the great Asian traditions—Indic and Chinese, Buddhist and Islamic—their aesthetic concern seems to have been expressed and satisfied more by the aesthetic quality of their temples and palaces, of their religious sculptures and paintings, and of their gardens and cities than by the art objects they produced. Buildings and artifacts were instrumental, but their forms went beyond the requirements of their use. Despite its broad scope, this generalization is, I think, cautious enough to be acceptable.

From a cross-cultural point of view, art objects probably have been made in all literate and complex societies, and in many nonliterate ones. They appear to have been somewhat marginal to aesthetic creativity and appreciation except in the case of post-Renaissance European societies and of industrially oriented societies. There the aesthetic concern has been localized in art objects. They are seen to be the main, if not the exclusive, support of the aesthetic experience. This experience is elsewhere sought in the visual forms of objects that are neither made for, nor used in, an artistic context.

At this point it may be useful to introduce an analytical tool, the concept of *aesthetic locus*.[4] Many artifacts, in fact most of them, have some noninstrumental formal features. After all, most of our mass-produced objects are "designed," and the purpose of industrial design is to make utilitarian objects aesthetically satisfying.[5] Consequently, practically everything we see around us embodies some aesthetic intention and has some aspects that are aesthetically relevant. This is not a phenomenon restricted to the industrially produced items. The handicrafted objects of the past also displayed noninstrumental forms. The aesthetic intentions were and are diffused in countless objects. In addition to that, they are also concentrated in certain categories of objects.

These categories of objects in which aesthetic expectations and performances are concentrated constitute what we call the aesthetic locus of a culture. In thirteenth-century Western Europe, the Christian ritual defined the aesthetic locus of the society. The aesthetic awareness of the society converged on the material items associated with the ritual, from cathedral architecture to church furniture, liturgical garments, statues, and paintings. In sixteenth-century Japan, the tea ceremony certainly was the center of an aesthetic locus which comprised landscape gardening, the tea-house and its interior

Four male Wodaabe dancers. West Africa.
Photo © Carol Beckwith, from Van Offelen and Beckwith 1983.

decoration, ceramic and lacquerware utensils, and textile motifs and materials for the appropriate vestments.

Ancestors' effigies and masks belonged to the aesthetic locus of many traditional societies of West and Central Africa. According to Jacqueline Delange, the aesthetic drive of the Bororo-Fulani (West African nomadic herdsmen also known as Wodaabe) is principally expressed in the elaborate attire and facial makeup of the young men during an annual celebration, which also is a beauty contest, and in the intricate and regular pattern of ties and knots they use to attach their belongings to the backs of carrier oxen.[6] Ceremonial adornments and utilitarian transportation fixtures are the aesthetic locus of the nomadic bands of these African pastoralists.

Since the eighteenth century the four disciplines of the fine arts in Europe have constituted the aesthetic locus of the Western societies. Except for one of them, architecture, the objects they produce—drawings, paintings, and sculptures—are art objects by destination. For approximately three centuries, the aesthetic locus of the Western tradition has been practically limited to art. In fact, we seem to be at the end of the dominance of art on the aesthetic locus of the industrially advanced societies. As I have argued elsewhere, art works are physically disappearing or are getting lost in our industrial environment. It is the time of the fading out of art.[7]

Whatever the prospects of art in our world, art objects were peripheral to the aesthetic locus of most societies. It is only in the West, and relatively recently—for three or four centuries—that creative and appreciative aesthetic efforts have converged on art.

When artifacts are uprooted from their culture of origin and are assimilated in another, several phenomena of culture change are triggered. Usually there is a shift from one aesthetic locus to another, and a metamorphosis of an object from instrument to art. The story of the transmutation of things made in traditional Africa into Western collector's items illustrates the interplay of many societal and cultural forces.

During European exploration and expansion overseas, which culminated in the colonial period of the nineteenth and twentieth centuries, many strange artifacts were brought to Europe from faraway countries by soldiers, traders, and missionaries. Not all of them, by far, were recognized as art objects. And for those that were, the process of acceptance was long. Descriptions of the ways European societies responded to the imported exotic artifacts may be found in the excellent studies written by Robert Goldwater and Jean Laude.[8]

The first man-made objects that reached Europe from sub-Saharan Africa arrived from the kingdom of Kongo at the end of the fifteenth century. They were few and were seen by few Europeans. Princes and rich merchants added them to the unique stones, unknown plants, ostrich feathers, and other natural rarities collected in their *cabinets de curiosités*. Lands abroad were believed to be very different from the familiar countries of Europe. There, flora and fauna were expected to be strange, even marvelous; and it was not evident that the people were human. Laude notes that it was only in 1537 that Pope Paul III officially made it known that the inhabitants of the newly discovered regions were truly human, thus worthy of becoming Catholics.[9]

In Lisbon and Rome, ancestral and other human representations were considered to be African idols worshipped under the influence of the devil and fetishes endowed with witchcraft power. Many were publicly burnt in the equatorial territories under Portuguese

authority, and those brought to Europe were at best somewhat frightening in their alien strangeness, and at worst marked by some satanic stigma. It should be noted that, despite the gross distortions of the religious significance of the African images, fifteenth- and sixteenth-century Europeans did not divest them of meanings pertaining to ritual and magical domains.

This is the basic reason these human icons were not apprehended only as visual forms during the first encounter between Black Africa and Western Europe. It was the time of the emergence of the notion of art. It had been prompted by the discovery of Greek and Roman statuary. Zeus and Athena, Apollo and Aphrodite were also foreign and pagan gods and goddesses, but as religious forces, they were dead, having been vanquished by victorious Christianity more than one thousand years before. Their statues, having lost all religious meaning, could only be assimilated in the culture of Renaissance Italy as beautiful visual forms. There was no other context for them: thus art became an essential category. African statues could not have become art because the gods they represented were still living forces, hostile to Christ and resisting his conquest. They could only be included in the religious segment of the Western reality as negative entities in the devil's camp. They were idols and fetishes, not statues.

A more superficial reason African images were not perceived as art is that their conceptual style of representation conflicted with the dominant idealized naturalism of the time. To admirers of the standards of beauty of the classical antiquity and the Renaissance, African images of man and woman could not fail to appear ugly or grotesque.

These characteristics of the first encounter of Black Africa with Western Europe more or less persisted until the colonial period. Political colonization, one of the consequences of the industrialization of Europe, established another relationship between Africa and the world. It lasted for about seventy-five years if we take two significant dates to mark its beginning and its end. In 1885 the European governments interested in expanding their sovereignty in Africa met at the Conference of Berlin and divided the interior of the continent into zones of influence. In 1960, at the peak of the movement for political independence, sixteen new states were formed from former colonial territories.[10]

During the period of European political domination of Black Africa, the number of artifacts imported into Europe increased tremendously. And they were seen by a great number of people. "Colonial" expositions and museums were organized as part of a public-relations effort to promote the colonial expansion. In Great Britain, France, Germany, and Belgium, only some business, military, and missionary groups were convinced that their countries should occupy and administer African territories; the general public and the elected assemblies were rather reluctant to see their governments engaged in what were called "colonial adventures." For these special-interest groups, to exhibit African objects was a means of propagating the colonial idea. Between 1850 and 1875, collections were begun for the museums of Berlin, London, Rome, Leipzig, Dresden, and Paris.[11] These were ethnological museums, not art museums.

Their exhibits were soon to be interpreted in terms of the evolutionary theory that became the dominant intellectual framework in the last decades of the nineteenth century. In his *Ancient Society*, published in 1877, Lewis H. Morgan applied to social and cultural phenomena some of the paradigms of biological evolution, such as the sequences from simple to complex and from inferior to superior. For Morgan, the first stage in cultural evolution is *savagery*, the period before pottery, subdivided into lower, middle,

and upper steps; the second stage is *barbarism*, the ceramic age, also with three steps; and the third stage, *civilization*, begins with writing.[12] Each contemporary society was understood to be on the evolutionary track, and its stage of development was assessed with reference to the general outline. The artifacts from "savage" and "barbarian" societies in the nineteenth-century collections were perceived as inferior to the ones produced in "civilized" societies, particularly those of Western Europe and North America, regions enjoying the highest level of "civilization."

The evolutionary theory provided an ideology making meaningful and acceptable the colonial enterprise. The bearers of cultures on a low rung of the evolutionary ladder did not have the right to stop the ascent of others and themselves to higher rungs. Those at the top of the ladder, the "civilized," had the right and the duty to develop mineral, vegetal, and human potentialities left unexploited in "inferior" societies. The latter were to be helped to progress toward "civilization" through a system of work and commerce, order and Christianity organized by the "civilized nations" for the benefit of humankind.

Colonial expansion and cultural evolutionism, so perfectly convergent, have to be taken into account if we wish to appreciate the nineteenth-century European understanding of African icons. It was taken for granted that in the fine arts, as in the other fields of culture, the nineteenth-century mainstream was the acme of a unilinear evolution—unilinear in the sense that all the cultural forms have to go through the same sequence

Three stages in the stylization of a bird and crocodile representation. Massim district, New Guinea. Photo from Haddon 1895.

184

186

188

"Cubist" mask. Grebo, Ivory Coast. Collection,
Musée de l'Homme, Paris.

and reach the same summit. And for the academic art tradition, any icon was aimed at reproducing the visual impression the beholder would have if looking at the object depicted. Anything deviating from a naturalistic representation was perceived as an unintended failure, the result of either incapacity or deterioration. Alfred C. Haddon, a biologist who led the Cambridge Expedition to the Torres Strait in the late nineteenth century, held the view that in the process of stylization and geometrization of animal forms (zoomorphs), there was a degeneration from the more realistic images, in which everybody can recognize, say, a crocodile, to the most simplified, in which verisimilitude is subordinated to regularity, symmetry, and economy.[13]

If one applies the criteria of academic realism to the African masks and figurines exhibited in European ethnographic museums, they are not acceptable as representations of men and women. They are more akin to children's drawings than to artists' works. This is how they were perceived at the turn of the century.

At that time, some artists in France and Germany did not share the optimism and complacency of the mainstream. They would later be called the "early moderns." They experimented with new forms and "new" emotions. In France, during the first decade of this century, Vlaminck, Derain, Braque, Picasso, and Matisse were concerned with translating the visual appearances of objects into structures made of cubes and other

regular volumes such as cones, cylinders, and spheres. These Cubists were surprised to discover that some analogous endeavors had been successfully completed in African statuary; traditional carvers of Africa, liberated from the imitation of visual impressions, had composed masks and statues with boldly assembled volumes that were not to be seen in the features of the human beings represented by the icons. In so doing, they expressed their conceptions of the nature of human beings and spirits, and they created works that had an existence of their own, and not merely as imitations.[14]

In Germany, also during the first decade of this century, Kirchner, Schmidt-Rottluff, Nolde, and Pechstein, united in Dresden's Die Brücke, attempted to develop a revolutionary art freely expressing deep and "primitive" emotions in simple linear forms and flat areas of plain colors. As art historian Werner Haftmann wrote, "they invoked the right to deform nature for the sake of expression."[15] When visiting the Dresden ethnographic museum, Kirchner was impressed by Melanesian and African forms, as Derain and Vlaminck were when they discovered African masks and statues in junk shops around Paris. The painters of Die Brücke found in icons from the world-without-writing (as well as in Gothic woodcuts) the expressive strength of simple forms and liberation from imitating nature.

These French and German painters were the first to recognize the aesthetic value of the images carved in nonliterate societies. Art critics followed the painters' lead. Carl Einstein, in an article published in 1915 and still read, analyzed African sculptures as visual forms only.[16] He concluded that the African tradition was the only one which had really solved the problem of the representation in three dimensions, the European sculpture remaining "painterly" to a large extent. In 1920, Roger Fry wrote that some African carvings were greater sculpture than anything produced in the Middle Ages because they had the special qualities of sculpture in a higher degree; their forms were really conceived in three dimensions.[17]

Books were written on "primitive art" from an exclusively aesthetic point of view, some even stating that ethnographical information was irrelevant.[18] Ancestral statues, ritual figurines, and ceremonial masks were metamorphosed into Western art objects. As most of them belonged to the aesthetic locus of their cultures of origin, and as art is our aesthetic locus, they shifted from the one to the other.

Anthropologists did not initiate the metamorphosis, but they accepted it. Curators of ethnographic museums and dealers in exotica followed avant-garde artists and critics: they organized temporary exhibits and sales of primitive art—which at last may appear without quotes since it now refers to a category of our Western reality. According to Goldwater's chronology, the first gallery exhibit of primitive art took place in New York as early as 1909, and the first museum exhibit opened in Paris in 1923.[19] Museums devoted exclusively to primitive art were founded: in 1957, the Museum of Primitive Art, in New York; and in 1960, the Musée des Arts d'Outremer, in Paris. The ultimate institutional recognition of the aesthetic achievements of the peoples-without-writing was given in the late seventies by the Metropolitan Museum of Art. The Michael C. Rockefeller wing was built expressly for "the art of Africa, the Pacific Islands, and the Americas."

The story of the assimilation of African objects into the art compartment of contemporary Western cultures sheds some light on the ways cultures change.

In the whole process of transmutation from African instrumentality to Western art,

human images were more important than other artifacts. From sixteenth-century mission-aries to twentieth-century art critics, more attention was focused on human representa-tions than on any other object. This is certainly due in part to our figurative bias. Our culture has accorded privilege to representations of tangible objects of our experience over nonfigurations which, for centuries, have been relegated to minor functions of ornamentation. It is also due—and more importantly, I think—to the strong significations imparted to the human figure. The way man and woman are represented encapsulates cultural values and gives some access to the imaginary world in which the members of a culture live: how they imagine gods and spirits, how they feel their impact, how they wish to be related to them.

These human icons, pregnant with the dreams and the ethos of a culture, have to make sense in the terms of the receiving culture if they are to find a place in it. The first human images that came to Europe were imported from the kingdoms of the Zaire river basin, particularly from the kingdom of Kongo. Some were charged with magical sub-stances stuffed in a cavity in the abdomen, some were covered with nails in order to increase their power. These strange additions and the threatening features of faces and attitudes suggested the intention of harming. In the European imaginary world of the time, these human images made sense as evil beings.

Images from other cultures do not come in a political and economic vacuum. The way they are integrated in the receiving culture reflects the relationships between the two societies. The Portuguese who, in 1482, reached the mouth of the Zaire river were few and far from Portugal; the kingdom of Kongo in which they entered was a well-organized and rich state. In the following years, Kongo and Portugal were two sovereign states, nominally equal and allied. In fact, Portugal, a world power in the sixteenth century, put pressure on Kongo to obtain slaves for the plantations in America and, simultaneously, to convert the Kongo nobility to Catholicism. Resistance to this program created tensions and conflicts. The human representations of "the false gods of the pagans" were received as such in Catholic Europe.

During the colonization stage, relationships between Europe and Black Africa were different. Africa was militarily occupied and economically exploited. Neither Africans nor their gods were to be feared any longer. Images, together with spears and arrows, pots and baskets, hoes and adzes, were integrated in the Western cultures as documen-tary evidence of the differences and the inferiority of those who were to be dominated by us. Ethnographic exhibits and museums expressed these crude views in the objective terminology of the scientific theory of evolution, which could not be offensive to anybody except the ignorant.

Later, the chance encounter of the aesthetic research of a few artists, who later would become leading painters of the twentieth century, and of the formal solutions embodied in many African carvings, called the attention of the art establishment to the aesthetic quality of these carvings.

This suggests that there are only two options for integrating instrumental objects which have lost their original function because they are no longer in their original context: to adopt them as documents, or as art. The loss of the original function does not only result from transfer from one culture to another: it frequently occurs from obsoles-cence within one culture. What are we to do at present in North America with an oxen yoke, an aircraft propeller, or a calumet? Place them in an ethnographic or folklore circuit

(curiosities stores and exhibitions, interior decoration supplies, specialized or local museums). Or place them in an art circuit (art galleries and museums, critics and collectors) if their aesthetic quality is deemed to be significant enough.

Noting the considerable number of art objects by metamorphosis on the art circuit, it is tempting to see one of the origins of the Western category of art in these items which lost their primary function by conquest or obsolescence, processes particularly frequent in Western history since the Renaissance. Rapid obsolescence of an increasing number of instruments is a result of the accelerating pace of technical change. Domination and exploitation have characterized the interaction of Europe with many distant countries since the age of the European exploration of the seas and continents of the earth. In the large quantity of objects having lost their original instrumentality, some displayed aesthetic forms. By perceiving and contemplating these forms, beholders gave a new meaning to these objects and made of them art works.

The Aesthetic Object as Symbolic

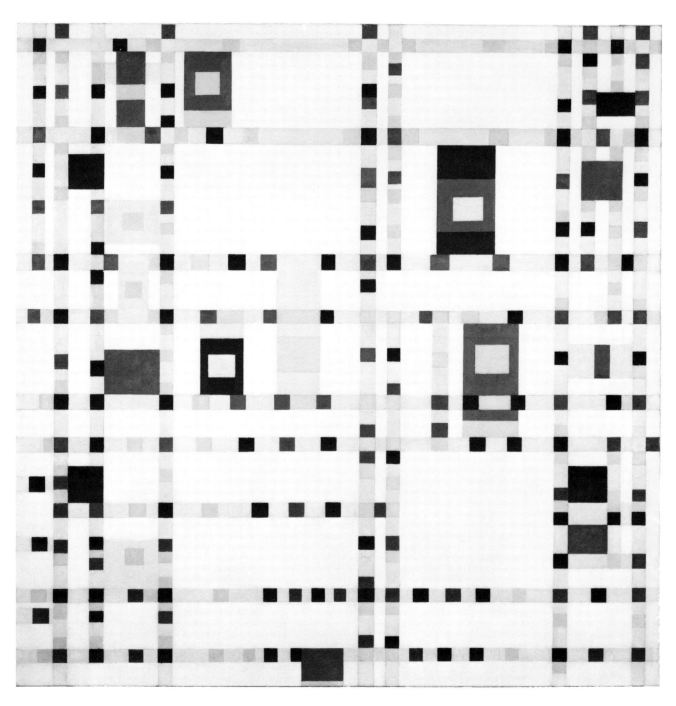

PIET MONDRIAN. *Broadway Boogie Woogie*. 1942–43.
Collection, The Museum of Modern Art,
New York.

CHAPTER EIGHT

Meanings in Aesthetic Objects

IN AESTHETIC ENCOUNTERS, BEHOLDERS' MINDS ARE ABSORBED IN CONTEMPLATING THE visual forms of objects. Content and material, anecdote and depicted subject, war horse and nude woman fade away and leave the beholder's attention concentrated on the "flat surface covered by colors arranged in a certain order."

These ideas, put forward in the first part of this book, seem to epitomize what has been called *formalism* and *aestheticism.* For those who use these terms in a derogatory sense, granting aesthetic significance only to visual forms amounts to divesting aesthetic objects of any meaning. It is their conviction that an object reduced to its visible forms may at the most offer some delight to the eyes of the effete and decadent but would offer no meaning worth the attention of the serious person. Bottles and apples, breasts and legs are deprived of sense when perceived as Cézanne's famous cylinders, spheres, and cones. If there is no subject matter, then there is no meaning.

In the aesthetic experience, do forms have meanings apart from what they represent?

Some time ago, I was looking at Mondrian's *Broadway Boogie Woogie* exhibited in the Museum of Modern Art in New York City. It is a typical Mondrian geometrical composition of vertical and horizontal bands that traverse the whole surface. In this painting, the bands are adorned with small colored squares, and in some of the rectangles delimited by the strips there are other squares and rectangles. Whereas Mondrian's style has shown a persistent trend toward simplification and reduction, *Broadway*, which was painted in 1942–43, at the end of Mondrian's life, indicates a sort of reverse movement. Although every shape is still rigorously at right angle or parallel to the fundamental grid structure of the painting, it is more filled in and varied than some of his earlier compositions.

Knowing this piece of information concerning Mondrian's evolution, I mentally compared *Broadway* with the older, "purer" Mondrians I had seen and that I remembered. These mental images of other paintings were soon replaced by an attempt at reading the picture as a map of city blocks—suggested by "Broadway" in the title. The bright colored

squares, irregularly spaced, were interpreted as cars in the streets, seen from above. But the oblique of Broadway north of 42nd Street was not to be found in the picture. Before long, the second part of the title, "Boogie Woogie," evoked sounds and rhythms of jazz and the bright colored squares became joyful musical notations. I reminisced about a period of my life when I simultaneously discovered jazz and Manhattan. I was still seeing the picture, but I was not looking at it.

I directed my attention to the canvas. Thoughts and comments, associations and remembrances, the sadness and pleasantness of nostalgia receded into the background and subsided. There was a shift to a nonverbal contemplation: a quiet but intense vision of the painting. It was perceived as if seen for the first time, as if seen "as it is." Everything inside the frame was vividly present; beyond the frame, the wall and the world had a weakened existence. I was not aware of the passing time. After a few seconds, or a few minutes, or perhaps even many minutes, Mondrian's grid appeared as an intended order, a firm underlying scheme for life, on which the bright points of particular actions and emotions are arranged and located, classified and controlled. This thought was not the result of reasoning; it did not arise as a possible interpretation of a nonfigurative painting, which should be compared to other possible interpretations so that the best one would be retained. It appeared as an insight about life, an intuition about a certain manner of ordering one's life. This idea was made visible in the Mondrian painting.

What is described here in retrospect is verbalized and analytical. When I was contemplating the painting there was no verbal analysis, no distinction between *order* as a concept and as visually expressed by the painting. Order had the evidence and the presence of an experience in which one is involved. Yet order did not appear as restricted to the painting; as beholder I was aware that the Mondrian canvas was not life, but I perceived life and the canvas as sharing the same quality of order. Order in life was better understood because of the Mondrian, and order on the painted surface was better apprehended because it corresponded to a part of the life experience of the beholder. At the time of the visual commerce with the painting, I did not make any of these distinctions. Order was not a word but an experience. It was what the aesthetic object meant to the beholder.

This meaning was not provided by what the painting represented nor by its title. It was not an image of entities that we, or even Mondrian's contemporaries, could have recognized. It was not a part of the map of Manhattan, it was not a picture of the lights of Times Square, and it was not a representation of a group playing jazz. The meaning was provided by visual forms that were not figurative. This meaning of order was directly perceived in the forms.

From Mondrian's *Broadway*, I walked to another painting on exhibition at the Museum of Modern Art, Jackson Pollock's *Number 1* (1948). It was impossible to miss: its size is about nine by seventeen feet. What I knew about Pollock irrupted in my mind. Pollock had been discovered by Peggy Guggenheim and had had a short and brilliant career as the leading figure of the Abstract Expressionist movement. He had been the inventor of *action painting*, a technique of dripping liquid paint on a canvas stretched on the floor. *Number 1* was, in fact, a good example of the result achieved by that technique.

After remembering these bits of information, I succeeded in visually concentrating my attention on the thick impasto. The painting became an overwhelming presence. At the top layer, the eye followed one of the many white lines formed by the drippings. Not for long, however, as these lines were short and unconnected, resulting from brisk

JACKSON POLLOCK. *Number 1, 1948*. 1948.
Collection, The Museum of Modern Art,
New York.

movements of the hand apparently liberated from any rational control (the painter, in a trancelike state, worked rapidly). My attention then shifted to the texture under the drippings, a field of blots and irregular small marks. After a period of purely visual concentration—during which time none of the above description was verbalized—the meaning of the painting imposed itself on the contemplative awareness of the beholder: undirected energy, random movements of a matter in the process of becoming.

Another Abstract Expressionist painting, *Edge of August* (1953), by Mark Tobey, hung nearby. He painted it in his particular "white writing" style, covering the ground with small marks looking like the characters of an Oriental script. The little white strokes constituted an intricate network which appeared to stand, as a white cloud, a few inches away from the canvas. A triangle in another texture in the bottom left corner, and a narrow area to the right side, part golden yellow like a wheat field and part dark blue like a night sky, contributed to the three-dimensional impression suggested by this nonfigurative painting. The visual attention of the beholder was effortlessly kept on the canvas. Once again, my state of self-awareness receded and was replaced in the foreground of the mind by a visual absorption in the painting.

During this contemplative commerce with the object, I intuitively perceived it as the visual equivalent of quiet illumination. It was not experienced as an outburst of light, but as a soft clarity which totally permeates what is to be understood. Illumination, as meaning of the painting, imposed itself on the beholder. It did not appear as the best interpretation that could be argued for, but as an evidence. *Edge of August* meant illumination because it suggested an experience of it.

In the three aesthetic encounters just described, the meanings of the paintings were conveyed by their formal features: lines and colors, shapes and textures, contrasts of light and darkness. These three works were not figurative: they were not images of people or things that could be recognized because they existed in the outside world. Certainly, some lines evoked streets as drawn on a map, some colored squares could be read as markers for cars, some areas suggested by their hues earth or sky, day or night. But none of these configurations was a visual representation of a street, a car, or a country landscape. The three pictures were content-free, uncontaminated by represented items; the meanings we read in them could not be derived from outside subject matter as none was to be found.

Clearly, forms have meanings.

When paintings are images, forms represent warriors or peasants, forests or seashores, apples or water lilies. Obviously, these items contain meanings for those who observe them in the outside world. When represented on a canvas and aesthetically perceived, are their meanings derived from the forms on the canvas, or from the subject matter, the object as it is in the outside world? After all, Cézanne's apples are apples and Monet's water lilies are water lilies. The external object as conveyer of meaning seems to be more evident in pop art, where the imagery from advertising, packaging, comic strips, and fast-food items is so eye-catching—as it is an unusual imagery in the Western repertory of artistic motifs. Meanings seem to be generated by the outside objects rather than by the forms on the painted surface.

I concentrate my attention on Roy Lichtenstein's *Blonde Waiting* (1964). It is not easy because only a book reproduction is available to me, whereas the original oil painting is a

MARK TOBEY. *Edge of August.* 1953. Collection, The Museum of Modern Art, New York.

ROY LICHTENSTEIN. *Blonde Waiting*. 1964. Private collection, Los Angeles. © Lichtenstein / VAGA, New York, 1985.

four-by-four-foot canvas. Nevertheless the picture is strong enough to sustain a visual contemplation even when reduced to a four-by-four-inch photograph. Intense attention is given to the flat colors and the thick black lines delimiting the shapes. What the picture conveys to me appears with sudden evidence, *instability* and *anxiety*.

Is this meaning in the formal features of the picture or on the face of the young woman represented on the canvas? I look again at the photograph, this time in an analytical mode. The central area of the picture is strongly framed. First, it is in the middle of the square surface of the canvas. Second, the brighter center is framed again by the vertical yellow and black straight lines on the left side, by two horizontal straight black lines below, and by an array of darker flowing and curved lines above and to the right of the smaller "square."

In fact, this central area is unbalanced. The darker organic lines at the top visually have more weight than the two straight lines at the bottom. When there is more visual weight above than below, it is perceived as a lack of stability. In order to check this interpretation, I turn the book around and look at the picture upside down. It is immediately stabilized as the parts with more weight are at the bottom, offering a firm basis for the heavy vertical lines at the sides.

Returning the picture to its normal position, I look at the center. There the dominant lines are oblique, from upper left to lower right, an orientation visually perceived as "descending." The forms, when analyzed as forms, are in disequilibrium, and those located at the visually most important position, the center, are moving downward.

This analysis, made in retrospect, seems sufficient to explain why the contemplated forms gave the beholder the intuitive meaning of instability and anxiety. Imbalance and slipping down are, indeed, destabilizing and do create anxiety.

In the case of *Blonde Waiting*, shapes and colors on the painted surface are also representational. We may look at this Lichtenstein as if it were a window—or a keyhole—through which we peek at a scene in an actual room, and analyze it in terms of the depicted subject matter: a young woman lying on a bed, her head resting on her shoulder and crossed forearms. She looks at an alarm clock on a table, near the brass headboard of her bed. Behind her, a Venetian blind is shut. Her face is very close to the beholder. The frown of her eyebrows, the tension of her mouth express annoyance and irritation. The whole scene suggests distress. The woman seems to expect somebody who is late; she is worried by the lateness which is ominous. The picture's caption, "blonde waiting," confirms this interpretation.

It is tempting to say that the Lichtenstein painting as a configuration of forms and as the representation of an anecdote, conveys similar meanings: instability and anxiety, worry and impending danger. First, there was an aesthetic apprehension of the painting, made in a contemplative mode of consciousness, during which the meanings of instability and anxiety were intuitively perceived. Then, in a cognitive mode of consciousness, I proceeded to two analyses. A formal analysis related the intuitive meanings to some features of the painted canvas, and a representational analysis revealed meanings convergent with the ones discovered in the forms.

If we admit the duality of form and subject matter, we can add that when form and subject matter compete for the attention of the beholder, what is represented is often the winner. The compelling presence of the outside world—here, the woman in the room—must be overcome if we want to concentrate our vision on the forms as such. But is the

form–representation distinction a useful one for clarifying the relation between aesthetic objects and the meanings they convey? Let us further consider the validity of this distinction in the light of a few more examples.

The human body in the nude is a perennial motif in the Western fine arts. For art historian Kenneth Clark, this "art form invented by the Greeks in the fifth century" is the only one of "those inheritances of Greece . . . revived at the Renaissance" which has survived in our century. "It may have suffered some curious transformations, but it remains our chief link with the classic disciplines."[1]

Innumerable images in two or three dimensions have the same subject matter, the female figure in the nude. Yet their meanings are quite different. The famous picture *The Source* (1856) by Ingres represents a girl standing with a water jug on her shoulder. A complete description of what is represented includes other features: she is standing on the edge of a pool of still water; behind her is a wall-like rock; and she is holding the jug so that water is gently flowing from its neck. But her body, in full frontal view, is obviously the dominant subject matter of the painting.

To this beholder, Ingres's *Source* conveys the meaning of poise, a blend of openness and reserve, which results in gravity and naturalness. This intuitive meaning is supported by subsequent formal analysis. The vertical lines of the left body contour and of the water flowing from the jug, the right angle of the elbow, and the short horizontal line of the forearm above the head give a straightforward linear composition and accentuate the frontality. The formal statement has directness but no rigidity: the curves on the right side of the body balance the straight lines on the left side.

These meanings conveyed by the forms are analogous to those we can read in the picture as representation. The eyes and traits of the woman's face express calm and serenity. She presents her body in full view without affectation and embarrassment, but by closing the knees, she makes herself sexually inaccessible. As Rudolf Arnheim wrote about this painting, "In the center of the silent plane lies the closed sanctuary of sex."[2]

From the point of view of formal and representational meanings, it is of interest to compare *The Source* by Ingres with its pop "interpretation," *Ode to Ang* (1972) by the Californian painter Mel Ramos. Stating that "art grows from art," Ramos has used famous pictures by Velázquez, Giorgione, David, Modigliani, de Kooning, and others as "sources" in the same way other pop artists—and Ramos himself—have taken comic strips as sources for their own paintings.[3] Ramos faithfully reproduces *The Source*'s composition in his *Ode to Ang* ("Ang" is another pop interpretation, this time of the name Ingres) but the style of representation is totally different. It is the pseudophotographic naturalism of commercial art in advertising and magazine illustration. This naturalism pretends to provide a representation as accurate as a photograph; and indeed sharpness of lines and distinctness in the rendering of details may duplicate a perfectly focused photograph. But lusciousness of shapes, smoothness of texture, and the glowing flesh reveal an idealization of the body that goes beyond the possibilities of a camera.

Difference in painting techniques—the slick sharpness of Ramos as opposed to the soft brushwork of Ingres—contributes to conferring completely different meanings to pictures otherwise so similar. Instead of poise with the connotations of gravity and sincerity, the Ramos painting conveys the meaning of fun. Certainly, the precise and glossy rendering is significant in the metamorphosis of an innocent nineteenth-century

JEAN INGRES. *The Source*. 1856. Musée du Louvre, Paris. Photo: Musées Nationaux.

MEL RAMOS. *Ode to Ang*. 1972. Wilp Collection, Düsseldorf.

youth into an inviting twentieth-century California girl. But, in addition, representational features concur in conveying the light and pleasant meanings summarized by the word *fun*. There is the representation of nakedness rather than nudity: the absence of clothes is felt as a lack because the selective suntan reminds the beholder that the woman usually wears a two-piece suit on the beach. There is the unexpected weasel and the suggestion of playfulness in water and sun. There is the light-hearted irreverence of the parodic interpretation of a classic masterpiece.

In a stable rectangle, in which the longer side is horizontally oriented, Modigliani painted the *Reclining Female Nude* (1917). Within this frame, the dominant direction is a

AMEDEO MODIGLIANI. *Reclining Female Nude.* 1917.
Staatsgalerie, Stuttgart. © ADAGP, Paris / VAGA,
New York, 1985.

descending oblique, from the upper left corner to the lower right one. This direction is
restated by a thin white line above the oblique. On the dark ground, the body contour
encloses a brighter area which extends, across the painting, along the axis of the domi-
nant oblique. Visually, this lighter surface is pulled down from the lower right corner by
the weight of the larger brighter surface in this corner. When we pay attention to the
person represented, we notice that this visually heavy area corresponds to her hips and
thighs—which are frontally seen whereas the body from waist to shoulders is presented
laterally. The eyes, open but dreamy, and the body lying in a sleep position suggest a
vegetative rest. All these traits contribute to the meaning of earthiness that can be
apprehended in this Modigliani painting.

　　This painting was a source for another interpretation by Mel Ramos. Despite the
aggressively pop title, *You Get More Salami with Modigliani No. 14* (1978), his painting is
serious. The general composition is similar to the Modigliani. The bright area of the body
is obliquely set up on the darker ground, but it is not weighted in the same way: the hip
region is thinner than in the Modigliani, and it is visually balanced by the large bright area
of the pillow. A strong projected light produces sharp shadows instead of the diffused
light in Modigliani's painting. Ramos's photographic style makes the woman repre-
sented more present. She does not daydream but establishes eye contact with the
beholder. For this beholder, the picture states that communion of thought and intimacy
of senses makes a woman-and-man relation whole.

　　In *The Blue Sofa* (1967) by Paul Delvaux, depth is obtained by an ostensible application
of the Renaissance principles of central perspective. From the plane of the canvas, the
planks of the floor and the girders of the glass roof converge to a vanishing point; the

MEL RAMOS. *You Get More Salami with Modigliani*
No. 14. 1978. Collection Dewain Valentine, Venice,
California.

glass wall, with repeated right angles, and the sofa are frontally placed as on a theater
stage. The structure of the space is made as visible as in the outside world. In fact, it is
more visible. The external world here is the trivial environment of a European suburb
with a cobblestone street, a railway bridge, and a distant cyclist. It is night, and the
almost-empty streets are lighted by a few public lamps.

Yet this commonplace scene is very strange. A strongly bluish light pervades the
whole picture and colors everything in cool blue. One nude young woman is sleeping on
the sofa while another one, standing, holds a candle. It can be said that the form (the
stressed elements of perspective, the blue tonality) and content (the incongruous nude
figures) contribute to the strangeness and eeriness of the depicted scene. Looking at the
central figure of the painting, the woman on the sofa, the beholder is made aware of the
actuality and consistency of her oneiric world. She is dreaming. What we see is what she
dreams, and at the same time it is the solid outside world of everyday life. The line cannot
be drawn between the inner world of dreams and the outer world of cobblestones and
street lamps. This is what the Delvaux picture means to this beholder.

Tom Wesselmann's series *The Great American Nude* was begun in 1962. Closer to the
Western fine arts tradition than are most of the other pop artists, Wesselmann has used
two classic art forms, the nude and the still life, and has duplicated some of Matisse's
color techniques. His *Great American Nude No. 92* (1967) is a composition radiating from a
central triangle from which centrifugal motion lines originate; they are kept in balance as
they compensate one another. The central triangle is also an image of the pubis of the
woman lying on a piece of material spotted as leopard fur.

The style of representation is abstract. Except for the three oranges, which are

PAUL DELVAUX. *The Blue Sofa*. 1967. Private
Collection, Brussels. © SPADEM, Paris / VAGA,
New York, 1985.

TOM WESSELMANN. *Great American Nude No. 92.*
1967. Private collection, New York. © Wesselmann /
VAGA, New York, 1985.

TITIAN. *The Rape of Europa.* c. 1560. Isabella Stewart
Gardner Museum, Boston.

shaded, there is no pictorial suggestion of volume: body, curtains, and tabletop are
rendered by colored fields of uniform value and intensity. It is also a style of simplification.
Only the erogenous parts, associated with sexual ecstasy, are represented. Ecstasy is
another classical theme. "In the nude of ecstasy, the will has been surrendered, and
the body is possessed by some irrational power . . . and flings itself backward."[4] The
Wesselmann *No. 92* displays an unexpected resemblance—even in the movement of the
raised leg—to the *Rape of Europa* (c. 1560) painted by Titian. The meaning of the Wessel-
mann picture is erotic. It is a joyful celebration of the fulfillment of desire.

In discussing this series of figurative pictures presenting the female figure in the nude as central motif, we analyzed each of them as conveying two sets of meanings, the formal and the representational. The representational meanings were derived from the depicted subjects as existing independently from their presence on the framed surface. If we had met Modigliani's model, we would have found her dreamy and passive; Ramos's model, on the contrary, would be lively and articulate. A painting is a window through which we look at actual persons—or so we think.

In fact, we do not *see* the Modigliani or Ramos women anywhere other than on the "flat surface covered by colors arranged in a certain order." The calm and serenity of *The Source* are not read on the face of a person but in some pictorial forms. The subject matter independent of the forms on the canvas cannot be visually attained. We may daydream about her, or him, or it, and let our imagination go; or we may build an abstract concept of the subject matter (the female figure in the nude, or the apples). But the meanings of visual objects do not lie in imaginary beings, nor in abstract concepts, they lie only in the visible.

From the point of view of the meanings of the visual, the form—subject matter distinction is of no use. There is no subject matter independent of lines and shapes, colors and textures, brightness and darkness. Figurative works are not different from non-figurative works in this respect. Their meanings lie exclusively in their forms.

CHAPTER NINE

Visual Forms as Signs

IN MY AESTHETIC VISION, MONDRIAN'S COMPOSITION OF VERTICALS AND HORIZONTALS stood for order, Tobey's light cloud stood for spiritual illumination, and Delvaux's scene in blue stood for the continuity of the external and oneiric worlds. In these and in the other cases discussed, "meaning something" was equivalent to "standing for something." However, the switch from "meaning" to "standing for" suggests another avenue of analysis.

In common language—our constant guide because it expresses the collective reality built by our society—something that stands for something else is called a *sign*. This directs us to the field of signification.

The relationship of signification may be formalized, on the basis of everyday language and the implications of its practice, in the following paradigm: *In context M, sign A stands for signified B to subject X.*

Sign and *signifier* are generic terms for any item that stands for something other than itself. Such items include the stars and stripes; the Rolls Royce; the color red; and the *liṅga*, the stylized phallus honored in some Hindu cults. Each of these respectively stands for the United States of America; having great wealth; danger; and Śiva, the god of destruction and creation. The concept antithetical to sign denotes that an item stands for itself. Let us refer to this concept using the word *entity*. A tree, a house, and a rock are entities.

But a Rolls Royce and a stone carved in phallic form are also entities, are they not? The sign−entity opposition is exclusively conceptual: any material item can be classified as an entity (it exists here and now) and as a sign (we may make it stand for something else). However, some items are primarily recognized as signs (for example, flags and traffic lights), while others are recognized as entities (for example, tools, animals, and people). If the question What does this item mean? is appropriate, we may conclude that the item is primarily regarded as a sign.

Reviewing examples illustrating the paradigm of signification, one soon realizes that there are different ways a sign stands for a signified, and that there are words denoting these various types of signification.

93

In English the word *sun* stands for the star that is the basis of the solar system and the source of light and heat; the word *moon* stands for a satellite of the planet Earth. The relationship between *sun* and its signified is arbitrary, as is the link between *moon* and its signified: other English sounds could have been used to signify the star of light and the night satellite. Because the word-signified connection is arbitrary, it is conventional; past and present generations of English speakers have implicitly agreed, and still agree, that what is written *sun* and what is spoken as *sun* stands for the day star. The implicit collective agreement is revealed by the transmission of English vocabulary from parents to their children, who must learn which word stands for what thing. Non-native English speakers must learn the conventional connections between words and things later in life. The lexicon of any language is an arbitrary and conventional code that has to be learned.

There are two partial exceptions to this generalization. Some spoken words of onomatopoeic formation imitate natural sounds (for instance, *buzz*, *crack*, and *cuckoo*); and some written words of pictographic formation imitate the visual appearance of the things for which they stand (for instance, the Chinese characters for tree, root, and rice paddy evoke the visible forms of their signifieds). These are only partial exceptions as their natural connections with sounds and forms have been formalized to such an extent that they too have become conventional.

Thus, words can be said to be signs that stand for their signifieds by conventional reference. Signs by reference may be called *referents*. Referents constitute a first subclass of signs.

A bicycle is an instrument for transportation. During the 1960s and 1970s in affluent industrial nations, it became a sign of ecological concern. The bicycle was and is perceived as an exemplary vehicle. It does not use energy from fossil fuels—nonrenewable sources—and it is not air-polluting. The bicycle makes it possible for one to apply in one's life the mottos "Small is Beautiful" and *vivere parvo*. The bicycle stands as a sign of ecological orientation by being associated with the reduction of wasted energy. It is an *indicator* of its signified by a usual and stable association with it.

Yet the association is incidental. In Europe during the 1920s and 1930s, the bicycle was an indicator of working-class status. In colonial Africa during the 1950s, it was associated with African white-collar employees. The connection this indicator has to each of the three signifieds is not arbitrary: ecology-minded people, working-class Europeans, and African clerks actually used bicycles. Nevertheless, indicator–signified associations, though lasting for some time, were not necessary. Bicycle as vehicle is not intrinsic to any of these three groups.

Indicators, defined as signs by association, constitute a second subclass of signs.

A third subclass of signs consists of *images*. The *Portrait of a Cardinal* by El Greco stands for a particular individual—presumably Cardinal Don Fernando Niño de Guevara—by a similarity of visual appearance. Looking at the portrait, we see Guevara pretty much as a visitor calling on him would have seen him during the year 1600, in his Inquisitor-General office in Madrid. Images are visual duplicates of persons, things, landscapes, and any other visual entity that can be seen in the external world.

Images thus stand for the visible entities they signify by resembling them.

Symbols constitute a fourth subclass of signs. Undulating lines engraved on a slab of stone symbolize flowing water as wavelike patterns appear both in streams and on the stone. In Sri Lanka, banners and other festive trimmings of a yellow-orange color

EL GRECO. *Portrait of a Cardinal,* probably Cardinal Don Fernando Niño de Guevara. c. 1600. The Metropolitan Museum of Art, New York. Bequest of Mrs. H. O. Havemeyer. The H. O. Havemeyer Collection.

symbolize the monastic order, as these banners and monks' robes have that color in common. The connection between a symbol and its signified is by partial identity or analogy: undulating lines and the yellow-orange color are identical in the signifiers (engraved slab and banners) and in the signifieds (flowing water and robes). Because of this connaturality, the relationship between symbols and what they symbolize is close and free from artificiality.

Symbols are defined as signs standing for their signifieds by participation.*

Referents, indicators, images, and symbols stand for what they signify in a *context*. The context is an essential part of the description of a signification relationship. Without the context of a sentence, the word *star* may, according to my dictionary, refer to ten signifieds.[1] A sentence is necessary and sufficient for clarifying to which of the ten possible signifieds the word *star* refers. For example: "The sky is clear tonight, there are many stars"; "This party is a success, there are many stars"; "There are many stars on the flag"; and "My horse is the one with the star."

The context may be a historical situation. The bicycle, as an indicator, is different in each of the three historical periods mentioned above. The context may be cultural. The swastika is a referent standing for a different signified in ancient India, among the Navaho, and in Nazi Germany.

Signs should not be separated from context. This is generally recognized. Yet contexts are often insufficiently described or are even forgotten altogether. Some studies purporting to interpret signs seem to ignore the importance of placing a sign in its historical and cultural environment.[2]

It is less generally recognized that the relationship of signification includes a *subject* as an essential element. To signify is a mental act: for the signification to exist it has to be posited as part of the construction of reality and be perceived as such.

The subject is the individual stating the relationship between signifier and signified and recognizing it—where else but in individual minds could this be done? Here, the subject is not the individual as unique and different from any other individual, it is the individual-in-collectivity as expressing the actual or potential consensus of a group. The group, or the collectivity, may be a society in its totality, a well-delimited segment of a society (as the members of a profession, for instance), or a nonorganized aggregation (as, for instance, a concert audience or the visitors to an art exhibit). It is the collectivity made of those who posit a signification and those who perceive it.

The consensus of a community of minds, a condition of any signification, should not be understood as the learning of a code, a condition of the signification by reference. A code, as previously stated, is conventional: it is based on an explicit or an implicit agreement. On the contrary, the association between an indicator and what it indicates, the resemblance between an image and what it represents, and the analogy between a symbol and what it is connatural with do not require the learning of a code. Nevertheless, it has to be stated and recognized in a certain context by a subject. In order to perceive the symbolism of natural similarity in the color of festive banners and monks' robes, one must achieve some familiarity with the Sinhalese culture. But there is no code to be learned.

*This terminology differs from the one used in my *Introduction to Aesthetic Anthropology* with respect to three concepts: what stands for something else (here, "sign" or "signifier") was called signifier, and never sign, in the *Introduction*; what the signifier stands for (here, the "signified") was called referent in the *Introduction*; and what stands for something else by convention (here, "referent") was called sign in the *Introduction* (Maquet 1979: 86, 89, 90).

We notice that a certain sign is distant from its signified whereas another sign is close to its own signified. In fact, the four subclasses of signs, when listed in the order of their presentation—referent, indicator, image, and symbol—reveal an increasing closeness between signs and what they stand for.

Referents (that is, mainly words) and their signifieds (things or ideas) belong to different logical categories. They are linked only by a convention validated by the continuous usage of those who speak a certain language at a certain time.

Indicators can be described as temporary metonyms. Like a metonym, an indicator is part of the configuration defining its signified. For example, the crown, an attribute of the royal government, designates the royal government as a whole. The indicator, however, is firmly associated to its signified only for a certain time and in a certain area. For a few decades, riding bicycles was one of the identifying features of working-class men. Indicators are closer to their signifieds than referents are: they are part of what they refer to, but not a necessary and intrinsic part, only an incidental one.

The connection between an image and what it stands for is not incidental; it is isomorphic. The image has a visual structure similar in appearance to the external object for which it stands. Of course, the visual structure is as similar to its object as the medium allows it to be. Sometimes the three dimensions of a volume are transposed into two on the surface of a canvas, or colors are transformed into shades of black and white in a drawing or photograph, or the rough texture of a stone may be represented on a slick and glossy paper. So the image is something other than the external visible entity it represents, but it could not have been made without it. The image stands on its own only after the external entity ceases to exist. There is no Cardinal Guevara any more, but there is still his portrait by El Greco.

Signification by participation establishes the closest relation between sign and signified. A symbol and what it symbolizes have something in common; they are partly identical. The yellow-orange color visible on banners and robes is the same. Banners symbolize robes by sharing the same color. We can go a step further and say that the sign–signifier duality is not entirely maintained in the symbolic relationship. It tends to become blurred.

The terms and definitions proposed here are consonant with common language and our humanistic tradition. They are not entirely congruent with the terminologies used by some contemporary social scientists interested in symbolism. Several of them, such as Milton Singer and Melford Spiro, have chosen to derive their semiotic terms from the conceptual framework designed during the last century by the famous Harvard logician and mathematician Charles Sanders Peirce (1839–1914). It is useful to indicate the main points of divergence.

One of Peirce's definitions of sign is "anything which is related to a Second thing, its Object, in respect to a Quality, in such a way as to bring a Third thing, its *Interpretant*, into relation to the same Object, and that in such a way as to bring a fourth into relation to that Object in the same form, *ad infinitum*."[3] In this triadic model Peirce relates sign to its object as something that refers to something else. Part of our paradigm, "sign stands for signified," is in accordance with the Peircian definition. *Object*, as used by Peirce, is a common and convenient term for *signified*. We use the latter in order to stay clear of any confusion with *object* denoting artifact.

The third term of Peirce's triad, interpretant, is more difficult to define. I have briefly discussed this matter elsewhere.[4] Suffice it to say that most social scientists who derive

their terminology from Peirce seem to ignore interpretants. We may do the same if interpretant is understood as the whole semiotic context which is a cultural constant.

Peirce's *icons* include *images, maps,* and *diagrams.* Our notion of image agrees with his acceptation of this term. For him, in "maps" and "diagrams" the similarity of sign and signified derives from internal organization and not from visual appearance.[5]

Peirce's *symbol* is a conventional sign. In our use, *referent* corresponds to what he calls symbol. We part company with Peirce and his followers in the social sciences on this important matter. Signification by participation is an essential type of relationship in the aesthetic field, and the word *symbol* was and still is used to denote it in the tradition of the humanities. This tradition is expressed in many important works. For instance, the use of symbols as nonconventional signs is constant in Jung. In the dictionary compiled by the members of the Société française de Philosophie, the symbolic relationship is described as natural, and symbol, as a sign "opposed to artificial sign in that it possesses an internal power of representation; for example, the serpent biting its tail as symbol of eternity."[6]

Peirce's *index* "which refers to the Object that it denotes by virtue of being really affected by that Object" is a concept between indicator and symbol in our terminology.[7] Like our indicator, the index is firmly associated to its signified, but like our symbol, it is connatural to it. For Peirce, the height of a mercury column in a thermometer is an index of temperature, and the symptoms of a disease are indices of that disease.

An excellent example of the three Peircian types of signs as used in cultural anthropology is provided by Spiro in a recent essay. He writes that, by Peirce's definitions, "a relic of the Buddha is (or is believed to be) an index of him; a sculpture of the Buddha is (or is believed to be) an icon of him; and the word 'Buddha' is a symbol of him."[8]

This brief discussion of the paradigm of signification provides us with a set of conceptual tools—the category "sign" and its four subclasses, the individual-in-collectivity, and the context—as essential parts of the relation of signification. Let us pursue our elucidation of the aesthetic experience by analyzing aesthetic objects as signs.

Many aesthetic objects are figurative, and thus they are images standing for an external signifier by visual resemblance. This iconic meaning, as far as it leads the viewer away from the representation and to an imaginary external thing or scene, has a negative impact on the aesthetic experience. It should be stressed that when beholders wander from the painted mountain or the Aphrodite carved in marble, they have no access to the great outdoors or a living goddess, but only to mental images of them. That there is no subject matter independent from the forms on the canvas was a conclusion of the last chapter. To approach paintings and sculptures as images distracts the viewer's attention from the visual object.

It also stimulates discursive thinking. On a plaque from Sarnath, we see the images of a sleeping woman, of other human figures, and of an elephant. If we mentally move from the low relief to the scene, we have to know the Buddhist story of the conception of Śākyamuni: his mother, Queen Māyā, dreamt that her unborn child was entering her womb in the form of a white elephant. It has been said that the carved reliefs inserted in the walls and around the doors of many Gothic cathedrals were a "Bible in stone" for the benefit of the illiterate Christians of the Middle Ages. They were images of the Old and New Testament narratives. Believers were expected to interpret cathedral representations using their previous knowledge of the biblical stories. Thus they had to analyze the carvings as images, remember the episodes they had heard while listening to their village

Māyā's dream. Bhārhut, Madhya Pradesh. 2d century B.C. Indian Museum, Calcutta.

priests, and find the anecdote appropriate to a particular image. This kind of mental activity is considered to be an obstacle to the contemplative absorption in the visible.

Some formal features in paintings and sculptures can be interpreted as referents, signs which stand for their signifieds by a convention explicitly or implicitly agreed upon by a group of people. The good shepherd carrying a lamb on his shoulders, the wheel of the law, the cross, and the trident are like words that one has to know in order to "read" the visual forms. In order to fully appreciate a visual object as a sign standing for something else by convention, one has to learn the code. For instance, that the halo surrounding the head of some human figures, or even of some animals, refers to the holiness of the figure represented in the Christian code of signs is a bit of knowledge that must be acquired by the viewer. That the knot of hair and the long fingers seen on many statues of the Buddha are two of the thirty-two marks of a superman in the Buddhist "vocabulary" of forms must be learned in the same manner. When learning these codes of forms and deciphering the signification of the referents, we are in the cognitive mode of consciousness, not in the contemplative one.

Indicators, signs that stand for their signifieds through incidental association, are numerous in the works exhibited in our museums of fine art. In London's National Gallery, *The Agony in the Garden of Gethsemane* (c. 1580) is one of El Greco's most powerful paintings. Contrasting with the dominant warm and dark browns, yellows, and reds, there is in the lower center a dark blue triangular area. Figuratively, it is a sort of cape upon which Jesus, the central figure of the painting, is kneeling.

I perceived this blue area as an indicator standing for Saint Mary; this blue spot suggested that Jesus, during his crisis of solitary agony when he so strongly expressed his feeling of being abandoned by God, was somehow aware of his mother's support. My

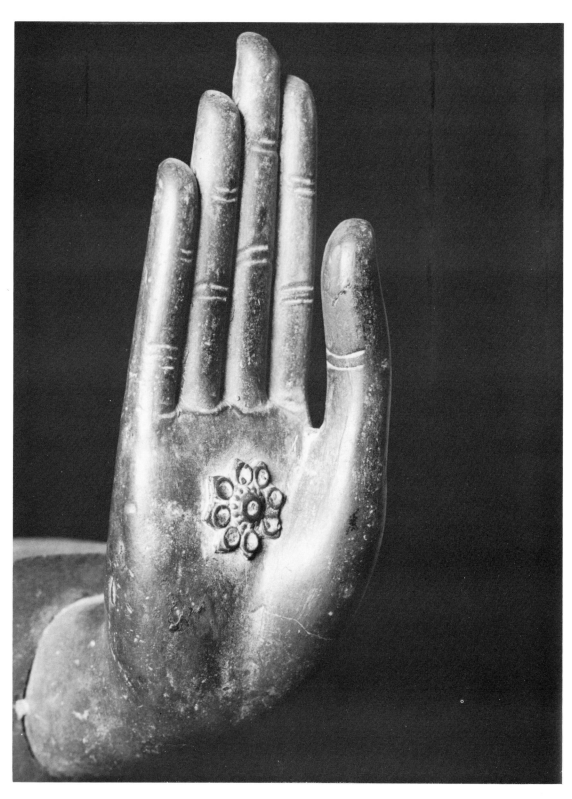

A Buddha's hand with the long fingers mark, in
the gesture of bestowing fearlessness *(abhaya mu-
drā)*. Thai. 20th century. Private collection, Los
Angeles. Photo by Jacques Maquet.

EL GRECO. *The Agony in the Garden of Gethsemane.* c.
1580. National Gallery, London.

interpretation was based on the association of blue with Saint Mary in Christian icon-
ography. Later, I saw that El Greco had painted Saint Mary wrapped in a cape of the same
blue in the *Assumption of the Virgin* (1577), made a few years before *The Agony*. I felt the
probability of my interpretation heightened. Recognizing indicators and determining the
signified with which they are associated require a cognitive familiarity with the specific
subcultures in which the visual objects were made. Again, it is more an intellectual than
a contemplative operation.

El Greco's *Agony in the Garden of Gethsemane* is the image of a scene that can be
recognized by those who are conversant with the New Testament. It includes referents,
such as the angel and the chalice, that can be read by those who know the Christian iconic
code, and at least one indicator that can be interpreted as an allusion to Saint Mary by
those who are familiar with incidental associations common in the Christian tradition.

Similar comments can be made about most of the art works displayed in our
museums: they are signs by resemblance, convention, and association. But these signi-
fications are not rooted in the aesthetic quality of the El Greco. In fact, many paintings
devoid of any aesthetic quality are also images, referents, and indicators. In our earlier
discussion of the form and substance dichotomy, we reached a similar conclusion: a

EL GRECO. *Assumption of the Virgin.* 1577. Courtesy
of The Art Institute of Chicago.

picture is not "beautiful" because it represents a beautiful person or a beautiful landscape.
Now we more clearly understand one reason for this: recognizing and imagining,
analyzing and interpreting are discursive mental activities bound to distract from contem-
plative attention to visible objects.

It is not as images, referents, and indicators that aesthetic objects convey meanings
specific to their aesthetic quality: it is as symbols.

Visual Forms as Symbols

SYMBOLS ARE SIGNS WHICH STAND FOR THEIR SIGNIFIEDS BY HAVING SOMETHING IMPOR-
tant in common with the latter. *Nature, essence,* and *identity*—if we take these terms rather
loosely and not in their technical sense in philosophy—express, at least partly, though
imperfectly, what symbolic signifiers and signifieds have in common. Connaturality,
partial identity, and mutual participation convey the sense of the relationship between
symbols and what they stand for.

None of these words is entirely satisfactory because they belong to the discourse
regulated by the principles of identity, contradiction, and the excluded third; the relation-
ship described here, on the contrary, states that the symbol is both identical and not
identical to its signified. This book, of course, belongs to the discourse of rational logic
and plans to remain as such. In order to characterize this relationship in rationally
acceptable terms, we have chosen *participation* as perhaps the best descriptive word: the
symbol participates in the nature of what it stands for.

Mondrian's *Broadway Boogie Woogie* is not only a visible thing which stands for an
invisible idea, order. It participates in what order is. Order is not outside the painting.
The painting makes order visible because it is order. In fact, there is no duality between
this Mondrian and order.

Participation sets symbols apart from other kinds of signs. Signs that stand for
something by conventional reference are clearly separated from their signifieds. The
word *dog* does not participate in the canine nature, nor in the individuality of any animal
designated by that word. We are in the realm of the principle of identity where the sign
"dog" is the sign "dog" and only that; it is not the concept of *Canis familiaris* nor any
particular dog. As already noted, signs by incidental association and by visual resem-
blance are closer to their signifieds than referents are, yet they certainly belong to the field
of duality: the indicator "bicycle" is not a class of people, and a snapshot of a friend, her
image, does not participate in her being.

It was raining in Paris one winter day. I entered the church of Saint-Louis, at the
Invalides, where the monumental tomb of Napoleon has a commanding presence. The

103

space under the dome was suffused with a sunny light which, for a while, looked strange, as the outside weather was dull, damp, and cold. The majestic tomb was bathed in subdued but warm colors. As it happened, there were no tourists that day. The silence was dense, and the immobility complete. Nobody was moving around. I could stand still for some time, just looking at the massive porphyry memorial visible in the open crypt below.

Accustomed to the golden light, imbued with the general stillness, I was, after a few minutes, under the visual influence of the somber tones of the tomb, the straight lines of its base, and the curved contour of its top. At the same time, I was aware of the quality of the space enclosed in the stately architecture of the church.

While I was in this receptive mode of contemplation, a meaning seemed to impose itself in an increasingly pressing manner. It was life as an overwhelming force, as a strong but slow and silent energy that moves on and cannot be stopped by any obstacle.

I left the memorial church still pervaded by these haunting and imposing significations. In the outside mist, I wondered how a visit to the tomb of that great adventurer had produced such powerful intimations on the nature of life. I realized that the glorification of the self-made emperor, who dominated France and Europe for a short time, had escaped me. I was puzzled. My visual perception of the forms had not triggered a recognition of the immortal glory of the emperor. Looking at Napoleon's tomb, I had forgotten Napoleon.

In a retrospective analysis of this aesthetic vision, the golden light and the mausoleum appeared to have been the focal points of the experience. The golden light under the dome, generated by the external light of an overcast sky passing through the stained glass, was perceived as a sign. It was an image of the sunlight when it shines outside, on Paris and elsewhere; it was a replica of the summer sun during a drab winter day. Visually, it was similar to an exhilarating sunny day. I did not perceive it as a referent, although I could have: a shining sun has been conventionally chosen to refer to Pharaoh Akhenaton, Saint Thomas Aquinas, imperial Japan, King Louis XIV, and other famous persons and collectivities. In fact, it would have been appropriate to be reminded of Louis XIV: he had the Invalides built during his reign, he took a sunburst as a personal emblem, and he liked to be called the Sun King. "Sunburst stands for Louis XIV" is a signification I had learned, but it remained buried in my inactive memory when I visited the church of Saint-Louis. On that day, the sunny light was not, for me, a referent. Neither was it an indicator, because I did not perceive it as incidentally associated to a signified.

It was a symbol of life. And indeed, the sunlight is what makes plants grow, what makes the Earth a warm and bright place. The sun is the source of life; it epitomizes life. Of course, I did not analyze in this way when I was under the dome surrounded by the sunny light; it was later that I tried to discover the basis of my immediate perception of the light in the church as a symbol of life.

The mausoleum, designed by architect Ludovico Visconti and completed in 1861, is another powerful symbol. Made in the shape of an oversized sarcophagus, its mass and the red porphyry in which it was carved, stand for everlasting indestructibility; it has the perennial stability of a natural rock with the polish and sharpness of contour of a man-made work intended to stand any impact. The large volutes on the top are spirals reproducing the natural growth of shells and other living organisms. These forms, as in

LUDOVICO VISCONTI. Napoleon's tomb. 1861. Photo:
by J. Feuillie, © Caisse Nationale des Monuments
Historiques et des Sites / SPADEM.

African traditional sculptures, where they appear so often, symbolize a law of growth, evoked by the exponential curves.[1] The synthesis of organic growth-forms with those of eternal durability constitute a powerful symbol of perennial life. Another allusion to life is the vegetal green of the granite base.

The ambient golden light and the formal composition of the monument reinforce each other as symbols of a constantly renewed energy, which, impersonally and irresistibly, will continue forever. No wonder I had forgotten Napoleon, a man limited in place and time: his memory could not emerge when confronted by such powerful symbols.

The warm light of the sun stands for life, is life-giving, is life. Marble stands for eternity, is stable and everlasting, is eternity. Spiral stands for growth, is the form of unfolding life, is growth.

This is what is meant by connaturality of signifier and signified, by participation of the symbol in the nature of what it stands for. These statements seem paradoxical, even contradictory. How can symbols, material things existing in the external world—slabs of marble, light diffused in air, and volutes deeply carved in heavy porphyry—have the same nature as the ideas for which they stand, such as eternity, life, and growth?

Let us consider the symbols more closely. Certainly, there are physical things in the external world that act as stimuli for our sensory organs, and to which the latter respond by creating mental contents which are deemed equivalents of the external things. The external things remain inaccessible. More precisely, a continual flow of stimulations is organized by our senses in discrete objects differentiated through the variations we can perceive by those senses. What we call "physical" or "external" things in ordinary language are elaborate mental transpositions of stimuli originating from aggregates we have isolated in the flux that surrounds us. As these transpositions have been constructed collectively, and have met the consensus of those who live in a similar environment and speak the same language, they constitute a coherent system. Consequently, for all practical purposes, we can forget the distance between the external aggregates, ultimately unknown 'in themselves' (what we call "things"), and their mental equivalents, the only items we know. We can speak and act as if there were stones out there exactly as we perceive them. Only in some circumstances, like the present discussion, we have to remember that the stones we look at and speak of are mental equivalents of external aggregates.

In this perspective, the usual statement that "the symbol, a material thing, stands for its signified, a nonmaterial item, such as an idea or an affect" should be phrased: "the symbol, a mental equivalent of an external aggregate, stands for another mental content, such as an idea or an affect." There is a different level of abstraction between the class of symbols and the class of symbolic signifieds—the latter being more abstract than the former—but the members of the two classes are mental objects or constructs or, if we dare use a word coined during the nineteenth century but still uncommon, mentations.

"Marble" is as mental as "eternity"; and so too are "golden light" and "carved spiral." The connaturality of marble and eternity is made possible because each of them is in the mind. Thus it is not contradictory to posit a continuity between symbols and their signifieds. The two terms, as well as the relationship between them, belong to the same realm.

The common nature shared by symbols and their signifieds is the basis for meanings

GUSTAV KLIMT. *The Kiss*. 1908. Österreichische
Galerie, Vienna. Photo: Fotostudio Otto.

apprehended by beholders. Symbols "suggest" or "cause" a sliding from themselves to their signifieds. Marble suggests eternity, marble means eternity because its solidity and durability are prolonged, as it were, into the idea of eternity. Lines and shapes, colors and textures, brightness and darkness are the material things which point to some ideas that are in continuity with one another.

I say "with one another" as there may be, and usually is, more than a single relation of signification. Sign A stands for signified B, which as signifier stands for signified C, which as signifier stands for signified D, and so on. Golden light means sun; sun means energy; energy means life. So far, in our analyses, we have considered only single significations; it will also be necessary to include chains of significations in our analyses. The starting point of such chains is a material object, its first signified may be an image, the second a referent, and a subsequent one a symbol. A stone sculpture of a *linga* is an image of an erected phallus, which is a referent to Śiva, who in the Hindu tradition is a symbol of the divine as creator and destroyer.

As indicated earlier, the material supports for aesthetic meanings are to be found in the forms of the objects. The overall composition of the work is an important formal feature. As Rudolf Arnheim has convincingly demonstrated, for the Western pictorial tradition, in his *Art and Visual Perception*, the rectangular surface of a painting is a dynamic field of forces, forces that are visually perceived.[2] For instance, the two diagonals—top right to bottom left and top left to bottom right—are apprehended as forces moving in different directions: the first one in an ascending movement, and the second one in a descending movement. Another example is that the part of the picture which is visually heavier (by being darker, for instance) gives imbalance to the composition if it is placed on top (as is the case in Lichtenstein's *Blonde Waiting*).

The color composition is also meaningful. Large areas of green and red in the same painting produce a strong contrast which is perceived as expressing violence and terror.[3] When "combined in many small doses," complementary colors generate an achromatic grey or white and are visually perceived as meaning peace and harmony.[4]

Separate formal elements within the surface of the painting or drawing also carry visual meanings. Straight and angular lines connote masculinity, strength, and swords; curved lines connote femininity, softness, and flowing rivers. In Gustav Klimt's *The Kiss* (1908), the man's cloak is covered with rectangular ornamentations suggesting phallic forms whereas the woman's clothing is decorated with oblong rings evoking vaginal shapes.

Triangular shapes pointing upward suggest the male sex, and when pointing downward, the female one. Red hues hint at fire, life, and blood; blue ones at coldness, ocean, and rationality; green ones at grass, trees, and nature. A circle evokes world, breast, and completeness.

In this brief enumeration of examples, we refrained from using the word *symbol*. Yet a moment of reflection is sufficient to realize that, indeed, the signifiers (such as heavy forms on top, straight lines, triangles, and green) stand for their signifieds (such as imbalance, phallus, sex, and trees) by participation in important common characteristics (such as disequilibrium, rigidity, shapes of the triangle and pubis, and the green color of the foliage).

In the holistic approach of the contemplative vision, symbolic meanings are intuitively perceived. Their recognition is not the result of an analysis. Reasoning and

analyzing may occur later, when and if the beholder wants to verbalize and explain his experience-as-recalled. In this reflection on the original intuitions, viewers may not be able to discover the explanation of their symbolic perceptions. They may have had the intuition of static order when looking at a Mondrian but they may be unaware that in a controversy about Mondrian's strict commitment to vertical and horizontal lines, it has been argued that obliques are spontaneously perceived as dynamic and creating depth.[5] Even if viewers have had an intuitive apprehension of masculinity when looking at Klimt's couple, they may disagree with the generalization about the phallic meaning of any straight line.

This suggests that the perception of symbols may even remain subliminal. The Freudian theoretical construct of the unconscious has proved to be useful in therapy and also as a principle of explanation, and it is nowadays generally accepted. Some psychological studies have demonstrated that children, when submitted to tests on the sexual meanings of abstract shapes, responded to them without being aware of their signification at a conscious level.[6] Symbolic meanings can be apprehended and recorded at a subliminal level.

To many of us, *unconscious* evokes an image of depth. It is like the ocean's depth in which there is a continuum from the surface to an inaccessible bottom. Subliminal is just below the surface and can often be made conscious by an effort of attention, recollection, or interpretation. It may be sufficient to be told that curve is related to softness to precipitate a process of recognition. Then there may be an intellectual reflection on the subliminal made conscious. It is another mental operation, and it is not essential to the aesthetic experience.

Our contention that a symbol and what it symbolizes are in continuity, that they are identical in some important respects, and that they participate in the same nature has a far-reaching consequence: when beholders have an experience of the symbol, they also have an experience of what is symbolized.

In our common language to be "experiencing something" or "going through an experience" is to be deeply and totally involved in some process. Here is an example of what we would refer to as an experience. "One day, I fell into the river and I was drowning. Then somebody saw me and I was saved. I experienced drowning." Experience is opposed to intellectual knowledge. The anthropologist who has read all the books on polygyny, its social functions, its economic consequences, its psychological impact, and its worldwide distribution has a purely intellectual knowledge of polygyny. On the other hand, the man who has lived as husband to several wives in a traditional household of a remote village in the African savanna has experienced polygyny, though he knows very little of it as a general social phenomenon. Learning from books and learning from experience are sharply distinguished in our culture. The latter is considered richer, deeper, and more intimate, as it includes affects and nuances that the purely intellectual knowledge does not convey. On the other hand, book learning is regarded as broader, more precise, and easier to communicate. *Understanding* and *knowing*, when opposed, express the distinction between what is apprehended by experience and what is acquired by an intellectual approach.

Experiencing is a conscious process. Suppose you lose consciousness in a car accident in which your leg has been broken: you do not have the experience of breaking a leg. After regaining consciousness, you experience the mental state of having had a leg

broken and the associated affects such as pain, regret, anger, or dependence. Or suppose you are in the arrival lounge of an airport after having safely landed. You are then told that the landing gear had been blocked until the last second; as it was too late for the aircraft to take off again, you had been in great danger of crashing onto the runway. Because you were unaware of the danger, you had no experience of it, nor of its associated emotions of fear or panic. If one is unaware of a situation in which one is, one has no experience of it.

Conversely, if we think we are in a situation in which, in fact, we are not, we may have an actual experience of a nonexisting situation. For instance, during my first airplane flight, there were turbulences and, at about the same time, a change in the running speed of the engines. It was night and we were above the ocean. I thought we were falling. In fact, the flight was proceeding normally; the turbulences and the change in engine humming did not signal a danger. Nevertheless, my experience of an imminent crash was genuine and terrifying.

Experiencing is always a mental process, whether it is triggered by an external stimulus or by an idea. More precisely, what we experience is a mental content (what we called a mentation), say "danger," which may or may not correspond to an external situation. The emotion hatred arises because the mentation "betrayal by my friend" is present in my consciousness. My experience of that emotion is the same whether my friend actually has betrayed me or not.

What we experience is mental. This conclusion is of crucial importance in our analysis of symbols. When looking at a physical object—Mondrian's grid, the golden light, or the porphyry sarcophagus—which is an external stimulus, we have a mental experience of what it symbolizes—order, life, or eternity.

Symbols are different from other signs in that they are partly what they stand for. Thus, when mentally apprehending symbols, the beholder is connected with the signified. Beyond intellectual knowledge, the beholder achieves understanding as a result of participating in an experience.

Painting 1946, by Francis Bacon, symbolizes, for me, ritual torture. The composition is symmetric and heavy. Diagonals are oriented to the middle of the picture, below the center; this area is weighted by its dark tones. In the lower part, two oval lines are centered around the vertical axis.

The imagery contributes to an impression of somber solemnity. A large hanging carcass suggests a butcher's shop. Garlands, high windows covered with shades, and the hint of considerable interior volume evoke the sacredness of a temple more than the ordinariness of a slaughterhouse or meat shop. The hanging carcass of a large animal has the shape of a headless crucifix; two smaller carcasses are exposed on the superior oval surface as on a sacrificial altar. In the focal area, but a little off center, a bulky figure—the butcher perhaps—in dark and apparently formal attire, stands motionless, as a powerful and ominous presence. His face is only half visible; from the mouth up, it is under the dark shade of an incongruous umbrella, a frequent motif in the Bacon pictures of the mid-forties. A heavy chin and a row of teeth between thick lips are the only visible features of the butcher's face.

Like any of our contemporaries, I know about torture. Humiliating for the victim, degrading for the torturer, ineffective for the government, it is, however, extensively used as an instrument of power. Sometimes, as in the Bacon picture, it is associated with

FRANCIS BACON. *Painting 1946*. 1946. Collection, The Museum of Modern Art, New York.

a ghastly ritual which seems to confer the impersonal inevitability of a ceremony. Also, I know that killing cattle in order to eat its flesh has some disturbing correspondence with execution and torture. This intellectual knowledge has not been increased by my contemplation of the Bacon painting, but my understanding of the experience of torture has deepened. The three headless carcasses, bled and gutted, prepared for retail sale, suggest the denial of identity suffered by torture victims: they experience the loss of their individuality. By looking at the massive and stable figure, one can even somewhat understand from inside the rigid and passionless cruelty of the torturer. The churchlike and altarlike features of the painting indicate that some executioners may see themselves as sacrificial performers.

This is a later verbalization of a visual contemplation of the Bacon picture as I recalled it at the time of my reflection. When I was looking at it, my vision remained holistic and nonanalytic. Also, it remained disinterested: I felt compassion for victims and torturers, and I felt an urge to support organizations like Amnesty International, but my mode of consciousness did not become emotional. Anger and indignation are ego-oriented. They express judgment, condemnation, and self-righteousness more than a concern for others' sufferings. These affective mental states are obstacles to the aesthetic commerce with a work of art.

Torture, as an experience for the victim, is in the victim's mind. If consciousness is lost, the victim does not experience suffering and humiliation until consciousness is regained. Torture is also an experience in the torturer's mind. If drunk or insane, the torturer has no experience of being a torturer. A symbolic picture, such as Bacon's *Painting 1946*, creates mental experiences which are in continuity with the actual torture experiences. Of course, they are not identical. Compared with experiences generated by physical pain and humiliation in the external world, symbolic experiences are of minimal intensity, but they are in continuity with those based on actual torture.

Among the ruins of Anurādhapura, which was the capital of Sri Lanka for thirteen centuries, there is an impressive statue of the Buddha; it was carved in stone in the third or fourth century A.D. Known as the "Buddha in *samādhi*" (mental concentration), it is one of the most ancient images of the Buddha.

I remember sitting in front of the statue, under the trees in what now looks like a quiet park. I was looking at it with visual attention, trying not to be analytical and not to let myself be invaded by the usual worries of daily life. When I first approached it, it was, for me, another piece of classical sculpture of South Asia.

After a few minutes of aesthetic contemplation, I was struck by the inner vitality conveyed by the forms. It was as if a force radiated from the statue. My body assumed a position analogous to the one of the statue, my breathing became slower, deeper, and more regular. My eyes focused on the visual center, the lower abdomen, chosen by many meditators as the place where they perceive each inhalation and exhalation. I had the visual perception of mental concentration. The statue was a symbol of mental concentration, and the statue made it visible. The statue was mental concentration itself. And this gave me an experience of mental concentration.

At the time of this experience, the perception of concentrated force was not even verbalized, and still less, analyzed. Described above is the experience-as-recalled; during the experience-as-experienced, I did not use words. The perception was pure intuition.

Buddha in *samādhi*. Anurādhapura, Sri Lanka.
3d or 4th century. Photo: Archaeological Survey.

Schema of the Anurādhapura Buddha. Drawings by
Bernard Maquet.

Frontal triangle.

Lateral triangles.

Frontal obliques.

Frontal horizontals.

Frontal verticals.

Frontal ovals.

Frontal rectangle.

Balance of forces.

Later, wondering what precisely had given me this intuition, I went back to the statue, and looked at it again, this time from an analytical perspective.

I saw that the triangle is the dominant structural form. Frontally seen, the contour can be inscribed in an equilateral triangle. Laterally seen, the back is the vertical line of two rectangular triangles: the baseline of one extends to the knee, and the other to the point where the glance of the Buddha would fall, about six feet in front of the statue. I realized too that the spine and the knees touch the ground at three points which also delimit a triangle. Within the frontal triangle, several other obliques were to be seen: the right leg resting on the left one in the half-lotus position, the thighs, the forearms, the shoulders, and the upper sides of the chest. Besides all these obliques, there were horizontals (particularly the strong baselines of the triangles), verticals (arms, spine), ovals (abdomen, head), and a squarelike four-sided form (arms, forearms, and shoulders).

These forms combine a firm stability with a strong dynamism. The stability is expressed by these forms: an equilateral triangle with one side at the horizontal, the visual weight of the legs, and the symmetry of the left and right sides. Dynamism may be perceived in another set of forms: the obliques which tend to "move" to the horizontal and vertical rather than "staying" where they are. Also, in the equilateral triangle standing on one side, there is an upward motion conflicting with the downward pull of the weighted base, and this creates a tension of forces. The oval tends to roundness, as the squarelike area tends to perfect squareness.

The visual center, where the lines of thighs, forearms, and hands converge, is the oval area located a little, but not significantly, below the geometric center of the frontal triangle. This gives a unity of concentration to the statue.

This analysis is a discursive explanation of a symbolic experience. It suggests how a mental experience of concentration may be triggered by, and lived in, the aesthetic vision of a statue.

Of course, the Anurādhapura statue is also the image of a man, Siddhārtha of the Gautama family and the Śākya clan, the historical Buddha. He lived in the sixth and fifth centuries B.C. (probably from c. 566 to c. 486) in Magadha and other neighboring king-doms in the Ganges valley of northern India. The resemblance of the Anurādhapura statue to Siddhārtha cannot be assessed, as there is no portrait or description of his physical appearance. Yet some beholders may perceive this statue as standing for the historical Buddha, as an image of him.

For many Sinhalese villagers this statue, as well as the many other representations of the Buddha seen in temples, homes, and public squares, stands for a superhuman being, nonmaterial but existing independently from any idea of him, a being with whom they can communicate through offerings and ritual ceremonies. For them, the Anurādhapura statue is a referent that stands for the living presence of a nonmaterial person.

For the spiritually advanced Buddhists, however—be they monks or lay men and women—this statue is a symbol standing for the enlightened state they hope to attain.[7]

This discussion of the Buddha statue, as symbolic sign and as referential sign, additionally affords a distinction between religion and spirituality. Both religious and spiritual systems are traditions of thought and practice concerned with the human predicament in the world (transitoriness and its dissatisfactions, action and responsibility, life crises and death) and the means to improve it, or at least to make it bearable. The most

significant element included in a religious system is the belief in the existence of, and the interaction with, one or several gods. They are perceived as more powerful than human beings, sometimes omnipotent, as having an essential role in human destiny, and as being free from the limitations of a material body. This view of religion is expressed in common-language dictionary entries and in the vocabulary of many scholars.[8] For instance, anthropologist Melford Spiro states that "the differentiating characteristic of religion is the belief in superhuman beings."[9]

As they are not material, the gods do not belong to the sensory experience of the believers. They are denoted by verbal and visual signs. Verbal signs are proper nouns such as Śiva, Jesus, the Buddha, or God. Visual signs are statues and pictures representing human forms, such as a graceful dancer with multiple arms, a tortured victim nailed to a cross, a meditator sitting in a cross-legged position, or an impressive elderly man with a white beard. And there are emblems, such as the *liṅga*, the Greek word *ikhthus*, an empty seat, or an eye inside of a triangle.[10] These names, human forms, and emblems are referents standing for the invisible and intangible beings they point to. The word *Śiva*, the dancing man, and the *liṅga* refer to the same nonmaterial signified. So do *Jesus*, the victim on the cross, and *ikhthus*; *the Buddha*, the representation of a man sitting in meditation, and the empty seat; and *God*, the noble old man, and the eye.

For religious believers, these nonmaterial signifieds actually exist outside the mind. They are prayed to and revered, solicited and expected to respond to requests, and when offended, they punish or forgive. As they do not have bodily supports, it is difficult to figure out "where" they are. Yet they are treated as living persons who are present where they act, or even omnipresent.

In spiritual systems, gods are irrelevant. Either these systems do not include superhuman beings (this is the case with spiritual systems expressed in philosophical terms, such as Stoicism), or they comprise words, pictures, emblems, and other signs that could refer to nonmaterial beings outside the mind, but which are interpreted as symbols. The man on the cross stands for the ultimate sacrifice of love; and Kṛṣṇa, the handsome flute player, for devotional self-surrender. The serene meditator symbolizes the archetype of man perfected by enlightenment, and the name God stands for the idea of the unconditioned.

Traditions of thought and practice are religious if proper names, human representations, and other personal signs are interpreted as referents. They are spiritual if personal signs are interpreted as symbols. Some traditions, like Buddhism and Hinduism, accept either interpretation. In fact, they hold the symbolic interpretation to be superior to the referential, which is considered too literal and "fundamentalistic." Other traditions, like the ones stemming from the Judeo-Christian-Islamic root, do not allow that freedom of interpretation and usually consider the symbolic interpretation as nonorthodox.[11]

This brief digression in the fields of religion and spirituality provides another example of the explanatory potential of the paradigm of signification. The concepts of symbol and referent have proved to be powerful tools of analysis.

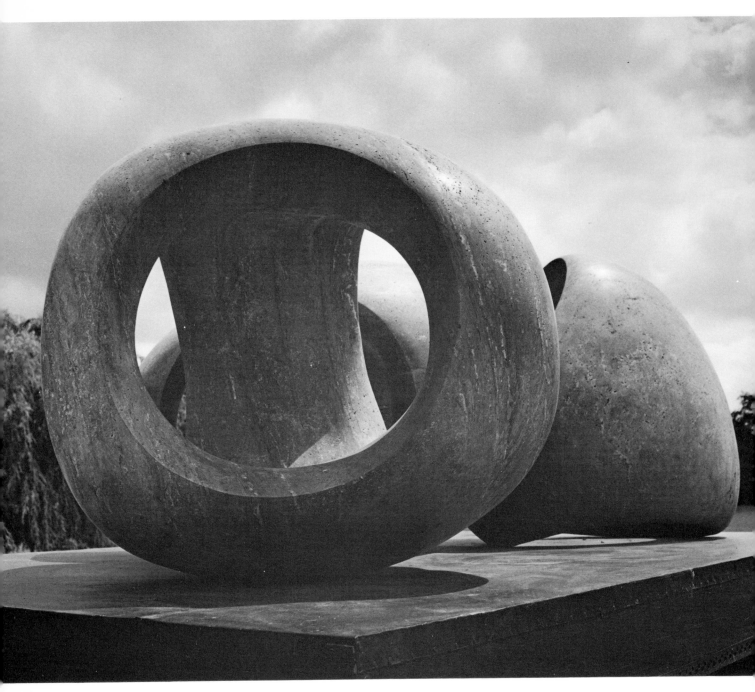

HENRY MOORE. *Three Rings*. Red travertine marble.
1966. Collection of Mr. and Mrs. Robert Levi,
Maryland. Photo by Errol Jackson, by kind
permission of The Henry Moore Foundation,
England.

CHAPTER ELEVEN

The Aesthetic Quality

AMONG THE NUMBERLESS ARTIFACTS SURROUNDING US, SOME WERE MADE, OR SELECTED, to be looked at. They are called art objects. Others, though made and used in contexts other than art, have an equally strong visual appeal. The latter together with the former are what we have termed aesthetic objects. Their forms can stimulate and sustain visual contemplation. This sets them apart from other tangible objects, the visual forms of which are minimally, or not at all, endowed with such potential.

At this point, a question that must be addressed is, What is this mysterious aesthetic quality that some forms display and others do not?

Visual contemplation is holistic. The beholder does not analyze the object in its visual parts, but perceives it as a whole. This gives a clue: the aesthetic quality of the forms should be an attribute of the whole configuration of forms, and not of any form in particular.

It is composition, the congruence of the forms with one another. Composition, from the Latin *compōnere* 'to put together' results from a process of integration. The different visual forms are related in such a way as to constitute an organized whole. Another word for composition is *design*. In sixteenth-century Florence, Giorgio Vasari—painter, architect, and art historian—called the classical fine arts (drawing, painting, sculpture, and architecture) the "arts of design." He believed the unity of the fine arts was founded on design, the disposition of elements according to a plan. The fine arts academy he established in 1562 was called the Accademia del Disegno.[1]

Composition seems to be a modest basis for assessing aesthetic quality. Any artifact not made from a visually uniform matter has parts which are organized in some way, and thus has composition. Certainly, there is some design in almost any man-made object. Nevertheless, excellence in the integration of forms is the ultimate support of the aesthetic quality of the artifact. It is not very common.

There are several principles of design organization. One of them is geometry. Forms are simple geometric shapes, or close to them, and are related to one another as parts of a system of squares and circles, cubes and cylinders, angles and parallels. In art history

119

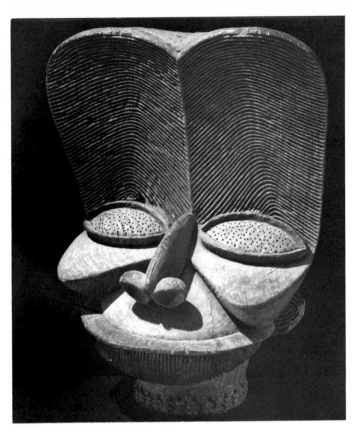

Mask. Tikar, Cameroon. Museum Rietberg, Zurich. Photo: Wettstein and Kauf.

textbooks, an array of straight lines and curves superimposed over a photograph of an art work makes the composition visible. This reveals the underlying structure of a painting or a sculpture, not always immediately evident to students. The reducibility of visible forms to the regular shapes of basic figures is a criterion of excellence in composition. Some traditional woodcarvings of West Africa, such as the blue Grebo mask of the Musée de l'Homme and the famous Tikar mask of the Rietberg Museum, and some Cubist paintings, such as the landscape of *La Roche-Guyon* (1909) by Braque, can be reduced to fundamental geometric volumes or planes almost without residue. This is extreme geometrization. The ability to geometrize exists, however, to a lesser degree or in a less evident manner, in many other art works.

Another principle of composition is based on the ways biological forms develop; it can be called organic. The different forms in a picture are linked as parts of a living organism. They are connected as tree trunks are rooted in the soil, as branches expand from the trunks, as leaves burgeon on the branches. Or, as a flexible neck connects head and shoulders, as muscles are attached to the bones and move them, and as soft breasts bloom on the chest. Henry Moore's *Three Rings* (1966) displays the organic composition of eggshells. Richard Hunt's *Why?* (1974) is a bronze sculpture composed of a rising hand growing out of the soil as a plant. Aldo Casanova's *Artemis of Ephesus* (1966) has a composition unified by female sexual forms. Jean Arp's *Ptolemy III* (1961) has a bonelike structure. These sculptures illustrate the principle of organic composition. They reveal how strong the integration of biological forms is.

Still another principle of composition is based on movement; it can be called dynamic. The surface of the canvas or the volume of the sculpture is field or space where formal elements seem to be animated and to move in an organized manner, as in a ballet. Movements have direction and force. Composition balances these dynamic variables in a

GEORGES BRAQUE. *Castle at La Roche-Guyon.* 1909. A.
S. Pushkin Museum, Moscow. © ADAGP, Paris /
VAGA, New York, 1985.

unified configuration. Antoine Pevsner's *Developable Column* (1942) seems to be still in the
process of ascending. Barbara Hepworth's *Pelagos* (1946) is in the process of unfolding its
spiral. Bruce Beasley's *Dione* (1964) is visually made of three components and each one
seems to be involved in the movement of the whole—horizontal and swift. Kasimir
Malevich's painting of a peasant carrying two buckets is entitled *Woman with Water
Pails: Dynamic Arrangement* (1912).

Geometric, organic, and dynamic shapes are the main bases of composition. More
specific shapes can also be bases of composition. Styles, in fact, are organized around
certain fundamental forms. In architecture, the Romanesque style favors round arches,
semicircular tunnel vaults, heavy walls, and strong towers. The round arch, structurally
as well as visually, was the geometric form that dictated the overall composition of a
Romanesque monastery. Cloister, chapter hall, library, and living quarters, together
with the church, the most important building, constituted a complex monastic institution.

The privileged form of Gothic style, the pointed arch, is visually a schematization of
tall trees, such as beeches, aligned along an avenue. Their branches crossing at acute
angles describe an arch. Thus, rib vaults are visually related to organic forms. Of course,
they were primarily a technical advance on Romanesque semicircular vaults: combined
with flying buttresses, they made the high naves of cathedrals possible. Here again, one
form, the ogive, was the principle of composition at the center of the complex configura-
tion that is called the Gothic style.

Composition makes it possible to grasp a visually complex object as a unified whole.

ALDO CASANOVA. *Artemis of Ephesus*. 1966. Franklin D. Murphy Sculpture Garden, University of California, Los Angeles. Photo by Jacques Maquet.

CASANOVA. *Artemis of Ephesus*, detail.

JEAN ARP. *Ptolemy III*. 1961. Franklin D. Murphy Sculpture Garden, University of California, Los Angeles. Photo by Jacques Maquet.

RICHARD HUNT. *Why?* 1974. Franklin D. Murphy Sculpture Garden, University of California, Los Angeles. Photo by Jacques Maquet.

Facing page. ARP. *Ptolemy III*, another view.

BRUCE BEASLEY. *Dione*. 1964. Franklin D. Murphy Sculpture Garden, University of California, Los Angeles. Photo by Jacques Maquet.

DAME BARBARA HEPWORTH. *Pelagos*. 1946. The Tate Gallery, London.

ANTOINE PEVSNER. *Developable Column.* 1942.
Collection, The Museum of Modern Art, New
York.

KASIMIR MALEVICH. *Woman with Water Pails:*
Dynamic Arrangement. 1912. Collection, The
Museum of Modern Art, New York.

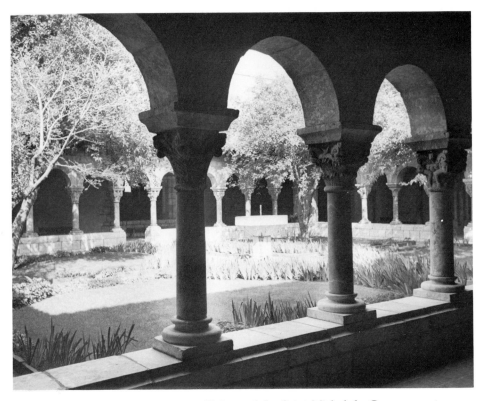

Cloister of the Saint-Michel-du-Cuxa monastery.
France. 12th century. The Metropolitan Museum
of Art, The Cloisters, New York. Photo by Jacques
Maquet.

Abbey of Sénanque. Provence. 12th century.
Photo by J. Feuillie, © Caisse Nationale des
Monuments Historiques et des
Sites / SPADEM.

Gothic windows of Sainte Chapelle. Paris.
13th century. Photo by J. Feuillie, © Caisse
Nationale des Monuments Historiques et des
Sites / SPADEM.

Cloister of Santa Giuliana. Perugia. 13th century.
Photo: Parthenon Publications.

In the aesthetic object, it corresponds to—and facilitates—the holistic perception of beholders.

Well-designed forms express, with compelling force, meanings and values perceived and ascertained by beholders. Composition generates in beholders' minds what is necessary to keep their full attention by clearly and strongly stating what the object stands for.

The configuration of forms in Picasso's *Guernica* (1937) has such expressivity. Angular contours, grey monochromatism, three-part composition centered in an upward triangle, and lighter shapes on the darker area of the ground forcefully convey the meaning perceived by this beholder: war is cruel and absurd. Likewise, the visual structure of the Anurādhapura Buddha, made of triangles and obliques, convincingly expresses meditative concentration.

The word *composition* refers to the congruence of the visual forms with one another. The word *expressivity* refers to the congruence between the configuration of forms and the symbolic meaning of the object. The forms included in the overall design have their own meanings, as discussed above. For example, an equilateral triangle resting on one side conveys the meaning of stability; straight lines, maleness; and a spiral, growth. Do these meaningful forms, organized in a visible configuration, convey the symbolic meaning of the whole work? If, with strength and economy, they do, then they give the object a high level of expressivity. This expressivity is a consequence, or an aspect, of the composition.

Reading contemporary criticism in art magazines and in the general press suggests that this criterion of expressive potential is widely used. Critics readily write that a particular art work is "a strong statement," and then they translate into words the visual symbolism of the piece.

Another consequence of an excellent composition is to set the object apart from its visual environment. The latter rarely displays a well-integrated array of visual forms. On the contrary, in the ordinary visual context of our lives the aesthetic object stands out through its design.

For most of us, everyday life is ego's arena. In that arena, actions and emotions, feelings and desires, analyses and judgments constitute an endless flow. This ceaseless flux has to be interrupted so that the contemplative attention, in which the aesthetic vision develops, may emerge. Usually, our first glance at an art object is part of the flow. In order to perceive an artifact aesthetically, we have to set it apart, as it were. Composition, by contributing to the separation of the object from its visual context, favors the emergence of the contemplative mode of consciousness.

PABLO PICASSO. *Guernica.* 1937. Museo del Prado, Madrid. © SPADEM, Paris / VAGA, New York, 1985.

The single element of composition that most contributes to our shifting to contemplative attention is the frame. By clearly setting the border line between the aesthetic object and its visual environment, the frame implicitly states that what is within its contour is different from the rest and should be approached differently. From ordinary space we move to aesthetic space.

In some cases, the frame seems almost to create the art work. Imagine an unframed Pollock in continuity with the visual surroundings of a parking structure or a shopping center. Would we notice it as a work of art, and look at it with the appropriate kind of mental approach? This should not be overstated. A heap of dirt thrown on the floor of an art gallery is "framed" by its presentation in an exhibition room with the proper labeling (such as "Joseph Beuys: *Fat Corner*, 1974").[2] Its incongruity may be amusing, or arresting, or suggesting some worthwhile reflections, but the object's only composition is its frame. It is not sufficient to bestow on it an aesthetic quality.

In the 1950s and 1960s, happenings and "environments" emerged and were categorized as visual art. The beholder was in the event, was surrounded by it, and became an active participant. There was no composition (everything happened spontaneously) and no frame (one crossed the border line between life and "stage" without noticing it; in fact, it was claimed that there was no stage). Such experiences may have been of value for those involved in them, but it is conceptually confusing to call them aesthetic.

In addition to favoring an initial contemplative attention, composition helps to maintain a disinterested stance. Distancing the self from what is represented—ego distanciation—is made possible by the high quality of visual integration. Let us consider two scenes of violence in which we see a man photographed at the moment he is shot and dies.

During the Spanish civil war (1936–39), *Life* photographer Robert Capa took many dramatic pictures: civilians expecting an announced air raid anxiously looking into the sky, soldiers on their way to the battlefield, refugees crossing the French border, and front-line combat troops in action. One of Capa's combat action photographs was published in newspapers all over the world a few days after it was taken. It made him

ROBERT CAPA. Death of a Republican volunteer, Spain. 1938. Photo: Magnum, New York, courtesy of *Life* magazine.

famous. It was a close-up of a Republican volunteer falling dead, hit charging toward a Fascist machine gun.

On the backdrop of a vast expanse of sky, the man's movement has been suddenly stopped by a bullet, one assumes, as it has left no visible trace. He has lost his balance and is falling backward, but his torso, for a split second, still holds a straight stance. The rectangular print looks as if it had been carefully centered and organized (though in point of fact, it was not).* The figure, slightly left of center, with an extended arm divides the picture in half; the fugitive shadow suggests depth; and the black rifle strangely balances the black shoulder straps of the belt bags.

This photograph has a high aesthetic quality. The gamut of greys, the coarse grain of the enlargement, the horizontal lines of the ground, and the vertical lines of the figure are formal features that keep the beholder's eye on the rectangular plane of the glossy print. A contemplative engrossment in the picture develops.

Some insights emerge: standing up and facing the ultimate threat; no futile gesture of self-protection; the serenity of a face with eyes and mouth closed. A meaning imposes itself in this beholder's mind. The photograph symbolizes man's dignity when confronting death. In this contemplative apprehension of the symbolic meaning of the picture, the beholder is without self-interest and ego-involvement; he does not feel any sorrow because he too will eventually die. While mentally moving from the picture to the unknown man who happened to die in front of the camera in an Andalusian field, during a sunny day in August 1938, the beholder is not self-centered, but compassionate.

Contrasting the Capa picture with another news photograph of a violent death reveals the importance of composition as a condition of the absence of self-involvement. It is the street murder of a Vietcong suspect by the Saigon police chief, in 1968, during the Vietnam War. The onlooker's visual attention cannot be held by the forms and shapes visible in the plane of the print. Because this picture lacks aesthetic excellence, it elicits no contemplative response. Our attention immediately moves from the image to the repulsive event it represents. We cannot maintain disinterestedness; feeling shame and anger, we are emotionally involved.

The aesthetic quality found in the forms of visual objects is not so mysterious after all. It is composition. Composition closely corresponds to, and stimulates, the aesthetic vision in its dimensions of attention, holism, and disinterestedness.

Visual composition also stands for something else. Like the other formal features of the object, it is a material symbol standing for a nonmaterial signified. Composition symbolizes order. Order is the arrangement of diverse elements into a configuration; it makes them operational or intelligible. It is the core value of the aesthetic quality because it is so basic to our mental life.

At the neurophysiological level, in our perceptual system "objects, figures, and patches are segregated from their environment as circumscribed entities."[3] Wertheimer termed these entities "perceived wholes." Experiments conducted by Gestalt psychologists in the early twentieth century led them to formulate laws of organization of

*Under combat circumstances, Capa "timidly raised his camera to the top of the parapet and, without looking, but at the instant of the first machine gun burst, pressed the button" (Capa and Karia 1974:18). That this composition was achieved by chance does not matter for our argument.

perceptions, such as the Law of Prägnanz, the tendency toward simple forms.[4] Submitted to a constant bombardment of visual stimuli from the external environment, we impose form as a matter of survival. In a work of art, the creator carries this ordering a step further by unifying the formal elements according to a geometric, organic, or dynamic composition, or according to a particular style.

At a subliminal or unconscious level, chaos is an ever-threatening condition. Death is the dissolution of an organization of elements which constituted a well-composed biological unit. Our individual and collective security is constantly imperiled by entropy. At a deep level of the mind, we fear chaos and strive to control it by maintaining or establishing order.

This abhorrence of disorder is transposed, at a philosophical level, into systems of thought which attempt to comprehend the external world—comprehend in the sense of intellectually understand, as well as in the sense of comprise and embrace. There, too, we seek order.

Any artifact with aesthetic quality is a tangible symbol standing for the idea of order. This surprising conclusion from our previous analyses is inescapable. If the configuration of forms in any aesthetic object displays an excellent composition, it necessarily symbolizes order as an idea. Any work revealing a concern for and achieving visual quality is a statement for order and against chaos. Order, of course, is only one of the signifieds of an object: it does not preclude other significations. Nevertheless, it will always be present as a primary symbol. If disorder is to be aesthetically expressed—as, for me, it is expressed in Pollock's action paintings—it will be in a composition that also symbolizes order. Or, if only disorder is expressed—as it is, for me, in Beuys's heap of dirt—it will be something outside the aesthetic realm.[5]

The search for visual order finds its source in the metacultural layer of the human psyche: neurophysiology and the unconscious are not culture-specific. The question so often asked, Are aesthetic criteria culturally determined? can be considered from the perspective presented here.

EDDIE ADAMS. Murder of a Vietcong by Saigon police chief. 1968. Photo: Associated Press / Wide World, New York.

Malanggan open work. New Ireland, Micronesia.
Museum für Völkerkunde, Basel. Photo by P.
Horner.

Cast bronze head surmounted by vultures. Benin,
Nigeria. 18th century. British Museum, London.

Stone carving of Quetzalcóatl. Aztec. Photo by G. Jani (Civilisations 1966).

Head. Nok, Nigeria. c. 250 B.C. The Nigerian Museum, Lagos.

Sculpted head on top of a *nimba* mask. Baga, Guinea. Musée des Arts Africains et Océaniens, Paris. Photo by Jacques Maquet.

Trophy head. Costa Rica. c. 1000−1300. Private
collection, Alfonso Jimenez Alvardo. Photo: Detroit
Institute of Art.

The wood carvers of New Ireland in Micronesia, the bronze casters of Benin, the
Aztec stone carvers, and the Art Nouveau painters and sculptors visually organized their
works in organic compositions of vegetal forms. Nok and Ife terra-cottas, some Teoti-
huacan stone carvings, the *nimba* masks of the Baga fertility dances, and French and
Russian Cubist paintings from the beginning of the twentieth century are geometrically
composed. Rayonist painters, Calder in his mobiles, and African carvers using forms of
the exponential curve type chose a dynamic composition.

These different manners of visually ordering forms were predominant in certain
societies during certain periods. But there were variations in time within the same
cultural tradition; the three principles of composition interpreted in several different
styles have existed successively, and sometimes simultaneously, in the societies of the
Western tradition. And as the few examples cited above demonstrate, the same principle
of order has been used in culturally dissimilar societies. We can conclude that the types of
composition are not culture-specific.

Aesthetic quality through visual order has been, and still is, achieved in most, if not
all, societies. It is achieved by similar means. Thus it may be cross-culturally appreciated;

it does not require familiarity with cultural codes. Neither composition nor the symbolization of order are based on cultural specificities.

At this point arises the objection How can geometric order be realized by carvers and painters whose culture does not include grids, rulers, and measurements? The answer is that it is not necessary to know geometry in order to organize forms geometrically. Makers of forms, as well as beholders, perceive that elements are, or are not, at the right place. Some artists confirm their visual evaluation by tracing schemata on squared paper. But most painters, carvers, and engravers—Western as well as non-Western—rely only on their visual intuition. Diagrams revealing the structure of art works are primarily used by teachers who want to explain *how* forms were designed, and *why* they are balanced.

Aesthetic quality is not limited to representations. Some actual views of external scenes—landscapes and cityscapes, mountains and gardens, animals and people—may display the formal features that make a painting or a sculpture aesthetic: they may have composition. The setup of these features is unintentional, the chance result of circumstances; thus such aesthetic encounters are exceptional and fleeting. But they tell us something about the aesthetic quality. Let us compare our mental responses to some pictorial representations of scenes with our responses to similar actual scenes.

I look at a Song (Sung) dynasty hanging scroll attributed to Li Ch'eng, a gentleman-painter of the tenth century. It is entitled *A Solitary Temple amid Clearing Peaks*. The rectangular surface, vertically oriented, is clearly divided into halves. In the upper half, vertical lines dominate, and the weight of the darker areas is at the top where attention is attracted. The lower half is graphically confused: short lines extend in all directions, and there are many irregular shapes. However, horizontal lines establish some order in the visual confusion: a large area at the bottom of the picture is irregularly horizontal; strictly straight lines are concentrated in the middle of the lower half of the picture, and at the top of the lower half. In the middle of the picture, a very stable triangular shape affords a strong point of focus for the entire scroll.

This triangle is the elevated rooftop of the temple, located on a rocky hill; it is sharply drawn on a misty background. A valley separates the temple hill from two towering, almost vertically steep, mountains. The summits are rather flat and covered with trees, but they appear inaccessible. Visually going down from the temple, we find entry buildings at the foot of the hill, on the riverbank. They seem to welcome travelers: there is no fence. In the galleries, around open pavilions built on river piles, two gentlemen leisurely converse, and another, resting on the rail, looks at the scenery.

In the confusion of worldly life, the temple brings peace, balance, and security. It is the focus of social life. Beyond the mainstream, on the other shore, there is the world of illumination, in the mountains. Perhaps a few hermits live in the forest at the top, if they have been able to climb the pathless clifflike slopes of the mountains. This quest is above and beyond the temple. The temple cannot be of much help, except as the last social shelter on this shore, before crossing.

Sitting on the porch of a cabin in the Colorado Rocky Mountains, I look at an actual landscape. Above the timberline, the summit of Longs Peak is bare and impressive. The view reminds me of the Li Ch'eng scroll; I cannot avoid the comparison. The foreground is also horizontal, but not because of a built environment, as on the scroll. Although there are a few cabins, the horizontal dimension is mainly provided by a meadow. Verticals are

limited to pines and aspens. The visual structure of the landscape is dominated by obliques. Between the place where I sit and the top of the mountain, there is a gradual continuity, not a sharp distinction, as on the scroll. The meaning conveyed to me is that reaching the summit of Longs Peak—as well as of human life—would not be an extraordinary feat, but would require endurance and perseverance.

As I reflect upon this experience-as-recalled, I can identify the components of the aesthetic quality of this actual landscape. A frame was visually provided by two of the posts supporting the porch roof and by the edges of the roof and the platform; they were in the foreground, at the periphery of my vision. This "frame," and still more the memory of the Li Ch'eng scroll, led me to see the mountain view as a painting; it established a discontinuity with my usual way of looking at an environment in which I am physically present. The configuration of forms dominated by obliques was "well organized" by chance, and highly visible. Clearly, there was a "composition" arresting enough to stop discursive thinking and replace it by contemplative vision. The symbolic meaning that emerged—gradual ascension to the peak of life—was perfectly expressed by the visible forms.

On a secluded California beach, a few friends are sea- and sunbathing. A young woman is resting, leaning on her right side. She is seen in the unlimited visual context of the ocean and the beach. Perhaps subliminally remembering Modigliani's *Reclining Female Nude*, I mentally "frame" her. In spite of the slight oblique of her left side, from shoulder to ankle, the dominant lines of her contour perfectly blend with the dominant horizontal lines of the natural setting. The brownish tan of her skin, the beige color of the beach towel on which she is lying, and the greyish yellow of the sand are matching. The lines and colors of her body and the landscape are in perfect accord. She symbolizes the harmony of woman with nature.

A few days later, looking at slides of Modigliani's *Reclining Female Nude*, and Ramos's interpretation of this Modigliani, I remember the view of my sunbathing friend. It is as if I were comparing three very similar paintings of women in the nude, each symbolizing a different idea: earthiness in the Modigliani, openness to communicating in the Ramos, and harmony with nature in the actual scene. The aesthetic quality of the actual scene and the aesthetic experience it triggered in my mind are the same as what resulted from my encounter with the paintings.

As described earlier, I perceived Tobey's *Edge of August* as symbolizing a soft clarity of mind. Later, while visiting Kyoto, I had the opportunity to quietly look at the rock garden of the Ryoan-ji temple. Visual contemplation of this carefully raked gravel rectangle in which fifteen rocks are irregularly placed resulted in a similar perception of mental clarity. Later, another meaning emerged, that of nonduality. The dark and asymmetrical shapes of the stones and the contrasting uniform white ground hid a deep unity under their obvious but superficial opposition. Here again, an actual garden and a painting have similar aesthetic impacts on a beholder. The aesthetic quality is, in either case, made of a well-integrated design supporting a strong symbolic potential.

During World War II, upon leaving an underground shelter after a night air-raid over a small European town, I was stunned by the view of the street. It looked like a stage, theatrically lit to dramatize the space where actors will perform a play. This strange effect was the result of bomb explosions somewhere in the vicinity: the blast had broken and scattered windowpanes. Blacked out window glass had fallen into the street, and lit-up

Attributed to Li Ch'eng. *A Solitary Temple amid Clearing Peaks.* Song (Sung) dynasty, 10th century. The Nelson-Atkins Museum of Art, Kansas City.

rooms shed patches of light. This lighting which, by accident, was visually organized, gave the impression of having been set up by a stage engineer. This view, so different from the ordinary appearance of the street after dark, had interrupted my usual flow of emotions and ideas. In that mode of consciousness, I saw the street littered with broken glass. An electric bulb was hanging from the ceiling in a room suddenly made visible by the absence of darkened glass and curtains. A woman and a child were lying motionless, having been hit by flying debris. Everything I saw meant the absurdity and cruelty of war. This perception did not last very long, perhaps only a few seconds; indeed, some action was required to help the victims.

The absurdity and cruelty of war were the meanings I perceived in *Guernica* when, a few years later, I saw this Picasso for the first time at the Museum of Modern Art, in New York. Two very different "aesthetic objects," the most usual one, a painting in a museum, and the most improbable one, a street devastated by an air raid, had stimulated similar attention and had symbolized the same idea.

These few cases illustrate our point that scenes and objects of the external world may have an aesthetic quality. When they have it, it is not different from the aesthetic quality of museum pieces: it generates the same kind of aesthetic perception

Of course we may discover differences when comparing a particular aesthetic perception triggered by, say, the Li Ch'eng scroll or a Modigliani painting, and the Rocky Mountain view or the actual nude on the beach. But such differences cannot be generalized and attributed to the category of 'actuality' or of 'representation'. For instance, we may expect the formal composition of a natural view, like the one from the cabin, to be weak. As any photographer knows, the "composition" of a landscape must often be improved by manipulating angles and frames before shooting. On the contrary, the painter Li Ch'eng could organize his landscape and give it the composition he wanted within the frame he selected. As it happens, the natural composition may, by accident, be better than the painter's intended composition.

Also, it could be expected that visual stimuli existing in the external world make it more difficult to keep one's mind disinterested. Indeed, when looking at the Rocky Mountain view, I could not help intermittently pondering an offer to sell me that view (as an appendage to the cabin). And while looking at my friend on the beach, I saw her not only as a symbol of harmony with nature, but as a lovely woman. But the ego's possessiveness may be as involved or even more involved, in art objects. The desire to acquire a Sung dynasty scroll or a Modigliani may be as distracting as the desire to own a mountain cabin or to dally with an attractive person.

Beauty, the common-language equivalent of our aesthetic quality, is not only in the eye of the beholder. Beauty is also in the object. In order to offer enough support for the beholder's aesthetic response, the object must have integrity of composition.

It is the overall design that integrates lines and shapes, colors and textures in a complex yet unified whole. This visual integration is achieved according to several principles of order, and several styles. Particular applications of one of these principles may be culture-specific, but the principles are not. Beauty as composition is accessible, even in unfamiliar cultures, as it is entirely comprehensible through vision. There is no need to know the cultural premises for grasping a visual order, or even for assessing the comparative excellence of design in a series of units, the forms of which are organized

Lovers *(mithuna)*. Madhya Pradesh, India. 11th century. The Cleveland Museum of Art. Purchase, Leonard C. Hanna, Jr., Bequest.

according to the same principle. An example of such a series is afforded by the ten, or more, Gothic cathedrals built in northern France between 1150 and 1250.

The expressive power of an object, its capacity to be a strong symbol, results from its excellence in design. Usually a beholder perceives only one symbolic meaning of an object which may support several meanings. Even so, the beholder perceives the expressive strength of the visual support. For symbolic meanings there is no code to be learned. An African carving may be a potent symbol for Westerners, even when its meanings, referential and symbolic, in its original culture are ignored. So it was with turn-of-the-century European painters as they discovered the beauty of African figurines.

Another result of a sound composition is the establishing of a discontinuity in the usual stream of consciousness of the beholders. This break brings beholders into the mental mode of contemplation, a mode devoid of self-indulgence. A well-composed eleventh-century Indian statue of two lovers, the man gently and voluptuously disrobing his partner, distanciates this amorous representation from the ordinary erotic daydreams of beholders in their everyday life. A painting of a Napoleonic battle does not involve the beholder's ego in the passions of violence and hatred if its composition is outstanding.

CHAPTER TWELVE

Preferences in Art

EVERYBODY HAS PREFERENCES IN ART. HOW PREFERENCES ARE JUSTIFIED HAS BEEN A MUCH-discussed question in the Western tradition, particularly during the last two centuries. Annual salons and awards formally introduced competition, thus assessments and judgments in the visual arts. Wherever similar societal developments have focused the general attention on the bases of evaluation for aesthetic objects, the same question has been raised.

These discussions have, in fact, generated much skepticism about the possibility of making aesthetic judgments. In this regard, an often-stated opinion is that preferences are a matter of taste. The implication is that the reasons for our preferences are based on idiosyncratic factors, not clear to ourselves, thus difficult to verbalize. Usually, when "taste" is put forward, the suggestion is that any further argumentation is futile.

Disillusionment with attempts at aesthetic evaluation stems, at least in part, from two incorrect assumptions. One is that aesthetic quality is expected to be the only legitimate basis for our preferences. This assumption is unrealistic: aesthetic objects are potent symbols. Their symbolic meanings, which emerge during the aesthetic encounter, cannot be ignored in our preferences.

Another incorrect assumption is that preferences should result from individual judgments made afresh by each beholder. Value assessments in religious, ethical, scientific, or political matters are part of the culture transmitted to us. For ordinary participants in a culture—and we are all ordinary participants except, perhaps, in the limited domain of the special expertise of each of us—value judgments are included in the tradition in which we have been enculturated. Even when we accept cultural values and their social legitimations with qualifications and reservations, we do not perceive them as "imposed" upon us: we share them with sincere conviction. Why should it be otherwise in aesthetic matters?

Though not an exclusive basis for preferences in art, aesthetic excellence is certainly relevant to them. How is it determined?

In the preceding chapter, I proposed that the excellence of composition together with its resultants, expressivity and visual discontinuity, form the bases for assessing aesthetic quality. We think this formulation reflects the practice of many art critics and art historians, even if they use a different vocabulary. In one way or another, assessments of aesthetic excellence are concerned with the internal congruence of forms, with the strength and clarity of expression, and with the presence of the object which compels attention and sets it apart.

Artifacts considered to achieve aesthetic distinction are included in art histories devoted to the visual production of a culture or a civilization during a certain period. Or they are the object of detailed monographic studies. Usually, these publications establish broad categories, like "masterpieces of outstanding aesthetic quality," "good pieces," and "minor pieces"; they do not attempt to rank the items competitively. There would be no point in doing so, of course. Nevertheless, comparisons of more or less successful solutions to the problems of integration of forms, of expressiveness, and of compelling presence in the same style do help us to understand better a certain style. The builders of the cathedrals of Rheims, Amiens, and Beauvais have organized Gothic forms differently. Detailed studies of these organizations give us a better grasp of the Gothic principles, and, as a by-product, afford the possibility of ranking these solutions.

In evaluating aesthetic quality, experts can differ, and do differ, but surprisingly very little. There is as much agreement among them as among specialists in such fields of the humanities as philosophy, literature, or the history of science. A cursory survey of the major art history books convincingly demonstrates the extent of agreement among art critics and historians on the inventory of masterpieces, good pieces, and second-rate pieces, and on the conclusions of detailed comparisons and rankings. The consensus is impressive. This reveals that aesthetic appreciation is not as subjective as it is said to be. In fact, it is no more subjective than, say, moral judgments made within the same ethical system (analogous to a stylistic system in the aesthetic realm). Within the system of Catholic theology, the consensus on the morality of a particular action is very high, and thus the judgment is not idiosyncratic. So it is within the system of the Gothic style.

Now we may address the question How is aesthetic excellence relevant to the beholder's preferences? Within an aesthetically ranked series of items belonging to the same stylistic system, the ranking will probably have an influence on the preferences of those who have studied the set of compared works. And the ranking will probably correspond to the intuitive preferences of other beholders who have not made a previous analytical study.

When objects from different stylistic systems belong to the same broad category of masterpieces or good pieces, the aesthetic quality cannot be a basis for preferences, as it is equivalent. The Parthenon, Notre Dame of Paris, and the Taj Mahal are recognized masterpieces; few art historians would consider ranking them in aesthetic quality. Yet many of them—and many common beholders—have definite preferences. On what are these preferences founded?

They are founded on the symbolic meanings of the masterpieces. For many beholders, the Parthenon (5th century B.C.), through its small size, its clarity of plan, and its Doric simplicity, stands for an austere equilibrium of rationality and an organized life free from intimations of a realm beyond the human world. This meaning is perceived when

Parthenon. Athens 447–432 B.C. Photo by Jacques Maquet.

Notre Dame. Paris. 1163–1250. Photo by J. Feuillie, © Caisse Nationale des Monuments Historiques et des Sites / SPADEM.

Taj Mahal. Agra. 1634. Photo by Nino Cirani (Civilisations 1966).

one contemplates the visual forms of what remains of the Parthenon; it is not separate, nor separable, from the vision. As these signifieds are in continuity with the Parthenon as it now stands among the ruins on the Acropolis, they are deeply experienced by the beholders. Balance, rationality, and the limitations of human life are more than cognitions, they are mental experiences.

Notre Dame of Paris (13th century) is a vision of luminous windows, a lofty nave, a forest of pointed arches and flying buttresses. It symbolizes the belief in the heavenly dimensions of life and the idea of a responsive suprahuman power; it makes the beholders experience transcendence. Beholders in the cathedral symbolically experience all this, even if they do not know it intellectually.

The Taj Mahal (17th century) is the grandiose mausoleum that houses the tombs of Shah Jihan and his favorite wife, whom he so passionately loved. The light and bulbous dome, the four elegant minarets, the white marble walls inlaid with semiprecious stones, the surrounding gardens remind beholders that life, even as incredibly sweet and

pleasurable as it may be tasted by those quietly sitting in the gardens and looking at the Taj, always ends in the sadness of death.

Each of these three buildings is recognized as one of the few highest achievements of world architecture. Each has what is needed to interrupt the ordinary mental flow and command the full attention of beholders. Each displays a perfect integration of the forms characteristic of its style. Each is effectively expressive of what it means. All this makes each of these buildings outstanding in aesthetic quality. But it does not give any basis for preferring one over the others. Aesthetically, they belong to the same category of highest achievements. Preferences cannot be founded on differences in aesthetic quality.

Preferences are founded on a consonance of the values symbolically expressed by the aesthetic object with the beholder's own values. A work of art stands for some intangible entity, is in continuity with it, and generates an experience of it. It is therefore preferred by beholders attuned to some values rather than to other ones. I prefer to undergo symbolically some experiences rather than other ones. For instance, I look forward to having an experience in continuity with the Anurādhapura Buddha's quiet and energetic concentration and not with the Bacon painting's passive and active torture. An abstract cognition is neither pleasant nor unpleasant, whereas an experience, even if symbolic, is either positive or negative.

In a less extreme illustration, contemporary beholders who believe that living is an endeavor that could and should be rationally controlled are attuned to the Parthenon's values. Notre Dame, on the contrary, is preferred by those who see in life a transcendental dimension of a dependence upon some power higher than man. Those who believe transitoriness and fleetingness are the most moving attributes of human life are likely to feel more in harmony with the Taj Mahal's symbolic significance.

That preferences are based on a consonance of values should not be rigidly construed. Because being a victim and being a torturer are aspects of the human condition, I sometimes welcome having a symbolic experience of torture. I do not wish to repeat such an experience frequently; I would like to experience concentration more often.

All of us are open to new values, although of course each of us has a different degree of openness. Experiencing them symbolically is always an enrichment, and sometimes produces a change in our previous system of values. Rivera, Orozco, and Siqueiros have introduced many non-Mexicans to some understanding of the values of the Mexican revolution. African carvings exhibited in France, Germany, Great Britain, and the United States during the first decades of this century have made some of the basic values of traditional Black Africa appreciated and respected in the industrialized West.

It can be said, then, that artifacts without aesthetic quality cannot convincingly support symbolic meanings. Thus they cannot be preferred, because preferences are based on the consonance of symbolically expressed values in the objects with the values of the beholder. Aesthetic excellence is not directly relevant to art preferences. It is the condition, but not the criterion, of preferences in art.

When young members of a contemporary industrial society slowly assume the common culture that existed before they were born, they are given an inventory of art works along with aesthetic judgments of them and preferences for some of them.

As mentioned above, aesthetic judgments primarily consist of very brief evaluations, such as "masterpiece," "good piece," and sometimes "inferior piece but valuable in this

or that regard." Finer judgments are not usually included in the common heritage of a society; they are transmitted in some subcultures, such as those of visual artists or of wealthy amateurs.

"The whole society" that makes collective judgments in aesthetic matters is not the whole society, of course, but "the art establishment." Those who have an impact on collective aesthetic judgments and art preferences belong to many categories: art practitioners, such as painters, designers, sculptors, and graphic artists; theorists, including art school teachers, critics, aestheticians, and art historians; museum curators and gallery dealers; art magazine and journal writers; art foundation executives and art school administrators; collectors of original works and buyers of prints and other reproductions of originals. In this heterogeneous group, the decisive influence belongs to the celebrities of the art and art-related professions and to those members of the privileged minority who are interested in the arts.

Preferences for a style, a genre, or an artist are also transmitted. Our present acquaintance with many different styles, genres, and artists gives us more scope for individual choices than ever before. For several generations of Renaissance Italians, the preference for the architectural styles of classical antiquity was culturally transmitted together with contempt for the other styles. The style of medieval churches was considered so ugly that it was called Gothic after the Goths, the barbarian invaders who sacked Rome in the fifth century. Such a preference, restricted to one style only, is very alien to the prevailing ecumenical approach. In fact, preferences transmitted in contemporary industrial societies reflect an openness to everything that has aesthetic quality, whatever the style, the origin, or period. Preferences are still strong, but they are not exclusive. Tolerance of other preferences is valued and even socially expected.

The art establishment—its leaders and followers—seems to reach a consensus on quality and preferences in the aesthetic field, past and present. The distinction between aesthetic quality (based on composition, expressivity, and discontinuity) and preferences (based on a correspondence between the meanings of the object and the beholders' values) is blurred in the prevailing opinions and convictions, views and sentiments which emanate from the art establishment. Our distinction is a useful conceptual tool for the analysis of the establishment's views and assessments, but it is rarely made explicit in the everyday aesthetic discourse of our culture.

In fact, views and opinions that express a consensus are rarely formulated as such. After reading a few favorable articles on an artist, seeing an artist's work frequently exhibited, noticing the high price of an artist's works and how often photographs of them appear in the media, we conclude that this artist is recognized as very good and is liked. We can summarize the many clues and marks of appreciation by concise, trivial statements like "Picasso is great," "Dali remains surprising," or "We all like Senufo masks." These terse statements summarize many analyses and evaluations, many judgments and intuitions; in their simplicity they encapsulate the art establishment's consensus. It is a fluid process which includes revisions and, rarely, revolutions.

The biography of a twentieth-century artist gives a glimpse of how the mechanisms of aesthetic recognition operate in our society.

Jackson Pollock was born in Wyoming in 1912. His artistic career began when, at thirteen, he entered an art school in Los Angeles. Four years later he moved to New York

and pursued his training under Thomas Benton, at the Art Students' League. When Pollock was twenty-six, he worked on the art programs of the Work Projects Administration, as did many young artists of his generation.

To be an art school graduate is, in our society, the first identification of professionalism in art. Attending a well-known school, having a renowned teacher, and living and working in one of the few international art centers—New York City was already one in the thirties—are additional assets.

In the early 1940s he joined the New York surrealist group. With them, he participated in the 1942 International Surrealist Exhibition in New York; it was Pollock's first breakthrough into fame. For a thirty-year-old painter, it was an achievement to be associated with surrealism at a time when this important trend was being passionately discussed in the art community. It was an opportunity to be represented in an exhibition that widely extended the visibility of surrealism to the large intellectual, literary, and artistic audience of the metropolitan area.

The following year, in 1943, he had a one-man exhibition at Peggy Guggenheim's gallery, Art of This Century, which became by contract his agent. From that time on, he had the benefit of the powerful support of Peggy Guggenheim, perhaps the most discriminating and committed art patron of the time, and the prestige of being associated with a historical name among the American elite, Guggenheim.

In the fifties, influential art critic Clement Greenberg devoted several supportive articles to Pollock; he made him known to, and appreciated by, the intellectual elite readership of *Partisan Review, The Nation*, and *Commentary*. No work by Pollock would go unnoticed. Indeed, his paintings, sometimes criticized, more often praised, were always discussed. As a celebrity could do, and should do, Pollock innovated. He transposed the surrealist "method" of automatic writing into painting. In order to be liberated from rational control, one should write fast, "let it go," and try not to impose a logical development on one's text. A similar liberation from rational planning was achieved by *action painting*: the new technique of painting Pollock made famous. A canvas was stretched on the floor; briskly walking around it, Pollock dripped fluid paint and spread a thick impasto. This technique, in addition to its effectiveness in freeing the mind from learned routines, had the necessary ingredients to make it newsworthy: it was outrageous, easy to understand, and associated with the glittering high society.

I do not mean to suggest that Pollock's success was due simply to a clever manipulation of public relations. His work was liked because of its consonance with the spirit of the time. The beholders of his action paintings belonged to an intellectual minority who had been made aware, through surrealism and psychoanalytic theories, of the repressive impact of rational structures. The symbolic meaning of action paintings—liberation from logical and social constraints—corresponded to the values of the New York art establishment.

In 1948 Pollock's work was exhibited in Europe with the Peggy Guggenheim collection. The following year, when Pollock was thirty-seven, *Life* magazine devoted an article to him entitled "Jackson Pollock: Is He the Greatest Living Artist in the United States?" What happened during the remaining seven years of Pollock's life was an answer to that question. To many, Pollock was indeed the greatest living artist in the United States. From 1949 to 1956, the year he was killed in a car accident, Pollock had more than a dozen one-man exhibitions in important galleries in Europe and America,

including one at the Museum of Modern Art in 1956. Since his death, his reputation has been further enhanced by recognition from critics, curators, and buyers.

Preferences are necessarily verbalized by individual voices. But the consensus of these voices in a certain society at a certain time indicates that the values and meanings symbolized in art are consonant with collective values, hopes, dreams, and fears. Individual preferences are secondary: they select from within the collective selection. If consensual preferences were not primary, what would be the explanation for the dominance of certain symbolic values and themes in a society at a certain period?

Symbolic meanings are strong in environments, happenings, and performance art events. A brief formal analysis of 116 photographs of such "art processes," which illustrate three chapters (covering the years 1955 to 1970) of Adrian Henri's *Total Art*, reveals that 88 pictures—representing 76 percent of the 116—symbolize chaos, deterioration, or destruction.[1] In some, shapes not visually reducible to Cézanne's spheres, cylinders, and cones are dominant and stand for chaos and messiness. In others, fluid but viscid forms evoke decay and disintegration. In still others, exploding forms evoke violent destruction. We know that environments, happenings, and performances constituted marginal categories on the art scene of the fifties and sixties. Nevertheless, the fact that three-quarters of their productions (as reflected in this apparently unbiased series of paintings) were so oriented at least indicates that the theme of destruction was haunting the collective psyche.

Using the same approach—brief, quick, but educated evaluations of the symbolic meanings of a set of book photographs—I glanced through the seventy or so pictures in Camilla Gray's book illustrating what the Russian avant-garde painted during the years 1912 to 1914.[2] Destruction was certainly not a meaning symbolized by the forms.

In the Rayonist compositions of Larionov and Goncharova, in Malevich's cylindrical

MIKHAIL LARIONOV. *Glass.* 1912. Solomon R. Guggenheim Museum, New York. Photo by Robert E. Mates.

NATALIA GONCHAROVA. *Cats.* 1913. Solomon R. Guggenheim Museum, New York. Photo by Robert E. Mates.

ADOLF WISSEL. *Kahlenberg Farm Family.* c. 1939.
Photo: Carl Hanser Verlag.

forms as well as in his Suprematist compositions, in Tatlin's oval shapes, curves, and pointed intersections of lines in his stage backcloths, and in Goncharova's machines, forms symbolize a vibrant and dynamic vitality. What these very different pictures have in common is the dominance of an oblique composition. In the early years of the second decade of this century, the intellectual and progressive audiences of Moscow and Saint Petersburg liked these artists' works because the symbols in their paintings corresponded to the values collectively held by the intelligentsia.

In these analyses, the concept *value* should be broadly understood. Here, we do not refer only to the values explicitly regarded as positive in a certain society, at a certain time—such as, in the Third Reich, work and family, war and sacrifice for Germany. We refer also to values not overtly recognized, such as eroticism, a hidden indulgence in many societies; to obsessions, such as death anxiety; and to fears, such as the contemporary horror of atomic doom. In fact, in the present context, the word *value* connotes the dominant themes and constant concerns that pervade the collective imagination of a society.

The art establishment consists of persons who belong to their time and society. They share the values, concerns, and themes of their cultures, and they perceive the corresponding visual symbols. Their positive responses to works of art are certainly influenced

by the symbolic meanings of the objects. It is not easy to determine the relative importance of the aesthetic quality and the symbolic meaning in the collective response of the art establishment. We should not forget that quality and meaning are simultaneously perceived in the aesthetic experience, and distinguished only in the experience-as-recalled by those inclined to discursive reflection.

Moreover, most art establishment people want their aesthetic judgments and art preferences to meet with public approval. Art dealers want to sell, curators want to attract visitors, publishers of art magazines and books want subscribers and readers, art schools want students. Certainly, they are leaders and pacesetters in aesthetic matters, but they have to be followed. The concern not to outdistance the general public cannot fail to orient, consciously or not, their selection to works that will have large appeal because of their consonance with dominant themes and values.

The components of aesthetic quality—clarity, simplicity, and integration of composition; expressive power; and discontinuity with the everyday environment—are not culture-specific, and consequently, aesthetic excellence may be intuitively perceived and discursively analyzed cross-culturally. Furthermore, certain aesthetic objects are preferred on the basis of the consonance of their symbolic meanings with the beholders' values and not on the basis of their aesthetic excellence, at least, not primarily, in most cases.

Are preferences, then, culture-specific? If preferences result from a correspondence between the symbolic meaning of the object and a cultural value, can we perceive the value symbolized by an object made in another culture? Can we like and prefer a visual object symbolizing an "alien" cultural theme?

Between Creators and Beholders

SO FAR, THE PARADIGM OF SIGNIFICATION HAS BEEN THE ONLY FRAMEWORK FOR THE DIS-cussions: *in context M, sign A stands for signified B to subject X.* There was an object, and there was the beholder looking at it. Nobody else or nothing else was involved in this visual and mental relationship. Often the creator of the visual forms was mentioned, but mainly in order to identify the object. No attempt was made to include the painter or engraver, the sculptor or designer in the aesthetic commerce between the beholder and the work. Should artists be included in the aesthetic experience?

It seems they should. Listen to conversations about paintings and sculptures, read newspaper reviews of exhibitions, and pay attention to arguments used when opinions about art objects are debated: to a large extent, discussions are about what the painter wanted to say, what the sculptor intended to state, and what the artist wished to convey to the audience. In fact, the search for the meaning of a particular art object is almost always expressed in terms of the artist's intentions. Our everyday discourse about visual arts implies that art works convey messages from artists to beholders, and that a main concern of the latter—if not the main concern—is to decipher the message hidden in the object.

How do visual forms convey messages? Are they vehicles for meanings in the process of communication?

Not all uses of terms concerning communication imply a commitment to the assumption that art is communication. Occasionally terms belonging to the communication vocabulary have been loosely used in sentences like "Picasso *tells us* in *Guernica* that war is absurd and cruel" and "The anonymous carver of the Anurādhapura *Buddha wanted to convey to Sinhalese people* that there was invulnerability in serene concentration." Despite this wording, we were primarily concerned with the meanings of the works, and not with the intentions and messages of the creators. In the following discussions, we shall strictly use the precise terminology defined by the paradigm of communication.

The relationship of communication includes two actors, the sender and the receiver, 151

CONSTANTIN BRANCUSI. *Adam and Eve.* 1916—21.
Solomon R. Guggenheim Museum, New York.
Photo by Carmelo Guadagno and David Heald.

and what is sent and received, the message. The sender translates a nonmaterial message into a physical medium (or vehicle) which is transmitted to the receiver. The receiver reconverts the medium into the message intended by the sender.

Adapted to the visual arts, the paradigm of communication may be so formulated: *in context M, sender Y embodies message B into form A; in context L, receiver X interprets form A as standing for message B.* Sender Y, the artist, transmutes idea B into a visual configuration of forms, aesthetic object A. Then object A is looked at by receiver X, the beholder, who apprehends in it idea B.

The second part of the formula—*in context L, receiver X interprets form A as standing for message B*—is similar to the signification paradigm—*in context M, sign A stands for signified B to subject X.* Do we conclude that the subject's meaning and the receiver's message are identical? Or do "message" and "meaning" stand differently for their respective signifieds?

A few years ago, in a retrospective exhibition of the works of Constantin Brancusi (1876–1957), I saw a striking carving in the beautiful space of the Guggenheim Museum. It was a complex wood structure, about eight feet high. It looked like a pillar, but strangely, it was made of two statues, each on its own pedestal, and one on top of the other. On the label were only two dates, 1916–1921, and the title, *Adam and Eve.*

This caption put me on the analytical track. Where was Adam? Where was Eve? And what was Brancusi's message about them? Because of the title, I assumed that each statue was a human figure, and I tried to identify Adam and Eve. Rendition was at the limit of the figurative. The style was Cubist in the sense that the two figures were represented by a few geometric-like forms selected from the human body repertory. Each figure seemed to have been carved out of a beam; symmetry and verticality dominated.

The top figure had, at its center, a bisected horizontal cylinder which I perceived as everted lips, a "mouth." Above it, the volumes appeared to be sections of a "face" and a "forehead." This reading might have come simply because these forms were above the mouth. At any rate, mouth, face, and forehead together constituted a "head." Under the central cylinder, and perpendicular to it, there were a long and narrow cylinder, the "neck," and two spheric forms, the "breasts." Eve was the figure on top.

Looking at the other figure, which was supporting Eve's pedestal, I did not see it as clearly masculine. Rather, to me, the general shape suggested a squatting woman, perhaps because it reminded me of a Luba chief's stool supported by a caryatid. The horizontal half-cylinder supporting the capital (which was at the same time Eve's pedestal), the capital itself, and the forms behind the caryatid's "neck" evoked to me a woman's face under a hat (the capital), and locks behind the neck. Without the *Adam and Eve* caption, I would have read Brancusi's message as stating that an older woman, represented as sexually neuter, supported a younger one, beautiful (the elegant long neck) and sexually attractive. The message could have been "mother superseded by daughter."

But this was not the message. The title clearly indicated that the figures were not two women. Adam was to be found. Perplexed and searching for clues of interpretation, I looked around. Among the other Brancusi works, I noticed a glittering *Male Torso,* made in polished brass and dated 1917. There was a striking similarity of forms between the three cylinders of the *Torso* and the neck and breasts of *Eve.* In the former, the vertical cylinder was the "trunk," and the two inferior cylinders at right angles were the sepa-

Chief's stool, village of Buli. Luba, Zaire. British Museum, London.

CONSTANTIN BRANCUSI. *Male Torso*. 1917. The Cleveland Museum of Art. Hinman B. Hurlbut Collection.

rated "legs." Also, the *Torso* had very explicit phallic connotations: it evoked penis and testicles.

Returning to *Adam and Eve*, I noticed that the top figure could as well be interpreted as including the masculine motive of the *Torso*. The trifurcated form was as much penis and testicles as neck and breasts. In that perspective, maybe Adam was the top figure, supported by Eve as caryatid. However, the mouth above the trifurcated form definitely was not masculine. If it was a mouth, it was a woman's mouth; its proximity to the phallic form also suggested the meaning of vulva.

Still perplexed, I saw another Brancusi: a columnlike carved wood piece, dated 1915 and called *Caryatid II*. The head and the capital it supported were different from the corresponding forms in the lower figure of *Adam and Eve*, but revealed some similarities too. The word *caryatid*, used in the title by Brancusi himself, referring to a supporting pillar in the form of a *woman*, not a man—which, as a sustaining column, was called a *telamon. Caryatid II*, with the protuberant abdomen of an African ancestress figurine, was distinctly feminine. How strange, I thought, to represent Adam by a figure without any sexual attribute (whereas Eve's sexuality was ostensively displayed) and formally so close to a female caryatid. Perhaps Brancusi wanted to say that a dominant Eve had castrated a dominated Adam.

Finally, I read the notes in the exhibition catalogue. I learned that the two statues had

been brought together long after they had been independently carved. The upper one was called *Eve* when created in 1916, and the lower one, "now figure, now base," probably did not acquire its appellation *Adam* before its association with *Eve*, in 1921. Art critic Sidney Geist concluded: "The work surely reflects Brancusi's current attitude on the social relations of the sexes: beautiful woman is now the crushing burden of responsible man."[1]

Disappointed, I left the museum. If Brancusi wanted to say what Geist assumed he wanted to say—that "beautiful woman is now the crushing burden of responsible man"—he had produced a poor vehicle for his message. In this work, he proved to be the unskilled sender of a message embodied in confusing forms.

A few days later, I had another opportunity to see the same piece. This time, I did not think about deciphering Brancusi's message. I looked at it with attention and receptivity. I had a deep and positive aesthetic rapport with the sculpture.

It was indeed a work of high aesthetic quality. Bisected cylinders, full and truncated spheres, and half-cubes are expertly arranged. The triangular indentations of the base provide a discrete rhythm. Oak, chestnut, and limestone give a varied texture. The whole sculpture is boldly vertical. Together, these formal characteristics build a well-balanced composition that has strength and lightness, stability and upward dynamism. The composition harmoniously blends the dominant geometric order with a less pervasive, but still strong, organic order.

When heedfully contemplated, these forms also offer meanings. To this beholder, the overall meaning of the work is a statement about the dominance of sexuality in an individual's life. This is intuitively perceived prior to any analysis. However, this holistic perception may be discursively explicated.

CONSTANTIN BRANCUSI. *Caryatid II.* 1915. Collection Musée National d'Art Moderne, Paris. Brancusi Bequest, 1957. Photo by Robert E. Mates.

The composition, divided by a central wooden block, presents an evident duality. I do not perceive the upper part as a human figure in which forehead and mouth, neck and breasts, or penis and testicles are parts of a body. I see it as a composite emblem of sexuality, feminine *and* masculine, rather than feminine *or* masculine. Let me make a comparison with optical perception tests designed to demonstrate space illusions. When we look at the outline of a cube drawn in perspective, the same square sometimes appears as the front surface of the cube, and sometimes as the rear surface. Analogously, in *Adam and Eve* the upper configuration of forms successively appears as a visual arrangement of female attributes, then of male attributes, or as the union of both. This dramatically suggests the fusion of the two sexualities. The placement of this emblem on the top pedestal, the symmetry and frontality of its two forms, and its relatively large size confer on this symbol solidity, eminence, and assertiveness.

The lower part, which I perceive as a human shape, is an asexual figure. Its sexuality—the neuter gender seems appropriate here—is separated from the human figure and dominates it. The squatting or sitting figure represents the self, the self of a woman or a man. Dominated by its sex impulses, the self supports the burden of the triumphant desire. The stooped, but enduring and sustaining, figure suggests that the struggle, if there was any, is over. The victory of sexuality has been secured and the self has accepted, or is resigned to being servant and provider of desire.

This is how this beholder verbalized and explained his second encounter with the Brancusi sculpture when he reflected upon his experience-as-recalled. For him, it symbolized the domination of self by sex impulses. To this beholder it was the signified for which the sculpture stood. This was its meaning, but certainly it was not Brancusi's message, as the latter must be somewhat related to the title, *Adam and Eve*.

If Geist's deciphering of Brancusi's message ("beautiful woman is now the crushing burden of responsible man") is correct—that is, conforms to the idea Brancusi wanted to convey—it is clear that meaning and message, at least in this case, are completely different. It is also clear that they are of unequal value. *Adam and Eve*'s meaning is strong and compelling; its message is unclear and uncertain.

That meaning and message of the same aesthetic object can be so dissimilar in content and value is a strange and paradoxical conclusion. But the paradox is of our own making. A symbol is a polysemic signifier: it stands for several signifieds. As the essential quality of a vehicle of communication is to stand for one signified only, that is to be monosemic, a symbol cannot be a good means for embodying messages. To try to transmit messages through symbols is to use the wrong kind of vehicle.

Approaching *Adam and Eve* in the contemplative mode of consciousness, I perceive it as a symbol of self and sexuality. Another beholder, also contemplatively approaching the same work, may perceive another meaning in it. Mondrian's *Broadway Boogie Woogie* may stand for Manhattan to one beholder, for joyful jazz to another, and for the underlying order of life to still another. Each beholder, while aesthetically looking at a configuration of forms, has an intuitive grasp of a symbolic meaning.

Subjects have the sense of perceiving a meaning in the forms. In fact, they endow the forms with a symbolic meaning. They create it, in the full acceptation of the word *create* 'cause to exist'. Such a creation occurred when I posited that Tobey's *Edge of August* stood for quiet illumination.

That several meanings may be attributed to the same aesthetic object is mainly

explained by the impact the beholders' past experiences have on the symbolic under-
standing. For instance, a beholder without any experience of meditation is unlikely to
endow the Tobey with the meaning of quiet illumination.

Though beholders endow and attribute meanings, they do not simply project mean-
ings onto aesthetic objects as if those objects were Rorschach plates. Meanings are not
arbitrary, they are clearly in the forms. What a symbol stands for arises from the symbol
itself: it compels recognition.

In relationships of communication, on the contrary, receivers do not create messages
on the basis of their life experiences. The receiver proceeds by applying to the vehicle the
appropriate code of interpretation, the one used by the sender for translating a message
into its embodiment. In the decoding of messages, the sender's function obviously has
priority. Senders select the messages and codes they use. Vehicles are referents which
stand for their signifieds by convention.

When mistaking symbols for referents, viewers use the wrong model of interpreta-
tion. Acting as receivers, they try to ascertain the artist's message. As visual forms are not
limited to one meaning, they look for clues external to the object such as preparatory
sketches, dates of beginning and completion of the work, and its title. Further apart from
the object, clues are looked for in the personal life of the artist as it is known through
letters, diaries, opinions of contemporaries, and recollections of friends. These sources,
usual for a biographer, and possibly for an art historian, are relied upon for deciphering a
message. For instance, they make it likely, or not, that Brancusi would express a strong
opinion on the exploitation of man by woman in a couple. In the search for Brancusi's
message, the decisive argument was external to what can be seen in the actual work: the
objection that a neuter figure could not represent Adam was removed by Geist's informa-
tion that *Eve* was placed on a base five years after being carved, and that base, a caryatid,
was called *Adam*. As in this case, the search for a message often leads to a discursive
investigation of circumstantial evidence and the message is reached as a conclusion of
elaborate reasonings.[2]

If art objects were media of communication, they would be very poor carriers of
messages. As they are symbols, each stands for several "messages," thus obliging the
receiver wanting to escape ambiguity to conduct a circumstantial research which is
unlikely to attain a definitive conclusion.

The paradigm of communication was evolved from language as a vehicle for
information. Language is the best instrument of communication we have. Words are
contextually monosemic referents: in everyday verbal communication, words have only
one meaning in the context of a sentence (unless they are puns). Admittedly, dictionary
entries list several acceptations for almost any word, but in the classroom, the office, the
shopping center, and at home, we do not use isolated words. We use them in sentences,
the natural units of oral or written language. If a word in an isolated sentence still remains
ambiguous, the broader linguistic context (the preceding and following sentences) or the
situational context (the circumstances in which the sentence is uttered) clarifies it. Each
sentence, in a text, has only one meaning, and so does the text as a whole. Any person
having learned the code, that is the vocabulary and grammar of the language, will
apprehend the single meaning. This makes the language an ideal channel for transmitting
messages without distorting the meaning intended by the sender.

In the last decades the linguistic metaphor has been popular in the social sciences. Kinship systems and marriage rules have been likened to communication systems, and so too have been works of art.[3] Using language as a *metaphor* for art, or for other cultural phenomena, suggests stimulating comparisons, but taking language as a *model* for aesthetic commerce is misleading.

Receivers of linguistic messages—the readers of this page, for instance—apprehend meanings embodied in the words, sentences, and texts by the sender—the writer of this book, for instance—ideally without adding anything to them. Encoding and decoding are tasks for the intellect. Feelings and emotions are not allowed to interfere. Whatever the variety of their past experiences, receivers should retrieve the same message from the same text: the one that the author has committed to the words.

Beholders, on the contrary, invest the visual object with meanings related, in part, to their past experiences. Because of this rooting in individual experiences, symbolic meanings attributed to the same object by different beholders are bound to be different. However, this symbolic variety is limited. The commonalities in our experiences are many: the human predicament provides a broad basis for a consensus of interpretation. Wasted energy, anxiety, gravity and sincerity, fulfillment of sexual desire—symbolic meanings we have posited in the Pollock, Lichtenstein, Ingres, and Wesselmann paintings we contemplated—are experiences familiar to everybody. Symbolic meanings attributed to the same work by several beholders are not idiosyncratic. Neither are they identical, as they should be—and as the linguistic messages perceived by different readers of the same book frequently are (if they are not identical, it is because of some inadequacies in writing or reading).

A receiver's interpretation of a text is valid if it does not distort the sender's message. A beholder's interpretation of a visual work is valid for the beholder if it has the quality of compelling evidence. In the perception of what a work stands for, there is an immediacy that makes arguments irrelevant. It is analogous to the conviction arising in ordinary vision from the vision itself. I am convinced that I see the green of a leaf through my sensation of it. In a similar manner, I am convinced that the Tobey is a symbol of quiet illumination because I perceive quiet illumination when looking at *Edge of August*. But, again, the validity of a symbolic interpretation is not restricted to a single subject. By sharing a verbal account of my insight with others, I may stimulate them to perceive the same symbolic meaning. In this sense, a consensus may arise. Whether a symbolic meaning remains unshared or becomes consensual, it is not validated by conformity to a sender's intention.

Language is an apt medium for conveying complex messages. Languages perfected by countless generations of speakers and writers, grammarians and lexicologists, ordinary users and expert "wordcrafters" are marvelous vehicles for messages. The analytical and combinative characteristics of linguistic elements make it possible to translate long, complex, and qualified messages into textual vehicles. Dictionaries and grammars provide precise linguistic codes for the translation of ideas into texts by senders, and the reversion from texts to ideas by receivers. By contrast, beholders approach composed works as totalities; meanings are intuitively perceived and not deciphered with the help of standardized codes. After the visual contemplation, if the beholders try to verbalize the symbolic meaning it is usually done in very few words: a noun referring to the symbolized entity (such as *joy* or *war* or *anxiety*), one or two adjectives or qualifiers (such

as *sensual* or *absurd* or *of death*), and maybe some value assessments (such as *good* or *fearful* or *degrading*). These few words have a poor analytical content. If it were a message, the message would be very crude: it would not include internal complexity, causal explanation, nor the unfolding of consequences. The informational content would be very limited or even trivial: everybody knows that "war is cruel," and "sensual fulfillment is a joy," and that "sun is life."

Being intuitive and holistic, symbolic interpretation proceeds from the whole mind, and not only from its intellectual function. Being discursive and analytical, linguistic communication is able to transmit accurately extended and intricate messages.

Language is the main tool for human cooperation. For collective survival, information on the environment, its dangers and its opportunities, must be transmitted quickly and precisely; warnings and orders have to be given and received. Linguistic messages are essential for producing commodities and transacting their sale, for acting one's roles in social organizations and institutions, for everyday living in the workplace and at home. The tower of Babel myth has reminded us for centuries that no common endeavor is possible in the confusion of messages.

Communication, of which language is the exemplary vehicle, belongs to cognition and action. Symbolic signification, of which aesthetic vision is one support, belongs to contemplation. The hypothesis that aesthetic forms, like a language, communicate messages from artists to beholders, has produced little more than confusion. It should be discarded.[4]

Yet creator and beholder are not isolated from one another, with nothing in common. Between them is a communion, a participation in corresponding experiences. The creator, when shaping forms, and the beholder, when looking at them, have corresponding experiences.

Sensual ecstasy perceived in the Wesselmann painting expresses the painter's experience of it and is in continuity with the beholder's experience of it. This experiential common ground, this shared understanding, establishes a close bond between creator and beholder: a communion. For my part, there is recognition of something I lived through. Because of this, it is evident to me that the painter has lived through something similar.

Communion is a deeper and more complete type of relationship between two persons than that resulting from the communication of messages. Communication only involves the cognitive function of the mind, whereas communion is more comprehensive. It is a sharing that gives rise to a broadened identity: beholder and creator constitute a 'we'. The 'we' is extended to other beholders who respond to the same work. They too have been through corresponding experiences. A nonorganized set of kindred minds is generated on the basis of experiences consonant with each other and with the creator's own experiences.

As we concluded in an earlier discussion, experiences are always mental, whether triggered by external events and processes or by inner stimuli. Recall the Bacon painting considered in chapter 10. I have never been tortured, but like almost everybody, I have been submitted to minor pains and humiliations. These external circumstances have produced some mental experience of inflicted distress which has been extended to a certain understanding of torture. This experience helped me to "recognize" the meaning of torture in the Bacon picture and to become aware of something common to Bacon and

me. I do not know if Bacon's experience of torture was based on an encounter with torture itself or with minor humiliations. But I do know that a shared understanding of torture establishes a bond between the painter and the beholders of this work.

Sharing a mental experience with an absent painter and an absent audience cannot be expressed in words. Like a silent gesture—my hand gently pressing your arm—a common experience is better left unqualified by words if its depth and concreteness are to be preserved.

Communion is not communication. The corresponding experiences are deep but undefined, important to self but inchoate—to use James Fernandez's telling word.[5] I perceive *Adam and Eve* as rooted in Brancusi's experience of the tensions of sexuality, and this corresponds to my own experience of those tensions. But if I want to go further and express in words what *Adam and Eve* means to me, I do not know if Brancusi would have focused the verbalization of his experience in the same way that I did, or if he would have even wanted to particularize his experience with words. At any rate, he did not do so. Instead, he has provided us, the beholders of *Adam and Eve*, with a work emanating from and reflecting a profound experience, but not limited to an aspect of that experience. His sculpture remains an "open work"—if we may use the formulation chosen by Umberto Eco as the title of one of his books.[6] Because they are open works, aesthetic objects are susceptible to accommodating several meanings, each validly posited by a different beholder. The polysemic character of symbols finds its source in the nonverbalized experience of the creator.

Different beholders may validly attribute different meanings to the open work, but not *any* meaning. The original experience reflected by the work must be respected. And it will necessarily be respected by the beholders who recognize this original experience of the artist as corresponding to an experience of their own.

Between those who design and shape aesthetic objects and those who contemplate these works, there is no communication through message. There is communion through experiences. What does the artist intend to say? is not the right question. The right question is, What experience does the artist want to express and share?

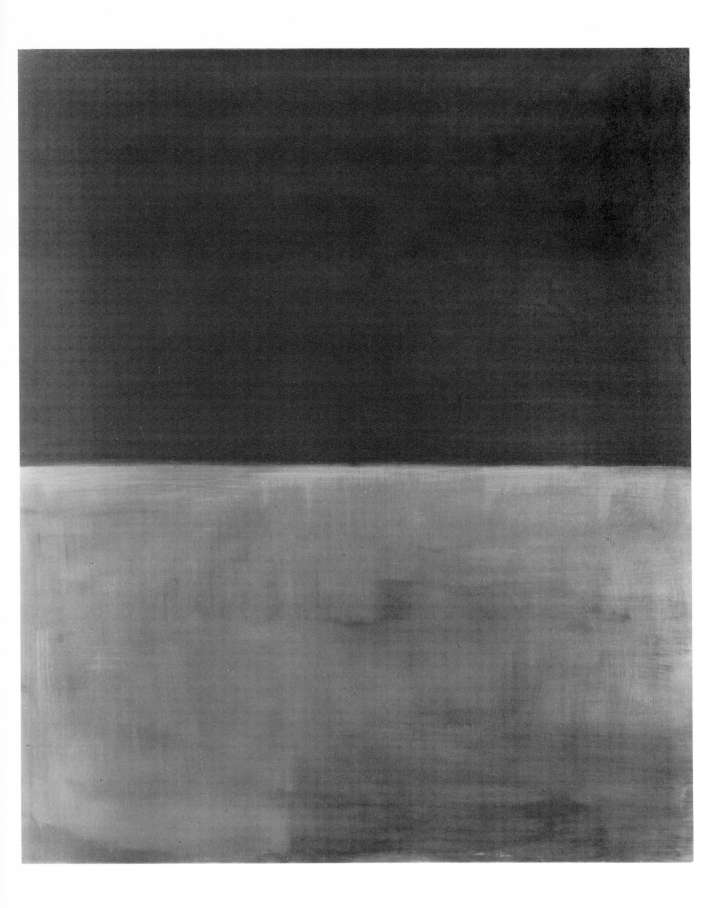

Aesthetic Vision, a Selfless Experience

EXPERIENCES ARTISTS WANT TO EXPRESS AND SHARE ARE EMBODIED IN AESTHETIC FORMS which suscitate and uphold perceptions of a specific kind. They are neither cognitions nor emotions. Early in this book (chapter 5),we noticed striking similarities in descriptions of aesthetic perceptions and meditative experiences. This convergence led to the conclusion that these two kinds of experiences were rooted in and revealed an original mode of consciousness, contemplation.

These observations were reinforced and became more intelligible when analysis of the visual forms as meanings allowed us to state that aesthetic objects are symbols, and that there exist important differences between symbolic signification, a contemplative mental process, and communication, a cognitive and action-oriented process.

Symbolic forms also establish a distance between the beholder's affectivity and the symbolized meanings or values. Remember the Capa photograph of the Spanish volunteer's violent death. Suppose an observer had been in the place of the camera and had seen, for the split second the event lasted, the man fall exactly as it had been framed and frozen on the film. The observer, immersed in this war action, caught in cross fire, would have had an experience of the death scene different from the one we have when looking at the photographic print. The observer's self-involvement would have normally generated an emotional experience different from the experience devoid of self-interest stimulated by the aesthetic excellence of Capa's photograph.

This question of emotional distance in aesthetic perceptions must be more clearly elucidated. In order to place it in context, we will begin by describing the contemplative process and its obstacles.

In the waking state of everyday life, we are, for a good part of the time, in what can be called a digressive frame of mind. Thoughts and emotions, sensations, and impressions, feelings and other mental contents follow each other at a rapid pace in what seems to be a constant process of digression: straying from one to another according to inner or external incitements. By contrast, when we perform a certain task, be it reading a book or

MARK ROTHKO. *Black on Grey.* 1970. The Mark
Rothko Foundation, New York.

listening to a lecture, fencing in the arms room or driving on a congested and slippery freeway, mental digressions stop. One's mind becomes concentrated on the task at hand.

Apart from putting an end to the wanderings of the mind, which is the common result of all focused mental attitudes, concentration is specific to the task to be performed. It is analytical when the task is solving a problem in science or technology or in everyday life decisions. It is comprehensive when the task is responding to a complex and changing situation which may include unexpected elements. The driver has a comprehensive attention to everything that happens on the road, the fencer to every move of the adversary.

These two types of mental concentration are familiar mental processes: analytical concentration is learned, and comprehensive concentration is spontaneously achieved.

Beginning in elementary school, we are trained to analytically concentrate our attention on intellectual matters such as reading, memorizing, and solving arithmetic problems. Later, we are encouraged to analyze our moral life through introspection by discriminating between good and bad actions, examining our intentions, setting goals, and planning ways to attain them. We are trained to focus our attention on an object for the sole purpose of dissecting it into elements as a preparation for action—such as repeating to a teacher what we have read, convincingly arguing in a discussion, and improving our chances of success.

Comprehensive concentration is not learned. Yet it is often experienced, at least for brief periods of time, as it naturally arises under the pressure of strong stimuli. Without effort, our attention focuses on the whole situation when we are confronted with a danger, engaged in competitive games, or submitted to other intense stimulations. The latter may be internal, such as acute pains, or external, such as large and shining images in motion on the screen of a darkened theater, or the commanding sounds of a Wagner overture.

Looking at an aesthetic object is another task that requires mental concentration. This concentration is an attention focused on the visible forms of an object, and limited to them, centered on and circumscribing the seen as seen, without any addition. Because of this focalization on the bare sensory, this type of concentration may be called bare attention.

This name comes from the Theravāda meditational tradition. ''Bare attention is the clear and single-minded awareness of what actually happens to us and in us, at the successive moments of perception. It is called 'bare', because it attends just to the bare facts of the perception as presented . . . through the five physical senses. . . .''[1] Beholders' as well as meditators' minds should not roam beyond the perceptible forms, attempting to associate them to mental contents of other known or experienced things. One's past experience is very important, as we have seen, but there is no effort to conjure it. It remains buried, as it were, under the conscious level, and if it appears as a reminiscence, it is not entertained by the beholder. There is no attempt at analyzing, comparing, and theorizing.

The effect produced in beholders by "just seeing" is similar to the one achieved in meditators by "just breathing" or "just sitting." It is a mental deconditioning. It is the suppression or the bypassing of the intellectual and emotional outgrowth which stands between beholder and object of vision, meditator and intended object of attention. In this

state of bare attention, things are perceived 'as they are'. This does not mean, as remarked earlier, that we reach things as they are 'in themselves'—that is, independently from anybody's perception—but that we apprehend them directly through our sense organs and not through conventional conceptualizations. For instance, it is to see the Brancusi sculpture as a configuration of visual forms and not through the title, *Adam and Eve*, which suggests that a male and a female figure should be identified.

Bare attention is not an easy type of concentration to achieve. In the seen, perceiving only the seen is a mental stance generally ignored in contemporary Western societies. In societies where meditation is recognized as an important spiritual exercise, a few individuals regularly practice contemplative attention, many occasionally have a taste of it, and everybody knows about it.

This ancient Buddhist practice, the bare attention to the sensed as sensed, is echoed, across centuries and continents, by Maurice Denis's notion of a picture as being essentially "a flat surface covered by colors arranged in a certain order." Here, too, forms should be devoid of their conventional accretions and individual associations. This concentration on the forms as seen makes it possible to take a first step in affective distanciation from the object. Both formulations epitomize the same attitude of exclusive attention to the visible, an attitude that decreases the possibility of ego-involvement in what is represented by the picture.* If we see first an arrangement of forms and colors rather than a bloody piece of meat or a sumptuous and voluptuous body, then distasteful or pleasing associations, frightening or erotic daydreams triggering anew a digressive state of mind will not develop. Bare attention necessarily generates an emotional distance, or it disappears.

Most easel paintings, drawings, and figurines do not impose their presence upon us. They discreetly call our attention. We have to make an effort in order to maintain concentration on them and to resist mental digressions. Nevertheless, mental digressions keep coming, and sheer willpower does not seem sufficient to push them away.

A few years ago, an exhaustive retrospective of Mark Rothko's works was presented at the Los Angeles County Museum of Art. To survey in one visit the creation of a major twentieth-century artist is a demanding experience. At the end of the exhibition, looking at a painting entitled *Black on Grey*, and dated 1970, I tried to pay attention, "bare attention," to its visual forms. But what I knew and felt kept interfering.

I knew that this particular painting belonged to Rothko's last period: black or brown on grey. The large acrylic works of this period are horizontally divided into two rectangles, the darker on top, the grey at the bottom. The two areas are separated by a thin white band which evokes —for me, at least—the horizon separating an icy surface, lake or snow, from a dark sky. After his previous periods, characterized by light rectangles floating on colored grounds and by glowing colors (red on orange, yellow on yellow), this picture was ominous. Its darker hues and rectangles, stabilized on the canvas plane, made *Black on Grey* the end of a stylistic development and of a life trajectory. Rothko could not have gone any further in darkness and simplicity of shapes and colors. A few weeks after finishing this painting, he committed suicide in his New York studio.

*Following common usage in everyday language, we call 'ego' or 'self' "the conscious subject, as designated by the first person singular pronoun." (American Heritage Dictionary 1982: s.v. "ego.")

I tried to look, just to look, at *Black on Grey*, in bare attention. Questions and comments, feelings and comparisons kept bubbling into my mind: Suicide as the perfect manner to bring a successful career to an end . . . "He had reached the farther shore of art," a comment read in the exhibition catalogue[2] . . . Marcus Rothkowitz's immigration to the States from czarist Russia, in 1913, when he was ten years old . . . The liberal and radical New York celebrity, so rich and famous in the fifties that he could refuse to sell his paintings to museums of which he disapproved[3] . . . The depressed man, who, in the sixties, feared that his work had reached a dead end . . . Picasso, who never reached a dead end, though he died at age ninety-two . . . I feel overwhelmed by this painting, but why? . . . The dark sky is not a sky, and this is not a landscape.

Through willpower, I could not stop these diversions which irrupted in my attempt at visual contemplation. Frustrated, I tried another tactic. Instead of struggling in vain to prevent them from reaching my consciousness, I stepped back, as it were, and let thoughts and feelings come and go. I noticed their appearance and also noticed that, left alone, they disappeared too. My previous attempts at getting rid of them had had the effect of reactivating them. I was still overwhelmed by the painting, but I was now aware that I was overwhelmed, and this, somehow, seemed to establish a distance between this emotion and me. After some time, diversions became less intense and less frequent, and I could more successfully develop a contemplative attention to the forms of *Black on Grey*.

Switching tactics—from forcibly repelling digressions to noticing them come and go—amounts to extending bare attention to any mental content appearing in our consciousness. Instead of focusing our attention only on the visually perceptible forms of the aesthetic object, we open our attention to encompass anything that happens in our mind. In so doing, beholders rediscover a mental approach which has been used for centuries in Theravāda meditation, *mindfulness*.[4] To be mindful is to be aware of what occurs in our minds from moment to moment. I hear a sound, and I am aware that I hear a sound. I am angry, and I notice that I am angry. I think of Rothko's immigration and I take note that I think of Rothko's immigration. This awareness function is similar to what, in contemporary psychology, is called by Charles Tart, the "Observer," and by Arthur Deikman, the "Witnesser."[5]

Being mindful of mental digressions as soon as they occur, instead of trying to bar them or to expel them, in fact has the effect of speeding up their disappearance. Noticing interfering thoughts and affects somehow weakens them. They fade away on their own more quickly than under the pressure of our will. When they are disappearing, the meditator gently directs the attention back to the object or process, such as the breathing, that was selected.

Mindfulness has effects other than causing thoughts, feelings, and emotions to dissipate. One of them, particularly relevant to aesthetic perception, is the distanciation between beholder and mentations. Most of the time, ego is deeply involved in its emotions and thoughts. When mindful of unwanted mental contents, of their emergence and disappearance, I perceive them as distinct from me, and alien to me. As I wish they would not be present in my mind at this time when I want to concentrate my attention on visual forms, I do not identify with them, and I do not feel responsible for them. I notice the emergence of an emotion of hatred against somebody who is close to me. As it arises against my volition, I do not assume responsibility for it. In an affective mode of consciousness, I would feel guilt and shame, regret and embarrassment for hating somebody I usually love. Being mindful of the genesis and transience of this sentiment of hatred, I

see it separate from me, at a distance. When I look at a painting, my imagination moves from the surface of lines, shapes, and colors to the amorous encounter represented, and pleasant erotic daydreams arise. As soon as I notice their unintended emergence, I perceive them as distant, and I can return my attention to the seen as seen.

This nonidentification of ego with its feelings and emotions allows the meditators' and beholders' minds to remain calm and quiet. They are fully alert to everything that occurs, but their egos are not involved.

Another effect of mindfulness is to give us an experience of ego's limitations. Ego is not the lord of the inner realm of consciousness: it cannot steadily fix its attention on a painted surface for more than a few moments, or on breathing for more than a few inhalations and exhalations, without the irruption of distracting thoughts and affects. In the digressive state of mind, prevailing most of the time, we have intimations of the limits of ego's power. But it is the sustained mindfulness which gives an insight into the extent of these limits.

In meditation, mindfulness of what happens in the body—breathing, back pain, hurting legs—makes one experience another borderline of ego's power. Processes essential for life are not related to the individual and unique ego; they operate impersonally and usually they are even beyond the reach of awareness.

During a meditation retreat in a Sri Lanka monastery, I wrote the following entry in my diary on the twenty-second day: "Impermanence of ego is experienced here as a vivid evidence. Ego amounts to the present body in constant entropy, a few memories that come and go, and a few limited projects for a dubious future. . . . Images and ideas, feelings and emotions enter and leave my field of consciousness, one linked to the other by trivial or bizarre associations. I do not perceive them as 'mine' any longer."[6]

Even as "Observer" or "Witnesser," ego is not experienced as a permanent and substantial entity. The observing function is another mental content which appears and disappears too. Like other mental states and processes, the mindful ego emerges into consciousness and fades away. Our socially constructed concept of a self—an individual core, resistant to essential change, and supporting the modifications occurring in the course of a lifetime—is not experienced in meditation.

Aesthetic contemplation is not a spiritual path. It is not practiced with as much method and sustained intensity as meditation. Yet mental concentration on a visual object and awareness of hindering digressions produce, to a lesser extent, some results analogous to those just described. In the aesthetic encounter of object and beholder, the object is given priority over ego, as it were. Aesthetician Harold Osborne, who describes aesthetic contemplation as a form of absorption, writes that "absorption is never complete to the point where ego-consciousness disappears," but that it includes a "loss of subjective time-sense, a loss of the sense of place, and a loss of bodily consciousness."[8]

This weakening of ego in the aesthetic absorption is the result of a process parallel to the process just described for meditation; but it is not as radical. The beholder's ego is not the conquering ego of action, the assertive ego of cognition, the introspective ego of affectivity. It is the disappearing ego of contemplation.

Disinterestedness is an essential quality of aesthetic contemplation. Contemplation has even been defined by it. "The word 'contemplation', " Osborne writes, "has been used to express this kind of disinterested engrossment which is central to aesthetic commerce with this environment." According to Osborne, the original meaning of this concept's use in aesthetic discourse is to be found in the philosophical and theological

controversies of seventeenth-century England and France. Against Thomas Hobbes's "intelligent egoism," Lord Shaftesbury and the other Cambridge Platonists maintained that virtue and goodness must be pursued for their own sake and not from "enlightened self-interest." In the controversies between Jansenists and Jesuits, the notion of "disinterested" love of God emerged: to love God for his own sake, and not from hope of heaven or fear of hell.[8] Clearly, for these seventeenth-century philosophers and theologians, to be disinterested meant to be devoid of self-interest.

The same idea is expressed in the tradition of insight meditation by the term *nonattachment*. Contrary to the usual view, there is nothing altruistic in "being attached to." This is obviously so in the case of attachment to things. If I am attached to my Picasso or to my summer house in the Rockies, it is not for their sake but for my sake: for the pleasure, the sense of security, and the prestige these material possessions afford me. Even if I am attached to something I do not own—the Golden Gate Bridge or Botticelli's *Birth of Venus*—it is because these famous works have special significance for me. Attachment to persons is also a gratifying emotion to the subject. When our affectivity toward another is purified from attachment, what remains is a concern for the other's well-being, called 'loving kindness' (the usual translation of the Pāli word *mettā*) and 'compassion' (*karunā*) in the Buddhist tradition.

In the Western philosophical tradition of aesthetics, as well as in the Buddhist tradition of meditation, ego is considered an obstacle to contemplation. The beholder should be disinterested, that is, not self-interested, and the meditator should be nonattached, that is, not self-attached. In the dialectic of contemplation, selflessness is a condition of the contemplative mode of consciousness and at the same time a consequence of it. Selflessness makes contemplation possible and thus is reinforced by contemplation.

In meditation, "one gradually shifts to detachment. Clinging to ego, things, and others begins to be experienced as childish" is what I wrote on the thirtieth day of the Sri Lanka retreat mentioned earlier. And two days later: "Detachment is not indifference. The concern for others (*mettā*) remains, but it is no longer possessive, as are all the worldly loves, even the mother and child one. Once again, love without possessiveness is possible only for those who have experienced the ego as an illusion."[9]

In the aesthetic vision, the reduction of self-interest is, again, parallel to what happens in meditation, but not as radical. It is the experience of ego's noninvolvement in the object's symbolic meaning.

From aesthetic vision and meditation, we inferred a specific mode of consciousness, contemplation; it is also manifested in other insight-oriented processes. The contemplative mode of consciousness cannot be reduced to cognition; neither can it be reduced to affectivity. In the preceding chapter, the differences between contemplation and cognition were analyzed; in the present chapter, contemplation was shown to be deeply different from affectivity.

In order to grasp the originality of aesthetic phenomena, it was necessary to bring to light their rooting in contemplation. Rarely, if ever, do phenomena studied by anthropologists require such an extended clarification. This is due, partly at least, because the distinctive character of the contemplative mental mode is not clearly recognized in the common Western construction of the human psyche. Intellectuality and affectivity, volition and action are easily distinguishable concepts in our ordinary communication. Contemplation is not. Yet contemplation is what confers on aesthetic objects their unique function, and fascination, in our lives.

The Aesthetic Object as Cultural

CHAPTER FIFTEEN

The Cultural Component in Aesthetic Objects

IT IS AN "OBSERVED FACT," WROTE ANTHROPOLOGIST CLYDE KLUCKHOHN AND PSYCHOLO-gist Henry Murray, "that everyman is like all other men, like some other men, like no other man."[1] In this succinct sentence, they intended to establish a framework in which to categorize personality determinants. We may use the same framework for distinguishing in any behavior and in any artifact a human, a cultural, and a singular component. This distinction is, of course, purely intellectual. One cannot sensorially apprehend the components as different aspects, nor physically separate them. Yet this distinction is a useful tool of analysis.

Having recognized the components, exclusive attention can be paid to one of them, granting it priority over the others. Thus far we have related aesthetic experience and aesthetic quality to the human component. The contemplative mode of consciousness was indeed interpreted as a function of the neurophysiological system common to all human organisms; the symbolic meanings of aesthetic objects were perceived as ground-ed in the common experience of the human predicament; and the ultimate value of order was considered to be rooted in an unconscious layer of our psyche.

The cultural component is also important in the analysis of the aesthetic experience. Yet two positions that practically ignore the relevance of culture in aesthetic creations have been important in Western thought.

In the Western tradition since Greek antiquity, an enduring intellectual trend has stated in various ways, that great art arises from a world different from the visible and tangible one in which we live, and that it reveals this ideal world or at least gives a glimpse of it. This trend is usually referred to as Platonism, though many of its variations are different from Plato's original doctrine. *Metaphysical idealism* is a better designation, as the artist is said to find inspiration in ideas rather than in visual forms, and because ideas are construed as ontological rather than as purely mental.[2]

Attributed to Calamis. *Zeus of Artemision.*
c. 460 B.C. National Museum, Athens. Photo by
Boissonas.

Let us start this brief discussion of the metaphysical idealist trend by alluding to Plato's famous myth of the cave. Prisoners are chained in a cave facing the back wall. Behind them is a fire; between them and the fire, people walk in procession. The prisoners, who cannot move or look behind them, just see moving shadows cast on the wall in front of them. As they never see the procession, they take the shadows to be actual people.

What is known through our senses—the multiplicity of people, animals, and things around us—is also a procession of shadows projected by eternal and unchanging Ideas. An Idea is like an independently existing essence—we would say a prototype—of which we see only imperfect replicas in nature. There is the Idea of Tree, and numberless trees. It should be added that, for Plato, Ideas can be apprehended only by reason, thus they could hardly serve as visual models for a painter or a sculptor. However, for the Neoplatonist Plotinus, who lived eight centuries after Plato, great artists have some intuitive perception of Ideas that they can render in their works. For instance, beholders of the *Zeus* by Calamis are made better aware of the Idea of Man at the peak of his maturity through this sculpture than by looking at actual handsome men.

The conception that art reveals some ideal realm beyond the appearances of the phenomenal world has persisted through some medieval and Renaissance philosophical trends to the works of Schopenhauer in the nineteenth century and the essays of Wassily Kandinsky in the twentieth century. At the popular level, metaphysical idealism has

Head of the Buddha. Gandhāra, Pakistan. 4th
century. Victoria and Albert Museum, London.

been translated in the vague and widespread belief that artists have some uncanny
understanding of mind and nature. Not unlike seers, they have access to what is behind
the ordinary and the tangible, and through their art, they have the power to share with us
some of their insights.

Eternal Ideas and ultimate reality, the noumenal beyond what senses can perceive,
are conceived of as transcendental and absolute. Thus they are not dependent upon a
particular culture. Because Ideas are metaphysical, self-sufficient, and immutable, they
are not submitted to cultural variability. And because great art is a partial reflection of the
ideal world, it is also free from cultural limitations. It is to be assessed relative to that
world, not to ephemeral cultural values. Thus it does not include a cultural component.

Art's freedom from cultural determinants is an illusion. Examples of art works
manifesting eternal Ideas are usually looked for in the classical Greek statuary of the fifth
century B.C. and in the sculptures of the neoclassicism of the seventeenth and eighteenth
centuries in Europe. It is about these human representations that the words *beauty,
sublimity, nobility, and idealization* are profusely repeated. Even if we take into considera-
tion all the aesthetic objects distantly inspired by the classical Greek model—for instance,
the Buddha statues of the Indian style of Gandhāra from the second to the fourth century
of the Christian era—this classical production is manifestly culture-bound. It is not closer
to the eternal Idea of the human figure than are the "conceptual" representations of men

and women by, for example, the Egyptian or the Dogon, the Cubists or the pop artists, and Moore or Giacometti. If there was an archetype or an eternal Idea of the human body somewhere in the collective unconscious or the conscious mind, there would be at least some convergence in its visual figurations. Obviously, this is not the case.

Metaphysical idealism also denies the relevance of the singular and the human components. The model's singularity and the artist's idiosyncrasies should not influence the aesthetic object, as its value only depends upon being an undistorted reflection of the Idea. For the same reason, the human component—the common neurophysiology and the common existential experience—is irrelevant in the perspective of metaphysical idealism. It is believed that Ideas, as objects, entirely dominate the subject; that artists and, through artists, beholders are passive spectators of the epiphanies of another world; and that this other world would manifest itself even without spectators.

Such transcendentalism, implicit in the idealistic approach to art objects, is alien to the intellectual reality built in this century. Yet sometimes it still lingers in our minds in the attenuated form of a belief that creation, appreciation, and experience of aesthetic objects would mysteriously escape any cultural influence. Or, as in a recurrent dream, we fantasize a world of shining and self-existing entities to which art would be bridge and gate. But, when sobered, we recognize that the cultural component is as present in art as in any other human activity and production.

Romanticism is the other intellectual trend that minimizes the cultural component in art. It does so by emphasizing the singular component.

During the dominance of romanticism on the intellectual and artistic scene—in the second half of the eighteenth century and the first half of the nineteenth century—a main tenet of this reaction against classicism and its universal rationality was that art expressed the uniqueness of an exceptional individual, a genius. A genius was not learning and slowly progressing; he was inspired, even compelled to create out of an inner necessity stemming from his own singularity. The social milieu, recognized as the main determinant in the ordinary lives of ordinary people, was a hindrance against which artists should rebel if they wanted to be great. Their genuineness and spontaneity should not be inhibited by social constraints. Artists were not thought to be inspired by a god, a daemon, or a muse (though these were commonly used metaphors) but by a force unique to each of them. How romantics conceived of the nature of this uniqueness does not matter for our present discussion; what is of interest to us is that this inner voice was considered as independent from society. It was, as we would say, culture-free.

Today these romantic conceptions are no longer held by art historians and aestheticians. Yet they still influence the aesthetic discourse. In critical assessments originality and self-expression are given high marks. They also influence the popular stereotypes; for instance, artists are expected to be "different," "marginal," or "bohemian."

Certainly, every individual is unique as a creator and as a beholder in the aesthetic field, just as every person is unique in other fields of human endeavor. This singularity is rooted in the particular genetic heritage of each individual. As life unfolds, singularity extends, because cumulative experience slowly shapes each of us differently—indeed, no two life histories are alike. But the singular component is as limited in the aesthetic field as it is in other fields.

The phenomenon of style in the visual arts makes this clear. Style is a constant configuration of forms which can be visually perceived in a set of objects. There is a

Abbey of Saint-Martin-du-Canigou. Pyrénées
Orientales, France. 11th century. Photo by J.
Dieuzaide, from Zodiaque, France.

Church of Chapaize. Saône-et-Loire, France.
Photo: Zodiaque, France.

Bodisattva Avalokiteśvara. East India. 12th
century. British Museum, London.

collective style made of patterns common to the artifacts of a school of painters, a group of wood-carvers in the same tribal society at the same period, or a guild of stonecutters and masons building churches in a vast regional area. And there is an individual style when a constant configuration of forms may be discovered in all, or most, of the art works created during one person's career.

When visiting the ancient towns of Western Europe, one can readily perceive collective styles in architecture. Beholders, at first sight, discern the characteristics of the Romanesque style—semicircular arches, barrel vaults, thick walls, and massive towers—in several churches. In other ones, they easily spot the Gothic configuration— pointed arches, rib vaults, flying buttresses, high naves, and tall towers. Recognizing the styles was a game I played with my parents when, as a child, I traveled with them. In a museum, it is not necessary to identify a particular painting by its title, author, and date before classifying it as Impressionist or Cubist. Nor do we have to read labels to state that a mask is Baule or Senufo, or that a statue of Avalokiteśvara is Indian or Japanese.

If a hitherto unknown visual object is discovered, where and when it was made can usually be determined by its style alone. Style is the first criterion used by archaeologists and art historians when they have to solve a question of origin. Suppose the Braque *Portuguese* was discovered today without any identification, say, in a New York City basement. Art historians and connoisseurs would have no difficulty attributing it to the Cubist school and determining that it was painted in Paris between 1905 and 1915. This attribution, based exclusively on stylistic evidence, would be unquestionable. Only the matter of authenticity—Is it a fake?—would remain open; it would be investigated by means other than a stylistic study, for example by chemical and radiographic analyses. If the object reflected only, or even mainly, the originality of an unknown genius, it would be impossible to situate it in the culture of a group, a trend, or a period. A collective style embodies the cultural component of an aesthetic object.

Individual styles also exist. The individual style of a painter may be so evident that another skillful painter may imitate it and create "originals" in the style of the first painter. In 1937, a hitherto unknown painting was offered to the Boymans Museum in Rotterdam. Experts attributed it to Jan Vermeer (1632–75), and one of them stated that it was the Vermeer masterpiece. The museum bought it. In 1945, after two other recently discovered Vermeers had been bought, one by the Royal Museum of Amsterdam and the other by Field Marshal Göring, an obscure painter named Van Meegeren was arrested for having sold a national treasure, a Vermeer, to the enemy during wartime. As a defense, Van Meegeren claimed to have sold only a fake Vermeer he had painted himself, like the other ones bought by the Dutch museums. To convince the court, he had to paint, under controlled conditions, still another Vermeer.

This story proves that individual styles indeed exist. If new paintings can be successfully made in the style of Vermeer and even sold as original Vermeers, then they certainly embody the Vermeer configuration of forms. But even in such an extreme case, the individual style is based on a more extended collective style, the seventeenth-century Dutch genre painting of scenes from daily life. More precisely, the Vermeer genre pictures are painted in the collective style of the Utrecht Caravaggisti, "painters who went to Rome in the first decade of the seventeenth century and were influenced by the technical methods of Caravaggio."[3] The indoor scenes were situated in a space of shallow depth and were rendered in warm hues with highlights on some items such as rich pieces of cloth. The Vermeer style is a particular approach to the broader collective

JAN VERMEER. *Woman Reading a Letter.* c. 1662–64.
Rijksmuseum, Amsterdam.

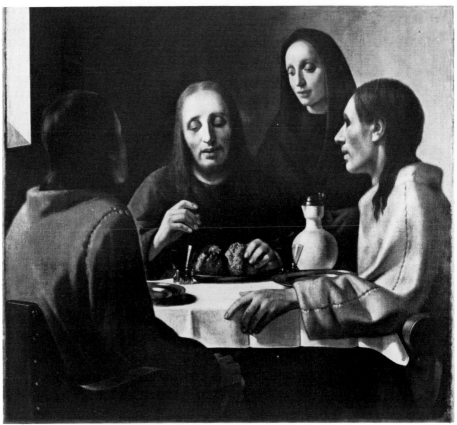

HAN VAN MEEGEREN. *Disciples at Emmaüs.* c. 1936.
Archives Centrales Iconographiques. © A.C.L.,
Brussels.

style of a school of seventeenth-century Dutch genre painting. An individual style belongs to the collective style just as a musical variation belongs to the theme: it is a modification and limitation of the theme.

By granting paramount importance to the artist's singularity in the creative process, romanticism denies, or at least ignores, the significance of culture in aesthetic objects. This is misleading. Style, as a collective configuration of forms, provides the framework in which artists develop their own individual approaches. The singular component of an aesthetic object is, as it were, encompassed in the cultural component.

Unlike metaphysical idealism and romanticism, the anthropological view expressed by Kluckhohn and Murray is comprehensive and balanced. The paradigm of the three components can be usefully applied to aesthetic phenomena.

"Like all other men," every human goes through a birth-to-death cycle. All of us need to eat and sleep every day. We are male or female and reproduce sexually. The long period of maturation our offspring require necessitates some sort of a social organization. This human component is metacultural, based on commonalities among all men and women: specific neurophysiological organisms, similar societal requirements, identical active sets of cognitive, affective, and contemplative responses to the earth environment. The aspects of behavior and production that can be logically related to these commonalities are not culture-bound. For that reason, they make a direct understanding across cultural boundaries possible. A traditional African carving symbolizing sex or death, joy or fear, friendship or hierarchy may be directly apprehended by non-African beholders as standing for these ideas.

"Like some other men"—men who belong to the same society, the same class, or the same group—we eat only the foods that the other members of our society, class, or group eat. We speak the language they speak, we marry according to the same rules, we believe in the same gods and worship them in the same temples. The cultural component refers to that part of our behavior that is similar in all the members of the society in which we have been born or in which we live and to that part of the artifacts that is similar in the artifacts made in the same society. Aesthetic styles are rooted in the cultural component, which may be a societal culture—associated with a nation (the Japanese style) or a traditional kingdom (the Benin style)—or a class culture (the proletarian style), or an institutional culture (the Jesuit or Bauhaus style).

Compared to the whole range of possibilities defined by the human component, the cultural range is limited. It may be understood as the result of a process of exclusion. Among all the foods that we could physiologically assimilate, among all the languages that we could speak, among all the world views that make sense, among all the configurations of forms that may be used to represent the human figure, only a few—sometimes only a single one—are offered by a culture to its bearers. In the year 1875, French people certainly had a large culinary selection from which to choose but it did not include borscht, chop suey, or tempura; they could speak only French as the language of everyday communication; they could adhere to a Christian, a rationalist, or, for some, a Judaic world view, but not to an Islamic, a Hindu, or a Taoist one; and French painters could be academic or Impressionist. In this perspective, the cultural component may be construed as obtained by excluding some of the possibilities in the human spectrum.

"Like no other man" in our culture, each of us speaks the common cultural language. Each of us plies the trade learned with other apprentices and creates forms by using the

repertory of a culturally accepted style in a unique manner. Some aspects of our actions, procedures, and results receive our singular marks better than others. The individual accent of a speaker is easily noticed and immediately recognized whereas the singular manner in which each of us writes is not as perceptible. The more complex the result of an endeavor, the clearer are the clues of the actor's uniqueness. Singularity may be more in the relationships between the elements than in the elements themselves. It is analogous to the uniqueness of each human face: each feature may be found identical in another face, but not the total configuration of all of them.

As the cultural is included in the human, so the singular is included in the cultural. Human, cultural, and singular are related to each other as Russian dolls, by inclusion. This also entails, in most cases, a process of restriction. Regarding the foods available in my society, I express my uniqueness by preferring some and abstaining from others and rarely by inventing a new recipe. Similarly, I dress in a unique manner by choosing a few items among those considered appropriate in our society at a certain time and rarely by designing an original outfit or by having one designed for my exclusive use.

During the nineteenth and twentieth centuries, international communication networks of ideas, artifacts, and people have considerably increased the range of what each industrial society makes available to its members. The result is that there is more from which to choose. But the individual difference is still achieved by decreasing the range of what is available. In the field of visual forms, our information has become encyclopedic and the range of acceptable styles has increased considerably. In the past, even in the great traditions, a single style was usually dominant in one or several societies during a certain period. Creators of forms, and their audiences, were limited to variations within the framework of a dominant style.

Among the three components are also relations of logical priority. Logically, the human component is first: one can posit a concept of human being as such, without cultural and idiosyncratic determinations, and reason about this abstract human being. This is what philosophers usually do. One cannot posit a purely cultural being who would not also be human. The same is true for the unique configuration of particularities: they have to be predicated upon a being who is both human and cultural. The singular styles of Picasso and Braque in the years around 1910 can only be contrasted as variations of Cubism, the cultural style they both used.

Perhaps anthropologists have not "discovered" culture, but they have certainly put it at the center of their constructions of reality. This focus on culture is expressed in their approach to any phenomenon they study: they consider it as cultural and focus their analyses on its cultural component. As in concrete personalities, behaviors, and things, anthropologists cannot disentangle one component from the remaining two and consider each separately. For them, emphasis on the cultural means awareness of it, and not exclusive attention to it.

This awareness of the cultural provides, in fact, the best perspective for elucidating, as much as possible, the interplay among the three components. The cultural dimension is, as it were, more extended and more significant than the singular one. The way female and male students are dressed on campus differs from the way women and men of the same age are dressed in business offices, and within each population individual differences are noticeable. But the latter, the intragroup differences, are less striking than the intergroup ones. If this impressionistic observation is correct, the cultural factor is in this

case more significant than the singular dimension. Similar observations can be made in the aesthetic field. There are more architectural similarities among the Romanesque churches built in central France during the twelfth century than there are between those Romanesque churches and the Gothic cathedrals of northern France erected at about the same time. Andy Warhol's work is certainly idiosyncratic, yet it forcefully reflects—and is explained by—the artistic and literary milieu of New York City in the sixties.

The human component is more fundamental than the cultural component. Yet universal needs are collectively met by a variety of cultural objects. Through their well-integrated forms, the Parthenon, the Taj Mahal, and Notre Dame induce aesthetic contemplation. But this conclusion is only a first step. We also want to know how the different styles of these three masterpieces affect and color visual experiences. The cultural is the domain of variety and multiplicity, the domain of the visible, whereas the human is its uniform foundation. It is with the cultural that visual commerce is established.

Encounters between cultural objects and singular beholders generate aesthetic experience rooted in a mode of consciousness common to all humans. Focusing our attention on the cultural component, in the anthropological manner, is the most promising approach at this stage of our study.

CHAPTER SIXTEEN

The Aesthetic Segment of a Culture

FOCUSING OUR ATTENTION ON THE CULTURAL COMPONENT OF AN AESTHETIC OBJECT IS not easy. Though conceptually the three components are clearly distinguished, in concrete objects they cannot be separated. So, instead of taking the arduous path of artifact analysis, we shall consider aesthetic objects in their cultural context. The best way to apprehend the cultural component in an object is to replace it in the concrete culture in which it is a living presence.

The cultural context is where the artifact is functioning as an item having an aesthetic relevance. Most often, it is the culture of the society where the object was made, but it may also be where the object has been assimilated as "good to look at."

The cultural contexts in which we locate aesthetic objects are, in the contemporary period, national cultures. In today's world, a nation is the broadest and most meaningful society for each of us. A national state gives its citizens their essential identity through a passport; it sanctions the use of an official language; and it regulates schools and courts of law, marriage and inheritance, professions and business. It is within the national framework that we find the essentials needed during our life cycle. For that reason, it may be called a total society. At other times, a cluster of hunters' bands, a tribe, a traditional kingdom, or a city-state constituted a total society for its members.

A total society is perceived, by those who live in it, as extending beyond the individual lives of its members. It was there before I was born, and it will be there after I die. And indeed, it generally encompasses many generations. To be born in a total society is to become heir to a collective property, moral and material. The societal culture is this vast heritage that every member of the society will slowly appropriate during an entire lifetime.

Aesthetic objects, and art objects where they are recognized as such, are included in these societal heritages. But what niche should observers assign to them when they analyze such a complex and diversified heritage? This is not an easy task, as a culture encompasses houses, castles, and roads built by preceding generations; philosophical doctrines, codes of ethics, and sciences elaborated or adopted by the members of the society; as well as specific forms of government, kinship, production of commodities, and economic transaction.

179

To bring some order to anthropological analyses of these congeries of cultural elements, several anthropologists divide societal cultures into three levels. Cornelius Osgood was among the first anthropologists who did so. In his studies of the Ingalik culture, Osgood treated in three separate volumes their material culture, social culture, and mental culture.[1] Independently, but less explicitly, I have used a similar ordering in my fieldwork in Rwanda and in my studies on the networks of power and the types of civilizations of sub-Saharan Africa.[2] There are other ways to arrange cultural items for descriptive and analytical purposes. But, as the three-layer model has proved to be satisfactory in other studies, we shall use it in the aesthetic field. The three levels are, in my formulation, the productive, the societal, and the ideational.[3]

Forms organized in a visual order are what make an artifact aesthetic. Formal organizations belong to the ideational level. Like a language, a science, a philosophy, a system of beliefs, or a body of laws, a style constitutes an ideational configuration. The word *configuration* suggests the integration of elements in a system, and the word *ideational* indicates that the elements of these systems are ideas, not relations between people and not material resources. A visual aesthetic object is a focus around which different sorts of human relations are woven, and it is, of course, a material thing. But what makes it aesthetic is its ability to sustain aesthetic contemplation, and that depends upon the configuration of visual forms.

The other ideational configurations also have productive and societal dimensions, but what is specific to them is that they are systems of ideas. What matters in a language are the meanings, not the sounds or the printed words—though they are indispensable supports for meanings. What matters in a book of philosophy or science is not the materiality of the book but its stimulation of a cognitive response in a prepared mind—though without the book, there would be no cognition. Analogously, though the material artifact is the necessary support, what matters is the form that stimulates an aesthetic response.

Aesthetic configurations primarily belong to the ideational level, but not exclusively. They are also significantly present on the other two levels.

Like other artifacts, aesthetic objects must be materially produced. Thus they also belong to the productive level of a culture. The system of production of a society is concerned with the raw materials and the potential energy contained in the societal environment, and with the productive processes. The latter should be applied to the transformation of the environmental resources into commodities necessary for the survival and development of the total society. The systems of production of a society are on the border line between nature (the environment) and culture (the techniques). Aesthetic objects, and art works where they exist, are submitted to the same production process as other items produced in the society. The stuff from which they are made comes from the same environmental resources, and the techniques used to make them are similar to those employed for other artifacts. The traditional masks of Africa were made out of the soft wood found in the forests around the villages; the same timber was used for carving bowls, plates, spoons, and sticks, and the same tools were handled by the same craftsmen. Calder's metal sculptures were welded according to usual shipyard techniques. Gods and goddesses of Greece were carved in marble extracted from the quarries that provided the slabs used for building temples and marketplaces.

Around aesthetic objects, networks of relationships involving members of the total

society have developed, and some have been formalized in institutions as impressive as the Metropolitan Museum of Art, in New York City; the Musée du Louvre, in Paris; the British Museum, in London; and the Hermitage, in Leningrad. Earlier in this book we discussed how, in contemporary capitalist societies, art galleries channel transactions from artist to customer, be the customer a corporation, museum, or private individual. Art magazines communicate information throughout the art constituency and the society at large, comment on recent works, review and criticize current exhibits, build and debunk reputations, and by doing so increase or diminish the market value of some artists' works. In socialist countries, analogous mechanisms seem to operate under the impulse of political patronage, the equivalent of our profit incentive. And in each society of the industrial world, be it capitalist or collectivist, art schools and university art departments teach the skills necessary for painting and drawing, designing and making graphics, carving and engraving. Art supply stores sell brushes and chisels, paints and easels, paper and crayons.

Aesthetic objects are present in each of the three large horizontal divisions of a culture: systems of production, societal networks, and ideational configurations. The word *horizontal* may surprise: the model we discuss is not in space but in the mind, where there are no verticals and horizontals. This is certainly true, but the term *layers* as previously used suggests horizontal and superposed divisions. The cake metaphor helps us to visualize the productive layer as the basis of a societal culture. A total society—a permanent group of people whose individual and collective needs are met within the group—must first provide its members with food and shelter if the group is to survive. This is why the systems of production are first and basic and thus are visualized at the bottom. Immediately above are the societal networks. Possessing techniques appropriate to extract food from the environment and to provide shelter is not sufficient: the group must organize the way decisions are made, conflicts are settled, and commodities are distributed. Ideational configurations are appropriately the top layer of the construct.

In locating aesthetic phenomena in a culture, we must start at the top layer. A material object is aesthetic because of its configuration of visual forms; the aesthetic specificity is ideational. It is at this level that we should assign, say, "Gothic style," "Tyiwara headdress," and "Rothko's rectangles." Under these configurations, in the middle layer of societal networks, we should note "guilds of master builders," "Bambara initiation association," and "New York School abstracts"—of course these brief notations do not represent an analysis.

Under the societal institutions associated with a certain configuration of forms, one should note, on the lower level, how the object is produced. For example, the techniques used to insure solidity to slender Gothic vaults and to large rose windows; the tools used by Bambara carvers when making antelope headdresses; the technique of applying acrylic to paper or canvas and the resulting floating quality of Rothko's rectangles.

Suppose we distribute the items of twelfth-century French culture on a three-layer diagram. If we enclose "Gothic style," "guilds of master builders," and "architectural techniques for building cathedrals" by drawing a vertical line cutting across the three horizontal divisions of the diagram, we circumscribe the aesthetic segment of the French culture of that time.

The aesthetic segment of a culture gathers in a single conceptual unit all the elements related to designing, financing, making, distributing, changing, and improving aesthetic objects. A diagrammatic presentation makes visually clear that the aesthetic encounter between a receptive beholder and an art object is deeply rooted in the culture of a particular society. Considering configurations of forms apart from the rest of the aesthetic segment of a culture has been a point of view often adopted in the past by art historians. Such an approach certainly concentrates on the essential, but it neglects important explanations of the essential. For instance, change in style or conservatism in forms may be due to fluctuations in production techniques or in the power structure of the professional establishment. Such change should not be explained by purely aesthetic considerations.

The somewhat elusive cultural component discussed in the preceding chapter is made more concrete and perceptible when it is related to the aesthetic segment. The cultural component of an art work is its internal reflection of the cultural context. The aesthetic segment is that part of the context which is closest to the object. The whole context—and not only the aesthetic segment—impinges upon the object. But, by its proximity, the aesthetic segment has the strongest influence on the configuration of forms.

In chapter 7, the concept of *aesthetic locus* was introduced. Does *aesthetic segment* add anything to it? It does. Aesthetic locus remains at the ideational level of the configurations of forms, whereas aesthetic segment encompasses everything that is related to the societal and technical determinants of the object.

But a conceptual distinction, however neat it may be, is not a sufficient reason for introducing a new intellectual tool. It must be useful for analysis. Aesthetic segment and aesthetic locus are, in fact, complementary. They are both needed for identifying aesthetic artifacts. This is true even in societies which, like our own, possess the category of "art" in their language.

In contemporary industrial societies, art objects—exclusively made or selected to be looked at—provide observers with sets of artifacts considered by the members of the group as displaying a high aesthetic quality. In the nineteenth century, the fine arts of drawing and painting, sculpture and architecture clearly indicated where aesthetic forms were to be found. Because pictures, statues, and edifices were made by specialists, it was easy to discern the limits of the aesthetic segment in social organizations and in production systems on the basis of the social category of "art objects." However, the aesthetic locus included more than art objects in the nineteenth century; it includes much more in the twentieth century.

The concept of aesthetic locus—which, as defined earlier, denotes the categories of objects in which aesthetic expectations and performances are concentrated—may help us to identify these classes of objects which are not "fine arts" but for which aesthetic expectations are high, for instance, the field of industrial design applied to household appliances, to office furniture, and to automobiles.

In cultures that have not evolved the concept of art there is, however, an aesthetic locus. And it is essential to determine it in order to delineate the aesthetic segment. It is as if the members of such a society had agreed to localize their concern for visual composition and expressive power in the forms of certain classes of objects. We mentioned earlier

the masks in several traditional societies of Africa, the paraphernalia of Christian ritual in the European Middle Ages, and the facial makeup of some nomads of West Africa.

Aesthetic loci may not be immediately identifiable to outside observers. A certain familiarity with the culture is necessary. One should listen to what people say about objects they make or acquire. One should look for noninstrumental forms as they may point to an aesthetic locus. When the members of the group pay attention to non-instrumental forms in certain objects, when these forms dominate the design or the surface of artifacts, when "designers" or "decorators" have a higher status than ordinary craftsmen, then an aesthetic locus is suggested.

Aesthetic diffusion would be the alternative to aesthetic locus. In that case, the aesthetic quality would be diffused more or less equally in all artifacts of a society. This is a logical possibility, but it does not seem that it exists or has ever existed. Even in a society permeated by a vigorous aesthetic concern, like traditional Japan, there were areas in which aesthetic creativity and appreciation were centered. Thus there were aesthetic loci and aesthetic segments.

The next three chapters will illustrate some of the relationships among the items located within the aesthetic segment as well as relationships between the aesthetic segment—more precisely, some parts of it—and the rest of the culture. It is important to consider how material, societal, and ideational elements of a culture both condition the configurations of forms and are conditioned by those configurations. We should also consider whether there are relationships of consistency between visual forms and other phenomena.

General statements such as "art is the mirror of society" or "art is part of the superstructure" do not help much in explaining the complex interplay of influences and equivalences, causes and effects, antecedents and consequents. Each relationship should be concretely observed and described in its particularity. Later, patterns will perhaps emerge. Even in aesthetic and symbolic matters, anthropology is an empirical discipline in the sense that it primarily relies on observation.

Above left, carving a shield from a tree trunk. *Above right,* carving almost completed. Rwanda. 1955. Photos by Jacques Maquet.

Below left, woman pounding in a mortar; figurine carved in one piece of wood. Lwena, Zaire. Royal Museum of Central Africa, Section of Ethnography, Tervuren, Belgium. Photo by Jacques Maquet. *Below center,* lineage ancestor figurine. Bembe, Zaire.

Royal Museum of Central Africa, Section of Ethnography, Tervuren, Belgium.
Below right, Kongo figurine carved in soft stone *(mintadi).* Angola. Royal Museum of Central Africa, Section of Ethnography, Tervuren, Belgium.

CHAPTER SEVENTEEN

Techniques of Production and Aesthetic Forms

HANDCRAFTED OR MANUFACTURED ITEMS ARE PRODUCED IN A PARTICULAR SOCIETY FROM raw materials available to the members of that society. Materials found in the physical environment of a society, on its territory, are preferred to imported ones, particularly when and where means of transportation are not developed. Imported raw materials are also used, and sometimes extensively—as, for instance, in the European countries that had colonial empires during the nineteenth and twentieth centuries. Few societies have ever been limited to working and transforming only what was available on their territories. Yet regional availability is an important factor. Societies inhabiting an environment lacking in trees usually do not produce wood artifacts.

On the other hand, the mere presence of certain kinds of raw materials does not insure their utilization. The techniques necessary to extract them from the ground and to transform them into commodities may not be offered in the cultural heritage of the group living there. Mineral oil has been in the subsoil of western Asia for thousands and thousands of years but was irrelevant to the societies of the region: they did not have the mechanical equipment to extract it, nor the large sources of energy necessary to operate it, nor the engines to consume that fuel.

It would not be worthwhile to state these truisms if we were fully aware of their consequences within the aesthetic segment. Materials, tools, and techniques of production influence aesthetic forms. Let us see how.

The human figures which were traditionally carved in West and Central Africa are less than life-size. Most of them are ancestors' statues not taller than two or three feet. Yet they convey an impression of importance and monumentality. Formally, they are characterized by frontality and verticality, upward orientation and symmetry of left and right sides.

These forms are well suited to the materials, tools, and carving technique used. The material is a section of a tree trunk or a branch. The tools are adzes, gouges, and knives appropriate for cutting out parts of the original piece of wood. The technique can be called a technique of subtraction: starting from a cylinder of timber, a sculptor removes parts of it and does not add anything to it. The figurine is carved in one piece out of the original cylinder. This suitability of forms to medium, tools, and technique can be better expressed by saying that the tree trunk and the removing procedure "suggest to" or "direct" the carver to make a columnlike shape: straight body, head on the axis, symmetrical arms close to the body.

This influence of the medium on the forms is also illustrated by the contrasting case of the *mintadi*, soft-stone funerary figurines of kingdom of Kongo chiefs. The material used, steatite, can be cut with the same knife used for wood carving. The block of stone from which the figurine is sculpted makes it possible to create a large repertory of shapes. Carvers have taken advantage of this potentiality: many *mintadi* are not symmetrical; for instance, the head may be tilted to one side.[1]

Sections of trunks and branches do not impose certain forms, but they orient carvers toward forms appropriate to their own cylindrical shapes. They do more. They direct carvers toward a certain principle of geometric composition: the contour acts as a rectangular frame standing on its narrow side and suggests vertical carving. This dominance of vertical lines provides the whole composition with a strong integration; and this makes it possible to achieve a high aesthetic quality. Expressivity is also sustained by the composition and suggests a meaning perceived by many beholders: several vertical lines standing on a narrow basis have a towering effect. It is not surprising that the African statues selected to be displayed in our museums stand for monumentality and nobility despite their modest dimensions.

Another stylistic consequence of the medium should be noted. Wood as material is short-lived under African conditions: the extreme climate and the vigorous action of termites cause rapid deterioration. Because of these environmental circumstances, "the average life of a wooden sculpture is between twenty and twenty-five years," according to Denise Paulme's estimate. As a consequence, "no style could ever be fixed by the presence of authoritative models. . . . Thus, every sculptor could give free rein to his inspiration within the limits of fixed canons."[2]

The quantity of available material has affected visual forms. Until the seventeenth century, the copper imported by the kingdom of Benin from the Mediterranean coast of Africa was carried by caravans across the Sahara Desert. Then it came by sea, in larger quantities. This resulted in a change of style in the bronze heads and plaques. As more copper was available to the casters, reliefs and figurines became heavily ornate: "the idealization of faces was replaced by stylization, and ornaments, especially the huge collars, took on a very great importance."[3]

New techniques open new formal possibilities. In the nineteenth century, prefabricated cast-iron beams constituted an important advance in engineering. Some imaginative architects used them to replace wooden and stone supports, the only ones ever used before in building. A new "glass-and-metal" style was born. Huge volumes were enclosed in very light walls. For the Great Exhibition of 1851, Sir Joseph Paxton erected, in Hyde Park, the largest building ever constructed until that time. Dubbed Crystal Palace

Bronze plaque showing an official holding a box.
Benin, Nigeria. Early 17th century. British
Museum, London.

Bronze plaque showing two officials, one carrying
an ivory gong. Benin, Nigeria. Late 17th century.
British Museum, London.

Bronze head. Benin, Nigeria. Late 17th century.
The Nelson-Atkins Museum of Art, Kansas City.
Nelson Fund.

JOSEPH PAXTON. Aerial view of the Crystal Palace. Hyde Park, London. 1851. Photo: Fox.

PAXTON. Interior of the Crystal Palace. Photo: Library of the Royal Institute of British Architects.

EERO SAARINEN. TWA terminal. 1956—62. JFK International Airport, New York. Photo: USIS.

in *Punch*, it was a "completely prefabricated structure based on standard units which were mainly multiples of twenty-four."[4]

Very high open structures were possible for the first time. For another industrial exhibition held in 1889, Gustave Eiffel built a thousand-foot tower in Paris. It was also prefabricated, and was assembled by only 150 men. In 1876 Eiffel had built for the Bon Marché a structure consisting of galleries surrounding a glass-roofed central space that rose the full height of the building. The Bon Marché building became a model on which other department store structures were drawn.[5] By the end of the nineteenth century, the glass-and-metal style was well established and widely spread. The Bradbury Building, designed by George Wyman and erected in Los Angeles in 1893, is an example of this style. The configuration of forms that characterizes it—visible skeleton, slender sup-

GUSTAVE EIFFEL. Eiffel Tower under construction in 1889. Paris. Photo: Delpire.

MORRIS LOUIS. *Alpha-Pi*. 1960. The Metropolitan Museum of Art, New York. Arthur H. Hearn Fund.

KENNETH NOLAND. *Song*. 1958. Collection of the Whitney Museum of American Art, New York.

ports, glass walls, and high-rise structures—has been made possible and has been suggested by a new technique in engineering.

Forms more revolutionary than those realized through glass and iron are achieved by ferroconcrete and prestressed concrete. With these new materials, the architect's freedom of design seems to have become illimited. The light, thin, and resistant slab can be shaped in curved and cantilevered forms that no building ever displayed before. Striking examples of the new forms made possible by prestressed concrete are the Exhibition Hall at La Défense, near Paris, the shelter above the marketplace at Royan, and the TWA terminal at JFK International Airport, New York.

Cast iron and steel in the nineteenth century and reinforced concrete in the twentieth century are dramatic illustrations of the impact of materials and techniques on forms. A less spectacular instance of the same phenomenon is the effect achieved by some painters' use of acrylic coatings. Art historian and critic Edward Lucie-Smith labeled them "post painterly abstractionists." Writing about Morris Louis, one of these abstractionists, Lucie-Smith mentions that "Louis achieved his originality partly through the exploitation of a new material, acrylic paint," and of a new technique, staining the canvas rather than painting on it. "The staining process meant a revulsion against shape, against light and dark, in favor of color."[6] A new chemical, acrylic, and a new technique, staining, made it possible for Morris Louis, Kenneth Noland, Mark Rothko, and others to dye canvas rather than apply pigments on it. This "directed" artists, "suggested" to them giving a paramount importance to color over the other visual forms—line, shape, brightness, or texture. As a consequence, no evocation of space was present. One should remember that space is perceived by beholders in many nonfigurative paintings where oblique lines are found. (See, for instance, Richard Diebenkorn's *Ocean Park* series—which are oils on canvas.)

GEORGE WYMAN. The Bradbury Building.
Los Angeles. 1893. Photo by Jacques Maquet.

RICHARD DIEBENKORN. *Ocean Park No. 94.* 1976.
Artist's collection.

In these illustrations, some features of the productive process of aesthetic objects in a particular society have influenced the forms of those objects. The processes fall into two categories.

First, the absence of some materials or techniques has prevented the emergence of some forms. The organic shapes of the shells in prestressed concrete, which enclose the inner volumes of many contemporary buildings, could not have been realized with the building materials previously used in architecture: wood, stone, bricks, and adhesives like clay or cement. The absence of stonecutting techniques for hard stone has prevented the development of large-scale three-dimensional forms in the savannas and forests of sub-Saharan Africa. This type of negative influence may be called a process of exclusion: the system of production excludes some aesthetic forms.

This process, it should be noted, does not imply its reverse. From the absence of a configuration of forms, one should not conclude that the necessary medium was un-available. Free-flowing forms were absent from the sculptural repertory of most societies of traditional Africa. We know that, in fact, some forms could develop only in the soft-stone medium. Soft stone was widely found in most natural environments of sub-Saharan Africa, and all the societies of the traditional era—from prehistory to the industrial age—had wood-carving tools, also appropriate for soft stone. Yet soft-stone carving remained exceptional in Africa; it does not seem to have been practiced except among the Kissi, the Kongo, and the inhabitants of Esie, a Yoruba village.

A second type of influence could be called a process of conduction: when materials and techniques are conducive to certain forms. To indicate the process, we have used the terms *to suggest, to direct, to orient, to be appropriate,* and *to be suitable.* The cylindrical section of a tree trunk suggests that it should be carved vertically and that straight lines will dominate. Heavy columns and walls are architectural forms particularly suitable to stone. Acrylic directs to give priority to color over other forms. Prestressed concrete is conducive to light shells covering large areas with very few points of support.

The process of conduction is not a relationship of necessity. A large quantity of copper made available to craftsmen will not necessarily result in overornate forms. But it is conducive to them; it makes them probable, not certain. Other influences or obstacles may restrain or destroy the expected consequence. Some carver who has traveled and has seen a technique of sculpturing by addition may adopt it and make disciples; for them, the cylindrical timber will no longer be conducive to elongated vertical shapes.

The process of conduction is what I have called elsewhere a partial conditioning.[7] The conditioned event cannot appear without the conditioning event, but the latter does not necessarily cause the conditioned one to occur. Architectural shells cannot appear without prestressed concrete, but prestressed concrete does not cause architectural shells to occur. In other terms, the building technique is the necessary condition for some form, but is not its sufficient condition.

In cultural matters, we are most often in the soft logic of partial conditioning—'if A, then probably B'. Unfortunately, we cannot often use the hard logic of causality—'if A, then B'.

So far, we have considered the part of production that is within the aesthetic segment; that is the raw materials, tools, and techniques of transformation used to make aesthetic objects. The rest, and the most significant part of the production system of the whole society, also has an impact on the forms.

Funerary figures. Ekoi, Nigeria. Photo: Nigerian Museums.

Particularly important is the relationship between the amount of commodities produced by a unit (be it the whole society or parts of it, such as the extended families) and the amount of commodities that unit consumes. When consumption is equivalent to production, the unit is at a level of subsistence; if the unit consumes more than it produces, the unit is below the subsistence level; and if it consumes less than it produces, it is above the subsistence level. The unit to be considered here is the total society, which may be as small as a tribe comprising a few villages or as large as an industrial state.

In societies with a subsistence production, the process of exclusion can be frequently observed. When there is no surplus, the society cannot afford to have professional craftsmen: persons obtaining an income from selling or exchanging what they make in their specialized occupation. In subsistence societies, there is no purchasing power. This was the situation among the tillers living in the clearings of the equatorial forest of Africa. Carvers were ordinary cultivators, simply more skillful than their neighbors; they did not undergo any training and used simple tools and easy-to-work timber.

These carvers were what we would call amateurs in our society. And this had an impact on the objects they made: the finishing was rough, the work sometimes revealed clumsiness of execution; lines and colors were often bold and vigorous, rarely intricate and shaded; and there were many, apparently unintended, irregularities. These features define what can broadly be called a folk style. In the civilization of the clearings—as we have called the dominant cultural model of the rain forest tillers of Africa—the subsistence level of production excluded the professional expertise needed for creating sophisticated forms and was conducive to a folk style.[8]

When production exceeds consumption, the society is above the subsistence level. Consequently, the range of aesthetic forms is less limited and certain stylistic characteristics are likely to be present. In the savanna state of the Kuba (in today's Zaire), and in the kingdom of Benin (in the south of today's Nigeria), the surplus was concentrated and controlled by the rulers. With it, they could support a retinue of courtiers and servants, advisors and craftsmen. The Kuba sculptors, being kept by the high chiefs, could devote time and energy to the exercise of their vocation. From hard wood, they carved cups

Tusk on head. Benin, Nigeria. Late 17th or 18th century. British Museum, London.

reproducing the features of a human head and made stools, boxes for cosmetics, and headrests. These artifacts were covered with carefully executed geometric or anthropomorphic engravings. A similar intricate ornamentation was woven in, or embroidered on, fabrics of raffia. The above-subsistence standard of the Kuba society resulted in forms characteristic of elite art: abundance, even overabundance, of decorative motifs; professional execution expressed in regularity and finishing; and media requiring specialized techniques.

Benin also was a prosperous state until 1897, the year of the famous British punitive expedition which brought back to London a huge quantity of works in bronze and ivory. These works were plaques representing government and military topics, memorial heads supporting carved tusks, and other objects in brass and ivory. The metal artifacts had been made by casters using the complex lost wax technique on imported copper. Equipment, material, and know-how were beyond the reach of amateurs. Forms, particularly in the flamboyant decadence beginning in the eighteenth century, revealed a concern for realistic representation. Decoration covered the whole surface, and a high standard of execution was evident. There was a predilection for precious materials: ivory and metals. These features were made possible through the rulers' concentration of the society's

resources. As with the Kuba, the probable occurred: forms revealing an elite configuration were created in a society producing a surplus of commodities.

When production does not meet the consumption requirements, the whole social fabric disintegrates. Colin M. Turnbull's dramatic study of the Ik of Uganda suggests that ideational systems are the first to fall apart.[9] Belief systems, ethical codes, and world views are lost in one generation even if the group survives longer. Getting food for oneself becomes the only motivation. Cognitive, affective, and contemplative modes of consciousness seem to be turned off. In societies living at a below-subsistence standard, the process of exclusion is at its maximum. It precludes the creation or appreciation of aesthetic forms.

These few cases, taken from traditional African cultures, illustrate how forms are conditioned by the ratio of consumption to production of the society as a whole. Other processes of production—also outside the aesthetic segment—have an impact on the system of forms. Let us consider the industrial techniques of production. Though not meant to be used for manufacturing aesthetic objects, some nevertheless were adopted for making them, and this had consequences on their forms.

Before the manufacture of series of identical objects by machines, all the artifacts of everyday life—from kitchen utensils to pieces of furniture—were crafted by hand. Each was made independently from the others, was different from the others, was unique. During the preindustrial era, the Western fine arts emerged as a specialized field of activities devoted to making aesthetic objects. Engravers and painters, sculptors and architects naturally used the only known method of making objects, handwork.

After the nineteenth-century switch from craft to industry for the production of everyday artifacts, artists continued to use manual techniques. This persistence was in tune with the romantic ethos dominant at that time. The uniqueness of the object corresponded to the uniqueness of its inspired creator.

In the last few decades, some industrial techniques have been used, still with timidity, in what is recognized in our society as the field of art. Victor Vasarely, the principal originator of the op art school, designed prototypes from which identical "multiples" were reproduced. Prototypes, more similar to architect's plans than to finished paintings, were not originals. Each multiple was an original.[10]

Vasarely designed the prototype; so does an industrial designer. As mentioned in Chapter 11, the concept of design is not new in the arts. In sixteenth-century Florence, Giorgio Vasari considered design to be the common and essential element of the fine arts. Designing is making a plan according to which the elements of the work will be put together when the object is fabricated. During Vasari's time and in the following centuries, artists were designing and handcrafting their works. In industrial production, the two tasks and the two roles are separated: the visual composition is drawn in plan by the artist as designer, and the object is manufactured by the machine according to the plan. This separation does not deprive the finished object of its art quality and originality— after all, architects themselves have never been expected to build the edifices they have designed.

Industrial fabrication does not affect the aesthetic potentialities of objects; they are not disqualified from having an aesthetic value because they are mass-produced. But the technique of production—hand or machine—affects their forms. Handmade objects

VICTOR VASARELY. *Kara.* 1956. © SPADEM,
Paris / VAGA, New York, 1985.

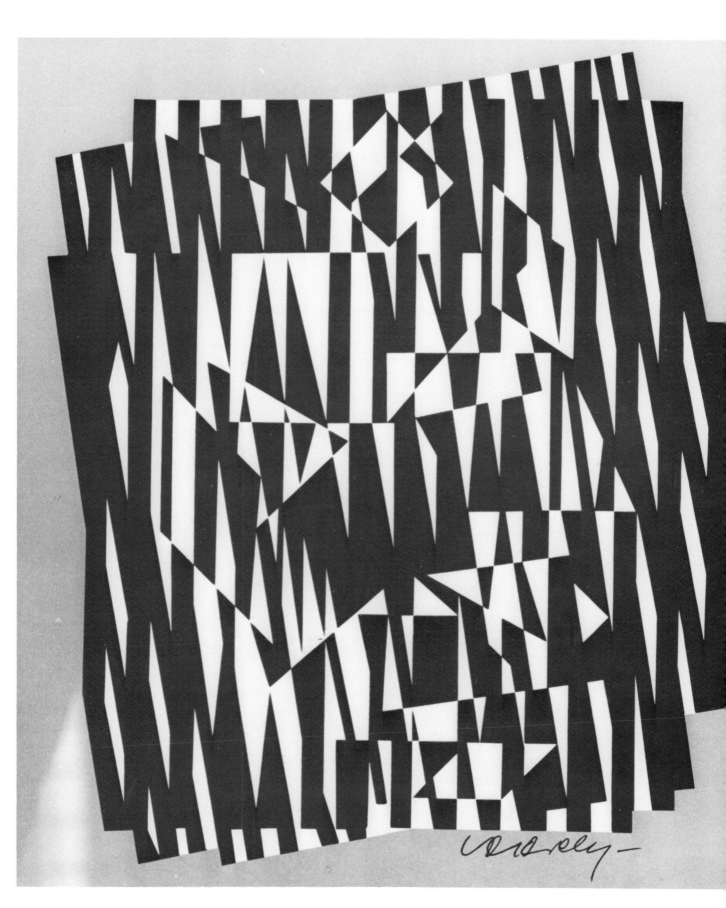

usually fail to achieve sharpness in lines, symmetry in shapes, regularity in textures, and uniformity in hues and brightness to the same degree that machine-processed objects do. This kind of formal perfection conveys meanings to the beholder other than what handmade forms convey.

This is the sense in which it can be said that new techniques of production introduced outside the aesthetic segment may influence the configuration of forms—in the case just discussed, by making them sharper and perfectly regular.

The influence of several aspects of material production on aesthetic forms concretely illustrates what is meant by cultural integration. Changes in the quality or quantity of raw materials or in the type of fabrication techniques have repercussions beyond the context of production in which they occurred. As these repercussions are indirect and distant, they are often unintended or even unexpected. It is only through analysis that these chains of conditions and consequences are brought to light. What has been uncovered suggests that this network of conditioning relationships is all-pervasive: a total culture operates as a system in which all the parts are indirectly interconnected. As an empirical discipline, anthropology attempts to make a detailed analysis of these interrelationships.

Although we have not gone far in this analysis, we have gone far enough to understand that an aesthetic configuration—a style, for instance—is interconnected with the rest of the cultural system; it is not autonomous from it and does not transcend it. This needs to be stated again, because the autonomy of what art historian Henri Focillon has called "the life of the forms" is still lurking in our minds as a half-accepted legacy of the Platonic world of Ideas.[11]

In these analyses, I take cultural materialism as a guiding principle. It is not a philosophic position concerning the ultimate nature of the world; it is simply a useful theory in research and in the construction of reality. The materialist principle in anthropology can be plainly formulated: in a cultural system, production is the primary condition. Why? A culture has an adaptive function; it makes possible the survival and development of a group and its individual members in a certain environment. The first requirement of collective and individual life is to obtain food and materials for shelter from the environment. This is achieved by the process of production implemented by the group, or by the processes of acquisition of hunters and gatherers who do not grow crops or breed cattle.

Post-Darwinian biology integrated evolution into its construction of reality, and post-Freudian psychology included unconscious processes in the commonly accepted models of the human psyche. Similarly, after Marx, considering production as the most significant force in the shaping of society became a part of the common reality of the social sciences. This theoretical assumption, essentially Marxian in origin, has been widely used in anthropology where it is usually known as cultural materialism.[12]

The materialist assumption is evidently appropriate to societies struggling against an adverse environment with rudimentary techniques, and to imaginary groups organizing for survival on an uninhabited island after a shipwreck—groups that social scientists used to posit for the sake of speculation. But, it may be objected, the materialist assumption is not fitting to the contemporary and industrialized world: our productive systems provide food and other commodities in abundance, and our urgent problems are of distribution and repartition, not of production.

This objection should be answered, first, by pointing out that our contemporary world is still a world of scarcity. Many developing nations do not produce enough food and other necessities for their people, and the so-called first world nations compete for natural resources to be transformed into energy. Thus production remains a constraint. A second answer is that the priority of production is not only manifested by the evident necessity of food and shelter; it is also expressed by the more subtle processes of exclusion and conduction analyzed above. The elucidation of these processes, deduced from the cultural materialist premise, contributes to our understanding of how aesthetic forms are integrated in the contemporary industrial societies.

Cultural materialism does not mean more than the concrete processes of influence we can discover in cultural interactions. Exclusion and conduction do not represent a rigid and necessary determinism. The systems of production limit the ideational potentialities that can develop in a culture, and they favor some potentialities which are particularly compatible with them.

CHAPTER EIGHTEEN

Societal Networks and Aesthetic Forms

SOCIETAL NETWORK IS, ADMITTEDLY, SOCIOLOGICAL JARGON. THIS CONCEPT HAS ABOUT THE same connotation as *institution* or *social organization*, but it is more precise. *Societal* is the adjective corresponding to the construct *total society*. In *societal networks*, the adjective reminds us that the networks we are considering are located within national states in the contemporary world, and, in the past, within tribes, kingdoms, city-states, or other groups in which members' activities were complementary in meeting everyone's total range of life concerns.

In everyday life, each of us is involved in many societal relations. We perceive them immediately as subsumed under different categories, as belonging to different networks. I visit with my father, it is a familial relationship; I buy a typewriter, it is a commercial relationship; I discuss a decision with the dean, it is a professional relationship. These interactions result from a continuous participation in different networks. The visit to my father expresses our belonging to the same kinship network, my purchase of the typewriter concretizes the cooperation between the dealer and me in the same economic network, and the discussion with the dean manifests our partnership in the same occupational network.

Networks are few. In a comparative study of some traditional and modern African societies, I distinguished seven of them: kinship, alliance, government, hierarchy, dependence, association, and exchange of goods.[1] Networks are stable and permanent. We perceive them as based on such fundamental interactions between members of the same society that they have been, and will be, there for countless generations. Before my father and me, descent from the same ancestor was recognized and a kinship network was built on it; and so it will be after me and my offspring. Similarly, a long-lasting government network developed from the basic relation of coercion between rulers and subjects; and a durable network of inequality grew from, and amplified, the fundamental relationship of

LUDWIG MIES VAN DER ROHE. Toronto-Dominion Center. Toronto, Canada. 1969. Photo by Bernard Maquet.

social superiority and inferiority. They constitute the commonly accepted grid that makes our relations with others relatively safe and predictable.

In the cultural model I have used, societal networks constitute the second level, above production, and below ideational systems. In this chapter we shall examine the conditioning of aesthetic forms by networks and take heed of any intimation of an influence in the opposite direction, from aesthetic forms to networks.

Within the aesthetic segment of a culture, specialized networks group together the makers of objects that belong to the aesthetic locus of the society. During the European Middle Ages, master builders and craftsmen, stonecutters and masons, cabinetmakers and goldsmiths were organized in guilds and corporations. In their heyday, guilds and corporations were powerful networks. Each was practically in charge of a specialized sector of the economy. Inside, they strictly regulated the work of their members. The number of new admissions was limited, promotion was through seniority and tests, and the established hierarchy could effectively pressure apprentices, companions, and masters. The conservatism built into the structure of guilds and corporations conditioned the formal configurations of the works. In order to succeed within that network, one had to imitate the authoritative models rather than be innovative. The senior masters, who, at the end of their creative careers, judged and assessed the works of the younger craftsmen, were not likely to reward departures from the traditional styles.

When makers of objects relevant to the aesthetic locus ceased to be regarded as craftsmen and became artists, the network situation changed. Artists were those who made artifacts intended for visual use only; they had learned the skills of their discipline, and they practiced it according to the doctrine of a certain group or movement. Like craftsmen, artists had to be technically proficient; in addition, they were expected to adhere to sets of convictions around which loosely organized associations were constituted. Such were the Wanderers and the Nabis, the Fauvists and the Cubists, the painters of Die Brücke and the Neue Sezession.

Though these groups are fluid and short-lived, say, the Abstract Expressionists and the Minimalists, they constitute networks important for esprit de corps and self-identification. And, of course, they influence the aesthetic forms of what is designed or painted, made by collage or assemblage, as the purpose of these movements is to promote some approach or style in aesthetic creations. In fact, this is often so successfully achieved that it is not easy to recognize one Rayonist from another, Goncharova from Larionov, or one Cubist from another, Braque from Picasso.

The training that makers of aesthetic objects must undergo was first provided by the guilds through apprenticeship in the masters' workshops and later by fine arts academies and art schools. These educational networks, confined to the aesthetic segment, went beyond teaching the skills: they promoted certain formal configurations, certain styles. This is still true today. The International Style in architecture, a dominant influence throughout the world from the 1940s to the 1960s, was also known as the Bauhaus style. It had, indeed, its origin in the Bauhaus, a school of architecture and the applied arts, which operated in Germany for only fourteen years, from 1919 to 1933. The style was geometrical, austere, and refined in lines and shapes; it extended, beyond architecture, to industrial design of furniture and mechanical equipment; it became synonymous with *modern*. This is an extreme example of an educational institution's impact on aesthetic

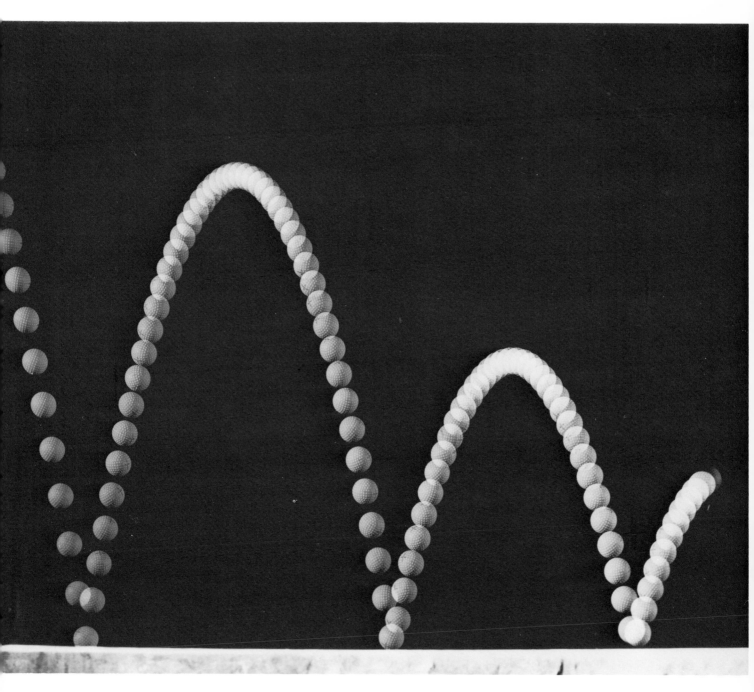

HAROLD E. EDGERTON. Stroboscopic photo of a
bouncing golf ball. 1959. Photo: Dr. Harold E.
Edgerton. Massachusetts Institute of Technology,
Cambridge, Massachusetts.

forms; to a lesser degree, all important art schools influence what their former students design during their careers.

Aesthetic objects are not always produced by professionals. In certain societies, or in certain disciplines, the contribution of amateurs is significant. Are they also organized in networks which condition some formal aspects of their works?

We use the term *amateur* to denote those makers of aesthetic objects whose production does not significantly contribute to their livelihood. The term itself does not suggest a proficiency inferior to professional expertise. Yet professionals often make better works because they have been through a longer training, use more costly and complex equipment, and are frequently in a competitive situation. This is the case in contemporary industrial societies where amateurs and professionals are often engaged in the same pursuits, such as drawing, painting, and photography. There are also societies where aesthetic objects are exclusively produced by amateurs. Societies with a subsistence production cannot afford the luxury of professional craftsmen, and this circumstance is conducive to a folk style.

In affluent societies of the industrial age, photography is predominantly a leisure activity, in terms of the proportion of pictures shot by amateurs. And, though many photographs by amateurs and professionals do not have an aesthetic quality, photography certainly belongs to the aesthetic focus of our time.

Amateur photographers are not grouped together in networks. Some join an association, but such associations rarely constitute strong networks with a clearly defined set of rights and duties supported by positive and negative sanctions. A pastime that does not require long and arduous training and may be taken up and dropped at will does not seem to offer a sufficient basis for a solid network. Yet the loose network constituted by the readership of magazines for amateur photographers has an impact on the forms. Photographs printed in these magazines tend to be imitated. When a new accessory permits achievement of some special effects, these magazines offer models to amateurs. In the mid-fifties, electronic strobes became widely available on the market; they made it possible to freeze high-speed movements. Magazines intended for amateurs published, at the same time, many sharp pictures of falling drops of water, bouncing golf balls, bullets striking targets, and seemingly exploding bottles of milk breaking on a hard floor. A loose network of amateurs was sufficient to add the sharpness of frozen movements to the repertory of aesthetic forms in photography.

The most influential network within the aesthetic segment of contemporary societies is probably the art market. As it is a part of the commercial market of the whole society, art works are thus also regarded as commodities.

They are bought by persons who want to look at them or to make a wise investment in inflationary times or to realize a quick profit from a lucky speculation. Ancient art has a constantly increasing value. Paintings, sculptures, and other artifacts made by established names of the past reach extremely high prices, and a drop in their monetary value is unheard of; the only risk for investors is to buy a forgery.

The value of current art is lower and considerably less stable. It fluctuates according to a combination of elusive factors such as the reputation of the artist, current trends, and relative rareness. Reputation depends on different factors such as participation in collective exhibitions and one-man shows; the purchase of pieces by celebrities, known collectors, and museums; representation by a prestigious gallery; and recognition by critics. When exercised with the vigor and clarity, the perceptiveness and convincing

power of a Clement Greenberg, art criticism may become the most significant factor in making the reputation of an artist. Greenberg is generally considered to have almost single-handedly gained recognition for such New York painters as Jackson Pollock, Barnett Newman, and Mark Rothko, through his essays published in the forties and the fifties.[2]

In the aesthetic segment, current trends express the fashion phenomenon that is so essential to our profit-oriented economic system. Every few years —say, every five years or so—a new aesthetic trend should emerge in order to stimulate sales. Demand for the trendy raises the prices for works belonging to the current movement, whereas prices for out-of-trend art objects remain stationary or even decline. There was less demand for Abstract Expressionist paintings when pop art was in favor.

Also, degree of rareness relates art works as commodities to the laws of supply and demand. When a commodity is scarce, its price goes up. When Picasso died in 1973, the number of Picassos in his estate was so large that if they had been put on the market at the same time, the value of other Picassos would have dropped. Instead, the mass of estate works was kept off the market and the works were slowly released one by one.

Some art galleries in Paris and New York are known to have made huge profits as sole agents for famous painters discovered when the yet-unrecognized artists were still at the beginning of their careers. No wonder gallery owners act as coaches of the painters in their stables and try to make their fame happen. The management of a career for profit is bound to affect the content and form of the works. Gallery owners are likely to advise their artists to produce objects that are salable at profitable prices and thus are in tune with recent trends and other market conditions—like the preference of the majority of buyers for a certain size of canvas or a certain price range.

Market requirements are many and varied. Yet one is predominant, innovation. Change is built into the system as a stimulant for purchasing; thus change for the sake of change is a rational guide for action. The commercial network of art objects favors innovation in aesthetic forms. I do not suggest that the rapid pace of innovation in current art is determined only by market necessities. Yet the latter makes innovation highly desirable.

The medieval guild organization and the current art market illustrate how societal networks, developed within the aesthetic segment, may influence the ideational system of forms. In each case, influence is achieved through pressure exerted on the makers of forms: craftsmen were encouraged to follow traditional models and to avoid being innovative, and contemporary artists are encouraged to change and to find newness. The mechanism of pressure is simple and universal: the stick and the carrot. Innovative craftsmen and conservative artists are punished in material losses and failure to achieve prestige and reputation; conservative craftsmen and innovative artists are rewarded in material gains and reputation.

This conditioning of forms by networks is not of necessity but of conduction. A network characterized by seniority and tradition is not a sufficient condition of conservatism in visual forms—some medieval companions resisted the pressures to conform. Neither is it a necessary condition—stylistic conservatism sometimes has been maintained where there was no rigid network of seniority. But a socially conservative structure is conducive to continuity in forms, and thus makes it probable. Anthropologists, and other social scientists, should not disregard the probable, although the probable is less satisfactory for the mind than the necessary.

MARCEL BREUER. Cesca side chair, manufactured by Thonet Brothers. 1928. Collection, The Museum of Modern Art, New York.

Outside the aesthetic segment, two societal networks are particularly relevant to aesthetic forms, government and hierarchy—also designated as social stratification. Through each of these networks, distinctions are established among the members of a total society. Rulers are separated from subjects through government institutions. Superiors like aristocrats, nobles, or upper-class members are distinguished from inferiors like traders, farmers, or middle- and lower-class members through a hierarchical network.

The two networks are conceptually different, but in concrete societies they partly overlap. Usually, most rulers belong to the superior stratum, only a few to the inferior strata, and many members of the superior stratum are not rulers.[3] Before the revolution of 1789, most of the members of the royal government of France, the rulers, were nobles (the superior layer). Some belonged to the bourgeoisie or third estate (the highest inferior layer); clergy, manual workers, and peasants were the other inferior layers. As the nobility was a relatively large stratum, and the royal government a rather small group, most of the nobles were thus outside the ruling group.

Those at the top of government and social hierarchy networks constitute a minority which has privileged access to the material, technical, and intellectual resources of the whole society. Privileged minorities are more closely associated with the makers of aesthetic objects than are ordinary farmers or middle-class citizens.

Art objects, and artifacts belonging to the aesthetic locus of a society, are always more expensive than purely instrumental objects. Aesthetic forms require superior skills and often better materials and tools; it takes more time to make them. The Cesca side chair designed by Marcel Breuer in 1928, and produced by Knoll International, was

The Abramtsevo church, designed and built on
the Mamontov estate. 1882. Photo from Gray
1971.

considerably more expensive than any ordinary chair; yet most ordinary chairs were just
as good for sitting on. To go beyond instrumentality and to design a chair that is also
good to look at is bound to be more expensive. Drawing an image that is good to look at,
be it a still life or a landscape, a nude or a portrait, necessitates long training and some
talent; the time of a highly skilled person is costly.

These expensive objects are also superfluous. There is certainly an aesthetic need
rooted in the contemplative mode of consciousness. The aesthetic experience is an
essential encounter with the world. But the satisfaction of the aesthetic need may be more
easily postponed, diverted, or counterbalanced than the need for most of the instru-
mental artifacts. For most of us, the need to have a chair to sit on is more urgent
than the need to have a chair to look at.

Only those who are privately affluent or are in a position to spend public or corporate
funds can afford works of art. In traditional Benin, only the *oba* and his courtiers and
officers—that is to say, the rulers—could devote large quantities of expensive imported
copper to the casting of high-relief ornamental plaques. In seventeenth-century France,
only King Louis XIV could assemble the best architects, landscape designers, painters,
sculptors, cabinetmakers, and engineers to build Versailles. In twentieth-century New
York City, only large corporations, public institutions, or the wealthy can commission the
painting of murals such as the ones by Diego Rivera in the Rockefeller Center.

For a long time, privileged minorities were also the leisure classes. They, and particularly their women, were the only groups who had the opportunity to frequently enter into visual commerce with aesthetic quality, to learn the appreciation of forms, to be influenced by artists, and to offer them an understanding and responsive audience.

In the second half of the nineteenth century, the most vital group of Russian artists was the Wanderers. They wanted to bring art to the village people and to revive traditional folk forms. When they were not on country roads, they were living as a colony of artists at Abramtsevo, the estate of Savva Mamontov, a capitalist entrepreneur and railroad builder. Mamontov, a trained singer and a sculptor, and his wife participated in the activities of the Wanderers. Through their financial and moral support, the Mamontovs made it possible for the Wanderers—also known as "Mamontov's circle"—to design, to paint, to carve, and to propagate the revival of traditional Russian folk art.[4]

During the late thirties, art collector Peggy Guggenheim was the discriminating Maecenas of the Surrealists; she financed and directed a London gallery, Guggenheim Jeune, committed to the promotion of this movement. Later, in the forties, she opened the Art of This Century gallery in New York City, where she organized one-man shows for Pollock, Motherwell, Hoffman, Rothko, and others. When she moved to Venice, in the early fifties, her collection was exhibited in several European cities.

The Mamontovs and Peggy Guggenheim were exceptional patrons of the arts, and their action on the aesthetic scene of their times was significant. Patrons less committed and of lesser means also interact with the creators of aesthetic forms. From artists they receive a practical visual education; and to them they make their preferences felt. By selecting the art works they buy, by expressing interest and appreciation for certain kinds of objects, for certain trends, or for certain styles, they determine what will become the aesthetic locus of their cultures.

In thirteenth-century Europe, the high dignitaries of the Christian church—the popes and their Roman court, the bishops of capital dioceses, the abbots of famous monasteries—belonged to the privileged minorities of England, France, Germany, Italy, Spain and other Christian countries. They made religious ritual one center of that century's rich aesthetic locus. In sixteenth-century Japan, the tea ceremony was developed in Zen monasteries and then adopted by the aristocracy. Around it many features developed, and together they constituted an aesthetic locus of the Japanese culture of that time. Again, this was a consequence of the Japanese establishment's influence on aesthetic creation.

Granted, the makers of aesthetic objects were dependent upon the establishment's patronage in medieval Christianity, in the Japan of the Ashikaga period, and in royal France. Are they as much in need of the support of the privileged minorities in the contemporary industrial world? After all, many aesthetic objects are produced or reproduced in large quantities. They are not that expensive.

Thanks to industrial design the aesthetic quality of many mass-produced objects has considerably improved. Certainly, posters and excellent photographic reproductions of paintings are available. Designers and artists who participate in these industrial processes may, indeed, become more independent from the wealthy few. However, just as haute couture sets the trend for the ready-to-wear in fashionable clothes, the original, unique, handmade pieces still dominate the art scene and the art market. Such pieces are expensive and are for those who have reached the top of the power and superiority networks.

NATALIA GONCHAROVA. *Haycutting.* 1910. Artist's collection.

Socialist realism in the Soviet Union offers an exemplary though intriguing illustration of the influence of a societal network, the governmental structure of the U.S.S.R., on the styles of representation in the visual arts. The case is exemplary because political decisions were explicitly and officially stated; it is intriguing because it seems to have developed in a manner that runs counter to Marxian doctrine.

During the first two decades of this century, the Moscow artistic scene was extraordinarily lively, innovative, creative, and aesthetically revolutionary. In 1906, the Blue Rose Group was constituted and the magazine *Golden Fleece* was founded. In close association, the group and the magazine organized four exhibitions, from 1907 to 1909, presenting French post-Impressionists and Fauvists as well as Russian painters, particularly Mikhail Larionov (1882–1964) and Natalia Goncharova (1881–1962). From then on, the Russian artistic life offered developments parallel to—not imitations of—what was happening during the same decades in Paris, Rome, Munich, and other avant-garde centers.

In that stimulating atmosphere, several movements, loudly announced by manifestos, were born, briefly came into bloom, and rapidly disappeared. Such were, in 1911, Larionov's and Goncharova's Rayonism (inspired by Italian futurism); in 1912, the Cubo-Futurism launched by Kasimir Malevich (1878–1935); in 1915, Suprematism promoted by Malevich again; and the rival movement, Productivism, whose leader was Vladimir Tatlin (1885–1953). To these names, one should add Aleksandr Rodchenko (1881–1956), Liubov Popova (1889–1924), Ivan Puni (1894–1956), better known by his French name, Jean Pougny, and Natan Altman (1889–1970) to have an idea of the variety of talents to be found in the Russian avant-garde during the years immediately preceding the Revolution of October 1917.[5]

Rather than deeply opposed schools, these movements were stages in the development of what could be considered one generation of artists. Fundamentally, despite

discussions and manifestos, they passed through these different stages together. Even Malevich and Tatlin—whose competition for the leadership of the avant-garde went to the point of physically fighting each other before the 1915 opening of 0.10. The Last Futurist Exhibition of Paintings—were on parallel paths. One basic characteristic common to the early twentieth-century Russian artists, therefore, should be emphasized: the repudiation of the naturalistic style of representation. This style was dominant in nineteenth-century academies everywhere; in Russia, it was particularly stressed at the Petersburg Academy of Art.

A representation is naturalistic when the painter attempts to convey a visual perception similar to what the retina records when looking at the object—person or thing—in the outside world. The naturalistic painter is concerned with imitating visible appearances, including an illusory rendition of three-dimensional space through linear perspective, through flat planes varying in luminosity, or through different colors suggesting different depths.

Antithetical to naturalistic, or perceptual, representation is conceptual representation. The sculptor, painter, or engraver wants to convey some characteristic of the represented entity which the artist thinks to be its essence or concept and which is not visible. For instance, I make a drawing of an adolescent's body as I see it, as everybody sees it, and as it would appear in a photograph: it is a naturalistic image. Suppose I want to show that this youthful body is transitory; transitoriness is its essence, it is an element of its concept, but it is unseen. In order to convey the idea of transitoriness, I may draw the skeleton under the skin and flesh, thus suggesting that death is already present in this adolescent: it is a conceptual representation.

Painters of the early modern period, in France, Germany, and Italy as well as in Russia, did not want to imitate the visual appearances of objects seen in the outside world. They wanted to convey what they perceived behind the appearances. German Expressionists depicted a scene *and* their personal reaction to the scene by simplifying and "distorting" lines. Fauvists transposed emotions and feelings into colors, bold and arbitrary. Cubists revealed the underlying geometrical forms by analyzing and unfolding volumes into interlocking planes. Rayonists represented light, as reflected on the angles of represented objects, by rays of color in all directions.

Through these different movements, paintings become more and more entities of their own, and less and less representations. Some Rayonist paintings by Larionov or Goncharova are on the borderline between representation and nonfiguration; one needs the title to recognize what is depicted. With Suprematism, the border is crossed, and one is in the nonfigural, more commonly called the abstract.

The repudiation of naturalistic representation, which had been dominant in the Western tradition since the Renaissance, was an aesthetic revolution. Another revolution, social and political, was in the making at the same time. They were somehow converging.

Though not directly involved in the preparation of the Revolution of October 1917, the Russian avant-garde was radically opposed to the czarist establishment, to its norms and values. Artists expressed their social alienation and marginality by outrageous costumes, nonsense plays, and "absurd poetry" recitals in bohemian coffeehouses such as Café Pittoresque, the interior of which was designed and decorated in 1917 by Tatlin, Rodchenko, and Georgii Yaculov (1882–1928). They dreamt of the Middle Ages when, they thought, art was integrated into life and artists were recognized as contributing

ANDRÉ DERAIN. *The Old Tree.* 1905. © ADAGP,
Paris / VAGA, New York, 1985.

ERNST KIRCHNER. *Two Against the World.* 1924.
Kunsthalle, Hamburg. Photo by Ralph
Kleinhempel.

WASSILY KANDINSKY. *Black Lines.* 1913. Solomon R.
Guggenheim Museum, New York. © ADAGP,
Paris / VAGA, New York, 1985.

members of society. So the October Revolution was welcomed. "Cubism and Futurism were the revolutionary forms in art foreshadowing the revolution in political and economic life of 1917," said Malevich.[6] "The events of 1917 in the social field were already brought about in our art in 1914 when material, volume, and construction were laid as its basis," said Tatlin.[7]

Artists were indeed given responsibilities in the new regime. In the Department of Fine Arts, created in 1918 under the People's Commissariat of Enlightenment, decision-making positions were occupied by Tatlin, Malevich, Rodchenko, and Altman. Wassily Kandinsky (1866–1944), who had returned to Russia from Germany where he had been involved in the Blaue Reiter movement, was also employed in the Department of Fine Arts. And Marc Chagall (1887–1985), also back from Berlin, was made Commissar for Fine Arts at Vitebsk, where he was born. Within four years, these artists-turned-commissars organized thirty-six museums throughout the country, and bought modern works of art with a budget of two million rubles.

They were not only administrators; they continued to design and produce works. In 1919 Tatlin was commissioned to design a *Monument to the Third International* to be erected in the center of Moscow. Described by Tatlin as "a union of purely plastic forms (painting, sculpture, and architecture) for an utilitarian purpose," the monument, according to Osborne, "was to be in glass and iron, twice the height of the Empire State Building, and the central glass cylinder was to revolve."[8] Models were made, but it was never built. In 1920, in an exhibition called Non-Objective Creation and Suprematism, new works by Malevich (including his famous *White on White*), Rodchenko, Popova, Kandinsky, and Antoine Pevsner (1886–1962) were shown.

In 1921, Tatlin and the former Productivists developed a new movement under the name of Constructivism. This movement was a continuation of Productivism, which promoted constructions in space made of "actual" materials—as opposed to two-dimensional paintings creating an illusory space. Consequently, the Constructivists considered easel painting obsolete and held the artists' participation in the industrial process more relevant to a new type of society whose techniques of production were industrial. Hence, the development of industrial design. Tatlin and Rodchenko designed furniture and clothing for workers; Malevich designed plates for the State porcelain factory; Popova designed textile patterns; and Altman designed stamps. Rodchenko and El Lissitzky (1890–1947) created new typographical systems and new graphic techniques such as photomontage.

Artists were also involved in education and propaganda. They designed stage sets for theaters and large public celebrations like the First of May and the anniversary of the October Revolution. They also drew posters and magazine covers.

During these effervescent and chaotic years, there were many internal tensions and struggles among the artist-commissars. Yet at the ideational level of the systems of forms, there was no confusion. During the first five years of the new regime, the forms were clearly modernist and in the line of the prerevolutionary trends that had been developed by the same artists. The aesthetic revolution against naturalistic representation had been won. The two trends that dominated the artistic scene were, for different reasons, opposed to naturalistic representation. Constructivism, the construction in actual space of utilitarian objects, condemned representations as such; and Suprematism had reached an extreme in nonfiguration with the 1919 Malevich monochrome paintings,

VLADIMIR TATLIN. Model for the *Monument to the Third International*. 1920. State Russian Museum, Leningrad.

KASIMIR MALEVICH. Cup and teapot. c. 1920.
Designed for the State Pottery, Leningrad.

ALEKSANDR RODCHENKO. *Hanging Construction*. 1920.
Museum of Modern Art, Oxford.

where the shape of a square was indicated only by a difference in texture obtained by the brushwork. The new forms, created during the last years of the old social order and in opposition to it, were still in the process of evolving. They provided the new ideational systems that corresponded to the new social order. What happened also conformed to Marxian doctrine: new relations of production generate a new superstructure. Thus the new economic basis of society was expected to be reflected by a new art.

Then socialist realism appeared. Its configuration of forms was in complete opposition to modernism. In painting and sculpture, it was a return to nineteenth-century academic naturalism, and in architecture, to a sort of neoclassicism. Instead of Suprematist painting built up from squares and circles, crosses and triangles, back were heroes and rulers, portraits and landscapes; instead of Constructivist dynamic forms in iron and glass, back were columns and Corinthian capitals, cornices and pillars, ballroom-size halls and monumental staircases. From a Marxian viewpoint, the return to naturalistic figuration and neoclassical styles introduced the incongruity of reestablishing a superstructure that had been generated by the exploitative capitalistic system. The subject matter was new—workers and Red Army soldiers, dams and industrial plants, Lenin and later Stalin—but the style of representation, idealized naturalism, was the same.

The first manifestations of socialist realism were, at the level of societal networks, closely associated with the state and party power structures. In May 1922, the Association of Artists of Revolutionary Russia was founded. It rejected the "abstract concoctions

ALEXANDROVICH DEYNEKA. *The Defense of Sebastopol.*
1942. Photo from Zimenko 1976.

ALEXANDROVICH DEYNEKA. *The Tractor Driver*. 1956.
Photo from Zimenko 1976.

M. SAVITSKY. *Partisan Madonna*. 1967. Photo from
Zimenko 1976.

ARKADY ALEXANDROVICH PLASTOV. *Spring. At the Bathhouse.* 1954. Photo from Zimenko 1976.

discrediting our Revolution in the face of the international proletariat," considered that "our civic duty before mankind is to set down, artistically and documentarily, this great moment of history in its revolutionary impulse,"and advocated "the monumental forms of Heroic Realism."[9] The name *socialist realism* was not used in 1922; it was introduced in 1934, at the first congress of the Union of Soviet Writers—Stalin is credited with having coined the term. But, since 1922, a doctrine stating that art should be a tool of social transformation, and that its style should be naturalistic, has been the explicit, and enforced, policy of the Soviet government.

The first aspect of the doctrine—that art should be a tool of social transformation—is consistent with those principles of Marxism that give priority to action over contemplation. It also fits the situation of a government that has to achieve societal stability and economic survival in an international environment of hostility—which was the situation of the Soviet Union during the twenties and thirties. What is puzzling is the second aspect of socialist realism. Why did the Soviet government and the party impose an idealized naturalism as the style of representation?

A clue to answering this question may be found in the seemingly surprising similarity between this Soviet policy and the "cultural policy" of the National Socialist regime in Germany. After Adolf Hitler became chancellor in 1933, as a consequence of the presidential elections of 1932, the artistic scene in Berlin and Munich, Dresden and Düsseldorf changed completely.

The scene had been modernist. The Bauhaus, founded in 1919 by Walter Gropius (1883–1969) was, first in Weimar and later in Dessau, the main center of diffusion for industrial design and nonfigurative art in the twenties and early thirties. Russian Constructivism had spread to Germany. In 1922, at a congress of artists held in Düsseldorf, an international association of Constructivists was formed. Later, several European groups of Constructivists—De Stijl of Piet Mondrian (1872–1944) in Holland, the Cercle et Carré of Michel Seuphor (b. 1901) in France—collaborated with the Bauhaus. Wassily Kandinsky, who had left the U.S.S.R. in 1921, held a teaching position at the Bauhaus.

From 1933, the National Socialist party mounted a campaign against "degenerate" art and artists. It culminated, in 1937, with an exhibition of "degenerate art" held in Munich. Among the nine categories listed in the guide to the exhibition, one was devoted to abstract and Constructivist paintings characterized as expressing "total madness" and the "height of degeneracy."[10] In another building, the newly built House of German Art, not far away from the "alien and cosmopolitan, Jewish and Bolshevist" art exhibit, the first Great German Art Exhibition was held during the same summer of 1937.

This German art exhibit, and the following seven which took place until 1944, gave a fair idea of what the government and party leadership meant by what they called "the art in the Third Reich." It was a representational art, depicting in idealized naturalistic style, interiors and family scenes, nudes and landscapes, portraits and subjects from classical antiquity. All of these paintings were in continuity with the art production of many second- and third-rate German painters of the nineteenth century. New subjects were treated in the same naturalistic style: war scenes of bombardments of London, tank battles, conquering troops entering Poland. There were also allegories pertaining to the National Socialist mythological world: German knights of the Middle Ages, young and

JOSEF THORAK. *Comradeship*. 1937. Photo from Frankfurter Kunsverein 1975.

WALTER HOECK. *Young Germany* (adapted by
Beatrice Fassell). Photo: Carl Hanser Verlag.

IVO SALIGER. *Diana at Rest.* Photo: Carl Hanser
Verlag.

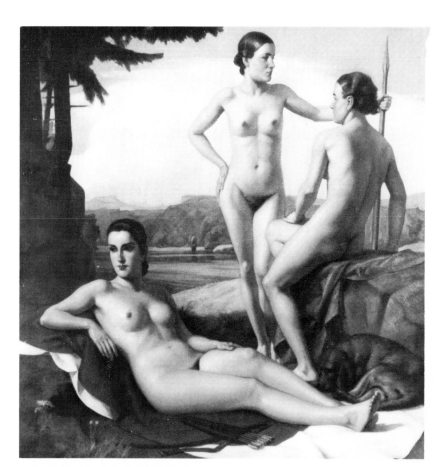

naked men defending the flag, and Olympic athletes in Greek nudity. And, of course, there were portraits of the Führer and other personalities of the regime.

The idealized images of Hitler and his associates, of the blond and healthy-looking young men and women of Germany, and of the sunny wheatfields of the German homeland were naturalistically rendered. It is ironic that Stalin and his associates, the workers, soldiers, mothers, and partisans of the Revolution, and the dams, railroads, steel plants, and electric works of the Soviet homeland were represented in exactly the same style.

We may rephrase the question on the Soviet imposition of naturalism. Why did the one-party governments of the U.S.S.R. and National Socialist Germany perceive visual modernism as a potential threat to their regimes?

Each of these countries was in the process of mobilizing its people's energies in an effort of economic and military development. Each had evolved a totalitarian system of government: a system in which as complete a control as possible is achieved through individual commitments to collective goals. The latter may be any national priority such as "industrialization, racial mastery, or proletarian unity."[11]

In this perspective, a naturalistic representation is more amenable to control than a conceptual one. Being a visual imitation of the appearance of an outside entity, a naturalistic representation immediately directs the beholder's attention to the outside entity. When I look at a realistic image of a Red Army soldier, my interest moves immediately beyond the canvas. The painting is a window through which I see the "real" soldier. In my thought, there is the soldier, not his picture. My comments are about him, not about his image: he looks strong and happy, his stance is impressive. A naturalistic representation, particularly if its aesthetic quality is mediocre, acts as a relay to what is represented; it does not retain the beholder's attention to the "flat surface covered by colors arranged in a certain order."

Picasso's *Guernica* is representational too. I recognize each element: bull, mother and child, horse, lamp, bulb, and the like. But it is not a window through which I can see the German bombers attacking the town of Guernica in 1937. Each element is represented according to what Picasso thinks, not according to what he sees. The figure I call the mother is a visual transposition of a certain idea of a suffering and despairing mother. It does not resemble the perceptual image produced by the view of any actual woman I have ever seen or will ever see. The whole picture does not look like an actual scene of destruction that one could photograph in a street after it had been hit by an air raid. The whole picture is a conceptual representation of it.

Because it does not open a window on the world out-there, *Guernica* has several possible meanings; it is polysemic. It is also polysemic because its aesthetic excellence makes it a powerful symbol. Polysemy bothers some beholders. When *Guernica* was shown in Paris three months after the bombing of Guernica, many friends of the legal government of Spain criticized Picasso for being obscure.[12]

Polysemy does not bother only some beholders. It makes the rulers' control of their subjects' thinking more difficult. How can rulers be sure that beholders will apprehend the "correct" meaning, that is, the one the rulers deem to be correct?

A sign's polysemy is derived from two possible sources. One, discussed earlier, is the aesthetic quality of a work. Aesthetic excellence makes a work a powerful symbol, and a symbol is polysemic. Even naturalistic images are symbolic if they have aesthetic quality—though some people see Botticellis and Raphaels only as images.

Conceptualism in representation is the second source from which polysemy is derived. When a painting visually represents what is thought rather than what is seen, it certainly suggests different meanings to different beholders; it also suggests different meanings to the same beholder in other circumstances. When a human face is drawn in profile, only one eye will be depicted if the work is treated in naturalistic style; the second eye is known to be on the other side of the face but is not seen. If the second eye is depicted on the face in profile, as Picasso sometimes did, it is a conceptual representation. As this feature is bound to be interpreted differently by different beholders, it is a multivocal sign.

Achieving a totalitarian control of meanings through conceptual representations is impossible. A case from the field of music makes this clear. In 1948, Soviet composers were invited by the central committee of the party to write operas, and other pieces with songs, instead of the symphonies and other forms of instrumental music they had usually produced. To operas and songs, words give an unambiguous content, whereas instrumental music allows a greater freedom of interpretation.

For totalitarian rulers, modernism in the visual arts presented a more threatening danger than the dissemination of some particular ideas which were prohibited: it trained minds to look beyond the surface of things. Cubism, Suprematism, surrealism, and other isms of modernity had in common the establishment of a distinction between what is seen and what is unseen but essential.

A modernist rendering of a partisan may suggest, even state, that under the appearance of an armed militant committed to a noble cause, there is a trained killer in a system of organized violence, or a naive victim who will be sacrificed for the defense of a privileged minority to which he does not even belong, or a killer and a victim at the same time.

Non-naturalistic images and nonfigurative compositions build into beholders' minds the habit of perceiving everywhere, even in rulers' statements, a dichotomy between what appears and what is hidden. Interestingly, the distinction between the face value of a position and the class interests it covers, and the disclosure of those interests, were weapons used by Marxists against their opponents. Such ideological analysis is at the origin of the sociology of knowledge.

If this interpretation is valid, it may be expected that totalitarian regimes, afraid of the freedom of thought stimulated by the polysemic character of visual symbols, will try to dry up the two sources of these symbols—aesthetic excellence and conceptualism. This is, in fact, what happened in Stalin's Russia and Hitler's Germany.

The condemnation and suppression of conceptualism and nonfiguration by socialist realism indeed offer a privileged case for studying how a societal network outside the aesthetic segment of the Russian society—the Soviet leadership of the government and the party—had, during more than half a century, a decisive and even brutal impact on what appears to be a purely aesthetic matter: the choice of a style of representation.

Dome of the Church at Chora. Constantinople.
13th—15th century. Photo by Guler (Civilisations
1966).

CHAPTER NINETEEN

Aesthetic Forms and Other Ideational Configurations

IN THE THREE-LEVEL MODEL OF A CULTURE USED IN THIS BOOK, THE THIRD LEVEL IS DEVOTED to systems of ideas. Idea is broadly understood as any product of mental activity such as perceptions and conceptions, inductions and deductions, cognitions and significations. These mental products are expressed or supported by material items such as written or spoken words; sounds produced by instruments; contours, volumes, and colors. These material items are not considered in their physical dimensions—words as printed characters, sounds as vibratory disturbances, and colors as electromagnetic radiations. They are considered in their mental dimensions—words assembled in a book as constituting a novel, sounds organized as a concerto, and colors disposed on a canvas as a still life. As these examples indicate, the units are, on the ideational level, configurations or systems of ideas. Such are the Navaho world view, nuclear physics, the Bantu languages, Greek mythology, electronic technology, Christian theology, and Islamic law.

To make these numerous systems of ideas more manageable for study, we may categorize them according to different criteria. Dominant function, for example, may be chosen as the principle of classification. From this point of view, one may distinguish cognition-oriented, action-oriented, affectivity-oriented, and contemplation-oriented configurations. The dominant function of sciences and philosophies, world views and cosmologies, models of the human psyche and physiology is to explain man and the world; these ideational systems are cognition-oriented. Technology, language (particularly in its rhetorical use), ethics, and ritual are examples of action-oriented systems of ideas; they provide mental means for changing the world and for acting upon men and gods. Affectivity-oriented systems generate and direct feelings, strivings, and impulses. Such are, for instance, language in its emotional uses, devotional ceremonies, and the visual eroticism of some pictorial traditions. Styles of composition, aesthetic systems,

methods of meditation, and spiritual paths are contemplation-oriented configurations; they provide the mental underpinnings favoring establishment and maintenance of the contemplative mode of consciousness.

Ideational configurations may be classified on the basis of principles other than the dominant function. One could use the mental process that predominates in each system and distinguish between empirical or deductive configurations, rational or nondiscursive methods, historical or scientific approaches. Still another principle of classification could be the subject matter on which each system is focused: universe or earth, inanimate world or biosphere, humankind or its environment, and many other categories.

Aesthetic configurations belong to the ideational level. They are systems of visual forms displaying an aesthetic quality because of their integrated design. It is in the ideational systems—not in the societal networks nor in the processes of production—that aesthetic specificity is to be found. It is because they embody an aesthetic system of forms that some artifacts have an aesthetic value—not because they are in a fine arts museum, have been made by professional artists, or display techniques taught in art schools. In this chapter, we shall explore how systems of forms are related to ideational configurations like theological doctrines, world views, conceptions of time, and kinship theories.

Byzantine Christianity conceived of God as transcendent. He was above, and independent of, the material universe of sun, moon, and stars he had created. He had caused the earth, living nature, and humankind to exist, but he did not need them to exist. Despite God's incarnation in the human form of Christ, the divinity was thought of as completely distinct and separated from man. Absolute and unrelated, God transcended everything that was not his own being.

Byzantine religious imagery has had a long tradition of eleven centuries, if we consider it as coextensive with the Byzantine Empire—which, historians have agreed, lasted from 330, when Emperor Constantine established Byzantium, under the new name of Constantinople, as the capital of the Roman Empire, until 1453, when the Turks conquered Constantinople. Of course, during this long era Byzantine art fluctuated—

Mosaic of Christ as Pantocrator. Hagia Sophia basilica. Constantinople. 11th century. Photo by Guler (Civilisations 1966).

there were three "Golden Ages" and, between them, periods of artistic depression—but it maintained a significant persistence in forms.

The religious iconography became standardized and thus remained constant in its themes and conventions. Integrated into the interior architecture of churches, religious imagery was set in mosaics or fresco painted on the semidome over the apse or on the dome over the center of the building, high above the heads of the congregation. The divine figures and referents were depicted on a uniform golden or blue background.

A hand pointing downward in the sky was an iconic referent for God the Father, and a dove was for the Holy Ghost. Christ as Pantocrator (universal ruler) was represented majestically standing or sitting on an imperial throne. His image dominated the pictorial field in glorious isolation. Sometimes, as in the church at Chora in Constantinople (dating from the Third Golden Age, 13th–15th century), Christ was at the apex of the dome; the apostles and disciples, much smaller in size, were disposed in a perfectly regular circle at the lower part of the dome. Sometimes, the Virgin Mary and apostles, prophets, and saints were depicted on the walls, also standing in front of a uniform background.

The rendering of Christ and the other heavenly figures is stylized. They are frontally depicted as elongated figures, rigidly motionless, remarkably impersonal, and abstract. The style of representation is definitely conceptual. Suggestions of volume, mainly by shading and overlapping of the folds of the tunics, are so limited that the figures appear flat. As there are no visual clues for the third dimension, there is no pictorial space. The figures seem to be floating in front of the ground.

These features—stylization, impersonality, absence of volume and pictorial space— characterize Byzantine representation. This style does not guarantee that mosaics and frescoes made in accordance with its canons have an aesthetic quality—no style guarantees that. But it certainly offers a framework for strong composition, and many Byzantine images have a compelling unity of design.

The expressivity of Byzantine style is also remarkable. Its features make many mosaics and frescoes the visual equivalents of the theological doctrine of God's transcendence. Represented outside our three-dimensional space, high above us, without human thickness and individual traits, the divine icons and referents are really separated from us, different from us: they transcend us. This, of course, produces a congruence of forms and meanings. Byzantine style, more than others, establishes a visual discontinuity between the heavenly world of the divine and the everyday environment, which is also ego's arena. This break facilitates an initial contemplative attention and helps to maintain it in the beholder's mind.

The close association of mosaics and frescoes with an architectural form, the dome, reinforced their aesthetic and symbolic value. Hagia Sophia (holy wisdom) basilica (532–537), built by architects Anthemios and Isidoros in Constantinople during the First Golden Age, exemplifies Byzantine religious architecture in its most impressive realization. Its dome, placed at the center of an almost square building, dominates the basilica by its massive presence. For ordinary Christian believers entering the sacred space of Hagia Sophia, the monumental dome stood for the heavenly abode of God and his celestial court of angels and saints; for scholars and theologians, it symbolized the transcendence of the divine.

Between two ideational configurations of Byzantine culture, the aesthetic system and the theology of transcendence, there is a relation of symbolism: the aesthetic forms

ANTHEMIOS AND ISIDOROS. Hagia Sophia basilica.
Constantinople. 532–537. Photo by Jacques
Maquet.

Hagia Sophia basilica, ground plan.

stand for transcendence by participation. Material signifiers—mosaics and dome—
display forms different and separate from, and superior to, the usual forms in our
environment. They transcend the material world and they convey the idea of transcen-
dence by participating in the divine world. By experiencing transcendence through
aesthetic forms we have a taste of the idea of the transcendence of the divine.

The relationship between Byzantine forms and Byzantine theology may also be
expressed in terms of correspondence. Each of the two configurations corresponds to the
other, each one is equivalent to the other. The words of theological treatises and, on the
other hand, the representational and architectural forms express in different idioms the
idea of divine transcendence. Accustomed as we are to look for causal relationships, we
wonder which is first, theology or visual forms. A detailed historical study could perhaps
solve this problem, but that is not certain. It is certain that the visual and intellectual
processes reinforced each other over the centuries of Byzantine civilization. The visual
environment of the church and the theological doctrine reflected each other. They
presented two highly consistent and parallel ideational systems to new members of the
society, who were in the process of enculturation.

POL DE LIMBOURG. A plan of Rome from the illumi-
nated *Très Riches Heures du Duc de Berry*. c.
1414. Musée Condé, Chantilly. Photo: Draeger
Frères.

In the Latin Christianity of the Middle Ages, the world was viewed as God-oriented. The world was conceived of as created by God and thus entirely dependent upon him. In fact, God's action was understood as continuous and permanent: it maintained the world in existence. What mattered was God's point of view, if we may say so.

Like their colleagues of Constantinople, Latin theologians such as Thomas Aquinas wrote about divine transcendence. But it seems that the dependence of the created, another facet of God's absoluteness in theological discourse, was more appealing to Latin Christianity. In the world view of ordinary Christians, God was mainly imagined as a good king upon whom his subjects were dependent. He was not too far from his creatures, he was concerned and he watched them.

Many towns, ports, villages, and castles were depicted in illuminated manuscripts made during the Middle Ages. In the famous masterpiece by Pol de Limbourg (active c. 1399–c. 1416), the *Très Riches Heures du Duc de Berry* (1408–16), there is an illumination of Rome. As in many other medieval images of towns, Rome is seen from above, enclosed within her walls. Inside the walls, we see only important monuments, each carefully drawn, each situated in relation to the others on an empty surface; no streets appear.

Limbourg, like many illuminators, used a perspective from above when representing a town. In the fifteenth century, this was an exercise of imagination. Nobody had yet seen Rome from above, at such a distance that the whole city could be embraced in one view. It was also an exercise in conceptualization, as Rome was reduced to her essential monuments. The picture was inscribed in an astronomic circle which makes it a separate whole. All this suggests that the quasi-aerial perspective is not simply a bird's-eye view.

ANDREA MANTEGNA. *Saint Sebastian.* c. 1472. Musée du Louvre, Paris. Photo: Vizzavona, Paris.

Facing page. MANTEGNA. *Saint Sebastian,* detail: a view of Rome in the background.

It could well be a God's-eye view. Rome is represented with, and only with, the buildings that make her identity and magnificence. It is the city in her own self, it is Rome in her own being: in her dependence upon God and her autonomy from human viewers. Rome is represented from what can be called an ontological point of view. This is "God's point of view" in the sense that he "sees" and creates persons and things as they are in their own being. This theological idea is expressed by an all-embracing view of the essentials. It is not an aerial perspective, but an ontological perspective: it visually apprehends entities as they are.

If this interpretation is valid, then there is a correspondence between two ideational configurations of Western medieval civilization: the God-oriented world view and the ontological perspective.

About sixty years after Limbourg made the illumination in the *Très Riches Heures*, another view of Rome was painted by Andrea Mantegna (1431–1506). In the background of a *Saint Sebastian* (c. 1472) is a "composed landscape" made from representations of actual sceneries—a medieval castle, a farmhouse, a church facade, and excavated ruins. Mantegna organized these sceneries as an imaginary landscape of the most improbable mountains.

The perspective is entirely different from that of the Limbourg. The pictorial space is achieved through the vanishing-point perspective, a Renaissance discovery. Lines start from the picture plane and converge to a vanishing point: the point where the lines intersect, beyond the background of the pictorial space. The illusion of the third dimension is thus obtained. In the Mantegna, the perspective is solidly established on the rectangular floor in the foreground. The lines also continue from the picture plane toward the viewer: invisibly, the pictorial space extends from the vanishing point beyond the picture plane; the diverging lines generate a space that includes the beholders.

Art historian Pierre Francastel discusses the Limbourg and the Mantegna in his book *Peinture et Société*; he writes that their comparison permits us "to apprehend one of the most striking jumps in figuration that can be imagined."[1] This jump from what I have called an ontological perspective to a vanishing-point perspective is equivalent to another striking jump, from a God-oriented world view to a man-oriented world view.

At the Renaissance, there was indeed a shift in orientation of the dominant conception regarding relations among God, man, and the world. With the retrieval of Greek and Roman thought, man again became the focus of ideational systems. Man's significance appeared more crucial than God's transcendence over the creation or the creation's dependence upon the creator. It is difficult not to interpret as corresponding phenomena the shift from one rendition of the third dimension to another rendition, and the shift from one world-view orientation to another.

A comparison between two other masterpieces illustrates the same correspondence. The altarpiece *Adoration of the Lamb*, begun by Hubert van Eyck (d. 1426) and completed by his brother Jan (1380–1441) in 1432, sits in splendor in the Saint Bavo Cathedral, in Ghent. It includes over two hundred figures. They are symmetrically disposed in four groups, two on each side of a central vertical axis on which a fountain and the lamb are placed. The whole scene is set in a meadow surrounded by trees; beyond, near the horizon, one can see the towers of a city. Visual depth is created through a diminution in size of the figures at a distance from those in the foreground, through partial concealment of those who are behind other figures, and through differences in hues and brightness.

HUBERT AND JAN VAN EYCK. *Adoration of the Lamb.* c. 1432. The Ghent Altarpiece. Saint Bavo, Ghent. © A.C.L., Brussels.

RAPHAEL (RAFFAELLO SANZIO). *The School of Athens.* c. 1509. Raphael Stanze; Pontifical Monuments, Galleries, and Museums; Vatican City.

The pictorial space stops at the picture plane; it does not extend toward, or include, the beholder. In fact, the world of the lamb and its worshippers exists there, in itself. Beholders look at the scene from a viewpoint that is neither aerial nor terrestrial; they look from "outside" at a world that is independent from where it is looked at and even independent from the fact that it is looked at or not. This is another example of the ontological perspective.

The School of Athens (c. 1509), the famous fresco by Raphael (1483–1520) painted on a wall of the Vatican Stanza della Segnatura, expresses the new status of philosophy in the Renaissance. Philosophy is no longer *ancilla theologiae*, servant of theology; reason is no longer subordinated to faith. Plato and Aristotle are in the center, and around them are all the Greek philosophers known at the time of Raphael. The meaning of the picture's content is clear, and it is completely different from the meaning of the *Adoration of the Lamb*—after all, the lamb is a referent for Christ, the incarnated son of God.

The composition of *The School* is frequently analyzed because it is a model of stability and movement, of centrality and diversity. Movements of hands and arms, directions of glances, and body postures organize and connect groups and figures so as to constitute a

harmonious and lively unity of fifty or so figures. Although Plato and Aristotle are clearly the most important persons—their figures are centrally placed—there are other discussions going on, and most of the figures do not look at them. This nonradiating composition expresses what philosophy should be. Philosophy progresses through discussion; the authority of even the greatest philosophers does not put an end to questioning; there is no hierarchy among philosophers—most figures are on a plane with Plato and Aristotle.

The perspective with a central vanishing point gives a strong stability to the pictorial space. Raphael has stressed perspective by placing the philosophers in the grandiose architecture of a Renaissance church opened to the sky. The stripes on the marble floor in the foreground, the high walls, and the vaults make the lines of perspective visible. Because of the centrality of the vanishing point, the beholder is placed at the center of the duplicated world the painting presents; it extends from the fresco into the actual space. The pictorial space invades, as it were, the actual space; the beholder is welcomed among the philosophers. This feature of the Italian Renaissance perspective is the visual equivalent of the man-oriented world conceived by Renaissance thinkers.

The Limbourg–Mantegna comparison and the van Eyck–Raphael comparison illustrate a term-to-term correspondence between God-oriented world view and ontological perspective, and between man-oriented world view and vanishing-point perspective. A structural analysis would emphasize the correspondence between the two relations and thus would include the four terms in a single homology.[2] 'God-oriented world view is to man-oriented world view as ontological perspective is to vanishing-point perspective.' This can be presented in the following formulation:

$$\frac{\text{God-oriented world view}}{\text{man-oriented world view}} :: \frac{\text{ontological perspective}}{\text{vanishing-point perspective}}$$

The relation-to-relation correspondence amplifies the term-to-term relation and adds another equivalence between two ideational systems, world view and aesthetic system.

The Dogon, Senufo, and Baule of West Africa traditionally conceived of the past as a time in which different events concerning their origin and human life, their migrations and the introduction of certain crops occurred without a fixed chronological order. Narratives of these events were not recited in the same order, neither were the events considered as having happened in a sequence. The past was construed as an undifferentiated field where *before, after,* and *simultaneously* were not relevant. Tales of what happened in the past could have been introduced by "once upon a time" as in our fairy tales. Anthropologists call this past without sequential structure a mythical time, as the cultural myths are localized in this broad temporal frame.

In the kingdoms of Dahomey and Benin, two other societies of traditional West Africa, the past was constructed as linear and chronological. Like our own past, their past was historical: reigns, battles, droughts, and confrontations with invaders—European and other—were remembered in chronological order.

In his analysis of doors carved in wood, low reliefs in clay, and plaques in bronze made in these societies, art historian Jean Laude has called attention to two different clusters of features characterizing the reliefs carved, molded, or cast.[3]

The cluster of traits observed on the Dogon, Senufo, and Baule wooden doors and shutters include a nonsequential disposition of the figures carved on the surface, and an

Door. Senufo, Ivory Coast. University Museum,
University of Pennsylvania, Philadelphia.

High relief in clay. Abomey, Dahomey. Musée de l'Homme, Paris. Photo: Hoa-Qui, Paris.

In the royal enclosure of Abomey, building with clay high reliefs. Dahomey. Photo: Hoa-Qui, Paris.

absence of depth. Laude mentions a Dogon shutter summarizing one of the creation myths: the sculptor has juxtaposed figures in a manner that does not suggest the order in which they should be "read."[4] Figures in low relief, lightly hollowed, and similarly disposed are frequent on Senufo doors.

Another cluster of traits characterizes Dahomey clay reliefs and Benin bronze plaques. Each new king of Dahomey had a new palace built; its walls were covered with deeply recessed squares from which emerged figures and motifs modeled in high relief. Each of these concave reliefs related historical events concerning kings, who were identified by emblems. An impression of perspective was achieved by the actual depth of the recessed square. In several Benin bronzes, there was an attempt to render perspective by casting figures in high relief, by placing the more distant at the higher part of the plaque, and sometimes by combining bird's-eye view and frontal view in the same plaque—as, for instance, in the famous sacrifice of a bull.

Here again, there is a term-to-term correspondence between mythical time and shallow relief, and between historical time and deep relief. Again, our conclusions can be formulated in a relation-to-relation correspondence comprising the four terms:

$$\frac{\text{mythical time}}{\text{historical time}} :: \frac{\text{shallow relief}}{\text{deep relief}}$$

'Mythical time is to historical time as shallow relief is to deep relief.'

It should be noted that the two corresponding ideational conceptions, mythical time and shallow relief, are found in the cultures of societies organized in villages under the authority of lineage patriarchs, whereas historical time and deep relief appeared in kingdoms governed by powerful rulers. Obviously, kings based their legitimacy and

Bronze plaque showing the sacrifice of a bull.
Benin, Nigeria. British Museum, London.

prestige on their predecessors, and thus historical past was important to them; by contrast, sacred origins were more relevant for elders of kinship groups.

The two societal networks, kinship founded on descent and government founded on coercion, were, in their turn, reflective of the material bases of the societies. The Dogon, Senufo, and Baule were farmers who produced just above the subsistence level; Dahomey, through her large plantations and slave labor, produced a considerable surplus, and Benin, through long-distance trade directly controlled by her rulers, was economically prosperous.

The processes of exclusion and conduction which we observed between systems of production and societal networks, and between societal networks and ideational configurations, combined with the process of correspondence we have analyzed among the ideational configurations, account for the dynamic and ongoing integration of a culture. A similar interplay of influences across cultural levels and of correspondences among ideational systems is found in traditional Africa regarding descent groups, ancestors' rituals, doctrines of kinship, and figurines of ancestors.

The source of group solidarity without which an individual would have been completely powerless in the crises of everyday life was the lineage comprising the living descendants of a certain ancestor. To be a descendant of ancestor A was an individual's essential identification. The lineage also endowed the descendant of A with a set of rights, for example, to have a plot of land for growing food, to be helped in case of a bad

crop, and, for a man, to have one's wives and children taken care of in case of untimely death. The importance of the societal network of kinship was expressed by the ancestor's ritual, an ideational configuration. It was a private and familial ritual: a simple altar in the family compound, everyday offerings of token foods, and a few words addressed to the ancestor.

Ancestors were often represented by statues. These statues were certainly an important part of the aesthetic locus in the cultures of Atlantic and equatorial forest tillers. Many of these ancestors' figurines—at least those we see in museums and art books— display a remarkable aesthetic quality: their composition is well integrated along vertical lines, and their meanings are expressed with force.

Ancestors' carvings did not portray singular individuals: recognition of somebody as a member of *a lineage* was more important than ascription to *a particular lineage*— indeed, in the subsistence societies of the forest clearings, all lineages were approximately equal in resources.

These figurines were usually represented in the nude, and their sexual organs were openly displayed. This is rather surprising as adult nudity was practically unknown in traditional Africa. Nudity in figurines reinforced the abstract quality of ancestors: their human nature was stripped of the cultural associations of clothes. Penis and vulva were emphasized as organs of generation, not of pleasure. They reminded the descendants that ancestors, male or female, were at the origin of many generations, and that they expected their strength to continue through new generations. The lineage would remain strong because the offspring of the living generation would be numerous.

This doctrine of kinship is not an anthropological inference. Sayings, proverbs, and narratives from Africa's past express it plainly. Men and women of innumerable villages of contemporary Africa still live by these values of kin solidarity and lineage fertility; they explicitly mention them. This kinship doctrine was, and still is, a cognitive configuration. The aesthetic configuration of ancestral figurines corresponds to it.

In this chapter we have reviewed several instances in which relations between an aesthetic system and another ideational configuration could be ascertained. These relations were, in all these cases, relations of correspondence. On the other hand, examples analyzed in the preceding chapters revealed that the relations among cultural phenomena distributed on different levels—production systems, societal organizations, and configurations of ideas—were conditioning relations.

Relations of correspondence are different from relations of conditioning. In the former, one term is equivalent to the other, homologous to the other, or isomorphic to the other: no priority of one term over the other is indicated or even implied. It may be that in a correspondence, one term has some precedence over its correspondent. For instance, the theological concept of transcendence may be anterior in time to the corresponding visual figuration of transcendence. This precedence is of secondary importance; what matters is the correspondence itself.

For a long time it has been recognized that some domains—such as myth, magic, and ritual—were not ruled by the rational logic of conditioning relations. These domains were thought to be exclusively found in non-Western cultures. It has been less readily recognized that some large areas of the Western cultures—such as the symbolic and the aesthetic domains—are also governed by a logic of correspondence.

Ancestors' figures. Dogon, Mali. Museum Rietberg, Zurich.

By contrast, in relations of conditioning, one term causes the other to exist; or one term is the antecedent of the other by preceding it; or, as an independent variable, one term determines, through its variations, the variations of the other; or one term excludes the other; or one term is conducive to the other. This logic of conditioning, in fact, does not extend its dominion much beyond everyday life, the techniques of production, and reasoning in scholarly and scientific knowledge.

In our examples, the conditionings were always in the same general direction: from productive systems to societal networks and from societal networks to ideational configurations. Is there ever a conditioning in the opposite direction? Do aesthetic systems ever have an impact on social structures or techniques of production? Or, to put it in Marxian vocabulary, Does the aesthetic part of the superstructure in any way determine social and economic realities?

In his 1942 talks at the Yenan forum on literature and art, Mao Zedong said that "literature and art are subordinate to politics, but in their turn exert a great influence on politics." He stated that "proletarian literature and art are parts of the whole revolutionary cause of the proletariat; they are, as Lenin said, cogs and wheels in the whole revolutionary machine. . . . If we had no literature and art even in the broadest and most ordinary sense, we could not carry on the revolutionary movement and win victory."[5]

In the same Yenan talks, Mao explained why literature and art are needed for revolution. "There is suffering from hunger, cold, and oppression, and also there is exploitation and oppression of man by man. These facts exist everywhere and people look upon them as commonplace. Writers and artists concentrate such every-day phenomena, typify the contradictions and struggles within them and produce works which awaken the masses, fire them with enthusiasm and impel them to unite and struggle to transform their environment. Without such literature and such art, this task could not be fulfilled, or at least not so effectively and speedily."[6] Even in the Marxist-Leninist tradition, the least likely to grant importance to aesthetic configurations, art is conceived of as a powerful force on societal networks through the mediation of its influence on people's minds. It can reveal to them what they do not perceive in their own lives, and move them to action.

In Mao Zedong's perspective, aesthetic configurations do have an impact, first, because art is more convincing than reality; and, second, because this apprehension through art is more conducive to action than the direct apprehension of the outside world.

From the point of view of this study, if a visual or literary representation provides a better understanding of what is represented than its direct consideration, it is because it is symbolic. *Workers Returning Home* (1913) by Edvard Munch (1863–1944) is an image of Norwegian men leaving the factory at the end of their shift. They are many; the dominant blue of their workclothes is like a uniform; the faces of the multitude are just indicated, except for four men in the foreground, who seem to be passing by the beholder. We could recognize them, particularly two of them, if we were to meet them again.

The picture's composition is clear. The vanishing-point perspective includes the viewer. The harmony of dark and muted hues is balanced. There is movement in the crowd, marching as it were, in the same direction. The center is marked by one of the four identifiable faces; it attracts the beholder's attention by its unique tonality—a slightly greenish grey—whereas the other faces are a warm reddish color.

EDVARD MUNCH. *Workers Returning Home*. 1913.
Munch Museum, Oslo.

The painting also reveals a compelling expressivity. It symbolizes the advance of the working class, quiet and irresistible. The strength of this class is in its numbers: it is an impersonal mass when seen at a distance. It is also in the uniqueness of each worker: seen at close quarters, each is a rugged individual.

In the outside world, I have sometimes walked against the flow of a crowd and have seen, like the beholder of the Munch painting, people walking by me on either side. Because of the noise, because I attempted to avoid colliding with anybody, because what I saw had no visual composition, I did not perceive any symbol in these situations. My vision had not been "concentrated" and "typified," as Mao said, and thus I had no understanding of the meaning of what I saw.

Let us now address the second point in our reading of Mao Zedong on art: perceiving a situation through its artistic representation is a stimulant for action. We interpret this to mean that an aesthetic perception is a better stimulant for action than an intellectual one.

According to the popular Western view of the human psyche—conceived of as having three main functions, intellection, affectivity, and will—a work of art generates emotions and feelings, even passions, and these affective states, more than cold intellection, stimulate the will to act. The picture of a starving child generates shame and indignation; and shame and indignation trigger my will to do something about hunger in the world. The picture of a massacre raises my anger, and my anger determines that I join a peace movement. In earlier discussions, we have questioned the validity of the popular construction of the psyche which ignores contemplation, and of the view that art arouses emotions. But some pictures certainly arouse emotions in some viewers, and these emotions incite them to act. Maybe this is what Mao Zedong had in mind when he spoke of the masses fired by writers and artists into changing the conditions in which they live.

In this book's perspective, aesthetic perception belongs to contemplation and not to affectivity. Does contemplation prepare us for action better than intellection and emotion? I think that it does.

An adequate justification of this answer would require more than the few comments appropriate here. Let me just sketch the main lines of the argument that I would develop. I would begin by repeating that in the aesthetic perception—attentive, total, and devoid of self-interest—there is no intention to change what we are looking at. It is only when this visual contemplation of a part of the outside world is over that action becomes a possibility.

Then it should be shown that the symbolic meanings attained in a contemplative perception afford a deeper understanding of the depicted situation than does a purely intellectual knowledge. Thus, if something is to be changed, the advisability or necessity of action is better grasped. In that sense, the contemplative mode of consciousness prepares us for action.

Finally, it should be pointed out that contemplation is better than affectivity because the latter is always ego-oriented. Anger and indignation are indeed strong impulsions for action because of ego-involvement. When another car passes me and makes me angry, the involvement of my pride and my ego gives me the impulse to act, that is to accelerate and overtake the presumptuous car. Affectivity is a good preparation for indiscriminate action. Contemplation is a good preparation for unselfish action.

We would then be able to conclude that, from this perspective, aesthetic responses to literature and art generate wise actions and wise revolutions.

CONCLUSION

The Individual Nexus

WHEN I WAS A CHILD, THE PARISH PRIEST GIVING US RELIGIOUS INSTRUCTION ONCE TACKLED the paradox of bliss in paradise. All those in paradise will be perfectly happy, he said, despite the fact that their rewards will not be equal. Rewards will indeed be commensurate with the degree of virtue each soul had reached when living on earth. The problem was thus: How can those with smaller rewards be perfectly happy? The priest solved the problem by using a metaphor: virtue is a bowl and bliss is what fills the bowl. What matters is to have one's bowl filled up to the brim. One is completely satisfied as one's bowl is full, be it small or large.

I am not sure we were convinced that a small ice cream cone is as satisfactory as a big cone because it is filled to its capacity. Yet the metaphor conveyed an important meaning: even the ultimate one can dream of, the beatific heavenly bliss, must be experienced in the individual. Divine happiness is what is perceived by each person. It is, as it were, localized in an individual nexus.

This emphasis on the individual suggests how the universal and the cultural dimensions of the aesthetic experience can be unified in individual beholders.

In the third part of this book aesthetic objects were shown to be deeply integrated in the particular cultures where they had been made or adopted. Aesthetic forms are among the ideational configurations of the culture of which they are part: they are influenced by the processes of production and are responsive to institutions and other societal networks. In a word, aesthetic objects are deeply cultural.

They are also deeply universal. In the first two parts of this work, I stressed the panhuman dimensions of aesthetic objects. Their aesthetic and symbolic qualities elicit responses across cultural boundaries because they are attuned to the common humanity of the beholders.

Intellectually, these two aspects—the human and the cultural—can be distinguished; that has been done in this book. Concretely, they are indissociable. The universal human can be reached only through the particular cultural. Serene concentration, a universal value, is symbolically experienced through a cultural embodiment, the Anurādhapura Buddha, a product of the Sinhalese culture of the third and fourth

centuries A.D. The geometric order of natural forms is perceived through Braque's *Roche-Guyon*, a product of French Cubism in the first decade of this century. The 'human as such' cannot be expressed or perceived because it cannot exist devoid of cultural determinations. In the visual experience, human and cultural are one.

It was mentioned earlier that any activity, behavior, or artifact includes a singular component. An anonymous craftsman interpreted the Sinhalese tradition of the time and carved in stone the Anurādhapura Buddha. Braque—not Picasso, Gris, or Delaunay—painted *Roche-Guyon*, and it is through his singularity that we perceive the French Cubism of his time. We may go a step further and realize that the oneness of the aesthetic experience is situated in the individual beholder.

There the connection between universal, cultural, and singular is established. The individual as the nexus of the aesthetic experience can actualize, unify, and make manageable some of the infinite potentialities of the object. The same, and other, potentialities of the object will be similarly appropriated by other individuals.

This final localization of aesthetic experiences in the individual beholder helps us to confront towering masterpieces with confidence and restraint. Confidence because masterpieces are not there to remain in their intimidating splendor but to be looked at by you and me, and to be related to our individualities. Restraint because our individual response is commensurate with the aesthetic capacity of each of us, capacity that has been shaped by our previous encounters with the visual arts, our memory of other life experiences, and the contemplative skills we have developed. Though our bowl may not be large, it will be filled.

As the aesthetic experience is enclosed within the purview of the beholder, so is the intellectual journey reported in this book.

The topics dealt with were towering too: What is art and what is the experience of it; what is contemplation and how does it differ from cognition and affectivity; what is signification and what is communication. These problems, and other ones touched on in this book, have dominated the intellectual history of the West for several centuries. They too could be intimidating.

Yet we—the readers and the author—embarked on this journey. The aim was to understand intellectually what is implied in our aesthetic encounters with visual objects and what these encounters reveal about art, symbols, and our psyche. Our inquiry was not set on the general level of philosophy, art history, or even anthropology. Certainly we used these disciplines and other ones, but as mirrored in our individual understandings. The moon was carefully observed in its reflection on the water of our bowls, not in the sky.

In this book, the observer of the visual arts was an anthropologist.

Aesthetic Anthropology as Critical Knowledge

AESTHETIC EXPERIENCE IS CONTEMPLATION. THE ANTHROPOLOGY OF AESTHETIC EXPERIENCE is cognition. And it is anthropological cognition, or knowledge: a reality built on the basis of certain data, through certain research methods and logical procedures, and expressed in a certain discourse. Data, methods, procedures, and discourse are anthropological— and not theological or philosophical, for instance—when recognized as such by anthropologists.

Anthropology is what anthropologists practice, anthropologists are those who practice anthropology—this circle is actually a spiral. Suppose a group of nineteenth-century scholars, say, the founders of the Anthropological Society of London, defined anthropology as some matters they wanted to study in a certain manner. Those who later joined the Society continued the same line of study; yet they abandoned some areas of inquiry and opened others, they modified some research techniques, and they invented new ones. For each new generation of anthropologists, anthropology is what they agree to do; it may be something slightly, or significantly, different from what previous generations agreed to do. Building the anthropological reality is an ongoing process of continuity and innovation. This is what the spiral metaphor suggests.

Aesthetic anthropology, as presented here, is in continuity with anthropology as a social science and as a discipline of the humanities. And, cautiously, it goes a little beyond the usual data, the usual research techniques, and the usual types of reasoning.

Critical knowledge is knowledge built with a constant concern for the cognitive value of each step. Scholars, by definition, have this constant concern. In order to achieve the highest certainty attainable in the different fields of scholarship, they use unambiguous concepts and reliable instruments, they carefully check their observations, they avoid unfounded extrapolations of the research results, and they are rigorous in their logical reasoning.

Everyday knowledge is noncritical when, as often happens, we do not check the veracity of gossip, or when we state others' motivations on insufficient grounds. Action-oriented knowledge is noncritical when a careful analysis of a situation matters less than a quick decision. Knowledge based on the authority of gods and scriptures, leaders and party doctrines, elders and tradition is not critical. In all these cases, we do not attempt to evaluate and improve the degree of certainty—the epistemic quality—of what we know.

In the first chapter, we briefly described the paradigm of critical knowledge—theory, hypothesis, and observation. The paradigm is common to the social sciences and humanities. It is mainly at the stage of verifying hypotheses through observation that the social sciences and humanities differ. In the social sciences, verification is principally achieved by correlating quantifiable variations of phenomena; in the humanities, verification is achieved through an interpretive observation of one or more cases.

In aesthetic anthropology, the social sciences' method of correlation of variables may be used and, in fact, has been used. An excellent example of this approach can be found in the article "Art Styles as Cultural Cognitive Maps," by anthropologist John L. Fisher.[1]

Fisher wants to study connections between art styles and sociocultural conditions "in a widely distributed sample of primitive, relatively homogeneous societies."[2] He begins by choosing two sets of variables previously and independently established by psychologist Herbert Barry III, for art styles, and by anthropologist George Peter Murdock, for sociocultural conditions. Barry had selected five stylistic variables (from simple to complex, from empty to crowded, from symmetrical to asymmetrical, from no enclosed figures to enclosed figures, and from straight lines to curved lines) and had rated the graphic arts of thirty societies on each of the five axes. For instance, on the axis from simple to complex design, Andamans is the first society at the "simple" end of the axis, and Marquesas is the first at the "complex" extremity of the same axis.[3]

Three social variables are chosen by Fisher from among those rated by Murdock in his "World Ethnographic Sample."[4] They are egalitarian to hierarchical, male-oriented residence in marriage to female-oriented residence in marriage, and polygyny to monogamy. Fisher's sample is determined by the overlap of Barry's and Murdock's samples; it includes twenty-nine societies.

Fisher's theory is that "a very important determinant of the art form is social fantasy, that is the artist's fantasies about social situations that will give him security or pleasure."[5] From this theory, Fisher deduces hypotheses—sometimes by a rather lengthy chain of deductions—that can be tested by the degree of correlation between some of the stylistic and social variables. One of these hypotheses is the following: "Design with a large amount of empty or irrelevant space should characterize the egalitarian societies; design with little irrelevant (empty) space should characterize the hierarchical societies."[6]

There is thus an expected positive correlation between egalitarian societies and empty forms. The correlation would be perfect if all the egalitarian societies in the sample, and only the egalitarian ones, had graphics with empty forms. In fact, of 19 egalitarian societies, 12 have empty space in design, and 7 have crowded space; and of 9 societies with high stratification, 2 have empty space, and 7 are crowded. The hypothesis is supported at a statistically significant level (p is less than .05).[7]

The correlation method is particularly fruitful in the investigation of limited prob-

lems where two variables may be numerically valued in a manner that does not stretch their usual meaning. Some years ago, Catherine S. Enderton, at that time a graduate student, wanted to test her hypothesis that the important political developments that had occurred in the People's Republic of China during the fifties and the sixties had been reflected in the visual arts.[8]

She took all the color plates published in the Beijing *Chinese Literature* journal from 1952 to 1972, as a nonrepresentative but significant sample of the paintings and drawings of recent China. Enderton rated each of the 523 color plates from 1 to 4 on four axes by answering these questions: Does it contain more contemplative or more active elements? Is it more in the traditional Chinese style or in the Western style? Is it more linear or more painterly? Does it emphasize more the dominance of nature or the dominance of man? "Objective" criteria—in the sense that they could be easily used by raters other than Enderton—were defined in the paper.

The values on the four axes were transformed into annual percentages. For example, in 1956, before the Great Leap Forward, a contemplative maximum of 88 percent was attained on the contemplation–action axis; in 1968, at the peak of the Cultural Revolution, an active maximum of 100 percent was reached.

During the seven years preceding the Cultural Revolution (1959 to 1965), 217 pictures with contemplative dominance were published in *Chinese Literature*, and 119 with active dominance. During the five years of the Cultural Revolution (1966 to 1971), 35 pictures with contemplative dominance and 151 with active dominance were published. At the .01 significance level, the chi-square value was 99.2; thus the correlation between contemplative dominance and pre-Revolution years, and between active dominance and Revolution years can be considered as significant.

The study of aesthetic phenomena by quantitative correlations has also been applied on a large scale. As far back as 1937, Pitirim A. Sorokin published his ambitious *Fluctuation of Forms of Art*, a 750-page book. It was the first volume of a still more ambitious work, the four-volume *Social and Cultural Dynamics*.[9]

The four volumes offer a theoretical explanation of the cultural history of the Western world from the fifth century before Christ to the twentieth century. Sorokin's theory may be summarized in a few statements. The part of a culture which has priority and a determining influence on the other parts is the cultural premise. The cultural premise is a conception of the ultimate reality and of the supreme value. Logically, there can be only three premises. The *sensate* premise states that what we can attain through our senses is the only 'reality'; the *ideational* premise holds that what is beyond our senses is 'real' whereas the world is but an illusory appearance; and the *idealistic* premise affirms the 'reality' of both the world of our senses and the world beyond what they can reach.

The different compartments of a culture are integrated around the dominant premise and reflect it. In the course of history, there has been a cyclical movement among the three premises. During the twenty-five centuries of Western civilization, the cycle has been repeated twice. Before the fifth century B.C., the premise was ideational; during the fifth and the fourth centuries, it became idealistic; and from the third to the first century B.C., the premise was sensate. After a period of transition—first to fourth century A.D.—the cycle was repeated: ideational from fifth to twelfth, idealistic from thirteenth to fourteenth, and sensate from fifteenth to twentieth century.[10]

Sorokin uses two methods of empirical verification: a qualitative analysis carried out by what he calls the logico-meaningful method, and a quantitative analysis achieved by what he calls the causal-functional method. "Such a combination appears to [him] to be the only sound approach in the social sciences. It gives full freedom to logical thought—generalizing and analytical—and, at the same time, it tests its deductions inductively by the relevant empirical facts."[11] In this discussion, we are concerned only with the quantitative procedures.

Paintings and sculptures were classified under different categories according to their content. For instance, they were classed as religious or secular. From the point of view of the "spiritual to sensual atmosphere," art works were classified under five categories: extremely spiritual, moderately spiritual, neutral, moderately sensual, and extremely sensual. Representations of the body, from covered to nude, were distributed under the following headings: body covered, partly covered, uncovered except sex organs, nude with sex organs not depicted, nude with sex organs depicted. Eight types of landscapes were distinguished: urban, rural, mountains, sea, seasons, sunny, gloomy, and with human beings. There were also tables of portrait types according to the social class and the sex of the persons depicted, as well as tables of genre paintings according to such types as everyday life, festivals, and military scenes. The classification according to styles comprised these headings: impressionistic, naturalistic, mixed, expressionistic, and formal.

The span of time to be analyzed was reduced to the twenty centuries of European history. The time distribution was made by century except for the first ten centuries, which were lumped together, and the last two centuries, which were divided into smaller periods.

Two samples of pictures and sculptures made during these two thousand years were independently tabulated. One, including 32,299 items, was analyzed in Prague; and the other, of 16,679 items, was distributed into the same categories in Cambridge, Massachusetts. Here is an example of the results obtained: among the 16,260 seventeenth-century items, 14,722 were classified as naturalistic and impressionistic, 969 as formal, and 569 as mixed.[12] The fluctuations of all these variables were reported on graphs. For Europe, as a whole, the curves of the religious, the spiritual, and the covered body in art revealed a somewhat similar profile. And so did the curves of the secular, the sensual, and the nude.[13]

Sorokin concluded that there was a parallelism between the second cycle of dominant cultural premises (his independent variable) and the fluctuations of several important aspects of art works during the same span of time (his dependent variables). These quantified correlations indeed support Sorokin's contention that at any period of time, the metaphysical part of a culture (its conceptions of ultimate reality and supreme value) and the aesthetic part are integrated.

Sorokin's use of the correlation method in the aesthetic field is open to many criticisms. His categories are often ambiguous and lack clear indicators. He does not say how the two samples were selected nor if they were overlapping. His statistical analysis is crude. Yet it is an attempt that deserves to be studied: it shows the pitfalls of applying the quantitative method to aesthetic data, and it suggests some improvements.

Critical knowledge of aesthetic phenomena may also be achieved through the interpretive observation characteristic of the humanities. In fact, over its short history,

mainstream anthropology has more frequently used interpretive description than quantitative correlation. The latter was confined to a supporting role.

Since the second decade of this century—during which Malinowski spent a long time in the field among the Trobrianders, and Radcliffe-Brown did the same among the Andaman Islanders—typically, anthropological research has been carried out by an anthropologist observing, alone, a small-scale society or a single community for a period of about one to two years. The observer usually went into the field with a theory in mind from which hypotheses were deduced. They were tested through an in-depth observation.

It is obvious that the participant-observer type of research offers more opportunities for interpretive analysis than for statistical correlation. During my first field work, I approached the traditional kingdom of Rwanda from the typical research situation just described. After two years in the field, my book on Rwanda was an interpretation of what the system of government, the social hierarchy, and the feudal institution of the *ubuhake* meant for the Rwanda people. It meant that a premise of inequality pervaded the whole social fabric.[14] Some crucial points of this interpretation were quantitatively verified: I administered a 100-item questionnaire to a sample of 300 individuals belonging to one stratum of the society.[15] The method was primarily interpretive—as in the humanities. Secondarily, it was quantitative in the sense that some of my interpretations were supported by correlated quantified data—as in the social sciences.

In some domains of anthropology, the variables correlation method is particularly appropriate. It is the case with economic anthropology, which deals with surplus and growth, with productivity of techniques and distribution of goods. But in most domains, and aesthetic anthropology is one of them, interpretation remains the primary method.

Remember our discussion about the African equatorial forest environment constituting an obstacle to the development of an elite style in visual objects and being conducive to a folk style. Suppose we want to test this hypothesis deduced from the theory of cultural materialism.

If we chose to test it through the quantitative correlation method, we would first establish a representative sample of the societies of tillers which are known to have existed between the fourth parallel north and the fourth parallel south, and west of the Great Lakes of Africa. Then we would determine whether their system of production was at the subsistence level by consulting a list such as the Human Relations Area Files. Also, we would determine the characteristics of elite art and folk art, find aesthetic objects made in these societies, and have one or several persons rate the objects in terms of the indicators of the characteristics. As a control, we would do the same with a sample of surplus societies of the southern savanna. Finally, we would correlate the numerical values of the "forest variables," stylistic as well as productive, and we would do the same with the "savanna variables." Statistically significant correlations between the production variables and the style variables would confirm the hypothesis.

It could be tested through interpretive observation too. We would select a forest society, for instance the Lega—because they have been studied by an excellent anthropologist, Daniel Biebuyck. We would read his book *Lega Culture*.[16] As readers, we would attempt to understand their farming system, their stateless organization, and their values. We would look at the pictures of their small human figurines and go to museums where some of these figurines could be seen. Then we would proceed in the same manner with, say, the Luba society, a kingdom of the savanna.

This would give us a concrete understanding of a forest subsistence culture and of a savanna surplus culture; and we would have a visual perception of the differences between concrete folk forms and elite forms. We could further expand our study, noticing that some of the elite characteristics of the Luba were analogous to others found in the artifacts of the Kuba, the Cokwe, and the Kongo. Similarly, some of the folk features of Lega objects could be related to some forms produced by the Amba, the Tetela, and the Fang. We might also see differences in styles and try to grasp the meanings of these differences, as well as of the similarities. Finally, we would conclude that there are—or there are not—two cultural models: the subsistence cultures of forest farmers with folk style, and the surplus cultures of savanna kingdoms with elite style.

Anthropologists, usual practitioners of the interpretive approach, sometimes have been intimidated by the dominance of the correlative approach in the natural sciences, such as physics and biology, and in the social sciences, such as economics and sociology. And we have become apologetic about the epistemic value of our enterprise. Should we be so?

As stated above, there is only one paradigm of critical knowledge—theory, hypothesis, and observation. Qualitative interpretation and quantitative correlation are different methods of hypothesis testing. Observations, made and presented either qualitatively or quantitatively, will confirm, or not confirm, the hypothesis. Correct observations are thus of paramount importance in the search for epistemic quality.

Observations are correct when made according to an explicitly described procedure that is always the same. The procedure defines the observation. Cold and warm are what is measured by the variations of the mercury in a thermometer. Light is what is measured by the variations of the indicator of a light meter. Gothic is the architectural configuration characterized by the pointed arch, rib vault, and flying buttress. Aesthetic perception is indicated by concentrated, holistic, and disinterested attention. Temperature, light, style, and a specific type of perception can be correctly observed if the same measuring instrument or the same conceptual tool is applied in each case.

Conceptual constructs, the usual tools of interpretation, and instruments, the usual tools of physical and biological observation, may be crude or elaborate, easy or difficult to apply. When consistently used, they provide observers with comparable and reliable observations.

Defining facts or data by the procedure of observation makes it possible for other researchers to replicate observations. When procedures are fully described, the research may be repeated; idiosyncratic biases, if there were any, can be discovered and eliminated. This is why replicability is essential to critical knowledge.[17]

When observations have been correctly made, they provide a valid basis for testing hypotheses. The method of quantitative correlation is not superior to qualitative interpretation. Each of them permits hypotheses to be confronted with "facts." As anthropologists, we habitually use the interpretive approach; we should not be ashamed of it.

The difference between the approach of the sciences and the approach of the humanities is in the kind of hypotheses to be tested. (I follow here the common usage which limits the term *science* to a discipline of knowledge primarily using the quantitative correlation method.) Scientific hypotheses are more abstract than those of the humanities. The social scientist will formulate only hypotheses that can be verified by correlating numerical values of variables, for example, the number of bodies represented "uncovered

except sex organs" in seventeenth-century pictures. The hypotheses that can be tested by such quantified data have to be pretty abstract—and shallow.

Between forty and fifty thousand art works have been "processed" by Sorokin's Prague and Cambridge evaluators. This has confirmed his hypothesis that there is a positive correlation between the fluctuations of the three metaphysical premises and the fluctuations of art variables. It also demonstrates that during the last twenty centuries of the Western European cultures, there has been a correspondence between world views and aesthetic configurations. This is one of the hypotheses of this book.

A scholar in the humanities would express the Sorokin idea in a similar hypothesis and test it by an in-depth interpretation of a few philosophic and artistic ideational systems within the context of a few concrete cultures of Western Europe. The hypothesis—that there is indeed a correspondence between metaphysical premises and visual forms—would be confirmed by the analysis of only a few cases. A thorough description would reveal the mechanisms of the correspondence, make it understandable, and indicate under what conditions we may expect it in cases not studied.

Like mainstream anthropology, aesthetic anthropology achieves critical knowledge through correlating quantified variables or through interpreting in depth the meanings of cultural phenomena. Because many aspects of the aesthetic experience cannot be translated into numerically valued variables without losing their significance, they will be approached in the perspective of the humanities. Anthropologists specializing in comparative aesthetics will assume the role of scholars more often than the role of scientists.

They also will have to assume the role of trailblazers. The aesthetic experience, as an object of anthropological study, introduces us to the field of inner phenomena. Anthropologists are not trained to deal with purely mental phenomena. Because these phenomena cannot be observed from without, they should be observed from within through the experiential approach; unfortunately, the experiential method seems to negate any possibility of critical knowledge. Finally, relations among ideational configurations are described as correspondences, and relations between symbols and their signifieds are analyzed as participations; a logic of correspondence and participation seems to be out of place in the discourse of critical knowledge that is dominated by a logic of causality.

We can identify art objects by external indicators, such as "being displayed in museums"; we did just that in the first stage of our study. But this identification does not reveal what these objects mean for the people of our culture. Another indicator we used, "objects made or selected for an exclusive visual use," also leaves the cultural meanings of these objects opaque. As a discipline of the humanities, anthropology is concerned with meanings. In this case, the meanings lie in the inner experience of the beholder.

Anthropological observers can certainly become beholders instead of being observers of beholders. This method of inquiry, the experiential method, is an active participation in the inner process to be studied, and an analytical observation of the process in one's own consciousness.[18] Obviously, there are limits to the applicability of this method, and in certain circumstances, the experiential approach may raise questions of deontology or plain personal honesty. I have briefly discussed some of these limits elsewhere.[19] The observer's participation in aesthetic perceptions does not bring up any of these problems, however. Here, we shall consider only the epistemic value of the experiential method: Does this method generate observations that meet the anthropological criteria of critical knowledge?

As in any other discipline of knowledge, the diversity of anthropological criteria

must meet the common requirement of replicability. Observations that cannot be replicated may be correct, but they are outside the scope of disciplines of knowledge. Can inner observations be replicated by other observers and used to test the same hypothesis? Can they confirm or not confirm the same hypothesis?

Inner observations may be replicated as field observations may be replicated. The conditions of conventional field research in anthropology—the anthropologist observing alone a small community for an extended period of time—do not allow the same kind of replication that is made possible by laboratory conditions. But anthropologists are expected to conduct research in such a way that similarly trained persons, using the same conceptual systems and the same techniques, can make comparable observations.

Observers of the inner field can also make their conceptual system clear and operational. After all, it is the aim of the terminology of a discipline. During the last two decades or so, the concern for the "natives' point of view" has become predominant; as a result emic categories, those "regarded as appropriate by the actors themselves," have been given priority over etic categories, those "judged appropriate by the community of scientific observers."[20] A system of etic categories in the fields of aesthetic experience and the contemplative mode of consciousness is still in the making.[21] Through explanation and discussion, examples and comparisons, concepts such as concentration, disinterestedness, and expressivity may be clarified and become unambiguous in the scholarly discourse of anthropological observers. They will retain in everyday discourse—and in literary discourse—some vagueness and uncertainty of meaning, but observers may agree on one meaning and make these concepts monosemic. An agreement is not even necessary: as long as an observer elucidates the meanings of the conceptual tools used in observation, this original observer makes it possible for others to replicate the observations. A clear conceptual system can always be translated into another conceptual system.

Emic categories are also translatable because anthropologists' inner observations allow them to understand what "natives" experience and say about those experiences. In that respect, the anthropologists' experiences are experiential referents that allow them to grasp what people of another culture say about their visual experience. We want to know if they have an emic category corresponding to, say, our etic category of "aesthetic experience."

Understanding conceptual systems that are alien because they were elaborated in another cultural tradition, or in the same cultural tradition but long ago, is not a new problem. Textual scholars, ancient commentators of all great traditions, as well as Western philologists of modern times, have demonstrated that hermeneutics, the methodology of interpretation, can retrieve conceptual systems and make them understandable across cultural barriers. A language, even the spoken language of everyday life, also reveals an emic conceptual system, if studied as a text.

Data provided by careful observation of our inner life should not be banished from the anthropological realm. These observations are replicable and therefore contribute to the building of a body of critical knowledge. They may have an epistemic value of the same order as the data collected in a usual field situation. Irrespective of their internal or external nature, observations will improve in cognitive value whenever their replicability increases through more rigorous and more explicit concepts and techniques.

Aesthetic anthropology demonstrates that our area of research should not be re-

stricted to what is conventionally recognized as "observable": tangible artifacts and visible behaviors. It should not be restricted to the logical field governed by the principles of identity and causality either.

Symbols participate in the nature of what they stand for. They are neither identical nor nonidentical to their signifieds. This is a type of unusual logical relation. It is logical in the sense that it is a pattern in the ordering of ideas; it is unusual in the sense that this symbolic relation does not fit into our rational logic based on the postulates of identity, contradiction, and the excluded third.

Anthropology is governed by rational logic, but the aesthetic and the symbolic studied by anthropologists are not. In descriptions and analyses we should venture into these fields, we should use the appropriate maps, and we should not impose a rational logic on ideas connected through other patterns.

Causality is another relationship belonging to the field of rational logic. We have discovered that it is not appropriate to describe by causality the relationships among configurations of ideas such as visual styles, philosophic doctrines, and world views. These relations are better qualified by the term *correspondences*.

The anthropological study of aesthetic and symbolic phenomena suggests that more scholarly attention should be paid to logics other than the rational, even in the industrial societies of the contemporary world.

As a concluding comment, I would like to say that the phenomenological perspective stated at the beginning of this book, though not mentioned again, was not lost.

Works of art and aesthetic objects, styles and societal networks, contemplation and the aesthetic experience are constructed realities. There are not external entities, material or nonmaterial, to which our cognitive constructs should be compared to assess their "truth." There are only realities built in the mind.

The facts we observe in order to test our hypotheses are previously built realities. Our newly constructed hypotheses must fit what are considered as facts by the consensus of scholars and scientists who have preceded us.

This is how critical knowledge is interpreted from a phenomenological perspective.

Notes

Chapter 1: *The Reality Anthropologists Build*

1. Maquet 1974a.
2. Maquet 1972a.
3. Tylor 1871:1.
4. Goldschmidt 1976:3.
5. Ibid.
6. Maquet 1979.
7. Berger and Luckmann 1966.
8. Kuhn 1962.

Chapter 2: *Art in Everyday Reality*

1. Lima 1971.
2. Maquet 1979.
3. Malraux 1967.
4. For a discussion of "primitive art" definitions proposed by Warren L. d'Azevedo and George Mills, and implied in Robert Farris Thompson's Yoruba studies, see Anderson 1970:13–22.

Chapter 3: *The Aesthetic Vision*

1. Staal 1975:124.
2. Brody 1970:27–31.
3. Osborne 1970b: 27–37.
4. Ibid., 28–29.
5. Ibid., 29.
6. Ibid., 30.
7. Ibid., 31.

Chapter 4: *The Significance of Form*

1. Haftmann 1972, 1:41–42.
2. Maquet 1979:18.
3. Weber 1980:109.
4. Osborne 1970b:31.

Chapter 5: *Aesthetic Vision as Contemplative*

1. On the *Yoga Sūtra,* see Woods 1927, Feuerstein 1979, and Hariharānanda Āraṇya 1981; on the *Visuddhimagga,* see Rhys Davids 1975 and Ñāṇamoli 1975.
2. The Vyāsa and Vāchaspatimiśra commentaries, together with the aphorisms, were translated by Woods (1927); the book is 350 pages.
3. For instance, Vivekananda 1973, Prabhavananda and Isherwood 1969, and Taimni 1972.
4. Woods 1927:8.
5. Ñāṇamoli 1975:85, 178.
6. Woods 1927:19, 24, 26, 31; Feuerstein 1979:30ff.
7. Ñāṇamoli 1975:248.
8. Osborne 1970b:30.
9. Woods 1927:36.
10. Osborne 1970b:35.
11. Ñāṇamoli 1975:144–61.
12. Maquet 1975, 1980.
13. Maquet 1975:183; Maquet 1980:141.
14. Maquet 1976.
15. Bogen 1973:111.
16. Ibid., 107.

Chapter 6: *Aesthetic Experience in Other Cultures*

1. Leiris and Delange 1968:40–45.
2. Munro 1965.
3. De 1963, Pandey 1950 and 1963, and Walimbe 1980. See also Gnoli 1956.
4. Maquet 1979:21.
5. For a discussion of the relationships between leadership and its aesthetic manifestations in traditional Africa, see Fraser and Cole 1972, and my review of it (Maquet 1973a).
6. For a discussion of the Baule whisks, see Himmelheber 1972:185–208; for the Lega ivory figurines, see Biebuyck 1973:149–81; and for the rank sculptures of New Hebrides, see Guiart 1963:35–38, 232.

Chapter 7: *Art in Other Cultures*

1. This was the case among the Dogon (Leiris and Delange 1968:142) and the Bamileke (Balandier and Maquet 1974:44–46).
2. Maquet 1979:36.
3. Leiris and Delange 1968:35.
4. Maquet 1979:36.
5. See Read 1964.
6. Delange 1974:148–50. The Bororo-Fulani are also known as the Wodaabe.
7. Maquet 1973b.
8. Goldwater 1967 and Laude 1971. For a thorough analysis of the African art influence on French painting during the years 1905–14, see Laude 1968.
9. Laude 1971:12.
10. Maquet 1972b:35, 41.
11. Goldwater 1967:5.
12. Morgan 1877.
13. Haddon 1895:317–18.
14. Laude 1968:29–36; Goldwater 1967:104–40; Kahnweiler 1963:222–36.
15. Haftmann 1972, 1:88.
16. Einstein 1961.
17. Quoted in Newton 1981:10.
18. For example, Apollinaire 1917, Guillaume and Munro 1926, and Olbrechts 1959.
19. Goldwater 1967:273ff.

Chapter 8: *Meanings in Aesthetic Objects*

1. Clark 1956:23–25.
2. Arnheim 1974:155.
3. Ramos 1979:5–7.
4. Clark 1956:359.

Chapter 9: *Visual Forms as Signs*

1. American Heritage Dictionary 1982: s.v. "star."
2. Such is the case of Cirlot 1962.
3. Peirce 1931–35, vol. 2, par. 92.
4. Maquet 1982:3.
5. See Peirce 1931–35, vol. 2 par. 92.
6. Lalande 1947:1058 (my translation).
7. Peirce 1931–35, vol. 2, par. 248.
8. Spiro 1982:55.

Chapter 10: *Visual Forms as Symbols*

1. Maquet 1972a:145.
2. Arnheim 1974.
3. Ibid., 359.
4. Ibid., 360.
5. See ibid., 425–26.
6. See McElroy 1954.
7. Maquet 1982:8.
8. See American Heritage Dictionary 1982: s.v. "religion."
9. Spiro 1966:95.
10. See Maquet 1982:7.
11. Ibid., 7, 8.

Chapter 11: *The Aesthetic Quality*

1. Munro 1967:31.
2. Henri 1974:148.
3. Kohler, in Henly 1971:116.
4. See Ellis 1967:54; and Arnheim 1949:163.
5. A most illuminating study of visual composition is Arnheim's *The Power of the Center* (1982). On the significance of form, see the first exponent of the "significant form" (Bell 1958:17ff.); Langer 1953:24ff.; and Langer 1976:203ff.

Chapter 12: *Preferences in Art*

1. Henri 1974:27–185.
2. Gray 1971:131–83.

Chapter 13: *Between Creators and Beholders*

1. Geist 1969:104.
2. The dichotomy presented by Alexander Alland, Jr. (1977:69–70), semantic information and aesthetic information, is analogous to the distinction between message and meaning.
3. See Francastel 1965.
4. For a semiotic discussion of signification and communication, see Eco 1976:32–47.

5. Fernandez 1982a, 1982b.
6. Eco 1962.

Chapter 14: *Aesthetic Vision, a Selfless Experience*

1. Nyanaponika Thera 1962:30.
2. Waldman 1978:69.
3. Ibid., 65.
4. See the *Māhā Satipaṭṭāna-Sutta,* translated from the *Dīgha-Nikāya* by T. W. Rhys Davids and C. A. F. Rhys Davids (1971:327–46). A better translation is found in Nyanaponika Thera 1962:117–35.
5. Zinberg 1977:205, 230.
6. Maquet 1980:149.
7. Osborne 1970b:35.
8. Ibid., 23.
9. Maquet 1980:150.

Chapter 15: *The Cultural Component in Aesthetic Objects*

1. Kluckhohn and Murray 1948:35, 46.
2. For a description of metaphysical idealism, see Osborne 1970a:87–99.
3. Oxford Companion to Art 1970: s.v. "Caravaggisti."

Chapter 16: *The Aesthetic Segment of a Culture*

1. Osgood 1940, 1958, 1959.
2. Maquet 1961, 1971, 1972a, 1972b.
3. See diagram in Maquet 1979:58.

Chapter 17: *Techniques of Production and Aesthetic Forms*

1. See Maquet 1972a:71; and Balandier and Maquet 1974: s.v. "ancestors" and "sculpture, stone."
2. Balandier and Maquet 1974:297.
3. Maquet 1972a:137.
4. Oxford Companion to Art 1970: s.v. "Paxton, Sir Joseph."
5. Ibid., s.v. "Eiffel, Gustave."
6. Lucie-Smith 1969:106.
7. Maquet 1979:70.
8. Maquet 1972a:68–73.
9. Turnbull 1972.
10. Vasarely 1965: 35, 36. See Maquet 1970:56n.
11. Focillon 1955.

12. See the contributions of Sidney Mintz, Maurice Godelier, and Bruce Trigger in *On Marxian Perspectives in Anthropology* (Maquet and Daniels 1984). On the term *cultural materialism,* see Harris 1968 and Harris 1979:x.

Chapter 18: *Societal Networks and Aesthetic Forms*

1. Maquet 1971:21–26.
2. See Greenberg 1961.
3. See a diagram of stratification and government in traditional Rwanda, in Maquet 1971:158.
4. Gray 1971:9–36.
5. See Gray 1971:185–218.
6. Quoted in Gray 1971:219.
7. Quoted in Oxford Companion to Twentieth-Century Art 1981: s.v. "Tatlin."
8. Ibid.
9. Ibid., s.v. "Russia and the U.S.S.R."
10. Hinz 1979:41.
11. Encyclopedia of the Social Sciences 1968: s.v. "Totalitarianism," by Herbert J. Spiro.
12. Berger 1965:164, 165.

Chapter 19: *Aesthetic Forms and Other Ideational Configurations*

1. Francastel 1965:100–01 (my translation).
2. Maquet 1974b:125.
3. Laude 1971:215–39.
4. Ibid., 217, 221.
5. Mao Tse-tung, 1965:25, 26. Mao Tse-tung was the usual romanization of the name of the Communist leader (1893–1976) before the presently accepted *pinyin* form, Mao Zedong.
6. Ibid., 19–20.

Appendix: *Aesthetic Anthropology as Critical Knowledge*

1. Fisher 1971.
2. Fisher 1971:172.
3. Barry 1957.
4. Murdock 1957.
5. Fisher 1971:173.
6. Ibid., 176.
7. Ibid., 180.
8. Catherine S. Enderton, "Mao Tse-tung and the Arts of China." Paper presented as a course requirement in aesthetic anthropology, Department of Anthropology, University of California, Los Angeles, 28 November 1972.

9. Sorokin 1937a, 1937b, 1937c, 1941.
10. Maquet 1974a:132–33.
11. Sorokin 1937a:xi.
12. Ibid., 393.
13. Ibid., 418–19.
14. Maquet 1961.
15. Ibid., 173–85.
16. Biebuyck 1973.
17. On the validity, reliability, and replicability of observations, see Pelto 1970:34, 35, 41, 42.
18. A sustained application of the experiential method was the main research approach of Larry Peters (1981) in his excellent study of Tamang Shamanism in Nepal.
19. Maquet 1981.
20. Harris 1968:571, 575.
21. Such a system of sophisticated categories has been presented in three books by Robert Plant Armstrong (1971, 1975, 1981).

Works Cited

Alland, Alexander, Jr. 1977. *The Artistic Animal. An Inquiry into the Biological Roots of Art.* Garden City, N.Y.: Doubleday, Anchor Books.

American Heritage Dictionary. 1982 [1969]. *The American Heritage Dictionary of the English Language.* Ed. William Morris. Rev. college ed. Boston: Houghton Mifflin.

Anderson, Richard L. 1979. *Art in Primitive Societies.* Englewood Cliffs, N.J.: Prentice-Hall.

Apollinaire, Guillaume. 1917. *Sculptures nègres.* Paris: Paul Guillaume.

Armstrong, Robert Plant. 1971. *The Affecting Presence: An Essay in Humanistic Anthropology.* Urbana: University of Illinois Press.

———. 1975. *Wellspring: On the Myth and Source of Culture.* Berkeley and Los Angeles: University of California Press.

———. 1981. *The Powers of Presence: Consciousness, Myth, and Affecting Presence.* Philadelphia: University of Pennsylvania Press.

Arnheim, Rudolf. 1949. "The Gestalt Theory of Expression." *Psychological Review* (Lancaster, Pa.) 56, no. 3: 156–71.

———. 1974 [1954]. *Art and Visual Perception.* Rev. ed. Berkeley and Los Angeles: University of California Press.

———. 1982. *The Power of the Center: A Study of Composition in the Visual Arts.* Berkeley and Los Angeles: University of California Press.

Balandier, Georges and Jacques Maquet, eds. 1974 [French ed. 1968]. *Dictionary of Black African Civilization.* New York: Leon Amiel.

Barry, Herbert, III. 1957. "Relationships between Child Training and the Pictorial Arts." *Journal of Abnormal and Social Psychology* (Washington, D.C.) 54:380–83.

Bell, Clive. 1958 [1914]. *Art.* New York: Capricorn.

Berger, John. 1965. *Success and Failure of Picasso.* Harmondsworth: Penguin Books.

Berger, Peter L., and Thomas Luckmann. 1966. *The Social Construction of Reality.* Garden City, N.Y.: Doubleday.

Biebuyck, Daniel. 1973. *Lega Culture.* Berkeley and Los Angeles: University of California Press.

Bogen, Joseph E. 1973. "The Other Side of the Brain: An Appositional Mind." In *The Nature of Human Consciousness,* ed. Robert E. Ornstein, 101–25. San Francisco: W. H. Freeman.

Brandt, Henry. 1956. *Nomades du soleil.* Lausanne: La Guilde du Livre et Editions Clairefontaine.

Brody, Grace F. 1970. "The Development of Visual Aesthetic Preferences in Young Children." *Sciences de l'Art / Scientific Aesthetics* (Paris) 7, nos. 1–2: 27–31.

256

Capa, Cornell, and Bhupendra Karia, eds. 1974. *Robert Capa, 1913–1954.* New York: Viking Press.

Chadwick, George F. 1961. *The Works of Sir Joseph Paxton, 1803–1865.* London: The Architectural Press.

Cirlot, J. E. 1962 [Spanish ed. 1958]. *A Dictionary of Symbols.* New York: Philosophical Library.

Civilisations. 1966. *Civilisations, peuples et mondes.* 7 vols. Paris: Editions Lidis.

Clark, Kenneth. 1956. *The Nude: A Study in Ideal Form.* Garden City, N.Y.: Doubleday.

De, S. K. 1963. *Sanskrit Poetics as a Study of Aesthetics.* Berkeley and Los Angeles: University of California Press.

Delange, Jacqueline. 1974 [French ed. 1967]. *The Art and Peoples of Black Africa.* New York: Dutton.

Eco, Umberto. 1962. *Opera Aperta.* Milan: Bompiani.

———. 1976. *A Theory of Semiotics.* Bloomington: Indiana University Press.

Einstein, Carl. 1961 [German ed. 1915]. "La Sculpture nègre." *Médiations* (Paris) 3: 93–114.

Ellis, Willis D., ed. 1967. *A Source Book of Gestalt Psychology.* New York: Humanities Press.

Encyclopedia of the Social Sciences. 1968. *International Encyclopedia of the Social Sciences.* Ed. David L. Sills. New York: Macmillan.

Fernandez, James W. 1982a. "The Dark at the Bottom of the Stairs." In *On Symbols in Anthropology. Essays in Honor of Harry Hoijer, 1980,* ed. Jacques Maquet, 13–43. Malibu, Calif.: Undena Publications.

———. 1982b. *Bwiti. An Ethnography of the Religious Imagination in Africa.* Princeton, N.J.: Princeton University Press.

Feuerstein, Georg. 1979. *The Yoga-Sūtra of Patañjali.* Folkestone, Kent: Dawson.

Fisher, John L. 1971 [1961]. "Art Styles as Cultural Cognitive Maps." In *Art and Aesthetics in Primitive Societies,* ed. Carol F. Jopling, 171–92. New York: E. P. Dutton.

Focillon, Henri, 1955 [1939]. *Vie des Formes.* Paris: Presses universitaires de France.

Fondation Maeght. 1967. *Dix ans d'art vivant, 1955–1965.* Saint-Paul, Alpes Maritimes: Fondation Maeght.

Francastel, Pierre. 1965 [1954]. *Peinture et société.* Paris: Gallimard.

Frankfurter Kunstverein. 1975. *Kunst im 3. Reich. Dokumente der Unterwerfung.* Frankfurt am Main: Frankfurter Kunstverein.

Fraser, Douglas, and Herbert M. Cole, eds. 1972. *African Art and Leadership.* Madison: University of Wisconsin Press.

Geist, Sidney. 1969. *Constantin Brancusi, 1876–1957: A Retrospective Exhibition.* New York: The Solomon R. Guggenheim Foundation.

Gnoli, Raniero. 1956. *The Aesthetic Experience According to Abhinavagupta.* Rome: Istituto Italiano per il Medio ed Estremo Oriente.

Goldschmidt, Walter. 1976. *Culture and Behavior of the Sebei: A Study in Continuity and Adaptation.* Berkeley and Los Angeles: University of California Press.

Goldwater, Robert. 1967. *Primitivism in Modern Art.* Rev. ed. New York: Random House.

Gray, Camilla. 1971 [1962]. *The Russian Experiment in Art, 1863–1922.* New York: Harry N. Abrams.

Greenberg, Clement. 1961. *Art and Culture: Critical Essays.* Boston: Beacon Press.

Guiart, Jean. 1963 [French ed. 1963]. *The Art of the South Pacific.* London: Thames and Hudson.

Guillaume, Paul, and Th. Munro. 1926. *Primitive Negro Sculpture.* New York: Harcourt, Brace.

Haddon, Alfred C. 1895. *Evolution in Art.* London: W. Scott.

Haftmann, Werner. 1972 [German ed. 1965]. *Painting in the Twentieth Century.* 2 vols. New York: Praeger.

Hariharānanda Āraṇya, Swāmi. 1981 [1963]. *Yoga Philosophy of Patañjali.* Calcutta: University of Calcutta.

Harris, Marvin. 1968. *The Rise of Anthropological Theory. A History of Theories of Culture.* New York: Thomas Crowell.

————. 1979. *Cultural Materialism: The Struggle for a Science of Culture.* New York: Random House.

Henly, Mary, ed. 1971. *The Selected Papers of Wolfgang Kohler.* New York: Liveright.

Henri, Adrian. 1974. *Total Art. Environments, Happenings, and Performance.* New York: Oxford University Press.

Himmelheber, Hans. 1972. "Gold-Plated Objects of Baule Notables." In *African Art and Leadership,* ed. Douglas Fraser and Herbert M. Cole, 185–208. Madison: University of Wisconsin Press.

Hinz, Berthold. 1979 [German ed. 1974]. *Art in the Third Reich.* New York: Pantheon Books.

Hoebel, E. Adamson. 1972. *Anthropology. The Study of Man.* 4th ed. New York: McGraw-Hill.

Kahnweiler, Daniel-Henry. 1963. *Confessions esthétiques.* Paris: Gallimard.

Kluckhohn, Clyde, and Henry A. Murray. 1948. "Personality Formation: The Determinants." In *Personality in Nature, Society and Culture,* ed. Clyde Kluckhohn and Henry A. Murray, 35–48. New York: Alfred A. Knopf.

Knoll. 1971. *Knoll au Louvre. Catalog of the Exhibition.* New York: Knoll International.

Kuhn, Thomas. 1962. *The Structure of Scientific Revolutions.* Chicago: University of Chicago Press.

Lalande, André, ed. 1947 [1902–23]. *Vocabulaire technique et critique de la Philosophie.* 5th ed. Paris: Presses universitaires de France (for the Société française de Philosophie).

Langer, Susanne K. 1953. *Feeling and Form. A Theory of Art Developed from "Philosophy in a New Key."* New York: Charles Scribner's Sons.

————. 1976 [1942]. *Philosophy in a New Key. A Study in the Symbolism of Reason, Rite, and Art.* 3d. ed. Cambridge, Mass.: Harvard University Press.

Laude, Jean. 1968. *La Peinture française et "l'Art nègre."* 2 vols. Paris: Klincksieck.

————. 1971 [French ed. 1966]. *The Arts of Black Africa.* Berkeley and Los Angeles: University of California Press.

Leiris, Michel, and Jacqueline Delange. 1968 [French ed. 1967]. *African Art.* New York: Golden Press.

Lima, Mesquitela. 1971. *Fonctions sociologiques des figurines de culte 'hamba' dans la société et dans la culture tshokwé (Angola).* Luanda, Angola: Instituto de Investigação Científica de Angola.

Lucie-Smith, Edward. 1969. *Late Modern. The Visual Arts since 1945.* New York: Praeger.

McElroy, W. A. 1954. "A Sex Difference in Preferences for Shapes." *British Journal of Psychology* (London) 45:209–16.

Malraux, André. 1967 [French ed. 1947]. *Museum Without Walls.* New York: Doubleday.

Mao Tse-Tung [Mao Zedong]. 1965 [Chinese ed. 1953]. *Talks at the Yenan Forum on Literature and Art.* Peking: Foreign Languages Press.

Maquet, Jacques. 1961 [French ed. 1954]. *The Premise of Inequality in Ruanda. A Study of Political Relations in a Central African Kingdom.* London: Oxford University Press.

————. 1971. *Power and Society in Africa.* New York: McGraw-Hill.

————. 1972a [French ed. 1962]. *Civilizations of Black Africa.* New York: Oxford University Press.

————. 1972b [French ed. 1967]. *Africanity. The Cultural Unity of Black Africa.* New York: Oxford University Press.

————. 1973a. "Establishment Images and Elite Adornments." In *Arts in Society* (Madison, Wis.) 10, no. 2: 297–301.

————. 1973b. "The Fading Out of Art in Industrially Advanced Societies." *Journal of Symbolic Anthropology* (The Hague) 2: 21–26.

————. 1974a. [French ed. 1951]. *The Sociology of Knowledge.* Westport, Conn.: Greenwood.

————. 1974b. "Isomorphism and symbolism as 'explanations' in the analysis of myths." In *The Unconscious in Culture. The Structuralism of Claude Lévi-Strauss in Perspective,* ed. Ino Rossi, 123–33. New York: E. P. Dutton.

————. 1975. "Expressive Space and Theravāda Values: A Meditation Monastery in Sri Lanka." *Ethos* (Berkeley, Calif.) 3, no. 1: 1–21.

—————. 1976. "The World / Nonworld Dichotomy." In *The Realm of the Extra-Human. Ideas and Actions*, ed. Agehananda Bharati, 55–68. The Hague: Mouton.

—————. 1979 [1971]. *Introduction to Aesthetic Anthropology*. 2d ed., rev. Malibu, Calif.: Undena Publications.

—————. 1980. "Bhāvanā in Contemporary Sri Lanka: The Idea and Practice." In *Buddhist Studies in Honour of Walpola Rāhula*, ed. Somaratna Balasooriya and others, 139–53. London: Gordon Fraser.

—————. 1981. "Scholar and Shaman." Introduction to *Ecstasy and Healing in Nepal*, by Larry Peters, 1–6. Malibu, Calif.: Undena Publications.

—————. 1982. "The Symbolic Realm." In *On Symbols in Anthropology. Essays in Honor of Harry Hoijer, 1980*, ed. Jacques Maquet, 1–11. Malibu, Calif.: Undena Publications.

Maquet, Jacques, and Nancy Daniels, eds. 1984. *On Marxian Perspectives in Anthropology. Essays in Honor of Harry Hoijer, 1981*. By Sidney Mintz, Maurice Godelier, and Bruce Trigger. Malibu, Calif.: Undena Publications.

Morgan, Lewis H. 1877. *Ancient Society*. New York: World Publishing.

Munro, Thomas. 1965. *Oriental Aesthetics*. Cleveland: Press of Western Reserve University.

—————. 1967 [1949]. *The Arts and Their Interrelations*. Cleveland: Press of Western Reserve University.

Murdock, George Peter. 1957. "World Ethnographic Sample." *American Anthropologist* (Washington, D.C.) 59: 664–87.

Ñāṇamoli, Bhikkhu, trans. 1975 [1956]. *The Path of Purification (Visuddhimagga) by Bhadantācariya Buddhaghosa*. Kandy, Sri Lanka: Buddhist Publication Society.

Newton, Douglas. 1981. "The Art of Africa, the Pacific Islands, and the Americas. A New Perspective." *The Metropolitan Museum of Art Bulletin* (New York) 39, no. 2.

Norberg-Schulz, Christian. 1975 [Italian ed. 1974]. *Meaning in Western Architecture*. New York: Praeger.

Nyanaponika Thera. 1962. *The Heart of Buddhist Meditation*. London: Rider and Co.

Olbrechts, Frans M. 1959 [Dutch ed. 1946]. *Les Arts Plastiques du Congo belge*. Brussels: Editions Erasme.

Osborne, Harold. 1970a [1968]. *Aesthetics and Art Theory. An Historical Introduction*. New York: Dutton.

—————. 1970b. *The Art of Appreciation*. London: Oxford University Press.

Osgood, Cornelius. 1940. *Ingalik Material Culture*. New Haven, Conn.: Yale University Press.

—————. 1958. *Ingalik Social Culture*. New Haven, Conn.: Yale University Press.

—————. 1959. *Ingalik Mental Culture*. New Haven, Conn.: Yale University Press.

Oxford Companion to Art. 1970. *The Oxford Companion to Art*. Ed. Harold Osborne. Oxford: Oxford University Press.

Oxford Companion to Twentieth-Century Art. 1981. *The Oxford Companion to Twentieth-Century Art*. Ed. Harold Osborne. Oxford: Oxford University Press.

Pandey, Kanti Chandra. 1950. *Comparative Aesthetics*. Vol. 1, *Indian Aesthetics*. Banaras [Varanasi], India: Chowkhamba.

—————. 1963 [1936]. *Abhinavagupta: An Historical and Philosophical Study*. 2d ed. Varanasi: Chowkhamba.

Peirce, Charles Sanders. 1931–35. *Collected Papers*. 8 vols. 1–6, ed. Charles Hartshorne and Paul Weiss. Cambridge, Mass.: Harvard University Press.

Pelto, Pertti J. 1970. *Anthropological Research. The Structure of Inquiry*. New York: Harper and Row.

Peters, Larry. 1981. *Ecstasy and Healing in Nepal*. Malibu, Calif.: Undena Publications.

Prabhavananda, Swami, and Christopher Isherwood, trans. 1969 [1953]. *How to Know God. The Yoga Aphorisms of Patanjali*. New York: New American Library, Mentor Books.

Ramos, Mel. 1979. *Mel Ramos. Watercolors*. Berkeley, Calif.: Lancaster-Miller.

Read, Herbert. 1964 [1934]. *Art and Industry. The Principles of Industrial Design*. Bloomington: Indiana University Press.

Rhys Davids, C. A. F., ed. 1975 [1920–21]. *The Visuddhimagga of Buddhaghosa.* London: Pali Text Society.

Rhys Davids, T. W., and C. A. F. Rhys Davids, trans. 1971 [1910]. *Dialogues of the Buddha, Part II.* London: Luzac and Co. (for the Pali Text Society).

Snellgrove, David L., ed. 1978. *The Image of the Buddha.* Tokyo and Paris: Kodansha International / UNESCO.

Sorokin, Pitirim A. 1937a. *Fluctuation of Forms of Art.* Vol. 1, *Social and Cultural Dynamics.* New York: American Book Co.

———. 1937b. *Fluctuation of Systems of Truth, Ethics and Law.* Vol. 2, *Social and Cultural Dynamics.* New York: American Book Co.

———. 1937c. *Fluctuation of Social Relationships, War and Revolution.* Vol. 3, *Social and Cultural Dynamics.* New York: American Book Co.

———. 1941. *Basic Problems, Principles and Methods.* Vol. 4, *Social and Cultural Dynamics.* New York: American Book Co.

Spiro, Melford E. 1966. "Religion: Problems of Definition and Explanation." In *Anthropological Approaches to the Study of Religion,* ed. Michael Banton, 85–126. London: Tavistock Publications.

———. 1982. "Collective Representations and Mental Representations in Religious Symbolic Systems." In *On Symbols in Anthropology. Essays in Honor of Harry Hoijer, 1980,* ed. Jacques Maquet, 45–72. Malibu, Calif.: Undena Publications.

Staal, Frits. 1975. *Exploring Mysticism.* Berkeley and Los Angeles: University of California Press.

Taimni, I. K. 1972 [1961]. *The Science of Yoga. The Yoga-Sūtras of Patañjali in Sanskrit, with Transliteration in Roman, Translation in English, and Commentary.* Wheaton, Ill.: Theosophical Publishing House.

Turnbull, Colin M. 1972. *The Mountain People.* New York: Simon and Schuster.

Tylor, E. B. 1871. *Primitive Culture.* London: J. Murray.

Van Offelen, Marion, and Carol Beckwith.

1983. *Nomads of Niger.* New York: Harry N. Abrams.

Vasarely, Victor. 1965. *Vasarely.* Neuchâtel: Editions du Griffon.

Vivekananda, Swami. 1973. "Patañjali's Yoga Aphorisms." In *Raja-Yoga,* by Swami Vivekananda, 105–267. Calcutta: Advaita Ashrama.

Waldman, Diane. 1978. *Mark Rothko, 1903–1970. A Retrospective.* New York: Harry N. Abrams (in collaboration with the Solomon R. Guggenheim Foundation).

Walimbe, Y. S. 1980. *Abhinavagupta on Indian Aesthetics.* Delhi: Ajanta Publications.

Weber, Ernst A. 1980 [German ed. 1978]. *Vision, Composition, and Photography.* Berlin and New York: de Gruyter.

Woods, James Haughton, trans. 1927 [1914]. *The Yoga-System of Patañjali.* Oriental Series. Cambridge, Mass.: Harvard University Press.

Zimenko, Vladislav. 1976. *The Humanism of Art.* Moscow: Progress Publishers.

Zinberg, Norman E., ed. 1977. *Alternate States of Consciousness.* New York: Macmillan, Free Press.

Analytical Table of Contents

CHAPTER ONE: *The Reality Anthropologists Build*

Anthropological and other scholarly evidence
Anthropology: holistic and cross-cultural
Phenomenological assumption: art as collective construction
Contributing to knowledge in a phenomenological framework
Art in everyday reality
Art as explicit category in common language
The contemporary city as starting place

PART I: ART IN HUMAN EXPERIENCE

CHAPTER TWO: *Art in Everyday Reality*

"Art object" as insiders' category
First indicator: being exhibited in museums and galleries
Art as positive value in common judgment
Art by destination
Art by metamorphosis
Metamorphosis into "primitive art"

CHAPTER THREE: *The Aesthetic Vision*

Looking at art: a specific visual approach
First approach to inner phenomena: experiential reference
Reflexive analysis of experiences
Second approach: what common language implies

Third approach: what experts say
The attentive, nonanalytical, and disinterested vision

CHAPTER FOUR: *The Significance of Form*

What aspects of the object are aesthetically relevant?
Not relevant: representation, subject matter, resemblance and perspective, skillful execution, and material
Relevant: frame, outline, lines, shapes, colors, light, texture
Visual and auditive perceptions as influenced by frame
Training for seeing: a deconditioning
Speculations, association: discursive thinking as distracting
Being free of self-interest in emotions and feelings

CHAPTER FIVE: *Aesthetic Vision as Contemplative*

Beholder's preparation and meditator's preparation
Patañjali and Buddhaghosa: concentration, nondiscursiveness, and detachment
Absorption as generating nonverbal understanding
Experiential reference available to Westerners
Validity and reliability of inner observation
Aesthetic vision and meditation: same mode of consciousness
Contemplative mode in everyday life, philosophy, and science
Contemplation and survival
Hemispheres of the brain: cognition and contemplation

CHAPTER SIX: *Aesthetic Experience in Other Cultures*

Is aesthetic experience widespread?
Common language and texts: clues of aesthetic experience
Noninstrumentality of forms: clues in silent cultures
Government, class, and kinship instrumentality

CHAPTER SEVEN: *Art in Other Cultures*

Is art universal?
In nonliterate world: art as marginal
Aesthetic locus
The "African art" story
 Idols, fetishes, and curiosities
 Colonial enterprise and evolutionary theory
 Metamorphosis in art by early modern painters
Artifacts integrated in alien cultures

PART II: THE AESTHETIC OBJECT AS SYMBOLIC

CHAPTER EIGHT: *Meanings in Aesthetic Objects*

Do forms have meanings?
Meanings of nonfigurative forms
In figurative objects: formal and representational meanings
A few nudes analyzed in terms of meanings
Meanings exclusively in forms

CHAPTER NINE: *Visual Forms as Signs*

Signs stand for things other than themselves.
Paradigm of signification; four subclasses
Context and subject included in the paradigm
Degrees of proximity: sign to signified in the subclasses
Comparisons in terminology
Discursive perception of meanings in subclasses

CHAPTER TEN: *Visual Forms as Symbols*

Symbols are signs by participation.
Symbols of life and eternity in Napoleon's tomb
Symbols as mental and connatural with signifieds
Meanings in line composition, color composition, elements
Experiencing as conscious and mental
Understanding the experience of torture
Understanding the experience of concentration
Religious referents and spiritual symbols

CHAPTER ELEVEN: *The Aesthetic Quality*

What is aesthetic quality?
Composition: the congruence of forms
Expressivity: the congruence of form and meaning
Outside ego's arena
Order: the core value
Cross-cultural aesthetic appreciation
Aesthetic quality in actual scenes
Beauty as excellence of design

CHAPTER TWELVE: *Preferences in Art*

Two incorrect assumptions
Consensus in judgments and diversity in preferences

Collective decisions of the art establishment
Mechanisms of aesthetic recognition
Dominant cultural values and themes
Are preferences culture-specific?

CHAPTER THIRTEEN: *Between Creators and Beholders*

Meanings expressed in terms of artists' intentions
Paradigm of communication
A sculpture as communication: its message
A sculpture as signification: its meaning
Polysemic symbols: poor vehicles for communication
Linguistic communication: no model for aesthetic encounter
Communion: sharing corresponding experiences

CHAPTER FOURTEEN: *Aesthetic Vision, a Selfless Experience*

Distance between symbolized values and beholders' affectivity
Digressions, concentration, and bare attention
Mindfulness
The effects of noticing
Disinterestedness and nonattachment

PART III: THE AESTHETIC OBJECT AS CULTURAL

CHAPTER FIFTEEN: *The Cultural Component in Aesthetic Objects*

The human, cultural, and singular components
Metaphysical idealism
Romanticism, collective and individual styles
The three components of aesthetic phenomena

CHAPTER SIXTEEN: *The Aesthetic Segment of a Culture*

The three-level model of societal cultures
The aesthetic segment across the levels
Segment and locus

CHAPTER SEVENTEEN: *Techniques of Production and Aesthetic Forms*

Material determinants of forms
The making of aesthetic objects
The processes of exclusion and conduction
Ratio of consumption to production in Africa
Industrial fabrication: prototypes and multiples
Cultural materialism

CHAPTER EIGHTEEN: *Societal Networks and Aesthetic Forms*

Networks order social relations.
Guilds, schools, and associations
The art market
Privileged minorities as patrons of the arts
Modernism in pre-1917 Russia
Suprematism and Constructivism
Socialist realism
The art of the Third Reich
Totalitarian government and naturalistic representation

CHAPTER NINETEEN: *Aesthetic Forms and Other Ideational Configurations*

Different classifications of ideational configurations
Transcendence and stylization in Byzantine civilization
God-oriented and man-oriented world views
Ontological and vanishing-point perspective
Conception of time and representation of depth
Kinship doctrine and ancestral figurines
Impact of aesthetic representation on social change

CONCLUSION: *The Individual Nexus*

Universal and cultural dimensions unified in individual beholders

APPENDIX: *Aesthetic Anthropology as Critical Knowledge*

The anthropology of aesthetic experience as cognition
Critical knowledge through the correlation method
Sorokin's use of the quantitative method
Critical knowledge through the interpretive method
Replicability: the measure of the quality of observations
Experiential observations as replicable
Considering other logical fields
Phenomenological perspective, a reminder

Index of Proper Names

(including works of art)

Abhinavagupta, 60
Adam and Eve (Brancusi), 152–56, 159, 163
Adoration of the Lamb (van Eyck), 37, 230–31
Agony in the Garden of Gethsemane, The (El Greco), 99, 101–02
Akan, 66
Albright, Ivan, 36
Alison, Archibald, 32
Altman, Natan, 209, 212
Amba, 248
Amiens cathedral, 142
Andaman Islanders, 247
Anthemios and Isidoros, 225
Anurādhapura Buddha, 112–16, 144, 151, 241, 242
Aphorisms. See Patañjali, *Yoga Sūtra*
Aphrodite, 38, 71, 98
Aquinas, Saint Thomas, 104, 228
Aristotle, 231–32
Arnheim, Rudolf, 86, 108
Arp, Jean, 120
Art Students' League, New York, 146
Art of This Century gallery, New York, 146, 208
Artemis of Ephesus (Casanova), 120
Asante, Ghana, 62, 66
Assumption of the Virgin (El Greco), 101
Autumn Rhythm (Pollock), 46
Aztec, 134

Bacon, Francis, 110–12, 144, 158–59
Baga, Guinea, 2, 134
Bambara, 2, 181
Barry, Herbert, III, 244

Baule, 2, 232, 235
Baumgarten, Alexander, 32
Beasley, Bruce, 121
Beauvais cathedral, 142
Bell, Clive, 32
Benin, Nigeria, 134, 186, 194–95, 207, 232–34
Benton, Thomas, 146
Berger, Peter, and Thomas Luckmann, 5
Beuys, Joseph, 129
Biebuyck, Daniel, 247
Birth of Venus (Botticelli), 166
Black on Grey (Rothko), 163–64
Blast, I (Gottlieb), 49
Blaue Reiter movement, 212
Blonde Waiting (Lichtenstein), 82, 85–86, 108
Blue Rose Group, 209
Blue Sofa, The (Delvaux), 88–89
Bogen, Joseph, 57–58
Bon Marché, 189
Bororo-Fulani (Wodaabe), 70
Botticelli, Sandro, 27, 166, 220
Bradbury Building, Los Angeles, 189
Brancusi, Constantin, 152–56, 159, 163
Braque, Georges, 44, 73, 120, 174, 177, 202, 242
Breuer, Marcel, 202
Broadway Boogie Woogie (Mondrian), 79–80, 103, 155
Brody, Grace F., 30–31
Buddha, 48, 98, 99, 112, 116–17
Buddhaghosa, *Visuddhimagga* (The Path of Purification), 51–55
Bullough, Edward, 32
Bulu, 59

Calamis, 170
Calder, Alexander, 29, 31, 134, 180
Cambridge Expedition, Torres Strait, 73
Capa, Robert, 129–30, 130n, 161
Caryatid II (Brancusi), 153
Casanova, Aldo, 120
Cercle et Carré, 218
Cézanne, Paul, 79, 82, 147
Chagall, Marc, 13, 212
Clark, Kenneth, 86
Cokwe, 13, 14, 59, 248
Courbet, Gustave, 36
Crystal Palace, 186, 189

Dahomey, 66, 232–35
Dali, Salvador, 145
Daza, 59
De, S. K., 60
de Kooning, Willem, 17, 86
Delange, Jacqueline, 59, 66, 70
Delvaux, Paul, 88–89, 93
Denis, Maurice, 41, 163
Derain, André, 73, 74
Descartes, René, 56
De Stijl, 218
Developable Column (Pevsner), 121
Diebenkorn, Richard, 191
Die Brücke, Dresden, 74, 202
Dione (Beasley), 121
Dogon, Mali, 2, 38, 172, 232–35

Echo of a Scream (Siqueiros), 49
Edge of August (Tobey), 82, 137, 155–56, 157
Eiffel, Gustave, 189

266

Einstein, Albert, 56
Einstein, Carl, 74
El Greco, 94, 97, 99, 101
Enderton, Catherine S., 245
Esie, a Yoruba village, 193
Etrog, Sorel, 26

Fang, 248
Fernandez, James, 159
Fisher, John, 244
Focillon, Henri, 198
Francastel, Pierre, 230
Fry, Roger, 32, 74

Gandhāra, Pakistan, 171
Gazzaniga, M. S., 57
Geist, Sidney, 154, 155, 156
Giacometti, Alberto, 172
Giorgione, 86
Golden Gate Bridge, 166
Goldschmidt, Walter, 3
Goldwater, Robert, 70, 74
Goncharova, Natalia, 147–48, 202, 209, 210
Gottlieb, Adolph, 49
Goya, Francisco, 36
Graham, Robert, 26
Gray, Camilla, 147
Great American Nude No. 92 (Wesselmann), 89, 91
Great Exhibition of *1851*, 186
Great German Art Exhibition (1937), 218
Grebo, Ivory Coast, 120
Greenberg, Clement, 146, 205
Gropius, Walter, 218
Guernica (Picasso), 128, 138, 151, 220
Guggenheim, Peggy, 80, 146, 208

Haddon, Alfred C., 73
Haftmann, Werner, 74
Hagia Sophia basilica, 225
Henri, Adrian, 147
Hepworth, Barbara, 121
Hitler, Adolf, 217, 220, 221
Hobbes, Thomas, 166
Hoebel, E. Adamson, 60, 60n
Hoffman, Hans, 208
Hopper, Edward, 36
Hunt, Richard, 120

Ife, 134
Ik, 196
Ingalic, 180
Ingres, Jean, 86, 157
International Surrealist Exhibition, New York (1942), 146
Introduction to Aesthetic Anthropology (Maquet), 3–4, 18, 96n

Jesus, 71, 99, 116, 224, 225, 231
Jung, Carl, 98

Kahnweiler (Picasso), 44
Kandinsky, Wassily, 35, 170, 212, 218
Kant, Immanuel, 42
Kirchner, Ernst, 74

Kiss, The (Klimt), 108
Kissi, 193
Klimt, Gustav, 108, 109
Kluckohn, Clyde, and George Murray, 176
Knoll International, 18, 202
Kongo, kingdom of, 70, 75, 186, 193, 248
Kraus, Nana, 21
Kuba, 7, 66, 194–96, 248
Kuhn, Thomas, 5

La Défense, Exhibition Hall, France, 191
La Roche-Guyon (Braque), 120, 242
Lamerie, Paul de, 18
Larionov, Mikhail, 147, 202, 209, 210
Last Futurist Exhibition of Paintings (0.10), The, 210
Laude, Jean, 70, 232
Lega, 62, 247, 248
Leibniz, Gottfried W., Baron, 56
Leiris, Michel, 59, 66
Lenin, Vladimir, 214
Les Renforts (Calder), 29n
Les demoiselles d'Avignon (Picasso), 44
Li Ch'eng, 135–37, 138
Lichtenstein, Roy, 82, 85, 108, 157
Lima, Mesquitela, 13
Limbourg, Pol de, 228–30, 232
Lissitzky, El, 212
Locke, John, 56
Louis XIV, king of France, 104, 207
Louis, Morris, 191
Luba, Zaire, 248
Lucie-Smith, Edward, 191

Male Torso (Brancusi), 152–53
Malevich, Kasimir, 121, 147–48, 209, 210, 212, 214
Malinowski, Bronislaw, 247
Malraux, André, 18
Mamontov, Savva, 208
Mantegna, Andrea, 230, 232
Mao Tse-tung. *See* Mao Zedong
Mao Zedong (Mao Tse-tung), 238, 240
Marilyn Diptych (Warhol), 45
Matisse, Henri, 73, 89
Māyā, Queen, 98
Miró, Joan, 13
Modigliani, Amedeo, 86, 87–88, 92, 137, 138
Mona Lisa (da Vinci), 43
Mondrian, Piet, 79–80, 93, 103, 109, 110, 155, 218
Monet, Claude, 82
Monument to the Third International (Tatlin), 212
Moore, Henry, 31, 120, 172
Morgan, Lewis, H., 71–72
Mossi, 66
Motherwell, Robert, 208
Munch, Edvard, 49, 238–40
Munro, Thomas, 59–60
Murdock, George Peter, 244
Murray, Henry, 169

Nabis, 202
Napoleon, 103–04, 106, 140
Nātyaśāstra, 60
Navaho, 96
Neue Sezession, 202
New Hebrides, 62
New Ireland, Micronesia, 134
Newman, Barnett, 205
New York School, 46, 181
Nizzoli, Marcello, 19
Nok, Nigeria, 134
Noland, Kenneth, 191
Nolde, Emil, 74
Notre Dame, Paris, 142–44, 178
Number 1 (Pollock), 80

Ocean Park (Diebenkorn), 191
Ode to Ang (Ramos), 86–87
Orozco, José Clemente, 144
Osborne, Harold, 32–33, 45, 52, 53, 165, 212
Osgood, Cornelius, 180

Painting 1946 (Bacon), 110–12
Pali Text Society, 51–52
Pandey, K. C., 60
Parthenon, Athens, 142–44, 178
Patañjali, *Yoga Sūtra* (Aphorisms), 51–55
Path of Purification, The. See Buddhaghosa, *Visuddhimagga*
Paulme, Denise, 186
Paxton, Joseph, 186
Peirce, Charles Sanders, 97–98
Pelagos (Hepworth), 121
Petersburg Academy of Art, 210
Pevsner, Antoine, 121, 212
Picasso, Pablo, 13, 44, 73, 138, 145, 151, 166, 177, 202, 205, 220, 221
Poincaré, Jules Henri, 56
Pollock, Charles, 19
Pollock, Jackson, 46, 80, 82, 129, 131, 145–47, 157, 205, 208
Pope Paul III, 70
Popova, Liubov, 209, 212
Portrait of a Cardinal (El Greco), 94
Portuguese, The (Braque), 44, 45, 174
Pougny, Jean (Ivan Puni), 209
Ptolemy III (Arp), 120

Radcliffe-Brown, Alfred, 247
Ramos, Mel, 86, 89, 92, 137
Rape of Europa, The (Titian), 91
Raphael, 220, 231–32
Rauschenberg, Robert, 38
Read, Herbert, 32
Reclining Female Nude (Modigliani), 87–88, 137
Red Army, 214, 220
Revolution of October *1917*, 209, 210, 212
Rheims cathedral, 142

Rivera, Diego, 144, 207
Rodchenko, Aleksandr, 209, 210, 212
Rothko, Mark, 163–64, 181, 191, 205, 208
Rwanda, 8, 66, 180, 247
Ryoan-ji temple, Kyoto, 137

Saint Sebastian (Mantegna), 230
Saint-Louis church, Invalides, 103–04
Schmidt-Rottluff, Karl, 74
School of Athens, The (Raphael), 231–32
School of the Ugly, 36
Schopenhauer, Arthur, 170
Scream, The (Munch), 49
Sebei, 3
Segal, George, 38
Senufo, Ivory Coast, 2, 145, 232–34
Seuphor, Michel, 218
Shaftesbury, Lord, 166
Shah Jihan, 143
Shields, Thomas, 65
Singer, Milton, 97
Siqueiros, David A., 49, 144
Śiva, 93, 108, 117
Société française de Philosophie, 98
Solitary Temple amid Clearing Peaks, A, (Li Ch'eng), 135–37
Song (Sung) dynasty, 135, 138
Sorokin, Pitirim A., 245–46, 249
Source, The (Ingres), 86
Spanish civil war, 129–30
Sperry, R. W., 57

Spiro, Melford, 97, 117
Staal, Frits, 29
Stalin, Joseph, 214, 217, 220, 221
Susu, 59

TWA terminal, at JFK International Airport, New York, 191
Taj Mahal, Agra, 142–44, 178
Tanguy, Yves, 36
Tart, Charles, 164
Tatlin, Vladimir, 209, 210, 212
Teke, 6
Teotihuacan, 134
Tetela, 248
Thonet Brothers, 18, 19
Three Rings (Moore), 120
Tikar, Cameroon, 120
Titian, 91
Tobey, Mark, 82, 93, 137, 155, 157
Très Riches Heures du Duc de Berry (Limbourg), 228–30
Trobrianders, 247
Turnbull, Colin M., 196
Tutsi, 66
Tyiwara, 181
Tylor, E. B., 3

Union of Soviet Writers, 217
Utamaro, Kitagawa, 48

van Eyck, Hubert and Jan, 37, 230, 232

Vasarely, Victor, 196
Vasari, Giorgio, 119, 196
Velázquez, Diego, 36, 65, 86
Vermeer, Jan, 174
Vietnam War, 130
Visconti, Ludovico, 104
Visuddhimagga (Buddhaghosa), 51–55
Vlaminck, Maurice de, 73, 74

Walimbe, Y. S., 60
Wanderers, 202, 208
Warhol, Andy, 17, 45, 178
Wertheimer, Michael, 130
Wesselmann, Tom, 89, 91, 157, 158
Why? (Hunt), 120
Woman (de Kooning), 17
Woman with Water Pails: Dynamic Arrangement (Malevich), 121
Woods, J. H., 52
Work Projects Administration, 146
Worker Returning Home (Munch), 238–40
World War II, 137
Wyman, George, 189

Yaculov, Georgii, 210
Yoga Sūtra (Patañjali), 51–55; commentaries, 51
You Get More Salami with Modigliani No. 14 (Ramos), 89

Zeus (Calamis), 170

Index of Topics

Absorption, 32–33, 52–53, 55, 82, 99, 165
Abstract. *See* Nonfigurative
Abstract Expressionism, 80, 82, 202, 205
Abstraction, Process of, 106, 109, 144
Acrylic, 163, 191, 193
Action painting, 80, 146
Active mode (of consciousness), 3, 55, 57, 158, 223
Aesthetic, defined, 32
Aesthetic anthropology, 2, 10, 249
Aesthetic concern (= intention), 62, 64, 68–69, 183
Aesthetic encounter. *See* Aesthetic experience
Aesthetic experience, 3, 32–33, 38, 50, 52, 55, 58, 60, 69, 98, 104, 109, 137, 169, 241, 242, 249
Aestheticism, 79
Aesthetic judgment, 35, 64, 141–45, 149; cultural vs. individual, 141
Aesthetic locus, 70, 74, 182, 202, 236; definition of, 69; vs. aesthetic diffusion, 183
Aesthetic object, 35, 65, 180; definition of, 33, 119. *See also* Cultural component; Human component; Singular component
Aesthetic perception. *See* Aesthetic experience
Aesthetic quality (= beauty), 4, 33, 58, 68, 119, 129, 130, 137–38, 145, 169, 183, 208, 220
Aesthetic relevance (= significance), 35, 38, 41–42, 50, 69, 79
Aesthetics, 2, 60, 249
Aesthetic segment, 179, 181–83, 196, 202, 205, 206

Aesthetic value, 17, 24, 37, 74; and artistic value, 17, 24, 33
Aesthetic vision. *See* Aesthetic experience
Affective mode (of consciousness), 3, 29, 30, 55–56, 57, 106, 110, 112, 164, 166, 176, 196, 223, 240 *See also* Emotion; Feeling
Africa, 2, 3, 7, 56, 59, 65, 66, 70, 71, 74, 75, 94, 106, 109, 121, 176, 185–86, 193, 194–96, 201, 232–26, 247–48
Aisthetikos, 32
Amateur artists, 204
Analytical thinking, 85, 104, 108, 109, 110, 112, 114, 116, 142, 152, 162, 246; and nonanalytical, 50. *See also* Discursive thinking
Anthropology, 1-5 passim, 9, 13, 14, 29, 35, 53, 59, 74, 109, 116, 166, 198, 243, 244, 247, 250; view of Kluckohn and Murray, 176
Anthropology of art, 2, 3
Anurādhapura, Sri Lanka, 112, 116, 128, 241, 242
Art, definition of, 2, 3, 4, 9, 10, 13, 23, 71
Art-by-destination, 17–18, 22, 65, 70
Art-by-metamorphosis, 18, 22, 38, 65, 70, 74, 76
Art criticism, 2, 32, 37, 74, 75, 128, 142, 146–47, 205
Art establishment, 145, 146, 148–49
Artifact, 2, 22, 52, 60, 62, 64, 68, 71, 119, 128, 179, 180, 196; definition of, 41
Art institutions, 65, 146
Art market, 3, 204–05, 208
Art Nouveau, 134
Art object, 3, 9, 13, 14, 15, 17, 22, 23, 31, 68–70, 112, 119; vs. aesthetic

object, 33, 45; definition of, 33, 119
Asia, 59, 68, 112, 185
Association, in signification, 94, 101
Attention, 17, 29, 32–33, 35, 41, 42, 45, 46, 48, 49–50, 52, 53, 54, 80, 82, 109, 112, 128, 154

"Bare attention" 163, 164; definition of, 162
Baroque, 37
Bauhaus style, 202, 218
Beauty, 2, 9, 30–31, 36, 57, 59, 64, 70, 102, 138–40, 154, 171. *See also* Aesthetic quality.
Brain, 55; hemispheres of, 57, 58
Buddhism, 51, 52, 53, 56, 68, 98, 112, 116, 117, 162–63, 166
Byzantine civilization, 224–26

Caryatid, 152, 153, 156
Catholicism, 70, 75, 142
Causality, 226; logic of, 193, 249, 251
Christianity, 69, 71, 72, 98, 99, 101, 228
Code, of signification, 94, 96, 99–101, 135, 140, 156–57
Cognitive mode (of consciousness), 3, 55, 57, 85, 99, 158, 176, 196, 223, 243
Color, 8, 38, 41, 42, 43, 60, 62, 74, 85, 96, 138, 191, 210, 223
Commercial art, 86
Communication, 4, 9, 151, 156–58, 177 paradigm of, 152
Communion, 159; defined, 158; symbolic, 158
Composition, 48, 49, 79, 93, 106, 108, 128–38, 155, 186, 224, 225, 231–32, 236, 238, 240; definition of, 119, 128; principles of, 135. *See also* Dynamic composition; Geometric composition;

269

Composition, (continued)
 Organic composition; Stylistic
 composition
Concentration: mental, 32, 52, 54, 56,
 82, 112, 116, 128, 144, 162, 250;
 definition of, 52. See also Attention
Concrete, 191, 193
Conditioning, 53, 196, 198, 205, 236–38;
 logic of, 193, 238
Conduction, process of, 193, 199, 205,
 235
Connaturality, 96, 103, 106
Consciousness, 29, 32, 42, 46, 52–53,
 54, 55, 165; meditative state of, 54;
 description of, 55. See also Active
 mode; Affective mode; Contem-
 plative mode
Consensus, 1, 5, 32, 106, 142, 145, 147,
 157, 251; in signification, 96
Construct, 3, 4, 8, 106, 109, 248
Constructivism, 212, 214, 218
Consumption, vs. production, 194
Contemplative mode (of conscious-
 ness), 3, 56–59 passim, 66, 76, 79,
 80, 82, 85, 99, 103, 104, 108, 112,
 119, 128, 130, 137, 155, 158, 161, 164,
 165, 169, 176, 180, 196, 223, 240, 250
Context, 22, 30, 32, 60, 61–64, 65, 71,
 75, 137; in signification, 96; in
 communication, 152, 156; cultural,
 179
Contradiction, principle of, 103
Correspondence, 149, 226, 230–32,
 236, 249
Craftsmanship, 7, 60, 63, 66, 194, 202,
 204, 205; and aesthetic value, 35,
 37–38
Creator, 159; and beholder, 158, 159
Critical knowledge, 26, 54, 243; para-
 digm of, 5, 7, 244, 248; and inner
 phenomena, 54, 243
Cross-cultural aesthetics, 2, 3, 58, 69,
 134, 149
Cubism, 44, 74, 121, 134, 152, 172–74,
 177, 202, 210–12, 221, 242
Cubo-futurism, 209, 212
Cultural component, in aesthetic
 objects, 169, 176, 182, 241
Cultural materialism, 5, 7, 198–99, 247
Cultural premise, 138; idealistic,
 ideational, sensate (Sorokin), 245
Cultural value, 75, 148, 171
Culture, 2, 10, 13, 23, 60, 68, 75, 144,
 180, 198, 241; definition of, 3, silent,
 60, 62, verbal, 62 societal, 179, 241;
 levels of, 180

Deconditioning, 43, 162
Decorative art, 10, 35, 61, 64, 76, 195
Design, 128, 138, 196, 224; industrial,
 69, 182, 196, 202, 212, 218; definition
 of, 119; excellence in, 140, 142; See also
 Composition
Digression, 161, 163–65, 183
Discursive thinking, 33, 44, 45, 52, 54,
 98, 116, 137

Disinterestedness, 32–33, 41, 44, 46,
 48, 50, 52, 53, 112, 129, 130, 138, 165,
 166, 250; and uninterestedness, 46;
 and self-interest, 46, 166
Distanciation, 48, 129, 140, 161, 163, 164
Dutch genre painting, 174–75
Dynamic composition, 114, 120–21,
 134

Eastern traditions, 51, 53, 55. See also
 Asia; Buddhism; Hinduism
Ego, 49, 55, 128, 138, 163n, 165, 166;
 -involvement, 10, 46, 112, 130, 138,
 140, 161, 163, 164, 240. See also Self
Egypt, 172
Elite, 146
Elite style (court style), 7, 8, 195, 247–48
Emblem, 104, 116, 117, 155
Emotion, 3, 4, 10, 26, 32, 45, 49, 52, 56,
 57, 73, 74, 80, 110, 112, 128, 138, 157,
 164, 166, 210, 240. See also Affective
 mode
Entity, 4, 5, 35, 71, 80, 94, 145, 165, 172,
 251; vs. sign, 93
"Environments," 129, 147
Epistemic quality, 244, 248, 249
Epistemology, 1
Eroticism, 48, 49, 91, 140, 148, 163, 165,
 223
Ethonocentrism, 10
Etruscan art, 22
Eucharist, 61
Europe, 22, 69–76, passim, 94,
 137–38, 140, 144, 166, 174, 185,
 208, 249
Evolution, 57, 71–72, 75, 198
Excluded third, principle of the, 103
Exclusion, process of, 176, 193, 194,
 196, 199, 235
Existentialism, 1
Experience, 1, 9, 26, 29, 30, 51, 110, 112,
 116, 158, 241;
 definition of, 109; as recalled, 109,
 112, 137, 149, 155; as experienced,
 112; past, 157, 162; experiential
 method, 249
Experiential reference, 29–30, 53, 54,
 250
Expressivity, 140, 142, 144, 186, 225,
 240, 250; definition of, 128

Fact, 7, 8, 248; definition of, 8
Fascism, 130
Fashion, 205, 208
Fauvism, 13, 202, 209, 210
Feeling, 3, 26, 29, 41, 49, 52–53, 55,
 128, 157, 210, 240
Figurative, 10, 35, 98, 172; definition of,
 36; and nonfigurative, 75, 210
Fine arts, 14, 18, 35, 70, 72, 89, 119, 208,
 247–48
Folk style, 7, 8, 13, 194
Form, 3, 7, 43, 50, 57, 60, 61, 79, 92, 104,
 108, 114, 212, 225; definition of, 41;
 and substance, 42; and representa-
 tion, 86

Formalism, 79
Frame, 41, 42–43, 48, 52, 85, 87, 129,
 137, 138
France, 5, 176, 181, 206
Freudianism, 1, 109, 198

Geometric composition, 119, 134, 135,
 152, 186, 242
Germany, 96, 148, 202, 217–21
Glass, 186, 189–91
God(s), 22, 75, 99, 116, 117, 166, 224,
 225, 228
Gothic style, 5, 98, 121, 140, 142, 145,
 174, 178, 181, 248
Greece, 68, 86, 171, 180

Hamba, 13, 14
Happenings, 129, 147
Hermeneutics, 250
Hinduism, 51–55, 93, 108, 117
Holism, 41, 56, 108, 112, 119, 128, 154;
 definition of, 58
Human component, 241–42; in
 aesthetic objects, 169, 172, 176, 178
Humanities, 7, 244, 246, 249; vs. social
 sciences, 4, 26, 243–44
Hypothesis, 5, 7, 8, 54, 158, 244;
 verification of, 244, 246, 248;
 testing, 248. See also Critical
 knowledge

Icons, 71–75 passim, 98, 225
Idea, 4, 56, 80, 103, 106, 138, 169, 223;
 Platonic, 170–71
Idealization, 71, 171, 186
Ideational configurations, 3, 4, 180–81,
 196, 223–38, 241
Identity, 9, 49, 53, 103, 109, 112, 146;
 principle of, 103, 251
Ideology, 72, 221
Image, 4, 5, 22, 29, 31, 35, 48, 56, 71, 75,
 82, 104, 108, 116, 220, 225; in
 signification, 94–102
Imitation, 37, 74, 210, 220
Impressionism, 13, 174, 209
Inclusion, process of, 1, 177
India, 8, 60, 96, 116
Indicator, 15, 17, 23, 31, 54, 59, 64, 103,
 104, 246, 249; in signification, 94–102
Inner processes. See Mental processes
Insight, 53, 54, 80, 130, 157, 166
Instrumentality, 65, 68, 74, 75, 76, 183,
 206–07; and noninstrumentality,
 60–62, 63–64, 69; formal, 60–64,
 66, 68, 75
Interpretation, 23, 62, 80, 82, 85, 89,
 101, 109, 117, 137, 247; model of, 156
Intuition, 53, 80, 85, 86, 108, 109, 112,
 114, 135, 142, 145; definition of, 56
Isomorphism, 97, 236

Jansenists, 166
Japan, 60, 69, 183, 208
Jesuits, 166

Knowledge, 1, 3, 4, 5, 8, 15, 43, 109, 110, 112, 243; sociology of, 1, 221; definition of, 4; common, 14, 15, 23, 26. *See also* Cognitive mode; Critical knowledge

Language, 158; common, 4, 55, 93, 97; everyday, 9, 13, 43, 59; as communication, 156–57
Liṅga, 108, 116
Logic, 177, 251; rational, 103, 251
Looking at, 17, 23, 29, 48, 80, 204; vs. only looking, 17, 25, 29, 30–31, 41; different ways of, 25, 29, 30

Marxism, 1, 198, 209, 214, 217, 221, 238
Material, 38, 79, 185, 195, 198, 206, 212; and aesthetic value, 35, 38; and forms, 186
Meanings, 13, 42, 62, 71, 76, 79, 80, 82, 85–92, 93, 106, 108, 109, 128, 128–43, 147, 151, 154, 156, 180, 221, 231, 249; and messages, 152, 155; formal vs. representational, 86, 92, 138
Meditation, 8, 51–53, 54, 55, 56, 58, 112, 116, 117, 156, 161, 163, vs. reflection, 108, 109, 112
Mental processes, 3, 54, 59, 249–50; observation of, 25; and experiential reference, 26, 29; and common language, 30; and experts' views, 31
Mentations, 106, 110, 164
Messages, 45, 59, 151; in communication, 152–58
Metaphor, 52, 53, 157, 181, 241, 243
Metaphysical idealism, 166, 169–72, 198, 231–32
Mexico, 144
Middle Ages, 66, 68, 74, 98, 183, 202, 210, 212, 228–30
Mind. *See* Consciousness
Mindfulness: definition of, 164, 165; as awareness, 177
Minimalists, 202
Mintadi, 186
Modernism, 214, 218, 220, 221
Monosemic, 155, 156, 250
Multiple, by Vasarely, 196
Multivocal. *See* Polysemic
Museum, 14, 15, 22, 25, 29, 31, 36, 37, 43, 71, 74, 154; behavior, 17; setting, 18, 22, 23, 36

National socialism, 217, 218, 220
New Testament, 98, 101
Nonanalytical, 50
Nonattachment (detachment), 32, 52, 54, 166
Nondiscursive, 44, 52, 224
Nonfigurative, 18, 29, 35, 42, 80, 89, 106, 109, 210, 212, 218, 221
Nude, in art, 18, 36, 86–92, 137, 218, 236

Object, 2, 4, 5, 22, 53, 110; vs. subject, 30, 50, 53

Objectivity, 4, 10, 25, 64, 245
Oblique (line), 49, 80, 85, 89, 109, 114, 128, 137, 148, 191
Observation, 1, 53; empirical, 7; reliability of, 54, 248, 250; interpretive, 244, 246; replicability of, 248. *See also* Critical knowledge; Fact
"Observer," 164, 165
Old Testament, 98
Order, 80, 103, 109, 110, 131, 134, 138, 169, 180; definition of, 130
Organic composition, 104, 106, 121, 154, 193
Oriental aesthetics, 60

Paradigm, 71, 176; of a science, 5; of valid knowledge, 8, 10; of critical knowledge, 244, 248
Participation, in signification, 96, 103, 108, 109, 110, 226, 249
Perspective, 38, 89, 155, 228–30; vanishing-point, 89, 230, 232, 238; quasi-aerial, 228; ontological, 230–31
Phenomenology, 1, 4, 5, 7, 10, 30, 55, 210, 251
Photography, 14, 42–43, 86, 89, 129–30, 161, 204
Plato and Platonism. *See* Metaphysical idealism
Polysemic, 155, 159, 220
Pop art, 82, 86, 89
Portugal, 70–71, 75
Prägnanz, Law of, 131
Preferences in art, 4, 30, 35, 141–45, 147, 149; definition of, 145; individual vs. collective, 147
Primitive art, 9–10, 13, 22, 65–66, 74
Privileged minorities, 145, 206, 208
Production: systems of, 3, 5, 180–81, 185, 196–98; industrial, 3, 10, 49, 54, 57, 59, 65, 70, 71, 144, 212; subsistence, 7, 194–96, 247; surplus, 7, 194–96, 235
Productivism, 209

Rayonism, 134, 147–48, 202, 209, 210
Reality, 3, 74, 243; definition of, 4, 5; common, 4, 8, 9, 10, 15, 17, 23, 57; scholarly, 5; as socially constructed, 5, 7, 8, 17, 66, 93; specialized, 8, 55, 177, 198, 243
Reasoning, 43, 45, 80, 108, 156, 243
Receiver, 152; in communication, 151, 156–57. *See also* Communication
Reference, in signification, 94, 99, 103, 104, 108, 116, 117, 156, 250
Referent, in signification, 94–102, 96n, 156, 225
Religion, 3, 71; definition of, 116, 117
Renaissance, 35, 36, 69, 71, 76, 86, 145, 170, 210, 230, 232
Representation, 4, 38; human, 10, 35, 70, 73, 75; in three dimensions, 17, 74; and aesthetic value, 35; naturalistic or perceptual, 71, 73, 210, 212, 217, 218, 220; conceptual, 71, 171, 210, 220–21,

225; vs. actuality, 138. *See also* Imitation
Resemblance, in signification, 1, 103
Restriction, process of, 177
Revolutionary art, 74, 209, 212, 238
Ritual, 22, 38, 61, 62, 63, 66, 69, 71, 110, 112, 116, 236
Romanesque style, 121, 174, 178
Romanticism, 172, 176, 196
Rome, 68, 70, 228–30
Russia, 147–48, 208, 209–10, 212–17, 220, 221

Samādhi (p.), 52, 53. *See also* Concentration
Self, 29, 129, 155, 163, 163n, 165, 230; everyday, 15; -awareness, 30, 32–33, 82. *See also* Ego; Self-interest
Self-interest, 46, 48, 56, 57, 130, 161, 166; and self-pity, 49; and self-indulgence, 49, 140
Selflessness, 8, 166
Semiotic system (Peirce, Singer, Spiro), 97–98
Sender, in communication, 151, 152, 154, 156–57
Sign, 22, 31, 93–101, 96n, 103, 104, 108, 110, 116, 117; definition of, 93; vs. entity, 93
Signification, paradigm of, 93–98, 108, 117, 151
Signified, in signification, 93–101, 96n, 103, 104, 106, 108, 117, 130, 143, 152, 155
Signifier, in signification, 93–99, 96n, 103, 104, 108, 226
Singular component, in aesthetic objects, 169, 172, 176, 242
Sinhalese (Sri Lanka), 54, 96, 116, 151, 241
Social variables, 244
Socialist realism, 209, 214–21
Societal networks, 3, 13, 180–81, 201–06, 238; hierarchy, 62–63, 66, 201, 206; family, 63–64, 201; Government, 66, 201, 206, 209
Society, total, 3, 96, 179, 180–81, 194, 201
South and Southeast Asia, 53, 53n
Spirituality, 1, 56, 93, 165; definition of, 117
Sri Lanka, 52, 53, 56, 94–95, 112, 165
Stoicism, 117
Structuralism, 1
Style, 2, 5, 7, 8, 121, 145, 172, 178, 181, 198, 202, 208, 225; definition of, 172, 176; individual and collective, 172
Stylistic composition, 121, 224
Stylization, 73, 186, 225
Subject, 9; vs. predicate, 9; in signification, 96
Subject matter, 36, 38, 70, 79, 85–86, 92, 98, 224
Subliminal perception, 35, 109, 131, 137
Substance, vs. form, 42, 101

Subtraction, technique of, 186
Superstructure, 183, 214, 238
Suprematism, 148, 208, 209, 210, 212, 221
Surrealism, 1, 146
Symbol, 4, 58, 103, 104, 106, 108, 109, 112, 116, 117, 141, 156, 169, 220, 225, 238, 251; in signification, 94–102, 103, 130, 131, 137; definition of, 106

Taste. *See* Preferences in art
Texture, 41, 60, 82, 86, 138, 191, 198, 214
Theory, 5, 7, 146, 244, 247. *See also* Critical knowledge
Time, historical and mythical, 234
Totalitarian government, 220–21
Transcendental, 144, 172, 224–26, 228, 230

Triangle, 82, 89, 99, 108, 114, 116, 128, 135, 154, 214
Truth, 5, 52, 56; definition of, 4

Unconscious, 31, 109, 131, 169, 172, 198
Understanding, 10, 144; vs. knowing, 109, 110
Univocal. *See* Monosemic

Vairāgya (Sk.), 52
Value, 9, 17, 57, 128, 145, 146, 147, 158; definition of, 148
Variables, correlation of, 244, 247, 249
Verisimilitude, 37, 42, 73
Vipassanā (P.), 53
Vipaśyanā (Sk.), 53
Visual arts, 1, 2, 35

Visual discontinuity, 140, 142, 225
Visual relation, 25, 58, 60; beholder and art object, 31

West, the, 10, 38, 51, 54, 55, 56, 58, 66, 70, 74, 82, 86, 135, 140, 163, 196
Western tradition, 57, 68, 108, 141, 166, 210, 245
"Witnesser," 164, 165
Wood, 60, 61, 65, 66, 134, 152, 186, 193, 232
Word, in signification, 94
World: as external, 4, 10, 55, 58, 82, 85, 112, 131, 138, 240; as ideal, 33, 171
World-view, 4, 5, 223, 249; man-oriented, 2, 230–32; god-oriented, 230–32



kale with buckwheat noodles 255
marinated tuna steaks 249
salmon with dill and tamari sauce 268
sprouted medley 204
spelt 106
flour 106
nutty sugar loaf 289
spices 116–9
spinach 67, 155
mung bean and spinach soup 209
poached eggs and spinach 182
sea bass with spinach and mango 250
spinach and ricotta filo rolls 230
stay supple juice 312
stir-fried spring vegetables 259
spirulina 130
squab 126, 159
squab breasts with goji berries 260
squalene 104
star anise 119
stevia 136
stilbenes 29
strawberries 39
sugar snap peas 76
sugars, slow-release 20, 41, 42
sulforaphanes 51, 69
sulfur 24, 51, 52, 53, 68, 81, 82
sunflower oil 120
sunflower seeds 94, 150, 162
baked oatmeal with goji berries and
cinnamon 187
sourdough rye bread 328
sprouted medley 204
sweet bell peppers 55, 149, 158, 167
ajvar 198
alert and joyful juice 313
beans baked in a pumpkin pot 253
fragrant rice and millet 283
griddled vegetable roll with cashew
and braised garlic cream 282
Mediterranean vegetable medley 272
nori vegetable roll 234
quinoa and vegetable stack 262
sprouted quinoa with vegetables 245
stuffed peppers 252
vegetable moussaka 278
sweet potatoes 88, 150
flatbread with sweet potato and
coriander 327
sweet potato and celeriac soup 216
Swiss chard and sweet potato 228
vegetable hot pot 256
vegetable moussaka 278
wild garlic soup 214

T
tannins 23, 30, 38, 42
tea 144
tempeh 123
theaflavins 144
theobromine 139

thiamin, food sources see vitamins
supplements chart (338–9)
thyme 101
thymol 101, 102
tiliroside 38
tofu 161
marinated tofu with shiitake and
noodles 258
tomatoes 65, 158, 161, 163
adzuki bean soup 220
ezze 195
French bean stew 274
grilled sardines with tomato salsa 276
lamb casserole with vegetables 279
Mediterranean vegetable medley 272
mushroom frittata with cherry
tomatoes and basil 236
quail egg and endive salad 224
raw tomato soup 210
spicy crackers 207
tomato crackers 205
trout and lettuce wraps 231
vegetable hot pot 256
vegetable moussaka 278
trout 129
trout and lettuce wraps 231
tryptophan 87, 111, 114, 125, 143
tuna 129
marinated tuna steaks 249
turkey 125
turmeric 89, 150, 154, 157
cooling, soothing juice 310
flatbread with sweet potato and
coriander 327
puy lentil soup with fresh turmeric 212
stay supple juice 312
turmeric and ginger oil 337
tyrosine 143

V
valerian root 98
deep sleep tea 321
venison 126
venison casserole with cranberries 270
vine leaves 148
stuffed vine leaves 233
violaxanthin 67, 74
vitamin A, food sources see vitamins
supplements chart (338–9)
vitamin C, food sources see vitamins
supplements chart (338–9)
vitamin D, food sources see vitamins
supplements chart (338–9)
vitamin E, food sources see vitamins
supplements chart (338–9)
vitamin K, food sources see vitamins
supplements chart (338–9)
vitamin U 52

W
wakame 131

walnuts 93, 163
butternut squash and walnut bites 200
cherry strudel 293
dried fruit and nut roll 303
elderberry and blackberry nutty
crisp 288
fragrant rice and millet 283
Mediterranean nut squares in rose and
cardamom syrup 298
nutty sugar loaf 289
poppy seed and walnut roulade 302
Savoy cabbage parcels 265
wasabi 54
watercress 68, 164
watercress and flaxseed soup 212
waterfowl 127
watermelon 44
wheatgrass 133
deeply purifying juice 317
wild garlic soup 214
winter squashes 59
health boost juice 310
see also butternut squash; pumpkin
witloof (Belgian endive) 73
wolf berries see goji berries

Y
yellow summer squash 60
yogurt 141, 148, 150, 154, 156, 162, 164

Z
zeaxanthin 36, 37, 44, 55, 60, 61, 67, 70,
75, 80, 143
zinc, food sources see minerals
supplements chart (340–1)
zingerone 90
zucchini 60, 167
adzuki bean soup 220
flowers 60
griddled vegetable roll with cashew
and braised garlic cream 282
Mediterranean vegetable medley 272
quinoa and vegetable stack 262
spicy raw vegetable spaghetti 246
sprouted quinoa with vegetables 245
stuffed peppers 252
vegetable moussaka 278
watercress and flaxseed soup 212

pineapple 48
pinoresinol 58
pistachio nuts 93
 almonds and pistachio macaroons 300
 banana and cranberry ice cream 296
 Mediterranean nut squares in rose and
 cardamom syrup 298
 millet and pears with cardamom 185
 sweet saffron rice with cardamom 191
 Valentine's special 315
 warm fruit salad in sweet wine
 sauce 290
plums 24
 millet and quinoa porridge with plum
 compote 185
polyhydroxylated fatty alcohols
 (PFAs) 50
polyphenols 20, 29, 46, 64, 80, 137, 144
pomegranates 46
popcorn 61
poppy seeds 95
 poppy seed and walnut roulade 302
pork 125
 sauerkraut parcels 264
potassium, food sources see minerals
 supplements chart (340–1)
potatoes 87, 162, 165
 French bean stew 274
 ginger chicken 261
 lamb casserole with vegetables 279
proanthocyanidin 32, 34, 93
protein 26, 42, 94, 95, 105, 106, 114, 124,
 126, 129, 130, 131, 142, 143
prunes 24, 164
 dried fruit and nut roll 303
 presoaked barley breakfast 190
pumpkin 59, 149
 beans baked in a pumpkin pot 253
pumpkin seeds 94, 150, 160, 162
 presoaked barley breakfast 190
 sourdough rye bread 328
 trout and lettuce wraps 231
purple broccoli rabe 51, 153, 248
pyridoxine, food sources see vitamins
 supplements chart (338–9)

Q

quail 126
 quail soup 217
quail eggs 143, 158
 quail egg and endive salad 224
 quail eggs on rye bread 184
quercetin, food sources see vitamins
 supplements chart (338–9)
quince 27
 baked quince 294
quinoa 105, 163
 artichokes in a sweet spicy sauce 239
 millet and quinoa porridge with plum
 compote 185

nori vegetable roll 234
 quinoa and vegetable stack 262
 Savoy cabbage parcels 265
 sprouted medley 204
 sprouted quinoa with vegetables 245
 stuffed peppers 252

R

radicchio 73
radishes 86
 five-flavor juice 312
 spicy raw vegetable spaghetti 246
raisins 29
 stuffed vine leaves 233
raspberries 38
 almond and raspberry cake 286
 buckwheat pancakes with fresh berry
 sauce 178
 rose and raspberry vinegar 334
 Valentine's special 315
 winter pick-me-up juice 309
red clover 96
 deep cleansing tea 322
 herring with cucumber and seaweed
 salad 227
reservatrol 29, 37
rheosmin 38
rhubarb 80
riboflavin, food sources see vitamins
 supplements chart (338–339)
rice 107
 fragrant rice and millet 283
 nori vegetable roll 234
 rice bran oil 107
 sauerkraut parcels 264
 stuffed peppers 252
 stuffed vine leaves 233
 sweet saffron rice with cardamom 191
 warm chicken congee 193
 wild rice salad 240
rose 145
 deep nurture tea 322
 Mediterranean nut squares in rose and
 cardamom syrup 298
 rose and fennel seed oil 333
 rose and raspberry vinegar 334
 rose petal and white wine sorbet 295
 rose syrup 315
rosehip tea 145
 winter pick-me-up juice 309
rosemary 101
 grilled sardines with tomato salsa 276
runner beans 74
rutin, food sources see vitamins
 supplements chart (338–9)
rye 110, 158
 flour 110
 quail eggs on rye bread 184
 sourdough rye bread 328
 sprouted rye 110

S

saffron 119, 161
 sweet saffron rice with cardamom 191
safranal 119
sage 101
St. John's wort 99
 a cup of happiness 317
salicylic acid 30, 132
salmon 128, 154, 157
 salmon with dill and tamari sauce 268
sardines 129, 148
 grilled sardines with tomato salsa 276
sauerkraut 122
 party aftermath 316
 sauerkraut 330
 sauerkraut parcels 264
schisandra 99
 astragalus and schisandra broth 324
 deep nurture tea 322
 deep sleep tea 321
sea bass 129
 sea bass with spinach and mango 250
seaweeds 131
 herring with cucumber and seaweed
 salad 227
 nori vegetable roll 234
 quail soup 217
 seaweed and miso broth 325
secoisolariciresinol 58
seeds and sprouts 94–7
selenium, food sources see minerals
 supplements chart (340–1)
serotonin 23, 93
sesame seeds 94, 161
 feta and oregano squares 180
 hummus with coriander 196
 marinated tofu with shiitake and
 noodles 258
 nori vegetable roll 234
 sesame heart cookies 299
 spicy raw vegetable spaghetti 246
sesamin 94
sesamolin 94
shiitake mushrooms 91, 149, 159, 161
 barlotto with chestnut purée 281
 beans baked in a pumpkin pot 253
 marinated tofu with shiitake and
 noodles 258
 quail soup 217
 quinoa and vegetable stack 262
shrimp 158
silicon 58, 74, 78, 84
silymarin 62
snow peas 76, 155, 161
 marinated tofu with shiitake and
 noodles 258
 stir-fried spring vegetables 259
sorbitol 24
soy sauce 123
 ginger chicken 261

hot lemonade with ginger and
 honey 305
lentils 115, 157
 puy lentil soup with fresh turmeric 212
 sprouted medley 204
lentinan 91
lettuce 66, 154
 trout and lettuce wraps 231
lignans 113
limes 150, 151, 153, 165
 herring with cucumber and seaweed
 salad 227
 mung bean and spinach soup 209
 sprouted quinoa with vegetables 245
limonoids 40
linolenic acid 29
licorice 118
 deep nurture tea 322
 marshmallow and licorice tea 320
liver 127
lunasin 104
lupeol 43
lutein 22, 36, 44, 51, 55, 60, 61, 65, 67, 70,
 74, 75, 76, 80, 84, 143
luteolin 55
lycopene 22, 44, 55, 65, 84
lysine 104

M
mackerel 128
 broiled mackerel with chard 275
magnesium, food sources see minerals
 supplements chart (340–1)
manganese, food sources see minerals
 supplements chart (340–1)
mangoes 43, 153, 167
 marinated duck with mango salsa 269
 mung bean and purple broccoli rabe
 stir-fry 248
 sea bass with spinach and mango 250
 sprouted quinoa with vegetables 245
 trout and lettuce wraps 231
manuka honey 134
maple syrup 137
 almond porridge with apricots 188
 presoaked barley breakfast 190
marjoram 154
 mint and friends tea 318
marshmallow root 99
 marshmallow and licorice tea 320
meats 124–7
medium-chain triglycerides (MCTs) 49
melatonin 28
melons 44
menthol 102
milk 140
 kefir milk 332
 kefir milk cheese 332
milk thistle 99
 party aftermath 316
millet 111

flour 111
 fragrant rice and millet 283
 millet and pears with cardamom 185
 millet and quinoa porridge with plum
 compote 185
 sprouted medley 204
 sprouted millet 111
mint 102, 152
 mint and friends tea 318
 stir-fried spring vegetables 259
 stuffed vine leaves 233
miso 123
 quail soup 217
 seaweed and miso broth 325
mizuna 69
molybdenum, food sources see minerals
 supplements chart (340–1)
monkfish 161
mulberries 37
mung beans 115, 153, 161
 adzuki and mung bean salad 226
 marinated tofu with shiitake and
 noodles 258
 mung bean and purple broccoli rabe
 stir-fry 248
 mung bean and spinach soup 209
 sprouted medley 204
mushrooms 91, 149
 chanterelles and chiles with pasta 267
 mushroom frittata with cherry
 tomatoes and basil 236
 mushroom and chestnut bites 202
 stuffed peppers 252
 venison casserole with cranberries 270
 see also shiitake mushrooms
mustard greens 69
myrosinase 86

N
nasunin 64
nectarines 22
 warm fruit salad in sweet wine
 sauce 290
neoxanthin 67, 74
nettles 72
 buckwheat pancakes with nettles and
 feta cheese 238
 deep cleansing tea 322
niacin, food sources see vitamins
 supplements chart (338–39)
nondialyzable material (NDM) 34
norepinephrine 23
nori 131, 234
nutmeg 118
nuts 92–3
 see also specific entries

O
oats 109, 148, 160, 166
 baked oatmeal with goji berries and
 cinnamon 187

granola 160
 oat milk 109
 oat straw 109
okra 75
 beans baked in a pumpkin pot 253
oleanolic acid 93
oleic acid 92, 105, 120, 124, 140
oligomeric proanthocyanidin complexes
 (OPCs) 29
oligosaccharides 91, 123
olive oil 120, 149, 153, 155, 164
omega-3 and omega-6 fatty acids, food
 sources see vitamins supplements
 chart (338–9)
onions 81, 151, 157, 159, 162, 164
 cabbage momos 235
 ezze 195
oranges 40, 164, 166
 alert and joyful juice 313
 five-flavor juice 312
 winter wake up 316
oregano 102
 feta and oregano squares 180
organic foods 32, 39, 59, 68, 124
oxalic acid 67

P
palmitoleic acid 92, 140
pantothenic acid, food sources see
 vitamins supplements chart (338–9)
papain 45
papaya 45, 166
parsley 100, 148, 153, 158
 deeply purifying juice 317
 party aftermath 316
peaches 22
 warm fruit salad in sweet wine
 sauce 290
pears 23, 164
 fresh fig delight with pear and red wine
 sauce 285
 millet and pears with cardamom 185
 warm fruit salad in sweet wine
 sauce 290
peas 76
 see also snow peas
pectin 20, 23, 24, 26, 40, 43, 59, 66
pepper 119, 158
perillyl alcohol (POH) 28
phlorizin 20
phosphorus, food sources see minerals
 supplements chart (340–1)
phthalides 78
phytoalexins 76
phytoestrogens 58, 96, 123
phytosterols 50, 93, 95, 107, 115
picrocrocin 119
pine nuts 93, 148
 fresh cilantro leaf pesto with pasta 241
 spicy raw vegetable spaghetti 246
 stuffed vine leaves 233

poached eggs and spinach 182
quail egg and endive salad 224
spinach and ricotta filo rolls 230
eicosapentaenoic acid (EPA) 128, 129
elderberries 35
deeply warming tea 321
elderberry and blackberry nutty
crisp 288
elderberry syrup 308
elderflowers 35
ellagic acid 30, 39, 93
erepsin 58
ergothioneine 91
essential fatty acids, food sources see
vitamins supplements chart (338–9)
eugenol 100

F

fats and oils 120–1
fava beans 74
fennel 79, 161
barlotto with chestnut purée 281
build-me-up juice 313
griddled vegetable roll with cashew
and braised garlic cream 282
lamb casserole with vegetables 279
rose and fennel seed oil 333
seeds 79
sprouted quinoa with vegetables 245
winter wake up 316
fenugreek 117
fermented foods 122–3
fiber
insoluble 23, 24, 30, 42, 75, 108, 111, 115
mucilaginous 73, 95, 96, 99, 110, 113,
117, 131
soluble 23, 26, 29, 30, 42, 61, 66, 75, 106,
109, 110, 112, 114, 115
figs 26
dried fruit and nut roll 303
fresh fig delight with pear and red wine
sauce 285
warm fruit salad in sweet wine
sauce 290
fish, oily 128–9
see also specific entries
flavonoids, food sources see vitamins
supplements chart (338–9)
flaxseed oil 121
flaxseeds 95, 150, 166
almond porridge with apricots 188
kefir cheese with flaxseed and
berries 184
spicy crackers 207
tomato crackers 205
watercress and flaxseed soup 212
folic acid/folate, food sources see
vitamins supplements chart (338–9)
fructan 29
fructose 23, 24, 41
fucoxanthin 131

G

gallic acid 30
gamma-linolenic acid 31, 121
garlic 82, 149, 153, 155, 165
adzuki and mung bean salad 226
ezze 195
griddled vegetable roll with cashew
and braised garlic cream 282
hummus with coriander 196
raw tomato soup 210
sea bass with spinach and mango 250
stir-fried spring vegetables 259
wild garlic soup 214
germanium 91
ginger 90, 157, 165, 167
astragalus and schisandra broth 324
build-me-up juice 313
deeply warming tea 321
ginger chicken 261
hot lemonade with ginger and
honey 305
puy lentil soup with fresh turmeric 212
sea bass with spinach and mango 250
stay supple juice 312
turmeric and ginger oil 337
glucosinolates 69
glutathione 52, 65, 77, 83
glycodelin-A 76
goji berries 36, 159
baked oatmeal with goji berries and
cinnamon 187
deep nurture tea 322
quail soup 217
squab breasts with goji berries 260
golden raisins 160
goose 127
eggs 143
gramine 109
grape antioxidant dietary fiber
(GADF) 29
grapefruits 152
health boost juice 310
grapes 29
see also raisins
green beans 74
French bean stew 274
greengages 24

H

haddock 161
hazelnuts 93, 154
fragrant rice and millet 283
mushroom and chestnut bites 202
nutty sugar loaf 289
hemp seed oil 121
hemp seeds 95
dried fruit and nut roll 303
herbs
culinary 100–3
medicinal 98–9
herring 128, 162

herring with cucumber and seaweed
salad 227
hesperidin 40
honey 134–5, 160, 165
aloe and honey hot toddy 305
hot lemonade with ginger and
honey 305
honeydew melon 44
horseradish 54, 162
hydroxycinnamic acid 69

I

indole-3-carbinol 51
inulin 62, 71, 77, 81
iodine 131
iron
absorption 40, 53, 72, 80
food sources see minerals supplements
chart (340–1)
nonheme iron 40
isatin 24
isoflavones 46, 115, 123
isorhamnetin 69
isothiocyanates 69, 70, 86, 122

J

juniper 118
coriander and juniper oil 333

K

kaempferol 39, 53, 67, 69, 100, 105
kale 53
kale chips 203
kale with buckwheat noodles 255
raw curly kale salad 223
kefir 142
kefir cheese with flaxseed and
berries 184
kefir milk 332
kefir milk cheese 332
kelp 131
kidney beans 115
kidneys 127
kimchi 122
kimchi 331
kiwi fruit 25

L

lactucarium 66
lactucopicrin 73
laetrile 21
lamb 125
lamb casserole with vegetables 279
lariciresinol 58
lauric acid 49, 120
leeks 81
adzuki bean soup 220
lemons 40, 148, 153, 157
barley grass and barley lemonade 306
blackberry lemonade 306
build-me-up juice 313

carrots 84–5, 151, 152, 153, 158, 159
 adzuki bean soup 220
 build-me-up juice 313
 cabbage momos 235
 carrot and coconut soup 213
 five-flavor juice 312
 French bean stew 274
 lamb casserole with vegetables 279
 vegetable hot pot 256
carvacrol 102
cashews 92
 fresh cilantro leaf pesto with pasta 241
 griddled vegetable roll with cashew
 and braised garlic cream 282
catechins 22, 29, 144
cavolo nero 53
cayenne powder 56
celery and celeriac 78
 alert and joyful juice 313
 astragalus and schisandra broth 324
 braised red chicory and celery heart
 salad 243
 build-me-up juice 313
 celery seeds 78
 cooling, soothing juice 310
 five-flavor juice 312
 health boost juice 310
 party aftermath 316
 raw tomato soup 210
 seaweed and miso broth 325
 stay supple juice 312
 sweet potato and celeriac soup 216
 vegetable hot pot 256
chamomile 98
 deep sleep tea 321
chard 83
 broiled mackerel with chard 275
 stuffed vine leaves 233
 Swiss chard and sweet potato 228
cheese 167
 buckwheat pancakes with nettles
 and feta cheese 238
 cabbage momos 235
 feta and oregano squares 180
 kefir milk cheese 332
 spinach and ricotta filo rolls 230
 vegetable moussaka 278
cherries 28
 cherry strudel 293
 sour cherry drink 308
chestnuts 92
 barlotto with chestnut purée 281
 mushroon and chestnut bites 202
 nutty sugar loaf 289
chia seeds 96
 spicy crackers 207
chicken 124, 150, 165, 167
 eggs 143
 ginger chicken 261
 warm chicken congee 193
chickpeas 115

 hummus with coriander 196
chicory (also Belgian endive) 73, 153
 braised red chicory and celery heart
 salad 243
 mung bean and purple broccoli rabe
 stir-fry 248
 quail egg and endive salad 224
chiles 56–7, 159, 161
 chanterelles and chiles with pasta 267
 ezze 195
 sea bass with spinach and mango 250
Chinese leaves 331
chives 154, 158
 stir-fried spring vegetables 259
chlorella 130
 Chlorella Growth Factor (CGF) 130
chlorogenic acids 22, 64, 87
chlorophyll 53, 58, 66, 68, 96, 131, 133
chocolate 139
 dried fruit and nut roll 303
 venison casserole with cranberries 270
choline 71, 83, 138, 143
chromium 24
chymonpapain 45
cilantro 100, 151, 157
 ezze 195
 fresh cilantro leaf pesto with pasta 241
 party aftermath 316
 spicy raw vegetable spaghetti 246
 winter wake up 316
cineol 116
cinnamon 116
 baked oatmeal with goji berries and
 cinnamon 187
 winter pick-me-up juice 309
citrate 40
citrulline 44
citrus fruits 40
 see also grapefruits; lemons;
 limes; oranges
cobalamin, *food sources see vitamins*
 supplements chart (338–9)
cocoa 139
coconut 49, 151, 167
 butternut squash soup 219
 carrot and coconut soup 213
 coconut milk 49
 coconut oil 49
 coconut water 49
 poached eggs and spinach 182
 Valentine's special 315
conjugated linoleic acid (CLA) 125, 140
copper, *food sources see minerals*
 supplements chart (340–1)
coriander 117
 coriander and juniper oil 333
 flatbread with sweet potato and
 coriander 327
 hummus with coriander 196
corn 61
 corn silk 61

cornmeal 61
 marinated tofu with shiitake and
 noodles 258
 popcorn 61
coumarin 78, 96
cranberries 34, 156, 163
 alert and joyful juice 313
 banana and cranberry ice cream 296
 buckwheat pancakes with fresh berry
 sauce 178
 Savoy cabbage parcels 265
 venison casserole with cranberries 270
crème fraîche 164
crocin 119
cucumbers 58, 157
 alert and joyful juice 313
 deeply purifying juice 317
 herring with cucumber and seaweed
 salad 227
 party aftermath 316
 stay supple juice 312
cumin 117, 150
 puy lentil soup with fresh turmeric 212
curcumin 89
cynarine 62

D

daikon radishes 86
damsons 24
dandelions 71
 dandelion roots 71
 deep cleansing tea 322
 deeply purifying juice 317
dates 42
 dried fruit and nut roll 303
decosahexaenoic acid (DHA) 128, 129
dill 102, 157
 salmon with dill and tamari sauce 268
diosgenin 117
dopamine 32
dried beans 114–15
duck 127
 eggs 143
 marinated duck with mango salsa 269
dulse 131

E

eggplant 64, 167
 ajvar 198
 eggplant dip 199
 griddled vegetable roll with cashew
 and braised garlic cream 282
 Mediterranean vegetable medley 272
 stuffed peppers 252
 vegetable moussaka 278
eggs 143, 154
 almond and raspberry cake 286
 buckwheat pancakes with nettles and
 feta cheese 238
 mushroom frittata with cherry
 tomatoes and basil 236

INDEX

Index entries in italic are full recipes from the recipe section (pp176–337). In addition, the main source of information for each food gives suggestions about other culinary uses.

A

acemannan 132
acorn squash 59
actinidin 25
adzuki beans 114
 adzuki and mung bean salad 226
 adzuki bean soup 220
AFA (aphanizomenon flos-aquae) 130
alfalfa seeds 96
 sprouted medley 204
algae 130
allicin 82
allyl isothiocyanate 54
almonds 92
 almond and raspberry cake 286
 almond porridge with apricots 188
 almonds and pistachio macaroons 300
 cherry strudel 293
 fresh cilantro leaf pesto with pasta 241
 stuffed vine leaves 233
aloe vera 132
 aloe and honey hot toddy 305
 aloe gel 132
 cooling, soothing juice 310
alpha-carotene 59, 65
alpha-linolenic acid (ALA) 31, 92, 93, 105, 121
amaranth 104
amino acids 104, 123, 130, 143
anthocyanins 22, 23, 24, 28, 29, 31, 32, 52, 53, 65, 75, 81, 87, 88, 90, 145
apigenin 100
apples 20, 148, 152, 156
 apple cider vinegar 157
 cooling, soothing juice 310
 elderberry and blackberry nutty crisp 288
 stay supple juice 312
 warm fruit salad in sweet wine sauce 290
apricots 21, 156, 164, 166
 almond porridge with apricots 188
 kernel oil 21
 venison casserole with cranberries 270
arabinoxylan 110
arginine 44
artichoke 62, 153
 artichokes in a sweet spicy sauce 239
 griddled vegetable roll with cashew and braised garlic cream 282
 herb artichokes 153
arugula 70, 167
asparagus 77, 155, 158

 stir-fried spring vegetables 259
aspartic acid 77
astragalus 98
 astragalus and schisandra broth 324
 deeply warming tea 321
 quail soup 217
avocado 50, 167
 avocado oil 50
 nori vegetable roll 234
 quail egg and endive salad 224
 raw curly kale salad 223

B

B vitamins, *food sources see vitamins supplements chart* (338–9)
bananas 41, 160
 banana and cranberry ice cream 296
 flowers 41
barley 112
 barley grass 112
 barley grass and barley lemonade 306
 barlotto with chestnut purée 281
 deeply purifying juice 317
 presoaked barley breakfast 190
basil 100
 basil oil 337
 raw tomato soup 210
 vegetable moussaka 278
beef 124
beets 83, 162
 beet soup 213
 build-me-up juice 313
 five-flavor juice 312
 rainbow vegetable broth 323
 spicy raw vegetable spaghetti 246
Belgian endive 73
beta-carotene, *food sources see vitamins supplements chart* (338–9)
beta-cryptoxanthin 55
beta-glucan 109
beta-sitosterol 36
betacyanins 83
betaine 36, 96, 108
betaxanthins 83
bioflavonoids, *food sources see vitamins supplements chart* (338–9)
biotin 93
black beans 114
black seed oil 121
blackberries 30
 blackberry lemonade 306
 blackberry vinegar 334
 buckwheat and blackberry cream 177
 elderberry and blackberry nutty crisp 288
 winter pick-me-up juice 309
blackcurrants 31
 blackcurrant smoothie 181
 deep cleansing tea 322
blackstrap molasses 138
 sourdough rye bread 328

blueberries 32–3, 162
 buckwheat pancakes with fresh berry sauce 178
 Valentine's special 315
 winter pick-me-up juice 309
bok choy 52
boron, *food sources see minerals supplements chart* (340–1)
broccoli 51, 153, 158
 mung bean and purple broccoli rabe stir-fry 248
bromelain 48
Brussels sprouts 52
buckwheat 113, 156
 buckwheat and blackberry cream 177
 buckwheat pancakes with fresh berry sauce 178
 buckwheat pancakes with nettles and feta cheese 238
 flour 113
 kale with buckwheat noodles 255
 sprouted buckwheat 113
bulgur wheat 108
butter 120
butter beans 114, 149
 beans baked in a pumpkin pot 253
butternut squash 59
 butternut squash and walnut bites 200
 butternut squash soup 219
butyric acid 112

C

cabbage 52, 163
 cabbage momos 235
 kimchi 331
 lamb casserole with vegetables 279
 sauerkraut 330
 sauerkraut parcels 264
 Savoy cabbage parcels 265
 vegetable hot pot 256
caffeic acid 58, 64, 101
calcium
 absorption 26, 41, 80, 84
 food sources see minerals supplements chart (340–1)
cantaloupe melon 44
capric acid 140
caprylic acid 49
capsaicin 56
capsanthin 55
carbohydrates, slow-release 29, 88, 108, 112, 113
cardamom 116
 almonds and pistachio macaroons 300
 fragrant rice and millet 283
 Mediterranean nut squares in rose and cardamom syrup 298
 millet and pears with cardamom 185
 sweet saffron rice with cardamom 191
carotenoids, *food sources see vitamins supplements chart* (338–9)

menstrual symptoms
blackstrap molasses 138
cranberries 34
milk thistle 99
rose 145
metabolic support
cardamom 116
coconut 49
duck and goose 127
fenugreek 117
goji berries 36
meats 124–7
oily fish 128–9
plums 24
raspberries 38
metabolic syndrome
eggs 143
licorice 118
milk 140
millet 111
peaches and
nectarines 22
rye 110
spelt 106
muscle health
celery and celeriac 78
goji berries 36

N
nausea
ginger 90
nervous exhaustion
pears 23
nervous system support
black strap molasses 138
eggs 143
lamb 125
oily fish 128–9
neurodegeneration
blackcurrants 31
rhubarb 80
turmeric 89
see also **dementia**
night vision
blackcurrants 31
carrots 84

O
ovarian cancer
cucumbers 58
mustard greens 69
spinach 67
oxidative stress
asparagus 77
cranberries 34
eggplant 64

P
pain relief
aloe vera 132
parasites, intestinal
cabbage 52
carrots 84
cucumbers 58
papaya 45
pregnancy, healthy
asparagus 77
healthy eating
plan 166–7
okra 75
raspberries 38
winter squashes 59
prostate cancer
blueberries 32
broccoli 51
carrots 84
cucumbers 58
garlic 82
grapes 29
mangoes 43
maple syrup 137
mustard greens 69
pomegranate 46
spinach 67
sweet bell peppers 55
tea 144
tomatoes 65
prostate enlargement
corn 61
maple syrup 137
nettles 72
zucchini 60

R
rheumatoid arthritis
nettles 72
turmeric 89

S
sedatives, natural
chamomile 98
chicory (Belgian
endive) 73
lettuce 66
oats 109
potatoes 87
rose 145
skin cancer
mangoes 43
skin health
apricots 21
blackberries 30
dandelion 71
healthy eating plan 154–5

meats 124–7
peaches and
nectarines 22
seeds and sprouts 94–7
sweet potatoes 88
watercress 68
sleep, restful
chamomile 98
cherries 28
goji berries 36
milk 140
millet 111
valerian root 98
sore throats
dates 42
quince 27
rosemary 101
thyme 101
sports injuries
pineapple 48
stomach cancer
carrots 84
peas 76
tea 144
stomach cramps
fennel 79
rose 145
stomach ulcers
arugula 70
bananas 41
cabbage 52
cranberries 34
honey 134
kale 53
marshmallow root 99
papaya 45
potatoes 87
yogurt 141
stomach upsets
chocolate 139
cranberries 34
dill 102
mint 102
quince 27
strawberries 39
stress
healthy eating plan 160–1
nutmeg 118
rose 145
seaweeds 131
stroke protection
bananas 41
chocolate 139
seaweeds 131
tea 144
winter squashes 59
zucchini 60

T
teeth *see* dental health
thyroid function
seaweeds 131
tissue growth and repair
amaranth 104
green beans 74
meats 124–7
quinoa 105
see also **collagen
synthesis**

U
ulcerative colitis
barley 112
honey 134
wheatgrass 133
ulcers *see* duodenal
ulcers; stomach ulcers
**urinary tract infections
(UTIs)**
blackcurrants 31
blueberries 32
cranberries 34

V
varicose veins
buckwheat 113

W
weight management
carrots 84
celery and celeriac 78
chiles 56
coconut 49
milk 140
peaches and
nectarines 22
seaweeds 131
yogurt 141
women's health
healthy eating
plan 164–5
see also **specific health
issues**
wound healing
blackcurrants 31
honey 134
melons 44

fever
cinnamon 116
elderberries 35
free-radical damage
apples 20
apricots 21
blackcurrants 31
cabbage 52
chocolate 139
goji berries 36
green beans 74
oregano 102
peaches and
nectarines 22
quince 27
quinoa 105
sweet potatoes 88
see also **oxidative
stress**

G
gallstones
millet 111
radishes 86
gastroenteritis
blueberries 32
glaucoma
blueberries 32
papaya 45
gout
cherries 28
juniper 118
pears 23
gum disease
aloe vera 132
cranberries 34
juniper 118
thyme 101

H
heart health
asparagus 77
bananas 41
beets 83
blackberries 30
chocolate 139
dates 42
dried beans 114–5
eggplant 64
healthy eating plan 148–9
maple syrup 137
oily fish 128–9
seaweeds 131
seeds and sprouts 94–7
stevia 136
sweet peppers 55
tea 144

tomatoes 65
winter squashes 59
zucchini 60
heart rate regulation
blackcurrants 31
dates 42
figs 26
HIV
aloe vera 132
mulberries 37
hormone balancing
fennel 79
kale 53
rice 107
sage 101
seeds and sprouts 94–7
hypertension *see* **blood
pressure regulation**

I
immune system support
aloe vera 132
arugula 70
asparagus 77
astragalus 98
blackcurrants 31
broccoli 51
chocolate 139
dandelion 71
fermented foods 122–3
garlic 82
kefir 142
kiwi fruit 25
liver 127
mangoes 43
meats 124–7
spelt 106
squab 126
stevia 136
tea 144
yogurt 141
indigestion
artichoke 62
citrus fruits 40
mint 102
infection, fighting
algae 130
arugula 70
papaya 45
peas 76
sweet potatoes 88
inflammation, fighting
aloe vera 132
amaranth 104
asparagus 77
bulgur wheat 108
cherries 28

cumin 117
fennel 79
ginger 90
kale 53
mushrooms 91
mustard greens 69
nuts 92–3
pineapple 48
potatoes 87
quince 27
rose 145
rosemary 101
spinach 67
turmeric 89
winter squashes 59
see also **antibacterial
action; antiviral
action**
**inflammatory bowel
disease**
pineapple 48
yogurt 141
insomnia
cherries 28
mulberries 37
oats 109
insulin resistance
milk 140
seaweeds 131
insulin secretion
cherries 28
juniper 118
oats 109
turkey 125
insulin sensitivity
maple syrup 137
stevia 136
iron stores, boosting
green beans 74
nettles 72
peas 76
**irritable bowel
syndrome**
artichoke 62
marshmallow root 99
mint 102

J
joint health
avocado 50
celery and celeriac 78
healthy eating plan 156–7
nuts 92–3
oily fish 128–9
pears 23
pomegranate 46
rose 145

K
kidney cancer
quince 27
kidney inflammation
parsley 100
kidney stones
citrus fruits 40
nettles 72
radishes 86

L
lactose intolerance
kefir 142
laxative action
artichoke 62
asparagus 77
kiwi fruit 25
peaches and
nectarines 22
pears 23
plums 24
liver support
algae 130
arugula 70
beets 83
cabbage 52
dandelion 71
healthy eating
plan 152–3
milk thistle 99
plums 24
radishes 86
see also **detoxification**
lung cancer
garlic 82
maple syrup 137
mustard greens 69
sweet bell peppers 55
tea 144

M
memory support
blueberries 32
cinnamon 116
eggs 143
hemp seed oil 121
sage 101
menopausal symptoms
fenugreek 117
milk thistle 99
rice 107
sage 101
men's health
healthy eating
plan 162–3
see also **specific health
issues**

cholesterol, unhealthy, lowering
amaranth 104
apples 20
artichoke 62
barley 112
carrots 84
chiles 56
citrus fruits 40
dried beans 114–5
fats and oils 120–1
healthy eating
 plan 148–9
kale 53
kefir 142
mustard greens 69
nuts 92–3
oats 109
papaya 45
rhubarb 80
rice 107
seeds and sprouts 94–7
tea 144
wheatgrass 133
zucchini 60
circulatory system support
buckwheat 113
see also **blood vessels, healthy**
colds, coughs, the flu
aloe vera 132
chocolate 139
dates 42
elderberries 35
honey 134
kiwi fruit 25
mangoes 43
star anise 119
thyme 101
colic
dill 102
thyme 101
collagen synthesis
broccoli 51
dandelion 71
kiwi fruit 25
sweet peppers 55
colorectal cancer
grapes 29
mangoes 43
mustard greens 69
okra 75
quince 27
raspberries 38
rice 107
watercress 68

congestion
cardamom 116
chiles 56
horseradish 54
licorice 118
radishes 86
constipation
apples 20
bananas 41
barley 112
bulgur wheat 108
figs 26
mulberries 37
parsley 100
pears 23
plums 24
see also **laxative action**

D

dementia
blackcurrants 31
sage 101
salmon 128
see also **Alzheimer's disease**
dental health
blackstrap molasses 138
cranberries 34
eggs 143
pomegranate 46
see also **gum disease**
depression
nuts 93
oats 109
St. John's wort 99
detoxification
algae 130
amaranth 104
blackberries 30
cabbage 52
chicory (Belgian
 endive) 73
chiles 56
cilantro 100
citrus fruits 40
eggplant 64
garlic 82
grapes 29
horseradish 54
mustard greens 69
okra 75
plums 24
seaweeds 131
seeds and sprouts 94–7
tomatoes 65
wheatgrass 133

diabetes
beets 83
cherries 28
milk 140
oats 109
stevia 136
see also **blood sugar regulation; insulin resistance; insulin secretion; insulin sensitivity**
diabetic neuropathy
black seed oil 121
okra 75
diarrhea
apples 20
kefir 142
poppy seeds 95
quince 27
digestive health
algae 130
aloe vera 132
barley 112
basil 100
buckwheat 113
chicory (Belgian
 endive) 73
coriander 117
corn 61
cucumbers 58
fenugreek 117
fermented foods 122–3
ginger 90
healthy eating plan 150–1
mangoes 43
mushrooms 91
onion family 81
peas 76
pepper 119
pineapple 48
rye 110
stevia 136
watercress 68
yogurt 141
diuretics
artichoke 62
asparagus 77
blackcurrants 31
celery and celeriac 78
chicory (Belgian
 endive) 73
cucumbers 58
dandelion 71
dill 102
elderberries 35
fennel 79
grapes 29

horseradish 54
nettles 72
parsley 100
peaches and
 nectarines 22
watercress 68
zucchini 60
duodenal ulcers
cabbage 52
kale 53
potatoes 87

E

eczema
black seed oil 121
cabbage 52
yogurt 141
energy boosting
asparagus 77
astragalus 98
bananas 41
beets 83
blackstrap molasses 138
buckwheat 113
fats and oils 120–1
green beans 74
healthy eating
 plan 158–9
maple syrup 137
meats 124–7
mulberries 37
peas 76
rice 107
schisandra 99
eye health 70
apricots 21
blueberries 32
broccoli 51
carrots 84
eggs 143
goji berries 36
mangoes 43
melons 44
mulberries 37
okra 75
see also **age-related macular degeneration; cataracts; glaucoma**

F

fatigue see **energy boosting**
fertility
avocado 50
peas 76
pineapple 48

INDEX BY HEALTH AREA

Beneficial foods are grouped under each specific health area.

A

age-related macular degeneration
apricots 21
arugula 70
corn 61
eggs 143
mangoes 43
melons 44
papaya 45
plums 24
rhubarb 80
saffron 119
sweet peppers 55

allergy relief
honey 134
kefir 142
pears 23
yogurt 141

Alzheimer's disease
blackcurrants 31
coconut 49
rhubarb 80
turmeric 89

anemia
beets 83

antibacterial action
astragalus 98
blueberries 32
citrus fruits 40
coconut 49
dill 102
horseradish 54
onion family 81
oregano 102
rose 145
stevia 136
tea 144

antifungal action
coconut 49

antiseptic action
cinnamon 116
juniper 118
licorice 118
rosemary 101

antiviral action
aloe vera 132
coconut 49
onion family 81
pomegranate 46
star anise 119

anxiety
oats 109

rose 145
valerian root 98

appetite stimulants
coriander 117
pepper 119
plums 24

arthritis
ginger 90
pears 23
potatoes 87
rose 145
tea 144

asthma
aloe vera 132
black seed oil 121

atherosclerosis
barley 112
grapes 29
kiwi fruit 25
maple syrup 137
quinoa 105
rye 110
spinach 67
strawberries 39

B

bladder cancer
garlic 82
mustard greens 69
sweet bell peppers 55
watercress 68

bladder infections
dill 102
parsley 100
see also **urinary tract infections (UTIs)**

bloating
ginger 90
kefir 142
lettuce 66
mulberries 37

blood builders
blackstrap molasses 138
meats 124, 127
nettles 72
wheatgrass 133

blood pressure regulation
avocado 50
blackberries 30
blackcurrants 31
celery and celeriac 78
eggs 143
fats and oils 120–1
figs 26
garlic 82
melons 44

okra 75
potatoes 87
radishes 86
yogurt 141

blood sugar regulation
apples 20
artichoke 62
barley 112
buckwheat 113
bulgur wheat 108
cinnamon 116
dates 42
dried beans 114–5
eggplant 64
garlic 82
grapes 29
nettles 72
plums 24
rye 110
spelt 106
stevia 136
sweet potatoes 88

blood vessels, healthy
asparagus 77
garlic 82
lettuce 66
maple syrup 137
melons 44
milk 140
pomegranate 46
quince 27
rye 110
seeds and sprouts 94–7
sweet bell peppers 55
tomatoes 65
see also **atherosclerosis**

bone health
apples 20
bananas 41
blackstrap molasses 138
bulgur wheat 108
dried beans 114–5
eggs 143
figs 26
green beans 74
kale 53
rhubarb 80
spinach 67
tea 144

bowel cancer
apricots 21
garlic 82
onion family 81
papaya 45
rice 107

bowel regularity
apricots 21
blackberries 30
bulgur wheat 108
dates 42
dried beans 114–5
figs 26
winter squashes 59

brain function
coconut 49
eggs 143
milk 140
see also **memory support; neuro-degeneration**

breast cancer
buckwheat 113
cucumbers 58
garlic 82
grapes 29
kale 53
mustard greens 69
peaches and nectarines 22
tea 144
wheatgrass 133

breast milk supply
fenugreek 117
star anise 119

C

cancer-fighting foods
blackberries 30
buckwheat 113
carrots 84
cucumbers 58
fermented foods 122–3
kefir 142
maple syrup 137
miso 123
mushrooms 91
mustard greens 69
strawberries 39
sweet bell peppers 55
tea 144
turmeric 89
see also **specific cancers**

cataracts
blackcurrants 31
papaya 45
sweet bell peppers 55

cholesterol, healthy, raising
artichoke 62
coconut 49
onion family 81

Nutrient	Functions	Rich Food Sources	Notes	Average Daily Intake/ Supplemental Range
Magnesium	Synthesis of proteins, carbohydrates, and lipids; DNA repair; energy production; modulation of muscle activity; homeostasis of calcium; heart and circulation health.	Kelp; seaweed; wheat bran and wheat germ; almonds; cashews; molasses; brewer's yeast; buckwheat; brazil nuts; nuts; millet; rye; tofu; beet greens; coconut meat; soy; spinach; brown rice; figs; apricots; dates; shrimp; sweetcorn; avocado.	Milling/refining of grains and cereals causes up to 90% losses.	ADI: 350mg SR: 300–800mg
Manganese	Antioxidant; enzyme activator; bone and ligament formation.	Nuts: pecans, brazil, almonds; barley; rye; buckwheat; split peas; whole wheat bread; spinach; oats; raisins; rhubarb; Brussels sprouts; avocado; beans.	Milling/refining of cereals causes 80–90% losses.	ADI: 2.5–7mg SR: 2–20mg
Molybdenum	Regulates iron, copper, and fat metabolism; teeth health; anticarcinogenic.	Lentils; liver, dried beans; cauliflower; wheat germ; spinach; kidney; brown rice; garlic; oats; eggs; rye; corn; barley; fish; chicken; beef; potatoes; onions; coconut.	Refining flour causes up to 80% losses.	ADI: 75–250ug SR: 100–1000ug
Phosphorus	Healthy bones; calcium homeostasis; RNA and DNA synthesis; energy metabolism and production; Vitamin B activator.	Brewer's yeast; wheat bran and wheat germ; pumpkin seeds; brazil nuts; sesame seeds; dried beans; almonds; cheese; rye; peanuts; cashews; liver; scallops; millet; barley; seaweed; chicken; brown rice; eggs; garlic; crab; mushrooms; milk.	Because phosphorus is so widespread in food, dietary phosphorus deficiency is extremely rare.	ADI: 800mg SR: 400–3000mg
Potassium	Blood pressure regulation; water balance regulation; hormone balance; muscle and nerve health.	Seaweed; sunflower seeds; wheat germ; almonds; raisins; nuts; dates; figs; yams; garlic; spinach; millet; dried beans; mushrooms; broccoli; banana; red meat; squash; chicken; carrots; potato.	Diuretics and certain medicines cause your body to lose potassium.	ADI: 4,500-5,100mg SR: 3–8g
Selenium	Antioxidant; detoxification of chemicals; anticarcinogenic; sperm health; reproductive system health; fertility; thyroid health; DNA repair.	Butter; herring; wheat germ; brazil nuts; cider vinegar; scallops; barley; lobster; shrimp; oats; chard; shellfish; crab; milk; fish; red meat; molasses; garlic; barley; eggs; mushrooms; alfalfa.	Milling/refining of cereals causes 40–50% losses.	ADI: 50–200ug SR: 200–800ug
Zinc	Antioxidant; anticarcinogenic; immune system regulator; antiviral; DNA and RNA synthesis; enzyme activator; wound healing; skin; hair; muscle and respiratory health; fertility; reproductive health; growth; insulin synthesis.	Oysters; ginger; red meat; nuts; dried beans; liver; milk; egg yolk; whole wheat; rye; oats; brazil nuts; peanuts; chicken; sardines; buckwheat; oily fish; shrimp; white fish.	Milling/refining of cereals causes 80% losses, freezing of vegetables causes 25–50% losses.	ADI: 15mg SR: 10–70mg

References for vitamin and mineral supplements charts: Osiecki, H., "*The Nutrient Bible 8th Edition*" (2010, Bioconcepts, Australia)
Liska et al, "*Clinical Nutrition: A Functional Approach*" (2004, The Institute for Functional Medicine, Washington USA)

MINERAL SUPPLEMENTS CHART

Just like vitamins, minerals are essential for our overall health and have specific roles to play in building bones, making hormones, and regulating heartbeat. Modern food production and farming methods remove important minerals from our food. The body cannot make its own, so it's essential to obtain minerals in adequate amounts from either food or good-quality supplements (find more on p17).

Nutrient	Functions	Rich Food Sources	Notes	Average Daily Intake/ Supplemental Range
Boron	Activates Vitamin D; bone and joint health.	Drinking water; almonds; apples; dates; nuts; beans; peanuts; prunes; soy.	Available from most plants grown where boron is present in the soil.	ADI: 2–3mg SR: 2–10mg
Calcium	Bone and teeth formation; regulates nerve and muscle function; hormones and blood pressure.	Kelp; seaweed; cheese; carob; molasses; almonds; yeast; parsley; corn; watercress; goats milk; tofu; figs; sunflower seeds; yogurt; beet greens; green leafy vegetables; wheat bran; cows milk; buckwheat; sesame seeds; olives; broccoli.	Water softeners remove calcium. Excess phytates (rhubarb, spinach, grains, and cereals) can decrease absorption.	ADI: 800–1400mg SR: 1000–2500mg
Chromium	Glucose metabolism; growth; insulin and cholesterol regulation.	Brewer's yeast; beef; liver; whole wheat bread; rye flour; chile; oysters; potatoes.	Refining flour causes up to 50% losses.	ADI: 50–200ug SR: 100–300ug
Copper	Synthesis of enzymes required for iron absorption; red blood cell formation; maintenance of skin, bone, and nerve formation; collagen synthesis.	Oysters; shellfish; nuts; brazil nuts; almonds; hazelnuts; walnuts; pecans; dried beans; split peas; liver; buckwheat; peanuts; lamb; sunflower oil; crab; copper water pipes.	Zinc and calcium are antagonists (high levels prevent absorption of copper).	ADI: 1–3mg SR: 2–10mg Metabolism of copper is highly individual.
Iodine	Synthesis of thyroid hormones.	Seaweed; kelp; clams; shrimp; haddock; shellfish; salmon; sardines; liver; pineapple; eggs; peanuts; whole wheat bread; cheese; pork; lettuce; spinach.	Often added to table salt but not sea salt.	ADI: 150ug SR: 100–1000ug
Iron	Red blood cell function; energy release; growth; bone regulation; healthy respiration, skin, and nails.	Kelp; yeast; molasses; wheat bran; pumpkin seeds; liver; sunflower seeds; millet; parsley; clams; almonds; prunes; cashews; red meat; raisins; nuts; chard; dandelion leaves; dates; cooked dried beans; eggs; lentils; brown rice; dried apricots; raw chocolate.	Vitamin C enhances iron absorption.	ADI: 10–20mg SR: 15–50mg

Nutrient	Functions	Rich Food Sources	Notes	Average Daily Intake/ Supplemental Range
Vitamin B$_{12}$— Cobalamin	DNA synthesis; new red blood cells; lipid production; myelin sheath; healthy nervous system, blood cells, gut mucosa, skin.	Liver; shellfish; kidneys; oily fish; egg yolk; lamb; beef; cheese.	Plants do not contain bioactive forms of B$_{12}$ so vegans must supplement.	ADI: 2–50ug SR: 300–5000ug
Folic Acid	DNA and RNA synthesis; new blood cells; protein synthesis; growth; healthy digestion; nervous system; red blood cells.	Yeast; Black-eyed peas; soybeans; wheat germ; liver; kidney beans; mung beans; asparagus; lentils; walnuts; spinach; kale; beet greens; peanuts; broccoli; barley; whole wheat cereal; Brussels sprouts; almonds; oatmeal; cabbage; figs; avocado.	Unstable to heat and light. Storage and cooking causes losses. Supplementation may be advisable before and during pregnancy.	ADI: 400ug SR: 500ug–5mg
Vitamin C— Ascorbic Acid	Antioxidant; healthy immune system, bones, teeth, gums, cartilage, capillaries, connective tissue, healing; synthesis of steroid hormones, absorption of iron, regulating cholesterol.	Acerola cherry; sweet bell peppers; kale; parsley; leafy vegetables; broccoli; watercress; strawberries; papaya; oranges; grapefruit; cabbage; lemon juice; elderberries; liver; mangoes; asparagus; oysters; radishes; raspberries.	Unstable to heat and light. Cooking may cause 10-90% losses.	ADI: 75–125mg SR: 250–2,000mg
Vitamin D— Calciferol	Controls calcium absorption for healthy bones and teeth; healthy immune system and nervous system; cancer-protective; hormone-balance.	Fish liver oils; sardines (canned and fresh); salmon; tuna; shrimp; butter; sunflower seeds; liver; eggs; milk; mushrooms; cheese.	Synthesized by the action of sunlight on the skin. Supplementation may be advisable if not exposed to sunlight regularly.	ADI: 1–5mg SR: 5–150mg
Vitamin E— Tocopherol, etc.	Antioxidant; healthy immune system; heart and circulation; lipid balance; sex hormone regulator; fertility; gestation; growth.	Sunflower seeds; sunflower oil; safflower oil; almonds; sesame oil; peanut oil; corn oil; wheat germ; peanuts; olive oil; butter; spinach; oatmeal; salmon; brown rice; rye flour; pecans; wheat germ; whole wheat bread; carrots.	Losses caused by heat and light. Milling of flour causes up to 80% loss.	ADI: 30mg SR: 100–800mg
Vitamin K— Phylloquinone, Menaquinone	Blood clotting; calcium metabolism; blood sugar-balance; healthy lung tissue; heart and circulation; metabolism; bones; skin; bacterial synthesis in the gut.	Broccoli; lettuce; cabbage; liver; spinach; watercress; asparagus; cheese; butter; oats; peas; whole wheat; green beans; pork; eggs; kelp.	Unstable to light. If bowel microflora are healthy up to 50% of Vitamin K needs are manufactured in the gut.	ADI: 70–150ug SR: 1–20mg
	Antioxidant; anti-inflammatory; healthy immune system; cancer-protective (Quercetin); healthy blood vessels (Rutin).	Apples; black and red berries; blackcurrants; buckwheat; citrus fruit; apricots; garlic; green-growing shoots of plants; onions; rosehips; cherries.	Some loss during cooking and processing.	ADI: N/A SR: 500–3,000mg
Essential Fatty Acids— Omega oils	Regulate inflammation; healthy blood coagulation; lipid balance; reproduction and growth; brain function; nervous system; eyes; skin; joints; metabolism; hormones; heart and circulation.	Fish liver oils; oily fish; milk; cheese; Flaxseed oil; hempseed oil; canola; soy oil; walnut oil; blackcurrant seed oil.	Hydrogenation, light, heat.	3–8% of calories

VITAMIN SUPPLEMENTS CHART

The better quality your food is, the more abundant it will be in the vitamins that are essential to your continued health and well-being. Processing, cooking, and storage, as well as soil-damaging pesticides and fertilizers can leave food nutrient poor. Supplementing at optimal levels can help fill the gap between what you need and what you often get—see p17 for details about ADI and Supplemental Range.

Nutrient	Functions	Rich Food Sources	Notes	Average Daily Intake/ Supplemental Range
Vitamin A and Carotenoids	**Vitamin A:** Antioxidant; vision and night vision; growth and reproduction; collagen production; moistness of mucosa. **Carotenoids:** Precursors to vitamin A; antioxidant; healthy heart and circulation; healthy mucosa.	**Vitamin A:** Fish-liver oils; animal liver; oily fish; egg yolks; whole milk; and butter. **Carotenoids:** Green and yellow fruits and vegetables; dark green leafy vegetables; sweet bell peppers; sweet potato; broccoli; carrots; dried apricots; prunes; kale; parsley; spinach; squash; and watercress.	Animal sources of Vitamin A may be much better absorbed than vegetable sources.	**Vitamin A—** ADI: 5,000–9,000IU SR: 10,000+ **Beta-carotene—** ADI: 5–8mg SR: 10–40mg
Vitamin B$_1$— Thiamin	Release of energy from carbohydrates; growth; appetite regulation; healthy digestion and nervous system.	Yeast extract; wheat germ; whole wheat flour; sunflower seeds; brown rice; brazil nuts; pecans; pork; beans; buckwheat; oatmeal; hazelnuts; rye; liver; cashews.	Unstable to light and heat e.g. milling flour causes 60–80% loss.	ADI: 1–5mg SR: 5–150mg
Vitamin B$_2$— Riboflavin	Combines with protein to regulate respiration; growth; healthy skin and eyes.	Yeast; animal liver; kidneys; almonds; wheat germ; wild rice; mushrooms; egg yolks; millet; wheat bran; oily fish; kale; cashews; sunflower.	Unstable to light.	ADI: 1.5–2mg SR: 10–200mg
Vitamin B$_3$— Niacin	Required for energy release and synthesis of steroids and fatty acids; healthy digestion, skin, and nervous system.	Yeast; wild rice; brown rice; whole wheat flour; peanuts; animal liver; turkey; trout; mackerel; chicken; sesame seeds; sunflower seeds; lean red meat; buckwheat; barley; almonds.	Relatively stable.	ADI: 15–20mg SR: 100–3,000mg
Vitamin B$_5$— Pantothenic Acid	Regulates carbohydrate and fat metabolism; resistance to stress; healthy immune system; digestion.	Yeast; animal liver; kidneys; peanuts; mushrooms; split peas; brown rice; soybeans; eggs; oatmeal; buckwheat; sunflower seeds; lentils; rye flour; cashews; oily fish; turkey; broccoli; avocados.	Unstable to heat (cooking), freezing and canning. Considerable loss when milling grains.	ADI: 5–10mg SR: 20–500mg
Vitamin B$_6$— Pyridoxine, Pyridoxal-5-phosphate	Metabolism of carbohydrate and protein; synthesis of hormones and fatty acids; healthy nervous system, hormone-balance growth, and skin.	Yeast; sunflower seeds; wheat germ; tuna; liver; soybeans; walnuts; oily fish; lentils; buckwheat flour; beans; brown rice; hazelnuts; bananas; pork; avocados; whole wheat flour; sweet chestnuts; egg yolk; kale; rye flour.	Unstable to light and cooking. Milling flour causes 75% losses.	ADI: 1.6–2.6mg SR: 10–150mg

TURMERIC AND GINGER OIL

 HELPS FIGHT INFLAMMATION **PROTECTS THE HEART AND BLOOD VESSELS** **AIDS HEALTHY DIGESTION**

This is a blend of fine seed oils and anti-inflammatory medicinal plants. Together they make an oil that is particularly beneficial for arthritic and rheumatic conditions, and protects the heart and digestive tract. This warming, immune-enhancing oil is delicious as a salad dressing, or drizzle a spoonful or 2 onto steamed vegetables or yogurt, or add to smoothies.

MAKES 1¾ CUPS

⅓ cup dried oregano
2 tbsp dried sage leaves
1½ tbsp juniper berries
3 tbsp dried rosemary leaves
1 tsp ground turmeric
1 tsp ground ginger
1 cup sunflower oil
3 tbsp flaxseed oil
3 tbsp hemp oil
3 tbsp borage oil
3 tbsp rosehip oil

1 Place the oregano, sage leaves, juniper berries, and rosemary leaves in a blender or food processor, and pulse to reduce their volume. Place the herbs and ground spices into a glass jar and cover with the sunflower oil.

2 Preheat the oven to 120°F (50°C), then turn it off. Wrap the bottom of the jar in a cloth (to prevent the glass from cracking while standing on the hot metal shelves) and put it, unsealed, in the oven. The dried ingredients need to infuse at a temperature of around 104°F (40°C) for 6–8 hours, so you may need to turn the oven briefly on and then off again every so often to keep the mixture warm.

3 Strain the oil and discard the dried ingredients; you should have at least a scant ½ cup of flavored oil. Pour into a sterilized glass bottle and add the flax, hemp, borage, and rosehip oils. Seal well and shake. Label and date, store in the refrigerator, and use within 3–4 weeks.

BASIL OIL

 HELPS EASE BRONCHIAL COMPLAINTS **HELPS ALLEVIATE PMS** 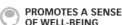 **PROMOTES A SENSE OF WELL-BEING**

Basil is beneficial for the respiratory, reproductive, and nervous systems. It is a good remedy for conditions that require relief from congestion, such as sinusitis, a loss of smell, and some bronchial conditions. Basil is traditionally known as an herb that awakens joy and courage because it helps restore vitality, enhance memory, and lift your mood.

MAKES 1 CUP

a small bunch of basil
½ cup extra virgin olive oil
½ cup grapeseed oil

1 Bring 2 cups water to a boil in a saucepan. Fill another small pan with cold water and add some ice cubes to it to make an ice-water bath. Holding the bunch of basil by its stems, immerse the leaves into the boiling water for 8 seconds. Plunge the wilted basil leaves into the ice-water bath to prevent them from discoloring and cooking further. Dry with paper towels, cut off the stems, and put the leaves into a blender or food processor. Add the two oils, and purée until smooth.

2 Use immediately, or if you want to store it for a few days in a refrigerator, leave to infuse for 1–2 hours, then strain the oils through a cheesecloth and discard the puréed basil leaves. Transfer to a sterilized bottle, seal, label, and date. Store in the refrigerator and use within 3–4 weeks.

Rose And Raspberry Vinegar

🌀 HAS A MILD
DIURETIC ACTION

⬚ ENHANCES DIGESTION
OF FATS

🖐 PROMOTES HEALTHY
SKIN AND HAIR

◎ HELPS EASE
MENSTRUAL CRAMPS

Infused vinegars are useful and versatile. This vinegar can be used as a flavoring for food, or drink 1 teaspoonful in a cup of warm water every morning to improve detoxification. For the best result, use the petals of fragrant, old-fashioned roses, such as *Rosa damascena* or *Rosa gallica* to benefit from their healing qualities, and choose a good-quality organic apple cider

MAKES 1¼ CUPS

⅔ cup fresh raspberries
2 tbsp fresh rose petals
1¼ cups organic
apple cider vinegar

1 Put the raspberries and rose petals in a clean glass jar, cover with the vinegar so the berries are completely submerged, and seal tightly with the lid. Leave in a dark cupboard to infuse for 2–3 weeks, then strain, pour the vinegar into a clean bottle, and seal, label, and date. Reserve the raspberries, if you like, and use in a smoothie. Use within 3 months.

Blackberry Vinegar

⬚ HELPS FIGHT COLDS
AND FLU

🖐 PROMOTES A HEALTHY
COMPLEXION

◎ HELPS IMPROVE
CIRCULATION

If picked when fully ripe, blackberries are a perfect foraging food, with many health benefits: they contain anthocyanins, salicylic acid, ellagic acid, and fiber, which are good for skin and hair. Traditionally, blackberry vinegar is used as a gargle for sore throats, and as a drink to avert the onset of a cold or the flu. Choose a good-quality organic apple cider vinegar.

MAKES 1¼ CUPS

⅔ cup fresh blackberries
1¼ cups organic
apple cider vinegar

1 Put the blackberries into a clean glass jar, cover with the vinegar so the blackberries are completely submerged, and seal tightly with the lid. Leave in a dark cupboard to infuse for 2–3 weeks, then strain, pour the vinegar into a clean bottle, and seal, label, and date. Reserve the blackberries, if you like, and use in a smoothie. Use within 3 months.

Rose and Raspberry Vinegar ▶

CORIANDER AND JUNIPER OIL

 PROMOTES A SENSE OF WELL-BEING **HELPS IMPROVE CIRCULATION** 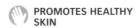 **PROMOTES PROSTATE HEALTH**

An aromatic oil blend to liven up your life. The therapeutic action of this combination of seed oils and spices has a warming, strengthening, and energizing quality that can help enhance your sense of well-being and sex drive. Use it as part of a dressing for salads or on its own to flavor cooked rice, spaghetti, or noodles.

MAKES ¾ CUP

2 tbsp peppercorns
⅓ cup + 1 tbsp coriander seeds
2 tbsp juniper berries
¼–½ tsp chili flakes
⅔ cup sunflower oil

For the base oil

2 tbsp walnut oil
2 tbsp pumpkin oil
1½ tbsp hemp seed oil
1½ tbsp black seed oil

1 Put the dried ingredients in a mortar and pestle and crush roughly. Transfer to a clean heatproof glass jar and cover with the sunflower oil.

2 Preheat the oven to 120°F (50°C), then turn it off. Wrap the bottom of the jar in a cloth (to prevent the glass from cracking while standing on the hot metal rack) and place it, unsealed, in the oven. The dried ingredients need to infuse at a temperature of around 104°F (40°C) for 6–8 hours, so you may need to turn the oven on and then off again briefly every so often, to keep the mixture warm.

3 Strain the oil and discard the dried ingredients; you should have at least ⅓ cup of flavored oil. Pour into a sterilized dark glass bottle and add the walnut, pumpkin, and hemp and black seed oils. Seal, shake well, label, and date. Store in the refrigerator and use within 3 weeks.

ROSE AND FENNEL SEED OIL

RELIEVES MENOPAUSAL AND PMS SYMPTOMS **HELPS FIGHT INFLAMMATION** **PROMOTES HEALTHY SKIN**

This is a rejuvenating oil blend to help us age beautifully. The body loses its ability to convert dietary fats into gamma-linolenic-acid (GLA) with age and, because this dietary oil blend contains significant levels of GLA, it may be helpful in age-related conditions resulting from GLA deficiency. It can also be useful for relieving menopausal symptoms and premenstrual syndrome.

MAKES ¾ CUP

3 tbsp dried thyme
1 tbsp fennel seeds
⅛oz (5g) dried rose petals
⅛oz (5g) dried marigold flowers
⅔ cup sunflower oil

For the base oil

3 tbsp evening primrose oil
2 tbsp borage oil
2 tbsp hemp seed oil
1 tbsp black seed oil

1 Put the dried ingredients in a mortar and pestle and crush roughly. Transfer to a clean heatproof glass jar and cover with the sunflower oil.

2 Preheat the oven to 120°F (50°C), then turn it off. Wrap the bottom of the jar in a cloth (to prevent the glass from cracking while standing on the hot metal rack) and place it, unsealed, in the oven. The dried ingredients need to infuse at a temperature of around 104°F (40°C) for 6–8 hours, so you may need to turn the oven on and then off again briefly every so often, to keep the mixture warm.

3 Strain the oil and discard the dried ingredients; you should have at least ⅓ cup of oil. Pour into a sterilized dark glass bottle and add the evening primrose, borage, and hemp and black seed oils. Seal, shake well, label, and date. Store in the refrigerator and use within 3 weeks.

KEFIR MILK

 FEEDS GOOD BACTERIA IN THE GUT **HELPS STRENGTHEN THE IMMUNE SYSTEM** **PROMOTES A SENSE OF WELL-BEING**

Milk cultured with kefir grains benefits the digestive system, which is closely linked to the immune, endocrine, circulatory, and central nervous systems. The smooth functioning of these internal systems in turn helps boost a feeling of well-being. For best results, use unpasteurized milk, otherwise use whole pasteurized nonhomogenized cow's, sheep's, or goat's milk.

MAKES 3½ CUPS

1 tbsp kefir grains

3½ cups unpasteurized or whole pasteurized nonhomogenized milk at room temperature

1 Put the kefir grains in a clean glass jar and add the milk. Cover with a clean kitchen towel and store in a dark place, such as a kitchen cupboard, for 18 hours–1 day.

2 Strain the milk through a clean plastic sieve. Reserve the kefir grains and add to a new batch of milk.

3 Store the kefir milk in a jug or a bottle in the refrigerator and use within 1 week, although it is best drunk fresh. It will continue to ferment at a lower rate during this time and have a consistency of thick milk.

KEFIR MILK CHEESE

 FEEDS GOOD BACTERIA IN THE GUT **HELPS STRENGTHEN THE IMMUNE SYSTEM** **PROMOTES A SENSE OF WELL-BEING**

Using kefir grains gives you a degree of control over the quality of dairy products you include in your diet. This soft, creamy cheese boosts immunity and digestion by enhancing intestinal health. Most of the lactose in kefir cheese is predigested by bacteria and yeasts before you ingest it, and some proteins are also broken down, so some lactose-intolerant people can tolerate it.

MAKES APPROXIMATELY 10OZ (300G)

1 tbsp kefir grains

3½ cups unpasteurized or whole pasteurized nonhomogenized milk at room temperature

1 Put the kefir grains in a clean glass jar and add the milk. Cover with a clean kitchen towel and store in a dark place such as a kitchen cupboard for 2–4 days or until the liquid separates into liquid whey and solid curds. The live kefir grains usually remain on the top layer of the curd; use a plastic spoon to remove as many of them as you can and reserve in the refrigerator to add to a new batch of milk, if you like.

2 Strain the curd and whey using a clean plastic sieve positioned over a large glass bowl. Retain the curd and use the whey for soups or as a drink, if you like. Store the cheese in a covered ceramic bowl in the refrigerator and use within 1 week on crackers or toasted rye bread.

3 If you want a smoother, denser soft cheese, wrap the curds in a piece of cheesecloth and hang it overnight or until the cheese is as firm as you like (the firmer you want the cheese, the longer you leave it to drain). If you want to add extra flavors, mix with cracked flaxseeds or other seeds and nuts, or fresh herbs, such as marjoram, basil, lemon thyme, and dill.

KIMCHI

 HELPS FIGHT INFECTION **HELPS IMPROVE CIRCULATION** **ENCOURAGES HEALTHY DIGESTION** **CONTAINS ANTICANCER SUBSTANCES**

A traditional Korean cabbage dish, kimchi has numerous variations and this is one of the simplest. The mixture of spices in kimchi can help the body fend off bacterial and viral infections. The spices also have a strengthening effect on the circulation and digestion. Kimchi uses cabbage as its base, which means it also contains a range of cancer-fighting nutrients.

MAKES 1–1¼LB (450–600G)

1 small head Napa cabbage
2 tbsp sea salt
4 scallions, chopped
1in (2.5cm) piece fresh ginger, peeled and grated
1 garlic clove, crushed
¼ cup rice vinegar
1 tbsp Thai fish sauce (nam pla)
juice of 1 lime
2 tbsp sesame oil
2 tbsp toasted sesame seeds
2 tbsp sambal oelek chili paste

1 Cut the head of the Napa cabbage lengthwise into quarters, then into 2in (5cm) chunks. Place in a colander over a bowl. Add the sea salt, toss well, and let stand overnight at room temperature.

2 Wash the cabbage to remove the salt, tossing the leaves with your hands to rinse them thoroughly. Drain and dry on paper towels.

3 Transfer to a freezerproof container (large enough to hold up to 1¼lb/600g of Napa cabbage) with a lid. Add the remaining ingredients and toss together thoroughly.

4 Place the lid on the container, let stand at room temperature overnight to marinate, then transfer to the refrigerator for a few days to allow the flavors to develop. Store in the refrigerator and use within 2 weeks.

Napa cabbage is a good source of antioxidants and vitamin C, which can help to protect from certain kinds of cancer.

SAUERKRAUT

 FEEDS GOOD BACTERIA IN THE GUT **HAS AN UPLIFTING EFFECT** **HELPS STRENGTHEN THE IMMUNE SYSTEM** **CONTAINS ANTICANCER SUBSTANCES**

Preserving vegetables in a brine solution, known as lactofermentation, encourages the growth of gut-friendly bacteria. Homemade sauerkraut not only tastes better, it is richer in enzymes that support a healthy gut which, in turn, can improve both physical and emotional health. It also preserves the immune-boosting and cancer-fighting properties of cabbage.

MAKES 3LB (1.35KG)

5½–6½lb (2.5–3kg) hard white or red cabbage, or half red and half white cabbage

about 2oz (60g) coarse sea or rock salt (see method)

1 tbsp caraway seeds

1 Remove the outer leaves of the cabbage, slice in half, remove the cores, quarter, and shred finely in a food processor or using a sharp knife. Weigh the shredded cabbage and calculate the amount of salt you need: approximately 2oz (60g) of salt per 5½lb (2.5kg) of cabbage.

2 Place the cabbage in a large, clean bowl and scatter evenly with salt. Using your hands, work the salt thoroughly into the cabbage—imagine you are making pie dough—until it begins to feel wet. Leave for a few minutes for the salt to soften the cabbage and draw out its juices.

3 Pack into a very large sterilized crock or jar. Add 2in (5cm) of shredded cabbage at a time and scatter with the caraway seeds. Pack each layer down with a clean tamper, such as the end of a rolling pin, a large pestle, or a jam jar. Leave 3in (7.5cm) of space at the top of the jar. Add any juices from the bowl and cover with cold brine (1½ tbsp of salt to 3½ cups boiled cooled water) to cover the cabbage.

4 Place the jar on a tray, place clean cheesecloth over the cabbage, and place a snug-fitting plate or saucer on top. Place a large jar, or a sandwich bag filled with water and sealed well, on top of the plate.

5 Leave in a well-ventilated place at room temperature (the ideal temperature is 68–72°F/20–22°C). Check every day that the cabbage is submerged. Remove any scum regularly and replace the cheesecloth with a fresh clean piece, if necessary.

6 Fermentation is complete when all the bubbling has ceased; if the room temperature is ideal, the sauerkraut will be ready in 3–4 weeks. Transfer to sterilized jars, seal, and store in the refrigerator.

TIP: If the room temperature is below 55°F (13°C), fermentation will stop, and if it is higher than 76°F (24°C) it will spoil. If your sauerkraut develops a pinkish hue on its surface, turns dark, or is very soft and mushy, it has not fermented properly and shouldn't be eaten.

SOURDOUGH RYE BREAD

 HELPS MAINTAIN ENERGY LEVELS

 HELPS STRENGTHEN BONES

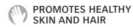 **PROMOTES HEALTHY SKIN AND HAIR**

 HELPS LOWER BLOOD PRESSURE

Good-quality bread is the ultimate slow food: taking time to make it means you get a flavorful loaf. Rye grain, commonly used to make sourdough bread, boosts energy levels, strengthens bones and fingernails, enhances the condition of hair, and is also thought to benefit the heart and circulatory system. Buy freshly milled whole grain rye flour that supplies the most nutrients.

MAKES 1 LOAF

For the sourdough starter

1½ cups whole grain rye flour

1½ cups springwater

For the bread

1lb (450g) sourdough starter

1 tbsp blackstrap molasses

2½–2¾ cups whole grain rye flour

1 tbsp sunflower seeds

2 tbsp pumpkin seeds

1 tbsp caraway seeds

a pinch of salt

1 tsp coriander seeds

a knob of butter, plus extra for greasing

1 To make the sourdough starter, mix ⅓ cup of the rye flour with ½ cup of springwater in a large clean jar, cover with a clean kitchen towel, and leave in a warm place for 24 hours. The ideal room temperature for the starter to ferment is 64–68°F (18–20°C). When the dough starter develops a bubbly texture and a fragrant sour smell, "feed" it with ⅓ cup more rye flour and ½ cup springwater. Stir, add a little more water or flour if necessary to keep it smooth, and leave for another 24 hours. It should now be bubbling, with a fruity sour taste. Add a further ¾ cup of flour and ¾ cup more springwater. Let rise overnight to become a fragrant, light dough.

2 Place 1lb (450g) of the starter dough in a large bowl, add ½ cup water and the blackstrap molasses, and stir. Add about 2 cups of the rye flour to begin with and work it in with your hands; it will be quite a sticky mixture. Add more flour if necessary until the dough is of a manageable consistency—neither too thin nor too thick—allowing for the fact that it is likely to thicken with standing, and that seeds will be added to it. Cover with a clean kitchen towel and let stand in the bowl in a warm place for a few hours; if the starter is vigorous enough, the dough should double in size within 8–12 hours.

3 Add the pumpkin, sunflower, and caraway seeds, and salt to the risen dough and mix in thoroughly using your hands. Heat a small skillet, add the coriander seeds, dry-fry until they release their aroma, then transfer to a mortar and pestle and crush to a powder. Grease the inside of a 2lb (900g) loaf pan with a little butter and sprinkle in the coriander powder, making sure it covers the insides of the pan evenly. Place the dough in the pan, smooth the top, dust with a little flour, cover with a clean kitchen towel, and leave in a warm place to rest for a few hours, or until it has visibly risen.

4 Preheat the oven to 410°F (210°C) and bake the loaf for 10 minutes. Lower the oven temperature to 350°F (180°C) and bake for a further 45 minutes. Remove the loaf from the oven, mix 2 tablespoons of boiling water with a knob of butter, and pour the liquid over the hot bread. Turn the oven off, return the loaf to the oven, and leave for 30 minutes, or until completely cold. Remove from the oven, cover with a linen cloth, and transfer to a wire rack to cool completely. The flavor of rye bread improves during storage. Wrapped in the linen cloth and stored in a wooden bread bin or a fabric bread bag, this loaf will last for 5–6 days.

FLATBREAD WITH SWEET POTATO AND CORIANDER

 HELPS KEEP JOINTS SUPPLE **SUPPORTS AND PROTECTS THE LIVER** **HELPS IMPROVE CIRCULATION**

This is a take on traditional Indian paratha, and is a versatile bread that tastes equally good freshly baked and spread with soft kefir cheese (p332) or eaten as an accompaniment to all sorts of hot dishes and salads. Its main ingredients are sweet potato, turmeric powder, and coriander, which together have anti-inflammatory benefits, support the liver, and help improve circulation.

MAKES 8–10

1 sweet potato

¾ cup all-purpose flour, plus extra for dusting

⅓ cup chickpea flour

½ tsp salt

2 tbsp ghee, or clarified butter

1 small red onion, finely chopped

1 garlic clove, minced

1 tsp coriander seeds, crushed

1 tsp turmeric powder

scant 1oz (25g) cilantro leaves, chopped

juice of ½ lime

1 Preheat the oven to 350°F (180°C). Wrap the sweet potato in foil and bake for 25 minutes, or until soft. When the potato is cool enough to handle, peel off the skin and discard, and chop the flesh finely.

2 Combine the 2 flours in a small bowl, add the salt, and mix well. Set aside while you heat 1 tablespoon of the ghee in a small saucepan. Add the chopped onion and cook over medium heat until it has softened. Add the garlic, coriander seeds, and turmeric powder, stir for 1 minute, then remove from the heat and add the cilantro leaves, sweet potato, and lime juice, and mix well.

3 Transfer the sautéed ingredients to a large bowl and mix thoroughly. When all the ingredients are combined, knead into a dough and let stand for 15 minutes.

4 Remove the dough from the bowl, place it on a lightly floured work surface, and shape into a long roll. Divide into 8 or 10 equal amounts and shape into small balls. Roll each ball out into an ⅛–¼in (3–5mm) thick round that will fit in a heavy skillet. Repeat with the rest of the dough balls. The thinner the flatbreads, the more quickly they will cook.

5 Place the skillet on medium heat and set a flatbread in it. Cook for about 3 minutes. Brush the surface of the flatbread with some of the remaining ghee before turning it over to cook on the other side for 3 more minutes. Keep in a warm place while you cook the rest of the flatbreads, then serve.

Sweet potato (p88), especially this dark-skinned variety, contains high levels of beta-carotene and can therefore help strengthen the immune system.

OILS, DRESSINGS, AND EXTRAS

IT'S THE LITTLE EXTRAS THAT MAKE A MEAL. BEAUTIFUL BREADS AND "LIVING" FERMENTED FOOD CONDIMENTS, DEEPLY **FLAVORED** OILS, AND **FRUITY** VINEGARS ALL ADD VARIETY AND BRING YOU THE BEST OF HEALTH.

Seaweed And Miso Broth

 HELPS LOWER CHOLESTEROL

 HAS A POWERFUL DIURETIC ACTION

HELPS CALM THE NERVES

Traditionally, seaweeds are used to alkalize the blood and help lower blood cholesterol. They are also used for their diuretic properties, and to help protect against the effects of radiation. If using as a drink, pour into 2 heatproof glasses and serve. You can also use all this broth as part of an individual detox treatment. Store it in a heatproof, resealable container and sip it through the day.

SERVES 1 (MAKES 2 CUPS)

⅛oz (5g) wakame

⅛oz (5g) dulse

1 small blade of kelp

2 sticks of lemongrass

3 kaffir lime leaves

½ tbsp coriander seeds

½ cup peeled chopped celeriac

½in (1.5cm) piece fresh ginger, chopped

1 carrot, chopped

1 tbsp barley miso

1 tbsp chopped cilantro leaves

1 Rinse the seaweeds in a bowl of cold water to help remove some of their salty taste.

2 Place all the ingredients except the barley miso and cilantro leaves in a medium saucepan, cover with 2 cups of water and bring to a boil. Reduce the heat to a simmer and cook, covered, for 1½ hours on low heat.

3 Strain the liquid and pour it into a heatproof resealable container. Discard the ingredients in the sieve. Add the barley miso and allow it to dissolve, then add the cilantro leaves. Store the broth in the container and sip through the day.

Dulse (p131) is a good source of chlorophyll, which helps remove toxins from the body.

Astragalus And Schisandra Broth

○ **PROMOTES A SENSE OF WELL-BEING** **HELPS FIGHT COLDS AND FLU** **HELPS DETOX AND ALKALIZE THE BODY**

We are so used to thinking of herbal teas and other plant essences as occasional or emergency "therapy" that we have almost forgotten the nutritional and health benefits they bring as part of a daily diet. You can also use all this broth as part of an individual detox treatment. Store it in a heatproof, resealable container and sip it through the day.

SERVES 2

⅛oz (6g) astragalus root
⅛oz (6g) schisandra berries
⅛oz (6g) wood ear mushrooms
6 thin slices of fresh ginger, peeled
4 garlic cloves, skins on
4 shallots, skins on
1 tbsp coriander seeds
½ tsp anise seeds
½ cup peeled chopped celeriac
1 large carrot, sliced
1 strand of kelp or wakame
10 black peppercorns

1 Place all the ingredients in a medium saucepan, cover with 2 cups water, and bring to a boil. Reduce the heat and simmer for 1½ hours, then strain.

2 If serving as a soup, transfer to 2 serving bowls. If using as a drink pour into 2 heatproof glasses and serve, or store the broth (see above) and sip through the day as a detox treatment.

Kelp (p131) *has a high iodine content, which supports a healthy thyroid function.*

RAINBOW VEGETABLE BROTH

 HELPS COMBAT FATIGUE **HAS A MILD DIURETIC ACTION** **HELPS STRENGTHEN THE IMMUNE SYSTEM**

This is an alkalizing broth that lifts energy levels by balancing the body's pH and fluid levels. Using vegetables in season assures a broad range of essential nutrients. Drink on its own at any time of day, or use as a base for stock for soup. Broths like this are excellent if you are recovering from an illness, and will fortify you against illness if you include them in your daily diet.

SERVES 2

½ leek, chopped
1 scallion, quartered
1 celery stick with leaves, chopped
1 carrot, chopped
1 potato with skin on, chopped
1 small beet with skin on, chopped
1 small radish with skin on, chopped
2 slices of fresh ginger
1 sprig of parsley
1 tsp coriander seeds
3½ cups mineral water
1 wakame seaweed, chopped (optional)

1 Place all the ingredients in a large saucepan, add the mineral water, and bring to a boil. Cover and simmer for 1½–2 hours over low heat.

2 Remove the pan from the heat and strain the liquid. Discard the vegetables. Pour the hot broth into a heatproof resealable container, add the chopped wakame seaweed, and seal. Drink glassfuls of the broth throughout the day.

1 CELERY STALK

1 SCALLION

½ LEEK

1 BEET

1 POTATO

1 CARROT

1 RADISH

EAT A RAINBOW

INCLUDING A VARIETY OF VIBRANTLY COLORED FRUITS AND VEGETABLES IN YOUR DIET GIVES YOUR IMMUNE SYSTEM THE BENEFIT OF A RANGE OF ANTIOXIDANTS.

DEEP CLEANSING TEA

 HELPS REMOVE TOXINS FROM THE BODY **PROMOTES CLEAR SKIN** **HELPS KEEP JOINTS SUPPLE**

This tea comprises herbs that have deep-cleansing properties and help remove toxic accumulations from the body while its antioxidant content improves skin tone. It can also benefit those who suffer from recurrent inflammatory arthritic conditions, such as gout. If you grow your own blackcurrants, harvest and dry the leaves to use throughout the year.

MAKES 5 DAYS' SUPPLY

¾oz (20g) dried blackcurrant leaves, chopped

¾oz (20g) dried red clover flowers, chopped

¾oz (20g) dried celery seeds, chopped

¾oz (20g) dried nettle leaves, chopped

¾oz (20g) dried dandelion leaves, chopped

1 Combine all the ingredients in a bowl, transfer to a sealed container, label, date, and store in a cupboard away from direct light.

2 To make the tea, put ¾oz (20g) of the dried leaves and 2½ cups water in a saucepan, cover, and bring to a boil. Lower the heat and simmer for 10 minutes. Remove from the heat, leave to infuse for 10 minutes, and strain the liquid into a heatproof resealable container. Sip throughout the day. To make a single drink, take 1 heaped teaspoon of dried herbs, or fill an infuser ball with the herb blend, cover with 1 cup boiling water, let stand for 10 minutes, strain, and drink.

DEEP NURTURE TEA

 HELPS PROTECT AGAINST POLLUTION **PROTECTS AGAINST FREE-RADICAL DAMAGE** **REMOVES ENERGY-DRAINING TOXINS** **PROMOTES HEALTHY SKIN**

The antioxidant, antiaging nutrients in this tea help to protect the body against environmental pollutants; wild fruits supply unique antioxidants that aren't typically found in commercially grown fruits and vegetables. Adding wild fruits to your diet can help enrich your blood, which in turn supports your energy production, skin health, and benefits your overall well-being.

MAKES 5 DAYS' SUPPLY

¾oz (20g) dried rosehips, chopped

¼oz (10g) dried bilberries, chopped

¾oz (20g) goji berries, chopped

¾oz (20g) dried orange peel (p220, step 1), chopped

¼oz (10g) dried hibiscus flowers, chopped

½oz (15g) dried schisandra berries, chopped

⅛oz (5g) dried licorice root, chopped

1 Combine all the ingredients in a bowl, transfer to a container, seal, label, date, and store in a cupboard away from direct light.

2 To make the tea, put ¾oz (20g) of the dried leaves and 2½ cups water in a saucepan, cover, and bring to a boil. Lower the heat and simmer for 10 minutes. Remove from the heat, let infuse for 10 minutes, and strain the liquid into a heatproof resealable container. Sip throughout the day. To make a single drink, take 1 heaped teaspoon of dried herbs, or fill an infuser ball with the herb blend, cover with 1 cup boiling water, let stand for 10 minutes, strain, and drink.

DEEP SLEEP TEA

 HELPS PROMOTE PEACEFUL SLEEP **RELAXES THE HEART**

Restful, refreshing sleep comes when we are able to switch off our minds fully and consciously let go of any physical tension in our bodies. This calming tea helps take the edge off ragged emotions, lowers stress levels, and releases any tension in your muscles. It also helps to naturally slow your heartbeat so you can and drift off to sleep easily.

SERVES 2

½oz (15g) dried valerian root (*Valeriana officinalis*), chopped

scant 1oz (25g) dried hawthorn flowers (*Crataegus sp.*), chopped

1oz (30g) dried passion flower leaf (*Passiflora incarnata*), chopped

20g (¾oz) dried schisandra berries (*Schisandra chinensis*), chopped

10g (¼oz) dried chamomile flowers (*Matricaria recutita*), chopped

1 Grind the valerian root briefly in a coffee grinder or blender if it is too thick to chop easily by hand.

2 Combine all the ingredients thoroughly in a bowl, transfer to a dark container, metal tea caddy, or a cookie can, and label and date.

3 Place ¾oz (20g) of the dried herbs in a small saucepan with a lid, cover with 2 cups water, and bring to a boil. Reduce the heat, cover, and let simmer for 10 minutes. Remove from the heat, leave to infuse for 10 more minutes, strain, and serve. Alternatively, pour the strained tea into a resealable heatproof container and sip through the day.

4 To make an occasional drink, place 1 heaped teaspoon of the dried herbs, or an infuser ball filled with the herbal blend, in a mug. Cover with 1 cup boiling water, let stand for 10 minutes, and strain. Add 1 tablespoon of Cherry Syrup (p308), if you prefer, because it is also an effective sleep aid; stir well and drink.

DEEPLY WARMING TEA

 PROTECTS FROM COLDS AND FLU **FIGHTS RESPIRATORY INFECTIONS**

Drinking 1 or 2 cups of this immune-boosting tea a day provides extra health insurance in cooler weather because it helps strengthen the body's innate immunity against colds, the flu, and upper respiratory tract infections. It is particularly beneficial if you have chronic immune deficiency.

SERVES 2

scant 1oz (25g) astragalus root (*Astragalus membranaceus*), finely chopped

¾oz (20g) dried elderberries (*Sambucus nigra*)

¾oz (20g) dried echinacea root (*Echinacea purpurea*), chopped

½oz (15g) fresh ginger, finely chopped

¾oz (20g) dried elderflowers (*Sambucus nigra*), rubbed

1 Combine all the dried herbs thoroughly in a bowl, transfer to a dark container, metal tea caddy, or a cookie can, and label and date.

2 Place ¾oz (20g) of the dried herbs and the ginger in a small saucepan with a lid, cover with 2 cups water and bring to a boil. Reduce the heat, cover, and let simmer for 10 minutes. Remove from the heat, leave to infuse for 10 more minutes, strain, and serve. Alternatively, pour the strained tea into a resealable heatproof container and sip through the day.

3 To make an occasional drink, place 1 heaped teaspoon of the dried herbs, or an infuser ball filled with the herbal blend, in a mug. Cover with 1 cup boiling water, let stand for 10 minutes, strain, and drink.

MARSHMALLOW AND LICORICE TEA

 HELPS TO RELAX AND UNWIND THE MIND

 HELPS TO REHYDRATE SKIN AND LUNGS

 PROTECTS AGAINST COLDS AND FLU

This is a refreshing, fragrant tea that is especially beneficial if you work in a crowded, centrally heated, stressful office environment. Together these herbs help calm, relax, and focus the mind. They also help protect against airborne microorganisms and provide relief from the effects of central heating by moistening and soothing the respiratory system and rehydrating the skin.

SERVES 2

1oz (30g) dried marshmallow root (*Althea officinalis*), chopped

¾oz (20g) dried marshmallow leaf (*Althea officinalis*), chopped

¾oz (20g) dried linden flower (*Tilia cordata*), chopped

¾oz (20g) dried vervain (*Verbena officinalis*), chopped

¼oz (10g) dried licorice (*Glycyrrhiza glabra*), chopped

1 Combine all the dried herbs thoroughly in a bowl, transfer to a dark container, metal tea caddy, or a cookie can, and label and date.

2 To make the tea, place ¾oz (20g) of the dried herbs in a small saucepan with a lid, cover with 2 cups of water and bring to a boil. Reduce the heat, cover with the lid, and let it simmer for 10 minutes. Remove from the heat, leave to infuse for 10 more minutes, strain, and serve. Alternatively, pour the strained tea into a resealable heatproof container and sip through the day.

3 To make an occasional drink, place 1 heaped teaspoon of the dried herbs, or an infuser ball filled with the herbal blend, in a mug. Cover with 1 cup boiling water, let stand for 10 minutes, strain, and drink.

Marshmallow root (p99) soothes irritation and inflammation, and is particularly useful for treating gastric ulcers and irritable bowel syndrome.

MINT AND FRIENDS TEA

 AIDS HEALTHY DIGESTION

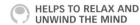 **HELPS TO RELAX AND UNWIND THE MIND**

The aromatic plants in this refreshing tea are useful digestive aids, helping to relieve stomach cramps and bloating. They may also relieve nervous tension headaches, because they generally help to relax the mind and ease tension. It's up to you how long you choose to infuse the herbs, according to your palate.

MAKE 2 CUPS

1 tbsp mint leaves, plus a few small leaves to garnish
½ tbsp fennel leaves
½ tbsp dill leaves
½ tbsp marjoram leaves

1 Remove the leaves from their stalks (although including a few odd stalks is not a problem, because they contain a lot of flavor). Chop each herb separately and transfer to a teapot.

2 Cover with hot, but not boiling, water (water at a temperature of 165–175°F/75–80°C is best for infusing the fine fragrant compounds in these plants).

3 Allow the herbs to infuse for 5 minutes or more, strain, and serve in heatproof glasses decorated with a few small mint leaves on top.

Sweet marjoram (p102) contains a natural analgesic that can ease abdominal cramps.

DEEPLY PURIFYING JUICE

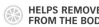 **HELPS REMOVE TOXINS FROM THE BODY** **AIDS HEALTHY/OPTIMAL DIGESTION** **PROTECTS AGAINST FREE-RADICAL DAMAGE**

This deeply nurturing juice strengthens the body's normal detoxifying processes because it is rich in chlorophyll, which enhances intestinal health and helps eliminate stored toxins. Barley grass and wheat grass supply valuable enzymes that support healthy digestion, help to regulate metabolism, and help protect vital tissues and organs from oxidative stress, and therefore premature aging.

SERVES 2

a bunch of wheat grass
a bunch of barley grass
1 bunch of flat-leaf parsley
8 large dandelion leaves
½ small cucumber
2 celery stalks
½in (1cm) piece fresh ginger

1 Using a juicer, juice all the ingredients and combine thoroughly in a pitcher. Pour into 2 glasses, add filtered water or springwater to adjust the taste if necessary, and serve.

A CUP OF HAPPINESS

 HAS AN UPLIFTING EFFECT **HELPS COMBAT FATIGUE**

Plants can have as powerful an effect on our mind and emotions as they can on our bodies. The herbs in this blend have long been used to promote an improved sense of well-being and to alleviate feelings of melancholy, depression, and exhaustion. Drink this tea for a quick lift, especially if you are recovering from a long illness or long-term debilitation.

SERVES 2

1 tsp dried St. John's wort (*Hypericum perforatum*), chopped
1 tsp dried skullcap (*Scutellaria lateriflora*), chopped
1 tsp dried silk tree flowers (*Albizia julibrissin*), chopped

1 Place the dried herbs in a teapot and cover with 2 cups boiling water. Leave to infuse for 15 minutes, then strain and drink.

TIP: Silk tree flower can be sourced from Chinese herbalists.

Winter Wake Up

 SUPPORTS HEALTHY LIVER FUNCTION **HELPS CLEAR CONGESTION** **HELPS IMPROVE CIRCULATION**

Bitter Seville oranges add a fantastic cleansing element to this juice, benefitting liver function and enhancing bowel regularity. This effect is enhanced by fennel, which helps clear mucus in the lungs, and cilantro, which helps eliminate any traces of heavy metals in the body. Ginger boosts the circulation and carrots act as an anti-inflammatory and antiallergic agent.

SERVES 2

4 Seville oranges, 3 peeled
1 large fennel bulb
1 large carrot
1 small bunch of cilantro leaves and stalks
½in (1cm) piece fresh ginger

1 Using a juicer, juice all the ingredients and combine in a pitcher. Mix well and serve in tall glasses.

Party Aftermath

 AIDS DETOXIFICATION SYSTEM **HELPS MAINTAIN WATER BALANCE** **AIDS DIGESTION, EASES CONSTIPATION**

This is a juice to get you going the morning after. All these ingredients have strong detoxifying properties, that stimulate the digestive and urinary systems to eliminate accumulated waste. Sauerkraut, which is traditionally used to maintain a healthy digestive system, is also included to help combat a hangover, especially if accompanied by an upset stomach.

SERVES 2

1 cucumber
4 celery stalks
1 small bunch of flat-leaf parsley
1 small bunch of cilantro leaves
¼ lemon with peel on
¼ cup sauerkraut (p330)
1 tbsp milk thistle tincture
freshly ground black pepper, to garnish

1 Using a juicer, juice the cucumber, celery, parsley, cilantro, lemon, and sauerkraut and combine in a pitcher. Add the milk thistle tincture and mix well. Pour into tall glasses, sprinkle a dash of black pepper on top, and serve.

ROSE SYRUP

 HELPS TO RELAX AND UNWIND THE MIND 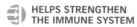 **HELPS STRENGTHEN THE IMMUNE SYSTEM**

Mildly sedative and immune-enhancing rose syrup can be used to sweeten herbal infusions, poured over pancakes and ice cream, drizzled over fruit salads, used in a sorbet, or diluted with water and drunk as a cordial. Highly perfumed damask rose (*Rosa damascena*) or French rose (*Rosa gallica*) are best for this recipe. Keeping the temperature low is key to preserving their

MAKES 2 CUPS

1 cup raw sugar
juice of 1 lemon
juice of 1 orange
3½oz (100g) dried red rose petals, or the petals of 10 fresh red rose heads

1 Dissolve the sugar in 1¼ cups water in a small saucepan over low heat without letting it boil (boiling will make the mixture cloudy).

2 Add the citrus juices, then turn the heat right down and simmer for 5 minutes. Over the next 15 minutes, gradually add the rose petals and stir thoroughly before adding more. Remove from the heat, let cool, and strain.

3 Meanwhile, sterilize a heatproof glass bottle and lid: wash them in hot soapy water; drain upside down; then place in a cool oven at 275°F (140°C) for 15 minutes. Pour the hot syrup into the sterilized glass bottle, seal, and label. Keep refrigerated and use within 6 weeks.

VALENTINE'S SPECIAL

 PROMOTES A SENSE OF WELL-BEING **HELPS COMBAT FATIGUE** **HELPS IMPROVE CIRCULATION**

This is a feel-good drink: nutritious, healthy, and life-enhancing. It contains antioxidant-rich soft fruits and coconut water, which help rehydrate the body and reduce feelings of fatigue, while the pistachio nuts, cardamom seeds, and concentrated rose in the rose syrup are said to keep love on your mind! If you prefer, add yogurt instead of the coconut water to make a smoothie.

SERVES 2

1 cup raspberries, washed
scant 1 cup blueberries, washed
a dash of rose syrup
¼ tsp cardamom seeds, crushed (no more than 10 pods)
2 tbsp pistachio nuts, shelled
1 cup coconut water,

1 Put all the ingredients in a powerful food processor or blender and blend to a smooth consistency. If serving immediately, pour into tall glasses and serve. Otherwise, the drink will last for up to 2 days if stored in a tightly sealed bottle and refrigerated.

BUILD-ME-UP JUICE

 AIDS DETOXIFICATION SYSTEM **HELPS RELEASE CELLULAR ENERGY** **HELPS IMPROVE CIRCULATION** **AIDS HEALTHY DIGESTION**

This particular blend of root vegetables is high in antioxidants and phytonutrients that help revitalize the blood by improving circulation and increasing oxygen levels. It also supports the health of major organs, such as the heart, liver, and kidneys, builds body tissues and fluids, and enhances the digestive process by promoting bowel regularity and general intestinal health.

SERVES 2

2 large carrots
1 large beet
4 celery stalks
½ celeriac, peeled
2 fennel bulbs
¾in (2cm) piece fresh ginger, skin on
1 small lemon, peel on
coconut water, to dilute

1 Using a juicer, juice each ingredient, transfer to a glass pitcher, stir to mix well, and add coconut water to taste. Serve in tall glasses and consume immediately to avoid any loss of valuable nutrients.

ALERT AND JOYFUL JUICE

 SUPPORTS HEALTHY LIVER FUNCTION **HELP PREVENT URINARY TRACT INFECTIONS** **HELPS ENHANCE FOCUS**

According to traditional Chinese medicine, sour flavors are said to tonify and enhance liver function, promote the elimination of waste products through the intestines and urinary system, calm emotions, improve your sense of well-being, and focus the mind. Adjust the flavor of this sour-based juice to your liking by adding some coconut water to modify its acidity.

SERVES 2

heaped ½ cup fresh or frozen cranberries
1 small Seville orange, peel on, and quartered
1 red bell pepper, seeded
3 celery stalks
1 small cucumber
¼ chile, seeded
½in (1cm) piece fresh ginger, skin on
coconut water, to dilute

1 Using a juicer, juice each ingredient, transfer to a glass pitcher, stir to mix well, and add enough coconut water to taste. Serve in tall glasses and consume immediately to avoid any loss of valuable nutrients.

STAY SUPPLE JUICE

 HELPS FIGHT INFLAMMATION 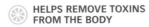 **HELPS REMOVE TOXINS FROM THE BODY** **HELPS COMBAT FATIGUE**

This pungent vegetable juice addresses the cause of joint problems. Cucumber, spinach, and turmeric combine to relieve joint inflammation and stimulate the circulation and, together with chile and ginger, they help expel accumulated toxins from the body by encouraging bowel movements, promoting sweating, and acting as a mild diuretic.

SERVES 2

1 small cucumber, skin on

2 cups spinach leaves

1½ in (4cm) piece fresh ginger, skin on

1½ in (4cm) piece fresh turmeric, skin on

4 celery stalks

2 green apples, skin on

½ fresh red chile, seeded

1 Using a juicer, juice each ingredient, transfer to a glass pitcher, stir to mix well, and serve. Consume immediately to avoid any loss of valuable nutrients.

FIVE-FLAVOR JUICE

 AIDS DETOXIFICATION SYSTEM **SUPPORTS AND PROTECTS THE LIVER** **PROMOTES HEALTHY SKIN**

Traditional Chinese medicine categorizes foods into 5 flavors—bitter, sweet, salty, sour, and hot. This recipe includes all 5 flavors to help keep the body in balance. In addition, hot black radish is a traditional Chinese remedy for liver conditions, while beets and carrots are both packed with antioxidants that increase oxygen and nutrient levels in the blood and benefit the skin.

SERVES 2

1 medium black radish or turnip

1 large beet

2 large carrots

8 celery stalks

4 small Seville oranges, with half the peel removed

1 Using a juicer, juice each ingredient, transfer to a glass pitcher, stir to mix well, and serve. Consume immediately to avoid any loss of valuable nutrients.

HEALTH BOOST JUICE

 PROTECTS AGAINST COLDS AND THE FLU 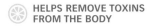 **HELPS REMOVE TOXINS FROM THE BODY** **AIDS HEALTHY DIGESTION**

This juice is a beneficial tonic, especially in the winter. Red kuri squash, which has a mild sweet flavor, supplies anti-inflammatory and antioxidant properties, while fragrant ginger can improve digestion. Tart grapefruit helps ward off common colds, improves liver function, and treats gallstones, and salty-tasting celery has a diuretic action that helps detoxify the body.

SERVES 2

3½ oz (100g) Red kuri squash
1 small piece fresh ginger, skin on
1 large grapefruit, peeled and pith removed
2 celery stalks and leaves, roughly chopped

1 Cut the squash in half, scoop out all the seeds, and discard or reserve them to roast later and use as an ingredient in other recipes (such as Presoaked Barley Breakfast, p190), or as a topping for salads and soups. Leave the skin on the squash to benefit from its nutrients and chop the flesh if necessary, so it fits through the hopper of your juicer.

2 Juice all the ingredients and combine in a pitcher. Strain through a sieve to remove the grapefruit seeds and serve immediately in tall glasses.

COOLING, SOOTHING JUICE

 PROMOTES A HEALTHY DIGESTIVE TRACT **HELPS REMOVE PARASITES IN THE GUT** **HELPS IMPROVE CIRCULATION**

Aloe vera has a cooling, anti-inflammatory effect on the gut; it helps relieve constipation and can help clear intestinal parasites. Turmeric has a similarly soothing effect on the gut, relieving pain and tension, and also helps improve circulation. Fresh ginger tones and stimulates the digestive tract, but it can raise blood pressure; if you suffer from high blood pressure, omit the ginger.

SERVES 2

¾in (2cm) piece fresh turmeric
¾in (2cm) piece fresh ginger
1 green apple
2 celery stalks
2 small leaves of aloe vera
coconut water, to dilute

1 Using a juicer, juice the fresh turmeric, fresh ginger, apple, and celery and combine the juices in a pitcher.

2 Using a sharp knife, remove the spine from each aloe vera leaf, slice the leaves open lengthwise, and scrape out the gel. Add the gel to the juices in the pitcher and mix thoroughly. Pour into 2 tall glasses. To serve, dilute with coconut water until the juice is your preferred consistency.

Winter Pick-Me-Up Juice

 PROTECTS AGAINST COLDS AND FLU

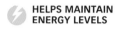 **HELPS MAINTAIN ENERGY LEVELS**

HELPS BUILD RED BLOOD CELLS

There is usually a brief window in the fall when wild rosehips, blackberries, and blueberries can be harvested at the same time. The high antioxidant levels of these wild berries help boost your immunity and energy levels, and traditionally they are considered to be a blood tonic. Cinnamon is rich in antioxidants too, and is also an effective aid in the treatment of colds and the flu.

SERVES 2

4oz (115g) rosehips, halved and seeded
¾ cup blackberries
¾ cup raspberries
¾ cup blueberries
¼ tsp cinnamon
2 tbsp elderberry syrup (left)
coconut water, to dilute

1 Put all ingredients except the coconut water in a food processor or blender and blend until smooth. Add coconut water until you achieve the desired consistency.

BLUEBERRIES

ROSEHIPS

BLACKBERRIES

RASPBERRIES

FIGHT THE COLD

THIS JUICE IS THE PERFECT WINTER GUARD. ANTIOXIDANT-RICH BERRIES ENHANCE YOUR IMMUNITY AND FIGHT COLDS AND FLU. THIS QUANTITY OF ROSEHIP ALONE ACCOUNTS FOR MORE THAN 1½ TIMES YOUR RECOMMENDED DAILY INTAKE OF VITAMIN C.

Sour Cherry Drink

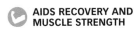 **AIDS RECOVERY AND MUSCLE STRENGTH** **HELPS PROMOTE PEACEFUL SLEEP** 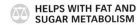 **HELPS WITH FAT AND SUGAR METABOLISM**

A popular drink in eastern Europe and western Asia where sour cherries commonly grow, this is a must-have remedy for building strength after a hard day's work, aiding recovery from a tough workout, and relaxing your mind to get a good night's sleep. Cherries also help balance blood sugar, and assist the liver in metabolizing fat after a meal.

SERVES 4

1 cup dried sour cherries, pitted

¾ cup sugar

1 tbsp vanilla extract

1½lb (675g) sour cherries, pitted

maple syrup to taste (optional)

1 lime, thinly sliced, to garnish (optional)

1 Rinse the dried cherries, transfer to a bowl, cover with water, and stir to remove some of the oil they are coated in. Drain and repeat. Transfer to a large bowl, cover with water, and soak for 6 hours or overnight to reconstitute. Drain, set aside the cherries, and reserve the soaking water.

2 Measure the soaking water and add enough fresh water if necessary to make ¾ cup. Transfer to a small saucepan, add the sugar, set over low heat, and let the sugar dissolve. Bring to a boil, turn the heat down, simmer for 10 minutes, and add the soaked cherries. Simmer for 20–30 minutes, or until the cherries are soft and the syrup has thickened. Strain the mixture, return the syrup to the pan, and discard the fruit. Bring the syrup back to a boil, remove from the heat, and stir in the vanilla extract. Set aside to cool while you juice the fresh sour cherries.

3 Mix 1¾ cups each of cherry juice and syrup in a pitcher and dilute with water. Add maple syrup to taste, and lime slices, if using. Store any unused syrup in a sterilized glass bottle in the refrigerator for 1–2 weeks.

Elderberry Syrup

 PROTECTS AGAINST COLDS AND THE FLU **HELPS CLEAR CONGESTION** **HELPS MAINTAIN WATER BALANCE** **HELPS EASE CONSTIPATION**

Pungent, bitter-sweet, ripe elderberries are rich in antioxidants that help prevent and treat colds, coughs, and the flu by promoting sweating, strengthening the lungs, maintaining water balance and bowel regularity, and shifting mucus. Use this syrup as a quick flu remedy or in cooking.

SERVES 2

10oz (300g) elderberries

1¾in (4cm) fresh ginger, grated

1¼ cups superfine sugar

juice of 2 lemons

1 Put the berries and ginger into a medium saucepan and add 1¼ cups water. Bring to a boil, cover, turn the heat down, and simmer over low heat for 20–30 minutes, or until the fruit is soft.

2 Strain the fruit through some cheesecloth or a very fine sieve into a clean saucepan. Discard the fruit and ginger left behind after straining.

3 Add the sugar to the pan and allow it to dissolve over low heat, stirring constantly. When it has dissolved, add the lemon juice and increase the heat. Bring to a boil and boil for 10–15 minutes, or until the liquid becomes syrupy. Transfer to a heat-sterilized bottle, seal, label, and date. Store in the refrigerator and use within 6 weeks.

BLACKBERRY LEMONADE

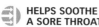 **HELPS SOOTHE A SORE THROAT** **SUPPORTS HEALTHY KIDNEY FUNCTION** **HELPS REMOVE TOXINS FROM THE BODY** 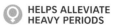 **HELPS ALLEVIATE HEAVY PERIODS**

Blackberries are a great medicine if you have a painful or swollen throat, mouth, or gums. Their antioxidant, kidney-toning, and detoxifying properties make them a must-have when in season. Collect the leaves too, because a blackberry-leaf infusion enhances the anti-inflammatory effects further. Serve with ice, or as a warm drink, if you have a throat condition.

SERVES 2

4 tsp dried blackberry leaves, or 12 fresh leaves

2 cups blackberries, rinsed

2 lemons, juiced, plus a few thin slices for decoration (optional)

3 tbsp maple syrup

1 To make an infusion with the leaves, boil 1¼ cups water, pour over the leaves, and let it infuse for 10 minutes. Strain the mixture, reserving the liquid to use in the lemonade. Discard the leaves.

2 Place the blackberries in a food processor or blender and purée to a pulp. If you don't like the gritty texture of the seeds in your drink, strain the pulp through a fine mesh strainer and collect the smooth juice.

3 Pour the lemon juice, blackberry juice, and 1 cup of the blackberry leaf infusion into a pitcher, add the maple syrup, and stir well. Pour into large glasses, decorate each with a slice of lemon, and serve.

BARLEY GRASS AND BARLEY LEMONADE

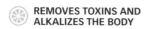 **REMOVES TOXINS AND ALKALIZES THE BODY** **FIGHTS URINARY TRACT INFECTIONS** **HELPS KEEP JOINTS SUPPLE**

This juice combines the benefits of the dry barley grain with those of the fresh barley juice to provide a powerful, alkalizing, anti-inflammatory, and purifying drink. It helps support healthy joints and benefits the intestines, urinary system, and skin, all of which eliminate waste materials from the body. It also helps revitalize and energize the body and slows signs of aging.

SERVES 4

½ cup whole, nonhulled barley (optional)

½ cup pearl barley

1in (2.5cm) lemon peel, cut into 4 strips

⅓ cup lemon juice

2 tbsp honey, or more as desired

⅓ cup barley grass juice

4 lemon slices, to garnish

1 If you want to grow your own barley grass, soak the nonhulled barley in a bowl of water overnight. Drain and arrange the soaked barley on a seed tray filled with organic propagation mix. Gently press the grains down into the soil and leave to germinate. Mist twice daily until it grows to 5–6in (12–15cm) high, when it is ready to harvest (about 10 days).

2 Place the pearl barley into a fine mesh strainer, pour boiling water over it, and allow to drain. Transfer to a medium saucepan, add the lemon peel and 4 cups water, and bring to a boil. Reduce the heat to low and simmer for 25 minutes. Remove from the heat and strain into a clean container. Add the lemon juice and honey to taste, mix well, and refrigerate until chilled. Juice the barley grass (if you have grown it yourself) just before serving and stir into the lemonade or simply add the store-bought barley grass juice. To serve, pour into tall glasses, add a slice of lemon to each glass, and stir.

HOT LEMONADE WITH GINGER AND HONEY

 HELPS FIGHT COLDS AND THE FLU **AIDS HEALTHY DIGESTION** **HELPS IMPROVE CIRCULATION** **CONTAINS SLOW-RELEASE SUGARS**

Lemon juice, mint, and ginger are the perfect trio to help combat the symptoms of a cold. The thin skin and fibrous root of fresh ginger have anti-inflammatory properties that can lessen the aches and pains, while honey is a natural antibiotic and lemon and mint have antibacterial benefits. Drink this healing tea as soon as you feel the first signs of a cold coming on.

SERVES 2

1in (3cm) piece fresh ginger, grated
zest and juice of 1 lemon
1 tbsp honey
1 tbsp chopped mint leaves

1 Place the grated fresh ginger in a small saucepan, cover with 1½ cups water, and bring to a boil. Turn the heat down to low and simmer for 15 minutes.

2 Pour the mixture through a strainer into a pitcher, add the lemon juice and zest, stir in the honey and mix well. Add the mint leaf and serve in heatproof glasses. Drink the tea and eat the chopped mint leaves.

ALOE AND HONEY HOT TODDY

 HELPS STRENGTHEN THE IMMUNE SYSTEM 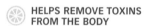 **HELPS REMOVE TOXINS FROM THE BODY**

Honey and aloe are known to help the body detoxify and to strengthen the immune system, which in turn enables all the major organs to function more efficiently. Traditionally, the variety of aloe known as *Aloe arborescens* (which produces red flowers when in bloom) is used for this recipe; it has a high concentration of complex sugars and other phytonutrients that work synergistically.

SERVES 2

5½oz (150g) aloe leaves
½ cup honey
3 tbsp grappa or Cognac

1 Clean the fresh aloe leaves with a damp cloth, cut off and discard the spines, chop the leaves, and put them in a blender or food processor. Add the honey and grappa or Cognac and purée. Add a dash of water if you want to dilute the flavor slightly. Pour into 2 heatproof glasses and serve. If using as a therapeutic drink, allow to cool, transfer to a dark glass bottle, seal, and store in the refrigerator for up to 1 week. Take 1–2 tablespoons a day.

DRINKS

SOOTHING, **UPLIFTING**, AND NUTRITIOUS DRINKS AND BEAUTIFUL BLENDS **DELIVER NUTRIENTS** QUICKLY AND IN AN EASILY **ABSORBABLE** FORM—WHETHER YOU OPT FOR REFRESHING COOL DRINKS OR **NURTURING** HOT BROTHS AND TEAS.

DRIED FRUIT AND NUT ROLL

 HELPS EASE CONSTIPATION

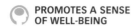 **PROMOTES A SENSE OF WELL-BEING**

Try this as a variation on a traditional fruit cake to grace your table during a festive celebration. It is high in fiber, which helps improve bowel regularity and enhances gut health. Prunes, figs, and dates also supply slow-release energy, while hemp seeds and walnuts are said to bring a sense of well-being and help strengthen the heart. You will need to start the recipe two days ahead.

SERVES 8–10

⅔ cup dried prunes, finely chopped

¾ cup dates, finely chopped

¾ cup dried figs, finely chopped

½ cup finely chopped fresh orange peel

1¼ cups walnuts, finely chopped

⅓ cup sugar

½ cup sweet Marsala wine

heaped ¼ cup cacao nibs, chopped

⅓ cup hemp seeds

confectioner's sugar, for dusting

1 Place all the ingredients except the confectioner's sugar in a medium saucepan. Heat gently over low heat, stirring until the sugar has dissolved and the mixture is thoroughly combined.

2 Dust a wooden cutting board or work surface with confectioner's sugar and transfer the fruit mixture onto it. Roll into a sausage shape, about 2in (5cm) thick and 12in (30cm) long, then wrap in a clean dish towel. Set aside in a cool place to dry out; it's best to let it stand for a few days. Cut into thin slices, about ¾in (2cm), to serve.

Dried figs (p26) are a fantastic source of fiber, which aids a healthy digestive system.

POPPY SEED AND WALNUT ROULADE

 HELPS COMBAT FATIGUE **PROMOTES A SENSE OF WELL-BEING** **SUPPORTS HEALTHY KIDNEY FUNCTION** **PROTECTS THE HEART AND BLOOD VESSELS**

The filling of walnuts and poppy seeds together deliver a revitalizing and physically strengthening boost in this sweet bread roulade. Poppy seeds have a balancing effect on emotions, while walnuts bring a sense of well-being and help strengthen the heart. Walnuts can also improve men's fertility, which may account for their traditional use as an aphrodisiac.

SERVES 8

For the dough

½oz (15g) fresh yeast

¼ cup sugar

1½ cups all-purpose flour, plus extra for sprinkling

a pinch of salt

3 tbsp butter, softened

½ cup milk

1 tbsp light rum

grated zest of 1 lemon

1 large egg yolk

1 tsp vanilla extract

oil, for greasing

1 large egg, beaten, for brushing

confectioner's sugar, for dusting

For the filling

2½ cups ground poppy seeds

½ cup chopped walnuts

¼ cup milk

grated zest of 1 lemon

a pinch of ground cinnamon

1 tbsp light rum

2 tbsp butter

¼ cup sugar

2 tbsp vanilla sugar, or ¼ tsp vanilla extract mixed with 2 tbsp superfine sugar

1 large egg, beaten

1 To make the dough, crush the yeast, add it to a medium bowl, and mix it with 1 tablespoon each of the sugar and flour. Add 1–2 tsp lukewarm water and stir it in with a fork until the yeast dissolves to form a thick paste. Cover and set aside in a warm place for about 15 minutes to rise.

2 Sift the remaining flour into a bowl and add a pinch of salt. Add the yeast paste mixture and gently rub it into the flour until the mixture resembles bread crumbs.

3 In a small saucepan, warm the butter gently to melt it. Remove from the heat and add the milk, remaining sugar, rum, lemon zest, egg yolk, and vanilla extract. Stir well and pour into the flour and yeast mixture. Mix together and knead gently until the dough is smooth and no longer sticks to the bowl. Knead the dough with a little flour if necessary to form a smooth dough. Sprinkle with flour, cover with a clean cloth, and set aside in a warm place for 20–30 minutes to rise.

4 Preheat the oven to 375°F (190°C). To make the filling, put all the ingredients in a large bowl and mix into a thick paste.

5 Turn the risen dough onto a well-floured wooden cutting board or work surface and roll it into a rectangle about 10in (25cm) x 7in (18cm), and ½in (1cm) thick. Cover the surface with the filling, leaving a border of about ½in (1cm), then fold one long edge of the dough over and roll carefully into a cylindrical shape. Place the dough roll on a well-greased baking sheet and set aside in a warm place for 20–30 minutes for the dough to rise again.

6 Brush the surface of the dough roll with the beaten egg and bake in the oven for 25–30 minutes. Remove from the oven and let cool on the baking sheet. Dust with confectioner's sugar, and cut into slices to serve.

TIP: To make your own vanilla sugar, put 2 cups of white sugar in an airtight container. Take 1 vanilla bean and split it and scrape out the seeds; add both bean and seeds to the sugar. Leave to infuse for 2 weeks before using.

ALMOND AND PISTACHIO MACAROONS

 SUPPORTS LUNG FUNCTION

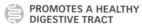 **PROMOTES A HEALTHY DIGESTIVE TRACT**

 HELPS IMPROVE CIRCULATION

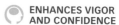 **ENHANCES VIGOR AND CONFIDENCE**

Almonds and pistachios are both good sources of protein and, together with cardamom, are beneficial for your respiratory system, circulation, and digestive health. They are also traditionally regarded as an aphrodisiac for both men and women. This recipe makes quite a number of macaroons, so halve the quantities if you like.

MAKES 45

3 large egg whites
1 cup superfine sugar
1 tsp crushed cardamom seeds
4 cups ground almonds
2 tbsp rose water
3 tbsp shelled whole pistachios

1 Preheat the oven to 300°F (150°C). Put the egg whites in a mixing bowl and beat into soft or stiff peaks with an electric hand mixer, gradually adding the sugar as you beat. When all the sugar has been incorporated, add the cardamom, ground almonds, and rose water and combine all the ingredients together.

2 Line a baking sheet with parchment paper. Wet your hands with water so the mixture won't stick to your fingers. Divide the mixture into small walnut-sized balls and arrange on the parchment paper, allowing sufficient space around each ball. Place a pistachio in the center of each.

3 Bake for 10–12 minutes, then transfer to a wire rack to cool. Store the macaroons in an airtight container. They will keep for up to 2 weeks.

Almonds (p92) are rich in cholesterol-lowering monounsaturated fatty acids.

SESAME HEART COOKIES

 HELPS CLEAR CONGESTION

 PROMOTES BOWEL REGULARITY

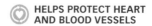 **HELPS PROTECT HEART AND BLOOD VESSELS**

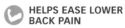 **HELPS EASE LOWER BACK PAIN**

A traditional tonic food, sesame seeds lubricate the lungs and intestines, relieving dry coughs and constipation, protecting the heart and easing rheumatic conditions and lower back pain. Soaking the seeds overnight and dry-frying them before grinding reduces their oxalic acid content (which prevents the absorption of other nutrients) and makes them more digestible.

MAKES 50–60 COOKIES

1¾ cups sesame seeds
8 tbsp butter
¼ cup sesame oil
1 cup superfine sugar
2 large eggs, beaten
2 tsp vanilla extract
1½ cups all-purpose flour
¾ cup self-rising flour

1 Place the sesame seeds in a bowl, cover generously with cold water, and let soak overnight. Drain the seeds, allow to drip-dry for 2–3 minutes, then lightly dry-fry them in a medium saucepan over low heat and set aside.

2 Preheat the oven to 350°F (180°C). Put the butter, sesame oil, sugar, eggs, and vanilla extract in a mixing bowl and beat together to a light, creamy consistency.

3 Place the sesame seeds in a blender or food processor, pulse briefly to crush them lightly, then beat into the butter and egg mixture. Sift the flours together and stir them into the mixture to make a dough.

4 Gather the dough together with your hands, pressing it gently into a round ball. Don't overwork the dough, because this will yield a cookie that is tough. Wrap the dough in plastic wrap and leave to rest for 30 minutes in the refrigerator.

5 On a lightly floured surface, roll out the dough until it is ¼in (5mm) thick, and cut out heart shapes using a small heart-shaped cookie cutter. Place on a baking sheet lined with parchment paper and bake for 7 minutes, or until the cookies turn golden. They burn easily, so watch them carefully. Remove from the oven, transfer to a wire rack to cool, and store in an airtight container. They will keep for 2–3 weeks.

Sesame seeds (p94) contain plant hormones that support cardiovascular health, making the heart shape of these cookies appropriate.

Mediterranean Nut Squares In Rose And Cardamom Syrup

 PROMOTES A SENSE OF WELL-BEING **ENHANCES VIRILITY** **HELPS COMBAT FATIGUE**

Also known as baklava, this "pick-me-up" from the eastern Mediterranean is a popular delicacy across Europe. Traditionally, walnuts and pistachios were considered beneficial to the mind, and to increase virility in men; here cardamom pods are added to enhance the rejuvenating benefits of these nuts. High-quality fresh walnuts are essential for this recipe.

MAKES 24 SQUARES

3 cups walnuts halves
1½ cups pistachio nuts, shelled
1 tbsp unsalted butter, melted
1lb 2oz (500g) filo pastry
⅔ cup walnut oil

For the syrup
1¼ cups raw sugar
3 tbsp rosewater
juice of 1 lemon
1 lemon, thinly sliced
10 green cardamom pods

1 Preheat the oven to 350°F (180°C). Roughly grind two-thirds of the walnuts into chunky pieces in a food processor or blender, and pulse the remaining walnuts until finely chopped; too many finely ground nuts will make the finished baklava heavy. Pulse the pistachios until finely chopped, then mix the walnuts and pistachios together in a bowl.

2 Use a rectangular baking pan a little smaller than the size of the sheets of filo pastry (to retain the filling) and brush it with some of the melted butter. Lay the first sheet of pastry in the pan, brush with a little walnut oil, and layer a second sheet on top; repeat with a third sheet and more walnut oil. Then spread a thin layer of chopped nuts on the pastry. Continue layering, alternating 1 layer of pastry with 1 layer of nuts, and brushing the pastry with walnut oil, until you have used all the nuts. Finish with 2 or 3 final layers of pastry, with a little walnut oil brushed in between them, and brush the top layer with melted butter.

3 With a sharp knife, slice lengthwise right through the pastry layers, all the way down to the bottom, at 1½in (4cm) intervals, to create strips of layered pastry. Rotate the baking pan by 60 degrees and repeat, cutting diagonally across the pastry strips at 1½in (4cm) intervals to make individual diamond-shaped portions. If the pastry starts lifting while you are cutting it, press it back in place. Bake for 25 minutes, then lower the temperature to 300°F (150°C) and bake for a further 25 minutes, or until the squares are crisp and golden.

4 Meanwhile, make the syrup by boiling the sugar with the rosewater, lemon juice, thinly sliced lemon, cardamom pods, and 1¼ cups water in a saucepan over high heat. Simmer uncovered for 10–15 minutes on medium heat. Remove from the heat and set aside to cool. Once cool, remove the cardamom pods and discard. When the squares are cooked, pour the syrup and sliced lemons over them and cover with a clean dish towel. Let cool a few hours or overnight. Baklava is best served the next day when the flavors have infused, and it will keep fresh for 4–5 days if stored in an airtight container in a cool place.

BANANA AND CRANBERRY ICE CREAM

 HELPS EASE CONSTIPATION

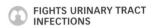 **HELPS LOWER BLOOD PRESSURE**

FIGHTS URINARY TRACT INFECTIONS

Ice cream without any cream—ideal for those who are allergic to cow milk. Ripe bananas promote bowel regularity and can help lower blood pressure, while cranberries have antibacterial properties that treat urinary tract infections (UTIs). In traditional Chinese medicine, cold food is thought to disrupt healthy digestion, so keep frozen foods for occasional treats.

SERVES 4

4 ripe bananas, sliced
2 cups cranberries
1 tbsp superfine sugar
1 tsp vanilla extract
scant ½ cup pistachio nuts, shelled and chopped

1 Put the bananas and cranberries in the freezer and remove when semifrozen. If they are completely frozen, allow to thaw slightly for about an hour. Place them in a blender or food processor and pulse until the fruits are coarsely combined and still have some texture. Divide among 4 freezerproof serving bowls (such as enamel bowls, which are freezerproof) and place in the freezer for 3 hours. Alternatively, freeze the ice cream in a clean plastic container.

2 Meanwhile, place the sugar in a small saucepan over low heat and add just enough water to wet the sugar. When the sugar has dissolved completely, add the vanilla extract and stir in the pistachios, then remove from the heat and allow to cool.

3 Remove the bowls, or container, from the freezer, let sit at room temperature for a short while, then use an ice-cream scoop to divide the ice cream among 4 serving bowls. Drizzle the sugar solution and nuts over each portion to serve.

TIP: If you have a weak digestive system, you may like to add a few drops of freshly squeezed ginger juice, instead of water, to the sugar to dissolve it (grate fresh ginger, wrap in a piece of cheesecloth, squeeze the cheesecloth, and collect the juice). Children may also benefit from ginger juice, because their digestive systems are still developing, but make sure they are familiar with, and enjoy the taste of, ginger before you include it. If you can't find fresh or frozen cranberries, use blueberries, which freeze well and taste just as good.

ROSE PETAL AND WHITE WINE SORBET

 HELPS RELAX AND UNWIND THE MIND

 HELPS IMPROVE CIRCULATION

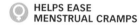 **HELPS EASE MENSTRUAL CRAMPS**

Roses have a deeply calming effect on the nervous system. Here they are combined with a small amount of sweet wine, which helps relax blood vessels and boosts their beneficial effect on circulation. Roses are also a good remedy for menstrual cramps and premenstrual symptoms. Highly perfumed roses (*Rosa damascena* or *Rosa gallica*) are best for this recipe.

SERVES 4

10 fresh red rose heads or a large handful of red rose petals, plus extra petals for decoration

1¼ cups sweet dessert wine (Marsala or Muscat are good choices)

1 cup superfine sugar

2 tsp agar flakes

juice of 1 lemon, strained

juice of 1 orange, strained

1 Combine half the roses and the sweet dessert wine in a pitcher or bowl and refrigerate. Infuse the rest of the roses in 1¾ cups boiling water and set aside to cool.

2 Strain the infused liquid and discard the petals. Transfer the liquid to a saucepan and add the sugar. Set the pan over gentle heat and stir frequently until the sugar has dissolved. Bring to a boil and boil (at 230°F /110°C, if you have a sugar thermometer) for 5–8 minutes, or until you have a light syrup. Remove from the heat and set aside to cool.

3 Melt the agar flakes in ¼ cup hot water and add it to the syrup. Stir, transfer to a bowl, and then refrigerate until completely cold.

4 Combine the chilled dessert wine and fresh rose petal mixture with the rose syrup. Stir in the strained lemon and orange juices and pour the mixture into an ice cream maker. Process the sorbet for 20–30 minutes, or until it is cold and the right consistency. Spoon the ingredients into a freezerproof container and freeze if not serving immediately. If you don't have an ice cream maker, pour the wine and syrup mixture into a freezerproof container and place in the freezer. Take it out every hour to give it a stir until the mixture is completely frozen.

CALM YOUR MOOD

A SMALL AMOUNT OF WHITE WINE RELAXES YOUR BLOOD VESSELS. INFUSED WITH ROSE PETALS— TRADITIONALLY USED TO TREAT NERVOUS TENSION— IT WILL ALSO HELP TO INCREASE YOUR SENSE OF WELL-BEING.

BAKED QUINCE

 SUPPORTS HEALTHY
LIVER FUNCTION

 HELPS IMPROVE
CIRCULATION

 HELPS RELIEVE JOINT
AND MUSCLE PAIN

 SOOTHES UPSET
STOMACHS

Quince is a well-regarded medicinal fruit and a liver remedy in traditional Chinese, Tibetan, and Bhutanese medicine. It helps increase blood circulation to the muscles and tendons, and is used in the treatment of rheumatic pain and cramp in calf muscles. It is also used to treat deficiency in the spleen and the associated symptoms of vomiting, diarrhea, and dyspepsia.

SERVES 4

4 small or 2 large quince, peeled, cored, and quartered

½ tsp cardamom pods

1 tbsp soft brown sugar

¼ cup sweet dessert wine, plus a little for drizzling (Marsala or Muscat are good choices)

¼ cup mascarpone cheese

1 Preheat the oven to 350°F (180°C). Put the quince in a baking dish, scatter with the cardamom pods and sugar, and drizzle with half the dessert wine and 2 tablespoons water. Bake in the oven for about 1 hour, or until cooked through and golden in color. Check the quince occasionally to make sure it doesn't dry out and add more wine or water if needed.

2 Mix the rest of the sweet wine and the mascarpone in a bowl. Transfer the quince to 4 small serving bowls. Drizzle with the cooking juices and add 1 tablespoon of the flavored mascarpone to each portion to serve.

CHERRY STRUDEL

 PROTECTS AGAINST FREE-RADICAL DAMAGE

 PROTECTS THE HEART AND BLOOD VESSELS

 HELPS EASE JOINT INFLAMMATION

 HELPS RELIEVE INSOMNIA

The tart morello cherries in this recipe are particularly rich in antioxidants, which help protect the heart and fight free-radical damage and inflammation, especially in the joints. They also contain melatonin, which aids restful sleep. If you can't find morello cherries, choose a sweet variety and marinate in the zest of an orange and the juice of half a lemon for a sharper flavor.

SERVES 4

scant ½ cup fresh breadcrumbs

¼ cup superfine sugar

¼ cup ground almonds

¼ cup ground walnuts

5 sheets store-bought filo pastry

2 tbsp unsalted butter, melted, plus a little extra for brushing

½ tsp ground cinnamon

11oz (325g) fresh morello cherries, pitted

3 tbsp sliced almonds (optional)

confectioner's sugar, for dusting

1 To make the filling, mix the breadcrumbs, superfine sugar, and ground almonds together in a bowl and set aside.

2 Preheat the oven to 375°F (190°C). If you can't find ground walnuts, grind some walnut pieces briefly in a food processor or blender. Arrange a sheet of parchment paper on a flat surface. Place a sheet of filo pastry on the parchment, with one of the longer edges of the pastry rectangle facing you. Brush the surface of the pastry with some of the melted butter and dust with a little of the cinnamon. Repeat with the rest of the pastry sheets, butter, and cinnamon. Scatter the breadcrumb filling over the pastry stack, leaving a 2in (5cm) border around the edge (this will help when you fold the pastry edges over to prevent the filling from escaping). If you want to make 2 strudels, cut the pastry in half, leaving a 4in (10cm) space in the middle. Scatter the ground walnuts over the filling and heap the cherries in a thick strip along the center of the pastry, leaving a 2in (5cm) gap at either end.

3 Fold in the short edges of the pastry rectangle. Then, using the parchment paper, fold over the long edge of the pastry rectangle nearest you, and roll up the pastry to enclose the filling and create a long roll. Brush the surface of the rolled pastry with more melted butter and scatter with the sliced almonds, if using.

4 Lift the parchment paper with the strudel, seam-side down, onto a large cookie sheet and bake in the oven for 30 minutes, or until the pastry is golden. Allow to cool for about 10 minutes, then dust with confectioner's sugar and serve.

Morello cherries (p20) are colored brightly with red pigments that produce a greater pain-relieving effect than aspirin.

WARM FRUIT SALAD IN SWEET WINE SAUCE

 HELPS REMOVE TOXINS FROM THE BODY **HAS AN UPLIFTING EFFECT** **HELPS EASE CONSTIPATION** **HELPS LOWER BLOOD PRESSURE**

The subtle flavors and textures of warmed fresh fruits, tossed in a sweet wine syrup, result in a deliciously different twist on a classic fruit salad. This combination of soft and crunchy fresh fruits and pistachio nuts is detoxifying, uplifting, and has a tonic effect on the whole body. The abundant fiber in the fruit supports healthy digestion and potassium helps lower blood pressure.

SERVES 4

3 tbsp butter
3 tbsp superfine sugar
1¼ cup sweet Marsala wine
1 ripe pear, cored and quartered
4 figs, halved
2 peaches, quartered, with pits removed
2 nectarines, quartered, with pits removed
1 apple, cored and quartered
¾ cup pistachio nuts, shelled and roughly chopped

1 Preheat the oven to 400°F (200°C). Melt the butter in a small saucepan, add the sugar and Marsala wine, and cook over low heat for 5–10 minutes, or until the mixture has a syrupy consistency. Remove from the heat and set aside to cool.

2 Place all the fruits in a bowl, add the pistachio nuts, and pour in two-thirds of the cooled Marsala syrup. Gently toss everything together to coat the fruit. Turn the fruit mixture out into a shallow baking dish and bake in the oven for 25–35 minutes, or until the fruit is warmed through, but not completely cooked.

3 Remove from the oven and spoon the warm fruit salad onto individual plates. Mix the remaining Marsala syrup with the juices from the baking dish, drizzle it over the fruit portions, and serve.

Nectarines (p22) of all types, including the white-fleshed variety, can help remove excess water from the body.

NUTTY SUGAR LOAF

 PROMOTES A SENSE OF WELL-BEING

 PROMOTES BOWEL REGULARITY

 HELPS KEEP JOINTS SUPPLE

Containing walnuts, chestnuts, hazelnuts, and sprouted spelt, this is a deeply satisfying dish that helps to improve digestion and bowel regularity, and also to strengthen and improve movement in muscles and joints. This recipe, great for a party, requires some advanced preparation, because the spelt grains need 3–4 days to sprout.

SERVES 6–8

1½ cups spelt grains
1 cup hazelnuts
1 cup walnuts
¾ cup fresh sweet chestnuts, cooked, peeled
⅓ cup raw sugar
1 tbsp vanilla extract
mascarpone cheese, to serve

1 To sprout the spelt grains, start soaking them 3–4 days before you need them. Soak a heaped ½ cup of the grains for 8–12 hours in clean water in a large, clean, wide-mouthed glass jar covered with cheesecloth, securing the cloth in place with a rubber band. Strain the water from the grains, rinse the grains in fresh water, drain, then set the jar aside, out of direct sunlight. Rinse and drain the grains again 8–12 hours later. It usually takes 2–3 rinsing cycles for the spelt to sprout; the grains are sprouted when most of them have a tiny rootlet just pushing through. They are ready to use 8 hours later.

2 Preheat the oven to 350°F (180°C). To toast the hazelnuts, put them on a baking sheet and place in the oven for 15 minutes, keeping an eye on them and shaking the sheet occasionally so they don't burn, or they will taste bitter. Transfer to a bowl and cover with plastic wrap to let the nuts sweat for 2–3 minutes. Transfer a small batch of nuts to a piece of paper towel and rub them roughly to remove the majority of the skins. Repeat with the rest of the hazelnuts. Transfer to a blender or food processor and pulse briefly until coarsely chopped.

3 To toast the walnuts, soak in 2 cups water for 30 minutes, then drain. Transfer to a baking sheet and place in the oven for 25–30 minutes, turning them regularly until they become dry and light brown in color. Set aside to cool.

4 Cook the remaining spelt in plenty of water for 1 hour 20 minutes, or until soft, and set aside to cool.

5 Use a coffee grinder, hand grinder, or a powerful blender to grind the cooked spelt, walnuts, and chestnuts, and transfer the ground ingredients to a mixing bowl. Add the whole sprouted spelt grains, raw sugar, and vanilla extract, combining all the ingredients well.

6 Using your hands, mold the dry mixture into a sugar loaf shape on a serving plate (if you find the mixture too dry, blend a small quantity in a blender or food processor to bind it together, and use as a base on which to build the other ingredients). Alternatively, press into individual serving bowls and turn out before serving. Cover with the toasted, coarsely ground hazelnuts. To serve, cut a slice from the sugar loaf and serve with a spoonful of mascarpone cheese.

Elderberry And Blackberry Nutty Crisp

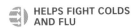 **HELPS FIGHT COLDS AND FLU**

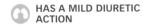 **HAS A MILD DIURETIC ACTION**

 PROTECTS THE HEART AND BLOOD VESSELS

The best time to make this crisp is when elderberries are fully ripened and blackberries are just beginning to ripen on the bush. They are both worth foraging for, because they enhance immunity, especially against colds and flu. They also have a mild diuretic action, and help maintain healthy blood vessels. If elderberries are no longer in season, use blueberries instead.

SERVES 4–6

1¼lb (550g) apples, peeled, cored, and sliced

1½ cups fresh elderberries

1¾ cups fresh blackberries

For the topping

1 cup all-purpose flour

7 tbsp organic butter

2¼ cups ground almonds

2 tbsp molasses sugar, or other dark brown sugar

½ cup walnuts, finely chopped

crème fraîche, to serve

1 Preheat the oven to 350°F (180°C). To make the topping, place the flour in a mixing bowl, add the butter, and rub it into the flour with your fingertips. Add the ground almonds and molasses sugar and mix together well until the mixture resembles breadcrumbs. Add the chopped walnuts and mix them in well.

2 Add the apples along with a little water to a large saucepan over low heat and simmer for 10 minutes. Transfer the softened apples to a large, deep baking dish and add the berries. Completely and evenly cover the fruit mixture with the topping, pressing it down lightly. Bake in the oven for 35–40 minutes, or until golden on top, then serve either hot or warm with the crème fraîche.

Elderberries are a good source of antioxidant anthocyanins, which help fight free-radical damage.

ALMOND AND RASPBERRY CAKE

 HELPS CLEAR CONGESTION

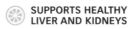 **SUPPORTS HEALTHY LIVER AND KIDNEYS**

 HELPS CALM NERVES

 HELPS PROTECT EYE HEALTH

This dense, gluten-free cake is made with ground almonds instead of flour. Almonds soothe and support the respiratory system, helping to remove phlegm. Raspberries have a tonic effect on the liver, and a calming effect on the mind. Rich in antioxidants, they also support healthy vision. In traditional Chinese medicine, raspberries are used to treat impotence and infertility in men.

SERVES 6

18 tbsp butter, plus extra for greasing

1 cup superfine sugar

5 large eggs, separated

3 cups ground almonds

1 tsp vanilla extract

1⅓ cups raspberries

1 Preheat the oven to 275°F (140°C). Grease a 10in (25cm) springform cake pan with the butter and line the base with parchment paper, making sure the paper is exactly the same size as the base.

2 Cream the butter and sugar in a large bowl. Add an egg yolk, mix well, then add a little of the ground almonds and stir well. Repeat until all the yolks and almonds have been added to the mixture. Add the vanilla extract and combine well.

3 In a separate, clean large bowl, beat the egg whites to stiff peaks with an electric hand mixer. Gently fold the egg whites into the cake mixture with a metal spoon to keep the mixture as fluffy and light as possible. Reserve 6–12 raspberries to use as decoration later. Transfer half the mixture to the prepared cake pan, arrange half the raspberries on top, then add the rest of the cake mixture and finish with the rest of the raspberries. Don't stir the raspberries into the cake mixture, because they will break up and discolor the cake.

4 Bake in the oven for 45 minutes–1 hour, or until cooked through. To test if the cake is cooked, insert a clean skewer into the center. If the skewer is clean when you take it out, remove the cake from the oven. If not, bake for a little longer and test again.

5 Transfer the cake to a wire rack and let cool. Once cool, carefully remove the springform pan and parchment paper. Decorate the cake with the reserved raspberries to serve.

Fresh Fig Delight With Pear And Red Wine Sauce

 SUPPORTS HEALTHY LUNG FUNCTION

 PROMOTES BOWEL REGULARITY

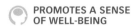 **PROMOTES A SENSE OF WELL-BEING**

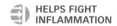 **HELPS FIGHT INFLAMMATION**

This impressive dessert combines a fig-filled sponge cake with a crisp almond base. It benefits the lungs and large intestine, 2 organs whose functions are closely related. Pears and almonds are cooling and uplifting and help lubricate the lungs, alleviating dry coughs, and also benefit the skin. Figs help to relieve constipation, alleviate inflammation, and build muscle.

SERVES 8

For the base

2 cup ground almonds

3 tbsp superfine sugar

4 tbsp butter, melted

pinch of salt

For the cake

12 tbsp butter, softened, plus extra for greasing

⅔ cup granulated sugar

4 large eggs, beaten

grated zest of 1 organic lemon

1 tsp vanilla extract

1 cup all-purpose flour

2 tsp baking powder

¼ cup whole blanched almonds

8–10 figs, quartered

For the sauce

3 soft pears, peeled, cored, and finely chopped

¼ cup red wine

¼ tsp ground allspice

1 tbsp maple syrup

freshly ground black pepper

1 Preheat the oven to 350°F (180°C). First, make the almond base. Mix together the ingredients for the base in a mixing bowl, combining well. Press the almond mixture evenly onto the base of a 9in (23cm) springform cake pan. Bake for 10 minutes, or until crisp, then transfer to a wire rack to cool. Reduce the oven temperature to 300°F (150°C).

2 Next, make the cake batter. Beat the softened butter and granulated sugar together in a clean bowl until pale and creamy. Then beat in the eggs, lemon zest, and vanilla extract until thoroughly combined. Sift in the flour and baking powder and fold into the wet ingredients until the cake batter is smooth. Finally, fold in the whole almonds. Smear a little butter around the inside of the springform pan.

3 Arrange the quartered figs all over the almond crust and cover with the cake batter. Bake in the oven for about 60 minutes, or until the top is golden and the sides of the cake have pulled away slightly from the inside of the pan. Remove from the oven and unclip the side of the springform pan, leaving the cake on its base. Let cool on a wire rack.

4 For the sauce, add the pears, red wine, and ground allspice to a medium saucepan, bring to a simmer, cover, and cook over low heat for 20 minutes, or until the pears are soft. Transfer to a blender or food processor and purée until smooth. Add the maple syrup and a pinch of black pepper. Purée again. Add more maple syrup to taste, if liked.

5 Place a slice of the cake on a serving plate and drizzle it with a little of the sauce to serve.

SWEET TREATS

WE ALL NEED A **LITTLE SWEETNESS** IN OUR LIVES.
WHETHER HOT OR COLD, DESSERTS WITH FRESH
FRUITS, NUTS, AND SEEDS AT THEIR CORE SUPPLY
THE **ANTIOXIDANTS**, PHYTONUTRIENTS, HEALTHY
OILS, AND **FLAVORS** THAT CAN UPLIFT AND HEAL.

FRAGRANT RICE AND MILLET

 AIDS HEALTHY DIGESTION

 PROMOTES A SENSE OF WELL-BEING

 HAS ANTIFUNGAL PROPERTIES

This fragrant blend of brown rice, millet, vegetables, nuts, and herbs is a great dinner party dish. Cinnamon, cardamom, and coriander are all warming, digestive stimulants, and cardamom is also thought to help stimulate the mind and spirit. Millet is a diuretic, but it is also known to have antifungal properties and is often used in the treatment of candidiasis.

SERVES 4

4oz (115g) mixed walnuts and hazelnuts, halved

¾ cup long grain brown rice

heaped ½ cup millet

1 tbsp olive oil

⅓ cup finely chopped red onion

1 medium leek, sliced

20 coriander seeds, crushed

6 cardamom pods, crushed

a pinch of ground cinnamon

3½ cups vegetable or chicken stock

8oz (225g) mixed bell peppers, halved and seeded

2 tbsp chopped cilantro leaves

salt and freshly ground black pepper

For the dressing

1 tsp tamari soy sauce

juice of 1 lime

2 tbsp chicken stock

1 Soak the mixed nuts in water for 30 minutes. Preheat the oven to 350°F (180°C).

2 Rinse the nuts in fresh water and leave to drain for 2–3 minutes. Then scatter onto a baking sheet and toast in the oven for 30 minutes, shaking or stirring them every 6–10 minutes until dry and light brown in color. Remove the nuts from the oven as soon as they are toasted and increase the temperature to 375°F (190°C).

3 Meanwhile, rinse the rice and millet in fresh water and drain. Heat the olive oil in a medium saucepan over low heat and cook the onion, leek, and spices in the pan for 2 minutes. Add the rice, millet, and stock and simmer for 30 minutes, or until all the liquid has been absorbed and the grains are soft. Avoid stirring the rice mixture while it cooks, because this will release starch and alter the texture.

4 Transfer the mixture to a serving bowl, remove the cardamom pods, if possible, and let cool.

5 Put the mixed peppers on a rimmed baking sheet and bake for 15–20 minutes, or until their skins start blistering and turning slightly brown. Remove from the oven, transfer to a bowl, cover with plastic wrap to sweat, and let cool. Once cool enough to handle, remove the skins and dice the flesh.

6 Mix together all the ingredients for the dressing. Combine the peppers, nuts, and cilantro leaves with the cooled grains, pour over the dressing, adjust the seasoning to taste, and serve.

Cardamom *(p116) is an excellent spice to aid digestion, and even boasts of antibacterial properties.*

GRIDDLED VEGETABLE ROLL WITH CASHEW AND BRAISED GARLIC CREAM

 HELPS LOWER CHOLESTEROL

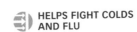 **HELPS FIGHT COLDS AND FLU**

 AIDS HEALTHY DIGESTION

These lightly cooked summer vegetables are bursting with nutrients that support the heart and blood vessels, and also enhance immunity and digestion. A sauce laced with a powerful combination of garlic and cashews enhances these tasty rolls' ability to lower blood cholesterol, and protect against viruses, colds, and the flu.

SERVES 4

2 tbsp olives in brine, drained and chopped

2 tbsp sun-dried tomatoes in oil, drained and chopped

1 red bell pepper, halved and seeded

1 yellow bell pepper, halved and seeded

a dash of olive oil

2 eggplants, sliced thinly lengthwise

2 zucchini, thinly sliced

2 small fennel bulbs, trimmed and quartered

2 marinated artichoke hearts in oil, drained and quartered

For the cashew and braised garlic cream

2 large garlic bulbs

¼ cup olive oil

1 small sprig of rosemary

⅓ cup cashews

a pinch of salt

1 tbsp finely chopped parsley leaves

1 garlic clove, minced

1 To make the braised garlic cream, preheat the oven to 350°F (180°C). Place the garlic bulbs, olive oil, and rosemary sprig in a small baking dish, cover with foil or a lid, and bake for 30–40 minutes or until the cloves are soft and just beginning to brown. Remove from the oven and, when cool enough to handle, squeeze the softened garlic from its skins into a small bowl.

2 Place the cashews and ⅓ cup of the braised garlic purée in a food processor or blender, add ½ cup water, and purée until smooth and sticky. Slowly add another ½ cup water or more until the consistency is like heavy cream and pourable. Add the salt to taste and purée again. Stir in the parsley leaves and garlic and set aside.

3 Increase the oven temperature to 375°F (190°C). Mix the olives and sun-dried tomatoes in a small bowl and set aside. Place the halved peppers on a rimmed baking sheet and bake in the oven for 15–20 minutes, or until their skins start blistering and turning slightly brown. Remove from the oven, transfer to a bowl, cover with plastic wrap to sweat and let cool. Once cool enough to handle, remove the skins and cut the flesh into quarters.

4 Brush a grill pan (or barbecue grill) with the olive oil and place over high heat. Add the eggplant slices in batches and grill for 2–3 minutes on each side. Repeat with the zucchini and fennel.

5 To assemble the vegetable rolls, place an eggplant slice on a cutting board, cover with 1 or 2 slices of grilled zucchini, and place a slice each of red and yellow pepper on top. Place an artichoke quarter on top of the layered vegetables at one side and a fennel quarter next to it. Carefully roll up the layered eggplant slice and fasten with a toothpick. Repeat with the rest of the ingredients. Arrange the vegetable rolls on a serving plate, scatter the olives and sun-dried tomatoes around them, drizzle the cashew and braised garlic cream on top, and serve with a kamut and pine nut salad, if you like.

BARLOTTO WITH CHESTNUT PURÉE

 HELPS MAINTAIN ENERGY LEVELS **HELPS IMPROVE CIRCULATION** **PROMOTES BOWEL REGULARITY** 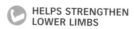 **HELPS STRENGTHEN LOWER LIMBS**

Barlotto is a version of risotto made with barley instead of short-grain rice. Barley is a good source of soluble fiber and together with sweet chestnuts assists the digestive and urinary systems. Black barley, an ancient grain that hasn't been hulled, is even more of a healing, energizing food, if you can find it. Toasting the barley first gives it a fragrant, nutty flavor.

SERVES 4

1¼ cups pearl barley
¾oz (20g) dried shiitake mushrooms
1 tsp sea salt or other unrefined salt
1 tbsp ghee, or clarified butter
8 small shallots, finely diced
1 medium carrot, diced
1 fennel bulb, cored and thinly sliced
2 garlic cloves, minced
¼ tsp freshly ground white pepper
¾ cup chestnut purée
1 large glass of dry white wine

For the vegetable stock

¼oz (10g) astragalus root (optional)
1 large carrot
2 celery stalks
6 thin slices of fresh ginger
3 thick slices of celeriac
3 shallots, quartered
4 small garlic cloves, with the skin left on
1 tbsp coriander seeds
a small handful of parsley leaves

1 To toast the barley, preheat the oven to 350°F (180°C), arrange the grains in a thin layer on a baking sheet, and place in the oven for 10–12 minutes. Toast the barley until it turns light golden, agitating it occasionally so it toasts evenly.

2 Put all the stock ingredients in a large stockpot and cover with 10½ cups water. Simmer on a low heat until the liquid reduces by roughly one-third. Strain through a colander into another pan and discard the stock vegetables, except the garlic. Squeeze the cooked garlic from its skin and add the paste to the strained stock.

3 Add the dried shiitake mushrooms and salt to the stock in the pan, and bring it back to a boil. Lower the temperature and simmer for 15 minutes to ensure the mushrooms have reconstituted fully.

4 Strain, reserving the stock, and mince the mushrooms. Place a heavy skillet over medium heat and add the ghee. Once the ghee has melted, add the shallots, cook for 2–3 minutes, then add the carrots, minced shiitake mushrooms, fennel, garlic, and white pepper, and cook for 10 minutes or until the vegetables have softened.

5 Stir in the toasted barley, making sure all the grains are well coated in the vegetable juices. Add a ladle of the hot stock and stir constantly until it is absorbed, then repeat with more stock. After 10 minutes of cooking, stir in the chestnut purée, and after 25 minutes, add the white wine. Cook for a further 5–15 minutes, or until the barley is cooked through, but still al dente (slightly firm to the bite). Remove from the heat and serve with a green salad.

LAMB CASSEROLE WITH VEGETABLES

 HELPS COMBAT FATIGUE **HELPS COMBAT ANEMIA** **SUPPORTS HEALTHY KIDNEY FUNCTION**

If you need help overcoming exhaustion, this recipe is a tonic for the whole body. Lamb meat is traditionally considered a blood-nourishing and stimulating food, and it also helps to strengthen the kidneys, alleviating numbness in the lower limbs and relieving lower backache and other signs of kidney deficiency. Slowly cooking this dish in a low oven enhances its tonifying quality.

SERVES 6

4 tomatoes

1 tbsp ghee or clarified butter

2¼lb (1kg) boneless lamb shoulder, diced

1 tbsp all-purpose flour, seasoned with a little salt

8 small shallots, diced

1 small red chile, seeded and cut into strips

1 tsp coriander seeds, crushed

1 tsp paprika powder

1 medium white cabbage, core removed, and cut into 8 segments

3 bay leaves

6 garlic cloves, with skins on

3 medium potatoes, peeled and quartered

2 medium carrots, peeled and diced

1 fennel bulb, core removed, and cut into 6 segments (optional)

½ tsp white peppercorns

1 Preheat the oven to 325°F (160°C). Cut a cross in the top of each tomato, dip in boiling water for 20 seconds, remove, and when cool enough to handle, remove the skin. Finely chop the flesh, then set aside.

2 Heat the ghee in a Dutch oven over high heat. Toss the lamb in the seasoned flour and add a few pieces at a time to the hot ghee. Brown on all sides, then remove and set aside. Repeat with the rest of the meat. Reduce the heat, add the shallots, and cook for 2–3 minutes, or until they turn translucent. Add the chile, coriander seeds, and paprika and cook for 1–2 minutes, or until they release their aromas. Return the meat with the tomatoes to the Dutch oven and stir well to mop up the spices.

3 Nestle half the cabbage segments in between the meat, then add 2 of the bay leaves and half the garlic, potatoes, carrots, and fennel, followed by a second layer of cabbage and the rest of the vegetables. Add the final bay leaf and sprinkle in the peppercorns.

4 Add 1¼ cups water to the Dutch oven. Cover and bake in the oven for 1½–2 hours. Once cooked, allow to rest for 10 minutes, then spoon onto 4 serving plates, ensuring everybody gets enough meat and a helping of vegetables. Spoon some of the juices onto each portion to serve.

***Fennel** (p79) contributes to the kidney-toning effect of this recipe with its gentle diuretic properties.*

Vegetable Moussaka

 HELPS STRENGTHEN THE IMMUNE SYSTEM **HELPS EASE CONSTIPATION** 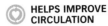 **HELPS IMPROVE CIRCULATION**

This layered vegetable dish is full of flavor and health benefits. The combination of ingredients supports immune health, helps relieve constipation, and improves blood circulation. If you are vegan, omit the creamy topping and marinate 1½–2 cups of walnuts in 2 tablespoons of tamari soy sauce instead and scatter over the moussaka before the final stage of baking.

SERVES 6

4 medium-sized red bell peppers, halved and seeded

2 tbsp olive oil, plus extra for greasing

14oz (400g) sweet potato, peeled and thinly sliced lengthwise

1 tsp smoked paprika

salt and freshly ground black pepper

2 medium eggplant, thinly sliced lengthwise

4 garlic cloves, crushed

4 medium yellow zucchini thinly sliced lengthwise

3 tbsp chopped parsley leaves

14oz (400g) tomatoes

8 shallots, minced

¼ cup chopped basil leaves

1 large egg, beaten

2 tbsp sour cream

¾ cup home-made kefir cheese (p332), or store-bought organic ricotta cheese

1 Preheat the oven to 400°F (200°C). Place the peppers on a lightly greased baking sheet and bake for 20–25 minutes or until their skins blister and begin to blacken. Remove from the oven, transfer to a bowl, cover with plastic wrap, and set aside to sweat and cool. When cool enough to handle, peel their skins off.

2 Heat the broiler to medium-hot. Broil the sweet potato slices on both sides until golden, then transfer to a bowl, add the smoked paprika and some seasoning, mix, and set aside.

3 Broil the eggplant slices on both sides, then transfer to a bowl and add 2 of the crushed garlic cloves, mix together, and set aside to infuse. Broil the zucchini slices on both sides, transfer to a separate bowl, add the parsley, mix well, and set aside.

4 Cut a cross in the top of each tomato, dip in boiling water for 20 seconds, remove, and when cold enough to handle, peel off and discard the skin. Finely chop the flesh.

5 To prepare the sauce, heat 2 tablespoons of olive oil in a saucepan over medium heat, add the shallots, and cook until they turn translucent. Add the remaining 2 garlic cloves, the tomatoes, and ¼ cup water, and cook for 15 minutes. Add salt and black pepper to taste, stir in the basil leaves, then remove the pan from the heat.

6 Arrange the seasoned sweet potato slices in an even layer in the bottom of a square baking dish. Spread a thin layer of the sauce over them and arrange the zucchini slices on top, making sure you include all the chopped parsley. Spread another thin layer of sauce over the zucchini, followed by a layer of red peppers. Repeat with another thin layer of sauce, followed by the eggplant. Pour the rest of the sauce on top and bake in the oven for 30–40 minutes.

7 Meanwhile, combine the beaten egg, sour cream, kefir cheese or ricotta, and seasoning in a bowl to make a creamy sauce. Remove the vegetable dish from the oven, pour the white sauce over the vegetables, return to the oven, and bake for a further 20 minutes. The moussaka is cooked when the edges are bubbling and the surface is golden. Cut into 6 squares and serve with a salad on the side.

GRILLED SARDINES WITH TOMATO SALSA

 HELPS IMPROVE CIRCULATION

 SUPPLIES OXYGEN TO CELLS

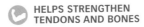 **HELPS STRENGTHEN TENDONS AND BONES**

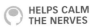 **HELPS CALM THE NERVES**

Salty-sweet sardines boost circulation and help build red blood cells, which in turn increase the flow of oxygen around the body, and strengthen tendons and bones. Here, they are cooked with flavorsome ingredients including basil, which has a soothing and supporting action on the mind and cognitive processes, and rosemary, which has anti-inflammatory properties.

SERVES 4

6–8 large sprigs of rosemary

8 fresh sardines

1–2 tbsp olive oil

sea salt and freshly ground black pepper

1–2 lemons, cut into quarters, to serve

For the salsa

8 tomatoes, skinned, seeded, and finely diced

1 red chile, seeded and minced

3 scallions, finely chopped

2 tbsp chopped basil leaves

1 garlic clove, finely chopped (optional)

2 tbsp raspberry vinegar, or red wine vinegar

¼ cup olive oil

sea salt and freshly ground black pepper

1 To make the tomato salsa, combine all the ingredients together well in a bowl and season to taste.

2 Preheat the broiler to medium. Arrange the large rosemary sprigs on a broiler pan and lay the sardines on top. Drizzle with the olive oil and season with sea salt and black pepper.

3 Broil the sardines for 3–5 minutes on each side, or until cooked (they should be opaque, but still firm).

4 Divide the sardines and salsa among 4 serving plates, place 1–2 lemon quarters on each plate, and serve with a green salad and boiled new potatoes.

Rosemary *(p101) is rich in the compound borneol, which acts as an energizing tonic for the nervous system.*

BROILED MACKEREL WITH CHARD

 PROTECTS THE HEART AND BLOOD VESSELS **HELPS FIGHT INFLAMMATION** **HELPS BALANCE BLOOD SUGAR LEVELS** **HELPS BUILD STRONG BONES**

Mackerel is beneficial for cardiovascular health, and here it is combined with Swiss chard, which is known for its anti-inflammatory, antioxidant, and detoxifying properties. In addition, Swiss chard helps balance blood sugar levels, protect the body from chronic oxidative stress, and support bone health. Choose young leaves with narrow stems for an even cooking time.

SERVES 4

4 whole mackerel, filleted

2 celery stalks, chopped

2 garlic cloves, chopped, plus 2 garlic cloves, crushed

1 chile, seeded and chopped

a bunch of parsley leaves, roughly chopped

juice of 1 lemon

2 tbsp olive oil

1lb 2oz (500g) Swiss chard, chopped, with stems removed and finely chopped

1 tbsp blackberry vinegar (p334) or the juice of ½ lemon

salt and freshly ground black pepper

For the dressing

juice of 1 lemon

2 tbsp teriyaki sauce

1 tsp finely grated fresh ginger

2 tbsp olive oil

1 tsp honey

salt and freshly ground black pepper

1 With a sharp knife, make several diagonal scores through the skin along the length of each mackerel fillet to stop them from curling up while being broiled. Place the fillets in a shallow dish.

2 Place the celery, chopped garlic, chile, parsley, and lemon juice in a blender or food processor, add ½ cup water, and blend. Pour this marinade over the mackerel fillets, ensuring they are thoroughly coated, and set aside to marinate for 1 hour. Meanwhile, prepare the dressing by blending all the ingredients together.

3 Heat the broiler to high. Remove the mackerel from the marinade and place the fillets, skin-side up, on the broiler pan. Cook for 4–5 minutes or until the skin is crisp and the flesh is cooked through and flakes when tested with a fork.

4 Meanwhile, heat the olive oil and ¼ cup water in a large heavy saucepan over medium heat. Add the 2 crushed garlic cloves and chard leaves and stems, and stir thoroughly. Cook until the leaves wilt, then sprinkle with blackberry vinegar and remove from the heat. Add seasoning to taste and a dash more of the vinegar, if you like.

5 Transfer the mackerel fillets to 4 warm serving plates, pour the dressing over each portion, and place a serving of chard beside it.

Mackerel (p128) *is abundant in healthy fats and nutrients that help support the cardiovascular and nervous systems.*

Yellow wax Bean Stew

 AIDS HEALTHY DIGESTION

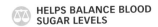 **HELPS BALANCE BLOOD SUGAR LEVELS**

 HAS A DIURETIC ACTION

This blend of vegetables enhances digestion, balances blood sugar levels, and helps remove excess fluid from the body. Fresh beans also have a diuretic effect. Tender, golden-yellow, wax beans are best for this recipe, although any fresh beans will taste good. Look for young, succulent beans that aren't stringy and snap easily if you bend them in half.

SERVES 4

2 large tomatoes

2 large potatoes, peeled and diced

2 tbsp olive oil

1 onion, finely chopped

2 carrots, sliced into thin rounds

1 chile, seeded and minced (optional)

1¾lb (800g) tender, yellow wax beans, trimmed and sliced into 1¼in (3cm) pieces

3 garlic cloves, chopped

salt and freshly ground black pepper

1 tbsp chopped dill leaves, plus a few extra leaves to garnish

1 Cut a cross on the top of each tomato, dip in boiling water for 20 seconds, remove, and when cool enough to handle, peel off the skin and finely chop the flesh.

2 Place the potatoes in a saucepan, cover with cold water, bring to a boil, reduce the heat, and simmer until the potatoes are cooked.

3 Meanwhile, heat the olive oil in a large frying pan with a lid over medium heat. Add the onion and sauté until soft and translucent. Add the carrots and chile (if using), stir, and sauté for 2–3 minutes. Stir in the beans, then lower the heat, cover, and let the beans sweat for 1–2 minutes. Add the garlic and tomatoes and allow them to cook in the vegetable juices for 2–3 minutes. Add 1–2 tablespoons of water if the vegetables are beginning to stick to the bottom of the pan.

4 When the beans are al dente (cooked, but still slightly crunchy), add the cooked potatoes and a small amount of their cooking water. Add some seasoning and the dill, combine with the other ingredients, and cook for a further 2–3 minutes. Remove from the heat, transfer to 4 serving bowls, and garnish with dill leaves.

Red tomatoes (p65) enhance the cleansing effect of this recipe and are a good source of heart-friendly lycopene.

MEDITERRANEAN VEGETABLE MEDLEY

 HELPS STRENGTHEN THE IMMUNE SYSTEM　　 **HELPS IMPROVE CIRCULATION**　　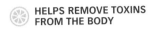 **HELPS REMOVE TOXINS FROM THE BODY**

This summer dish is full of vegetables with antioxidant and anti-inflammatory phytonutrients that help protect the body at a cellular level. Try to cut the peppers, eggplant, and tomatoes the same size to improve the appearance and cooking time of this simple dish. The zucchini is best left in larger cubes. It cooks quickly and its nutrients can be lost if overcooked.

SERVES 4

1 tbsp olive oil

4 shallots, minced

salt and freshly ground black pepper

a pinch of oregano or marjoram

2 red bell peppers, seeded and chopped

2 yellow bell peppers, seeded and chopped

1 medium eggplant, chopped

1 medium zucchini, chopped

4 tomatoes, skinned (optional), and chopped

2 garlic cloves, crushed

2 tbsp olive oil

¼ cup finely chopped parsley leaves, plus leaves to garnish

1 Heat the olive oil in a large, heavy saucepan over medium to low heat. Add the shallots and a pinch of salt, and stir until the shallots begin to turn translucent. Add a dash of water to bring the temperature down and to add moisture to the pan. After 2–3 minutes add the oregano or marjoram and the peppers. Cook until the peppers have softened.

2 Add the eggplant and the zucchini, and when the liquid in the pan has reduced, add the tomatoes. Let the mixture simmer for 15 minutes over low heat, taking care not to let the vegetables stick to the bottom of the pan and burn.

3 Add the garlic and a little more olive oil for added flavor and cook for a further 5 minutes. Stir in the chopped parsley and season with salt and black pepper to taste. Serve on a bed of brown basmati rice with some parsley scattered on top.

Eggplants (p64) have the ability to help remove harmful toxins from the body.

VENISON CASSEROLE WITH CRANBERRIES

 HELPS RELEASE CELLULAR ENERGY **HELPS INCREASE LIBIDO** **STRENGTHENS THE REPRODUCTIVE SYSTEM** **FIGHTS URINARY TRACT INFECTIONS**

Colder months are the time for this warming venison stew, best eaten at lunchtime to benefit from its energizing properties; iron-rich venison is traditionally eaten to help combat fatigue, as well as impotence and infertility. Cranberries are both astringent and antibacterial, and are commonly used to help prevent infections in the urinary tract, kidneys, and bladder.

SERVES 6

1 tbsp vegetable oil

2¼lb (1kg) lean venison shoulder, chopped into 1in (2.5cm) cubes

2 tbsp all-purpose flour, seasoned

1 tsp whole coriander seeds, coarsely crushed

7oz (200g) small shallots, quartered

3½oz (100g) crimini or brown button mushrooms, sliced

¼ cup dried apricots (without sulfur), roughly chopped

1 cup fresh or frozen cranberries

3 kaffir lime leaves

1 tbsp cacao nibs or dark chocolate (optional)

1½ cups red wine

salt and freshly ground black pepper

1 Preheat the oven to 350°F (180°C). Heat the vegetable oil in a Dutch oven on medium-high heat. Toss the venison cubes in the flour and brown in the pan in small batches. Set aside the browned meat, reduce the heat, and add the coriander seeds, followed by the shallots and mushrooms, to brown. Add a little water if necessary.

2 Add the apricots and gently stir them in. Return the meat to the Dutch oven together with all the juices, and add the cranberries and kaffir lime leaves. Stir in the cacao nibs and red wine. Stir everything thoroughly, cover, and place in the oven.

3 Let the stew cook for 1–1½ hours or until the meat is tender and the juices have thickened. Remove the kaffir lime leaves, add salt and black pepper to taste, and serve with boiled rice.

TIP: If you can't find fresh or frozen cranberries, substitute with ¾ cup fresh blueberries and ½ cup of dried cranberries instead.

MARINATED DUCK WITH MANGO SALSA

 HELPS MAINTAIN ENERGY LEVELS　　 **HAS A DIURETIC ACTION**　　 **SOOTHES AND TONES THE DIGESTIVE TRACT**　　**ENHANCES SPERM QUALITY**

Duck meat is considered an empowering food in traditional Chinese medicine: it provides the body with energy and helps to increase stamina levels. Its diuretic properties help to reduce water retention and, coupled with a sweet and sour mango salsa, it benefits the digestive system and can help to alleviate nausea. It is also thought to boost men's sperm count.

SERVES 4

3 kaffir lime leaves

1 tsp honey

zest of 1 orange and juice of 2 oranges

1 tbsp tamari soy sauce

¼ tsp five-spice powder

4 duck breasts, without skin

¾ cup jasmine rice

4 fresh figs (optional) to garnish

For the mango salsa

2 medium mangoes, peeled, seeded, and diced

3 scallions, finely chopped

1 small green chile pepper, seeded and minced

1 small red chile pepper, seeded and minced

¼ cup chopped cilantro leaves

3 tbsp chopped basil leaves

1 small cucumber, seeded and finely diced

1 large tomato, seeded and finely diced

1 tbsp balsamic vinegar

2 tbsp extra virgin olive oil

salt and freshly ground black pepper

1 Place the kaffir lime leaves in a large mixing bowl, cover with ¼ cup boiling water, and leave to infuse for 15 minutes. Add the honey and stir until it dissolves. Add the orange zest and juice, tamari soy sauce, and five-spice powder and blend well. Immerse the duck breasts in the marinade to ensure they are well coated. Let marinate for 30 minutes.

2 Meanwhile, bring a medium saucepan of water to a boil and cook the jasmine rice following package directions.

3 Heat a heavy skillet over high heat. Remove the duck breasts from the marinade and transfer them to the pan to brown on both sides. Lower the heat, strain the marinade juices, and add them to the pan. Cook the duck breasts for a further 5–6 minutes, turning them frequently so they don't stick to the bottom of the pan or burn. Test to see how well cooked the meat is by carefully cutting into the center of the breast with a sharp knife. The center of the meat should still be pink after this time, so let it cook for a little longer if you prefer it well done. Remove the pan from the heat and set aside briefly. Make 2 deep cuts at right angles in the top of each fig, if using, and open out the 4 tips to create a flower-petal effect.

4 Transfer the duck breasts from the pan to a cutting board and slice diagonally into thin slices. Add all the mango salsa ingredients to the pan with the marinade juices and stir to mix and warm through. To assemble the dish, place a cook's ring in the center of each serving plate, half-fill with cooked jasmine rice, top off with some of the warm mango salsa, and carefully remove the ring. Arrange a sliced duck breast on each portion, position a fig "flower" on top of the duck, and serve.

SALMON WITH DILL AND TAMARI SAUCE

 HELPS MAINTAIN ENERGY LEVELS

 EASY TO DIGEST

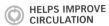 HELPS IMPROVE CIRCULATION

This simply baked salmon dish is paired with fresh dill for a classic combination of flavors. Salmon is considered a good food to eat if you are feeling debilitated or are recovering after an illness, because it helps improve energy levels and is easily digested. It is also rich in omega-3 fatty acids and selenium, which promote heart health and support healthy aging.

SERVES 4

4 salmon fillets, approximately 10oz (300g) each

¼ cup tamari soy sauce

a generous dash of lemon juice

¼ cup olive oil

4 garlic cloves, minced

4 thin slices of lemon

2 tbsp chopped dill leaves

1 Preheat the oven to 350°F (180°C). Place the salmon fillets in a ceramic baking dish. Blend the tamari soy sauce, lemon juice, olive oil, and a dash of water in a small bowl, add the garlic, combine the ingredients together well, and pour over the fish.

2 Arrange the lemon slices on top of the fish and sprinkle with the dill. Cover with foil and bake for 20–25 minutes. Carefully insert a sharp knife into the center of one fillet to check if the fish is cooked; the flesh should be opaque. Serve either hot or cold.

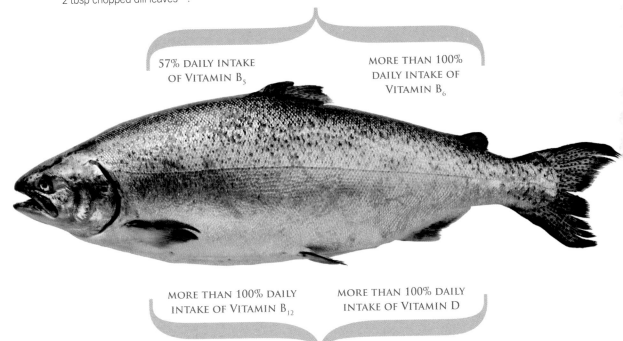

57% DAILY INTAKE OF VITAMIN B_5

MORE THAN 100% DAILY INTAKE OF VITAMIN B_6

MORE THAN 100% DAILY INTAKE OF VITAMIN B_{12}

MORE THAN 100% DAILY INTAKE OF VITAMIN D

BOOST YOUR VITAMIN INTAKE

EACH LARGE SALMON FILLET PROVIDES EXCELLENT QUANTITIES OF VITAMIN D AND AN ARRAY OF KEY B VITAMINS.

CHANTERELLES AND CHILES WITH PASTA

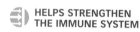 **HELPS STRENGTHEN THE IMMUNE SYSTEM**

 PROMOTES HEALTHY SKIN

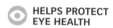 **HELPS PROTECT EYE HEALTH**

Like many mushrooms, chanterelles are rich in the amino acids that are essential for building protein in the body. They also contain vitamin A and so benefit eye health. Kamut is an ancient grain closely related to modern wheat. Even though it contains gluten, it has been found to be more easily digestible for people with allergies or intolerances to wheat.

SERVES 4

14oz (400g) fresh chanterelle mushrooms, sliced

4 tsp olive oil

2–3 garlic cloves, crushed

1–2 small chiles, seeded and finely chopped

⅓ cup sour cream

salt and freshly ground black pepper

1lb 2oz (500g) pasta, such as tagliatelle or spaghetti, made from kamut wheat

1 tbsp finely chopped flat-leaf parsley leaves, to garnish

1 Place the mushrooms in a medium saucepan and dry-fry them over low heat, shaking the pan gently, until their juices run. Then, turn the heat up so the liquid evaporates and the mushrooms are soft, but reasonably dry. Add 3 teaspoons of the olive oil to coat the mushrooms, then add the garlic, chiles, and sour cream. Let the mixture simmer over low heat for 2–6 minutes. Season with salt and black pepper.

2 Meanwhile, cook the pasta following package directions until it is al dente, adding the last teaspoon of olive oil to the cooking water to prevent it from boiling over and to enhance the flavor of the pasta. Drain and transfer to a warmed serving dish. Spoon the sauce over the pasta, garnish with the parsley, toss the ingredients well to combine, and serve with a green salad.

Chanterelle mushrooms (p91)
contain vitamins D and K, which work together to protect the heart and bones.

SAVOY CABBAGE PARCELS

 HELPS MAINTAIN ENERGY LEVELS

 HELPS BUILD MUSCLE

 ENHANCES VIGOR

 CALMING AND COMFORTING

This dish is great comfort food, but it is also packed with healthy ingredients that boost energy levels. It is a good choice for men of all ages, because quinoa provides protein and essential amino acids that help the body build muscle, while walnuts can help improve men's fertility and are heart-healthy. This also makes an ideal complete meal for vegetarians and vegans.

SERVES 4

1¾ cups quinoa

½ cup walnuts, roughly chopped

⅓ cup sun-dried tomatoes, chopped

2 garlic cloves, minced

1 medium red onion, finely chopped

4 small shallots, finely chopped

scant ½ cup chopped parsley

¾ cup fresh or dried unsweetened cranberries

2 tsp ground allspice

½ tsp ground coriander

2 level tsp Italian herbs seasoning

Himalayan salt and freshly ground black pepper

1 large Savoy cabbage, leaves removed

4 bay leaves

2 tsp all-purpose flour, arrowroot, or kudzu (a popular Asian thickener)

thick plain yogurt, to serve

1 To make the stuffing, wash the quinoa grains, allow to drip-dry in a sieve, then add to a mixing bowl along with the walnuts, tomatoes, garlic, onion, shallots, parsley, and cranberries. Season with the allspice, ground coriander, Italian seasoning, and salt and black pepper. Stir to combine all the ingredients thoroughly.

2 Choose 10–12 tender medium-sized cabbage leaves and blanch in boiling water for 1–2 minutes, removing them as soon as they wilt. Reserve the cabbage cooking water. Allow the leaves to cool for a moment, then cut away the thick vein at the back of each leaf.

3 Place a spoonful of stuffing in the center of a cabbage leaf. Fold in the sides of the leaf and roll it up to form a closed parcel. Repeat with the rest of the stuffing and cabbage leaves.

4 Tightly arrange the parcels, loose ends facing down, in the bottom of a medium saucepan with a lid. Layer the parcels if necessary, adding the bay leaves as you work.

5 Add the reserved cabbage water to the pan, making sure that the bottom of the pan is covered but that the parcels are only partially covered with liquid. Bring to a boil, reduce the heat, cover, and simmer gently for 30 minutes.

6 Dissolve the flour in a little water in a bowl and whisk it into the pan. Simmer for another 15 minutes, or until the sauce has thickened and the parcels are cooked. Serve accompanied with a spoonful of thick yogurt.

Savoy cabbage (p52) *is a source of sulfur, essential for healthy bones, cartilage, tendons, and skin.*

SAUERKRAUT PARCELS

 PROMOTES A HEALTHY DIGESTIVE TRACT **CALMING AND COMFORTING**

Fermented cabbage, or sauerkraut, is rich in vitamin C and contains a type of lactic acid that aids digestion by clearing harmful bacteria and combating toxins, food stagnation, and wind. Some nutritionists also maintain that it is an effective preventive food for cancer and degenerative diseases. Whole sauerkraut leaves can sometimes be found in Polish or Italian delicatessens.

SERVES 4

salt and freshly ground black pepper

2 tbsp wine vinegar

6 black peppercorns

16 whole sauerkraut leaves, or large cabbage leaves, stem and leaf veins removed

1 tbsp olive oil

2 medium onions, finely diced

3 garlic cloves, crushed

1lb 2oz (500g) ground meat (pork, beef, or a mixture of the two)

⅔ cup white or brown rice, rinsed

2 tsp paprika

2 tbsp chopped flat-leaf parsley leaves

1½ cups sauerkraut

7oz (200g) smoked rib of pork or smoked bacon, chopped

For the sauce

1 tbsp olive oil

3 tsp all-purpose flour

a pinch of salt

a few black peppercorns

2 tbsp tomato paste

1 small chile, seeded and minced

1 cup crème fraîche

1 If using fresh cabbage leaves instead of the whole fermented sauerkraut leaves, bring a large saucepan of water to a boil and add a pinch of salt, the wine vinegar, and black peppercorns. Place the leaves into the water, 2 at a time, and blanch for 2–3 minutes. Watch them carefully and remove as soon as they begin to wilt. Set aside to dry on paper towels.

2 Heat the olive oil in a skillet and sauté the onions and garlic until soft and translucent. Add the ground meat and cook for 10–15 minutes, or until it is lightly browned. Add the rice, paprika, and parsley, stirring well for 2–3 minutes. Remove from the heat and set aside until cool enough to handle.

3 Place a ball of the stuffing in the center of a sauerkraut or cabbage leaf. Fold in the sides of the leaf and roll it up to form a closed parcel. Repeat with the rest of the stuffing and cabbage leaves.

4 Arrange a layer of sauerkraut in the bottom of a large saucepan with a lid, followed by the cabbage parcels, loose ends facing down, and topped with the smoked pork or bacon. Carefully add hot water to the pan until it half-covers the contents of the pan. If necessary, weigh the parcels down with a small heatproof plate. Cover and simmer over low heat for 2 hours, or until cooked, making sure the water doesn't evaporate. The water should remain at the same level, half-covering the contents of the pan, throughout the cooking time.

5 Meanwhile, make the sauce. Heat the olive oil in a small saucepan, add the flour, and allow to brown slightly, then add the salt, black peppercorns, tomato paste, chile, crème fraîche, and enough water to make a sauce with the consistency of light cream. When the sauerkraut parcels are cooked, divide between 4 serving plates and pour some of the hot sauce over each portion.

TIP: Try making your own sauerkraut leaves by using the recipe on p330.

QUINOA AND VEGETABLE STACK

 HELPS MAINTAIN ENERGY LEVELS

 SUPPORTS TISSUE GROWTH AND REPAIR

 EASY TO DIGEST AND GLUTEN FREE

 HELPS STRENGTHEN THE IMMUNE SYSTEM

High in protein and fiber, quinoa contains all the essential amino acids the body needs to sustain energy levels and support healthy tissue growth and repair. It is also gluten free, which makes it a good choice for anyone with gluten sensitivity. The sauerkraut brings multiple benefits for immunity and gut health and a selection of colorful fresh vegetables add valuable nutrients.

SERVES 4

5 small shallots or small red onions, finely sliced

1 medium-hot chile, minced

2 large red Romano peppers, or other red bell pepper, halved lengthwise, seeded, and sliced into ½in (1cm) strips

3 medium yellow squash, cut into ¼in (5mm) slices

3½oz (100g) shiitake mushrooms, stalks removed, sliced

2 garlic cloves, crushed

sea salt and freshly ground black pepper

2 tbsp olive oil

1¾ cups quinoa

a sprig of parsley, chopped, to garnish

a drizzle of extra virgin olive oil

½ cup sauerkraut, to serve (optional)

1 Pour in enough water to cover the bottom of a medium saucepan. Add the shallots and cook gently over low heat with the lid on until tender, adding more water if necessary. Add the chile and sauté gently. Add the peppers and let soften, then add the squash. Finally, add the shiitake mushrooms and garlic, season to taste with a pinch of sea salt, stir for a minute, and drizzle in the olive oil. Stir the mixture, replace the lid, then turn off the heat and leave the pan on the stove top to keep warm.

2 Cook the quinoa following package directions, drain, and set aside.

3 When you are ready to serve the food, take a serving dish, place a large cook's ring on it, and fill with a 1in (2.5cm) layer of the quinoa. Spoon a layer of vegetables on top of the quinoa and scatter with some chopped parsley. Remove the ring and repeat with 3 more stacks of quinoa, vegetables, and parsley. Season the stacks with black pepper and a drizzle of extra virgin olive oil, and serve with some sauerkraut arranged around the base of the stacks.

4 If you don't have a cook's ring, use a dome-shaped small bowl brushed with olive oil. Fill the bottom half of the bowl with the vegetables, top with quinoa, place the serving dish face down on the bowl, turn both upside down, and gently remove the bowl. Scatter with the parsley, season, drizzle with the extra virgin olive oil, and serve with the sauerkraut.

GINGER CHICKEN

 PROTECTS AGAINST COLDS AND FLU

 AIDS HEALTHY DIGESTION

 SUPPLIES OXYGEN TO CELLS

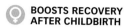 **BOOSTS RECOVERY AFTER CHILDBIRTH**

The marinade in this chicken dish contains fresh ginger, which is one of the most important foods for helping prevent and treat common colds. Its warming nature is enhanced here with lime, garlic, and honey—all known to help boost the immune system. This dish is ideal if you need to increase your resistance to seasonal bugs or build your strength after an illness.

SERVES 4

1 organic free-range chicken, approximately 3¼lb (1.5kg), cut into 8 pieces

1 tbsp ghee or clarified butter

2¼lb (1kg) potatoes, peeled and thinly sliced

½–1 tsp salt

1 tbsp paprika

½ tsp freshly ground black pepper

For the marinade

¼ cup tamari soy sauce

1 heaped tbsp finely chopped fresh ginger

3–5 garlic cloves, crushed

zest and juice of 1–2 limes

3 tbsp honey

1 Prepare the marinade by mixing the tamari soy sauce, ginger, garlic, lime juice, and honey in a large plastic container with a lid. Add the chicken pieces and marinate for 8–12 hours or overnight in the refrigerator.

2 Preheat the oven to 425°F (220°C). Grease a large ovenproof dish with the ghee. Arrange the sliced potatoes in thin layers in the dish and sprinkle with salt, paprika, and black pepper. Place the chicken pieces on top of the potatoes. Pour any remaining marinade on top and season with a little more salt and black pepper. Bake in the oven for 45–50 minutes, or until the chicken juices run clear when the meat is pierced with a sharp knife, and the potatoes are cooked. Serve with a salad.

Ghee (p120) is a good source of lauric acid, a healthy fat with antibacterial and antifungal properties.

SQUAB BREASTS WITH GOJI BERRIES

 HELPS MAINTAIN ENERGY LEVELS

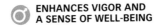 **ENHANCES VIGOR AND A SENSE OF WELL-BEING**

 REPLACES IRON LOST IN MENSTRUATION

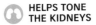 **HELPS TONE THE KIDNEYS**

Squab meat is lean, tender, and nutritious. In China, it is regarded as an excellent kidney tonic, but it is most commonly eaten to help combat male and female infertility by boosting blood circulation and improving energy levels. It also helps build iron levels after substantial blood loss, such as at childbirth or heavy menstruation. Goji berries are added to give a metabolic boost.

SERVES 4

4 whole squab

scant 1oz (25g) dried shiitake mushrooms

2 medium carrots, halved lengthwise

1 medium onion, peeled and quartered

1 medium red chile, whole

4 garlic cloves in their skins

½ tsp black peppercorns

a pinch of salt

4 tsp cornstarch

2½ tbsp goji berries

a dash of olive oil

cilantro leaves, chopped, to garnish

1 Remove the breast meat in whole pieces from each bird and reserve. Place the filleted birds in a large Dutch oven and add the mushrooms, carrots, onion, chile, garlic, black peppercorns, and salt. Pour in just enough water to cover, bring it to a boil, and simmer over low heat for 1½ hours, skimming off any impurities from the top of the stock as necessary. Watch the liquid level and add more water if needed. Toward the end of the cooking time, you should have approximately 2 cups or more of stock remaining.

2 Strain the stock, reserving the cooking liquid, shiitake mushrooms, garlic cloves, and some of the peppercorns. Discard the rest of the ingredients, including the squab meat, bones, and skin. Shred the mushrooms and squeeze the softened garlic cloves from their skins. Set the garlic paste aside.

3 Return the stock to the Dutch oven, reserving ¼ cup in a bowl, and set over medium-high heat. Thicken the liquid by mixing the cornstarch with the reserved stock in the bowl and adding it to the pot. Add the goji berries, shredded mushrooms, and the garlic paste and simmer the stock for 10–20 minutes until it thickens to the consistency of heavy cream. Adjust the seasoning if required.

4 Add a dash of olive oil to a skillet and warm over medium heat. Add the reserved squab breasts and pan-fry for 2 minutes on each side until just cooked through. Transfer to the Dutch oven and cook for 2–3 minutes.

5 Arrange the breasts on a warm serving plate, spoon over a little of the sauce, and garnish with the cilantro leaves. Serve with the remaining sauce and some boiled rice.

Goji berries (p36) are rich in pyridoxine (vitamin B₆), which supports efficient metabolism.

STIR-FRIED SPRING VEGETABLES

 FEEDS GOOD BACTERIA IN THE GUT **HELPS FIGHT INFLAMMATION** **HELPS LOWER BLOOD PRESSURE** **HELPS BALANCE BLOOD SUGAR LEVELS**

Eating plenty of fresh, young, green vegetables in spring is a good way to cleanse the body after the dark days of winter. Asparagus stimulates the digestion by acting as a prebiotic. It also contains compounds that have an anti-inflammatory effect, so it is beneficial if you have high blood pressure and blood sugar imbalance. Young mint and chives gently invigorate the body.

SERVES 4

2 tbsp olive oil

¾lb (350g) asparagus, cut into 2in (5cm) pieces

9oz (250g) snow peas

5½oz (150g) wild garlic leaves, chopped

7oz (200g) small spinach leaves

1 tbsp raspberry vinegar

2 tbsp chopped mint leaves

2 tbsp finely chopped chives

1 Heat the olive oil and a dash of water in a wok over high heat. Add the asparagus and snow peas and stir-fry for 3 minutes, then add the wild garlic leaves and spinach and stir until they wilt.

2 Remove the wok from the heat and add the raspberry vinegar, mint, and chives. Combine and serve while hot with steamed rice or quinoa.

Asparagus (p77) contains antioxidants that help fight free-radical damage and has a mild laxative effect—perfect for a spring detox.

MARINATED TOFU WITH SHIITAKE AND NOODLES

 HELPS FIGHT INFLAMMATION　　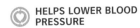 **HELPS REMOVE TOXINS FROM THE BODY**　　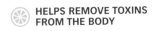 **HELPS LOWER BLOOD PRESSURE**

Soy is a traditional remedy for inflammatory conditions of the lungs and gut. Its phytoestrogens (plant hormones) can also help protect the heart and lower blood pressure. In small amounts, unfermented soy can help neutralize toxins in the body—helpful if you have a hangover—though high, regular consumption can lower the absorption of some minerals in food.

SERVES 6

10oz (300g) organic tofu, cut into bite-sized cubes

¼ cup sunflower oil

a pinch of salt

approximately 10oz (300g) medium noodles (egg or rice) for 6 people

10oz (300g) fresh shiitake mushrooms, halved or quartered

1 carrot, julienned

9oz (250g) mung bean sprouts, rinsed and drained

9oz (250g) snow peas, cut in half

3½oz (100g) baby corn, halved

1–2 tbsp tamari soy sauce

1 tbsp black sesame seeds

a small handful of cilantro leaves, chopped, to garnish

For the marinade

3 garlic cloves, crushed

1½in (3cm) piece fresh ginger, grated

1 small chile, seeded and minced

3 tbsp mirin sauce

2 tbsp toasted sesame oil

3 tbsp teriyaki sauce

3 small shallots, finely sliced

1 Arrange the tofu in a flat dish. Mix together the marinade ingredients and pour over the tofu cubes, making sure they are thoroughly coated. Cover the dish and let marinate overnight in the refrigerator. Turn the cubes over at some point to allow the flavors to infuse completely.

2 Remove the tofu cubes from the marinade and drain for a moment to let the juices drip away. Reserve the marinade.

3 Heat 2 tablespoons of the sunflower oil with 2 tablespoons of water in a wok over medium heat. Add the tofu cubes and fry until lightly browned on all sides, turning them gently so they don't break. Remove from the wok and transfer to a warm dish.

4 Meanwhile, bring a large saucepan of water to a boil, add a pinch of salt, and cook the noodles following package directions. Drain the noodles and rinse in cold water to stop them from cooking any more.

5 Scrape off any burned remnants of tofu in the bottom of the wok and add another tablespoon each of sunflower oil and water. Add the shiitake mushrooms and stir-fry for 2–3 minutes, then transfer to a warm dish. Add the carrot, mung bean sprouts, snow peas, baby corn, and tamari soy sauce, and stir-fry briefly. Then transfer to the warm dish of mushrooms.

6 Wipe the wok down again, and heat the last tablespoon of oil. Add the reserved marinade, let it heat through, then add the cooked noodles and stir-fry them briefly. Return all the vegetables to the wok and mix them into the noodles. Add the tofu and mix it in gently. Sprinkle the black sesame seeds on top, then transfer to 6 warmed noodle bowls. Scatter each portion with the chopped cilantro leaves to serve.

Mung beans (p115) *produce the thick, juicy sprouts that are popular in Asian cuisine. They are renowned for their detoxifying properties.*

VEGETABLE HOT POT

 PROMOTES A SENSE OF WELL-BEING

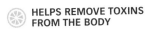 **HELPS REMOVE TOXINS FROM THE BODY**

 HELPS FIGHT INFLAMMATION

 AIDS OPTIMAL DIGESTIVE HEALTH

Dishes such as this medley of vegetables and spices, cooked slowly over low heat, are warming, sustaining, and uplifting for the mind and body. Sweet potato helps remove toxins and calm inflammation, while cabbage and garlic are antiparasitic and help improve digestion. The art of this dish lies in carefully layering the ingredients, so each diner receives a little of all the vegetables.

SERVES 4–6

5½oz (150g) shallots, quartered

1 tbsp ghee or clarified butter

¾ cup vegetable stock

½ cup dry white wine

1lb 5oz–1¾lb (600–800g) white cabbage, outside leaves removed, and cut into 8 segments

1 medium (7oz/200g) sweet potato, peeled and cut into 6 segments

2 small carrots, peeled and sliced

6 garlic cloves, minced

2 small chiles, seeded and chopped

4 inner celery stalks and leaves, chopped (discard stringy outer stalks)

9oz (250g) baby plum tomatoes

6 bay leaves

1 tsp ground coriander

1 tsp freshly ground black pepper

2 tsp smoked paprika

1 tbsp olive oil

salt

a small handful of chopped cilantro leaves, to garnish (optional)

1 Place half the shallots in a Dutch oven, add half the ghee, and a splash of vegetable stock and wine, and mix. Add some of the cabbage segments, sweet potato, and carrots, half the garlic, 1 chile, half the chopped celery and tomatoes, 3 bay leaves, and a dash of the spices to create a layer of ingredients. Repeat with the rest of the ghee, vegetables, and spices to create another layer.

2 Drizzle the olive oil over the top. Mix the stock and wine, season with a little salt, and pour two-thirds of the liquid into the pot. Bring it to a simmer on the stove top, cover with a lid, and simmer on low heat for 1 hour, occasionally adding more wine and stock blend. Remove the lid for the last 15 minutes of cooking time to allow any excess stock to evaporate. Remove from the heat, fish out the bay leaves, if possible, and discard, and serve. Garnish each portion with cilantro leaves, if using.

KALE WITH BUCKWHEAT NOODLES

 HELPS LOWER CHOLESTEROL　　 **CONTAINS ANTICANCER SUBSTANCES**　　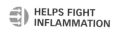 **HELPS FIGHT INFLAMMATION**

This dish of buckwheat noodles and kale benefits the heart. Kale is the ultimate leafy vegetable, full of antioxidants, omega-3 fatty acids, and natural substances that give it anti-inflammatory properties and can help reduce the risk of estrogen-related cancers. Any type of kale will do for this quick, easy dish, and it is best cooked lightly for a minimal amount of time.

SERVES 4

14oz (400g) soba (buckwheat) noodles

2 tbsp walnut oil, plus extra for sprinkling

1 red chile, seeded and minced

2 garlic cloves, crushed

2 tbsp tamari soy sauce

1¼lb (600g) fresh kale, cut into strips with the stalks removed

2 tbsp fresh orange juice

¼ cup walnut pieces, toasted, to garnish

1 Cook the soba noodles following package directions. Add a dash of walnut oil and a pinch of salt to the water before you add the noodles, if you like.

2 Meanwhile, place a large, heavy saucepan with a lid over medium heat and add the walnut oil along with 2 tablespoons of water. When the oil has warmed through, add the minced chile and crushed garlic, and stir. Add the tamari soy sauce, followed by the kale, and stir to coat the leaves in the other ingredients.

3 Add the orange juice, cover, and let the kale steam for 2–3 minutes, or until it is just cooked. Stir occasionally while it cooks, to stop it from sticking to the bottom of the pan, and add a dash of water if necessary. Remove from the heat. Arrange the soba noodles on a warmed serving dish, pile the kale on top, and scatter with the toasted walnuts. Sprinkle the dish with a few drops of walnut oil to serve.

BEANS BAKED IN A PUMPKIN POT

 HELPS REMOVE TOXINS FROM THE BODY **HELPS LOWER CHOLESTEROL** 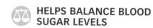 **HELPS BALANCE BLOOD SUGAR LEVELS**

This combination of okra, peppers, mushrooms, and spices works synergistically to support nearly every body system and aids the removal of waste and toxins, while eating legumes, such as lima beans, is a particularly good way to lower cholesterol and help balance blood sugar levels. Presenting the beans in a pumpkin adds extra nutrition, flavor, and a "wow" factor at the table.

SERVES 4

2 tbsp olive oil, plus extra for greasing

8 shallots, finely chopped

1 tsp coriander seeds, coarsely crushed in a mortar and pestle

1 red or green chile, seeded and minced

1 red bell pepper, seeded and diced

1 yellow bell pepper, seeded and diced

3 garlic cloves, minced

1 level tsp hot smoked paprika

14oz (400g) can organic lima beans, drained

salt and freshly ground black pepper

5½oz (150g) shiitake mushrooms, sliced

3½oz (100g) small whole okra, stems removed

1 bay leaf, fresh or dried

1 large or 2 medium pumpkins or winter squash (optional)

a small handful of roughly chopped cilantro leaves, to garnish

1 Preheat the oven to 350°F (180°C). Gently warm the olive oil with a spoonful of water in a medium saucepan over low heat. Add the shallots and stir until they turn translucent and golden. Add the coriander seeds and chile, stir, and add the diced peppers, garlic, and hot smoked paprika. Add the beans and stir well to coat them in the spices. Season with salt and black pepper and then add the shiitake mushrooms, okra, and bay leaf to the pan.

2 If you don't want to use a pumpkin, simply transfer the bean mixture to a shallow ovenproof dish with a lid. Add a dash of water, cover, and bake in the oven for 45–50 minutes. Remove from the oven, scatter with cilantro leaves, and serve.

3 If you want to bake and serve the baked beans in a pumpkin "pot," cut the top off the pumpkin and reserve. Remove the soft center and seeds, and scrape out a little of the flesh if necessary; the thicker the pumpkin wall, the longer it will take for the dish to cook.

4 Smear the inside of the pumpkin with a little olive oil, season with a little salt, and add the bean mixture and a dash of water. The pumpkin itself will add some liquid to the dish. Cover with the pumpkin "lid," place on a baking pan, and bake in the oven for 1 hour, or until the pumpkin is cooked through.

5 Remove the pumpkin lid and lift out the bay leaf and discard it. Scatter the beans with the fresh cilantro, and bring the pumpkin to the table. To serve, dig the serving spoon into the pumpkin flesh so that each portion contains a mixture of both pumpkin flesh and beans.

Lima beans (p114) *contain iron and fiber to support a healthy heart and circulation.*

STUFFED PEPPERS

 HELPS STRENGTHEN THE IMMUNE SYSTEM 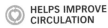 **HELPS IMPROVE CIRCULATION**

This vegetarian recipe is a substantial meal, with satisfying flavors equal to any meat dish. Bell peppers provide a broad range of antioxidant and anti-inflammatory nutrients that help improve circulation and build red blood cells, among other things. With the addition of mushrooms, garlic, and black pepper, this dish also helps enhance your resistance to seasonal infections.

SERVES 6

heaped ⅓ cup pine nuts

3½oz (100g) crimini mushrooms, finely diced

1 yellow squash, finely diced

1 small eggplant, finely diced

5 shallots, finely diced

3 garlic cloves, minced

1 red chile (optional, depending on how spicy you want the dish to be)

scant ½ cup brown or white rice, rinsed

2 tbsp quinoa

1 tbsp olive oil

a large sprig of flat-leaf parsley, finely chopped

2 tsp hot smoked paprika

salt and freshly ground black pepper

8 bell peppers of the same color, or a mixture of yellow, green, orange, and red bell peppers

1 tbsp chopped flat-leaf parsley leaves, to garnish

1 Preheat the oven to 375°F (190°). Dry-fry the pine nuts in a skillet until they are lightly golden. Place the finely diced vegetables in a large mixing bowl and add the pine nuts, rice, quinoa, olive oil, and parsley. Sprinkle in the hot smoked paprika and season, then combine the ingredients well.

2 Using a sharp knife, carefully remove the stalk and the "seeded heart" from each pepper so they remain whole. Stuff each pepper with the vegetable mixture, making sure that each pepper is packed full (the vegetables in the stuffing have a tendency to shrink during cooking).

3 Stand the stuffed peppers in a deep baking dish or casserole dish. Pour enough hot water into the dish to cover the bottom third of the peppers. Bake in the oven for about 50 minutes. Once the skin on the peppers turns slightly brown on top, cover the dish with a lid or foil. To check whether the filling is cooking, test the rice and quinoa. If it feels or looks dry, pour a splash of water inside each pepper to aid cooking. When the peppers are cooked, garnish with chopped parsley and serve with a side dish of hot mashed sweet potatoes.

SEA BASS WITH SPINACH AND MANGO

 HELPS COMBAT ANEMIA **HELPS PROTECT EYE HEALTH** **AIDS HEALTHY DIGESTION** **HAS A DIURETIC ACTION**

This dish of firm-textured oily fish and iron-rich spinach helps lower blood pressure and prevent recurring headaches and dizziness. Antioxidants in the mango support healthy vision. The cooling effect of the spinach is balanced by the heat of chile, garlic, and ginger—all of which promote healthy circulation and digestion, and also help remove excess water from the body.

SERVES 4

4 sea bass, about 9oz (250g) each

a pinch of salt

3 tbsp finely chopped fresh ginger,

2 small chiles, seeded and minced

4 garlic cloves, minced

1 lemon, cut in half, with one half thinly sliced and the other half juiced

2 heaped tsp whole grain mustard

generous ⅓ cup olive oil

½ cup white wine

7oz (200g) spinach leaves

For the sauce

1 medium mango, peeled, seeded, and roughly chopped

2 tsp lime juice

1 tbsp olive oil

1 If you have time, soak the fish in a large bowl of salted water (1 tablespoon of salt to 3½ cups water) half an hour before cooking to clean them thoroughly. Preheat the oven to 350°F (180°C). Pat the fish dry with paper towel and place in a large ceramic baking dish. Sprinkle with the salt and pack the insides of the fish with the ginger, chile, and garlic. Arrange a few lemon slices on top of each fish. Blend the mustard, lemon juice, olive oil, and the wine (or ½ cup water) in a bowl and pour over the fish. Cover with foil and bake for 25–35 minutes, or until the fish flakes easily when you test it with a fork.

2 Meanwhile, prepare the sauce. Put the mango flesh, lime juice, and olive oil in a food processor or blender, pulse briefly, and set aside.

3 Boil a large saucepan of water, add the spinach, and cook for 30 seconds or until it wilts. Drain away the hot water, quickly rinse the spinach in cold water to halt the cooking process, then drain again very thoroughly. Place the sea bass on 4 serving plates. Divide the spinach into 4 portions, arranging it around the edge of each fish if you like. Drizzle a little of the mango sauce over the sea bass and serve the rest of the sauce in a small bowl on the side.

MARINATED TUNA STEAKS

 AIDS HEALTHY DIGESTION

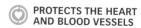 **PROTECTS THE HEART AND BLOOD VESSELS**

Tuna steaks have an astringent quality and are traditionally used in Asia to soothe the digestive tract, while capers enhance this effect. This fish is a healthy choice for the heart if you want a substitute for red meat; its substantial flavor is deepened here by the addition of Japanese tamari soy sauce, which has more complex undertones than Chinese soy sauce.

SERVES 4

3 tbsp olive oil
2 tbsp tamari soy sauce
1 tbsp capers, rinsed
¼ cup Marsala wine or sweet sherry
1 tbsp whole grain mustard
2 garlic cloves, crushed
4 thin slices of lemon
4 tuna steaks

1 Place the olive oil, tamari soy sauce, capers, Marsala wine, mustard, garlic, and lemon slices in a ceramic baking dish and mix well. Add the tuna steaks and coat them in the marinade. Cover the dish with a lid or foil and leave in the fridge for 1 hour to marinate.

2 Preheat the oven to 350°F (180°C). Place the covered dish of tuna steaks in the oven and bake for 15–25 minutes. Cook the steaks lightly, turning them over after 10 minutes; thinner steaks will cook more quickly. To test if the fish is cooked, slice through a small section with a sharp knife; the center of the steak should still be slightly pink. Serve with steamed rice and salad or steamed vegetables.

Lemon (p40) aids good digestion and, with its antibacterial properties, also helps maintain a healthy urinary tract.

Mung Bean And Purple Broccoli Rabe Stir-fry

 SUPPORTS HEALTHY LIVER FUNCTION

 PROMOTE BOWEL REGULARITY

 HAS A DIURETIC ACTION

This dish is bursting with ingredients to strengthen the liver, which helps the body to eliminate toxic substances, clear blood vessels, and enhance bowel movements and urine output. Both Belgian endive and artichokes are known as remedies for issues relating to the liver; in traditional Chinese medicine, sour foods and leafy green foods are thought to help strengthen and cleanse the liver.

SERVES 4

¼ cup vegetable stock

1 tbsp tamari soy sauce

1 tbsp olive oil

¾in (2cm) piece of fresh ginger, peeled and julienned

1 small chile, seeded and julienned

2 medium carrots, peeled and julienned

14oz (400g) purple broccoli rabe, trimmed and chopped into florets

2½ cups mung bean sprouts

1 small green mango, seeded and julienned

4 large heads of Belgian endive, leaves separated

1 tbsp black sesame seeds

For the dressing

juice and zest of 1 lime

2 tbsp pumpkin oil

1 tsp whole grain mustard

1 tsp honey

1 To make the dressing, in a pitcher, combine the lime juice and zest, pumpkin oil, mustard, and honey, and set aside.

2 Place the vegetable stock in a wok and heat gently. Add the tamari soy sauce, olive oil, ginger, and chile, and stir. Add the carrots and broccoli, stir again, and add the mung bean sprouts and mango, and sauté for 1 more minute.

3 Divide the Belgian endive leaves among 4 serving plates, arranging them in a rosette. Spoon a small amount of stir-fried vegetables into the middle of each rosette. Drizzle with the dressing and scatter with black sesame seeds. Serve with boiled rice.

Purple broccoli rabe *(p51) is packed with immune-boosting antioxidants. Stir-frying it lightly, as here, will help retain all its benefits.*

SPICY RAW VEGETABLE SPAGHETTI

 HAS A DIURETIC ACTION PROMOTES CLEAR SKIN HELPS EASE CONSTIPATION PROMOTES DETOX AT CELL LEVEL

Raw vegetables provide more enzymes, vitamins, and other essential nutrients than if cooked, and the combination of ingredients used here has a cleansing effect on the body. A spiralizer is a gadget that turns the vegetables into lovely spaghetti-like strands, which changes their texture—the root vegetables in particular taste surprisingly light and vibrant.

SERVES 4

a handful of pine nuts

2 tbsp furikake, or 1 tbsp each of black and white sesame seeds

2 carrots, peeled

2 medium beets, peeled

1 zucchini and 1 yellow squash, stalks removed

3 small radishes

a large bunch of fresh cilantro leaves, large stalks removed, and finely chopped

For the dressing

juice of 3 celery stalks (about ¼ cup)

1 tbsp hemp oil

2 tbsp pumpkin seed oil

1 tbsp fresh lemon juice

2 tsp tahini

salt and freshly ground black pepper

1 To make the dressing, combine all the ingredients together in a food processor or blender, then set aside.

2 To toast the pine nuts and sesame seeds, heat a small skillet over medium heat, add the pine nuts and seeds, and dry-fry, stirring until lightly golden.

3 Put the carrots, beets, zucchini, yellow squash, and radishes through a vegetable spiralizer to turn them into long, thick spaghetti-like strips. Or, use a vegetable peeler and cut them into long thick ribbons.

4 Place all the vegetable strips, except the beets, in a serving bowl and toss with the chopped cilantro leaves (adding the beets separately stops the whole salad from turning pink). Distribute among 4 serving plates, add the beets, pour over the dressing, scatter each portion with a few of the pine nuts and furikake or sesame seeds, and serve.

Furikake is a Japanese seasoning of sesame seeds, seaweed, and other flavorings. Sprinkling a little over a salad, rice, or noodles is a great way of increasing the nutrient density of a dish.

SPROUTED QUINOA WITH VEGETABLES

 EASY TO DIGEST AND GLUTEN-FREE

 HELPS BALANCE BLOOD SUGAR LEVELS

 MAINTAINS HEALTHY BLOOD VESSELS

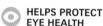 **HELPS PROTECT EYE HEALTH**

Sprouted seeds and grains are not just a pretty garnish. This gluten-free, fiber-rich dish is easy to digest and helps keep blood sugar levels stable. It's packed with vitamins, minerals, amino acids, and beneficial digestive enzymes that helps us extract maximum nutrition from food. Bell peppers, yellow squash, and green mango supply antioxidants to support cardiovascular and eye health.

SERVES 4

2 tbsp broccoli seeds

2⅓ cups quinoa

1 large red bell pepper, seeded and finely diced

1 large orange bell pepper, seeded and finely diced

1 fennel bulb, finely diced

1 yellow squash, finely diced

1 small unripe mango, peeled, seeded, and finely diced

1 garlic clove, minced

juice of 1 lime

3 tbsp extra virgin olive oil

salt and freshly ground black pepper

1 To sprout the broccoli seeds, place them in a large glass jar, pour in enough tepid water to liberally cover the seeds, fasten cheesecloth over the mouth of the jar with an elastic band, and set aside overnight. The next morning, pour the water out through the cheesecloth, pour in more water to rinse the seeds, and drain. Leave the jar upside down at an angle of 45 degrees, away from direct sunlight, so the excess water can drain away. Repeat the rinsing process every morning and evening for 3–5 days depending on the room temperature and how quickly the seeds sprout. Once sprouted, store the seeds in a glass jar sealed with a lid in the refrigerator and consume within 1–2 days.

2 To sprout the quinoa, place the seeds in a large glass jar, pour in enough tepid water to liberally cover the seeds, fasten cheesecloth over the mouth of the jar, and set aside for 2 hours. Pour the water out through the cheesecloth, pour in more water to rinse the seeds, and drain. Leave the jar upside down at an angle of 45 degrees, away from direct sunlight, so the excess water can drain away. Repeat the rinsing process the following day and you may find that little shoots are already breaking through. The quinoa is ready when most of the seeds have sprouted.

3 To assemble the dish, combine all the sprouts and diced peppers, fennel, yellow squash, and mango in a large bowl.

4 In a small bowl, mix together the minced garlic, lime juice, and olive oil, and add a pinch of salt. Pour this dressing over the ingredients in the bowl, mix well, and add black pepper. Taste and adjust the seasoning if necessary before serving.

Yellow squash (p60) skin is rich in antioxidant carotenes, such as lutein, which promote healthy eyes.

Main Meals

MAKE SURE YOUR MAIN MEAL FORMS A **HEALTHY** CENTERPIECE TO YOUR DAY, WHATEVER TIME OF DAY YOU EAT IT. **FRESH** INGREDIENTS BALANCED FOR FLAVOR, COLOR, AND TEXTURE—AND MOST IMPORTANTLY **HEALING POWER**—ARE KEY.

BRAISED RED CHICORY AND CELERY HEART SALAD

⚙ **AIDS DETOXIFICATION SYSTEM** ≡ **PROMOTES A HEALTHY DIGESTIVE TRACT** ◔ **HELPS MAINTAIN WATER BALANCE** ◑ **HAS NATURAL SEDATIVE PROPERTIES**

A detoxifying meal with significant benefits for the body. Chicory, which has a bitter taste, stimulates digestion, improves both gallbladder and liver function, and cleanses the urinary tract. Celery helps regulate the body's water balance. Both vegetables are a good source of fiber and have important sedative and stress-relieving properties. This recipe makes a perfect side dish.

SERVES 4

1 tbsp olive oil

2 long (or banana) shallots, finely chopped

2 garlic cloves, minced

1 small chile, seeded and finely chopped

1 large bunch of celery, split into inner and outer stalks, with inner stalks finely chopped

8 heads of red chicory, halved lengthwise

1 tsp chopped lemon thyme leaves

salt and white pepper

1 Preheat the oven to 350°F (180°C). Heat the oil with a tablespoon of water in a medium saucepan over medium heat. Add the shallots, allow to soften, then add the garlic, chile, and chopped inner stalks of celery, or celery hearts, and cook for 2–3 minutes.

2 Meanwhile, juice the outer stalks and leaves of the celery in a juicer. Add the celery juice to the pan.

3 Arrange the chicory halves in an ovenproof ceramic dish with a lid. Pour the shallot and celery mixture over the chicory, cover, and bake in the oven for 20 minutes.

4 Transfer the chicory halves to a serving plate. Pour the celery mixture into a small saucepan, bring to a boil, add the lemon thyme, and boil for 3 minutes to reduce the liquid. Season with salt and white pepper to taste, pour the mixture over the chicory halves, and serve.

Red chicory (p73) is a variant of blanched white chicory. It contains high amounts of volatile oils that aid digestion.

FRESH CILANTRO LEAF PESTO WITH PASTA

 HELPS ELIMINATE TRACES OF METALS

 PROTECTS AGAINST NEURODEGENERATION

 AIDS HEALTHY DIGESTION

 PROTECTS THE HEART AND BLOOD VESSELS

This dish offers the detoxifying properties of fresh cilantro, which is a good chelating agent, helping to remove traces of heavy metals from the body. High levels of heavy metals are implicated in certain arthritic conditions, depression, memory loss, muscle pain, and weakness. Coriander seeds aid digestion, and pine nuts, cashews, and almonds help support heart health.

SERVES 4

a large bunch of organic cilantro leaves

⅓ cup olive oil

1 garlic clove

¼ tsp ground coriander

2 tbsp blanched almonds

2 tbsp cashews

2 tbsp pine nuts

2 tbsp lemon juice

8oz (225g) fresh pasta, such as spelt spaghetti

1 scant cup sun-dried tomatoes in olive oil, drained and chopped

freshly ground black pepper

grated Parmesan cheese, to garnish

a small handful of chopped cilantro leaves, to garnish

1 Place the cilantro leaves and olive oil in a food processor or blender and purée until finely blended. Add the garlic, ground coriander, almonds, cashews, pine nuts, and lemon juice, and purée the ingredients to a paste. Alter the consistency and flavor of the pesto slightly, if you like, by adding a little more olive oil and/or lemon juice keeping to a 3:1 ratio of oil to juice.

2 Cook the pasta following package directions and drain. Immediately stir the pesto through the hot pasta so it melts, then add the sun-dried tomatoes, and toss the ingredients together. Season with black pepper. Scatter generously with grated Parmesan and cilantro leaves to serve.

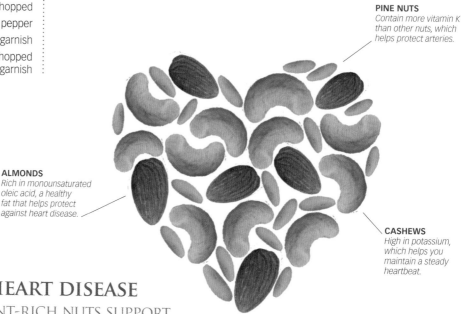

PINE NUTS
Contain more vitamin K than other nuts, which helps protect arteries.

ALMONDS
Rich in monounsaturated oleic acid, a healthy fat that helps protect against heart disease.

CASHEWS
High in potassium, which helps you maintain a steady heartbeat.

HELP FIGHT HEART DISEASE
THREE ANTIOXIDANT-RICH NUTS SUPPORT ARTERIES, STRENGTHEN BLOOD VESSELS, AND LOWER BLOOD PRESSURE.

WILD RICE SALAD

 PROTECTS AGAINST FREE-RADICAL DAMAGE

 AIDS HEALTHY DIGESTION

 PROTECTS THE HEART AND BLOOD VESSELS

Black wild rice, which was once cultivated solely for China's emperors to consume, is a nutritious protein and antioxidant-rich grain with a nutty taste and chewy texture. Rice is classified as a sweet, neutral food in Chinese medicine, and is eaten to ease many stomach and digestive problems including diarrhea, indigestion, and constipation. Its fiber helps protect the heart.

SERVES 4

¾ cup black wild rice

1 cup vegetable or chicken stock

a pinch of salt

2 kaffir lime leaves

1 tsp orange zest

1 tsp lemon zest

¼ cup sun-dried tomatoes, chopped

1 large red pepper, seeded and diced

2 tbsp chopped cilantro leaves

For the dressing

2 tbsp basil oil

1 tbsp blackberry vinegar

a pinch of salt

1 Rinse the rice in cold water, drain, and transfer to a medium saucepan. Add the stock, salt, kaffir lime leaves, and citrus zest. Bring to a boil, then cover, reduce the heat, and simmer for 25–30 minutes, or until the rice is cooked and water has been absorbed.

2 Meanwhile, make the dressing. Place all the ingredients in a bowl or jar with a screwtop lid, add 1 tablespoon water, and mix well. When the rice is cooked pour the dressing over the rice while it is still hot, stir in the sun-dried tomatoes, and set aside until the rice has cooled.

3 When the rice is cold, mix in the chopped pepper. Garnish with the cilantro leaves, and serve.

ARTICHOKES IN A SWEET SPICY SAUCE

 HAS A MILD DIURETIC ACTION

 HELPS LOWER CHOLESTEROL

 SUPPORTS HEALTHY LIVER FUNCTION

 PROMOTES A HEALTHY COMPLEXION

Globe artichokes are not only good to eat, they are a therapeutic herb—a bitter digestive remedy that helps stimulate and strengthen the urinary system and support the liver. Artichokes also help with fat metabolism and can reduce "unhealthy" (LDL) cholesterol levels in the blood. The hot sauce supports detoxification, which in turn can help improve the condition of the skin.

SERVES 4

4–8 artichokes

2 tbsp lemon juice

½ tsp salt

1 garlic clove, finely chopped

2 tbsp dry white wine

2 tbsp olive oil

2 cups quinoa, rinsed and soaked until sprouted (p204)

salt and freshly ground black pepper

3 tbsp pine nuts, toasted (optional)

3 tbsp fresh pomegranate seeds (optional)

For the dressing

¼ cup roasted sesame oil

⅔ cup Marsala wine

2 tbsp teriyaki sauce

3 tbsp fresh orange juice

2 garlic cloves, minced

1 medium-hot chile, seeded and minced

2 tbsp finely chopped flat-leaf parsley leaves

2 tbsp chopped lemon thyme leaves

1 Trim the artichoke heads by removing the tough outer scales to expose the paler, softer leaves, and cutting away the spiky leaves on the top. If the artichokes have their stems intact, peel off the stringy outer layer with a sharp knife. Slice each artichoke in half lengthwise and scrape away the furry choke with a spoon. Place the artichokes in a large bowl of water with the lemon juice to stop them from discoloring.

2 Bring a large saucepan of water to a boil. Turn the heat down, add the salt, garlic, wine, olive oil, and artichoke halves and poach gently for 20 minutes. Remove the artichokes from the water and drain.

3 Heat the sesame oil with 2 tablespoons of water in another large saucepan, and add the artichoke halves. Let them brown gently for 2–3 minutes, then remove and set aside.

4 Add the Marsala wine, teriyaki sauce, orange juice, garlic, and chile to the pan. Mix the ingredients briefly, then add the parsley and thyme, and remove the pan from the heat.

5 To assemble the dish, divide the sprouted quinoa among 4 serving plates and season with salt and black pepper. Swirl a spoonful of the sauce over the sprouted quinoa and arrange 1–2 artichoke halves on top of each portion. Spoon more sauce over the artichokes, sprinkle with toasted pine nuts and pomegranate seeds, if using, and serve.

TIP: Start to sprout the quinoa 1–3 days ahead, depending on how big you like the sprouts. Rinse and drain the quinoa every 8–12 hours.

Artichokes (p62) *support immune function by detoxifying the liver and gallbladder.*

BUCKWHEAT PANCAKES WITH NETTLES AND FETA CHEESE

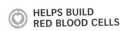 **HELPS BUILD RED BLOOD CELLS**

 HELPS ALLEVIATE DRY COUGHS

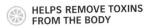 **HELPS REMOVE TOXINS FROM THE BODY**

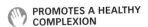 **PROMOTES A HEALTHY COMPLEXION**

When combined, nettles and buckwheat enrich the blood, helping to increase red blood cells and restore metabolic balance. This dish is ideal for anyone with anemia, a dry cough, or a weak constitution. It can also aid those in need of a detox, or recovering from a long illness. Young nettles in spring are best, because they are small yet potent; wear gloves to gather them.

SERVES 4

For the pancakes

1–1¼ cups buckwheat flour

a pinch of salt

1 large egg

¼ cup milk

1 tbsp olive oil

1 tsp butter, plus extra for greasing

For the filling

3½oz (100g) young nettle leaves, finely chopped

3½oz (100g) feta cheese

3 large eggs

3½oz (100g) ricotta cheese

2 tbsp crème fraîche

a pinch of salt

1 Add the flour to a mixing bowl along with the salt, and make a well in the center. Crack the egg into the well and add the milk. Using a wooden spoon, stir the egg and milk, letting the flour gradually tumble in. Gradually add ⅓–½ cup water, little by little, stirring continuously until all the flour has been incorporated and the mixture is lump-free. If necessary, adjust the liquids or add a little more flour. If you have time, place the batter in the refrigerator to rest for 30 minutes to allow the milled grain to swell, which helps make the batter light and not heavy.

2 Preheat the oven to 350°F (180°C). Place the nettle leaves in a bowl and crumble in the feta cheese. Add the eggs, ricotta cheese, crème fraîche, and salt, combine all the ingredients together, and set aside.

3 To make the pancakes, heat the olive oil and butter in a medium skillet. When hot enough, add a ladle of the batter and swirl it around in the pan to make a thin pancake. Cook for 2–3 minutes, or until golden, then toss or turn the pancake and cook on the other side. Repeat until you have 8 pancakes.

4 Spread some of the filling over a pancake and roll it up. Repeat with the rest of the pancakes and the filling, then arrange all the pancake rolls in a buttered baking dish. Pour the remaining filling over the pancakes, and bake in the preheated oven for 20–25 minutes until cooked through and golden in appearance. The filling may ooze out of the pancakes during cooking, but this won't detract from the final look or flavor of the dish. Serve hot with a salad.

Buckwheat flour (p113) is rich in natural antioxidants that help protect the heart.

Mushroom Frittata With Cherry Tomatoes And Basil

 HELPS STRENGTHEN THE IMMUNE SYSTEM **AIDS HEALTHY DIGESTION** **HELPS EASE RHEUMATIC PAIN** 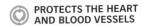 **PROTECTS THE HEART AND BLOOD VESSELS**

This is an ideal meal if you are recuperating. Like other mushrooms, morels (*Morchella esculenta*) are rich in the essential amino acids the body needs to build protein, while shiitake and crimini mushrooms help improve digestion and have anti-inflammatory properties. Wash the morels thoroughly under running water because their spongelike caps often contain soil and grit.

SERVES 4

For the braised tomatoes

½ tbsp ghee, or clarified butter, for greasing

1½ cups ripe cherry tomatoes

salt and freshly ground black pepper

1 tbsp chopped fresh basil leaves, to garnish

For the frittata

scant 1oz (25g) dried morels, soaked in boiling water for 5 minutes to rehydrate, or 2½oz (75g) fresh morels, cleaned and finely chopped

3½oz (100g) shiitake mushrooms, sliced

3½oz (100g) crimini mushrooms, sliced

2 tbsp ghee

salt and freshly ground black pepper

2 tbsp finely chopped chives

8 large eggs, beaten

3 tbsp crème fraîche

1 Preheat the oven to 350°F (180°C). To braise the tomatoes, grease a baking sheet with the ghee, add the cherry tomatoes, season with salt and black pepper, and cook in the oven for 8–10 minutes, or until the tomatoes are cooked.

2 Meanwhile, place a large, nonstick skillet over medium heat and dry-fry all the mushrooms for 1–2 minutes to enhance their flavor, and allow them to release some of their moisture. Add 1 tablespoon of the ghee, let it melt, then sauté the mushrooms for 3–5 minutes, adding salt and black pepper to taste. Add half the chopped chives, reserving the rest to use as a garnish. Remove the mushrooms from the skillet and set aside.

3 Beat together the eggs and crème fraîche in a medium bowl with a little more salt and black pepper to taste. Melt the remaining tablespoon of ghee in the pan and pour in the egg mixture. Cook for 2–3 minutes over low heat until the base is firm, then add the mushrooms and cover to cook for 3–5 minutes, or until both the underside and top of the frittata are set.

4 To serve, scatter with the rest of the chives, divide among 4 serving plates, and add the braised cherry tomatoes. Garnish the tomatoes with the basil and serve immediately.

CABBAGE MOMOS

 AIDS HEALTHY DIGESTION

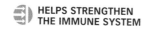 **HELPS STRENGTHEN THE IMMUNE SYSTEM**

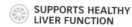 **SUPPORTS HEALTHY LIVER FUNCTION**

These dumplings, known as momos, are traditionally served at Bhutanese social gatherings. They can be filled with either meat or vegetables, but they are always served with a hot chile relish locally known as ezze (p195). Both cabbage and warming chile stimulate the digestion, help strengthen the immune system, combat seasonal infections, and cleanse the liver.

MAKES 24 MOMOS

For the filling

¼ medium cabbage, finely chopped

3 large onions, finely chopped

3 carrots, finely chopped

1 tbsp chopped lovage or celery leaves

1 tbsp chopped parsley or cilantro leaves

olive oil, for frying

¾ cup cream cheese (preferably home-made kefir cheese, p332)

2 garlic cloves, very finely crushed or powdered

1 tbsp soy sauce

¼ tsp salt

For the dough

2¾ cups whole wheat flour

2 large eggs, beaten

2 tsp baking powder

1 tsp salt

1 For the filling, fry the chopped vegetables, lovage or celery, and parsley or cilantro, in a very little olive oil over medium heat in a heated wok for 5–6 minutes. Stir in the cream or kefir cheese, garlic, soy sauce, and salt and set aside.

2 Make the dough for the momos by sifting the flour into a large bowl, adding the beaten eggs, and mixing lightly. Stir in ⅔ cup water and the baking powder and salt. Combine the ingredients well, then transfer the dough to a floured surface. Knead the dough lightly until smooth. Cover with a damp cloth and set aside for 5–10 minutes. This will allow the baking powder time to activate so that the momos swell when steaming.

3 Roll the dough into a large sausage and cut into 24 evenly sized pieces. Roll each piece into a thin circle 4in (9–10cm) wide. Place a tablespoonful of the filling in the center of the dough circle, gather the edges of the circle together, pinch the edges together with your fingers, and twist to seal. Repeat with the rest of the dough circles and filling.

4 Stand the momos in an oiled steaming basket. Place over a large saucepan of simmering water, cover, and steam for 12–14 minutes. If you don't own a steaming basket, place the momos in a heatproof colander or sieve over a saucepan filled with a 2in (5cm) layer of water; the base should not touch the water. Cover with the lid and bring the water to the boil; steam for 12–14 minutes. Serve the momos with Ezze relish (p195).

NORI VEGETABLE ROLL

 HAS NATURAL SEDATIVE PROPERTIES
 PROMOTES BOWEL REGULARITY
 HELPS MAINTAIN ENERGY LEVELS
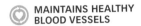 **MAINTAINS HEALTHY BLOOD VESSELS**

Brown rice and red quinoa, which both have a nutty flavor, are known to have a calming effect on the nervous system. The high fiber content of brown rice also benefits digestion. Nori, like quinoa, is high in protein, keeping your energy levels higher for longer. It also helps strengthen blood vessels. This wholesome dish is a practical food to eat on the go or serve as a picnic snack.

SERVES 4–6

¾ cup short grain brown rice

scant 1 cup red quinoa

¼ tsp Himalayan pink salt or other natural salt

1 tbsp rice vinegar

1 tbsp mirin sauce

1–2 tbsp sesame seeds

6–8 sheets of nori, toasted

1–2 tbsp toasted sesame oil

For the dipping sauce

1 tbsp tamari soy sauce

juice of 1 orange

For the filling

1 large avocado, pit removed, peeled, and cut into strips

1 carrot, peeled and julienned

¾in (2cm) fresh ginger, peeled and julienned

1 small chile, seeded and julienned

1 red bell pepper, seeded and julienned

1 celery stalk, julienned

1 small leek, white part only, julienned

1 Place the rice and quinoa in a large saucepan, add 2½ cups water and bring to a boil. Reduce the heat, cover, and simmer for 1 hour, or until the water is absorbed.

2 Remove the pan from the heat and add the Himalayan pink salt, rice vinegar, and mirin sauce. Combine well and set aside to infuse.

3 Meanwhile, toast the sesame seeds by dry-frying them in a saucepan until they turn golden, then set aside to cool. Combine the ingredients for the dipping sauce in a small bowl and set aside.

4 If you don't have a sushi roll mat, use a sheet of parchment paper slightly larger than the nori sheets (which will enable you to store the rolls for a few hours before serving) or you might find it just as easy to roll without either. To assemble a roll, place a sheet of nori, shiny-side down, on a clean, flat surface. Spread a thin layer of rice, about 2in (5cm) thick, on top of the sheet. Scatter with toasted sesame seeds and drizzle over a few drops of toasted sesame oil. Carefully arrange one or two of each of the sliced vegetables at one end of the nori sheet so that they all lie horizontally across the rice. Fold the nori sheet over the vegetables and continue to roll it up. Seal the end of the nori sheet by running a little water along the seam side with your finger. Repeat this process until you have the desired amount of rolls.

5 To serve, dip a serrated knife into water and slice the nori rolls into bite-sized pieces. Stand the rolls upright on a serving plate with the bowl of dipping sauce on the side.

STUFFED VINE LEAVES

 AIDS HEALTHY DIGESTION

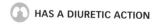 HAS A DIURETIC ACTION

Dark green vine leaves contain fiber, vitamins, and minerals, including vitamins C and K, folate, and manganese. These nutrients help reduce water retention and benefit the urinary system, and together with pine nuts, almonds, and mint they also benefit the digestive system. The leaves have a subtle acidic flavor and soft texture similar to spinach once cooked.

SERVES 4

30 vine leaves, or Swiss chard leaves, stalks removed
¾ cup white or brown basmati rice
4 shallots, minced
3 tbsp olive oil
2 tbsp pine nuts, toasted
2 tbsp sliced almonds, toasted
2 tbsp raisins
2 tbsp finely chopped mild mint leaves
1 tsp smoked paprika
salt and freshly ground black pepper
2½ cups vegetable stock or broth
1 tbsp tomato paste
1 tbsp lemon juice
thin lemon wedges, to serve

1 Preheat the oven to 350°F (180°C). Blanch the vine leaves by immersing them in a large saucepan of boiling salted water for 30 seconds, then quickly rinse in cold water to halt the cooking process, drain, and set aside. Cook the rice following package directions.

2 Heat a thin layer of water in a saucepan, add the shallots, and stir for about 5 minutes until they have softened. Stir in the cooked rice, olive oil, pine nuts, sliced almonds, raisins, mint, and smoked paprika, and season with salt and black pepper. Remove from the heat and allow the mixture to cool before handling it.

3 Arrange some of the vine leaves, vein-side up, on a flat surface. Place a small ball of the filling at one end of each leaf, fold 3 sides of the leaf up over the filling, and roll into a cylindrical parcel. Place each parcel, with the loose end of the vine leaf facing down, in an ovenproof dish with a lid. Repeat with the rest of the vine leaves and filling. Arrange the parcels tightly together to stop them from unfolding while cooking.

4 Heat the stock in a small saucepan, add the tomato paste and lemon juice, mix well, bring to a boil, and gently pour the hot stock over the stuffed vine leaves. Cover them with a small ovenproof plate to keep them in place and then cover with the lid. Cook in the oven for 1 hour, or until all the liquid has been soaked up. Transfer the stuffed vine leaves to a serving dish, decorate with lemon wedges, and serve.

Vine leaves are rich in antioxidants and are a traditional remedy for pain and inflammation.

TROUT AND LETTUCE WRAPS

 AIDS HEALTHY DIGESTION

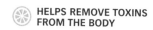 **HELPS REMOVE TOXINS FROM THE BODY**

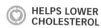 **HELPS LOWER CHOLESTEROL**

This dish enhances digestion and can aid weight reduction. In addition, cooling lettuce has detoxifying properties and mangoes can help relieve symptoms of motion sickness, while the omega-3 fatty acids in trout bring cardiovascular benefits. Using a bed of fresh rosemary, fennel, or dill leaves on which to broil the trout gives them a fragrant, smoky aroma.

SERVES 4

8 large lettuce leaves, such as romaine, butter, escarole, or iceberg, or use 12 leaves of Little Gem lettuce

2 trout (12oz/350g each), filleted

a bunch of rosemary sprigs

a bunch of fennel or dill fronds

a dash of olive oil

a pinch of salt

2 tbsp pumpkin seeds

For the filling

1 large mango, peeled, seed removed and discarded, flesh cubed

a bunch of cilantro leaves, chopped

3 tbsp scallions, finely chopped

1¾ cups cherry tomatoes, halved

1 small chile, seeded and minced

1 tbsp olive oil

½ tbsp lemon juice

salt and freshly ground black pepper

1 If using large lettuce leaves, remove any thick veins so they can be folded over without breaking.

2 Preheat the broiler to high. Score the trout fillets with several diagonal cuts through the skin along their length to prevent them curling up while being broiled. Line the broiler pan with sprigs of rosemary and large fronds of fennel or dill. Arrange the trout fillets skin-side up on top and drizzle with olive oil rubbing it into the skins. Season the fish with salt and place under the hot broiler. Broil for 4–5 minutes, or until the skin is crisp and the flesh is cooked through and flakes when tested with a fork. Remove the fillets from the broiler and allow to cool.

3 To make the filling, combine the mango cubes, cilantro leaves, scallions, tomatoes, and chile in a bowl. Add the olive oil, lemon juice, and salt and black pepper, mix together gently, and set aside.

4 To toast the pumpkin seeds, heat a small saucepan over medium heat. Add the pumpkin seeds and dry-fry for 2–3 minutes, or until they darken slightly and give off a fragrant aroma. Shake the pan regularly and stir the seeds with a wooden spoon as you heat them. Cut the cooled trout fillets into squares and gently fold them into the filling.

5 To make the wraps, divide the filling between the lettuce leaves, placing a little in the middle of each leaf. Sprinkle some toasted pumpkin seeds on top and fold the edges of each lettuce leaf up and over the filling. Use a toothpick to secure each wrap. If using small leaves, such as Little Gem lettuce, don't wrap the filling but use the leaves like a scoop to enjoy the filling. Arrange the wraps on a plate to serve.

SPINACH AND RICOTTA FILO ROLLS

 HELPS COMBAT ANEMIA **AIDS HEALTHY DIGESTION** **HELPS PROTECT EYE HEALTH** 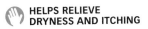 **HELPS RELIEVE DRYNESS AND ITCHING**

The primary therapeutic benefit of this iron-rich dish is to help build the red blood cells that carry oxygen throughout the body and help improve anemia. It can also assist digestion and help moisten the lungs and colon. Spinach is often recommended in cases of night blindness and hypertension while soft cheese also has a moistening effect on dry, itchy skin.

SERVES 4

1lb 2oz (500g) ricotta cheese
5 large eggs
a pinch of salt
1lb 2oz (500g) young spinach leaves, roughly chopped
½ cup crème fraîche
2 tbsp olive oil
1 package store-bought filo pastry
thick or Greek-style yogurt, to serve

1 Preheat the oven to 400°F (200°C). In a large bowl, mix the ricotta cheese with the eggs and salt. Add the spinach and crème fraîche and mix well.

2 Grease a square baking dish with a little olive oil. Lay a large piece of parchment paper on a flat surface and place a sheet of filo pastry on it with one of the longer edges facing you. Drizzle the pastry with a few drops of olive oil and spread a thin layer of the spinach, egg, and cheese filling over it. Roll up the pastry sheet into a neat roll, pushing it away from you, and using the parchment paper to help you. Transfer the roll to the baking dish, curving the ends up if the dish is smaller than the length of the pastry sheet.

3 Repeat with the rest of the filo pastry sheets and filling. Drizzle a few drops of olive oil over the rolls and bake for 30–40 minutes, or until the rolls are golden on top and the filling is cooked through. Serve with some thick yogurt on the side.

Spinach (p67) is famous for its iron content, which is more easily absorbed by the body when cooked.

SWISS CHARD AND SWEET POTATO

 HELPS FIGHT INFLAMMATION **HELPS MAINTAIN WATER BALANCE** **HELPS PROTECT EYE HEALTH** 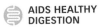 **AIDS HEALTHY DIGESTION**

Here's a different way of serving leafy, fiber-rich Swiss chard, which is high in vitamin K and antioxidant carotenoids. Its slightly bitter taste fades with cooking, and marries well with the sweet potato in a dish that helps relieve inflammation and dryness in the body, for instance in the mouth, skin, nose, and lungs, supports eye health, and improves digestion. This also makes a great side dish.

SERVES 4

1 tbsp olive oil, plus extra to drizzle

2 shallots, peeled and finely chopped

1 tsp coriander seeds, crushed

1 chile, seeded and finely chopped

2 garlic cloves, minced

2 large sweet potatoes, peeled and cubed

9oz (250g) Swiss chard, stalks removed and finely chopped, and leaves finely sliced

salt and freshly ground black pepper

1 Heat the olive oil with a tablespoon of water over low heat in a medium saucepan with a lid. Add the shallots and coriander seeds and cook, stirring occasionally, until the shallots have softened.

2 Add the chile and garlic, and cook for 1 minute. Add the sweet potato and cook over medium heat for about 5 minutes, adding a dash of water if necessary. Then add the chopped chard stalks, cover with the lid, and cook for 10 minutes.

3 When the sweet potato is almost cooked, add the shredded chard leaves, cover, and let them wilt for about 3 minutes. Season with salt and black pepper, drizzle over a few drops of olive oil, and serve.

Swiss chard is a good source of phytonutrients that help protect the pancreas and balance blood sugar.

HERRING WITH CUCUMBER AND SEAWEED SALAD

 HAS A DIURETIC ACTION **HELPS REMOVE TOXINS FROM THE BODY** **HELPS IMPROVE CIRCULATION** **FIGHTS THE EFFECTS OF STRESS**

This dish offers the health-boosting properties of seaweed and oily fish. Seaweed has a diuretic effect, helping to detoxify the body, and also helps protect blood vessels and fight the effects of stress. The omega-3 fatty acids and vitamin D in herring benefit the heart and blood circulation, too. If you can't find a packaged seaweed mix, try using nori and dulse seaweeds.

SERVES 4

1 package of dried mixed seaweed vegetables (approximately scant 1oz/25g)

½ cup dry white wine

juice of 2 limes

1 tsp coriander seeds, crushed

1 tbsp white wine vinegar

½ tsp salt

2 kaffir lime leaves

4 fresh herring fillets, about 3½oz (100g) each

1 cucumber, thinly sliced

3½oz (100g) red clover sprouts

1 carrot, peeled and julienned

4 lemon wedges, to garnish.

For the dressing

1 tbsp tamari soy sauce

1 tsp honey

2 tsp rice vinegar

2 tbsp finely chopped dill leaves, plus extra to garnish

1 Rinse the seaweed vegetables in a colander under running water, place in a bowl, and cover with tepid water. Set aside to reconstitute for at least 15 minutes or until soft, then drain.

2 Place the white wine, lime juice, coriander seeds, white wine vinegar, salt, kaffir lime leaves, and ½ cup water in a medium saucepan and bring to a slow boil. Turn the heat down low, let the ingredients simmer for 2–3 minutes, then turn the heat down again to its lowest setting, add the herring fillets, and let them poach for 10–12 minutes, or until cooked through. The fish are cooked when their flesh is opaque. If you like, you can reserve the poaching liquid, thicken it with 1 tablespoon of kudzu (a popular Asian thickener) or all-purpose flour or cornstarch, and serve it as a warm sauce to pour over the fish and seaweed and vegetable salad.

3 Meanwhile, combine all the ingredients for the dressing in a small bowl. Place the reconstituted seaweed, cucumber slices, red clover sprouts, and julienned carrot in a large bowl, pour over the dressing, and mix well.

4 Divide the salad among 4 serving plates and place a herring fillet on top of each. Garnish with a little more dill and the lemon wedges.

Adzuki And Mung Bean Salad

 HELPS MAINTAIN WATER BALANCE

 PROTECTS THE HEART AND BLOOD VESSELS

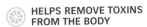 **HELPS REMOVE TOXINS FROM THE BODY**

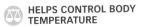 **HELPS CONTROL BODY TEMPERATURE**

Both adzuki and mung beans have diuretic properties and can help reduce water retention, particularly in the lower abdomen and legs. In addition, they can benefit the heart and vascular systems, and help the body eliminate toxins. Mung beans are also known to cool the body's internal temperature, so they are a useful food to eat if you are suffering from heatstroke.

SERVES 4

3/4 cup dried adzuki beans

3/4 cup dried mung beans

6 garlic cloves with skins on

1 lemon, sliced in half

2 bay leaves

1 1/3 cups cherry tomatoes, sliced in half

a pinch of salt

For the dressing

2 garlic cloves, peeled

juice of 1/2 lemon

juice of 1/2 lime

1/3 cup extra virgin olive oil

a handful of basil leaves, coarsely torn into shreds

a handful of flat-leaf parsley leaves, chopped

a handful of mint leaves, chopped

1 Soak the beans following package directions, then drain and rinse in cold water. Transfer to a large saucepan and add the garlic, lemon, and bay leaves. Pour over plenty of water, bring to a boil, and simmer for about 1 hour over low heat until the beans are cooked.

2 Meanwhile, preheat the oven to 350°F (180°C). Arrange the tomato halves on a greased baking sheet, sprinkle with a little salt, and roast in the oven for 15–20 minutes.

3 To make the dressing, pound the garlic with the lemon and lime juices using a mortar and pestle. Slowly add the extra virgin olive oil and herbs until all the ingredients are combined. Keep the dressing ready to pour over the hot beans as soon as they are cooked.

4 Drain the beans and remove the lemon, garlic, and bay leaves. Reserve the garlic cloves, if you like, and squeeze the softened garlic paste into the dressing. Discard the rest of the flavorings. Toss the hot beans in the dressing, add the tomatoes, and set aside until cool to serve as a light summer salad.

SUPPORT YOUR HEART

THE GARLIC CLOVES IN THIS RECIPE PROVIDE A HIGH DOSE OF THE COMPOUND ALLICIN, WHICH CAN HELP LOWER CHOLESTEROL AND PROMOTE HEART HEALTH.

QUAIL EGG AND ENDIVE SALAD

 HELPS MAINTAIN ENERGY LEVELS

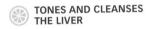 **TONES AND CLEANSES THE LIVER**

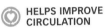 **HELPS IMPROVE CIRCULATION**

Known in the East as "animal ginseng," quail eggs have a sweet flavor and are very nutritious. They are an excellent energy-giving food, helping to improve the circulatory system, which in turn strengthens muscles and bones. Here the eggs are combined with Belgian endive leaves, which have a slightly bitter taste and act as a gentle stimulant and tonic for the liver.

SERVES 4

12 quail eggs

salt and freshly ground black pepper

5½oz (150g) assorted lettuce leaves

1 medium avocado, peeled and sliced

2 medium heads of Belgian endive, leaves separated

1½ cups cherry tomatoes, halved

a large handful of cilantro leaves, roughly chopped

For the dressing

2oz (60g) feta cheese

¼ cup extra virgin olive oil

1 large garlic clove, crushed

2 tbsp lemon juice

1 tsp green peppercorns in brine, drained, with a little extra brine

2 tbsp roughly chopped parsley leaves

1 To make the dressing, cut the feta cheese into small cubes and place them in a small bowl or screwtop glass jar. Pour over the olive oil, garlic, and lemon juice. Add the green peppercorns together with a little of their brine and the chopped parsley. Stir gently to combine well and leave for 3–4 hours for the flavors to develop.

2 Put the quail eggs in a saucepan, cover with water, add a pinch of salt, and bring to a boil. Cook in the boiling water for 3 minutes, then drain and rinse under cold water to prevent the yolks from discoloring. Remove the eggshells.

3 Arrange the lettuce, avocado slices, endive leaves, and cherry tomatoes on 4 serving plates. Slice the eggs in half and divide them among each portion. Spoon the feta cheese dressing over the salad, garnish with the chopped cilantro leaves, season with salt and black pepper, and serve.

Quail eggs *are high in phosphorus— essential for cell membranes, and strong bones and teeth.*

Raw Curly Kale Salad

 HAS ANTICANCER PROPERTIES

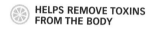 **HELPS REMOVE TOXINS FROM THE BODY**

 PROTECTS AGAINST COLDS AND FLU

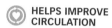 **HELPS IMPROVE CIRCULATION**

Kale is rich in antioxidant, anti-inflammatory, and anticancer nutrients. It also contains sulfur, making it an ideal food to help detox the body, and is known to help lower "unhealthy" (LDL) cholesterol levels in the blood. Leaving the dressed leaves to stand for 30 minutes softens them and makes cooking unnecessary, but if they are large and tough, steam them first for just 5 minutes.

SERVES 2

1lb 2oz (500g) kale, stems removed
juice of 1 lemon
2 tsp coriander seeds
¼ small lemon (with peel on)
2 avocados, pits removed, peeled
2 tbsp olive oil
salt and freshly ground black pepper
1 red chile, seeded and minced
4 garlic cloves, minced

1 Place the kale in a large bowl and sprinkle with the lemon juice. Using your hands, toss the leaves to coat them thoroughly in the lemon juice. Set aside for 30 minutes to let the kale soften.

2 Place the coriander seeds and lemon quarter in a blender or food processor and pulse briefly. Add the avocados, olive oil, salt, and black pepper and purée to a paste.

3 Transfer to the large bowl. Add the minced chile and garlic, and stir until well combined and the kale is thoroughly coated. Set aside for 15–30 minutes for the flavors to develop fully and to enhance the availability of the nutrients. Serve.

Avocados (p50) contain healthy monounsaturated fat, which helps in lowering blood pressure and lubricating joints.

LIGHT MEALS AND SALADS

LIGHT DOESN'T HAVE TO MEAN INSUBSTANTIAL. ENJOY A FUSION OF **FRESH** INGREDIENTS, **THERAPEUTIC** HERBS, AND FLAVORFUL SPICES THAT **HEAL** AND SATISFY YOUR NEED FOR **SUSTAINED ENERGY**.

ADZUKI BEAN SOUP

 HAS A DIURETIC ACTION

 AIDS HEALTHY DIGESTION

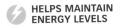 **HELPS MAINTAIN ENERGY LEVELS**

Tangerine peel is thought to aid digestion and so is excellent in combination with adzuki beans, which are also known to benefit digestive health, eliminate toxins, and reduce water retention, particularly in women who are menstruating. They also help sustain energy levels. This is an unblended, chunky soup, so it's up to you how small you want to chop the vegetables.

SERVES 4–6

1 tangerine or orange
4oz (115g) adzuki beans
2 tbsp olive oil
4 shallots, finely chopped
1 medium leek, chopped
2 carrots, finely diced
2 garlic cloves, crushed
2 celery stalks, finely diced
4 medium tomatoes, skinned and finely chopped
1 tsp tomato paste
2½–3 cups chicken or vegetable stock
2 bay leaves
2 zucchini, finely diced
2 tbsp finely chopped parsley
salt and freshly ground black pepper
2 tbsp finely chopped basil leaves, to garnish

1 Using a potato peeler, remove the peel from the tangerine or orange and arrange it on a baking sheet. Leave the sheet in the oven on a low temperature (225°F/110°C) for 1 hour, or until the skin has dried. Grind the peel to a powder in a pestle and mortar, or leave whole and remove at the end of cooking.

2 If you are using dried adzuki beans, soak them following package instructions, then drain, discarding the soaking water. Place the beans in a saucepan, cover with fresh water, bring to a boil, simmer for 15 minutes, and drain. If using canned beans, simply drain and rinse.

3 Meanwhile, heat the olive oil in another large saucepan and sauté the shallots over low heat until they soften. Add the leek, carrots, and garlic, stir, and cook for 2–3 minutes. Add the celery, allow to soften, then add the tomatoes and tomato paste. Cook for 5–10 minutes, or until soft. Add the adzuki beans to the onion and tomato mixture.

4 Pour in the stock, add the bay leaves and dried tangerine peel, and bring to a boil. Reduce the heat immediately and let simmer slowly for 30 minutes, then add the zucchini and parsley. Simmer for a further 10 minutes, then remove the bay leaves and whole peel, if using. Season with salt and black pepper to taste, and serve in bowls garnished with the basil. Serve with rye bread on the side.

BUTTERNUT SQUASH SOUP

 AIDS HEALTHY DIGESTION

 SUPPORTS HEALTHY LUNG FUNCTION

 HELPS STRENGTHEN THE IMMUNE SYSTEM

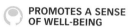 **PROMOTES A SENSE OF WELL-BEING**

Squash has fiber, which benefits the stomach and digestive system. It's a good choice if you have allergies or food sensitivities, because it's nonallergenic. Squash is also rich in beta-carotene to strengthen lungs, pancreas, and spleen. Combined with garlic, onions, and spices, this makes an immune-boosting meal. Both lemongrass and coconut milk add a mental and emotional uplift.

SERVES 6

2 tbsp olive oil

3 small onions, finely chopped

2¼lb (1kg) butternut squash, seeded and cut into small chunks

5½ cups vegetable stock

4 kaffir lime leaves

1 stalk lemongrass, bruised

2 garlic cloves

¾ cup coconut milk

zest and juice of 1 lime

salt and freshly ground black pepper

a few sprigs of cilantro leaves, to garnish

1 lime, cut into 6 wedges with a cut across the center of each wedge, to serve

1 Heat the olive oil in a large saucepan, add the onions, and sauté over low heat for 2–3 minutes, or until they are translucent. Add the squash and cook over medium heat, stirring occasionally until the vegetables are softened at the edges. Add the stock, kaffir lime leaves, lemongrass, and garlic. Bring to a boil, then lower the heat. Simmer for 30 minutes or so, or until the squash is cooked through, but still retains some shape.

2 Remove the kaffir lime leaves and lemongrass and discard. Add the coconut milk and bring back to a boil. Remove from the heat, add the lime zest, and season with salt and black pepper to taste. Pour the soup into a food processor or blender, and purée to a smooth consistency. Add some fresh lime juice to taste, pour into bowls, and garnish with the fresh cilantro. Just before serving, fix a lime wedge to the rim of every bowl for each person to add a little extra lime juice, if they like.

TIP: Keep the skin on the butternut squash to take advantage of the extra fiber, especially if it is a young one. Once cooked and blended the texture will become smooth.

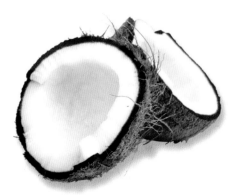

Coconut milk (p49) is rich in antioxidants, such as beta-carotene, and bowel-healthy fiber.

QUAIL SOUP

 BOOSTS IRON STORES TO COMBAT FATIGUE

HELPS IMPROVE CIRCULATION

PROMOTES EFFICIENT METABOLISM

HELPS STRENGTHEN THE IMMUNE SYSTEM

This cold-weather soup is best eaten at lunchtime; quail meat, shiitake mushrooms, goji berries, and astragalus root are all well known for being traditional tonics that help boost energy levels and improve circulation. They can also support the lungs, spleen, and kidneys, building resistance to infections, lowering the rate of perspiration, and reducing water retention.

SERVES 4–6

2 quails

¼oz (10g) astragalus root, or astragalus root powder

6 shallots, trimmed but with skins on

3 garlic cloves, with skins on

1 large carrot, sliced

10 black peppercorns

½oz (15g) goji berries, washed

7oz (200g) shiitake mushrooms, sliced

a large piece of wakame or nori seaweed, cut into small pieces

1 tbsp barley miso paste

1¾oz (50g) buckwheat noodles, to thicken

a large sprig of flat-leaf parsley, finely chopped

1 Place the quails in a large Dutch oven, add the astragalus root, shallots, garlic, carrot, and peppercorns, cover with water, and bring to a boil. Turn the heat down, half-cover the pot with the lid, and simmer on very low heat for 1½ hours.

2 Remove the pot from the heat, remove the quails, and set aside to cool slightly. Strain the soup through a sieve and reserve the liquid. Discard the astragalus root and carrot slices and reserve the rest of the ingredients in the sieve. Measure the soup and return it to the pot.

3 When the quails are cool enough to handle, carefully remove the meat from the bone, shred it with 2 forks, and return it to the pot. If the birds are from wild stock, look for lead shot and discard any shot you find while you shred the meat. Squeeze the garlic cloves and shallots from their skins directly into the soup.

4 Adjust the quantity of soup by adding more water if needed to make 3½ cups of soup. Bring the soup back to a boil, add the goji berries, and lower the heat to a simmer.

5 Add the shiitake mushrooms, followed by the wakame seaweed and barley miso paste. Let the soup simmer for 10 minutes, then add the buckwheat noodles and let them cook through for 5–7 minutes.

6 Pour into serving bowls, garnish with the parsley, and serve with some rye bread on the side.

QUAIL
copper and iron

SHIITAKE MUSHROOMS
panthothenic acid (vitamin B₅)

GOJI BERRIES
pyridoxine (vitamin B₆)

INCREASE YOUR ENERGY

THESE THREE FOODS, ARMED WITH THEIR RESPECTIVE NUTRIENTS, HELP BOOST THE METABOLISM'S ABILITY TO GENERATE ENERGY.

Sweet Potato And Celeriac Soup

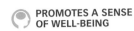 **PROMOTES A SENSE OF WELL-BEING**

 HELPS MAINTAIN ENERGY LEVELS

 HELPS IMPROVE CIRCULATION

 SUPPORTS HEALTHY KIDNEY FUNCTION

Root vegetables and spices are the essential ingredients in this comforting, warming, and healthy soup. These foods increase your energy levels, boost the circulatory system, aid digestion by promoting bowel regularity. They also strengthen the kidneys and enhance urine output. Turmeric also benefits muscles and joints and helps to alleviate any inflammation.

SERVES 6

1 tbsp ghee, or clarified butter

1 onion, finely chopped

1 garlic clove, chopped

1 tsp coriander seeds, crushed

½ tsp turmeric powder or ground turmeric root

½ tsp chili flakes

2 sweet potatoes (9oz/250g total weight), peeled and diced

1 celeriac (14oz/400g total weight), peeled and diced

4 cups vegetable stock

salt and freshly ground black pepper

⅓ cup natural yogurt

2 tbsp pumpkin oil

a small handful of cilantro leaves, chopped

1 Melt the ghee and a little water in a large, heavy saucepan with a lid over medium heat, then add the onion and cook until soft. Add the garlic, coriander seeds, turmeric powder, and chili flakes and stir. Add the sweet potato and celeriac, cover, reduce the heat, and let sweat for 5 minutes, making sure they don't discolor. Add the stock and bring to a boil, then reduce the heat, cover, and simmer over low heat for 30 minutes, or until the vegetables are tender.

2 Remove the pan from the heat, let the soup cool slightly, season with salt and black pepper to taste, and use an electric hand blender to blend to a smooth consistency. Alternatively, purée the soup in several batches in a food processor or blender.

3 Transfer the soup to 6 serving bowls, stir a spoonful of yogurt into each portion, drizzle each with a little pumpkin oil, scatter with cilantro, and serve.

WILD GARLIC SOUP

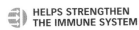 **HELPS STRENGTHEN THE IMMUNE SYSTEM**

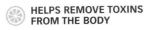 **HELPS REMOVE TOXINS FROM THE BODY**

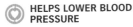 **HELPS LOWER BLOOD PRESSURE**

Sweet potato, wheatgrass, and wild garlic, all have anti-inflammatory and cleansing properties, so this is the perfect soup if you are feeling the cold or your immune system is sluggish after any winter bugs or illnesses. Wild garlic are only available in spring, so if you want to make this soup at other times of the year, substitute it with a mixture of wild arugula and spinach.

SERVES 4

1 tbsp sunflower or vegetable oil

4 medium shallots, chopped

1 medium sweet potato (about 14oz/ 400g), peeled and chopped into small cubes

2½ cups vegetable stock

1 tbsp wheatgrass juice or 1 tsp wheatgrass powder (optional)

¼ cup crème fraîche or plain yogurt, to serve (optional)

7oz (200g) wild garlic leaves

salt and freshly ground black pepper

1 Heat the oil in a medium saucepan over low heat, add the shallots and a little water, and allow the shallots to soften. Add the sweet potato and sauté for 5 minutes. Pour in the hot vegetable stock, bring to a boil, and simmer for about 15 minutes, or until the sweet potato softens.

2 Meanwhile, if using the wheatgrass juice or powder, mix it with the crème fraîche or yogurt in a small bowl.

3 Remove the pan from the heat, pour the mixture into a blender or food processor, and purée until smooth. Add the wild garlic and purée again until smooth. Season to taste. Pour the soup into 4 individual serving bowls, swirl a tablespoon of crème fraîche or yogurt into each portion, and serve.

Wild garlic (p82) *is a seasonal leafy food that is easy to digest and can be eaten cooked or raw.*

CARROT AND COCONUT SOUP

 AIDS HEALTHY DIGESTION 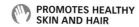 **PROMOTES HEALTHY SKIN AND HAIR** **HELPS EASE RHEUMATIC PAIN** 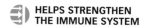 **HELPS STRENGTHEN THE IMMUNE SYSTEM**

With the combined powers of carrot and coconut, this soup enhances the digestive system, soothes inflammation, and protects against premature aging and degenerative diseases. Carrots are also a traditional remedy for conditions such as acne and rheumatism, while coconuts promote a healthy complexion, glossy hair, and support the health of the immune system.

SERVES 4

1 tbsp coconut oil
3 shallots, chopped
½lb (250g) carrots, chopped
2 garlic cloves, crushed
3 cups coconut water
juice and zest of ½ lime
salt and freshly ground black pepper
4 tsp coconut milk
a small handful of cilantro leaves, chopped, to garnish

1 Heat the coconut oil in a saucepan over medium heat, add the shallots, and cook until translucent. Add 3 tablespoons water and the carrots and sweat for 2–3 minutes. Add the garlic and cook for 15 more minutes or until the carrots are soft. Add more water if needed.

2 Pour the contents of the saucepan into a blender or food processor, add 2 cups of the coconut water, and blend. Return the blended soup to the pan and add more coconut water until you achieve a consistency you like. Heat the soup through gently (there is no need to bring it to a boil). Add the lime juice and zest, season with salt and black pepper to taste, and divide among 4 serving bowls. Swirl a teaspoon of coconut milk into each portion and garnish with the chopped cilantro leaves.

BEET SOUP

 HELPS LOWER BLOOD PRESSURE **PROMOTES A HEALTHY DIGESTIVE TRACT** **BOOSTS IRON STORES TO COMBAT FATIGUE** **HELPS STRENGTHEN THE IMMUNE SYSTEM**

Good for balancing blood pressure, this soup also enhances circulation and relieves constipation. Antioxidant-rich beets are traditionally used in many parts of Europe as a nourishing food for patients who are recovering, to help combat fatigue, improve digestion, and support healthy immunity. Lemon thyme is antibacterial and helps to combat lingering infections.

SERVES 4–6

3 tbsp olive oil
1 medium onion, minced
salt and freshly ground black pepper
1 medium leek, cut in short thin strips
3 medium beets, peeled and grated
1 large carrot, grated
2 garlic cloves, crushed
3½ cups hot vegetable stock
2–3 tsp chopped lemon thyme leaves
2 tbsp plain yogurt

1 Heat the olive oil in a large saucepan over medium heat, add the onion along with a pinch of salt, and cook until translucent. Add the leek and let soften, then add the other vegetables and garlic and cook for a further 2–3 minutes.

2 Add the stock and simmer for about 20 minutes, or until the vegetables are soft. Add the thyme 5 minutes before the end of cooking and season to taste. Divide the soup among 4 serving bowls and swirl a little yogurt into each portion just before serving.

PUY LENTIL SOUP WITH FRESH TURMERIC

 HELPS EASE JOINT INFLAMMATION **HELPS LOWER CHOLESTEROL** 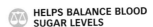 **HELPS BALANCE BLOOD SUGAR LEVELS** 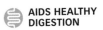 **AIDS HEALTHY DIGESTION**

The ingredients in this soup have anti-inflammatory properties, helping to relieve the swelling and pain associated with rheumatic and arthritic pain. Lentils help to lower "unhealthy" (LDL) cholesterol levels and balance blood sugar levels too, and turmeric helps to improve digestion.

SERVES 4

1¼ cups puy lentils
2 tbsp sesame oil
4 banana shallots, finely chopped
salt
1¼in (3cm) piece each fresh ginger and turmeric, peeled and sliced
1 chile, seeded and minced
2 tsp cumin seeds, crushed
½ tsp coriander seeds, crushed
½ tsp ground turmeric
2 garlic cloves, crushed
2½ cups vegetable stock
¼ cup chopped cilantro leaves

1 Although puy lentils can be cooked without soaking, it's worth doing so for at least 2 hours to make them more easily digestible. Rinse thoroughly afterward.

2 Heat the sesame oil with 3 tablespoons of water in a Dutch oven over medium heat. Add the shallots and a pinch of salt and cook until they have softened. Add the fresh ginger and fresh turmeric, followed by the chile, cumin seeds, coriander seeds, ground turmeric, and garlic.

3 Add the lentils and stir until coated. Cook for 1–2 minutes to let them absorb the flavors of the spices and shallots, then pour in the stock and bring to a boil. Reduce the heat and let the lentils simmer for about 20 minutes. Scatter with the chopped cilantro and serve with Flat Bread with Sweet Potato (p327) on the side.

WATERCRESS AND FLAXSEED SOUP

 AIDS HEALTHY DIGESTION **HELPS CLEAR CONGESTION** 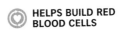 **HELPS BUILD RED BLOOD CELLS** 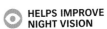 **HELPS IMPROVE NIGHT VISION**

Pungent, bittersweet watercress is an excellent digestive and is most beneficial when eaten raw or in soups. It also helps moisten the respiratory tract, making this warming soup an excellent remedy if you have a sore throat or lung infection. Eaten regularly, this soup can help boost iron levels, improve night vision, support healthy kidney function, and improve skin condition.

SERVES 4

1 leek, finely chopped
2 small zucchini, diced
1 garlic clove
salt and freshly ground black pepper
5½oz (150g) watercress
3 level tbsp flaxseeds and 1 tsp coriander seeds, crushed to a powder in a coffee grinder or blender
2 tbsp extra virgin olive oil
¼ cup Greek-style yogurt (optional)

1 Place the leek and zucchini in a medium saucepan with enough water to cover the bottom of the pan. Sweat for 5–10 minutes over low heat, stirring occasionally, and adding more water if needed to prevent the vegetables from sticking to the bottom of the pan.

2 When the vegetables are tender, add the garlic and salt. Transfer the mixture to a blender or food processor, add 2 cups hot but not boiling water, and purée.

3 Add the watercress, 1 tablespoon of the flaxseed and coriander seed powder, and the extra virgin olive oil, and purée until smooth. Season to taste, then transfer the soup to 4 serving bowls, add a spoonful of yogurt to each, if using, sprinkle with the remaining seed powder, and serve.

RAW TOMATO SOUP

 HELPS LOWER BLOOD PRESSURE

 TONES AND CLEANSES THE LIVER

 HELPS CLEAR CONGESTION

 HAS AN UPLIFTING EFFECT

Comprising more than 90 percent water and rich in antioxidants, tomatoes cleanse the liver, purify the blood, and are cooling and hydrating. They are useful in treating high blood pressure accompanied by red eyes and headaches. The freshly juiced basil in this recipe enhances digestion, helps clear respiratory congestion and phlegm, and can lift the mood.

SERVES 4

8 large ripe tomatoes
2 stems of basil
8 celery stalks
1 red chile, seeded and minced
2 small garlic cloves, roughly chopped
2 tbsp extra virgin olive oil
salt and freshly ground black pepper

1 Using a sharp knife, cut a light cross through the skin at the top of each tomato, then place the tomatoes in a bowl and cover with hot water. Let the water cool a little, then drain. Peel the skins off the tomatoes, cut into quarters, and remove the seeds. Dice the flesh and place it in a blender or food processor.

2 Remove the basil leaves from their stems and reserve the leaves as a garnish. Juice the basil stems with the celery stalks in a juicer and add the juice to the blender, along with the chile and garlic.

3 Blend the ingredients until smooth. Add the olive oil, season to taste, and blend once more. Pour the soup into 4 serving bowls. Garnish with the basil leaves, tearing them roughly with your fingers if they are large, or leaving them whole if they are small, and serve.

Basil has a reputation in traditional Chinese medicine for "restoring vital spirits, quickening the brain, and awakening joy and courage." Its oil has a powerful anti-inflammatory effect.

MUNG BEAN AND SPINACH SOUP

 HELPS LOWER BLOOD PRESSURE　　 **AIDS DETOXIFICATION SYSTEM**　　 **HELPS EASE CONSTIPATION**

If you suffer from high blood pressure, headaches, or constipation, or are in need of a detox, try this soup. Mung beans contain lots of fiber and potassium, both of which help lower blood pressure. They also have detoxifying properties and are anti-inflammatory, as is iron-rich spinach. Plan ahead and soak the beans overnight or sprout them for 3 days before cooking.

SERVES 4

1 cup mung beans

5 small shallots, finely chopped

¾in (2cm) piece fresh ginger, finely chopped

2 garlic cloves, finely chopped

½ tsp turmeric powder

½ tsp crushed coriander seeds

1 tbsp olive oil

3½ cups vegetable stock, or your choice of broth (pp323–325), or water

3 cups baby spinach leaves

juice of 1 small lime

salt and freshly ground black pepper

2 tbsp chopped cilantro leaves, to garnish

1 Soak the beans following package directions or sprout them for 3 days (p204).

2 Pour a thin layer of water into a medium saucepan, set over medium heat, and bring to a simmer. Reduce the heat, add the shallots, ginger, garlic, turmeric powder, and coriander seeds, and cook over low heat, stirring occasionally and adding a little more water if necessary. Meanwhile, drain and rinse the beans.

3 When the shallots have softened, add a dash of water, the olive oil, and the beans to the pan. Pour in the vegetable stock, increase the heat, and bring to a simmer. If you are using sprouted beans, let the soup simmer gently for 20–25 minutes, or until the sprouts are soft. Otherwise, simmer for 30–40 minutes, or until the cooked soaked beans fall apart. Stir in the baby spinach leaves and add the lime juice.

4 Serve the soup as it is, or purée to a smooth consistency using an immersion hand blender or in a food processor or blender. Add salt and black pepper to taste just before serving (adding salt to beans while you cook them makes them harder), then transfer to 4 serving bowls and garnish with the chopped cilantro leaves.

Limes (p40) contain high levels of vitamin K, which stimulates the liver to support blood coagulation.

SOUPS

EVEN THE **SIMPLEST** INGREDIENTS CAN BE QUICKLY
TRANSFORMED INTO EASY-TO-DIGEST SOUPS THAT
STIMULATE, **PROTECT**, **DETOX**, AND **STRENGTHEN**.
WARM YOURSELF UP—OR COOL YOURSELF DOWN—
WITH THESE SATISFYING BLENDS.

SPICY CRACKERS

 PROMOTES BOWEL REGULARITY

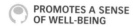 **PROMOTES A SENSE OF WELL-BEING**

Seeds are packed with protein for energy and fiber to boost digestive health. Here flaxseeds, chia seeds, and black and white sesame seeds (ingredients in furikake, a dried Japanese condiment) are enlivened by flavorsome tomatoes, spices, and herbs. Drying or baking the seed mixture on very low heat to make "raw" crackers means the seeds retain more of their beneficial nutrients.

MAKES 50 CRACKERS

1¼ cups whole flaxseeds

⅓ cup cracked flaxseeds

⅓ cup whole chia seeds

2 tablespoons furikake (or black and white sesame seeds)

¼ cup sun-dried tomatoes (not in oil) or tomato paste

salt and freshly ground black pepper

chili flakes, to taste

1 tsp dried Italian seasoning (basil, thyme, and garlic powder), or similar mixed herbs

10oz (300g) tomatoes

1 Mix the seeds and furikake together in a bowl. Pulse the sun-dried tomatoes, if using, to fine pieces in a food processor or blender. Add the tomato pieces or the tomato paste to the seeds and season with salt, black pepper, chili flakes, and the dried mixed herb seasoning. Mix everything thoroughly, taste, and adjust the seasoning if necessary.

2 Place the fresh tomatoes in a food processor or blender and pulse to a fine purée. Gradually mix this fresh tomato purée into the dry seed mixture with a wooden spoon.

3 Divide the cracker mixture into 3 equal batches and spread it thinly (⅛–¼in/2–4mm thick) onto 3 silicone baking mats or sheets of parchment paper. Score the surface of the seed mixture into small triangles, squares, or rectangles to define the shape and size of the crackers.

4 If you have a dehydrator, place the crackers in it and dry at 113°F (45°C) for 6–7 hours, turning them halfway through. If you don't have a dehydrator, preheat the oven to 120°F (50°C). If using parchment paper or silicone baking mats, cover the top of the cracker layer with another sheet of parchment. Place the crackers in their parchment or on the silicone baking mats onto cookie sheets and bake for 2 hours. Remove the cookie sheets from the oven and carefully turn each cracker layer over to dry out the bottom. Remove from the parchment paper or silicone baking mats, place the cracker layers directly on the oven racks, and bake for a further 1 hour. Remove from the oven and allow to cool.

5 Once cool, break along the scored lines to make individual crackers. Store in airtight containers. They will keep for up to 2 weeks.

TIP: Rather than choosing sun-dried tomatoes stored in oil, look for ones that are packaged like dried fruit; they have a drier texture that is excellent for this recipe.

TOMATO CRACKERS

 HELPS KEEP BLOOD VESSELS SUPPLE 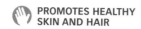 **PROMOTES HEALTHY SKIN AND HAIR** **AIDS HEALTHY DIGESTION**

These crackers are a great substitute for other savory snacks, and are full of health benefits. Flaxseed and tomatoes help improve blood circulation and maintain the health of blood vessels. They also help nourish the skin, help restore dull, unruly hair, and soften and strengthen dry, brittle nails. Chew the crackers well to benefit from the rich healing oil in the flaxseeds.

MAKES 50

1½ cups whole flaxseeds
1 tsp dried oregano
heaped 1 cup sun-dried tomatoes (not in oil)
⅓ cup cracked flaxseeds
10oz (300g) tomatoes
salt and freshly ground black pepper

1 Take ⅓ cup of the whole flaxseeds, place them in a food processor or blender, add the oregano, grind to a fine consistency, and empty into a bowl. Add the sun-dried tomatoes to the food processor, pulse to fine pieces, and transfer to the bowl. Add the rest of the whole and the cracked flaxseeds to the bowl and mix.

2 Add the fresh tomatoes to the food processor and pulse. Add the puréed tomatoes to the dry ingredients, season with the salt and pepper, and mix everything together well with a wooden spoon.

3 Taste and adjust the seasoning as required, then set the mixture aside for 2–3 hours for the seeds to partly absorb the liquid. When the mixture has thickened and is sufficiently dry yet pliable, divide into 3 equal parts.

4 Spread the cracker mixture thinly (⅛–¼in/2–4mm thick) over 3 silicone sheets or sheets of parchment paper. Score the surface of the cracker mixture into small triangles, squares, or rectangles with a sharp knife to define the shape and size of the crackers.

5 If you have a dehydrator, set it to 113°F (45°C) and dry the crackers for 6–7 hours, turning them halfway through. Otherwise, preheat the oven to its lowest setting—120°F (50°C) or lower. Cover the top of the cracker layer with another sheet of parchment paper and bake for 2 hours. Carefully turn each cracker layer over, remove the parchment paper or silicone sheets, place the cracker sheets directly onto the oven racks, and bake for 1 hour more. Remove from the oven and allow to cool for 6–7 hours, turning the cracker sheets over halfway through so they dry out completely.

6 Once cool, break along the scored lines to make individual crackers. Store in an airtight container and consume within 1–2 weeks.

SPROUTED MEDLEY

 PROMOTES HEALTHY SKIN

 PROMOTES EFFICIENT METABOLISM

 HELPS MAINTAIN ENERGY LEVELS

 AIDS HEALTHY DIGESTION

This healthy snack is full of enzymes, flavor, and vital nutrients: germinated seeds provide amino acids to support skin and cell regeneration in the body and boost energy levels and digestion. They may also help fight the signs and symptoms of premature aging. For this dish, prepare a little ahead—3 types of sprouts are used and they all take different amounts of time to sprout.

SERVES 6

1 tbsp alfalfa seeds
½ tbsp celery seeds
1 tbsp clover seeds
½ tbsp radish seeds
¼ cup green or Puy lentils
¼ cup mung beans
2 tbsp millet
2 tbsp wheat grain
2 tbsp quinoa
¼ cup sunflower seeds

For the dressing

2 tbsp chopped lemon thyme leaves
3 tbsp toasted sesame oil
2 tbsp orange juice
1 tbsp tamari soy sauce
1 tsp honey

1 When you sprout each type of seed, legume, or grain, put it into a separate 3½–5½-cup wide-mouthed jar and cover with cheesecloth, securing the cloth in place with a rubber band. To drain the water from a jar, pour it out through the cheesecloth cover. Pour fresh tepid water into the jar through the cloth, and drain in the same way.

2 Half-fill the jars of alfalfa, celery, clover, and radish seeds with tepid water and place them away from direct sunlight at room temperature for 5 hours. Drain, rinse, and drain again, then let the seeds stand without water for 8–12 hours. Rinse and drain the seeds twice a day for the next 6 days. On the seventh day, rinse and drain the seeds and leave the jars in broad daylight for 12 hours to increase their chlorophyll content. The sprouted seeds should have expanded to 8 times their original size.

3 Half-fill the jars of lentils and mung beans with tepid water, place the jars away from direct sunlight at room temperature, and let soak overnight. Drain, then rinse and drain twice a day for 3 days. The sprouted legumes will expand to 2–3 times their original size.

4 Half-fill the jars of millet, wheat, and quinoa with tepid water, place the jars away from direct sunlight at room temperature, and let soak overnight. Drain, then rinse and drain twice a day for 2 days, or until they sprout small "tails" no bigger than the grains themselves.

5 Half-fill the jar of sunflower seeds with tepid water, place the jar away from direct sunlight at room temperature, and let soak overnight. Drain, then rinse and drain the seeds twice at 6-hourly intervals. Sunflower seeds have a delicate filmlike skin that detaches from the seed during sprouting. Remove the cheeecloth cover and skim as many of these skins off the surface of the water as you can while you rinse the seeds, because they quickly spoil and can cause the sprouts to rot. Leave to sprout for 18 hours or until the seeds have a ¼–½in (5mm–1cm) long "tail" and a crunchy texture.

6 Mix all the ingredients for the dressing together in a small bowl. Drain the sprouts and serve them as 3 different medleys in separate serving bowls: alfalfa, celery, clover, and radish sprouts in the first; lentil and mung bean sprouts in the second; and sunflower, quinoa, wheat, and millet sprouts in the third. Combine each of these medleys with one-third of the dressing, and invite the guests to graze.

KALE CHIPS

 PROMOTES A HEALTHY DIGESTIVE TRACT **HELPS LOWER CHOLESTEROL** 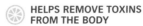 **HELPS REMOVE TOXINS FROM THE BODY**

Kale, which retains its vibrant color when dried (rather than baked), supports the body's detoxification processes and helps to lower levels of "unhealthy" (LDL) cholesterol in the blood. Its high fiber content also improves digestion and benefits intestinal health. Drizzling lemon juice on the leaves and leaving them to stand enhances their concentration of phytonutrients.

MAKES 3½OZ (100G)

1lb 2oz (500g) kale, tough stems removed, and the leaves torn into bite-sized pieces

juice of 1 lemon

1 tbsp extra virgin olive oil

¼ tsp salt

½ tsp garlic powder

1 Place the kale in a large bowl, add the lemon juice, and set aside for 30 minutes. Add the olive oil, salt, and garlic powder and combine well.

2 If you have a dehydrator, set it to 104°F (40°C). Cover the silicone sheets with parchment paper and arrange the leaves on top, ensuring they don't touch. Dehydrate for 6–8 hours, turning them halfway through. When dry, store in an airtight jar and consume within 2 days.

3 Otherwise, preheat the oven to its lowest setting—120°F (50°C) or lower. Arrange the leaves on large rimmed baking sheets, making sure they don't overlap. If they won't all fit, make the chips in batches. Dry in the oven for 1–2 hours or until the leaves are dry and crisp, switching the baking sheets from back to front and top to bottom halfway through, and turning the leaves over if needed.

YELLOW SUMMER SQUASH CHIPS

 HAS A DIURETIC ACTION **AIDS HEALTHY DIGESTION** 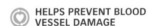 **HELPS PREVENT BLOOD VESSEL DAMAGE**

Yellow squash, like other summer squashes, have cooling, refreshing properties, and are a mild diuretic. Here they are marinated in warming, heart-friendly spices and then dried to make healthy snacks. The trick is to slice them thinly so that they dry out more quickly and turn crisp. Smaller summer squash with mild-tasting yellow skins are best, but any summer squash will work well.

MAKES 1LB (450G)

juice of 3 lemons

3 medium yellow squash, thinly sliced

For the spice powder

1 tsp coriander seeds

1 tsp cumin seeds

¼ tsp ground turmeric powder

¼ tsp chili powder

¼ tsp ground ginger

¼ tsp garlic powder

½ tsp Himalayan pink salt, or sea salt

1 For the spice powder, dry-fry the coriander and cumin seeds over medium heat until their aromas develop. Transfer to a mortar and pestle, grind to a powder, and combine with the spice powders and salt.

2 Pour the lemon juice into a large bowl, add 1½ tsp of the spice powder, and mix to a thin consistency, adding more lemon juice if necessary. Add the squash and combine well. Set aside for 1 hour.

3 Cover silicone sheets or baking sheets with parchment paper and arrange the squash slices on top. If using a dehydrator, set it to 104°F (40°C) and dry the slices for 10–12 hours, turning them halfway through.

4 Otherwise, preheat the oven to its lowest setting—120°F (50°C) or lower—and dry the slices for 1–2 hours or until crisp, turning them halfway through. Store in an airtight jar and consume within 1 week.

BUTTERNUT SQUASH AND WALNUT BITES

 PROMOTES A SENSE OF WELL-BEING

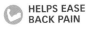 **HELPS EASE BACK PAIN**

AIDS HEALTHY DIGESTION

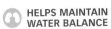 **HELPS MAINTAIN WATER BALANCE**

Astringent walnuts and creamy butternut squash promote a sense of well-being, support bone and muscle health, and benefit the digestive and urinary systems. Tamari sauce—a Japanese dark soy sauce—helps give these bites a complex depth of flavor. You can turn this into a light meal for four people, if you like, by simply tossing the cooked bites in some salad leaves.

SERVES 8–10 (ABOUT 30 BITES)

½ cup walnut halves
1 medium-sized butternut squash, peeled and seeded
2 garlic cloves, minced
2 tbsp olive oil
2 tbsp tamari soy sauce

1 Count how many walnut halves you have, then cut the squash into the same number of small cubes, making sure each cube is just big enough for a walnut half to sit on top of it. Place the cubed squash in a bowl. Add the walnuts, garlic, olive oil, tamari soy sauce, and 1 tablespoon of water, and mix well. Set aside to marinate for 1–2 hours.

2 Preheat the oven to 350°F (180°C). Transfer the marinated squash and walnuts to a baking dish arranging them in a single layer. Cover with foil and bake in the oven for 20–30 minutes.

3 Arrange the squash cubes on a serving dish, decorate each with a walnut half, and serve as a finger food with drinks.

Walnuts *(p93) contain beneficial oils that promote healthy skin and hair.*

EGGPLANT DIP

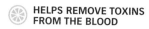 **HELPS REMOVE TOXINS FROM THE BLOOD** **HELPS EASE MENSTRUAL CRAMPS** **HAS A DIURETIC ACTION**

The eggplant in this dip is rich in dietary fiber, which can help to remove toxins from the blood. Eggplant is also great for easing premenstrual and menstrual symptoms, and the addition of fatty-acid rich Rose and Fennel Seed Oil (p333) makes this dish a particularly good choice for abdominal cramps and water retention. Serve with Ajvar (opposite) as part of a mezze, if you like.

SERVES 4–6 AS PART OF A MEZZE

3–4 large eggplants (total weight approximately 2¼lb/1kg)

1 medium onion, chopped

4 garlic cloves, crushed

½ tsp chili flakes

1 tbsp olive oil, or Rose and Fennel Seed Oil (p333)

½ cup sour cream

2 tbsp chopped cilantro leaves, to garnish

1 Preheat the oven to 350°F (180°C). Prick the eggplants all over with a fork. Place on a baking sheet and bake for 1 hour or until tender and the skins are blackened. Remove from the oven, transfer to a ceramic bowl, cover with plastic wrap, and leave to sweat (so the blackened skins can be removed more easily). When cool enough to handle, remove the skins and roughly chop the cooked flesh. Place in a colander to drain— there will be a lot of excess juice. Leave to drain while you prepare the other ingredients and when you are ready to use them, press the eggplant pieces down gently to remove the last of the juices (too much liquid will result in a watery dish).

2 Heat 3 tablespoons of water in a skillet, add the onion and garlic, and sauté over medium heat for 3–4 minutes, or until the onion is soft and translucent, adding a dash of water if necessary. Add the chili flakes and olive oil or Rose and Fennel Seed Oil blend, stir well, and transfer the mixture to a mixing bowl or a blender or food processor (you can use a hand-held immersion blender if you have one, to blend the ingredients in the bowl). Add the chopped eggplants and sour cream and mix or purée to a smooth paste.

3 Transfer to a serving bowl, garnish with the chopped cilantro leaves. This dip is good served as part of a mezze, with chunks of French bread and a green salad for lunch, or with melba toast as a starter.

MUSHROOM AND CHESTNUT BITES

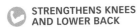 **STRENGTHENS KNEES AND LOWER BACK**

 PROMOTES A SENSE OF WELL-BEING

 PROMOTES A HEALTHY DIGESTIVE TRACT

These bites make great party canapés and are a tasty vegetarian alternative to sausage rolls. Chestnuts and hazelnuts are traditionally considered to be a tonic for the body, including muscles and joints. Shallots, oregano, and parsley bring the added benefit of helping to boost energy levels. Oregano and shallots can aid the body's digestion of the puff pastry in this recipe, too.

MAKES 24

1 tbsp olive oil, plus extra for greasing

5 small shallots, finely chopped

heaped ½ cup hazelnuts, toasted, finely chopped

3½oz (110g) chestnuts, cooked, peeled, and finely chopped

6oz (175g) button mushrooms, chopped

salt and freshly ground black pepper

1 tbsp chopped parsley leaves

½ tsp dried oregano

12oz (350g) store-bought puff pastry

1 large egg, beaten

1 Preheat the oven to 400°F (200°C). Place the olive oil in a medium skillet and heat gently. Add the shallots and cook over medium heat until soft and translucent. Add the hazelnuts, chestnuts, and a dash of water and mix well.

2 In a separate skillet, dry-fry the mushrooms, stirring constantly to prevent them from sticking to the bottom of the pan and burning. This process help to dry them out and concentrates their flavor. When all the mushroom juices have been released and have evaporated, transfer the mushrooms to the shallot and nut mixture, season with salt and black pepper, add the parsley and oregano, and combine all the ingredients.

3 Roll out the puff pastry to 5mm and cut it into 3 long strips, each 3in (7.5cm) wide. Spoon the mixture down the center of each strip. Brush the edges with beaten egg, roll up the pastry strips lengthwise to make long sausage shapes, and seal the edges well. Slash the top of each pastry roll with a sharp knife in criss-cross shapes and cut each roll into 8 pieces. Arrange the bites on an oiled baking sheet and bake in the oven for 10 minutes, or until golden. Serve warm or cold.

Hazelnuts (p93) are a good source of biotin, a B vitamin that supports musculoskeletal health by strengthening connective tissues.

AJVAR

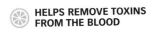 **HELPS REMOVE TOXINS FROM THE BLOOD**

 HELPS EASE MENSTRUAL CRAMPS

 AIDS HEALTHY DIGESTION

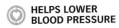 **HELPS LOWER BLOOD PRESSURE**

This traditional relish is popular in southeastern Europe. It contains bell peppers and eggplants, which boost blood circulation and help alleviate period cramps and water retention, together with chile peppers, which aid detoxification, help to lower blood pressure, and protect the heart. The bell peppers and eggplants are traditionally baked in the ashes of a barbecue.

MAKES 1LB 2OZ (500G)

6 large red bell peppers, stems removed

2 large eggplants, stems removed (and cut in half lengthwise if very wide)

½ cup olive oil

1 red chile, seeded and minced

juice of 1 lemon

2–3 garlic cloves, minced

salt and freshly ground black pepper

2 tbsp chopped cilantro leaves, to garnish (optional)

1 Preheat the oven to 450°F (230°C), if not using a barbecue. Place the peppers and eggplants on a baking sheet and bake for 25–30 minutes, or until their skins are blistering and turning black.

2 Remove from the oven, transfer to a ceramic bowl, cover with plastic wrap, and leave to sweat (so the blackened skins can be removed more easily). When cool enough to handle, remove the skins, core, and seed the peppers, and peel the eggplants. Reserve the juices in the ceramic bowl and drain the peeled eggplants in a colander to remove some excess juice, which can be discarded.

3 Transfer the peppers and eggplants to a blender or food processor and pulse to a coarse or smooth texture, depending on your preference.

4 Heat 2–4 tablespoons of the olive oil with some of the reserved juices in a large heavy saucepan over medium heat. Add the chile and then the pepper and eggplant mixture. Simmer over low heat for 30 minutes, or until the juices have thickened. Occasionally add a little more oil (retaining about 1 tablespoon) to stop the mixture from sticking to the bottom of the pan. When the mixture has thickened, add the lemon juice and garlic, let them heat through, season with salt and black pepper, and remove the pan from the heat. If eating immediately, transfer to a serving bowl and garnish with the chopped cilantro leaves. Serve with Rye Sourdough Bread (p328) as a snack or as a part of a mezze.

5 To store the relish instead, transfer to a hot, sterilized glass jar. Pour 1 tablespoon of the olive oil on top to seal the relish, fasten the lid on, label, and set aside to cool. Store in the refrigerator and use within 1 week.

6 LARGE RED BELL PEPPERS **2 LARGE EGGPLANTS** **1 RED CHILE**

BOOST CIRCULATION

BELL PEPPERS AND EGGPLANT ENCOURAGE BLOOD CIRCULATION—HELPING TO SOOTHE MENSTRUAL CRAMPS AND RELIEVE COLD EXTREMETIES OR PINS AND NEEDLES.

HUMMUS WITH CORIANDER

 **HELPS EASE
CONSTIPATION**

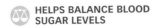 **HELPS BALANCE BLOOD
SUGAR LEVELS**

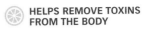 **HELPS REMOVE TOXINS
FROM THE BODY**

The high-fiber chickpeas in hummus benefit gut health, while sesame seeds act as a general tonic. For the best flavor and the most antioxidants, choose a dark variety of dried chickpeas and soak and cook them yourself; otherwise canned chickpeas are fine. Store any leftover garlic purée under a layer of olive oil in a tightly sealed jar. Refrigerate and use within 2 weeks.

MAKES 1LB (450G)

14oz (400g) chickpeas, cooked, drained, and rinsed, or 14oz can chickpeas, drained and rinsed

3 tbsp dark tahini paste

juice of ½ lemon

1 tsp coriander seeds, very finely crushed

½ tsp smoked paprika

1 tbsp extra-virgin olive oil

salt and freshly ground black pepper

2 tsp black sesame seeds (or use white sesame seeds instead)

1 tbsp pomegranate seeds, to garnish

a small bunch of cilantro leaves, finely chopped, to garnish (optional)

For the garlic purée

2 heads garlic, cloves separated and peeled

½ cup olive oil

1 tbsp white wine

½ tsp chopped thyme leaves

½ tsp chopped rosemary leaves

1 Preheat the oven to 325°F (170°C). To make the garlic purée, place the garlic cloves in a small baking dish, add the olive oil, wine, thyme, and rosemary, cover the dish with a lid or foil, and bake for 40 minutes, or until the garlic cloves are soft. Pulse the softened mixture briefly in a food processor or blender to make a purée.

2 To make the hummus, put 1 tablespoon of the garlic purée and the rest of the ingredients except the sesame seeds in a food processor or blender, and pulse to a semicoarse paste. Add the sesame seeds, taste the hummus, and add more seasoning and/or lemon juice if needed. If the mixture is quite dry, add a little water to loosen it. If you prefer a very smooth texture, use a hand-held stick blender and add the sesame seeds along with the rest of the ingredients. Serve in a bowl scattered with pomegranate seeds and garnished with cilantro leaves, if using.

EZZE

 HELPS IMPROVE CIRCULATION

 AIDS HEALTHY/OPTIMAL DIGESTION

 HELPS STRENGTHEN THE IMMUNE SYSTEM

This hot Bhutanese relish brings together the therapeutic properties of chiles, onions, garlic, cilantro, and tomatoes to help stimulate blood circulation and enhance the digestive system. It is also a good food to eat in winter to bolster your immune system. The large chiles used here are not as hot as some smaller varieties, but if you prefer a milder relish, substitute them for bell peppers.

SERVES 4

3 large tomatoes

5 large red chiles, seeded and minced

5 large green chiles, seeded and minced

1 large red onion, finely chopped

3 garlic cloves, crushed

a small bunch of cilantro leaves, chopped

juice of ½ lime

1 tbsp extra virgin olive oil

salt and freshly ground black pepper

1 Cut a cross on the top of each tomato with a sharp knife, then dip the tomatoes in a bowl of boiling water for 20 seconds. Remove with a slotted spoon and, when cool enough to handle, remove the skins and finely chop the flesh. Transfer to a large bowl.

2 Add the chiles, onion, garlic, cilantro leaves, and lime juice to the mixing bowl. Pour in the olive oil, mix well, and season to taste with salt and black pepper. Serve with Cabbage Momos (p235), or with other snacks as a sauce.

Chiles (p56) have antioxidant and anti-inflammatory properties, which means they can help lower cholesterol and balance blood sugar levels.

SNACKS

WHY WASTE TIME ON EMPTY CALORIES? THESE **NUTRIENT-DENSE** NIBBLES ARE GREAT ON THEIR OWN OR FOR DAYS WHEN YOU NEED SOMETHING EXTRA TO **SUSTAIN YOU**. YOU COULD ALSO TRY THEM AS DELICIOUS SIDE DISHES.

WARM CHICKEN CONGEE

 SOOTHES UPSET STOMACHS

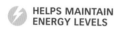 **HELPS MAINTAIN ENERGY LEVELS**

Congee is a soothing, nourishing food for anyone recovering from gastric upsets or recuperating from exhaustion and illness. This Chinese dish is traditionally made by gently simmering rice and water on the lowest possible heat for up to 6 hours, stirring regularly to prevent it from sticking. This recipe is an adaptation of the original and cooks in half the time or less.

SERVES 4–6

1 organic free-range chicken, about 3¼lb (1.5kg)

1 cup long grain or basmati brown rice

2in (5cm) piece of fresh ginger, grated

1 tbsp tamari soy sauce

1 tbsp sesame seed oil (toasted sesame seed oil is fine)

sea salt and freshly ground black pepper

2 tbsp finely chopped scallions, to garnish

2 tbsp finely chopped cilantro leaves, to garnish

1 Place the chicken, rice, and ginger in a large, heavy saucepan with a lid. Cover the ingredients with water and bring to a boil. Then reduce the heat to low and gently simmer for 1½–3 hours, or until the chicken meat is falling off the bones and the rice is soft. Add more water if necessary during cooking to prevent the congee from boiling dry. Congee should have a thick souplike consistency.

2 Remove the pan from the heat, transfer the chicken to a plate, and carefully remove the bones and skin. Shred the chicken meat and return it to the pan. Add the tamari soy sauce, sesame oil, and sea salt and black pepper to taste, and stir to combine.

3 Divide the congee among 4 serving bowls, garnish with the scallions and cilantro leaves, and serve.

TIP: Tamari is a type of soy sauce that contains little or no wheat, making it a good, gluten-free choice.

SWEET SAFFRON RICE WITH CARDAMOM

 HELPS IMPROVE CIRCULATION

 FIGHTS AGE-RELATED VISION LOSS

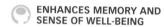 **ENHANCES MEMORY AND SENSE OF WELL-BEING**

This is a version of desi, a sweet rice eaten on the first morning of the new year by Buddhist communities to symbolize their hopes and expectations for a new cycle of life. Supported by cardamom, the yellow pigments in saffron aid memory retention and recall, help slow age-related macular degeneration, improve blood circulation, and impart a sense of well-being.

SERVES 4–6

¾ cup jasmine or basmati rice

a pinch of salt

2in (5cm) piece of cinnamon stick

¼ cup milk

a pinch of saffron strands

2 tbsp butter, melted

1 tbsp brown sugar

½ tsp cardamom pods, crushed

zest of 1 orange

1 tbsp raisins

3 tbsp pistachio nuts, plus a few extra to garnish

2 tbsp almonds

1 Rinse the rice in a sieve under cold running water, then place in a bowl. Pour in enough water to cover, and set aside to soak for 30 minutes.

2 Drain the rice, place it in a medium saucepan, and add 1¼ cups water, the salt, and the cinnamon stick. Bring to a boil, turn the heat down, and simmer for 10–12 minutes.

3 Meanwhile, place the milk and saffron in a separate saucepan and warm gently over low heat. Add the melted butter and sugar and stir until the sugar dissolves. Add the cardamom pods and orange zest and allow all the ingredients to infuse for 2–3 minutes on very low heat.

4 Using a thick-bottomed medium saucepan, toast the raisins over medium heat for 1–2 minutes. Remove from the heat and set aside, then add the nuts, toast until golden, and remove from the heat.

5 When the rice is cooked and the water has been absorbed, add the toasted raisins and nuts and combine well. Pour in the infused milk, stir well, and cook over low heat for 1–2 minutes until the aromas and saffron color have suffused the rice.

6 Transfer to small serving bowls, heaping up the mixture to symbolize prosperity, and serve with few pistachio nuts scattered on top.

Saffron threads (p119) *have long been used in traditional medicines for their stimulating and mood-lifting qualities.*

Presoaked Barley Breakfast

 HELPS MAINTAIN ENERGY LEVELS **HELPS EASE CONSTIPATION** **RELIEVES FLUID RETENTION** **LOWERS RISK OF HEART DISEASE**

Make this "instant" energizing breakfast cereal of toasted barley before you go to bed at night and it will be ready when you get up in the morning. It is a great way to set you up for an active day. Barley is often used as a traditional remedy for nonspecific inflammatory conditions of the urinary system and, together with prunes, helps maintain bowel regularity and blood pressure.

SERVES 4

¾ cup toasted barley
2 tsp vanilla extract
¼ cup soft prunes, chopped
¼ cup maple syrup
¼ cup toasted pumpkin seeds

1 Place the toasted barley in a large heatproof resealable container (which can hold 2½–3½ cups to accommodate the threefold increase in the volume of barley grains). Add the vanilla extract and pour 1¾ cups boiling water over the barley. Seal the container and leave overnight.

2 In the morning, empty the soaked barley into a mixing bowl, stir in the soft prunes, divide the mixture among 4 serving bowls, drizzle with maple syrup, scatter with toasted pumpkin seeds, and serve.

Prunes (p24) *are renowned for promoting bowel regularity, but their high fiber content also helps to balance blood sugar levels.*

ALMOND PORRIDGE WITH APRICOTS

 HELPS LOWER CHOLESTEROL

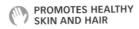 **PROMOTES HEALTHY SKIN AND HAIR**

 REPLACES IRON LOST IN MENSTRUATION

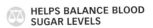 **HELPS BALANCE BLOOD SUGAR LEVELS**

This simple breakfast is a good source of iron, which helps build red blood cells so they can carry more oxygen around the body to benefit your heart, skin, hair, and general health. It is also good for replenishing iron lost during menstruation. If you don't want to prepare ahead and soak the almonds overnight first, simply grind the dry raw nuts coarsely and use store-bought almond milk.

SERVES 4

1 cup raw almonds

1 tsp vanilla extract

12 apricots, halved, with pit removed

2 tbsp maple syrup

2 tbsp chia seeds

2 tbsp flaxseeds, crushed in a mortar and pestle

1 Rinse the almonds, add them to a bowl, and pour in twice the amount of water to cover, so the nuts can swell and still remain submerged. Leave to soak overnight.

2 Strain the soaked almonds, rinse, and place in a blender or food processor. Add 2 cups water and the vanilla extract, and purée until the ingredients turn into a milky liquid.

3 Strain the liquid through a sieve, reserving the almond milk and leaving the almond meal in the sieve to drip-dry.

4 Pour enough water into a medium saucepan to cover the bottom of the pan. Add the apricots and cook over medium-high heat for 15–20 minutes, or until they soften, adding a little more water if necessary. When the apricots are soft, but not mushy, add the maple syrup, stir to combine, and remove the pan from the heat.

5 To serve, put 2 tablespoons of almond meal into each serving bowl and sprinkle each portion with ½ tablespoon each of chia seeds and crushed flaxseeds. Put some of the apricots and maple syrup on top and pour in a little of the reserved almond milk to serve.

Flaxseeds (p95) are a great source of soluble fiber that help balance blood sugar levels and suppress hunger.

BAKED OATMEAL WITH GOJI BERRIES AND CINNAMON

 EASY TO DIGEST **HELPS MAINTAIN ENERGY LEVELS** 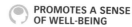 **PROMOTES A SENSE OF WELL-BEING**

Oats and goji berries are full of slow-release energy and fiber, and both contain nutrients to help support a healthy nervous system. They are also considered to be natural sedatives, helping to lift low moods and calm the nerves. The addition of cinnamon and black sesame seeds provides a warming quality that makes this an excellent dish if you are feeling weak or are recuperating.

SERVES 4

butter, for greasing
2½ cups rolled oats (not instant)
2¾ cups rice or cow milk
1 tbsp maple syrup
¼ cup goji berries
1 tsp ground cinnamon
½ cup sunflower seeds
2 tbsp black sesame seeds
a pinch of salt

1 Preheat the oven to 375°F (190°C). Generously grease a glass or ceramic ovenproof dish with the butter. Place all the ingredients in the dish, stir well to combine, and bake in the oven for 30 minutes. After 15 minutes, check the oatmeal and give it a stir, adding some hot water or more milk if it is sticking or becoming too thick and solid.

2 Remove from the oven, divide among 4 serving bowls, and serve with warmed milk.

MILLET AND QUINOA PORRIDGE WITH PLUM COMPOTE

 PROMOTES BOWEL REGULARITY

 PROMOTES METABOLIC BALANCE

 SUPPORTS HEALTHY LIVER FUNCTION

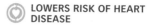 **LOWERS RISK OF HEART DISEASE**

Plums are often used in the treatment of diabetes and liver conditions—and stewed plums also help relieve constipation—while millet and quinoa benefit the metabolic balance. Although millet is one of the most easily digestible grains, sprouting it and the other grains and seeds enhances their digestibility further, and therefore the body's ability to assimilate the nutrients they provide.

SERVES 4

¼ cup quinoa, sprouted
¼ cup millet, sprouted
2 cups organic rice milk
12 purple plums, cut in half with the pit removed
1 small cinnamon stick (optional)

1 Heat the sprouted quinoa and millet with the rice milk in a small saucepan over medium heat. Bring to a boil, reduce the heat, and simmer for 10–12 minutes.

2 Meanwhile, place the plums and cinnamon stick, if using, in a separate pan, add water to cover, and simmer over low heat for 10–12 minutes.

3 Remove the cinnamon stick and discard. Divide the porridge among 4 serving bowls, spoon the plum compôte on top, and serve.

MILLET AND PEARS WITH CARDAMOM

 HELPS BALANCE BODY pH

 RELIEVES VOMITING AND DIARRHEA

 SUPPORTS HEALTHY KIDNEY FUNCTION

 HELPS ALLEVIATE MORNING SICKNESS

The soothing properties of millet, cooling pears, mind-enhancing cardamom seeds, and energy-boosting pistachio nuts are united in this comforting recipe. It's a perfect breakfast if you are suffering from acidosis (excessive acid buildup in the body), but you can enjoy its benefits any time. It is also a useful dish to eat in the days before embarking on a detox regime.

SERVES 4

1lb 2oz (500g) millet
a pinch of salt
3 pears, peeled, cored, and sliced
1 tbsp raisins
¼ tsp cardamom seeds
1 tbsp kudzu (an Asian thickener), or all-purpose flour or cornstarch
1 tsp vanilla extract
2 tbsp maple syrup
1 tbsp chopped pistachio nuts

1 Rinse the millet in cold water and drain thoroughly. Transfer to a skillet and dry-fry over medium heat until it releases a fragrant aroma.

2 Bring 2½ cups water to a boil in a medium saucepan. Add the millet and salt, reduce the heat, and simmer for 10 minutes.

3 Add the pears, raisins, and cardamom seeds to the millet and cook for 15 minutes more over low heat.

4 Dissolve the kudzu in 2 tablespoons water and add to the millet. Stir in the vanilla extract and keep stirring until the mixture thickens. Divide among 4 serving bowls, drizzle with the maple syrup, scatter the pistachio nuts on top, and serve.

QUAIL EGGS ON RYE BREAD

 HELPS MAINTAIN ENERGY LEVELS　　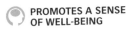 **PROMOTES A SENSE OF WELL-BEING**

As a hearty breakfast or brunch on cold winter mornings, this recipe is ideal. Quail eggs, which are considered to be an energizing food in traditional Chinese medicine, are combined here with bell peppers, chile, garlic, and chives, which have warming properties. This dish is particularly beneficial if you need to regain your strength after a prolonged illness, surgery, or childbirth.

SERVES 4–6

2 tbsp olive oil

1 small onion, finely chopped

½ red chile, minced

1 large yellow bell pepper, seeded, skinned (optional), and finely chopped

2 large tomatoes, skinned (optional), and finely chopped

1 garlic clove, crushed

salt and freshly ground black pepper

6 slices of rye bread

1 tbsp ghee, or clarified butter

6 quail eggs

1 tbsp chopped chives

1 Heat the olive oil in a medium saucepan over medium heat and sauté the onion and chile for 2–3 minutes, or until the onions soften. Add the yellow pepper and continue stirring for 2–3 minutes, then add the tomatoes, crushed garlic, and 2 tablespoons water. Cook over low heat until the mixture thickens. Remove from the heat and season with salt and black pepper.

2 Meanwhile, toast the rye bread and heat the ghee in a medium skillet. Break the eggs into the pan and fry them, removing them as soon as the whites are cooked and while the egg yolks are still soft.

3 Divide the slices of toast between 4 or 6 hot serving plates. Top each slice of toast with a spoonful of sautéed vegetables and an egg. Garnish with the chopped chives, and serve while hot.

KEFIR CHEESE WITH FLAXSEED AND BERRIES

 HELPS FIGHT INFLAMMATION　　 **HELPS IMPROVE CIRCULATION**　　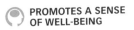 **PROMOTES A SENSE OF WELL-BEING**

This pairing of high-quality dairy produce and anti-inflammatory, omega-3-rich flaxseed oil is a twist on a healing regimen, the Budwig Diet, which helps to counter the effects of modern diets that are high in unhealthy fats. The diet has been used to treat and help prevent heart disease, diabetes, arthritis, and even cancer. The probiotic kefir cheese also helps to boost immunity.

SERVES 2

¼ cup flaxseeds

heaped ⅓ cup organic kefir cheese (p332), or use quark or cottage cheese

⅓ cup flaxseed oil

about 1⅔ cups soft berries

1 Place the flaxseeds in a food processor or blender and pulse briefly to crush them roughly.

2 Add the kefir cheese and flaxseed oil to the food processor and pulse again until combined. Transfer the mixture to 2 serving bowls.

3 Add the berries to the food processor and purée until smooth. Spoon the berry sauce onto the kefir cheese mixture in the bowls, and serve.

POACHED EGGS AND SPINACH

 BOOSTS IRON STORES TO COMBAT FATIGUE 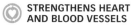 **STRENGTHENS HEART AND BLOOD VESSELS** 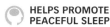 **HELPS PROMOTE PEACEFUL SLEEP**

Organic, freerange eggs are high-quality foods that, when prepared correctly by poaching or soft-boiling, provide complete nutrition. Traditionally, egg yolks are considered nourishing to the liver, heart, and kidneys, and are known to contain antioxidant amino acids that protect against heart disease. They can also help combat anemia, diarrhea or constipation, and even insomnia.

SERVES 4

1 tbsp olive oil
4 shallots, finely chopped
1 chile, seeded and minced
1 tsp ground turmeric
2 garlic cloves, crushed
¼ cup coconut cream
7oz (200g) spinach, chopped
salt and freshly ground black pepper
1 tbsp white wine vinegar
4 chicken or duck eggs
4 slices of whole wheat toast, or some cooked millet, to serve
a bunch of cilantro leaves, finely chopped, to garnish (optional)

1 Heat a tablespoon of water with the olive oil in a small saucepan over low heat. Add the shallots and chile, and cook until the vegetables are soft. Stir in the turmeric, then add the garlic and coconut cream. Cook until the coconut cream is heated through, and then add the spinach. Stir the mixture until the spinach wilts then remove from the heat. Add a pinch of salt and sprinkle with black pepper.

2 Heat a wide, shallow pan filled with water until tiny bubbles appear on the bottom (don't allow the water to boil before adding the eggs). Add the vinegar to the water to help keep the egg protein from disintegrating (the acid in the vinegar acts as a coagulant). Give the water a few swirls with a spoon, which will keep the eggs in the center of the pan. Crack each egg into a small plate or ramekin and slide into the water, just below the surface. The egg will sink to the bottom and rise as it cooks. Poach the eggs for about 3 minutes.

3 Place a piece of whole wheat toast on each plate, or fill a cook's ring with a ¾in (2cm) layer of cooked millet, and spoon some of the spinach on top. Remove the ring, if using. Place a poached egg on top of each stack and scatter with cilantro leaves, if using. Season with a little black pepper and serve immediately.

Duck eggs (p143) are traditionally believed to have a cooling, anti-inflammatory effect on the lungs, which makes them useful for asthma, dry coughs, and sore throat.

BUCKWHEAT PANCAKES WITH FRESH BERRY SAUCE

 HELPS KEEP BLOOD VESSELS SUPPLE PROMOTES A HEALTHY DIGESTIVE TRACT PROTECTS AGAINST FREE-RADICAL DAMAGE

This antioxidant-rich breakfast dish is heart-healthy and full of beneficial fiber, and contains warming cinnamon, which has antiseptic properties. For the maximum nutrients, why not grind your own flour (see Tip below); use either raw buckwheat or roasted buckwheat grains. Raspberries, cranberries, and blueberries are ideal, either on their own or in combination.

SERVES 4–6

1¼ cups fresh berries, such as raspberries, cranberries, and blueberries

1¾ cups organic buckwheat flour

1 tsp baking powder

¼ tsp rou gui (Chinese cinnamon bark) or ½ tsp ground cinnamon

a pinch of salt

1¼ cups rice milk (or milk if dairy is not an issue)

1 large egg

1–2 tbsp ghee

1 Place the fresh berries in a food processor or blender, and purée until smooth (avoid puréeing blueberries, if using, because their flavor is lost when blended with other berries). If you want the sauce to be free from seeds, strain it through a fine sieve. Set the sauce aside while you make the pancakes.

2 Mix together the buckwheat flour, baking powder, rou gui or cinnamon, and salt in a mixing bowl. In another bowl, whisk together the rice milk and egg. Gradually pour the egg mixture into the dry ingredients, whisking constantly as you do so, to form a smooth batter.

3 Heat a skillet, brush the base and sides with a knob of ghee, then ladle a little of the pancake mixture into the pan to make a thin pancake. Fry for 2–3 minutes, then toss or turn the pancake and cook it on the other side. Keep the cooked pancakes hot by stacking them on a plate set over a bowl of very hot water while you repeat with the rest of the batter.

4 Stir the blueberries, if using, into the berry sauce. Drizzle the pancakes with maple syrup and serve with the berry sauce.

TIP: Grinding your own flour is always a healthier choice because once the grains are crushed, their nutrients begin to deteriorate quickly. As a result, whole grains have a much longer shelf life than ready-milled flour, which may already be up to 1 year old by the time you buy it. Buckwheat is a soft grain (it has had the hull, or bran, already removed), so it is easy to turn into flour. Simply grind a few handfuls of grain at a time in a coffee grinder (or use a powerful food processor or blender).

Cassia bark *or "rou gui" (Cinnamon cassia or Cortex Cinnamoni) is a pungent variety of Chinese cinnamon, with properties similar to culinary cinnamon (Cinnamon zeylanicum).*

BUCKWHEAT AND BLACKBERRY CREAM

 PROTECTS THE HEART AND BLOOD VESSELS

 CONTAINS SLOW-RELEASE SUGARS

 HELPS ALLEVIATE HEAVY PERIODS

EASY TO DIGEST AND GLUTEN-FREE

This is a quick, antioxidant-rich porridge recipe. Both blackberries and roasted buckwheat help strengthen the heart, lower cholesterol, and have hemostatic properties, meaning that they help reduce the flow of blood. This makes it a good choice for women who suffer from heavy bleeding during menstruation. It can also be beneficial for men with prostate discharge.

SERVES 4

½ cup buckwheat grains
3½ cups almond milk
a large pinch of salt
4 tsp vanilla extract
2¾ cups blackberries

1 To toast the buckwheat, preheat the oven to 350°F (180°C). Spread the buckwheat grains thinly over some baking sheets and toast in the oven until they are golden. Shake the baking sheets occasionally to stop the grains from burning. Remove from the oven.

2 Place a handful of roasted buckwheat in a coffee grinder or a powerful food processor or blender, and grind into a fine meal. Repeat with the rest of the roasted buckwheat. Pour the almond milk into a small saucepan and heat it gently over low heat. Spoon in the buckwheat, add the salt and vanilla extract, and whisk thoroughly until the mixture is smooth. Cook for 5 minutes, adding more almond milk, if necessary, until you achieve the consistency you prefer.

3 Meanwhile, place the blackberries in the clean food processor or blender and purée to a smooth sauce.

4 Remove the pan from the heat and pour the buckwheat cream into 4 serving bowls. Pour the blackberry sauce on top and serve.

***Blackberries** (p30) need to be fresh, because nutrients can deteriorate with age. They contain salicylic acid, which helps protect against heart disease.*

BREAKFASTS

DON'T SKIMP ON THE MOST **IMPORTANT MEAL** OF THE DAY. FRESH FRUIT, WHOLE GRAINS, AND HIGH-QUALITY PROTEIN SET THE TONE FOR YOUR DAY WITH **BALANCING AND SUSTAINING** MEALS THAT FEED YOUR **BODY AND MIND**.

OILS, DRESSINGS, AND EXTRAS
Sauerkraut p330
Kefir Milk p332
Kefir Milk Cheese p332
Coriander and Juniper Oil p333
Basil Oil p337

◉ EYE HEALTH

BREAKFASTS
Sweet Saffron Rice With Cardamom p191

SOUPS
Watercress and Flaxseed Soup p212

LIGHT MEALS AND SALADS
Spinach and Ricotta Filo Rolls p230

MAIN MEALS
Sprouted Quinoa with Vegetables p245
Sea Bass with Spinach and

Mango p250
Chanterelles and Chiles with Pasta p267
Swiss Chard and Sweet Potato p272

SWEET TREATS

◉ MEN'S HEALTH

MAIN MEALS
Squab Breasts with Goji Berries p260
Savoy Cabbage Parcels p265
Marinated Duck with Mango Salsa p269
Venison Casserole with Cranberries p270

SWEET TREATS
Mediterranean Nut Squares in Rose and Cardamom Syrup p298

OILS, DRESSINGS, AND EXTRAS
Coriander and Juniper Oil p333

♀ WOMEN'S HEALTH

BREAKFASTS
Buckwheat and Blackberry Cream p177
Millet and Pears With Cardamom p185
Almond Porridge with Apricots p188

SNACKS
Ajvar p198
Eggplant Dip p199

MAIN MEALS
Squab Breasts with Goji Berries p260
Ginger Chicken p261
Venison Casserole with Cranberries p270

SWEET TREATS
Rose Petal and White Wine Sorbet p295

DRINKS
Blackberry Lemonade p306

OILS, DRESSINGS, AND EXTRAS
Rose and Fennel Seed Oil p333
Rose and Raspberry Vinegar p334
Basil Oil p337

Venison Casserole with Cranberries p270

Blackberry Lemonade p306

◕ MUSCLES AND JOINTS

SNACKS
Butternut Squash and Walnut Bites p200
Mushroom and Chestnut Bites p202

SOUPS
Puy Lentil Soup with Fresh Turmeric p212
Carrot and Coconut Soup p213
Sweet Potato and Celeriac Soup p216

LIGHT MEALS AND SALADS
Mushroom Frittata with Cherry Tomatoes and Basil p236

MAIN MEALS
Savoy Cabbage Parcels p265
Broiled Mackerel with Chard p275
Grilled Sardines with Tomato Salsa p276
Barlotto with Chestnut Purée p281

SWEET TREATS
Nutty Sugar Loaf p289
Cherry Strudel p293
Baked Quince p294
Sesame Heart Cookies p299

DRINKS
Barley Grass and Barley Lemonade p306
Sour Cherry Drink p308
Deep Cleansing Tea p322

OILS, DRESSINGS, AND EXTRAS
Flatbread with Sweet Potato and Coriander p327
Sourdough Rye Bread p328

◕ SKIN AND HAIR

BREAKFASTS
Feta and Oregano Squares p180
Almond Porridge with Apricots p188

SNACKS
Sprouted Medley p204
Tomato Crackers p205

SOUPS
Carrot and Coconut Soup p213

LIGHT MEALS AND SALADS
Spinach and Ricotta Filo Rolls p230
Buckwheat Pancakes with Nettles and Feta Cheese p238
Artichokes in a Sweet Spicy Sauce p239

MAIN MEALS
Spicy Raw Vegetable Spaghetti p246
Chanterelles and Chiles with Pasta p267

SWEET TREATS
Sesame Heart Cookies p299

DRINKS
Five-Flavor Juice p312
Marshmallow and Licorice Tea p320
Deep Cleansing Tea p322
Deep Nurture Tea p322

OILS, DRESSINGS, AND EXTRAS
Sourdough Rye Bread p328
Rose and Fennel Seed Oil p333
Rose and Raspberry Vinegar p334
Blackberry Vinegar p334

◕ MIND AND EMOTIONS

BREAKFASTS
Poached Eggs and Spinach p182
Quail Eggs on Rye Bread p184
Kefir Cheese with Flaxseed and Berries p184
Baked Oatmeal with Goji Berries and Cinnamon p187
Sweet Saffron Rice With Cardamom p191

SNACKS
Butternut Squash and Walnut Bites p200
Mushroom and Chestnut Bites p202
Spicy Crackers p207

SOUPS
Raw Tomato Soup p210
Quail Soup p217
Butternut Squash Soup p219

LIGHT MEALS AND SALADS
Nori Vegetable Roll p234
Fresh Cilantro Leaf Pesto with Pasta p241
Braised Red Chicory and Celery Heart Salad p243

MAIN MEALS
Vegetable Hot Pot p256
Sauerkraut Parcels p264
Savoy Cabbage Parcels p265
Grilled Sardines with Tomato Salsa p276
Fragrant Rice and Millet p283

SWEET TREATS
Fresh Fig Delight with Pear and Red Wine Sauce p285
Almond and Raspberry Cake p286
Nutty Sugar Loaf p289
Warm Fruit Salad in Sweet Wine Sauce p290
Cherry Strudel p293
Rose Petal and White Wine Sorbet p295
Mediterranean Nut Squares in Rose and Cardamom Syrup p298
Almond and Pistachio Macaroons p300
Poppy Seed and Walnut Roulade p302
Dried Fruit and Nut Roll p303

DRINKS
Sour Cherry Drink p308
Alert and Joyful Juice p313
Valentine's Special p315
Rose Syrup p315
A Cup of Happiness p317
Mint and Friends Tea p318
Marshmallow and Licorice Tea p320
Deep Sleep Tea p321
Astragalus and Schisandra Broth p324
Seaweed and Miso Broth p325

Elderberry and Black Berry Nutty Crisp p288
Cherry Strudel p293

DRINKS
Hot Lemonade with Ginger and Honey p305
Aloe and Honey Hot Toddy p305
Blackberry Lemonade p306
Health Boost Juice p310
Stay Supple Juice p312
Rose Syrup p315
Deeply Purifying Juice p317
Marshmallow and Licorice Tea p320
Deeply Warming Tea p321
Deep Nurture Tea p322
Rainbow Vegetable Broth p323
Astragalus and Schisandra Broth p324

OILS, DRESSINGS, AND EXTRAS
Sauerkraut p330
Kimchi p331
Kefir Milk p332
Kefir Milk Cheese p332
Rose and Fennel Seed Oil p333
Blackberry Vinegar p334
Turmeric and Ginger Oil p337

⚡ ENERGY BOOST

BREAKFASTS
Buckwheat and Blackberry Cream p177
Feta and Oregano Squares p180
Blackcurrant Smoothie p181
Poached Eggs and Spinach p182
Quail Eggs on Rye Bread p184
Baked Oatmeal with Goji Berries and Cinnamon p187
Presoaked Barley Breakfast p190
Sweet Saffron Rice with Cardamom p191
Warm Chicken Congee p193

SNACKS
Sprouted Medley p204

SOUPS
Beet Soup p213
Sweet Potato and Celeriac Soup p216

Quail Soup p217
Adzuki Bean Soup p220

LIGHT MEALS AND SALADS
Quail Egg and Endive Salad p224
Nori Vegetable Roll p234

MAIN MEALS
Squab Breasts with Goji Berries p260
Quinoa and Vegetable Stack p262
Savoy Cabbage Parcels p265
Salmon with Dill and Tamari Sauce p268
Marinated Duck with Mango Salsa p269
Venison Casserole with Cranberries p270
Lamb Casserole with Vegetables p279
Barlotto with Chestnut Purée p281

SWEET TREATS
Mediterranean Nut Squares in Rose and Cardamom Syrup p298
Poppy Seed and Walnut Roulade p302

DRINKS
Hot Lemonade with Ginger and Honey p305
Stay Supple Juice p312
Build-Me-Up Juice p313
Valentine's Special p315
A Cup of Happiness p317
Deep Nurture Tea p322
Rainbow Vegetable Broth p323

OILS, DRESSINGS, AND EXTRAS
Sourdough Rye Bread p328

Butternut Squash Soup p219

Beans Baked in a Pumpkin Pot p253
Kale with Buckwheat Noodles p255
Stir-fried Spring Vegetables p259
Ginger Chicken p261
Quinoa and Vegetable Stack p262
French Bean Stew p274
Broiled Mackerel with Chard p275
Grilled Sardines with Tomato
Salsa p276

DRINKS
Sour Cherry Drink p308

OILS, DRESSINGS, AND EXTRAS
Sauerkraut p330
Kimchi p331

Chanterelles and Chiles with Pasta p267

Cherry Strudel p293

IMMUNE SUPPORT

BREAKFASTS
Buckwheat Pancakes with
Fresh Berry Sauce p178
Blackcurrant Smoothie p181
Kefir Cheese with Flaxseed
and Berries p184

SNACKS
Ezze p195

SOUPS
Carrot and Coconut Soup p213
Beet Soup p213
Wild Garlic Soup p214
Butternut Squash Soup p219

LIGHT MEALS AND SALADS
Raw Curly Kale Salad p223
Mediterranean Vegetable
Medley p272
Cabbage Momos p235
Mushroom Frittata
with Cherry Tomatoes and
Basil p236
Buckwheat Pancakes with
Nettles and Feta Cheese p238

MAIN MEALS
Stuffed Peppers p252
Kale with Buckwheat
Noodles p255
Vegetable Hot Pot p256
Marinated Tofu with Shiitake
and Noodles p258
Stir-fried Spring Vegetables p259
Ginger Chicken p261
Quinoa and Vegetable Stack p262
Chanterelles and Chiles with Pasta
p267
Swiss Chard and Sweet Potato p272
Broiled Mackerel with Chard p275
Vegetable Moussaka p278
Griddled Vegetable Roll with
Cashew and Braised Garlic
Cream p282
Fragrant Rice and Millet p283

SWEET TREATS
Fresh Fig Delight with Pear
and Red Wine Sauce p285

Almond and Raspberry Cake p286

Banana and Cranberry Ice Cream p296

Sesame Heart Cookies p299

Almond and Pistachio Macaroons p300

DRINKS
Winter Wake Up p316

Deeply Warming Tea p321

OILS, DRESSINGS, AND EXTRAS

DETOX

BREAKFASTS
Millet and Quinoa Porridge with Plum Compote p185

Millet and Pears with Cardamom p185

Quail Egg and Endive Salad p224

SNACKS
Hummus with Coriander p196

Ajvar p198

Eggplant Dip p199

Kale Chips p203

SOUPS
Mung Bean and Spinach Soup p209

Raw Tomato Soup p210

Wild Garlic Soup p214

LIGHT MEALS AND SALADS
Raw Curly Kale Salad p223

Quail Egg and Endive Salad p224

Adzuki and Mung Bean Salad p226

Herring Cucumber and Seaweed Salad p227

Mediterranean Vegetable Medley p272

Trout and Lettuce Wraps p231

Cabbage Momos p235

Buckwheat Pancakes with Nettles and Feta Cheese p238

Artichokes in a Sweet Spicy Sauce p239

Fresh Cilantro Leaf Pesto with Pasta p241

Braised Red Chicory and Celery Heart Salad p243

MAIN MEALS
Mung Bean and Purple Broccoli Rabe Stir-fry p248

Beans Baked in a Pumpkin Pot p253

Vegetable Hot Pot p256

Marinated Tofu with Shiitake and Noodles p258

SWEET TREATS
Almond and Raspberry Cake p286

Warm Fruit Salad in Sweet Wine Sauce p290

Baked Quince p294

DRINKS
Aloe and Honey Hot Toddy p305

Blackberry Lemonade p306

Barley Grass and Barley Lemonade p306

Health Boost Juice p310

Cooling, Soothing Juice p310

Stay Supple Juice p312

Five-Flavor Juice p312

Build-Me-Up Juice p313

Alert and Joyful Juice p313

Winter Wake Up p316

Party Aftermath p316

Deeply Purifying Juice p317

Deep Cleansing Tea p322

Deep Nurture Tea p322

Astralagus and Schisandra Broth p324

OILS, DRESSINGS, AND EXTRAS
Flatbread with Sweet Potato and Coriander p327

METABOLIC BALANCE

BREAKFASTS
Millet and Quinoa Porridge With Plum Compote p185

Almond Porridge with Apricots p188

SNACKS
Hummus with Coriander p196

Sprouted Medley p204

SOUPS
Puy Lentil Soup with Fresh Turmeric p212

LIGHT MEALS AND SALADS
Raw Curly Kale Salad p223

MAIN MEALS
Sprouted Quinoa with Vegetables p245

Spicy Raw Vegetable Spaghetti p246

Nutty Sugar Loaf p289
Warm Fruit Salad in Sweet Wine Sauce p290
Baked Quince p294
Banana and Cranberry Ice Cream p296
Sesame Heart Cookies p299
Almond and Pistachio Macaroons p300
Dried Fruit and Nut Roll p303

DRINKS
Hot Lemonade with Ginger and Honey p305
Health Boost Juice p310
Cooling, Soothing Juice p310
Five-Flavor Juice p312
Build-Me-Up Juice p313
Party Aftermath p316
Deeply Purifying Juice p317
Mint and Friends Tea p318
Seaweed and Miso Broth p325

OILS, DRESSINGS, AND EXTRAS
Sauerkraut p330
Kimchi p331

Kefir Milk p332
Kefir Milk Cheese p332
Rose and Raspberry Vinegar p334
Turmeric and Ginger Oil p337

URINARY
BREAKFASTS
Millet and Pears with Cardamom p185
Presoaked Barley Breakfast p190

SNACKS
Eggplant Dip p199
Butternut Squash and Walnut Bites p200
Yellow Summer Squash Chips p203

SOUPS
Sweet Potato and Celeriac Soup p216
Adzuki Bean Soup p220

LIGHT MEALS AND SALADS
Adzuki and Mung Bean Salad p226
Stuffed Vine Leaves p233

Artichokes in a Sweet Spicy Sauce p239
Braised Red Chicory and Celery Heart Salad p243

MAIN MEALS
Spicy Raw Vegetable Spaghetti p246
Mung Bean and Purple Broccoli Rabe Stir-fry p248
Sea Bass with Spinach and Mango p250
Squab Breasts with Goji Berries p260
Marinated Duck with Mango Salsa p269
Venison Casserole with Cranberries p270
Swiss Chard and Sweet Potato p272
French Bean Stew p274
Lamb Casserole with Vegetables p279

SWEET TREATS
Elderberry and Blackberry Nutty Crisp p288
Banana and Cranberry Ice Cream p296
Poppy Seed and Walnut Roulade p302

DRINKS
Blackberry Lemonade p306
Barley Grass and Barley Lemonade p306
Elderberry Syrup p308
Alert and Joyful Juice p313
Party Aftermath p316
Rainbow Vegetable Broth p323
Seaweed and Miso Broth p325

OILS, DRESSINGS, AND EXTRAS
Rose and Raspberry Vinegar p334

RESPIRATORY
SOUPS
Raw Tomato Soup p210
Watercress and Flaxseed Soup p212
Butternut Squash Soup p219

SWEET TREATS
Fresh Fig Delight with Pear and Red Wine Sauce p285
Almond and Raspberry Cake p286

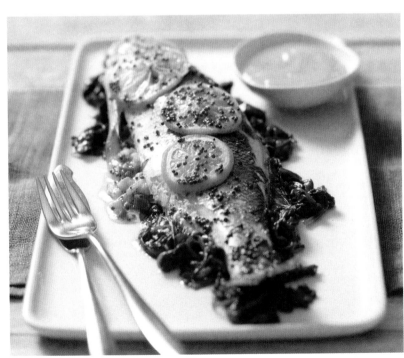

Sea Bass with Spinach and Mango p250

DRINKS

Hot Lemonade with Ginger and Honey p305
Cooling, Soothing Juice p310
Build-Me-Up Juice p313
Winter Wake Up p316
Valentine's Special p315
Deep Sleep Tea p321
Seaweed and Miso Broth p325

OILS, DRESSINGS, AND EXTRAS

Flatbread with Sweet Potato and Coriander p327
Sourdough Rye Bread p328
Coriander and Juniper Oil p333
Blackberry Vinegar p334
Turmeric and Ginger Oil p337

DIGESTION

BREAKFASTS

Buckwheat and Blackberry Cream p177
Buckwheat Pancakes with Fresh Berry Sauce p178
Feta and Oregano Squares p180

Blackcurrant Smoothie p181
Millet and Quinoa Porridge with Plum Compote p185
Millet and Pears with Cardamom p185
Baked Oatmeal with Goji Berries and Cinnamon p187
Presoaked Barley Breakfast p190
Warm Chicken Congee p193

SNACKS

Ezze p195
Hummus with Coriander p196
Ajvar p198
Butternut Squash and Walnut Bites p200
Mushroom and Chestnut Bites p202
Kale Chips p203
Yellow Summer Squash Chips p203
Sprouted Medley p204
Tomato Crackers p205
Spicy Crackers p207

SOUPS

Mung Bean and Spinach Soup p209
Puy Lentil Soup with Fresh Turmeric p212

Watercress and Flaxseed Soup p212
Carrot and Coconut Soup p213
Beet Soup p213
Butternut Squash Soup p219
Adzuki Bean Soup p220

LIGHT MEALS AND SALADS

Adzuki and Mung Bean Salad p226
Swiss Chard and Sweet Potato p228
Spinach and Ricotta Filo Rolls p230
Trout and Lettuce Wraps p231
Stuffed Vine Leaves p233
Nori Vegetable Roll p234
Cabbage Momos p235
Mushroom Frittata with Cherry Tomatoes and Basil p236
Wild Rice Salad p240
Fresh Cilantro Leaf Pesto with Pasta p241
Braised Red Chicory and Celery Heart Salad p243

MAIN MEALS

Sprouted Quinoa with Vegetables p245
Spicy Raw Vegetable Spaghetti p246
Mung Bean and Purple Broccoli Rabe Stir-fry p248
Marinated Tuna Steaks p249
Sea Bass with Spinach and Mango p250
Vegetable Hot Pot p256
Stir-fried Spring Vegetables p259
Ginger Chicken p261
Quinoa and Vegetable Stack p262
Sauerkraut Parcels p264
Salmon with Dill and Tamari Sauce p268
Marinated Duck with Mango Salsa p269
French Bean Stew p274
Vegetable Moussaka p278
Barlotto with Chestnut Purée p281
Griddled Vegetable Roll with Cashew and Braised Garlic Cream p282
Fragrant Rice and Millet p283

SWEET TREATS

Fresh Fig Delight with Pear and Red Wine Sauce p285

Spicy Raw Vegetable Spaghetti p246

RECIPE CHOOSER

♥ HEART AND CIRCULATION

BREAKFASTS
Buckwheat and Blackberry Cream p177

Buckwheat Pancakes with Fresh Berry Sauce p178

Blackcurrant Smoothie p181

Poached Eggs and Spinach p182

Kefir Cheese with Flaxseed and Berries p184

Millet and Quinoa Porridge with Plum Compote p185

Almond Porridge with Apricots p188

Presoaked Barley Breakfast p190

Sweet Saffron Rice With Cardamom p191

SNACKS
Ezze p195

Ajvar p198

Kale Chips p203

Yellow Summer Squash Chips p203

Tomato Crackers p205

SOUPS
Mung Bean and Spinach Soup p209

Raw Tomato Soup p210

Puy Lentil Soup with Fresh Turmeric p212

Watercress and Flaxseed Soup p212

Beet Soup p213

Wild Garlic Soup p214

Sweet Potato and Celeriac Soup p216

LIGHT MEALS AND SALADS
Raw Curly Kale Salad p223

Quail Egg and Endive Salad p224

Adzuki and Mung Bean Salad p226

Herring Cucumber and Seaweed Salad p227

Mediterranean Vegetable Medley p272

Spinach and Ricotta Filo Rolls p230

Trout and Lettuce Wraps p231

Nori Vegetable Roll p234

Mushroom Frittata with Cherry Tomatoes and Basil p236

Mushroom Frittata with Cherry Tomatoes and Basil p236

Buckwheat Pancakes with Nettles and Feta Cheese p238

Artichokes in a Sweet Spicy Sauce p239

Wild Rice Salad p240

Fresh Cilantro Leaf Pesto with Pasta p241

MAIN MEALS
Sprouted Quinoa with Vegetables p245

Marinated Tuna Steaks p249

Sea Bass with Spinach and Mango p250

Stuffed Peppers p252

Beans Baked in a Pumpkin Pot p253

Kale with Buckwheat Noodles p255

Marinated Tofu with Shiitake and Noodles p258

Stir-fried Spring Vegetables p259

Quinoa and Vegetable Stack p262

Salmon with Dill and Tamari Sauce p268

Broiled Mackerel with Chard p275

Grilled Sardines with Tomato Salsa p276

Vegetable Moussaka p278

Lamb Casserole with Vegetables p279

Barlotto with Chestnut Purée p281

Griddled Vegetable Roll with Cashew and Braised Garlic Cream p282

SWEET TREATS
Elderberry and Blackberry Nutty Crumble p288

Warm Fruit Salad in Sweet Wine Sauce p290

Cherry Strudel p293

Baked Quince p294

Rose Petal and White Wine Sorbet p295

Banana and Cranberry Ice Cream p296

Sesame Heart Cookies p299

Almond and Pistachio Macaroons p300

Poppy Seed and Walnut Roulade p302

NUTRITIOUS LUNCH

Lunch is a good time to have a protein-rich meal to benefit you and your baby. Chicken contains B vitamins that help the body cope with stress, release energy, and form DNA. This lunch includes chicken shaken in a spicy toasted coconut mix, stir-fried, and served with a tropical salad.

TO MAKE THE SALAD

Put 2 tablespoons of toasted coconut, 1 teaspoon each of ground ginger and cinnamon, a pinch of ground nutmeg, and zest of ½ lemon in a food bag. Seal and shake to mix. Add 1 chicken breast cut into strips. Season and shake well to coat the chicken. Stir-fry the coated chicken for 3–4 minutes in olive oil. Mix with the salad ingredients and add lemon juice.

GINGER
One of nature's best antinausea remedies, ginger also stimulates digestion

AVOCADO
Rich source of omega fatty acids, vitamin K, and fiber

COCONUT
Contains manganese and healthy essential fatty acids

ARUGULA
Source of folate and antioxidant phytonutrients

CHICKEN
Source of protein and tryptophan to help the body cope with stress

MANGO
Prebiotic qualities, plus fiber, vitamins B_6, and C

SUSTAINING DINNER

Sweet potatoes are both nourishing and easy to digest, making them a great food to eat in the evening. They are combined here with eggplant and sweet bell peppers—all good sources of phytonutrients known to be beneficial for the healthy development of new cells.

SEE VEGETABLE MOUSSAKA RECIPE *p278*

EGGPLANT
Anthocyanins in the skin of the eggplant help brain cell development

CHEESE
Good source of calcium to build strong bones and teeth, and for muscle and nerve function

RED BELL PEPPERS
Contains carotenoids for healthy heart and eyes

SWEET POTATO
Contains nutrients that act as antioxidants, and are anti-inflammatory and blood-sugar regulating

ZUCCHINI
Source of B vitamins including folate

A DAY OF... HEALTHY PREGNANCY

While you are pregnant, eat foods that are packed with as much nourishment as possible for you and for your growing baby. It is particularly important to concentrate on foods that contain abundant minerals, such as calcium and iron. Consume as few additives as possible, so eat organic if you can.

DIGESTION-FRIENDLY BREAKFAST

Ease yourself into the day with foods that are nourishing and easily digested. This smoothie of fresh fruits, crushed flaxseeds, and orange juice is the perfect choice. Eggs are also a good breakfast option.

APRICOTS
Good source of fiber, iron, and antioxidants

PAPAYA
Contains enzymes that assist the digestive system

ORANGE JUICE
Rich in vitamin C and bioflavonoids to help prevent varicose veins

FLAXSEEDS
Help prevent constipation and a good source of omega-3 fatty acids

OAT CRACKERS
A slow-release carbohydrate to balance blood sugar levels, and easily digested

IMMUNITY-ENHANCING DINNER

Chicken is particularly suitable for women in terms of nourishment and rejuvenation because it has immune-boosting properties and high B vitamin levels to help the body produce energy. Eat with stress-reducing potatoes and salad.

SEE GINGER CHICKEN RECIPE *p261*

CHICKEN
Low-fat protein and selenium for metabolic and thyroid health

GARLIC
Contains compounds to protect the heart and prevent infection

LIME
Excellent source of vitamin C

HONEY
This antioxidant-rich elixir protects heart and waistline

GINGER
Improves digestion and protects against aging

POTATOES
Source of vitamins B and C to protect against stress

A DAY OF... WOMEN'S HEALTH

It's much easier to cope with the demands of modern life if you eat healthy meals that boost your energy levels and sense of well-being. Here are foods that are particularly suitable for women's health, and known for their anticancer, antistress, nourishing, and balancing benefits.

BALANCING BREAKFAST

Choose a breakfast of ingredients that are full of essential nutrients, such as iron, calcium, and the antioxidant vitamin C. Eating plenty of soluble fiber-rich dried fruits, such as prunes and apricots, will also help balance blood sugar levels and prevent constipation.

PLAIN YOGURT
Contains probiotics for gut health and calcium for bones

ORANGE
Excellent source of vitamin C and bioflavonoids to support the circulation

APRICOTS
Rich in fiber, vitamin A, carotenoids, and iron to to promote better digestion, improve eyesight, and build red blood cells

PRUNES
Source of fiber and antioxidant phytonutrients

HORMONE-PROTECTIVE LUNCH

Research has confirmed watercress as a true superfood. It contains an abundance of phytonutrients including substances renowned for their anticancer properties, and also iron and vitamin K to help prevent osteoporosis. Try this light yet filling watercress soup.

ONION
Its phytochemical compounds contribute to healthy skin and help prevent infections

WATERCRESS
Contains gluconasturtin with potent cancer-inhibiting properties

PEARS
Low in calories and high in dietary fiber and antioxidants

HOW TO MAKE THE SOUP

Fry 1 onion in butter until soft, stirring to prevent burning. Add the stalks of a large bunch of watercress, 3 chopped pears, and 3½ cups vegetable stock and season. Simmer for 15 minutes. Remove from the heat, add the watercress leaves, and purée. Add 1 cup crème fraîche and the juice of ½ lemon. Garnish with Parmesan to serve.

CRÈME FRAÎCHE
Good source of calcium for bone health

OLIVE OIL
Mediterranean diet staple containing omega-3, -6, and -9 fatty acids

PROTEIN-PACKED DINNER

Quinoa provides important protein with essential amino acids and helps build muscle, while tomatoes contain lycopene, which aids healthy circulation. The addition of strength-building walnuts makes this a great meal for active men.

SEE SAVOY CABBAGE PARCELS RECIPE *p265*

CABBAGE
Good source of detoxifying and anticancer compounds

TOMATOES
Great source of lycopene for heart health

QUINOA
One of the best cereal-sources of protein

WALNUTS
Renowned in China for improving men's health and stamina

CRANBERRIES
Contain proanthocyanidins, which help cells resist bacterial infection

A DAY OF... MEN'S HEALTH

To enhance men's health, choose foods that improve vitality, support the body's energy levels, and are good for the heart and circulation. Men also benefit from a diet rich in antioxidants, essential fatty acids, strengthening minerals, and protein. Try this menu for a day of health-boosting benefits.

FUEL-UP BREAKFAST

Start the day with a combination of fresh fruit, seeds, and yogurt—good for your vitamin and mineral intake—or try buckwheat pancakes or oatmeal with fresh fruit. Other suitable options for breakfast are eggs or fish.

PUMPKIN SEEDS
An excellent source of zinc—essential for reproductive system and prostate health

BLUEBERRIES
An immune-boosting superfood packed with antioxidants for the prevention of cancer

SUNFLOWER SEEDS
A rich source of omega oils and B vitamins for both heart and brain health

PLAIN YOGURT
Good source of calcium, and enhances gut health

ACTIVE-LIFE LUNCH

Coldwater oily fish, such as salmon, mackerel, and herring, are rich in omega-3 and other essential fatty acids good for heart and brain health and for keeping joints flexible. Mix cured or pickled herring with cooked root vegetables, such as potato (capable of building reserves of energy) and beets (particularly good for the heart and circulation).

TO MAKE THE DRESSING

Mix ⅔ cup of mayonnaise, 1 tablespoon of creamed horseradish, and 1–2 teaspoons of Dijon mustard with lemon juice.

HERRING
A very good source of protein, vitamin B_{12}, selenium for longevity, and EPA and DHA

BEETS
Highly nutritious source of magnesium, iron, and betaine for cardiovascular health

POTATOES
Good source of fiber, and rich in vitamins C and B_6 and potassium

ONIONS
Phytochemical compounds allium and allyl disulfide have anticancer and blood-sugar-regulating properties, while quercetin helps prevent heart disease

HORSERADISH
Naturally antibiotic and anticatarrhal herb with decongestant properties

STRESS-BUSTING LUNCH

Sustain your body and mind with foods packed with the nutrients you need to fight stress, such as this fish soup, full of B vitamins, magnesium, and phytonutrient-rich herbs and spices.

TO MAKE THE SOUP

Fry 1 chopped onion in olive oil over medium heat until soft. Add 1 crushed garlic clove and 1 finely chopped fennel bulb, and cook until the fennel softens. Stir in 1 minced red chile, a splash of white wine, a 14oz can of tomatoes, 3 cups hot fish stock, and a pinch of saffron. Bring to a boil, then reduce to a simmer for 45 minutes. Purée to a smooth soup. Pour into a clean saucepan and add 1¼ cups hot water. Simmer gently. Add 7oz (200g) cubed monkfish and haddock loin and cook over low heat for 6–10 minutes.

MONKFISH
An excellent source of B vitamins, important for alleviating stress

CHILE
A warming, stimulating source of nutrients for optimal health

TOMATOES
Source of carotenoids and potassium, for good nerve health

HADDOCK
Rich in magnesium, the antistress mineral

FENNEL
Strong antioxidant that contains cell-protective components

SAFFRON
Used in herbal medicine for its antidepressant properties

RECOVERY DINNER

Shiitake mushrooms are renowned for being adaptogenic, which means they help the body recover quickly from all kinds of stress. Marinated tofu, which is made from soybeans, is easy to digest.

SEE MARINATED TOFU WITH SHIITAKE AND NOODLES RECIPE *p258*

SESAME SEEDS
Rich in beneficial minerals

SHIITAKE MUSHROOMS
Potent phytonutrients increase resistance to stress and fatigue

SNOW PEAS
Its B vitamins help produce the hormones necessary to fight stress

TOFU
A good source of tryptophan for stress relief and better sleep

MUNG BEAN SPROUTS
Contain B vitamins and magnesium to manage stress symptoms

A Day Of... Stress Relief

Traditionally, many foods have been known to support the nervous system during times of stress. Today we understand that in fact these foods have an effect on neurotransmitters in the body, such as the hormone serotonin, which is why they generate a "feel-good" factor.

Positive Breakfast

Eating a healthy breakfast can set the scene for a positive attitude through the day and sustained energy levels. This combination of granola, fresh fruits, and honey provides many nutrients to support the sense of well-being.

TO MAKE THE GRANOLA

On an oiled baking sheet, drizzle rolled oats with honey. Toast in the oven at 350°F (180°C) until golden. Remove and let cool. Mix with ingredients, such as pine nuts, pumpkin seeds, dried fruits, corn flakes, and bran flakes, to taste.

ROLLED OATS
A traditional remedy to support a stressed nervous system

BANANA
Contains potassium to regulate nerve function

PUMPKIN SEEDS
Full of stress-busting magnesium, B vitamins, and serotonin

GOLDEN RAISINS
Good source of energy, vitamins, minerals, and antioxidants

HONEY
A sweet source of antioxidants to protect cells from oxidative damage

ENERGY-SUSTAINING DINNER

To support long-term energy, eat a light cooked meal in the evening. Squab is tasty, tender, and nutritious, and is regarded as an excellent kidney and energy tonic. Goji berries are added to give a metabolic boost.

SEE SQUAB BREASTS WITH GOJI BERRIES RECIPE *p260*

SQUAB
Excellent source of iron and B vitamins for energy

ONION
A warming and nourishing source of phytonutrients to boost good health

CHILE
Stimulating to taste buds and improves energy levels

SHIITAKE MUSHROOMS
Considered a good general tonic that boosts various body systems

GOJI BERRIES
A superfood packed with essential nutrients

CARROTS
Good source of slow-release energy

A Day Of... Boosted Energy

Great energy comes from a good balance of rest, exercise, and eating foods that are packed with nutrients to strengthen reserves and provide vitality. This 1-day plan provides an introduction to some of the foods that are known to act as a tonic for the body.

Power Breakfast

Quail eggs are renowned in China for invigorating and strengthening the body. They are a rich source of protein, iron, potassium, and B vitamins, and taste delicious scrambled with lightly fried chopped tomatoes.

TOMATOES
A superfood containing antioxidants, such as lycopene and vitamin C

PARSLEY
Contains energy-promoting iron and vitamins A, C, and K

QUAIL EGGS
Packed with 3–4 times the energy-boosting nutrients of the egg of a chicken

BLACK PEPPER
Volatile oils stimulate digestion to promote the absorption of all nutrients from food

RYE BREAD
A rich source of magnesium, promoting enzymes involved in the body's use of glucose and insulin secretion

Vitality Lunch

Asparagus is packed with energy-promoting nutrients. Stir-fry with other vegetables, such as immune-boosting broccoli and carrots, adding the ones that need the most cooking to the wok first. Combine with protein-rich shrimp and cleansing, anti-inflammatory fresh ginger for an easy yet revitalizing feast.

RED BELL PEPPER
A gently stimulating vegetable full of essential nutrients

SHRIMP
A warming, nourishing food high in protein and carotenoids, such as astaxanthin

CHIVES
A simple way to add stimulating qualities to a dish, chives also promote a healthy appetite

ASPARAGUS
A source of the essential energy nutrients potassium and B vitamins

BROCCOLI
Enhances detoxification, which helps enhance energy

CARROTS
Root vegetables help boost reserves of energy and are a source of beta-carotene

JOINT-HEALTH LUNCH

Coldwater salmon, tuna, herring, mackerel, and halibut contain omega-3 fatty acids, which are potently anti-inflammatory. Bake in the oven until cooked through and serve cold with an apple cider vinegar dressing.

TO MAKE THE DRESSING

A yogurt-based apple cider vinegar dressing is a great accompaniment to baked salmon. Mix together 2 tablespoons each of apple cider vinegar and finely chopped mint, and ¼ cup Greek yogurt. Drizzle over the cold salmon.

LEMON
A source of vitamin C and bioflavonoids, and can help reduce inflammation

DILL
Good source of calcium to help reduce bone loss, and antioxidants

SALMON
High in protein to help build healthy connective tissue, and in anti-inflammatory omega-3 fatty acids

CUCUMBER
May improve inflamed joints because it helps eliminate uric acid and contains vitamin C

APPLE CIDER VINEGAR
Traditionally used to alkalize the body and relieve the pain of arthritis

ANTI-INFLAMMATORY DINNER

This soup is packed with the powerful anti-inflammatory properties of turmeric and so can help relieve swelling and pain including rheumatic and arthritic pain. Use either dried turmeric or fresh turmeric in your recipes.

SEE PUY LENTIL SOUP WITH FRESH TURMERIC RECIPE *p212*

DRINK

Apple cider vinegar mixed with honey is a traditional remedy for arthritis because the overall effect of apple cider vinegar and honey is alkalizing. To make, add 2 teaspoons each of honey and unpasteurized apple cider vinegar to a glassful of lukewarm water. Drink 2 or 3 times a day before meals.

TURMERIC
Contains curcumin, a potent anti-inflammatory

PUY LENTILS
Vegetarian source of collagen-building protein

GINGER
Zingibain suppresses substances that trigger pain and cause tissues to swell

ONIONS
Source of quercetin, which reduces inflammation

CILANTRO
Source of vitamins A, C, and K for healthy bones and joints

A Day Of... Healthy Joints

To reduce the inflammation and pain associated with arthritis and joint problems, switch to a diet that contains foods known to reduce inflammation and cleansing foods, which help remove the toxins that aggravate the problem. Sample this 1-day plan to learn which foods to incorporate into your diet.

Easy-mover Breakfast

Fruit is a source of antioxidants that helps rid the body of cell-damaging free radicals and suppresses inflammation (avoid oranges because they may make some arthritis pain worse). Apple (fresh or dried) is particularly good for joint problems, but keep its skin on—this is what contains many of the best nutrients. Serve with buckwheat grains, toasted in a moderate oven until golden, and plain yogurt.

PLAIN YOGURT
Provides calcium for
healthy bones and joints

APPLES
Contain inflammation-fighting
antioxidants. Use dried apple rings
for extra flavor

DRIED CRANBERRIES
Contain vitamin C to help
reduce pain and inflammation

BUCKWHEAT
A highly nutritious, gluten-free
grain. Contains quercetin, which
has anti-inflammatory properties

DRIED APRICOTS
Good source of
anthocyanidins

RADIANCE-BOOSTING DINNER

Eating fresh, young green vegetables regularly is a good way to cleanse the body and keep the complexion clear. Include asparagus because it stimulates the digestion by acting as a prebiotic and contains compounds that have an anti-inflammatory effect and help to prevent the signs of aging.

SEE STIR-FRIED SPRING VEGETABLES RECIPE *p259*

OLIVE OIL
High in polyphenols, known to help postpone aging and boost cell repair....

ASPARAGUS
A storehouse of vitamins and minerals that can benefit the skin...

SNOW PEAS
Good source of vitamins A and C for skin health

SPINACH....
Rich in iron and antioxidants, which have anti-inflammatory effects

WILD GARLIC....
Contains sulfur compounds to keep skin blemish-free

A Day Of... Skin Health

Choosing foods that are packed with the vitamins and minerals your skin needs will, over time, actively nourish your skin and dramatically boost its appearance. Start with this day of delicious meals and build from there, selecting skin-friendly foods and turning them into tasty recipes.

Collagen-boosting Breakfast

Eggs are powerhouses of nutrients that are beneficial for the skin. They include collagen-building protein, vitamin A, omega fatty acids, and carotenoids to protect against UV aging. Cook scrambled eggs with chopped fresh herbs to add valuable antioxidants.

CHIVES
Contain detoxifying sulfur and anti-inflammatory quercetin

TURMERIC
Excellent antioxidant properties to prevent free-radical damage

EGGS
Choline and lutein help promote skin elasticity and prevent wrinkles

MARJORAM
Popular Mediterranean herb with antiseptic and anti-inflammatory properties

Omega-rich Lunch

Oil-rich coldwater fish, such as salmon, are a real superfood when it comes to skin health: their anti-inflammatory properties help to improve dry skin and relieve eczema and psoriasis. Serving baked salmon in a salad with a yogurt dressing is a great way of getting many of the nutrients your skin needs.

TO MAKE THE SALAD DRESSING

Mix together the juice of 1 orange and ½ tablespoon each of chopped hazelnuts, sherry vinegar, plain yogurt, and hazelnut oil.

PLAIN YOGURT
Contains protein and zinc for skin health

HAZELNUTS
Good source of vitamins and minerals for healthy hair, skin, and nails

SALMON
Contains omega oils to keep skin elastic and prevent wrinkles

LAMB'S LETTUCE
Its antioxidants prevent free-radical damage

LIVER-BOOSTING LUNCH

Cynarin, an active chemical constituent in globe artichokes, helps improve the proper functioning of both the liver and gallbladder—it causes increased bile flow and is an aid to digestion, making artichokes an ideal food to support the health of the liver.

LEMON
The ultimate liver-cleansing fruit, it is high in vitamin C and bioflavonoids

TO MAKE THE HERB ARTICHOKES

Cut off each stalk but leave ¾in (2cm) at the top. Peel the remaining stalk, cutting away the tough exterior. Cut off the top of the cone and scoop out the hairy choke. Squeeze lemon juice into the cavity. Mix 2 chopped garlic cloves, 1 tablespoon of finely chopped mint, and a bunch of finely chopped flat-leaf parsley. Stuff the mix into the cavity. Simmer the artichokes in a pan of water on medium heat for 30 minutes, or until tender. Ensure they stay upright in the pan.

GLOBE ARTICHOKE
Contains bioactive phytonutrients for liver and gut health

OLIVE OIL
Stimulates activity in the liver, gallbladder, and bile duct

GARLIC
Activates liver enzymes that support detoxification

PARSLEY
A gently stimulating herb that encourages the elimination of toxins; also contains vitamins and minerals

REGENERATIVE DINNER

In traditional Chinese medicine, the liver is strengthened by eating sour-flavored foods and cleansed by green leafy foods. This dish is bursting with ingredients that help the body eliminate toxic substances, clear blood vessels, and enhance bowel movement and urine output.

SEE MUNG BEAN AND BROCCOLI RABE RECIPE *p248*

GREEN MANGO
Its sweet-sour flavor increases liver and gallbladder function

MUNG BEAN SPROUTS
Abundant in minerals and fiber, which are essential for detoxing

CARROTS
Contain antioxidants renowned to enliven the liver

LIME
Source of healing vitamin C and liver tonic

BROCCOLI RABE
Contains sulfur compounds that support the liver's ability to detoxify chemicals in the body

BELGIAN ENDIVE
Traditionally used to cool and cleanse the liver

A Day Of... Liver Health

The liver needs all the help it can get—it has the job of breaking down and eliminating every dietary and environmental toxin in our bodies. This 1-day plan will give you an idea of which foods can help stimulate the natural detoxifying processes in the liver and encourage regeneration.

Cleansing Breakfast

Grapefruit is an effective liver-cleansing and antioxidant-rich fruit.
Combine it with a detoxifying, freshly juiced fruit and vegetable juice
for an invigorating start to your day.

APPLE
Triterpenoids in the
skin have potent
protective activity
for liver cells

CARROT
Its carotenoid content
helps prevent oxidative
damage inside the body

MINT
An herb with tonic and
decongestant properties

GRAPEFRUIT
Contains enzymes that
help the liver break
down toxins more
efficiently

EASILY DIGESTED DINNER

Soup can make an ideal light meal to enjoy in the evening. This carrot soup is easily digested, packed with nutrients, and you can make enough to last for a couple of days. In traditional Chinese medicine, cooked carrots are thought to improve digestion because they contain fiber, thus aiding bowel regularity. The fiber also promotes a feeling of fullness, which is good if you are trying to cut down on calories.

SEE CARROT AND COCONUT SOUP RECIPE *p213*

COCONUT
Helps fight off
inflammation and
unwanted bacteria

ONION
Provides a source of
phytonutrients

CARROT
Easily digested source
of carotenoids

CILANTRO
Promotes a healthy
digestion

LIME
Source of vitamin C
and a digestive tonic

A Day Of... Good Digestion

In most cultures, good digestion is considered fundamental to general health. Try this plan of eating the right foods at the best time, using ingredients that boost digestive health. To encourage efficient absorption and elimination don't rush, and always chew your food thoroughly.

Balancing Breakfast

Breakfast is a good time to eat a balance of foods: fiber to keep your bowels regular; protein to sustain you; and carbohydrates to give you energy for the day ahead. Top this off with some antioxidant-rich fruit.

BERRIES
A delicious way to boost your vitamin and antioxidant intake

TOASTED FLAKES
Whole grain wheat flakes provide B vitamins and fiber for roughage. To make, toast whole grain flakes in an oven at 350ºF (180ºC) for 20 minutes, turning occasionally.

SUNFLOWER SEEDS
Good source of pantothenic acid, phosphorus, copper, and manganese

PUMPKIN SEEDS
Contain high levels of essential fatty acids and zinc

PLAIN YOGURT
A natural probiotic to keep gut flora healthy

FLAXSEEDS
Gentle bulk laxative that provides omega-3 and omega-6 fatty acids

Sustaining Lunch

Make lunch your main meal. Chicken provides a low-fat source of protein and assists healthy digestion; here it is rubbed with lime juice, grilled until cooked through, and served with a spicy sauce.

TO MAKE THE SAUCE

Sauté, in olive oil, crushed garlic, a thumb of grated fresh ginger, and chopped scallions and sweet potato, and a spice mix (turmeric, cumin, and coriander seeds) for 10 minutes. Cook until the vegetables are tender, then add 1¼ cups of stock and some lime juice. Purée in a blender.

CHICKEN
Rich in many nutrients including selenium and zinc

LIME JUICE
Excellent source of vitamin C, and can help relieve indigestion

SWEET POTATO
Easily digested source of carotenoids

TURMERIC
Anti-inflammatory that helps prevent wind

CUMIN
Stimulates digestive enzymes

HEART-PROTECTIVE DINNER

Dried beans are known to lower the risk of heart attack and strokes because they help lower "unhealthy" (LDL) cholesterol levels in the blood and balance blood sugar levels. Recent studies have also proven that shiitake mushrooms can help protect against cardiovascular diseases.

SEE BEANS BAKED IN A PUMPKIN POT RECIPE *p253*

RED AND YELLOW BELL PEPPERS
Contain vitamins C, E, and K for heart and circulation health

SHIITAKE MUSHROOMS
Help keep blood vessels clear and prevent oxidative stress

BUTTER/LIMA BEANS
Very good source of cholesterol-lowering fiber

GARLIC
Cardioprotective by helping repair damage to blood vessels

OLIVE OIL
Provides healthy omega-3, -6, and -9 fatty acids

PUMPKIN
The carotenoids it contains help to protect the circulatory system

A Day Of... Heart Health

Many studies have shown that eating a healthy diet and increasing the amount of exercise you get can radically improve your heart health. These cholesterol-lowering recipes are packed with foods to improve your circulation and lower your blood pressure.

Cholesterol-busting Breakfast

Start your day with a steaming bowl of oatmeal, which is full of heart-healthy folate and potassium. This fiber-rich superfood can help lower levels of "unhealthy" (LDL) cholesterol and keep arteries clear. For the tastiest oatmeal, soak the oats in water first, and stir in some freshly grated apple while you cook the oats.

APPLE
Lowers "unhealthy" (LDL) cholesterol and is a source of vitamin C and heart-healthy antioxidants

PLAIN YOGURT
Yogurt is a natural source of calcium, and regular consumption can help prevent high blood pressure, and therefore, lower the risk of heart attack and stroke

OATMEAL
Cooking oats breaks down their phytate content, ensuring that you receive all the benefits of their nutrients

Omega-rich Lunch

Oily fish, such as sardines, are one of the most concentrated sources of the omega-3 fatty acids EPA and DHA, which help lower triglycerides and "unhealthy" (LDL) cholesterol levels.

TO PREPARE THE SARDINES

Mix together 1 tablespoon each of cooked and cooled short-grain rice, toasted pine nuts, and currants, a dash of lemon juice, and 1 teaspoon each of chopped parsley, mint, and dill. Divide among 6 whole, cleaned sardines, packing the stuffing inside each fish. Wrap a vine leaf around each fish to hold it together. Brush with olive oil and broil for 4–5 minutes, turning halfway through. Serve with lemon wedges.

SARDINES
Rich in numerous nutrients, including vitamins B_{12} and D, which have been found to support cardiovascular health

VINE LEAVES
A staple of heart-healthy Mediterranean cuisine; rich in vitamins and minerals

PINE NUTS
Contain an abundance of vitamins and minerals that help maintain normal metabolic functions

LEMON JUICE
Particularly high in magnesium, important for a healthy heart. Its pectin content and limonoid compounds also reduce cholesterol

PARSLEY
Particularly high in vitamin K for heart and circulatory health

RECIPES THAT HEAL

THE RIGHT COMBINATION OF INGREDIENTS
DOES MORE THAN SIMPLY **ENHANCE** THE
FLAVOR OF YOUR FOOD. MANY FOODS WORK
SYNERGISTICALLY TO BOOST **HEALTH** AND
VITALITY. DISCOVER THE PERFECT COMBINATIONS
WITH THESE UNIQUE RECIPES BASED ON THE
PRINCIPLES OF TRADITIONAL **HEALING**.

ROSE

 PROTECTS AGAINST BACTERIAL INFECTION

 HELPS EASE MENSTRUAL CRAMPS

 HAS NATURAL SEDATIVE PROPERTIES

 HELPS EASE JOINT PAIN

A member of the same family as plums, cherries, apricots, and almonds, rose has many of the same benefits. The petals contain volatile oils that help **calm nervous tension** and are **antibacterial**—useful for treating **urinary tract infections** and **digestive upsets**. They are also rich in vitamins C, D, E, and B$_3$, **beta-carotene**, and **antioxidants**, such as lycopene, lutein, and **anti-inflammatory** quercetin.

WHAT IS IT GOOD FOR?

ANTIBACTERIAL Its essential oils have proven antimicrobial properties.

WOMEN'S HEALTH The dried leaves and hips can be used to make an iron-rich tangy tea to make up for lost iron and as a tonic to soothe stomach cramps during menstruation.

STRESS Its scent has been proven to calm breathing and lower blood pressure, while its essential oils have a calming effect on frayed nerves and can lower feelings of anxiety.

ARTHRITIS Rosehips contain flavonoids, such as anthocyanins and quercetin, which have antioxidant properties. With their high vitamin C content, the hips can help decrease inflammation in arthritis and joint pain.

HEART Oil pressed from rosehip seeds is high in vitamin C and linoleic (omega-6) fatty acid and linolenic (omega-3) fatty acids. Eating hips from the *Rosa canina* (dog rose) for just 6 weeks helps reduce both blood pressure and "unhealthy" (LDL) cholesterol in the blood.

HOW DO I GET THE BEST FROM IT?

ORGANIC AND NATURAL Look for organic or wild-crafted sources to avoid a variety of toxic pesticides and fungicides. Choose 100-percent natural rosewater, steam-distilled from rose petals and preservative-free.

ROSEHIP OIL Heart-healthy rosehip oil can be consumed, but it is too delicate to heat. It should make up no more than 20 percent of the total oil content of a salad dressing.

HOW DO I USE IT?

MAKE A TEA For a calming, anti-inflammatory tea, steep rosehips and hibiscus flowers in equal amounts in boiling water for 5 minutes.

ROSEHIPS Can be eaten raw, though some may find the taste too tart so add to jams, jellies, syrups, fruit crisps, and pies.

ROSEHIPS
These fruits are full of vitamin C, and their seeds yield a healthy oil that can help treat inflammation.

DAMASCENA ROSE
The oil from this rose is traditionally used to calm and uplift the mind. It is anti-inflammatory, cooling, and soothing.

ROSEWATER
An extraction of the essential oils found in rose petals, rosewater retains the astringent, toning, soothing, and antiseptic properties of the whole plant.

DRIED ROSES
Rose tea is a traditional remedy for menstrual complaints.

TEA

 ANTIOXIDANT AND ANTIBACTERIAL

 HELPS LOWER CHOLESTEROL

 CONTAINS ANTICANCER SUBSTANCES

 HELPS BUILD STRONG BONES

The average tea leaf contains as much as 30 percent **antioxidant** polyphenols, which help protect against **heart disease** and **cancer** and are **anti-inflammatory,** benefitting joints. Tea also contains **beta-carotene**, vitamins B_2, C, D, and K, and potassium. Even the caffeine in tea, when taken in moderation, has health benefits: it helps **boost metabolism**, **burn fat**, and acts as a **mild diuretic.**

GREEN TEA
This delicate tea is produced by lightly steaming and then drying the freshly cut tea leaves. It is rich in a group of antioxidant polyphenols called catechins.

BLACK TEA
The dominant antioxidant polyphenols in black tea— theaflavins and thearubigins— have been shown to be as beneficial as those in green tea.

OOLONG TEA
Oolong is a semifermented sun-dried black tea rich in the antioxidant polyphenols called theaflavins.

WHITE TEA
Less bitter than green tea, white tea is minimally oxidized but contains similar catechins to green tea.

WHAT IS IT GOOD FOR?

IMMUNE SUPPORT Its powerful antioxidant catechins and theaflavins are antibacterial and antiviral. Studies show they can be effective against the flu virus and common causes of bacterial diarrhea. The catechins in green and oolong teas may also have antiallergy properties, and there is some evidence they can help reduce symptoms of eczema.

HEART Moderate consumption of black and green tea lowers "unhealthy" (LDL) cholesterol, reducing the risk of heart disease and stroke.

ANTICANCER A regular intake of green tea can protect against breast cancer, while tests suggest green and black tea help stop cancer cells from forming and will even kill bone, lung, stomach, and prostate cancer cells. The catechin epigallocatechin-3-gallate (EGCG) in green tea binds to certain carcinogens and helps remove them from the body.

HEALTHY BONES Consumption of green and black tea has been associated with higher bone mineral density in older adults, especially in the lumbar spine region.

ARTHRITIS Green tea polyphenols can prevent the breakdown of collagen and cartilage, so are a useful potential treatment for arthritis.

HOW DO I GET THE BEST FROM IT?

THE PERFECT CUP Use water that has boiled for no more than 10 seconds.

ORGANIC IS BEST Tea is treated with a vast number of pesticides. To avoid a toxic cup of tea, always choose organic.

HOW DO I USE IT?

DECAFFEINATE YOUR OWN TEA Pour boiling water on tea leaves. After 30 seconds discard the liquid to remove roughly 60 percent of the caffeine. Pour on more water and drink. (Waiting longer than 30 seconds destroys many vitamins and polyphenols, and much flavor.)

EGGS

 HELPS PROTECT EYE HEALTH

 HELPS BUILD STRONG BONES AND TEETH

 BOOSTS MENTAL PERFORMANCE

 HELPS PREVENT METABOLIC SYNDROME

Eggs are an excellent source of high-quality **protein**. They contain **vitamin D**, necessary for healthy bones and teeth, and nutrients that help **balance blood sugar levels**, protect against **heart disease**, and support the healthy function of **nerves** and the **brain**. Egg yolks contain cholesterol, but studies show "unhealthy" (LDL) blood cholesterol is raised more by excess saturated fats than it is by eggs.

WHAT IS IT GOOD FOR?

AN ANTIOXIDANT BOOST Egg yolks contain the antioxidants lutein and zeaxanthine, which help protect eyes from age-related macular degeneration (loss of vision), and tryptophan and tyrosine, antioxidant amino acids that help prevent cancer and heart disease.

BONES One of the few food sources of vitamin D, and rich in phosphorus. This combination helps provide the body with the necessary building blocks for healthy bones and teeth.

BRAIN FOOD An excellent source of choline, other B-vitamins, and the mono- and polyunsaturated fats necessary to support a healthy nervous system and brain. Choline helps improve memory, and evidence shows a protein-rich breakfast, such as eggs, improves mental performance throughout the day.

METABOLIC BALANCE Evidence suggests that during digestion, egg proteins are converted into peptides that help lower blood pressure in the same way as conventional drugs, such as ACE inhibitors. In addition, most of the fat in eggs is mono- and polyunsaturated, and other fatty acids called phospholipids help reduce the absorption of cholesterol.

HOW DO I GET THE BEST FROM IT?

FREERANGE AND ORGANIC Organic freerange eggs contain more vitamin A, omega-3 fats, and vitamin E than intensively formed eggs, and less saturated fat.

EASY ON THE HEAT Eggs lose nutritional value when cooked, so try light methods of cooking, such as poaching or soft boiling.

HOW DO I USE IT?

A SIMPLE PROTEIN MEAL Add poached or soft-boiled eggs to salads for a healthy protein-enriched meal.

TRY QUAIL EGGS Substitute 3–4 quail eggs for 1 large chicken egg in salads or on toast.

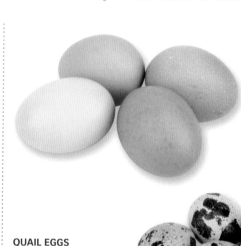

CHICKEN EGGS
A good source of vitamin D, B-complex, and trace minerals that support cellular development and a healthy nervous system. They also contain less cholesterol than other types of egg.

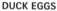

QUAIL EGGS
These small eggs contain more phosphorus—essential for cell membranes and strong bones and teeth—than other commonly consumed eggs. They are also high in folate.

DUCK EGGS
Weight for weight, duck eggs are higher in omega-3 fats, iron, folate, and choline than other types of eggs.

GOOSE EGG
Contains a mixture of nutrients similar to other commonly consumed eggs, but has a much higher omega-3 fat content.

KEFIR

HELPS STRENGTHEN THE IMMUNE SYSTEM

HELPS REDUCE BLOATING AND WIND

CONTAINS ANTICANCER SUBSTANCES

HELPS LOWER CHOLESTEROL

This probiotic and fermented food is made by culturing fresh milk with kefir "grains"—live colonies of bacteria and yeasts. Kefir is a good source of **calcium**, **protein**, and **potassium**, may have **anticancer** benefits, helps maintain the heath of the **digestive tract**, and **boosts immunity**. Kefir grains, which contain many more live bacteria than yogurt, remain alive indefinitely and can be used repeatedly.

KEFIR GRAINS
These small gelatinous nodules contain colonies of more than 30 bacteria and yeasts that are bound together in a stable, symbiotic relationship. After the grains have fermented milk, they can be filtered out and added to a new batch of milk.

KEFIR CHEESE
Cheese made from kefir contains all the beneficial probiotic microorganisms that kefir is famous for.

KEFIR MILK
Probiotics in kefir can control the growth of harmful bacteria and aid digestion, and some even manufacture vitamins in the gut.

WHAT IS IT GOOD FOR?

IMMUNE SUPPORT Kefiran, an indigestible fiber unique to kefir, has anti-inflammatory and immunity-supporting properties. Regular consumption may increase the activity of the body's natural killer cells and T-helper cells (a type of blood cell that helps kickstart the immune response). Kefir helps maintain the balance of healthy bacteria in the gut necessary to fight harmful fungi, viruses, and bacteria.

DIGESTION By breaking down lactose in milk, kefir may significantly reduce symptoms of lactose intolerance, including bloating and stomach pain, as well as speeding recovery from diarrhea in infants. It may help with other food allergies too, such as those to eggs.

ANTICANCER POTENTIAL Its probiotic properties can have anticancer effects. Laboratory and animal studies have found that kefir can slow breast cancer cell growth.

HEART Various studies have shown that kefir may help lower "unhealthy" (LDL) cholesterol and blood pressure, though results are mixed.

HOW DO I GET THE BEST FROM IT?

MAKE YOUR OWN Many kefir products are mixed with sugars and other additives and don't have the same medicinal benefits. Where possible, make your own kefir (p332).

HOW DO I USE IT?

FOR VEGETARIANS Use kefir grains to ferment nondairy milks, such as almond, soy, coconut, or oat milk.

A VERSATILE INGREDIENT Kefir can be made into a huge variety of products including cheese, spreads, and yogurt. It can also be used in baked goods, and is especially good as a sourdough starter.

TENDERIZES MEATS Kefir's mildly acidic nature can help tenderize meat. Added to sauces, it acts as a thickener.

YOGURT

 HELPS STRENGTHEN THE IMMUNE SYSTEM

 ASSISTS WEIGHT MANAGEMENT

 HELPS LOWER BLOOD PRESSURE

 SOOTHES STOMACH AND BOWEL UPSETS

The human intestines contain around 400 different species of bacteria, good and bad. Live yogurt, which is colonized by or cultured with certain types of "good" bacteria, can help keep things in balance; good bacteria help to turn organic acids into glucose, **lower cholesterol**, help **metabolize nutrients**, break down the enzymes, proteins, and fibers in food, and help kickstart the **immune system**.

WHAT IS IT GOOD FOR?

IMMUNITY Probiotics in yogurt have a general immunity-boosting effect and inhibit a range of pathogenic bacteria and yeasts in the gut. Probiotics also show potential in preventing allergies, such as eczema, particularly in children. In older or immune-compromised people, live yogurt may help increase resistance to bacterial and viral diseases.

WEIGHT MANAGEMENT Regular consumption of calcium-rich foods is linked to lower body weight in children and adults. Yogurt helps reduce fat around the waistline and retain more lean muscle than diets that don't include it.

LOWERS BLOOD PRESSURE Calcium helps keep blood vessels more supple, enabling them to expand slightly when necessary to keep blood pressure low.

DIGESTIVE HEALTH Gut health is inseparable from the health of the rest of the body. Live cultures in yogurt can improve the microflora of the gut, which in turn helps ease symptoms of inflammatory bowel disease and lowers the incidence of ulcers.

HOW DO I GET THE BEST FROM IT?

CHOOSE LIVE Look for products that state specifically that yogurt is "live" or "probiotic."

KEEP IT NATURAL Avoid yogurts with artificial colors, flavors, thickeners, and sweeteners. Buy a good-quality organic, plain, live yogurt and add your own ingredients.

TRY ALTERNATIVES Sheep- and goat-milk yogurts may be easier for some to digest than cow-milk yogurts. Sheep milk is richer in fat and is a particularly creamy alternative.

HOW DO I USE IT?

AN OMEGA-3 BOOST Stir 1 tbsp ground flaxseed into organic plain yogurt to add both fiber and healthy omega-3 fatty acids.

PLAIN YOGURT
Yogurt is made by culturing milk with a starter culture of friendly bacteria such as *Lactobacillus delbrueckii* subsp. *bulgaricus* and *Streptococcus salivarius* subsp. *thermophilus*. Other beneficial bacteria may be added during the culturing process.

YOGURT DRINK
Flavored yogurt drinks have become a popular way to get concentrated daily "shots" of probiotic cultures, though beware of additives, such as sugar, in the drinks.

GREEK-STYLE YOGURT
This yogurt is strained to remove some of the watery whey. This results in a thicker, creamier yogurt.

MILK

 HELPS KEEP BLOOD VESSELS SUPPLE

 HELPS REGULATE SLEEP CYCLES

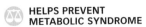 **HELPS PREVENT METABOLIC SYNDROME**

Evidence shows that milk has a place as a healthy food, despite being defamed by food faddists. Its **calcium** and **vitamin D** content helps the body **burn calories** more efficiently and maintain a **steady weight**, while its healthy fats help **lower blood pressure**. Organic and raw milks are higher in these **healthy fats** and **essential cofactors** than cheap milk and so are much better for you.

GOAT MILK
Nutritionally comparable to the milk of a cow, goat milk is higher in B vitamins than either cow or sheep milk. If you are allergic to cow milk, you may be able to tolerate goat or sheep milk.

SHEEP MILK
Milk from sheep is higher in fat than cow and goat milk, but has 40 percent more protein than both. It is also marginally higher in phosphorus, magnesium, zinc, and iron, and is a comparable source of calcium.

COW MILK
A good source of protein and calcium, and is high in phosphorus and vitamin B_{12}.

WHAT IS IT GOOD FOR?

HEART HEALTH Calcium may help reduce the risk of hypertension by keeping blood vessels elastic. Goat and sheep milks contain capric acid, a healthy fat that can help raise levels of "healthy" (HDL) cholesterol. Palmitoleic acid, another healthy fat, protects against insulin resistance and diabetes.

HEALTHY MIND A good source of B vitamins, especially B_{12}, for the healthy functioning of the brain and nervous system, cell metabolism, and for helping to regulate sleep/wake cycles.

METABOLIC BALANCE Can significantly reduce your risk of metabolic syndrome (a group of factors that can lead to diabetes and heart disease) and even some cancers.

WEIGHT CONTROL Contains a novel form of vitamin B_3 (niacin), which may help maintain a steady weight and improve energy expenditure. The calcium in dairy foods also increases the metabolism of fat.

HOW DO I GET THE BEST FROM IT?

HEALTHY FATS Half the fat in milk is saturated fat, but the other half has healthy fat, such as oleic acid (found in olive oil), palmitoleic acid, and conjugated linoleic acid (CLA). Sheep and cow milks are rich sources of CLA.

ORGANIC IS A MUST Milk from grass-fed cows contains CLA. Test-tube studies indicate that CLA helps to kill skin, colorectal, and breast cancer cells. It may also help to lower "unhealthy" (LDL) cholesterol and prevent atherosclerosis (hardening of the arteries).

HOW DO I USE IT?

USE FULL FAT Full-fat milk contains only 4 percent fat; take out the fat, and its fat-soluble vitamins A, D, E, and K are also reduced.

TRY RAW MILK Many nutritionists believe that pasteurizing milk impairs its nutritional value so try unpasteurized, or raw, milk in your diet.

CHOCOLATE

 LOWERS RISK OF HEART DISEASE AND STROKE

 PROTECTS AGAINST FREE-RADICAL DAMAGE

 AN EFFECTIVE COUGH SUPPRESSANT

 SOOTHES UPSET STOMACHS

Scientific research into chocolate is turning up some intriguing possibilities about its healthful nutrients, including improved **immunity**, greater **longevity**, and **quicker recovery** from intense exercise. Dark chocolate without unhealthy additives and sugar has been shown to lower the risk of **cancer** and **stroke**, and lowers **blood pressure** as effectively as antioxidant-rich fruit and vegetables.

WHAT IS IT GOOD FOR?

HEART HEALTH Moderate consumption protects the heart by thinning the blood in much the same way as low-dose aspirin, while its beneficial flavanols protect artery walls and lower blood pressure and cholesterol.

IMMUNE SUPPORT Weight for weight it has the same amount of antioxidants as red wine. These support overall immunity and intestinal immunity by boosting the response of antibodies and T-helper cells (a type of blood cell that helps kickstart the immune response), and strengthening the intestinal lining against invading microorganisms.

EASES COUGHS One of the stimulants in cocoa, theobromine, has been shown to be more effective than codeine (a traditional cough suppressant) for soothing a sore throat.

DIGESTION Studies show substances in dark chocolate help ease gastrointestinal upsets.

HOW DO I GET THE BEST FROM IT?

CHOOSE ORGANIC At least 30 pesticides are used in conventional cocoa so opt for organic.

GO DARK For the most antioxidants, choose semisweet or unsweetened chocolate with at least 70 percent cocoa solids and less sugar. Milk chocolate contains fewer antioxidants.

A LITTLE OF THE BEST Eating a little high-quality chocolate will be far more satisfying than a highly processed bar. Avoid bars with hydrogenated or partially hydrogenated oils.

HOW DO I USE IT?

RAW CACAO NIBS The minimally processed nibs contain all the cocoa bean's nutrients. Eat as they are or add to fruit salads or baking.

HOT COCOA Milk inhibits the absorption of cocoa polyphenols, so mix 2 tbsp high-quality cocoa powder with hot water and drink in a demitasse cup as you would an espresso.

COCOA POWDER
Unsweetened cocoa powder has twice the level of antioxidant polyphenols as processed dark chocolate, and 4 times that of milk chocolate (white chocolate contains no antioxidants).

COCOA BEANS
Catechin and epicatechin, the antioxidants found in cocoa beans and cocoa products, are the same as those that give green tea its anticancer properties.

CACAO NIBS
These are dried, roasted, and crushed cacao, or cocoa, beans, which are used to make chocolate. Like cocoa powder, they are high in antioxidants.

DARK CHOCOLATE
Studies show that people who eat dark chocolate regularly have a lower risk of heart disease and stroke.

BLACKSTRAP MOLASSES

 HELPS RELEASE CELLULAR ENERGY

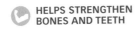 **HELPS STRENGTHEN BONES AND TEETH**

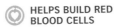 **HELPS BUILD RED BLOOD CELLS**

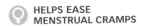 **HELPS EASE MENSTRUAL CRAMPS**

Unlike refined sugar, corn syrup, and artificial sweeteners, which contain no nutrients and are linked to a variety of health problems, this viscous black-gold residue (produced when sugar cane is turned into refined sugar) is rich in **bone-building** calcium, iron to **enrich the blood**, potassium to **ease muscle cramps**, and B vitamins to fuel efficient **metabolism** and help strengthen the **nervous system**.

BLACKSTRAP MOLASSES
One tablespoon of it contains almost 26 percent of your daily requirement of iron, 20 percent of calcium, and 61 percent of magnesium.

SUGAR CANE
Blackstrap molasses is obtained during the third and final refinement process of boiling sugar syrup derived from sugar cane.

WHAT IS IT GOOD FOR?

ENERGY RELEASE Provides the same quick energy boost as refined sugar. Unlike sugar, it is a source of important nutrients including selenium, manganese, and the B vitamins pyridoxine (B_6) and choline.

STRONG BONES A great source of calcium, which helps build and maintain strong bones and teeth. Calcium also promotes a healthy gut, helps maintain a steady heartbeat, and enhances the function of the nervous system.

HEART HEALTH Choline supports healthy nerve function, strengthens cell membranes, and prevents the buildup of homocysteine, a substance linked to heart disease and osteoporosis. Iron helps build the red blood cells that transport oxygen to all parts of the body, and is necessary for cellular energy production and metabolism.

WOMEN'S HEALTH It is a useful remedy during menstruation. Taking 2–3 tsp daily can help balance any iron lost.

HOW DO I GET THE BEST FROM IT?

IRON TONIC A useful iron supplement for those who cannot tolerate the constipation associated with iron tonics and supplements.

A MORNING ENERGIZER A natural laxative as well as an energy-booster, molasses is best taken first thing in the morning before food.

LOOK FOR UNSULFURED MOLASSES True blackstrap molasses does not need added sulfur as a preservative. If it contains sulfur, it is an inferior product without the nutrients.

HOW DO I USE IT?

GREAT FOR COOKING It gives baked goods, like gingerbread, a distinctive flavor. It is also used in barbecue sauces and baked beans.

MAKE A TEA Add 1 tsp to ginger tea as a remedy for menstrual or abdominal cramps.

Honey is a powerhouse of healing nutrients and enzymes and is one of the world's oldest natural remedies. The darker the color of the honey, the more concentrated these substances will be.

HONEY

 HELPS HEAL ULCERS

 FIGHTS RESPIRATORY INFECTIONS

 HELPS SPEED WOUND HEALING

 PROVIDES SEASONAL ALLERGY RELIEF

Even though honey is made up of mostly simple sugars and water, it has many medicinal properties, including its ability to help **heal skin wounds** and **ulcers**. Its effectiveness lies in its levels of **vitamins C, D, E, K, and B-complex,** and **beta-carotene**, minerals, enzymes, and essential oils. It's also a **natural antibiotic** and rich in **antioxidants**, making it effective at **fighting respiratory infections**.

HONEYCOMB
Raw honey extracted from the honeycomb is not sterilized or pasteurized, leaving its vitamins and enzymes intact and undamaged.

MANUKA HONEY
The antimicrobial properties of this honey (manuka is a wild shrub native to New Zealand) are well known and defined by the Unique Manuka Factor (UMF). A UMF of 10 and above is considered very beneficial.

HONEY
Studies show that honey can be as effective for treating coughs and sore throats as conventional cough syrups.

WHAT IS IT GOOD FOR?

HEALS ULCERS Its antioxidants may help to heal the colon in cases of ulcerative colitis. Manuka honey contains, in addition to hydrogen peroxide, unique antibacterial substances that are useful against *Helicobacter pylori* bacteria, which causes stomach ulcers.

RESPIRATORY INFECTIONS Can be as effective as the cough suppressant diphenhydramine, and may help children sleep better. Types of honey shown to work well for coughs include buckwheat, eucalyptus, citrus, or labiatae (mint family) varieties. The antimicrobial properties of manuka honey make it a good choice if you or your child has a cold.

ANTISEPTIC Contains hydrogen peroxide, one reason why it may be effective at inhibiting bacterial growth in laboratory studies. Used topically, it can help speed wound healing.

ALLERGIES Unfiltered honey, rich in pollen, can relieve the symptoms of seasonal allergies.

HOW DO I GET THE BEST FROM IT?

COLOR COUNTS Choose the darkest honey you can find, because it has more nutrients. Buckwheat, avocado, sagebrush, and tupelo honeys are particularly good choices.

BEWARE OF FAKE HONEY Unpasteurized and unfiltered honey is the most nutritious. Avoid ultrapurified honey, which has had all traces of pollen removed, and cheap fake honeys (often pale in color and sold in squeeze bottles). These have no medicinal benefit.

STORE CAREFULLY Store away from light at room temperature to preserve its properties.

HOW DO I USE IT?

SIMPLE COUGH SYRUP Take 1 tbsp of honey or combine with a little lemon juice and/or grated fresh ginger for a warming cough syrup that will boost your vitamin C intake.

WHEATGRASS

 HELPS REMOVE TOXINS FROM THE BODY

 HELPS BUILD RED BLOOD CELLS

 HEALS AND STRENGTHENS THE GUT

Before they form seed heads, young wheat shoots, called wheatgrass, consist of 70 percent **chlorophyll**. Wheatgrass supports the **immune system**, removes **toxins** from the blood and body tissues, improves **digestion**, is **gluten-free**, unlike other forms of wheat, and is high in vitamins C, E, and B-complex, **beta-carotene**, calcium, magnesium, potassium, iron, natural enzymes, and amino acids.

WHAT IS IT GOOD FOR?

DETOXIFIER Chlorophyll aids detoxification and, along with other plant-based nutrients, is a natural chelator (a substance that helps to draw heavy metals out of the body). In women with breast cancer, wheatgrass juice has been shown to remove the toxic byproducts of chemotherapy from their blood. There is also evidence that chlorophyll helps to protect the liver from toxins.

BLOOD BUILDER Its vitamin C and folate may help treat anemia resulting from deficiencies in these nutrients. Its high chlorophyll content assists in the formation of healthy red blood cells; studies show it reduces the transfusion requirements of people with thalassemia—a genetic disorder in which the body makes an abnormal form of hemoglobin.

DIGESTION Because it contains nutrients but little fiber, wheatgrass juice is a good way to supply nutrition to people with ulcerative colitis. There is also some evidence that daily ingestion of wheatgrass juice can help heal some of the symptoms of ulcerative colitis.

HEART HEALTH Animal studies have shown the juice can help lower total cholesterol and other blood fats, such as triglycerides (a type of fat in the blood), and which can specifically lower "unhealthy" (LDL) cholesterol levels.

HOW DO I GET THE BEST FROM IT?

RINSE WELL It is grown in moist conditions so is prone to mold; wash well before juicing.

ON ITS OWN It doesn't mix with food so take on an empty stomach 1 hour before eating.

HOW DO I USE IT?

AS A SHOT Serve in a shot glass with a slice of orange to help absorb its mineral content.

RECONSTITUTE IT The convenience and consistency of reconstituted dried powders can be a better option than fresh wheatgrass.

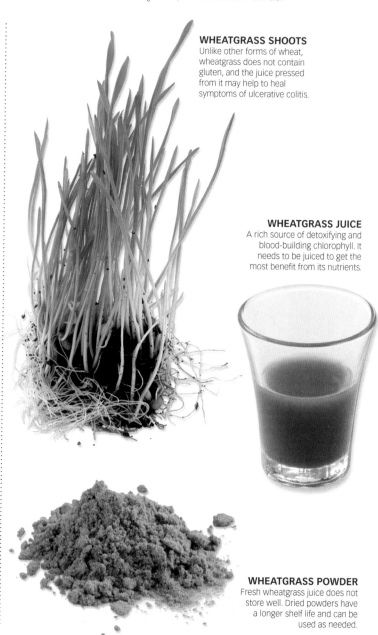

WHEATGRASS SHOOTS
Unlike other forms of wheat, wheatgrass does not contain gluten, and the juice pressed from it may help to heal symptoms of ulcerative colitis.

WHEATGRASS JUICE
A rich source of detoxifying and blood-building chlorophyll. It needs to be juiced to get the most benefit from its nutrients.

WHEATGRASS POWDER
Fresh wheatgrass juice does not store well. Dried powders have a longer shelf life and can be used as needed.

ALOE VERA

 CONTAINS POTENT ANTIVIRAL SUBSTANCES

 HELPS EASE BRONCHIAL COMPLAINTS

HELPS BALANCE INTESTINAL FLORA

The swordlike leaves of aloe vera contain a clear mucilaginous gel with **detoxifying**, **antiseptic**, and **anti-inflammatory** properties that is used internally and externally to **treat respiratory complaints** and **aid digestion**. In some Asian countries, the whole leaf, which contains **immunity-boosting** and **antioxidant** beta-carotene and vitamins C, E, many B vitamins, and minerals, is cooked and eaten.

Leaves
The antiviral potential of aloe gel in the leaves has been shown to boost the effectiveness of HIV treatments

ALOE PLANT
Of the 200-plus species of aloe plants, only 2—Aloe Barbadensis Miller and Aloe Arborescens—are grown commercially, with Aloe Barbadensis Miller being the most widely used.

PURE ALOE GEL
Unprocessed aloe gel contains aloin, a powerful laxative. Processed aloe vera juices contain much less of this substance.

WHAT IS IT GOOD FOR?

IMMUNITY STIMULANT Contains a substance called acemannan, an immune stimulant and an antiviral. It is effective against the herpes virus, and in HIV patients it may work synergistically with conventional medicines.

RESPIRATORY EASE Can help soothe coughs and bronchial asthma. Its antiseptic properties can help to heal colds and sore throats.

DIGESTION Helps balance intestinal flora. Can be useful in cases of irritable bowel syndrome, and is a laxative that is reputed to help expel parasites from the digestive tract.

ANTI-INFLAMMATORY Blocks the formation of histamine, which makes it a useful remedy for allergic conditions. Also contains natural salicylic acid, the base material for aspirin, so it is useful for general aches and pains and also conditions such as arthritis. As a gargle, it is also a beneficial treatment for gingivitis, an inflammatory condition of the gums.

HOW DO I GET THE BEST FROM IT?

GROW YOUR OWN Aloe plants are relatively easy to grow, but they don't like cold weather. Plant in pots and bring indoors in winter.

PURE GEL Aloe is most effective if minimally processed. If you can't get fresh aloe, look for 100 percent aloe juice products and pure gels, not extracts from the macerated leaves.

HOW DO I USE IT?

MAKE A FRESH JUICE Cut 1 aloe leaf (10–12in/25–30cm long) into manageable sections, peel like an avocado or mango, and scoop out the clear gel "fillet." Blend in a food processor or blender with 1 cup apple juice and drink while very fresh.

MIX INTO HEALTHY JUICES Aloe juice can be bitter so mix with apple and cucumber juice or fresh pineapple juice and coconut water.

SEAWEEDS

 ASSISTS WEIGHT MANAGEMENT

 HELPS REMOVE TOXINS FROM THE BODY

 LOWERS RISK OF HEART DISEASE AND STROKE

 FIGHTS THE EFFECTS OF STRESS

Every type of seaweed has a unique taste and texture, but all possess broadly the same nutritional benefits. They are, for instance, **protein-rich** and a source of **iodine**, necessary for **metabolism**. They are also a good source of **fiber** and **chlorophyll**, which help **remove toxins** from the body, and **heart-healthy** magnesium and potassium, which **protect blood vessels** and fight the effects of **stress**.

WHAT IS IT GOOD FOR?

METABOLISM Its high iodine content helps support healthy thyroid function, which in turn helps regulate the metabolism of cells and assists weight management. Brown seaweeds, such as kelp and wakame, contain the antioxidant carotenoid fucoxanthin, which improves insulin resistance and helps metabolize fat more efficiently.

DETOX A source of detoxifying chlorophyll and mucilaginous (gumlike) fiber that helps maintain bowel regularity and binds to and removes toxins and fats from the body.

HEART HEALTH Contains high amounts of magnesium, which lowers blood pressure, and folate, which breaks down homocysteine, a risk factor for heart disease and stroke.

STRESS Magnesium, pantothenic acid, and riboflavin support the health of the adrenal glands, which play a critical role in our response to stress. Without this nutritional support, constant stress can exhaust the adrenal glands, resulting in chronic fatigue, lowered immunity, and mood changes.

HOW DO I GET THE BEST FROM IT?

FRESH OR DRIED Drying does not damage its nutritional content. If you can forage fresh seaweed, make sure you rinse it well.

VEGETABLE PROTEIN If you don't eat meat or want to cut back on animal protein, seaweed provides high-quality vegetable protein.

HOW DO I USE IT?

FLAVOR ENHANCER Use ground seaweed as a flavor enhancer instead of salt, to flavor and thicken stocks, or add to soups, broths, or miso for extra protein and vitamins.

ADD TO BREAD To balance blood sugar levels and add protein, replace half the flour with ground seaweed. Use water, not milk, omit the salt, and add 1 extra tbsp oil or butter.

DULSE High in protein, dulse contains all the essential trace minerals as well as the antioxidant beta-carotene and vitamins C, E, and B-complex.

KELP A rich source of iodine and other important trace minerals.

NORI Particularly high in protein, which makes up 50 percent of its dry weight, and contains a comparable amount of fiber to spinach.

WAKAME Contains a high amount of magnesium, which improves heart function and acts as a diuretic.

ALGAE

 HELPS FIGHT INFECTION

 FEEDS GOOD BACTERIA IN THE GUT

 SUPPORTS AND PROTECTS THE LIVER

This group of aquatic plants is prized by Asian cultures as a delicacy and a rich **source of nutrients** and **antioxidants**, such as beta-carotene and zeaxanthin, **selenium**, zinc, and **vitamins C, E, and B-complex**. It is also rich in **protein** and **amino acids** that help the body to **fight infection**, and a beneficial type of **fiber** that encourages the growth of **good bacteria** in the gut and aids **detox**.

CHLORELLA
Chlorella is a green algae and is one of the richest sources of the detoxifying plant pigment chlorophyll.

SPIRULINA
The most commonly used type of blue-green algae, spirulina is a rich source of beta-carotene and amino acids.

AFA (APHANIZOMENON FLOS-AQUAE)
A unique blue-green algae found in Upper Klamath Lake in Oregon. AFA contains phenylethylamine (PEA), which may help balance mood and improve mental clarity.

WHAT IS IT GOOD FOR?

BOOSTS IMMUNITY Chlorella contains "Chlorella Growth Factor" (CGF), which can enhance immune function and stimulate tissue repair. Laboratory studies suggest that blue-green algae can fight the viruses that cause herpes, HIV, and influenza, though evidence in human beings is still lacking.

PROBIOTIC Helps to promote the growth of friendly bacteria in the gut. It is a good choice after a course of antibiotics, which can kill both good and bad gut flora in the intestines.

DETOX Helps support and protect the liver, and has a laxative effect. Blue-green algae may protect the liver from toxic damage. Chlorella has been shown to help remove heavy metals (such as cadmium and mercury), pesticides, and industrial pollutants from the body.

ANTIOXIDANTS Green and blue-green algae can help fight inflammation and damage to tissues and organs caused by free radicals.

HOW DO I GET THE BEST FROM IT?

DRIED CONCENTRATE Fresh algae doesn't keep well so it is often sold as supplements in a dried, powdered form. Many algae are now farmed rather than wild-gathered; this is not a bad thing, because they can easily become contaminated with waterborne pollutants.

USE IN SMALL QUANTITIES The drying process concentrates the nutrients so a little goes a long way. Mega-dosing with algae can produce uncomfortable stomach cramps.

HOW DO I USE IT?

SALAD DRESSING To give your salad a boost, try mixing 1–2 tsp algae powder into an oil and vinegar salad dressing.

A HEALTHY ADDITIVE Dried algae are versatile and generally have a mild taste ideal for mixing into soups, stir-fries, salsas, guacamoles, smoothies, and vegetable juices.

SARDINES

WHAT IS IT GOOD FOR?

LOWERS CHOLESTEROL Sardines are one of the most concentrated sources of the omega-3 fatty acids EPA and DHA, which have been found to lower triglycerides (fatty deposits) and "unhealthy" (LDL) cholesterol levels in the blood. They are an excellent source of vitamin B_{12} and a great source of vitamin D, which plays an essential role in bone health since it helps to increase the body's absorption of calcium.

HOW DO I USE IT?

QUICK AND CONVENIENT Canned sardines make a convenient and nutritious quick meal served on toast or pasta. Fresh sardines are delicious broiled or grilled. Cooking them quickly in this way keeps their essential nutrients intact.

Sardines

TROUT

WHAT IS IT GOOD FOR?

A GOOD SOURCE OF PROTEIN Lower in fat than some other fish, but still contains good amounts of omega-3 fatty acids. Also a good source of protein, potassium, phosphorus, vitamin B_{12}, and iron, which protect the heart and build healthy bones. Like most oily fish, semi-oily trout contains cholesterol, which is necessary for the synthesis of vitamin D and the production of vital hormones in the body, including the different sex hormones testosterone, progesterone, and estrogen.

HOW DO I USE IT?

MIX WITH FRESH FLAVORS When served with dried beans, oily fish, like trout, help increase the absorption of iron from the beans. Or cook with a lemon and almond crust or a rub of ground dried herbs and garlic mixed in a little olive oil. Grill on high heat.

Trout

SEA BASS

WHAT IS IT GOOD FOR?

IMMUNE ENHANCING An excellent source of high-quality protein and very rich in vitamins A, D, and E, which, with its omega-3 oils, are anti-inflammatory, immune-enhancing, and may help protect against degenerative diseases and cancer. It is also high in phosphorus, potassium, calcium, magnesium, zinc, and selenium. A semi-oily fish, it contains a good balance of fats but in lower quantities than oily fish, so it's a good choice if you want to limit your consumption of total fats.

HOW DO I USE IT?

A LOW-FAT CHOICE Grill simply with lemon and garlic, or spice it up with ginger, chile, and scallions.

Sea bass

TUNA

WHAT IS IT GOOD FOR?

HEART HEALTH Like trout and sea bass, tuna is a semi-oily fish. It is an excellent source of protein, as well as selenium, magnesium, potassium, and omega-3 essential fatty acids. Tuna also contains the B vitamins niacin, B_1, and B_6, and folate; B vitamins help lower levels of homocysteine, which can cause atherosclerosis (hardening of the arteries due to the buildup of plaque).

HOW DO I USE IT?

THINK SMALL Tuna concentrates toxins like mercury. Smaller species like skipjack are safest to eat, but limit consuming any type to once a week. Soy sauce and wasabi makes a good marinade for fresh grilled tuna.

Tuna

OILY FISH

 PROTECTS THE HEART AND BLOOD VESSELS

 SUPPORTS A HEALTHY NERVOUS SYSTEM

 HELPS LUBRICATES JOINTS

 SUPPORTS EFFICIENT METABOLISM

This group of fish are unique because their **heart-healthy** fats are distributed through their flesh rather than concentrated in their liver, as with white fish. They are particularly high in certain **omega-3 fatty acids**, which protect the **cardiovascular** and **nervous systems**. The fat-soluble vitamins A, D, E, and K are also abundant, benefitting bone, joint, muscle, skin, and eye health, and metabolic balance.

Salmon

SALMON

WHAT IS IT GOOD FOR?

SUPPORTS HEALTHY AGING Uniquely rich in the omega-3 fatty acids eicosapentaenoic acid (EPA) and decosahexaenoic acid (DHA). In combination with its abundant supply of selenium, these omega-3 fatty acids help lower blood pressure, "unhealthy" (LDL) cholesterol levels in the blood, and inflammation, reducing the risk of heart disease, stroke, and cancer. They also protect the eyes and joints and feed the brain, helping to prevent dementia and loss of mental functions. Salmon is also relatively low in the pro-inflammatory omega-6 fatty acids (already overabundant in the modern diet).

HOW DO I USE IT?

GO WILD Choose wild or organic as farmed salmon can contain residues of veterinary medicines. Grill on a high heat to seal in its nutrient.

Herring

HERRING

WHAT IS IT GOOD FOR?

HEART HEALTH A good source of eicosapentaenoic acid (EPA) and decosahexaenoic acid (DHA), fatty acids that lower hypertension, triglycerides (fatty deposits) in the blood, and inflammation, helping to reduce the risk of heart disease and stroke. It also contains vitamin D, calcium, and phosphorus, which are all important for bone health, and also vitamin B$_{12}$, which aids the production of cellular energy.

HOW DO I USE IT?

A LIGHT BITE Smoked herring is known as kippers, a delicacy that can be eaten at any meal. Rollmops are pickled herrings. Make your own with subtly flavored vinegar and serve with fresh bread, or cut into chunks and add to potato salad.

Mackerel

MACKEREL

WHAT IS IT GOOD FOR?

HEALTHY AGING Contains an abundance of nutrients, including vitamins A, B-complex, C, D, E, and K, calcium, potassium, selenium, and magnesium, which help regulate the metabolism, including blood sugar and cholesterol levels, and support healthy heart, bones, teeth, nerves, and muscles. It is rich in anti-inflammatory omega-3 fatty acids that keep blood vessels elastic and reduce swollen joints, pain, and stiffness associated with arthritis.

HOW DO I USE IT?

A HEALTHY MEAL Serve warm with asparagus on a bed of noodles and a miso and ginger dressing, or serve cold on a bed of sprouted lentils or other sprouted seeds, walnuts, and chives. To make fish cakes, blend with scallions, lima beans, mustard, parsley, and a little egg.

WATERFOWL

WHAT IS IT GOOD FOR?

GOOD FATS Duck and goose, known collectively as waterfowl, are particularly good for fueling the metabolic processes. Both are rich in iron and B vitamins, and duck, in particular, can contain up to 3 times more iron than chicken. Although waterfowl is perceived as a fatty meat, both duck and goose have a fat profile that is similar to chicken, meaning that both are high in heart-healthy monounsaturated and polyunsaturated fats. Both meats are also a good source of selenium, an antioxidant mineral that supports a healthy immune system.

HOW DO I USE IT?

NUTRITIOUS VARIETY Try cooking duck breasts instead of chicken breasts to provide variety and extra nutrition, or cook a goose as an alternative to seasonal roasted turkey. Duck and goose fat are very heat-stable alternatives to using olive oil or lard in cooking.

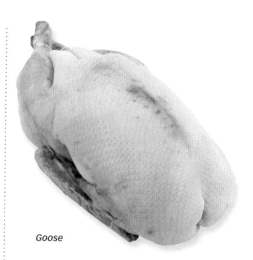

Goose

LIVER

WHAT IS IT GOOD FOR?

BLOOD BUILDER The liver is a storehouse of valuable nutrients for the body. All types of liver provide essential iron and B_{12} to support healthy blood. Whether from mammals or birds (or even fish), liver is also a tremendous source of protein and vitamin A, which is necessary for proper immune function as well as healthy skin, eyes, and mucous membranes. Lamb and calf liver are the richest sources of vitamin A, while chicken livers are a rich source of folate. As long as the animal it comes from was healthy and organic, all types of liver provide a major boost for the immune system, skin, eyes, and lungs.

HOW DO I USE IT?

A CLASSIC DISH Only eat organic liver, and enjoy it in patés or as a main meal. Marinating liver in lemon juice for 1–2 hours to draw out any impurities will give it a better texture. Lightly frying liver so it is still slightly pink in the middle, and serving on a bed of sautéed onions, is a classic way to enjoy this meat.

Pork liver

KIDNEYS

WHAT IS IT GOOD FOR?

ANTIOXIDANT-RICH Kidneys, most often from beef or lamb, are a good source of the antioxidant mineral selenium, which has a role to play in protecting against heart disease and cancer. They also contain moderate amounts of vitamin A, which promotes healthy skin, and large amounts of B vitamins, iron, and zinc. Men benefit from the zinc and selenium in kidneys, both of which help maintain fertility and a healthy prostate, while women of childbearing age will benefit from the iron, which can help replace what is lost during menstruation.

HOW DO I USE IT?

ADD TO CASSEROLES Kidneys add richness to beef and lamb dishes. Before cooking, marinate in lemon juice or brine for 1–2 hours to remove any trace of ammonia and improve their texture. Or cook simply with mushrooms and serve on toast.

Kidneys

MEATS CONTINUED

Venison

VENISON

WHAT IS IT GOOD FOR?

METABOLIC BOOST Venison is deer meat that is very low in fat. Like other red meats, it is high in protein and iron, which is necessary for efficient metabolism, but is low in saturated fats. It is also rich in potassium, phosphorus, and zinc. Venison contains useful amounts of vitamins B_1 and B_3, which help keep the metabolism in good shape and aid the growth, repair, and detoxification of tissues and bones. It is also a good source of the heart-protective vitamins B_6 and B_{12}, which can help keep arteries healthy.

HOW DO I USE IT?

ANTIOXIDANT-RICH MEAL Many recipes recommend long, slow cooking, although venison is probably best served medium-rare. For an antioxidant-rich meal, cover the raw meat with a dry rub of pepper, paprika, garlic, onion, thyme, and crushed juniper berries, and serve with roasted beets, sweet potatoes, and apple sauce.

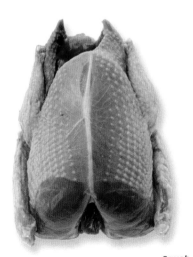

Quail

QUAIL

WHAT IS IT GOOD FOR?

LOW-FAT ENERGY BOOSTER Quail is lower in fat and higher in protein than chicken. The meat of this small bird has a sweet, delicate taste and is a great source of copper and iron, which are important nutrients for helping to generate energy. Quail also contains vitamin B-complex and vitamins C, E, and K, which help to strengthen the immune system. It is also a great source of iron, which helps transport oxygen throughout the body, and copper which, along with iron, helps prevent anemia and is necessary for healthy joints, skin, hair and connective tissue.

HOW DO I USE IT?

KEEP IT SIMPLE Choose quail that hasn't been intensively farmed. A single quail provides around 3–5oz (85–140g) of meat—essentially a single serving; cook quickly in a moderate oven 350°F (180°C) for 10 minutes only to preserve its moisture and nutrients. Quail quickly absorbs the flavor from marinades, so don't let any strong mixtures overpower its delicate flavor.

Squab

SQUAB

WHAT IS IT GOOD FOR?

IMMUNE-BOOSTING A wild bird with a distinctly gamey flavor, squab is high in key immunity-boosting trace elements, such as iron, zinc, and selenium; zinc is particularly important for male prostate health. Squab also contains the highest levels of phosphorous, necessary for healthy bones, tissue repair, and hormone production, of all commonly consumed game. It is low in fat—containing less fat than lamb or duck—and is a better source of blood-building iron than beef.

HOW DO I USE IT?

COOK QUICKLY Squab has a deep crimson color and great depth of flavor. It tastes wonderful in pies or on its own in a red wine sauce. As with quail, it benefits from quick cooking. Try serving hot on a bed of leafy greens or lentils, or in a salad with blackberry vinegar.

LAMB

WHAT IS IT GOOD FOR?

HEALTHY NERVOUS SYSTEM Lamb contains good amounts of B vitamins and is particularly rich in B_{12} and folate. These nutrients are necessary for a healthy central nervous system and aid the prevention of heart disease, mood disorders, and dementia, including Alzheimer's disease and vascular dementia in older people. Lamb is one of the few commercial meats that is still mostly pasture fed, which means it is naturally lower in cholesterol than some other meats and contains omega-3 and omega-6 fatty acids and conjugated linolenic acid (CLA).

HOW DO I USE IT?

NONSTARCHY VEGETABLES Animal protein meats, such as lamb, are healthiest and easiest to digest when eaten with nonstarchy vegetables (rather than rice and potatoes). Choose vegetables such as green beans, broccoli, kale, collards, and spinach to serve with lamb.

Leg of lamb

PORK

WHAT IS IT GOOD FOR?

A SOURCE OF GOOD FATS Pork is unique in that it contains more monounsaturated and polyunsaturated fats than saturated fat. This means that, as part of a healthy diet, it has a role to play in lowering cholesterol levels and reducing the risk of stroke and hypertension. Unlike beef and lamb, it is not a source of vitamin A, but it does contain useful amounts of the minerals zinc and iron, which help regulate energy release. It also contains B vitamins, specifically B_1, B_2, and B_3 (thiamine, riboflavin, and niacin), which are also necessary for energy regulation as well as muscle growth and repair.

HOW DO I USE IT?

FRESH CUTS We consume a lot of pork in the form of preserved meat. The link between these processed meats and bowel cancer is now well established, so opt for fresh cuts you can cook yourself. Try eating pork with fermented vegetables, such as sauerkraut, to aid digestion, and feed good bacteria in the gut.

Rolled pork leg joint

TURKEY

WHAT IS IT GOOD FOR?

CONTROLS INSULIN SECRETION Turkey belongs to a small group of high-protein animal foods (which also include tuna and egg whites) that can help keep post-meal insulin levels balanced for longer. The combination of B vitamins and tryptophan amino acid in turkey has a balancing effect on blood sugar levels, helps keep the nerves calm, avoids hypoglycemia and low moods, and has an immune-enhancing effect. It also contains selenium, necessary for the efficient function of the immune system and thyroid. Selenium is an antioxidant that helps combat the oxidative stress caused by free radicals in the body.

HOW DO I USE IT?

EAT THE DARK MEAT As with chicken, there are benefits in choosing the darker meat of the leg and thigh because it contains more metabolism-boosting iron, zinc, and B vitamins than the white meat. Use the dark meat as a filling for a sandwich or wrap with mango chutney and watercress.

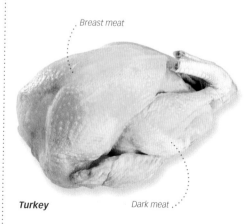

Breast meat

Turkey

Dark meat

MEATS

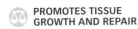 PROMOTES TISSUE
GROWTH AND REPAIR

 HELPS RELEASE
CELLULAR ENERGY

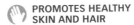 PROMOTES HEALTHY
SKIN AND HAIR

Meat is an important source of nutrients and **bioavailable** (easily absorbed) protein that helps the body repair and **build tissue**, **generate energy**, and maintain **healthy skin and hair**. However, eating too much highly processed, intensively reared meat contributes to health problems, such as heart disease and cancer. Organic meat has a much healthier nutrient profile, particularly in terms of fats.

Breast meat

Dark meat

Chicken

CHICKEN

WHAT IS IT GOOD FOR?

IMMUNITY-ENHANCING Chicken contains all the B vitamins, which help the body produce energy and form red blood cells, and also help strengthen the nervous system. Chicken meat is particularly high in the heart-healthy vitamin B_3 (niacin): the dark meat contains double the amount of zinc and iron of the light meat, giving it immune-boosting properties; while the white meat is higher in potassium and phosphorus, helping to build strong bones, teeth, and tissues.

HOW DO I USE IT?

CHICKEN SOUP Laboratory studies suggest that the synergistic action of nutrients in chicken may help halt the spread of infection and fight inflammation. If you have a cold or the flu, a bowl of chicken soup may be your best medicine.

Beef Rolled Rump

BEEF

WHAT IS IT GOOD FOR?

METABOLIC BALANCE A source of high-quality protein, beef also contains B vitamins, which fuel cellular energy production. The iron in beef helps produce more red blood cells that carry oxygen around the body. Beef also contains zinc, which aids cell division and helps in the formation of protein.

CHOLESTEROL HEALTH Stearic acid, a saturated fatty acid that accounts for 50 percent of beef fat, is converted by the body to monounsaturated oleic acid, the main fat in heart-healthy olive oil.

HOW DO I USE IT?

ADD GREEN VEGETABLES Beef can be harder to digest than white meat. Marinating or rubbing raw beef with spices such as rosemary, mustard, black pepper, garlic, onions, or horseradish can aid digestion and prevent the formation of carcinogenic heterocyclic amines—substances that form when red meat is cooked at a high temperature.

Healthy animals produce healthy meat

Outdoor-bred, pasture-fed, organic animals produce meat with lower total fat and higher levels of healthy fats, such as omega-3 fatty acids; they are also less prone to contamination with *E. coli* and other bacteria. Meat does contain cholesterol, but this fat is also an essential nutrient that helps the body synthesize steroid hormones, including those that regulate blood sugar, blood pressure, and sex hormone balance. Eating meat with antioxidant-rich green vegetables, as opposed to starchy ones, can help prevent the free-radical damage to cholesterol that is associated with heart disease.

Soy Sauce

What Is It Good For?

SUPPORTS A HEALTHY GUT
Fermenting soybeans to make soy sauce creates unique carbohydrates, called oligosaccharides, which are probiotics that feed friendly bacteria in the gut. Although high in sodium, which could contribute to raised blood pressure in some individuals, recent research suggests that the peptides in soy sauce, created by the fermentation process, help to keep blood pressure low. Soy sauce is rich in antioxidants, which can help protect blood vessels and lower cholesterol. It also contains niacin (B_3) and manganese, which help support an efficient metabolism.

How Do I Use It?

BUY THE BEST QUALITY Look for properly fermented products. If you have a wheat sensitivity, try tamari soy sauce. Use to season sautéed vegetables or combine with garlic and fresh ginger as a marinade for tempeh, fish, or chicken. Use instead of table salt to season foods. Avoid soy sauces containing MSG (monosodium glutamate, a synthetic flavor enhancer), which can cause headaches and rashes.

Soy sauce

Miso

What Is It Good For?

ANTICANCER PROPERTIES Rich in cancer-protective isoflavones, which protect the heart and aid hormone balance in both men and women. Evidence suggests that women who consume 3 or more bowls of miso soup daily have a significantly lower risk of breast cancer.

AIDS DIGESTION Miso is a high-antioxidant fermented food that feeds friendly bacteria in the gut, helping to enhance immunity and aid digestion. It is made from grains, such as barley and rice, or soybeans, and contains all the essential amino acids required by the body, which makes it a complete protein.

How Do I Use It?

AS A VERSATILE PROTEIN Look for organic, naturally aged, nonpasteurized miso, which is sold as a thick paste. The longer it is aged, the darker its color. Use dark miso in a vegetable-bean casserole to supply plenty of high-quality protein, or mix with water to make an energizing, alkalizing broth. Use a light-colored miso as a substitute for milk, butter, and salt in creamed soups, or as a marinade to tenderize meat.

Miso

Tempeh

What Is It Good For?

PHYTOESTROGEN-RICH High in phytoestrogens, tempeh helps protect against heart disease and cancer, regulates immune function, and may help relieve menopausal symptoms. Not to be confused with tofu (which is not fermented), tempeh is made from fermented, lightly cooked soybeans. Fermentation increases its antimicrobial benefits, providing protection against gastrointestinal upsets. Tempeh is rich in dietary fiber, which helps maintain a healthy digestive tract. This fiber also helps remove fats from the blood. It has also been shown to help lower levels of "unhealthy" (LDL) cholesterol while raising levels of "healthy" (HDL) cholesterol.

How Do I Use It?

MEAT SUBSTITUTE Tempeh has a hearty, nutty flavor that makes it a popular meat substitute. It can be baked, sautéed, steamed, or marinated, and used in sandwiches, curries, and salads. Its relatively neutral taste means it absorbs whatever flavors it is cooked in.

Tempeh

FERMENTED FOODS

 HELPS STRENGTHEN THE IMMUNE SYSTEM

 FEEDS GOOD BACTERIA IN THE GUT

 CONTAINS ANTICANCER SUBSTANCES

The biochemical process of fermentation in foods encourages the growth of friendly bacteria that help maintain a **healthy gut**. It is not an overstatement to say that a healthy gut—one that digests food and nutrients efficiently—is the basis of good health. Healthy and balanced intestinal flora is also a way of **preventing intestinal disorders**, from **irritable bowel syndrome** to **cancer**.

Sauerkraut

SAUERKRAUT

WHAT IS IT GOOD FOR?

INHIBITS CANCER CELLS Laboratory studies show that isothiocyanates, the antioxidant chemicals in fermented cabbage, or sauerkraut, can inhibit the growth of cancer cells

SUPPORTS HEALTHY GUT FLORA Cabbage naturally contains the friendly bacterium *Lactobacilli plantarum*. Fermenting promotes the growth of this organism, which can help balance intestinal flora and inhibit the growth of *E. coli*, salmonella, and candida. It can also help improve the general health of the digestive tract.

HOW DO I USE IT?

A BETTER CONDIMENT Use uncooked as a condiment. Add sauerkraut to a sandwich or bagel instead of lettuce, or serve to accompany rich meats and sausages. Mix 1–2 tbsp into stir-fried brown rice, scrambled eggs, shiitake mushrooms, carrots, or onions, and drizzle with a little soy sauce and sesame oil. Avoid pasteurized brands of sauerkraut because these have fewer nutrients.

Kimchi

KIMCHI

WHAT IS IT GOOD FOR?

ANTICANCER BENEFITS A Korean version of sauerkraut, kimchi is a pungent blend of fermented cabbage, radish, red chiles, garlic, and salt, and is the national dish of Korea. The anticancer and heart-healthy benefits in kimchi derive from the many nutrients in the cruciferous cabbage. The mixture of spices and beneficial bacteria in kimchi is also powerfully antimicrobial against harmful bacteria, such as *Helicobacter pylori*, *Shigella sonnei*, and *Listeria monocytogenes*.

HOW DO I USE IT?

A SPICY SIDE DISH Kimchi can be served not only as a side dish with steamed rice, but also with tempeh, noodles, fish, meat, and vegetables. Use as you would a relish on burgers, roasted meat, and baked potatoes.

The benefits of brine

Vegetables can be preserved in brine using a natural process known as lacto-fermentation. The brine solution allows beneficial bacteria and enzymes to flourish while retarding the growth of harmful organisms. The result is a food with multiple health-giving properties for the digestive tract. However, unlike homemade pickled vegetables, most commercially available kinds are produced using a strong mixture of processed salt and industrial-strength vinegar. This added salt eliminates any health benefits, while the pasteurization (heating) process destroys precious enzymes.

FLAXSEED OIL

WHAT IS IT GOOD FOR?

HEART HEALTH Flaxseed oil, which is extracted from flaxseeds, contains the essential fatty acid alpha-linolenic acid (ALA), which can help prevent heart attacks and stroke. Studies suggest ALA may reduce heart disease risk in a variety of ways, including reducing inflammation and excessive blood clotting, promoting blood vessel health, and reducing the risk of arrhythmia (an irregular heartbeat). The oil also contains polyunsaturated omega-3 and omega-6 fatty acids. Consumed daily, it can help improve the dry eyes associated with Sjogren's syndrome.

HOW DO I USE IT?

KEEP IT COOL Flaxseed oil doesn't keep well. Buy in a dark container and store away from light and heat. It's not heat stable, so use it cold. Drizzle on cottage cheese, or scoop out the flesh of a baked potato, mix with quark cheese and flaxseed oil, and replace in the potato skin. Add to juices and smoothies or use to enrich condiments such as ketchup, mayonnaise, and salad dressings.

Flaxseed oil

HEMPSEED OIL

WHAT IS IT GOOD FOR?

ANTI-INFLAMMATORY Hempseed oil contains the highest percentage of essential fatty acids in any oil and contains the perfect ratio of omega-3, -6, and -9 fatty acids, which are crucial for healthy circulation, cell growth, and the immune system. Its high omega-3 content makes it a good vegetarian alternative to fish oil, and means it is both anti-inflammatory and an antioxidant. Including it in your diet will benefit your heart and nervous system as well as improving your skin and helping to maintain healthy joints. A good brain food, hempseed oil can support memory and cognitive function and may help prevent dementia.

HOW DO I USE IT?

KEEP IT SIMPLE Store in a dark container away from heat and light. Look for oils that have not been bleached or deodorized. The oil is not suitable for frying or cooking at high temperatures and should be used cold to enjoy its benefits. Add to juices, smoothies, yogurts, cottage cheese, salad dressings, and steamed vegetables, or use a little on bread instead of butter.

Hempseed oil

BLACK SEED OIL

WHAT IS IT GOOD FOR?

ANTI-INFLAMMATORY Studies show its anti-inflammatory and detoxifying effects can help treat arthritis and rheumatic conditions, and can relieve symptoms in cases of allergic rhinitis (hay fever), eczema, and asthma. It also contains a component called gamma linolenic acid (GLA), which has been shown to reduce the pain associated with diabetic neuropathy (damage to the nerves due to high blood pressure from diabetes). In addition, black seed oil can help raise levels of "healthy" (HDL) cholesterol in the bloodstream.

HOW DO I USE IT?

A HEALTHY ADDITIVE Makes a pungent addition to salad dressings and stir-fries. Mix with honey and garlic to treat allergies and coughs and ward off colds and flu. To treat diarrhea, mix 1 tsp black seed oil with 1 cup of plain probiotic yogurt and eat as needed. Mix 1 tsp of the oil with a glass of orange juice as an energy boost to start the day.

Black seed oil

FATS AND OILS

 ANTI-INFLAMMATORY PROPERTIES

 A READY SOURCE OF ENERGY

 HELPS LOWER CHOLESTEROL

A mixture of different oils and fats in small amounts is crucial for optimal health, **energy**, and **metabolism**. They also help us absorb fat-soluble vitamins D, E, and K, and the carotenoids that we need to make vitamin A. A good balance of polyunsaturates, monounsaturates, and saturated fats (needed for the synthesis of vitamin D) has an **anti-inflammatory** effect and promotes **heart health**.

Butter

Ghee

BUTTER

WHAT IS IT GOOD FOR?

MAINTAINS ENERGY Butter and ghee, a form of clarified butter, have similar properties and are a source of energy. Both contain medium- and short-chain fatty acids, of which one, lauric acid, is a potent antimicrobial and antifungal substance. These fats are not associated with heart disease in the way that long-chain fatty acids (present in some vegetable oils) are, because they are used directly as energy by the body and not stored as fat. Butter supplies saturated fat, but it contains other fats, such as monounsaturates, that help us absorb fat-soluble nutrients. Organic butter has higher levels of these healthy fats.

HOW DO I USE IT?

VERSATILE INGREDIENT Use in moderation as a spread, in baking, and in sauces. Ghee is used in much the same way as butter in cooking.

Olive oil

OLIVE OIL

WHAT IS IT GOOD FOR?

LOWERS CHOLESTEROL Protects against heart disease by raising levels of "healthy" (HDL) cholesterol while keeping levels of "unhealthy" (LDL) cholesterol in check. Contains more monounsaturated fatty acids than any other natural oil. These fatty acids help normalize blood clotting and control blood sugar levels, making olive oil a good choice for helping prevent metabolic syndrome. The oil is easy to digest, which gives it a healing effect on stomach ulcers.

HOW DO I USE IT?

A GOOD ALL-ROUNDER Regular filtered olive oil is better for cooking because it has a higher "smoke point," but it has fewer nutritional benefits. Save cold-pressed extra virgin oil for uncooked dishes and dressings. Store away from heat and light.

Sunflower oil

SUNFLOWER OIL

WHAT IS IT GOOD FOR?

LOWERS BLOOD PRESSURE Sunflower oil is low in saturated fats and high in vitamins E and D and beta-carotene. The best sunflower oils are pressed from plants that have been naturally bred to provide more monounsaturated fat and omega-9 fatty acids, which can help reduce blood pressure, preserve memory, and help prevent cancer. Look for high-oleic content sunflower oil and avoid regular sunflower oil—it is low in monounsaturates and high in omega-6 fatty acids, making it pro-inflammatory.

HOW DO I USE IT?

ALTERNATIVE TO ANIMAL FATS Good for both sweet and savory recipes. Use the nutrient-rich unrefined oil for cold dishes; the refined oil has a higher smoke point that is better for cooking.

PEPPERCORNS

**STIMULATES APPETITE
AND AIDS DIGESTION**

WHAT IS IT GOOD FOR?

DIGESTIVE AID Pepper aids digestion and stimulates the appetite. It has antioxidant and anti-inflammatory properties and is traditionally used to aid detoxification, ease lung and bronchial infections, and relieve shock and stress. In laboratory tests, piperine, a compound found in peppercorns, halted the growth of breast cancer cells. True peppers are green, black or white; pink "peppercorns" are actually from an unrelated species and do not have the same health benefits.

HOW DO I USE IT?

USE THE WHOLE SPICE Always buy whole peppercorns and grind as required; if preground, they quickly lose their active properties. Use in stocks and marinades and grind liberally onto hot vegetable dishes and salads. Crush the peppercorns roughly and use to completely coat meat before grilling, or add to oil and vinegar for a spicy dressing.

Pepper

SAFFRON

**FIGHTS AGE-RELATED
VISION LOSS**

WHAT IS IT GOOD FOR?

A POTENT ANTIOXIDANT Saffron is actually the dried stigmas of the saffron crocus. It contains the potent antioxidants crocin, safranal, and picrocrocin, which can help delay age-related macular degeneration (loss of vision), help prevent hardening of the arteries (atherosclerosis), and inhibit the growth of cancer cells. Added to tea or milk, it can help treat insomnia and may help lift depression. Its anti-inflammatory properties may be helpful in treating asthma and allergies, and as a stimulant it can help improve the circulation.

HOW DO I USE IT?

USE SPARINGLY Saffron is expensive, but a little goes a long way. Use it to flavor and color dishes, such as paella, risotto, bouillabaisse, spicy lamb, chicken dishes, and even sweet desserts. Mixed with garlic, thyme, and oil it makes an excellent marinade for fish. Saffron can also be used in bread and cake baking.

Saffron

STAR ANISE

**PROTECTS AGAINST
COLDS AND FLU**

WHAT IS IT GOOD FOR?

ANTIVIRAL Although traditionally used to ease wind, hiccups, and water retention, star anise excels in helping speed recovery from viral infections. Its potent antiviral properties are effective against both the herpes virus and the flu virus—so much so that its constituents have been harnessed by pharmaceutical companies to produce flu medicines, such as Tamiflu. Star anise also contains plant estrogens that can stimulate breast milk supply and help increase vitality in women.

HOW DO I USE IT?

ADD SPICE TO DESSERTS Star anise has a spicy taste that is similar to licorice, and adds an edge to sweet dishes. The seeds go particularly well with figs. Try adding a little ground star anise to ground coffee before brewing, or to some vanilla-flavored yogurt. Add the whole spice or the seeds to fish and vegetable dishes.

Star anise

SPICES CONTINUED

Juniper

Licorice

Nutmeg

JUNIPER

 HELPS STIMULATE INSULIN SECRETION

WHAT IS IT GOOD FOR?

A DIABETIC AID Stimulates insulin release, making it a useful aid if you are diabetic. It can also support and, where there has been no permanent damage, help to heal the pancreas. Traditionally, it has been used as a digestive aid, and an antiseptic for treating urinary infections and water retention. Chewing the berries is a traditional remedy for inflamed and infected gums. Essential oils in the berries contain active compounds that help to clear uric acid from the body, making it useful for rheumatic conditions, such as gout.

HOW DO I USE IT?

USE THE FRESH BERRIES Crush the berries lightly and add to meat and game recipes. Combined with garlic and sea salt, they add a wonderful flavor to cabbage and other green vegetables. The fresh berries can also be used in stuffings, sauces, marinades, and pâtés.

LICORICE

 HELPS FIGHT BACTERIAL AND VIRAL INFECTIONS

WHAT IS IT GOOD FOR?

METABOLIC STIMULANT Its antidiabetic and antioxidant properties aid the treatment of metabolic syndrome (a group of risk factors that can lead to diabetes and heart disease). It can help support liver health, and is an antiseptic that helps to calm the stomach. It is also an expectorant and decongestant that can help fight respiratory infections. There is some evidence that licorice in small amounts can be used to decrease sugar cravings. In addition, it can be used as a treatment for low blood pressure.

HOW DO I USE IT?

MAKE A TEA Boil the root to make a tea if you are feeling nauseous or are coming down with a cold. Licorice tea is also good for maintaining dental health; try gargling with the cooled tea. Licorice and soy sauce, which marry well together, help counter the effects of stress, and give a deep, delicious flavor to Asian dishes.

NUTMEG

 FIGHTS THE EFFECTS OF STRESS

WHAT IS IT GOOD FOR?

HELPS YOU ADAPT As an adaptogen, it can be both a stimulant and a sedative, according to the body's needs. In times of stress, it can help lower blood pressure. Conversely, it can lift your mood and acts as a tonic and stimulant, making it beneficial if you are recovering from an illness or overtired. It is also a digestive that can soothe stomachaches, ease wind, and help stop diarrhea. Its volatile oils have anti-inflammatory properties that make it useful for treating joint and muscle pain. In traditional Indian medicine, it is used to calm respiratory problems, such as asthma.

HOW DO I USE IT?

THE ORIGINAL COMFORT FOOD A great addition to cooking when you feel stressed. Use in milk and rice puddings and in white or cheese sauces. It can also transform mashed potatoes and other vegetable dishes. Sprinkle or grate onto hot chocolate or warm milk for a quick pick-me-up.

CORIANDER

 STIMULATES APPETITE AND AIDS DIGESTION

WHAT IS IT GOOD FOR?

LOWERS CHOLESTEROL Valued in traditional Ayurvedic medicine for its anti-inflammatory properties, modern research shows that coriander has cholesterol-lowering effects. It can stimulate appetite, help increase the secretion of gastric juices, and aid digestion. It is also a diuretic and an antibacterial shown to be effective against salmonella, *E. coli*, and MRSA. Recent studies suggest that the antioxidants in coriander may also have a role to play in protecting the nervous system from free-radical damage. This can help to lower the risk of neurodegenerative illnesses, such as Alzheimer's and Parkinson's diseases.

HOW DO I USE IT?

AN EVERYDAY SPICE The seeds can be used in curries, chutneys, stews, soups, rubs, and marinades. They blend well with smoked meats, game, and even fish. Ground coriander seeds also add an extra dimension to breads, desserts, and sweet pastries.

Coriander

CUMIN

 RICH IN ANTI-INFLAMMATORY ANTIOXIDANTS

WHAT IS IT GOOD FOR?

A POWERFUL ANTIOXIDANT A good general tonic, cumin is also antiseptic and antibacterial, and can help to improve blood circulation. It helps fortify the digestive tract, relieving nausea, bloating, and constipation. Laboratory tests suggest its antioxidant oil content can inhibit the growth of cancer cells. Ordinary cumin seeds are brown in color and contain many beneficial properties. However, black cumin seeds, known as "black seed," have a much higher concentration of these medicinal oils.

HOW DO I USE IT?

USE THE WHOLE SEED Buy the whole seeds and use in pickles or preserves. Add the ground seeds to rubs or marinades, or make a spicy Eastern-style salad with tomatoes, green bell peppers, zucchini, and/or eggplant and then sprinkle a little ground cumin on top.

Cumin

FENUGREEK

 SOOTHES AND PROTECTS THE GUT

WHAT IS IT GOOD FOR?

A METABOLIC BOOST The seeds are a good source of mucilaginous (gumlike) fiber that soothes and protects the digestive tract from free-radical damage. A tonic and antioxidant, fenugreek can also help boost the metabolism, and it is also a traditional remedy for stimulating the production of breast milk. The seeds are rich in diosgenin, a plant estrogen that may boost women's vitality during menopause by easing symptoms including hot flashes, anxiety, and insomnia. In laboratory tests, diosgenin has also demonstrated anticancer effects.

HOW DO I USE IT?

ADD SOME SPICE The seeds have a strong aroma that lifts pickles, dahls, curries, and vegetable and rice dishes. They can be sprouted like bean sprouts and used as a vegetable. A tea made from the seeds mixed with honey and lemon can help soothe flulike symptoms.

Fenugreek

SPICES

Made from the bark, root, bud, or berry of a plant, spices are generally used **dried** rather than fresh, which means their **essential oil** content is highly concentrated and they have a more **pungent** taste. Research into many common spices has found that they possess **powerful antioxidant** and **antibiotic** qualities, and benefit **digestive health**.

Cardamom

CARDAMOM

 HELPS CLEAR UP CONGESTION

WHAT IS IT GOOD FOR?

METABOLIC BOOSTER A volatile oil constituent called cineol in cardamom can help break up chest congestion, making the spice a good choice for treating bronchitis, laryngitis, and colds. An effective digestive stimulant and diuretic, cardamom boosts the metabolism and helps the body burn fat more efficiently. It is also effective against *H. pylori*, the bacterium that causes ulcers. Studies also show it can help maintain healthy circulation and prevent the free-radical damage that can lead to stroke and atherosclerosis.

HOW DO I USE IT?

USE WHOLE SEEDS Buy the pods or whole green or bleached white seeds to use, lightly crushed, in rice dishes, curries, and meat stews. Freshly ground cardamom can give a surprisingly tangy lift to an everyday fruit salad. It can also be infused in milk to settle the stomach or to make a spicy custard or rice pudding.

Cinnamon

CINNAMON

 HELPS BALANCE BLOOD SUGAR LEVELS

WHAT IS IT GOOD FOR?

ANTISEPTIC Cinnamon is a digestive aid that helps normalize levels of both glucose and triglycerides (a type of fat) in the blood, reducing the risk of diabetes and heart disease. It is also a first-class antiseptic that can help fight bacteria, viruses, and fungal infections. It is rich in antioxidants, which give it a mild analgesic and anti-inflammatory effect, and perhaps this is why it was traditionally used to aid recovery from colds and flu, sore throats, fevers, and headaches. Just smelling cinnamon is said to boost cognitive function and memory.

HOW DO I USE IT?

A VERSATILE FLAVOR For a quick pick-me-up, use a cinnamon stick to stir tea, hot chocolate, or milky coffee. It is equally nice grated or crumbled into savory dishes, such as stews, stuffings, casseroles, pickles, and relishes as it is added to sweet dishes, such as stewed fruits, pies, and rice or milk puddings.

Aromatherapy in your kitchen

Like all plant products, spices contain a wealth of vitamins, minerals, and trace elements. Unlike fresh herbs, spices are generally used in their dried form, and because we use dried spices in such minute amounts in cooking, we benefit less from these nutrients than we do their powerful essential oils, which are highly concentrated. If stored properly—in airtight containers away from light—spices can keep their beneficial properties for a very long time. Wherever possible, buy spices whole and grind or crush them as needed. Their aroma will be stronger and their active ingredients more potent.

CHICKPEAS

WHAT IS IT GOOD FOR?

BONE HEALTH Beyond their fiber content, chickpeas may also be good for bone health. They are rich in manganese, which helps build bones and is necessary for healthy bone structure, and calcium, phosphorus, and magnesium, which are also vital bone-healthy minerals. The fiber in chickpeas has been shown to help reduce levels of "unhealthy" (LDL) cholesterol and help regulate appetite and reduce food cravings.

HOW DO I USE IT?

CHICKPEA GAZPACHO Add chickpeas to gazpacho for a more satisfying dish. The antioxidant lycopene, found in abundance in tomatoes, also works synergistically with chickpeas to reduce oxidative stress (caused by free radicals in the body) on bones.

Chickpeas

KIDNEY BEANS

WHAT IS IT GOOD FOR?

DIGESTION AND BOWEL REGULARITY Kidney beans contain both soluble and insoluble fiber. Soluble fiber can help lower "unhealthy" (LDL) cholesterol; insoluble fiber helps to promote good digestive health and bowel regularity. Also high in blood-building iron, phosphorus—a cofactor in maintaining healthy bones and teeth—and vitamin K, which helps protect the nervous system from free-radical damage and may even have an anticancer effect.

HOW DO I USE IT?

RICE AND BEANS Cooked rice and kidney beans make a complete protein meal. Add sautéed chopped onion, garlic, bell peppers, and tomatoes and season with chili powder, fresh cilantro, thyme, salt, and black pepper to taste.

Kidney beans

LENTILS

WHAT IS IT GOOD FOR?

CARDIOVASCULAR HEALTH Lentils of all types are extremely high in molybdenum and iron, making them an excellent food for helping to oxygenate the blood and aid the release of cellular energy. The insoluble fiber they contain also helps to keep cholesterol at healthy levels. Lentils are also rich in vitamin B_1 (thiamine), which helps to regulate the nervous system and maintain a steady heartbeat.

HOW DO I USE IT?

SPROUT IT Dried lentils are deficient in 2 essential amino acids, cysteine and methionine. However, sprouting them increases their levels of all amino acids, including these 2, and produces a food that is a complete protein in its own right.

Red lentils

MUNG BEANS

WHAT IS IT GOOD FOR?

DETOXIFICATION Green mung beans have long been used in traditional Chinese and Indian medicine to keep the body running smoothly due to their detoxifying properties and anti-inflammatory benefits. Mung beans are also rich in fiber and isoflavones and phytosterols (plant hormones) that can help lower cholesterol. In addition, they contain a useful amount of potassium, which can help lower blood pressure.

HOW DO I USE IT?

AS BEAN SPROUTS The beans can be added to stews, but they are usually eaten as bean sprouts. A staple of Chinese cooking, they can be added to any stir-fry, salad, or sandwich.

Mung beans

DRIED BEANS

PROMOTES BOWEL REGULARITY

PROTECTS THE HEART AND BLOOD VESSELS

HELPS BUILD STRONG BONES

Including more dried beans in your diet is a terrific way to **maintain digestive health**, **lower cholesterol levels**, and **regulate blood sugar levels** because they contain **protein** and **fiber**. Most are good sources of **iron**, an integral component of red blood cells, which transport oxygen from the lungs to every cell in the body. Beans are also an excellent choice if you want to cut back your meat intake.

Adzuki beans

ADZUKI BEANS

WHAT IS IT GOOD FOR?

HEART HEALTH Rich in soluble fiber, which is absorbed during digestion and helps maintain "healthy" (HDL) cholesterol levels in the blood. The beans contain potassium and magnesium, which are good for regulating blood pressure and improving blood flow, and essential B vitamins including B_6, B_2, B_1, B_3, and folate—all necessary for the cellular energy production that fuels metabolism. Also a good source of the trace element molybdenum, which aids liver detoxification.

HOW DO I USE IT?

ADZUKI BEAN PATTIES Combine cooked adzuki beans with rice, egg, garlic, onion, and fresh herbs; form into patties and shallow-fry. Or add the beans to casseroles or soups for extra fiber, protein, and flavor, or sprout them and add to salads.

Black beans

BLACK BEANS

WHAT IS IT GOOD FOR?

BLOOD HEALTH Black beans are abundant in both iron and the trace element molybdenum. Iron is essential for carrying oxygen to our red blood cells, and for the production of hemoglobin, a primary component of red blood cells. Molybdenum is essential for healthy liver function and is a key component in chemical reactions that release iron in the body. In addition, the beans are a good source of fiber to help cleanse and protect the colon.

HOW DO I USE IT?

BLACK BEAN SALAD Mix cooked black beans, orange segments, sliced red onion, and cumin seeds with an oil and vinegar dressing. Eating legumes with vitamin-C-rich foods increases iron absorption, as the type of iron (non-heme) in plants is harder to absorb than iron in meat (heme).

Butter beans

BUTTER BEANS

WHAT IS IT GOOD FOR?

BLOOD AND TISSUE HEALTH A milder, creamier relative of the fava bean, butter beans are a good source of potassium, iron, copper, manganese, and soluble fiber—all essential for a healthy cardiovascular system and digestive tract. They also contain molybdenum, which promotes liver health, and are high in tryptophan, an amino acid, and protein, which is necessary for building and repairing tissue and muscle in the body.

HOW DO I USE IT?

BUTTER BEAN HUMMUS Purée cooked butter beans with sautéed onion and garlic, and lemon juice in a food processor or blender. Gradually add enough extra virgin olive oil until the mix reaches a thick but smooth consistency. Season to taste and serve.

BUCKWHEAT

 PROTECTS THE HEART AND BLOOD VESSELS 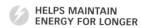 **EASY TO DIGEST** **HELPS MAINTAIN ENERGY FOR LONGER**

Buckwheat is not a true cereal, but is instead related to rhubarb, sorrel, and dock. The grain contains both insoluble and soluble fiber, which help to **lower "unhealthy" (LDL) cholesterol**, **balance blood sugar levels**, and keep the **gut healthy**. Buckwheat is also rich in **antioxidant** flavonoids that help **protect the heart**, and, because it doesn't contain gluten, is ideal for **gluten-free** diets.

WHAT IS IT GOOD FOR?

CIRCULATORY SYSTEM Contains important antioxidant flavonoids: quercetin, thought to have anti-inflammatory and antiallergic properties; and rutin, which strengthens the capillaries and improves circulation, and can help protect against painful varicose veins.

DIGESTION AND CONSTIPATION Its gumlike mucilaginous fiber is lubricating and soothing to the digestive tract. Buckwheat also contains a type of indigestible fiber that acts like a prebiotic, feeding helpful bacteria in the gut.

ENERGY BALANCE The grain contains slow-release carbohydrates that help maintain steady blood sugar levels. It is abundant in magnesium and manganese, both of which are necessary for carbohydrate metabolism.

ANTICANCER Like most whole grains, it contains plant hormones called lignans, which can promote hormone balance in both men and women. One lignan, enterolactone, has been shown to protect against breast and other hormone-dependent cancers.

HOW DO I GET THE BEST FROM IT?

BUCKWHEAT SPROUTS Soak raw, untoasted seeds for 30 minutes, drain, and keep moist until they begin to sprout. (Toasted buckwheat has a golden brown color, whereas raw buckwheat is white or light green.)

BUCKWHEAT FLOUR The flour is gluten-free and can be used in baking. Dark-colored buckwheat flour contains the husk and a greater proportion of protein than the light flour, while sprouted buckwheat flour is even more nutrient-rich.

HOW DO I USE IT?

MAKE A PORRIDGE Soak and sprout the seeds to release their mucilaginous fiber and use to make "porridge" by combining with yogurt or nut milk and fruit.

GRAIN
Buckwheat contains 8 essential amino acids required by the body, as well as high proportions of manganese, magnesium, and fiber.

SPROUTS
Sprouting the grain makes its nutrients more available to the body and activates enzymes, which lower blood pressure.

BARLEY

 FEEDS HEALTHY GUT BACTERIA

 HELPS LOWER CHOLESTEROL

 HELPS BALANCE BLOOD SUGAR LEVELS

Barley is a grain with a number of fantastic medicinal properties. Thanks to its **high fiber content**, it is great for **improving digestion** and **lowering cholesterol**, while its low glycemic index is one of a number of its properties that helps to **improve blood sugar levels** and **reduce the risk of diabetes**. It is also versatile, and can be served instead of rice, added to casseroles, or used in baking.

GRAINS
Studies show that whole grain barley can help maintain steady blood sugar levels for up to 10 hours after consumption—much longer than whole grain wheat.

GRASS
Barley grass is an easily digested green food sprouted from barley seeds.

WHAT IS IT GOOD FOR?

DIGESTION AND CONSTIPATION Barley grain has a very high fiber content. One portion provides nearly half the daily recommended amount. Barley fiber feeds good bacteria in the gut, which in turn produce butyric acid, the primary fuel for intestinal cells necessary for maintaining a healthy colon. In addition, barley grass juice has been shown to improve the symptoms of ulcerative colitis.

HEART HEALTH The high levels of soluble fiber in barley help to remove excess fat and cholesterols from the bloodstream, lowering the risk of hypertension and atherosclerosis (hardening of the arteries).

MANAGING BLOOD SUGAR Barley is a slow-release carbohydrate that helps maintain steady blood sugar levels. In addition, barley is abundant in magnesium and manganese, both of which are necessary for carbohydrate metabolism.

HOW DO I GET THE BEST FROM IT?

WHOLE BARLEY When selecting barley, choose whole barley, or pot barley, rather than pearl barley. The husk, which contains much of the grain's nutrients, remains intact in whole barley.

BARLEY GRASS To get the best from the antioxidants in barley grass, juice the young shoots when they are 3–7 days old.

HOW DO I USE IT?

BARLEY RISOTTO Don't simply add barley to casseroles. Whole barley grains make an excellent risotto; the sweet taste of the grain works especially well with mushrooms.

ENRICH YOUR BAKING Barley is low in gluten so use it in baking. Substitute up to half the quantity of regular wheat flour for barley flour. As well as reducing the gluten content, it adds extra flavor and texture.

MILLET

 HELPS PROMOTE PEACEFUL SLEEP **PROTECTS AGAINST METABOLIC SYNDROME** **HELPS PREVENT GALLSTONES**

Once a staple grain of Africa and India, today millet ranks as the sixth most important grain in the world and sustains around one-third of the global population. It is a **nutritious**, **nonacid-forming** grain considered to be one of the **least allergenic** and **most digestible** grains available. It is **high in protein**, fiber, B-complex vitamins, iron, magnesium, phosphorus, and potassium.

WHAT IS IT GOOD FOR?

PEACEFUL SLEEP Contains substantial amounts of tryptophan, an amino acid that can help induce a good night's sleep.

CONTROLLING METABOLIC SYNDROME The B vitamins in millet, especially niacin (B_3), can help lower "unhealthy" (LDL) cholesterol, while magnesium helps lower blood pressure and reduces the risk of heart attack, especially in people with atherosclerosis (hardening of the arteries) or diabetes. It also helps reduce the severity of asthma and the frequency of migraines. Its high fiber content helps increase insulin sensitivity and reduce levels of blood fats (lipids).

HELPS PREVENT GALLSTONES Evidence shows that eating foods (such as millet) high in insoluble fiber can help prevent gallstones. Insoluble fiber helps to reduce the secretion of bile acids, excessive amounts of which contribute to the formation of gallstones.

HOW DO I GET THE BEST FROM IT?

HULLED MILLET Usually sold with the largely indigestible hull removed. Hulled millet can be used like any other grain.

A LITTLE PREPARATION Presoaking millet shortens its cooking time. Its flavor can be enhanced by lightly roasting the grains in a dry pan before cooking; stir for 3 minutes or until you detect a mild, nutty aroma.

SPROUT IT Millet can also be sprouted to use in salads and sandwiches. Soak the raw, untoasted grains for about 30 minutes, drain, and keep moist until they begin to sprout.

HOW DO I USE IT?

A BETTER BREAKFAST Millet can form the basis of a nutritional porridge. Serve with dried fruit and sliced almonds.

IN A SALAD Use cooked millet instead of rice or pasta in salads to add flavor and nutrition.

FLOUR
This unusual flour can be added to breads to reduce their gluten content.

WHOLE GRAINS
Millet seeds are antioxidant-rich and especially high in magnesium, necessary for maintaining healthy nerve and muscle function.

RYE

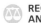 **REGULATES APPETITE AND BLOOD SUGAR**

 PROMOTES A HEALTHY DIGESTIVE TRACT

 HELPS KEEP BLOOD VESSELS SUPPLE

A hardy, cold-climate grain, rye berries (also known as rye seeds) are a rich and versatile **source of dietary fiber**, especially arabinoxylan, which helps to **balance blood sugar levels** and **lower "unhealthy" (LDL) cholesterol**. They are also **nutrient-dense**, supplying high levels of iron, calcium, potassium, zinc, vitamin E, a variety of B vitamins, and an array of **antioxidant compounds**.

BERRIES
Rye has fewer calories and is higher in soluble fiber than wheat. The whole grains are rich in manganese.

SPROUTED RYE
This form of rye is rich in carbohydrates needed for quick energy and vitality.

FLOUR
Rye flour, which contains gluten, produces a dense, dark, richly flavored bread.

WHAT IS IT GOOD FOR?

BLOOD SUGAR REGULATION A type of fiber in rye, arabinoxylan helps balance blood sugar levels, reducing the risk of type-2 diabetes and heart disease. Whole grain rye bread is the best way of providing this fiber. It also regulates the appetite more effectively than wheat bread, and reduces the signs of inflammation more effectively than potato or wheat bread in people with metabolic syndrome (which can lead to diabetes and heart disease).

DIGESTION Contains mucilaginous (gumlike) fiber, which helps to lubricate the digestive tract and ease gastritis and stomach pain. Its lubricating action is also good for maintaining healthy skin and mucous membranes.

HEART HEALTH Its soluble fiber helps to maintain the elasticity of blood vessels, so lessening the risk of atherosclerosis (hardening of the arteries) and hypertension.

METABOLIC SIGNALING Studies show that rye can actually switch off certain genes involved in metabolic syndrome, including those that regulate insulin, stress response, and overactive immune response.

HOW DO I GET THE BEST FROM IT?

SWITCH TO RYE BREAD Rye bread is a superb dietary aid, helping you feel fuller for longer and ensuring a steady supply of energy.

DRINK IT To make a mildly laxative and energizing drink, boil 2 tbsp of rye berries in 3½ cups of water for 10 minutes. Allow to cool, then strain and add honey and lemon juice to taste.

HOW DO I USE IT?

RYE FLOUR Rye flour can be used for pancakes, muffins, and scones. Use it just as you would use wheat flour, or mix it 50:50 with wheat flour for a lighter result.

OATS

 HAS NATURAL SEDATIVE PROPERTIES

 EASY TO DIGEST

 HELPS CONTROL INSULIN SECRETION

 HELPS LOWER CHOLESTEROL

Long before we relied on a bowl of sugary instant cereal, breakfast often meant porridge cooked with oats; they can also be used in healthy cereals, snacks, cookies, and breads. Oats contain **multiple nutrients** and a gummy, **water-soluble fiber**, beta-glucan, which helps **reduce "unhealthy" (LDL) cholesterol**. They are also known to be a **natural sedative**, and excellent for **easing indigestion**.

WHAT IS IT GOOD FOR?

SOOTHES NERVES Oats contain the alkaloid gramine, a natural sedative, which can treat depression, anxiety, and insomnia without side effects. Tea made from oat straw is a traditional remedy for anxiety and insomnia.

DIGESTION Oats are easy to digest and useful in diets for recovering patients and for easing upset stomachs. The fact that oats contain more soluble fiber than any other grain also means that they are digested more slowly, creating an extended sensation of fullness.

DIABETES As well helping to prevent big spikes in blood sugar levels, the beta-glucan fiber has beneficial effects for diabetics. Useful amounts of magnesium in the grain also help regulate insulin secretion.

REDUCES CHOLESTEROL Oats, oat bran, and oatmeal contain a specific type of fiber known as beta-glucan, which can quickly help lower "unhealthy" (LDL) cholesterol levels. Studies show that including just ½–¾ cup of oats a day in a low-fat diet can reduce LDL cholesterol by 8–23 percent. In addition, avenanthramides, antioxidant compounds unique to oats, help prevent free radicals from damaging LDL cholesterol, thus reducing the risk of cardiovascular disease.

HOW DO I GET THE BEST FROM IT?

RAW AND COOKED Oats deliver benefits whether eaten raw or cooked.

OAT MILK Made from soaked oat groats, this is a nutritious alternative to dairy milk.

HOW DO I USE IT?

BREW A TEA You can buy oat straw to make a soothing tea for adults and children.

SPROUTED OAT PORRIDGE Use sprouted oats and combine with chopped walnuts, dried fruit, such as raisins or dates, a little cinnamon, and a drizzle of maple syrup.

OAT STRAW
The immature tops of the oat plant can be dried to make a soothing tea that calms the nerves.

WHOLE OATS (ROLLED)
Oats contain more soluble fiber than any other grain.

OAT GROATS
Oat groats are the hulled grains of oats.

OAT MILK
Oat milk naturally contains more calcium than cow's milk.

BULGUR WHEAT

 HELPS FIGHT INFLAMMATION

 PROMOTES BOWEL REGULARITY

 HELPS BUILD STRONG BONES

 HELPS BALANCE BLOOD SUGAR LEVELS

Bulgur wheat is a low-fat whole grain **rich in dietary fiber**. It aids digestion, acts as an **anti-inflammatory**, and **protects against cholesterol** and **gallstones**. It has a characteristic crumbly texture, produced by precooking, drying, and crushing whole grains, often from several varieties of wheat. This process prevents bulgur wheat, one of the world's earliest processed grains, from spoiling.

Wheat berries
In a process discovered 4,000 years ago, wheat berries are parboiled, dried, and ground to produce bulgur wheat grains

Grains
Bulgur wheat is rich in manganese and magnesium, which help keep inflammation at bay and maintain metabolic balance. The grain is a healthy "fast food" that can be prepared in just 20 minutes

WHAT IS IT GOOD FOR?

ANTI-INFLAMMATORY The antioxidant betaine in bulgur wheat is a potent anti-inflammatory. Regular consumption of betaine-rich foods can help prevent the inflammation of joints and arteries by as much as 20 percent.

DIGESTION AND CONSTIPATION High in insoluble fiber, which promotes bowel regularity, and aids the production of butyric acid, which fuels cells that maintain a healthy colon. The carbohydrates in bulgur wheat are absorbed slowly, helping to maintain steady blood sugar levels.

STRONG BONES Around half of all dietary magnesium is required for building healthy bones. As a result, this mineral needs to be constantly replaced and bulgur wheat is a good natural source. Magnesium also relaxes nerves and muscles and maintains the cardiovascular system.

METABOLIC BALANCE High in manganese, a trace mineral with an anti-inflammatory, antioxidant effect essential for most body systems. It supports healthy bones, maintains normal blood sugar levels, helps the body form tissue, and balances sex hormones.

HOW DO I GET THE BEST FROM IT?

A BETTER FAST FOOD Unlike many types of grain, bulgur wheat is quick to prepare. It is a fantastic alternative to rice and potatoes and can be a better choice than a sandwich to maintain energy throughout the day.

HOW DO I USE IT?

BOOST YOUR BREAD Enrich a bread recipe by substituting ⅓ cup of flour with the same amount of reconstituted bulgur wheat.

IN A SALAD Combine cooked bulgur wheat, puy lentils, sliced scallions, radishes, and tomatoes with cumin, and mint and cilantro leaves. Toss in an olive oil and lime dressing.

RICE

 HELPS LOWER CHOLESTEROL

 PROTECTS AGAINST COLON CANCER

 HELPS RELEASE CELLULAR ENERGY

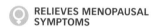 **RELIEVES MENOPAUSAL SYMPTOMS**

Rice is a near-perfect food, and the predominant staple food for around half the world's population. This **cholesterol-lowering** food is available in many varieties and colors and is a good source of thiamine, riboflavin, niacin, and **dietary fiber**. Certain rice varieties help to maintain stable **blood sugar levels**. Rice bran may also help lower the risk of **bowel cancer**.

WHAT IS IT GOOD FOR?

LOWERS CHOLESTEROL The fatty acid content in whole brown rice has cholesterol-lowering properties. It is also rich in magnesium, which has been shown to lower the risk of diabetes.

HEALTHY GUT Brown rice contains fiber and selenium, which help protect the gut. Fiber helps remove waste products efficiently from the body, while the trace mineral selenium has been shown to substantially reduce the risk of colon cancer.

ENERGY RELEASE Rich in manganese, a trace mineral that helps produce energy from protein and carbohydrates. It is also involved in the synthesis of fatty acids, which are important for a healthy nervous system.

HORMONE BALANCE The phytosterols in rice bran oil have been shown to help relieve menopausal symptoms, such as hot flashes.

HOW DO I GET THE BEST FROM IT?

CHOOSE BY COLOR White rice is nutrient-poor, but brown rice is an all-round healthy choice. Its minimal processing preserves the grain's nutritional value and healthy oils, much of which concentrates in the bran. Deeply colored red or black rice has been proven to actively reduce the progress of atherosclerosis (hardening of the arteries).

RICE BRAN OIL This versatile oil is high in monounsaturates and contains the antioxidant y-oryzanol, as well as a range of tocopherols (the vitamin E family) and phytosterols (plant hormones). Heating does not appear to destroy its constituents. Use rice bran oil for cooking, marinades, and dressings.

HOW DO I USE IT?

EXOTIC COCONUT RICE Boil brown rice and grated fresh ginger in unsweetened coconut milk and water. Serve garnished with finely chopped fresh cilantro.

BROWN RICE
This minimally processed rice is one of the most nutritionally dense varieties.

WHITE RICE
Milled or polished white rice has had its hull and bran removed. It is a good source of protein, but most of its other nutrients are removed with the hull.

WILD RICE
Although not a true rice, wild rice is eaten just like one. It contains twice the amount of zinc and 8 times the amount of vitamin E as brown rice.

RED RICE
This variety has the highest iron and zinc content of all commercially available rice. Red rice contains a variety of anthocyanins that give its bran a red or deep purple color.

SPELT

 HELPS BALANCE BLOOD SUGAR LEVELS

 HELPS STRENGTHEN THE IMMUNE SYSTEM

 EASY TO DIGEST

An ancient variety of wheat with a subtle sweet, nutty flavor, spelt has a tough outer husk that makes it difficult to process. However, this protective husk helps the grain maintain its nutrient value. It is **high in fiber**, **B vitamins**, and **minerals**, such as copper, iron, zinc, magnesium, and phosphorus. It also contains more **protein** than conventional wheat, and is highly **water-soluble** and **easier to digest**.

GRAINS
Spelt is a good source of B vitamins and certain minerals, and is higher in protein than conventional wheat.

SPROUTED SPELT
Sprouting breaks down indigestible starches into more easily digested sugars.

FLOUR
Though the reasons are not fully understood, some people sensitive to conventional wheat find they can tolerate spelt.

WHAT IS IT GOOD FOR?

METABOLIC SYNDROME Spelt and whole spelt flour offer more soluble fiber than both standard and durum wheat flours. Soluble fiber is particularly beneficial for lowering "unhealthy" (LDL) cholesterol and regulating blood sugar levels.

IMMUNITY It is higher in niacin (B_3) than conventional wheat. Like other B vitamins, niacin aids in energy metabolism. It has additional functions, including antibacterial properties that help strengthen the body against disease. It also supports the adrenal glands and helps improve circulation.

DIGESTION Spelt is easily soluble in water and contains less gluten than conventional wheat, making it easier to digest. However, as spelt contains gluten, it is not suitable for celiacs.

HOW DO I GET THE BEST FROM IT?

WHOLE GRAIN Add the whole grain to soups and stews in the same way you would barley, or cook it on its own as an alternative to rice.

FLOUR Spelt flour can be used wherever wheat flour is indicated, though its high water-solubility means you may need to use less liquid than with conventional flours. You can also buy sprouted spelt flour.

SPROUT IT Spelt sprouts are high in vitamins E, C, and B, phosphorus, magnesium, iron, calcium, amino acids, and protein. Select hulled spelt for sprouting.

HOW DO I USE IT?

SPELT RISOTTO Whole grains can be cooked on their own and used as a side dish or combined with vegetables, fresh herbs, and Parmesan cheese to make a risotto.

SPELT PASTA Pasta made from spelt is a delicious alternative to durum wheat pasta, and because of its easy digestibility it may leave you feeling less bloated.

QUINOA

 HELPS PREVENT HARDENED ARTERIES

 STRENGTHENS CONNECTIVE TISSUES

 PROTECTS AGAINST FREE-RADICAL DAMAGE

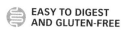 **EASY TO DIGEST AND GLUTEN-FREE**

Easily digestible quinoa (pronounced keen-wah) grains are cooked in the same way as rice, and have a sweet, grassy flavor and texture. Quinoa is a complete **source of protein** and a **good source of anti-inflammatory**, **monounsaturated**, and **omega-3 fatty acids**. A heart-healthy grain, it is known to reduce "unhealthy" (LDL) cholesterol, and contains high levels of **antioxidants**.

WHAT IS IT GOOD FOR?

HEART HEALTH Unlike many other grains, quinoa contains oleic acid, a monounsaturated fatty acid and alpha-linolenic acid (ALA; an omega-3 fatty acid) in useful amounts. This combination can help to reduce "unhealthy" (LDL) cholesterol levels in the blood and fight inflammation that can lead to hardening of the arteries (atherosclerosis).

GOOD SOURCE OF PROTEIN Considered a complete protein because it contains all the essential amino acids; it is particularly high in lysine, important for tissue growth and repair.

ANTIOXIDANTS In addition to a spectrum of E vitamins including alpha-, beta-, gamma-, and delta-tocopherol, quinoa contains two antioxidant flavonoids, quercetin and kaempferol, which fight free radicals and are present in concentrations equal to or higher than high-flavonoid berries, such as cranberries.

DIGESTION Quinoa is easy to digest and doesn't contain gluten, making it suitable for anyone on a gluten-free diet.

HOW DO I GET THE BEST FROM IT?

WHOLE GRAIN The grains cook quickly, usually in 15 minutes, and are ready when translucent and the white germ on each grain has partially separated like a little white tail.

SPROUT IT Sprouting activates the beneficial enzymes in quinoa and boosts its nutrient content. Sprouted quinoa can be used in salads and sandwiches just like alfalfa sprouts.

HOW DO I USE IT?

INSTEAD OF RICE For a nutritious side dish, serve quinoa like rice pilaf, cooked in stock and combined with vegetables. It is also good as a stuffing for squash and bell peppers.

ENRICH YOUR BAKING Add cooked quinoa to muffins, breads, and even pancakes.

WHITE GRAINS
Quinoa grains contain all the essential amino acids (such as lysine), and good quantities of iron, calcium, and phosphorus.

RED GRAINS
The antioxidant pigment betacyanin, which also gives beets their coloring, is responsible for the bright red hue of this variety.

AMARANTH

 HELPS LOWER CHOLESTEROL

 SUPPORTS CELLULAR METABOLISM

 HELPS PROTECT AGAINST POLLUTION

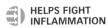 **HELPS FIGHT INFLAMMATION**

Like buckwheat and quinoa, amaranth is actually the seed of a broad-leafed plant rather than a grass. It has been cultivated for 8,000 years, and was a staple of the Aztec diet. Today, both the grain and the leaves, which are high in **antioxidants**, are used in medicinal cooking as a source of **high-quality protein**, **cholesterol-lowering phytosterols**, and **anti-inflammatory phytochemicals**.

Grains
The grains contain phytosterols, plant hormones that help to lower cholesterol

Greens
Nutritionally similar to Swiss chard and spinach, but higher in calcium and 3 times higher in niacin, amaranth greens are worth seeking out in Asian supermarkets

WHAT IS IT GOOD FOR?

HEART HEALTH Regular consumption of the seeds (or oil) can help reduce blood pressure and "unhealthy" (LDL) cholesterol levels, and improve immunity. Unlike other grains, it is not its fibrous content that protects the heart, but its levels of phytosterols and squalene.

TISSUE GROWTH AND REPAIR A good source of amino acids. In particular, it has good amounts of lysine, an essential amino acid found in limited amounts in other grains and plant sources. Amino acids are the building blocks for proteins in the body. They also aid metabolism and tissue growth and repair.

DETOX Squalene is a strong antioxidant that can help reduce the impact of toxic substances, such as pollution and industrial chemicals, on body systems. It can also improve the symptoms of chronic fatigue.

ANTI-INFLAMMATORY Contains lunasin, an anti-inflammatory substance. In addition to fighting inflammation, lunasin has been shown to halt the growth of cancer cells.

HOW DO I GET THE BEST FROM IT?

SPROUT IT The small size of the grains makes them fiddly and difficult to chew thoroughly; whether raw or cooked, a substantial number may pass undigested through the digestive tract with their nutrients unutilized. Instead, sprout them to get all their benefits.

USE THE LEAVES The leaves are a good source of vitamins K and C, iron, calcium, and folate.

HOW DO I USE IT?

ADD TO SALADS Add the sprouted amaranth grains to salads and sandwiches.

FOR BAKING Amaranth flour is gluten-free. On its own it is somewhat bitter, and most recipes recommend that amaranth should comprise no more than 10–15 percent of the total weight of flour in any baked recipe.

Tie a selection of herbs into a bouquet garni to flavor dishes while they cook, and remove the bundle before serving. The classic combination is thyme, parsley, and bay leaf, although you can add other herbs.

CULINARY HERBS CONTINUED

Dill

DILL

 HAS A POWERFUL DIURETIC ACTION

WHAT IS IT GOOD FOR?

ANTIBACTERIAL Dill is a natural diuretic and antibacterial that can be effective against cystitis and bladder infections. Its essential oil constituents have a calming, anti-inflammatory effect on the digestive tract, which is why it has long been used as a treatment for stomach upsets and colic. Studies on animals suggest it may also have a useful role to play in helping to regulate blood sugar and cholesterol levels.

HOW DO I USE IT?

SCATTER LIBERALLY Both the seeds and fresh herb have similar benefits. The minty, aniseed flavor of fresh dill goes well with seafood, especially salmon, and makes a pleasant tea, or scatter on salads, new or baked potatoes, and steamed vegetables. Add the seeds to soups or casseroles, or scatter onto vegetables and rice.

Mint

MINT

 SOOTHES UPSET STOMACHS

WHAT IS IT GOOD FOR?

RELIEVES INDIGESTION Menthol, the active oil in mint, is responsible for the antiseptic and antibacterial properties that make mint a good choice for relieving indigestion, irritable bowel syndrome, and soothing an upset stomach. Its adaptogenic properties mean it can help balance the body in whatever way is needed, so it can be both invigorating and mildly sedative. It also fortifies the nervous system and helps to relieve headaches.

HOW DO I USE IT?

ALL-ROUNDER Mint sauce is a traditional condiment served with lamb, and helps aid digestion of the meat. Mix into dressings, or chutney or yogurt to serve with spicy foods like curries. Scatter onto new potatoes or peas or, for a tasty salad, mix with cooked bulgur wheat. For tea, steep 1 tsp dried or 2 tsp fresh mint in ¾ cup boiling water for 5 minutes. Drink hot or cold.

Oregano

OREGANO

 PROTECTS AGAINST FREE-RADICAL DAMAGE

WHAT IS IT GOOD FOR?

ANTIBACTERIAL Contains the volatile oils thymol and carvacrol, which have an antioxidant effect, helping to protect against the oxidative stress caused by free radicals in the body. These volatile oils have been shown to also inhibit the growth of bacteria, including *Pseudomonas aeruginosa* and *Staphylococcus aureus*, as well as inhibiting the growth of the *Candida albicans* fungus. An analgesic, oregano can ease menstrual cramps and other abdominal pain. It is also a useful diuretic and appetite stimulant and helps clear mucus, so it can be helpful in cases of colds, the flu, headaches, and respiratory illness.

HOW DO I USE IT?

A CLASSIC INGREDIENT Use in pasta sauces and salad dressings, in vegetable, fish, and chicken recipes, or in dishes with eggs and/or cheese. It is a good addition to stews, but add it toward the end of cooking to keep its beneficial oils and resins intact.

ROSEMARY

 HELPS FIGHT INFLAMMATION

WHAT IS IT GOOD FOR?

A NATURAL ANTISEPTIC Contains caffeic and rosmarinic acids, both potent antioxidant and anti-inflammatory agents that also have strong antiseptic properties. Its antioxidant action can help reduce inflammation, thereby helping to lower the risk of asthma, liver disease, and heart disease. If used in a tea or gargle, it can help fight gum disease and relieve sore throats. It also contains a number of volatile oils, which have a sedative effect that help calm the nerves and ease stomach upsets.

HOW DO I USE IT?

A MEDITERRANEAN STAPLE Use to infuse meats, such as lamb, before or while they cook, add to potatoes before roasting them, to vegetables, such as green beans, peas, and mushrooms, or use to make flavorful salad oils and vinegars. You can even use rosemary to flavor custard. For a medicinal tea, brew 1 tsp dried or 2 tsp fresh rosemary in ¾ cup of boiling water for 5 minutes.

Rosemary

SAGE

 AIDS HORMONAL BALANCE

WHAT IS IT GOOD FOR?

WOMEN'S HEALTH Traditionally used to "normalize" the female reproductive system, sage is useful for helping to treat heavy or irregular periods and relieving menopausal symptoms. Eaten raw, it can also be effective in helping to treat rheumatic conditions, catarrh, excessive sweating, and upset stomachs. In laboratory tests, its antioxidants have shown potential for helping to improve memory and concentration levels in both healthy individuals and those with dementia. It also has a mild diuretic action.

HOW DO I USE IT?

MAKE SAGE HONEY Make a uniquely flavored honey by packing a jar with fresh sage and covering with honey (both are antibacterial). Let it infuse for 2–3 days or longer. Use in herbal teas and sweet dishes for a therapeutic boost. Add the fresh herb to salads, soups, and stuffings for rich meats, such as pork and goose. Make a seasoning by grinding dried sage leaves with coarse sea salt to use on almost any savory dish.

Sage

Thyme

THYME

 HELPS FIGHT COLDS AND FLU

WHAT IS IT GOOD FOR?

A COLD REMEDY Can help loosen and expel mucus, making it a good choice if you have asthma, bronchitis, a cold, a cough, the flu, or a sinus headache. A general tonic, antioxidant, and aid to digestion, it is also useful for treating colic in babies and excess wind in children and adults. Thymol, a constituent of thyme's essential oil, is an antibacterial that is effective against *Streptococcus mutans, E. coli, Staphalococcus aureus*, and *Bacillus subtilis*. When made into a tea, thyme can be used to treat sore throats and gum disease.

HOW DO I USE IT?

GREAT WITH MEAT Fresh thyme is best in marinades, sauces, stocks, stuffings, and slow-cooked stews and casseroles. Its high iron content enriches the nutritional value of meat dishes and makes them more digestible. The crushed leaves make excellent herb oils and vinegars. For a medicinal tea, use dried thyme. Brew 1 tsp dried or 2 tsp fresh thyme in ¾ cup boiling water for 5 minutes.

CULINARY HERBS

Traditionally, culinary herbs were used not only to add subtle flavor but to preserve and enhance the healthful properties of foods; many have been shown to be concentrated sources of antioxidants and medicinal oils with antibacterial effects. Eaten regularly, herbs can work synergistically with other foods to boost health in many ways, including enhancing digestive health and detoxification.

Basil

Cilantro

Parsley

BASIL

 AIDS HEALTHY/OPTIMAL DIGESTION

WHAT IS IT GOOD FOR?

EASES DIGESTION Basil fortifies the digestive and nervous systems, and can be a good remedy for headaches and insomnia. Eugenol, a constituent of the oil in the basil leaf, has an anti-inflammatory effect on joints and the digestive tract. It is also a mild diuretic. In addition, it contains a range of natural antioxidants, which can help protect body tissues against free-radical damage.

HOW DO I USE IT?

EAT FRESH Use fresh basil and wait until the last moment to add the leaves to a dish. Scatter onto tomato salads, soups, and egg, rice, and mushroom dishes. Make a pesto sauce or put some fresh leaves into olive oil for a pungent salad dressing (don't worry if they turn black).

CILANTRO

 HELPS REMOVE TOXINS FROM THE BODY

WHAT IS IT GOOD FOR?

DETOXIFYING Contains detoxifying, antibacterial, and immune-enhancing essential oils, and can help remove heavy metals from the body. Cilantro also aids digestion, fights nausea and stomach cramps, balances blood sugar levels, and is mildly laxative.

ANTIOXIDANT The plant's green tops contain a higher concentration of antioxidants, such as quercetin, kaempferol, and apigenin, than the seeds. These substances are known to have cancer-fighting properties.

HOW DO I USE IT?

DON'T COOK IT Cooking destroys cilantro's flavor and essential oils. Use instead as a garnish on rice dishes, salsas, and stir-fries, or juice with celery, cucumber, and carrot in a juicer for a quick detox drink.

PARSLEY

 SUPPORTS HEALTHY KIDNEYS AND BLADDER

WHAT IS IT GOOD FOR?

DIURETIC AID Parsley has a diuretic action and is rich in antioxidants that can help relieve congestion and inflammation in the kidneys and bladder. It is also an effective treatment for constipation. It has numerous other medicinal uses, including as a general tonic for the body and as a digestive aid. It is also rich in vitamin K, which helps support healthy bones.

HOW DO I USE IT?

A VERSATILE ADDITION Stir into omelets and vegetable and rice dishes, or mix with butter, spread on crusty bread, and broil briefly for a quick snack. Add to mashed potatoes, fish cakes, or meat patties. Chew at the end of a meal to aid digestion and sweeten the breath.

SCHISANDRA

 HELPS BOOST PHYSICAL AND MENTAL ENERGY

WHAT IS IT GOOD FOR?

RESPONDS TO THE BODY'S NEEDS An adaptogen, it stimulates or calms the body according to its needs. It can help improve physical, mental, or spiritual energy and is a renowned aphrodisiac for men and women.

It supports kidney and lung function and helps improve circulation, which in turn provides benefits for the heart and skin, and may help revive a poor memory and build stamina.

HOW DO I USE IT?

SAVORY AND SWEET A common ingredient in traditional Chinese and Korean cuisines. Add the berries to rice dishes, soups, vegetable patties, jelly, preserves, and even drinks.

Schisandra

MARSHMALLOW ROOT

 HELPS HEAL STOMACH ULCERS

WHAT IS IT GOOD FOR?

SOOTHES IRRITATION Rich in mucilaginous (gumlike) fiber, it acts to soothe irritation and inflammation of the mucous membranes, stomach, and intestines. It may be particularly useful for gastric ulcers and irritable bowel syndrome. It can also help heal respiratory and urinary disorders. Its mild laxative effect makes it useful for treating occasional constipation.

HOW DO I USE IT?

DRINK IT Make into a medicinal drink: soak ½ cup of root in 2 cups cold water overnight and strain. The liquid will be very viscous and may need further dilution. Drink small servings throughout the day.

Marshmallow root

MILK THISTLE

 SUPPORTS HEALTHY LIVER FUNCTION

WHAT IS IT GOOD FOR?

SUPPORTS THE LIVER A powerful antioxidant that helps heal the liver and support its ability to break down and metabolize fats and proteins. It is considered a good treatment for gallbladder inflammation, and any premenstrual and menopausal symptoms that are related to liver function. It can also help increase breast milk production.

HOW DO I USE IT?

A SOOTHING BREW Grind 1 tsp of seeds in a coffee grinder and steep in ¾ cup boiling water for 5–10 minutes. Or peel fresh stalks, soak overnight to remove bitterness, boil until just tender, and add butter.

Milk thistle

ST. JOHN'S WORT

 HELPS LIFT DEPRESSION

WHAT IS IT GOOD FOR?

FIGHTS DEPRESSION It can help treat mild-to-moderate, but not severe, depression. In many studies it has been shown to work as well as conventional antidepressants. It is also a remedy for seasonal depression, PMS, and depression and anxiety in menopause. Less well known are the herb's antibacterial, anti-inflammatory, and antiviral properties, which make it an effective wound healer when used externally.

HOW DO I USE IT?

USE INSTEAD OF WATER Take as a tea or, like chamomile, substitute water with a strong infusion of the herb in baking or savory broths and stocks.

St. John's wort

MEDICINAL HERBS

There are fewer distinctions between culinary and medicinal herbs than we sometimes think; in fact, most medicinal herbs can be incorporated into our daily diet. Their healing benefits are most concentrated as a tincture or tea; they are subtler when used in smaller ratios for cooking. Prolonged exposure to heat is not recommended for any herb, however, so add toward the end of cooking.

Astragalus

ASTRAGALUS

 HELPS BOOST ENERGY LEVELS

WHAT IS IT GOOD FOR?

IMMUNITY ENHANCER A tonic that can help raise your energy levels if you are feeling run down or are recuperating. Astragalus is also useful for enhancing the function and number of white blood cells. It has natural antibiotic properties, so can help increase resistance to viral infections. It is full of antioxidants that protect cells against free-radical damage, and is a natural diuretic.

HOW DO I USE IT?

ADD TO SOUPS AND STOCKS Astragalus is a healthy ingredient in soups. Try combining ¼–½oz (10–15g) of the herb with shiitake mushrooms, onions, garlic, miso, and carrots, or use as a base for a stock in which to cook rice. To make a tea, steep 2 tsp fresh or 1 tsp dried herb in ¾ cup of boiling water for 5 minutes.

Valerian root

VALERIAN ROOT

 HELPS CALM THE NERVES AND PROMOTE PEACEFUL SLEEP

WHAT IS IT GOOD FOR?

RELIEVES NERVOUS CONDITIONS Used to treat a variety of conditions including insomnia, anxiety, and nervous restlessness. Sometimes described as "nature's tranquilizer," it has been extensively researched in recent years. Test results suggest it works in a similar way to prescription tranquilizers by increasing gamma aminobutyric acid (GABA)—a substance that has a calming effect on the nervous system—in the brain. Other uses include treating digestive problems, nausea, liver problems, and urinary tract disorders.

HOW DO I USE IT?

TAKE AS A TEA Considered to be inedible raw, valerian root is best taken as a soothing hot tea; combine in equal parts with fresh ginger as a good circulation booster too.

Chamomile

CHAMOMILE

HAS NATURAL SEDATIVE PROPERTIES

WHAT IS IT GOOD FOR?

RESTORES CALM A classic remedy for anxiety and sleep disturbances. It is excellent for children, for easing colic, teething, restlessness, and hyperactivity. Soothes gastrointestinal cramps, and also inflammation in mucous membranes and the skin. Its antibacterial action helps fight infection, while its sedating qualities benefit the immune system by helping to lower levels of immune-compromising stress hormones.

HOW DO I USE IT?

IN COOKING Its sweet, apple scent makes it a pleasant garnish for salads, rice, or fish dishes. Chop and add to butter or sour cream to top baked potatoes. For bread and cakes, replace the water with a chamomile infusion and add 3 tbsp each of dried chamomile and lavender flowers.

Sprout seeds for *a concentrated source of nutrients all year round. You can sprout seeds in almost any kind of container, but a glass jar with a sprouting mesh or cheesecloth on top enables easy rinsing and draining.*

SEEDS AND SPROUTS CONTINUED

Alfalfa seeds

ALFALFA SEEDS

WHAT IS IT GOOD FOR?

DETOXIFIER Rich in nutrients and antioxidants, particularly chlorophyll, which helps remove toxins from the blood. Alfalfa seeds also have a natural diuretic action, which maintains water balance and helps lower blood pressure. In addition, they contain coumarin, a blood thinner that is useful for maintaining good blood circulation and for preventing strokes. They also contain betaine, an enzyme that helps to break down proteins and fats, and so aid good digestion.

WOMEN'S HEALTH Alfalfa seeds are a good source of phytoestrogens and are often used to promote better hormonal balance in women.

HOW DO I USE IT?

HELPS DIGEST PROTEINS Add alfalfa sprouts to any meal to assist digestion. Combine with other diuretic or digestive herbs, such as dandelion, for a synergistic effect.

Chia seeds

CHIA SEEDS

WHAT IS IT GOOD FOR?

HEALTHY HEART High in omega-3 fatty acids, which help lower the undesirable fats (LDL cholesterol and triglycerides) in your blood that can cause heart disease and stroke.

STRONG BONES Chia seeds are high in calcium and magnesium, which promote healthy bones and teeth, and in iron, folate, and soluble fiber.

HEALTHY GUT The mucilaginous (gumlike) fiber in the sprouted seeds promotes bowel regularity and helps stabilize blood sugar levels. Briefly soaking the seeds for 1 hour releases more of their beneficial fiber. Or, leave to soak for longer and sprout the same as you would other seeds.

HOW DO I USE IT?

SOAKED OR SPROUTED Add soaked seeds to yogurt, cereal, and muffin recipes, or scatter on a salad. They are also delicious stirred through warm oatmeal. Chia sprouts can be used the same way as any salad green or sprout. Try adding them to soups or stews as a natural thickening agent. They also add flavor and nutrition to baked goods, such as breads, muffins, and home-made crackers.

Red clover seeds

RED CLOVER SEEDS

WHAT IS IT GOOD FOR?

WOMEN'S HEALTH These seeds are perhaps best known as a source of phytoestrogens (plant hormones) that can help relieve menopausal symptoms, such as hot flashes, water retention, and anxiety. They are also a source of calcium and so can promote strong bones and teeth.

CARDIOVASCULAR HEALTH Contains vitamins C, B-complex, and K, and beta-carotene—all helpful in lowering high blood pressure, improving blood circulation, and reducing the risk of heart disease. Similar in taste to alfalfa seeds, red clover seeds are exclusively for sprouting, not for eating raw.

HOW DO I USE IT?

HEALTHY ADDITION Red clover sprouts add flavor and crunch to food without overloading it with calories. They are best eaten raw, but can be used to add a distinctive flavor to soups and stir-fries.

FLAXSEEDS

WHAT IS IT GOOD FOR?

HEART HEALTH Flaxseeds are a great source of soluble mucilaginous (gumlike) fiber that can lower "unhealthy" (LDL) cholesterol in the blood, balance blood sugar levels, and act as a hunger suppressant. Their high omega-3 fatty acid content can help lower undesirable fats (triglycerides) in the blood, reducing the risk of stroke and heart attack, and is also beneficial to the eyes, joints, and brain health. Flaxseed shells are hard so either grind or sprout the seeds, or buy them ready-cracked, to benefit from their nutrients.

HOW DO I USE IT?

GRIND OR SPROUT If you buy whole flaxseeds, grind as needed and add to yogurt, oatmeal, cereal, smoothies, casseroles, and baked goods. Sprouting flaxseeds releases more of their protein and omega-3 fats.

Flaxseeds

POPPY SEEDS

WHAT IS IT GOOD FOR?

PROTECTS THE HEART The seeds contain both polyunsaturated and monounsaturated fatty acids, which can help protect the heart. They also contain iron, phosphorus, and fiber, as well as an array of B vitamins.

A GENERAL TONIC In traditional Ayurvedic medicine, poppy seeds are considered a general tonic and a remedy for diarrhea. A tea made from the seeds is an age-old remedy for anxiety and nervous tension. Like hemp, most culinary-grade poppy seeds have been sterilized to prevent germination (into the opium poppy), although you cannot get "high" from eating poppy seeds. Because they are too small to chew thoroughly, grind the seeds before use to release their beneficial fats and nutrients, or soak and sprout them.

HOW DO I USE IT?

GRIND OR SPROUT Sprinkle the dried seeds on yogurt and use in savory dishes, such as pasta, fish, and baked goods. If you are able to find unsterilized seeds, soak and sprout them; the sprouts can be eaten raw or incorporated into other foods, such as breads and cakes.

Black poppy seeds

White poppy seeds

HEMP SEEDS

WHAT IS IT GOOD FOR?

BOOSTS HEART HEALTH Contains a perfect balance of omega-3, 6, and 9 fatty acids, which help boost brain and heart health. They are also a source of complete protein and fiber that benefits gastrointestinal and heart health, and a source of phytosterols (plant hormones) that helps lower cholesterol and promote hormonal balance in the body.

ANTI-INFLAMMATORY Hemp seeds also reduce inflammation, and keep skin and joints in good condition. In some countries, selling "live" hemp seed is illegal because the hemp plant is a member of the cannabis family. In these countries, the seeds are sterilized to prevent sprouting. You cannot get "high" from eating hemp seeds or sprouts.

HOW DO I USE IT?

LIVE SEEDS Try scattering hemp seeds on a salad, or use as a topping for yogurt, cereal, or desserts. Where you can buy live seeds, hemp sprouts make a nutritious addition to baked goods and smoothies, as well as to salads and sandwiches.

Hemp seeds

SEEDS AND SPROUTS

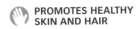 **PROMOTES HEALTHY SKIN AND HAIR**

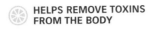 **HELPS REMOVE TOXINS FROM THE BODY**

 SUPPORTS HORMONE BALANCE

 PROTECTS THE HEART AND BLOOD VESSELS

Though tiny, seeds are packed with nutrients such as **protein, fiber, iron, vitamins,** and **omega-3** fatty acids that help promote **healthy skin and hair, remove toxins, balance hormones,** and support **cardiovascular health.** Sprouting seeds converts their starch to slow-release carbohydrates, releases enzymes that **aid digestion,** and makes their nutrients more **bioavailable** (easily absorbed).

Sesame seeds

Sunflower seeds

Pumpkin seeds

SESAME SEEDS

WHAT IS IT GOOD FOR?

HELPS IMPROVE SKIN A good source of vitamin E, which helps improve the condition of the skin as well as strengthen the heart and the nervous system. Also contains the plant hormones sesamin and sesamolin, which have been shown to lower blood pressure and protect the liver from toxic damage. Sesame seeds are very high in calcium, which is necessary for healthy bones and teeth. All varieties—white, brown, and black—are suitable for eating raw or soaking and sprouting.

HOW DO I USE IT?

A VERSATILE SEED Scatter the seeds on steamed vegetables, and add the sprouts to salads, stir-fries, baked goods, sandwiches, and quiches. Ground sesame seeds are the basis of tahini, a sesame paste that can be used in hummus recipes or salad dressings, or simply spread on toast and drizzled with honey or miso.

SUNFLOWER SEEDS

WHAT IS IT GOOD FOR?

MAINTAINS HEALTHY HAIR AND SKIN An excellent source of vitamin E, an antioxidant that helps maintain healthy hair and skin, protects cells from damage, and has anticancer properties. The seeds are an excellent source of B vitamins too, especially folate, which helps support a healthy pregnancy and aids the immune system. They are also rich in protein and heart-healthy fats. Eat raw, or soak and sprout.

HOW DO I USE IT?

AS A SNACK OR IN DISHES Eat a handful as a snack or add to salads, stir-fries, baked goods, and trail mixes. Soaking and sprouting the seeds produce a substantial microgreen (smallest edible plant) that is very nutritious.

PUMPKIN SEEDS

WHAT IS IT GOOD FOR?

MEN'S HEALTH High in zinc, they are useful for promoting men's fertility and preventing prostate problems.

CARDIOVASCULAR HEALTH A good source of B vitamins, magnesium, iron, and protein. The seeds have high levels of essential fatty acids that help maintain healthy blood vessels and lower "unhealthy" (LDL) cholesterol in the blood. Eat raw or dry-roasted; they are nearly impossible to sprout, but soaking them for 1–2 hours helps release their nutrients.

HOW DO I USE IT?

SOAK THEM Eat the raw, dry-roasted, or soaked seeds on their own as a snack, and use in baking, cooking, as a soup garnish, and with granola.

HAZELNUTS

WHAT IS IT GOOD FOR?

RICH IN ANTIOXIDANTS High in monounsaturates, which protect the heart and help lower "unhealthy" (LDL) cholesterol levels in the blood, and vitamins E and K. Also a rich source of folate and the B vitamin biotin, which promotes healthy skin and hair, and copper, which helps build red blood cells, protects cells from free-radical damage, and strengthens connective tissues. Eaten with their skins on, hazelnuts contain 3 times as much antioxidant proanthocyanidin, which helps prevent free radicals from damaging organs and cells, as other nuts.

HOW DO I USE IT?

AS A GARNISH Crush and sprinkle over baked fruit, granola, fruit desserts, and savory dishes.

Hazelnuts

PINE NUTS

WHAT IS IT GOOD FOR?

A GOOD SOURCE OF PROTEIN Contains more vitamin K, which protects bones and arteries, than other nuts. A good source of magnesium and potassium, which help maintain a steady heartbeat, lower blood pressure, and improve circulation. Although higher in fat than other nuts, they are richer in phytosterols, plant hormones that lower "unhealthy" (LDL) cholesterol levels in the blood, reduce the risk of certain types of cancer, and enhance immune function.

HOW DO I USE IT?

ADD A HANDFUL Pine nuts added to a meal can help to create a feeling of fullness and satisfaction. Toss into hot pasta or pilaf or add to stuffed tomatoes, zucchini, or eggplants.

Pine nuts

PISTACHIO NUTS

WHAT IS IT GOOD FOR?

ANTI-INFLAMMATORY Their vibrant color indicates a high antioxidant content. Pistachios are also high in beta-carotene and the compound oleanolic acid, both potent anti-inflammatories, and phytosterols, a type of anti-inflammatory plant hormone associated with improved immune function, lower levels of "unhealthy" (LDL) cholesterol, and a reduced risk of cancer. They contain valuable minerals, such as potassium, calcium, zinc, iron, and magnesium.

HOW DO I USE IT?

KEEP IT COOL Heat can reduce their nutritional value so use as a garnish, sprinkle on probiotic yogurt, or combine with nettles, dandelion leaves, and Parmesan cheese to make a detoxifying springtime pesto sauce.

Pistachio nuts

WALNUTS

WHAT IS IT GOOD FOR?

SUPPORTS A HEALTHY HEART A rich source of alpha-linolenic acid (ALA), an omega-3 fatty acid. ALA helps lower "unhealthy" (LDL) cholesterol levels and keeps arteries healthy. Walnuts also contain the antioxidants ellagic acid and a mix of tocopherols (the vitamin-E complex) including alpha, delta, and gamma tocopherol, which help reduce the risk of cancer and heart disease and maintain skin and tissue health. In addition, they contain serotonin, a brain chemical that can help lift depression.

HOW DO I USE IT?

COOKED OR RAW Use in stuffings, baked goods, as a topping for fruit and yogurt, or in salads.

Walnuts

NUTS

 FIGHTS INFLAMMATORY DISEASES

 HELPS LOWER CHOLESTEROL

 HELPS KEEP JOINTS SUPPLE

Some of the highest **antioxidant** levels of all plant foods are found in nuts. Antioxidants are vital for helping to **fight inflammation** and **cell and tissue damage** caused by free radicals (toxic byproducts of metabolism). Nuts are also **rich in fiber**, healthy fats, **vitamins**, and minerals, and research shows they help to **lower cholesterol**, **improve blood vessel function**, and **benefit muscles and joints**, too.

Almonds

ALMONDS

WHAT IS IT GOOD FOR?

LOWERS CHOLESTEROL Almonds are a good source of the minerals zinc, magnesium, and potassium, and are very rich in antioxidant vitamin E, which supports the brain, the cardiovascular and respiratory systems, and helps keep skin healthy. They are especially rich in cholesterol-lowering monounsaturated fatty acids, such as oleic and palmitoleic acids. Their high fiber content also helps regulate blood sugar levels.

HOW DO I USE IT?

A VERSATILE INGREDIENT Eat with their skins on, as the flavonoids in the skins work synergistically with the vitamin E to more than double their antioxidant power. Use ground almonds as a low-starch, gluten-free flour in baking or to make almond milk, a useful alternative to dairy.

Cashews

CASHEWS

WHAT IS IT GOOD FOR?

GOOD FOR BONES A good source of monounsaturated oleic acid and omega-3 alpha linolenic acid (ALA), which are both healthy fats that help protect against heart disease and cancer. Cashews also contain calcium, magnesium, iron, zinc, and folate, making them an excellent source of minerals that contribute to bone health. These nutrients also help with the formation of collagen, which is essential for supporting healthy skin and body tissues.

HOW DO I USE IT?

SWEET AND SAVORY Cashews contain starch so are useful for thickening water-based dishes, such as soups, meat stews, and some Indian milk-based desserts. Cashew cream made from blended soaked cashews can be used as a healthy alternative to dairy cream.

Chestnuts

CHESTNUTS

WHAT IS IT GOOD FOR?

PROTECTS THE HEART Chestnuts can be classed as the only really low-fat nut, because they contain a fraction of the calories of other types of nuts. However, they are high in fiber, beta-carotene, and folate, and are also the only nuts that contain a significant amount of antioxidant vitamin C. In addition, they contain high levels of palmitic acid and oleic acid, the heart-healthy fatty acids found in olive oil.

HOW DO I USE IT?

AN ALTERNATIVE TO WHEAT Eat boiled, puréed, or roasted and added to pastries, soups, poultry, stuffings, casseroles, and appetizers. Chestnut flour is gluten-free and is used in many Italian dishes, such as polenta, gnocchi, sweet breads, and cookies.

MUSHROOMS

 CLEANSING AND ANTI-INFLAMMATORY

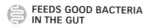 **FEEDS GOOD BACTERIA IN THE GUT**

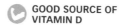 **GOOD SOURCE OF VITAMIN D**

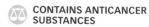 **CONTAINS ANTICANCER SUBSTANCES**

Most commercial mushroom varieties are actually the same mushroom at different stages of growth, and share common medicinal traits. Others, such as shiitake, rei-shi, and wild wood ear, are "super" mushrooms with extraordinary **healing powers**. All types contain varying degrees of **fiber**, protein, **B vitamins**, and **vitamin D**. They are also known to have **anti-inflammatory** and **antibacterial** effects.

WHAT IS IT GOOD FOR?

ANTIOXIDANT All mushrooms are considered "cleansing," and all except oyster and maitake contain ergothioneine, an amino acid that can help reduce inflammation. They also contain germanium, which improves cellular oxygenation and enhances immunity.

A PREBIOTIC Eaten raw, mushrooms contain higher levels of prebiotic oligosaccharides, such as chitin and beta-glucan, which feed friendly bacteria in the gut.

A GOOD SOURCE OF VITAMIN D Common white mushrooms are one of the few non-animal sources of vitamin D—essential to bone health, hormone balance, immune defense, and as a cancer preventive.

ANTICANCER PROPERTIES Shiitake contains lentinan, which has anticancer, antiviral, and antibacterial properties. It also boosts the immune system by stimulating the production of white blood cells.

HOW DO I GET THE BEST FROM IT?

CLEANING MUSHROOMS Most store-bought mushrooms have been cleaned, while foraged mushrooms benefit from a brief wash or brush. Their nutrient quality is not affected.

HOW TO COOK IT Cooking mushrooms increases their starch, fiber, and fat content, and frees more antioxidants, including carotenoids and ferulic acid, but does destroy some of their vitamin C content.

HOW DO I USE IT?

DRIED EXOTICS Dried mushrooms have an intense flavor. To reconstitute, soak in boiling water. Reserve the water, which will have leeched some nutrients out of the fungi, to use as a broth or as a stock for soups and stews.

AS A MEAT SUBSTITUTE Mushrooms take on a meaty texture when cooked that can help make a meal more satisfying.

SHIITAKE
Contains lentinan, a substance that has anticancer properties and also keeps the blood from getting "sticky."

REI-SHI
A good general tonic with antiallergic and antiviral properties.

WOOD (JELLY) EAR
Helps control blood sugar levels and has anticancer, anticoagulant, and cholesterol-fighting properties.

WHITE
Even the most unassuming mushrooms have been shown to support immune function.

GINGER

 HAS POWERFUL ANTI-INFLAMMATORY OILS

 HELPS ALLEVIATE ARTHRITIC PAIN

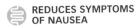 **REDUCES SYMPTOMS OF NAUSEA**

This pungent root is known for its ability to settle **upset stomachs** and **alleviate nausea**. Its active constituent, gingerol, is a relative of capsaicin and piperine, found in hot chiles. Studies show that its volatile oils have **anti-inflammatory** properties similar to those of NSAIDs (nonsteroidal anti-inflammatory drugs) so it can ease the symptoms of **colds and flu, headaches,** and **menstrual pains.**

MATURE GINGER ROOT
Gingerol has analgesic, sedative, antipyretic, and antibacterial effects; another component, zingerone, is an antioxidant.

YOUNG GINGER ROOT
Contains the same substances as the mature root, but the thinner pink/purple skin doesn't need to be peeled.

PICKLED GINGER
Made from young roots, it is naturally pink and contains beneficial anthocyanin antioxidants.

WHAT IS IT GOOD FOR?

FIGHTS INFLAMMATION Reduces inflammation, lessens pain, and can lower medication intake in cases of osteoarthritis.

NAUSEA Studies show it can ease morning sickness, motion sickness, and nausea caused by cancer chemotherapy and after surgery.

DIGESTIVE HEALTH Protects and heals the gut, hastens the movement of food through the gastrointestinal tract, and reduces wind, bloating, and cramps. It also awakens the taste buds and gets digestive juices flowing.

HOW DO I GET THE BEST FROM IT?

PEEL IT CAREFULLY The richest resins and volatile oils concentrate in and near the skin so peel carefully. The best way to peel ginger is with a teaspoon. Gently scrape the skin off rather than using a vegetable peeler.

EAT FRESH Whenever possible, choose fresh ginger. It is not only superior in flavor to dried but contains higher levels of active constituents, such as gingerol and zingibain. Store in a dry place.

LOOK FOR YOUNG ROOTS Most supermarkets sell the mature roots, though Asian supermarkets often sell the younger pale pink roots. These don't need peeling, are juicier, and have a milder taste.

HOW DO I USE IT?

SOOTHING SYRUP For sore throats or congestion, make a syrup of 2 tsp each ginger juice, turmeric, and black pepper, 1 tsp each honey and vinegar, and 3 tbsp water. Use as needed. An easy way to collect the juice is to grate the root and squeeze the juice from the shreds.

MAKE A TEA Mix 1 tsp freshly grated ginger, the juice of ½ lemon, and 1 tsp honey in a mug. Add boiling water. Take at the first signs of a cold or chill, or for indigestion or nausea.

TURMERIC

 HELPS RELIEVE ARTHRITIC PAIN

 HELPS PREVENT HARDENED ARTERIES

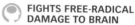 **FIGHTS FREE-RADICAL DAMAGE TO BRAIN**

 CONTAINS ANTICANCER SUBSTANCES

Known to be extremely beneficial for health, turmeric is a key ingredient in almost any curry, and can be used fresh or as a powder. Its main healthy constituent is curcumin, a well-researched **antioxidant** and powerful **anti-inflammatory** that helps to fight **free-radical damage** and prevent and treat **arthritis**, **cardiovascular problems**, **diabetes**, and even **neurological conditions**.

WHAT IS IT GOOD FOR?

ANTI-INFLAMMATORY Contains potent volatile oils with anti-inflammatory properties and, perhaps most importantly, curcumin, which gives it its vibrant color. Curcumin has a medicinal effect comparable to drugs, such as hydrocortisone and phenylbutazone, and can be used to provide relief from rheumatoid arthritis, treat inflammatory bowel disease, protect against diabetes, and avoid heart disease and stroke by preventing the build-up of plaque in the arteries.

ALZHEIMER'S PROTECTION Curcumin reduces the build-up of the protein amyloid-b in the brain. Amyloid-b causes oxidative (free radical) damage and inflammation in the brain and is one of the main causes of Alzheimer's disease. Antioxidants in turmeric help to fight this free-radical damage.

CANCER PROTECTION In laboratory studies, curcumin has been shown to stop the growth and spread of cancer cells.

HOW DO I GET THE BEST FROM IT?

FRESH OR DRIED The fresh root can be used in place of ginger in most meals. The powder is a key component in most Indian curries.

LEAVES The leaves can be used to flavor dishes, such as curries, or to wrap around food during cooking.

DON'T FORGET THE OIL Curcumin is better absorbed in the presence of oils, such as coconut, olive, ghee, and butter. Heating it slightly aids absorption.

HOW DO I USE IT?

AN ANTIOXIDANT DRINK Stir 1 tbsp turmeric powder into warm whole or low-fat milk to treat painful joints or eczema.

A SPICY RICE DISH Enliven brown rice with cashews and raisins, and season with turmeric, cumin, and toasted coriander seeds.

Root
Its vibrant internal color is due to curcumin—a powerful antioxidant and anti-inflammatory

Leaves
The leaves also contain curcumin, along with trace amounts of vitamins and minerals. They have a less pungent flavor than the root and can be brewed as a medicinal tea

SWEET POTATOES

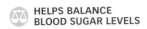 **HELPS BALANCE BLOOD SUGAR LEVELS**

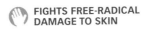 **FIGHTS FREE-RADICAL DAMAGE TO SKIN**

 PROTECTS AGAINST INFECTION

They may look uninteresting, but sweet potatoes are a superfood. A single sweet potato contains more than a day's worth of **beta-carotene** and nearly all your daily **vitamin C** requirements. They help combat **free radicals** in the body, benefit **skin health**, and support the **immune system**. Because of their high level of slow-release carbohydrates, they can also help maintain **steady blood sugar levels.**

YELLOW FLESH, BROWN SKIN
High potassium levels regulate heart rate and help combat the effects of stress.

PURPLE SKIN AND FLESH
Rich in anthocyanin pigments, which support and protect the gut.

PURPLE SKIN, YELLOW FLESH
This colorful variety contains the highest amount of beneficial antioxidants.

WHAT IS IT GOOD FOR?

GLUCOSE CONTROL Sweet potatoes are a traditional treatment for diabetes. They contain slow-release carbohydrates and the hormone adiponectin, a combination that helps keep blood sugar levels steady.

BEAUTIFUL SKIN Its high levels of beta-carotene means sweet potato benefits skin by fighting the free radicals that cause skin aging.

IMMUNE BOOSTING High in beta-carotene and vitamin C, regular consumption of sweet potatoes can strengthen the immune system and help develop resistance to infection, and may also provide anticancer benefits.

HOW DO I GET THE BEST FROM IT?

KEEP THE SKIN ON The skin is healthy and contains nutrients similar to that of the flesh underneath. To get your full complement, eat sweet potatoes with their skins on.

HOW TO COOK THEM Steaming or boiling, rather than roasting, preserves their slow-release carbohydrates and essential nutrients.

ADD SOME FAT Eat with a little butter or oil to ensure all the antioxidants, such as beta-carotene, are fully absorbed.

THINK PURPLE The purple-fleshed sweet potato is rich in antioxidant and anti-inflammatory anthocyanins—primarily peonidins and cyanidins—that can protect against irritable bowel and ulcerative colitis.

HOW DO I USE IT?

MASHED Peel and cut roughly into chunks. Boil for 30 minutes or until soft, mash with butter, and serve. Add brown sugar, cinnamon, and/or nutmeg for extra flavor.

AS A SALAD Add steamed (or leftover) sweet potatoes and sliced red peppers to arugula or spinach. Dress with a balsamic vinegar dressing. Add goat cheese too, if you like.

POTATOES

 HELPS FIGHT INFLAMMATION

 HELPS LOWER BLOOD PRESSURE

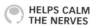 **HELPS CALM THE NERVES**

Potatoes are a surprisingly good source of vitamin C, potassium, fiber, B vitamins, copper, tryptophan, manganese, and even lutein. Their alkaline nature helps to **detoxify** and balance excess **acidity** in the body and relieve the **inflammation** and pain of **ulcers.** They are a **natural sedative** and encourage healthy **blood circulation**, and the skin contains chlorogenic acid, which helps prevent cell mutation.

WHAT IS IT GOOD FOR?

REDUCING INFLAMMATION Alkalizing and anti-inflammatory, potatoes soothe stomach and duodenum ulcers and reduce stomach acidity. They may also relieve the inflammation associated with arthritis.

HIGH BLOOD PRESSURE Potatoes are high in chlorogenic acid and anthocyanins, chemicals that help to lower blood pressure. The polyphenol in purple potatoes may also help.

CALMING THE NERVES Potatoes contain tryptophan, an amino acid with natural sedative properties.

HOW DO I GET THE BEST FROM IT?

USE THE JUICE Drinking the juice is a quick way to benefit from its anti-inflammatory properties. Wash and grate several red-skinned potatoes, put in cheesecloth, and squeeze to remove the juice. Drink as needed.

KEEP THE SKIN ON Potato nutrients leech into the cooking water and so lose a great deal of their nutritional value if they are peeled before boiling. When buying potatoes, avoid those that are already washed. The washing process destroys their natural protective coating, making them more vulnerable to bacteria and thus decay. Buy organic potatoes to ensure the skins are free from pesticides.

HOW DO I USE IT?

POTATO AND NETTLE RÖSTI Boil potatoes until al dente (still slightly firm). When cool, roughly grate, blend with a handful of chopped nettles, season, shape into small flat cakes, and shallow-fry. Drain and serve.

POTATO SALAD Use red-skinned potatoes in a potato salad for an extra dose of antioxidants.

CRUSHED POTATOES AND WILD GARLIC Cook new potatoes until just tender and crush rather than mash them together with a handful of wild garlic and butter or oil.

White flesh
The sedative tryptophan in potatoes makes them a good choice if you are stressed

Red skin
Contains antioxidant anthocyanins, which are good for the heart

NEW POTATOES
New potatoes are eaten with the skin on, which is rich in nutrients.

PURPLE POTATOES
In Korea, the purple potato is eaten as a way to lose weight.

RADISHES

 SUPPORTS HEALTHY LIVER FUNCTION

 HELPS LOWER BLOOD PRESSURE

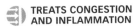 **TREATS CONGESTION AND INFLAMMATION**

Belonging to the cruciferous family of vegetables, fiery-tasting radishes grow in a variety of sizes, shapes, and colors, and are available all year round. Both the roots and leaves are rich in **vitamin C**, potassium, magnesium, **B vitamins**, and trace elements, which help to fight **hypertension**. Its pungent essential oils help support a **healthy liver** and fight inflammation and congestion.

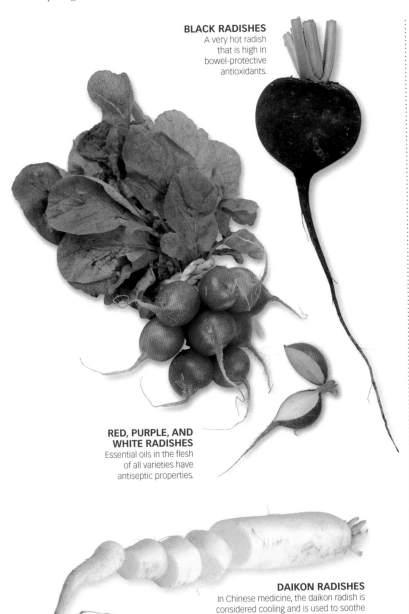

BLACK RADISHES
A very hot radish that is high in bowel-protective antioxidants.

RED, PURPLE, AND WHITE RADISHES
Essential oils in the flesh of all varieties have antiseptic properties.

DAIKON RADISHES
In Chinese medicine, the daikon radish is considered cooling and is used to soothe coughs, bronchitis, and laryngitis.

WHAT IS IT GOOD FOR?

DETOX The radish is a useful tool for fat digestion because it stimulates the flow of bile. It also has a cleansing, decongesting action on the gallbladder, liver, and blood. Traditionally, radishes have been used to help break up gallstones and kidney stones. They also have a diuretic and laxative action.

FIGHTS HYPERTENSION Radishes are high in potassium, which helps keep blood pressure low.

CLEARS CONGESTION The high vitamin C content in radishes can help treat colds and the flu. The juice pressed from grated, fresh radish root is a traditional remedy for coughs, inflamed joints, and gallbladder problems.

HOW DO I GET THE BEST FROM IT?

USE THE GREEN TOPS Radish leaves contain 6 times more vitamin C than the roots, and also supply calcium.

LOOK FOR DAIKON RADISHES The daikon radish, a staple of Eastern cooking, is high in the enzyme myrosinase: it both aids digestion and, during the digestive process, produces isothiocyanate, an antioxidant that has anticancer benefits.

HOW DO I USE IT?

JUICE IT Make a fiery detox drink by juicing apples, celery, and radishes. As a cold remedy, try mixing equal parts of radish juice and honey. Take 1 tbsp 3 times a day.

A SIMPLE SIDE DISH Gently braise radishes in butter and vegetable stock. Turn off the heat, add some fresh watercress, season, and serve.

ENERGIZING SALAD Make a salad from thinly sliced radish, a soft leaf lettuce (e.g. butter lettuce), and ruby grapefruit segments. Dress with a mustard vinaigrette containing some of the grapefruit juice.

A tea made from chlorophyll-rich carrot tops makes a delicious, detoxifying drink. Choose organic carrots with leaves that haven't been treated with chemicals.

GARLIC

 A NATURAL ANTICOAGULANT

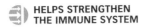 **HELPS STRENGTHEN THE IMMUNE SYSTEM**

 REMOVES TOXINS AND POLLUTANTS

 CONTAINS ANTICANCER SUBSTANCES

The main beneficial ingredients of this member of the allium family are allicin and diallyl sulfides—sulfurous compounds that are **antibacterial** and **antifungal**. Garlic is universally recognized for its health-promoting benefits: **aiding the circulatory** and **digestive** systems, boosting the **immune system**, lowering **blood pressure**, and fighting **heart disease**. It even helps to **eliminate toxins**.

DRIED GARLIC BULB
Contains abundant antibiotic and antifungal sulfur compounds including allicin, alliin, and ajoene.

Wild garlic leaves
Use sparingly in salads, pestos, soups, and risottos for extra flavor

FRESH GARLIC
Has the same benefits as the dried bulb and with edible stems.

WILD GARLIC
Only the leaves and flowers are usually eaten, making it easier to digest than bulb garlic. The leaves contain chlorophyll in addition to adenosine.

Flowering stalks
Garlic scapes are harvested in late spring/early summer and can be added to salads …

GARLIC SCAPES
These are immature flowering stalks of garlic that have the same benefits as the mature bulb, but with a mild flavor.

WHAT IS IT GOOD FOR?

HEART HEALTH The sulfur in garlic stimulates nitric oxide production in blood vessels. This relaxes and improves their elasticity, helping lower blood pressure and reducing the risk of stroke and atherosclerosis (hardening of the arteries).

IMMUNITY Its volatile oils are antibiotic and can be used to treat colds and coughs.

DETOXIFYING Contains sulfhydryl, which works by helping to remove toxic substances, such as heavy metals, from the body.

CANCER Garlic is recognized for helping to prevent numerous types of cancer, including bowel, breast, and lung cancer. It purportedly also helps treat prostate and bladder cancer.

REGULATES BLOOD SUGAR LEVELS A regular intake of garlic lowers the amino acid homocysteine, a risk factor in diabetes and heart disease.

HOW DO I GET THE BEST FROM IT?

FRESH IS BEST Choose fresh rather than bottled in water or oil, because its healthful allicin compounds degrade dramatically.

TRY BLACK GARLIC Fermented black garlic has a molasses-like balsamic flavor, twice the amount of antioxidants of white garlic, and leaves no trace of bad breath after eating it.

HOW TO COOK IT Cooked garlic doesn't have the same levels of allicin as raw, but it does retain other compounds. Let it stand for 10 minutes after crushing or slicing to allow the allicin to develop before being heated. Microwaving kills off nearly all its benefits.

HOW DO I USE IT?

FRESH GARLIC Cook the stems like leeks, or slice and use in soups and omelets or as a garnish for salads.

EAT RAW Scatter raw over cooked vegetables.

ONION FAMILY

 HAS A POWERFUL ANTIBIOTIC ACTION **HELPS LOWER CHOLESTEROL** 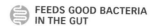 **FEEDS GOOD BACTERIA IN THE GUT**

The onion family is part of the allium family, which also includes garlic. The Chinese, East Indians, Ancient Greeks, Romans, and even Egyptians all revered onions, and modern science has proved them right. Onions contain dozens of medicinal chemical compounds that have **antibacterial** and **anti-inflammatory** actions in the body and promote good **heart** and **gut health**.

WHAT IS IT GOOD FOR?

ANTIBACTERIAL ACTION The sulfur compounds in onions—including thiosulfinates, sulfides, and sulfoxides—are responsible for their powerful antibacterial and antiviral action, and unique taste.

HEART HEALTH A good source of heart-healthy quercetin. This flavonoid helps avoid heart disease by preventing blood clots and cholesterol from sticking to arterial walls. Over time, quercetin can also help raise levels of "healthy" (HDL) cholesterol in the blood.

HEALTHY GUT Contains a fiber called inulin and a range of other fructo-oligosaccharides. These compounds, known as prebiotics, provide the right food to encourage the growth of healthy bacteria in the gut. This may be why including more onions in your diet has a role to play in preventing bowel cancer.

HOW DO I GET THE BEST FROM IT?

RAW IS BEST Its benefits are mostly lost when cooked. To enjoy at its medicinal best, use raw or braise lightly in stock or broth.

USE STRONG VARIETIES Highly flavored onions contain the most healthful compounds.

HOW DO I USE IT?

A SIMPLE COLD REMEDY Mix onion juice with honey and take 2–3 tsp daily when you are fighting a cold or feel one coming on.

A VARIETY OF TASTES Onions and shallots add punch and bite to omelets, soups, and stews, while leeks lend a rich, creamy flavor. Scallions are ideal in stir-fries or with steamed fish, and can enliven mashed potato.

SPROUT THE SEEDS Add sprouting onion seeds to salads, sandwiches, and other dishes.

RAMPS These immature flowering stalks, available in late spring/early summer, are delicious in a spring detox salad.

RED ONION Pigments known as anthocyanins give red onions an antioxidant boost.

WHITE ONION Contains the flavonoid quercetin, which can help prevent heart disease.

SPRING ONION Even "baby" onions such as these contain immunity-boosting sulfur compounds.

LEEK This mild-flavored relative of the onion stimulates appetite, and is a gentle diuretic and laxative.

RHUBARB

 HELPS STRENGTHEN BONES

 PROTECTS AGAINST NEURO-DEGENERATION

 HELPS LOWER CHOLESTEROL

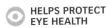 **HELPS PROTECT EYE HEALTH**

Although we think of rhubarb as a fruit, it is actually a vegetable and a member of the buckwheat family. It is too sour to eat raw, but even cooked it contains a number of beneficial properties, including helping to **strengthen bones** and protect against **neurological damage**. It is also a good source of **fiber** and is known to help reduce "unhealthy" (LDL) **cholesterol** levels in the blood.

OUTDOOR RHUBARB
Field rhubarb has bright green leaves and is less tender than the forced variety, but has a better flavor.

FORCED RHUBARB
Forced rhubarb is grown in the dark, but it has all the same healing properties.

WHAT IS IT GOOD FOR?

BONE HEALTH Contains calcium and notable amounts of vitamin K, especially important for protecting against bone fractures as we age.

PROTECTING THE BRAIN Adequate vitamin-K levels can protect against the neurological damage linked to Alzheimer's disease. Vitamin K is also a useful clotting agent for blood, so may protect against bleeding and stroke.

HEART HEALTH Studies show that including rhubarb in your diet can help reduce an overbalance of "unhealthy" (LDL) cholesterol levels in the blood. It is also a good source of fiber and has moderate levels of vitamin C.

EYE HEALTH Contains useful amounts of lutein, which can reduce the risk of age-related macular degeneration (loss of vision).

HOW DO I GET THE BEST FROM IT?

RED IS BETTER THAN GREEN Red stalks contain more beta-carotene than green varieties. They also contain small amounts of polyphenolic flavonoid compounds, such as zeaxanthin and lutein.

MAKE SURE IT'S RIPE Rhubarb contains oxalic acid, which prevents the absorption of nutrients, such as iron and calcium. Most oxalic acid concentrates in the leaves, but it can be especially high in unripe stalks too. Look for stalks that are deeply colored.

COOK IT The stalks are sour and considered inedible raw, so always cook before eating.

HOW DO I USE IT?

SPICE IT UP Sauté garlic and onions in olive oil, add chopped rhubarb, root vegetables, and presoaked lentils. Add a little stock, season with pungent curry spices, and simmer until tender. Serve over rice.

AS A FRUIT Use in preserves, jams, muffins, and fruit pies instead of cherries and berries.

FENNEL

 EASES STOMACH CRAMPS

 CONTAINS ANTI-INFLAMMATORY OILS

 A GENTLE HORMONE REGULATOR

 HAS A DIURETIC ACTION

Aromatic fennel looks like a larger version of its relative dill, but has a distinct aniseed flavor. Since Roman times it has been valued for it ability to soothe **digestive troubles.** It also helps to relieve **water retention** and regulate **female hormones**. A low-calorie source of **vitamin C**, dietary fiber, and potassium, it also contains a range of **antioxidants** and **anti-inflammatory** volatile oils.

WHAT IS IT GOOD FOR?

STOMACH SOOTHER It encourages healthy digestion and eases stomach cramps. Can be effective against worms and parasites due to the volatile oil anethole, which gives fennel its characteristic aniseed flavor.

EASING COUGHS AND COLDS A syrup made from the juice is traditionally used to thin mucus and make coughs more productive.

HORMONE REGULATION Its estrogenic qualities may help bring hormonal balance to females of all ages—from young mothers to women in menopause.

MAINTAINING WATER BALANCE Fennel can relieve water retention and bloating.

HOW DO I GET THE BEST FROM IT?

HOW TO COOK IT The tender stems can be added to soups or roasted in oil. Fennel can also be eaten raw in salads.

MAKE USE OF THE SEEDS A mild, cooled tea made from the seeds and sweetened with a touch of honey is a time-honored way of settling the stomach and easing colic in babies.

HOW DO I USE IT?

BREW A TEA Boil 1 tsp of fennel seeds in 1 cup water or milk and drink as required.

HEALING SYRUP To make a syrup from fennel juice as a traditional remedy for coughs, juice the whole plant—or steep the seeds in a little boiling water to make a strong decoction—and mix with lemon juice and honey to taste.

LIGHTLY ROAST Slice the bulb into wedges, arrange in an ovenproof dish, season, dot with butter, add a generous handful of fresh thyme, and bake at 350°F (180°C) until tender.

MAKE A SOUP To ease menstrual symptoms, cook equal quantities of fennel, asparagus, and fresh parsley in a broth of water and milk until soft. Purée, season to taste, and serve.

SEEDS
Contain concentrated volatile oils that sooth upset stomachs.

BULB AND LEAVES
Contain anti-inflammatory and antioxidant substances including rutin, quercetin, kaempferol glycosides, and anethole.

CELERY AND CELERIAC

 HELPS LOWER BLOOD PRESSURE

 HAS A DIURETIC ACTION

PROMOTES FEELING OF FULLNESS

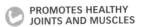 **PROMOTES HEALTHY JOINTS AND MUSCLES**

There is more to bitter, aromatic celery than a pleasant crunch; in Eastern medicine, both the stalks and roots are used to **treat high blood pressure**. Celery and its close cousin celeriac are mildly **diuretic** and help reduce levels of the **stress hormone** cortisol. They are also rich in **B vitamins**, trace elements, **fiber**, and **circulation-supporting coumarins**. Its taste and nutritional quality are highest when in season.

SEEDS
Rich in volatile oils and essential fatty acids.

STALKS
The water and fiber content can aid weight control.

CELERIAC CORM
High in phosphorus, which benefits the nervous, lymphatic, and urinary systems.

WHAT IS IT GOOD FOR?

LOWERS BLOOD PRESSURE Contains coumarins, which help lower blood pressure and aid water balance, and phthalides, anti-coagulants that reduce the risk of blood clots and stroke and lower stress hormone levels.

A DIET AID Celery is mostly water and fiber—two things that can aid weight control. Adding celery to your meal may help you to eat more slowly and chew more thoroughly, and therefore increase a feeling of fullness.

SOURCE OF SILICON It contains good amounts of silicon as well as vitamin K, which is not only beneficial for skin and hair but also for joints, bones, muscles, arteries, and connective tissues.

HOW DO I GET THE BEST FROM IT?

STALKS Low in calories and high in fiber, the stalks (and leaves) have, in addition to their other benefits, diuretic and laxative properties.

SEEDS Rich in volatile oils, traditionally used as a diuretic and sedative, and to reduce inflammation and treat menstrual discomfort. Studies show they may help lower blood pressure and "unhealthy" (LDL) cholesterol. Use as a seasoning or brewed as a tea.

HOW DO I USE IT?

COMBINE WITH FRUIT Celery is one of the few vegetables that combine well with fruit. Slice some into a fruit salad for extra crunch.

ADDS FLAVOR The phthalides in celery and celeriac have no flavor of their own but can act as a natural flavor enhancer in meals.

AS A COLD REMEDY Combine celery juice with a little lemon juice to help treat the feverish symptoms of cold and flu.

JUICE IT Both stalk and corm yield an alkalizing, revitalizing, and detoxifying juice that helps regulate the body's water balance.

ASPARAGUS

 HAS A MILD LAXATIVE ACTION

 REMOVES ENERGY-DRAINING TOXINS

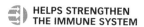 **HELPS STRENGTHEN THE IMMUNE SYSTEM**

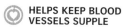 **HELPS KEEP BLOOD VESSELS SUPPLE**

Asparagus is a member of the lily family. It has been prized for millennia for its unique flavor, succulent texture, and medicinal qualities: it has **detoxifying properties** and contains **antioxidants** that strengthen the heart and blood vessels. Traditional Chinese medicine also suggests it can benefit people with **respiratory illnesses** and **ease menstrual problems**.

WHAT IS IT GOOD FOR?

SUPPORTS THE GUT Asparagus contains inulin, a prebiotic that encourages healthy gut flora. Also has mild laxative and diuretic properties.

BOOSTS ENERGY Aspartic acid neutralizes excess ammonia in the body, which could otherwise result in a sense of feeling drained and lacking in vigor.

ANTI-INFLAMMATORY Contains rutin and glutathione, which protect cells against oxidative stress by free radicals in the body, promote a healthy immune response, and can strengthen blood vessels.

PROTECTS THE HEART AND MORE A great source of B vitamins, especially folate, which may help control homocysteine, a substance that promotes heart disease, cancer, and cognitive decline. Increased folate intake during pregnancy can help fight birth defects.

SKIN HEALTH A combination of detoxifying properties and beta-carotene in asparagus has a purifying effect on the skin.

HOW DO I GET THE BEST FROM IT?

BUY IN SEASON To get the most nutrients, always buy it in season. Depending on area, asparagus season lasts from February to June.

USE IT QUICKLY Asparagus deteriorates quickly when stored. Buy and use within a couple of days to get the maximum benefit.

HOW TO COOK IT Broil or steam for 3–5 minutes (avoid boiling). Or braise quickly in a little vegetable broth to ensure the maximum flavor and retention of nutrients.

HOW DO I USE IT?

IN SALADS Add cooked cold asparagus to a colorful salad to make a delicious light meal.

AS A SPECIAL INGREDIENT Cook and serve with hot pasta, cooked fresh fish and chicken, or add to vegetable quiche.

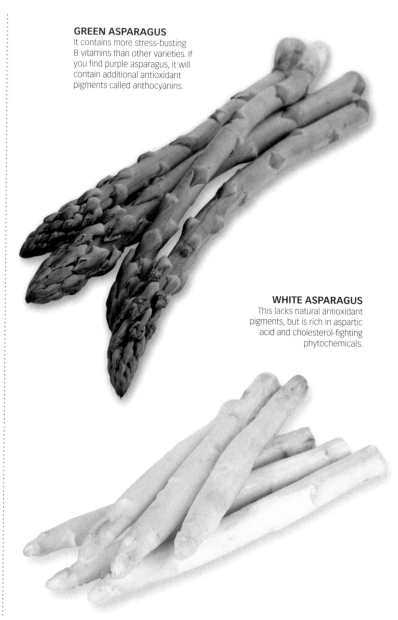

GREEN ASPARAGUS
It contains more stress-busting B vitamins than other varieties. If you find purple asparagus, it will contain additional antioxidant pigments called anthocyanins.

WHITE ASPARAGUS
This lacks natural antioxidant pigments, but is rich in aspartic acid and cholesterol-fighting phytochemicals.

PEAS

 PROMOTES A HEALTHY DIGESTIVE TRACT

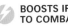 **BOOSTS IRON STORES TO COMBAT FATIGUE**

 HELPS FIGHT INFECTION

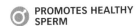 **PROMOTES HEALTHY SPERM**

While neither exotic nor rare, this naturally sweet legume has a nutrient content that guarantees it a place in the medicinal food world. Peas are rich in **vitamin K**, **manganese**, and **vitamin C**, and are a good source of **folate** and **trace elements**. Their **insoluble fiber content** is good for the gut and also helps to reduce the risk of **heart disease** and **stroke**.

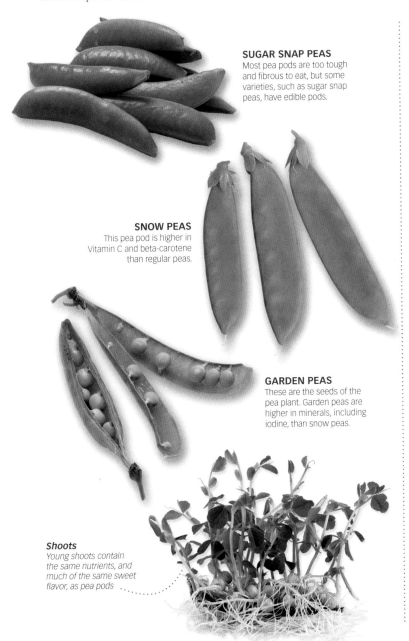

SUGAR SNAP PEAS
Most pea pods are too tough and fibrous to eat, but some varieties, such as sugar snap peas, have edible pods.

SNOW PEAS
This pea pod is higher in Vitamin C and beta-carotene than regular peas.

GARDEN PEAS
These are the seeds of the pea plant. Garden peas are higher in minerals, including iodine, than snow peas.

Shoots
Young shoots contain the same nutrients, and much of the same sweet flavor, as pea pods

WHAT IS IT GOOD FOR?

DIGESTION Its fibrous content makes it useful for maintaining a healthy digestive tract.

ENERGY BOOST A good source of iron, which helps prevent anemia and combats fatigue.

IMMUNITY Rich in vitamin C; a single serving of peas or snow peas supplies half your daily needs. Peas, especially pea shoots, also contain phytoalexins, an antioxidant that can inhibit *H. Pylori*, the bacterium that causes stomach and duodenal ulcers, and stomach cancer.

MEN'S HEALTH Glycodelin-A, a substance found in snow peas, can help strengthen sperm and improve their ability to fertilize a female egg.

EYE HEALTH The carotenoid pigment in green peas is lutein, which is well known for reducing the risk of cataracts and macular degeneration (loss of vision).

HOW DO I GET THE BEST FROM IT?

EAT RAW Get the best flavor and nutrients by eating fresh peas straight from their pods.

FROZEN OR DRIED The sugar in fresh peas quickly turns to starch with storage. Frozen peas are processed immediately after picking, which is why they tend to taste sweeter. Dried peas are sold in green and yellow varieties (usually split), and you can also buy dried wild peas. All of them are great for enjoying the benefits of peas beyond their summer season.

HOW DO I USE IT?

AS AN ALTERNATIVE TO LETTUCE Swap salad leaves for pea shoots in a stir-fry or salad.

SNOW PEAS WITH CASHEWS Heat 1 tsp coconut oil in a skillet. Add 3 handfuls of snow peas and the zest of ½ orange and cook on low heat for 3–4 minutes. Season and serve scattered with a handful of cashew nuts for a skin-nourishing dish.

OKRA

 HELPS BALANCE BLOOD SUGAR LEVELS

 AIDS DETOXIFICATION SYSTEM

 HELPS PROTECT EYE HEALTH

 PROMOTES A HEALTHY PREGNANCY

Okra, also known as bhindi and lady's fingers, is a flowering plant that belongs to the mallow family. It has a unique, slightly peppery taste somewhere between eggplant and asparagus. Its main medicinal value lies in its extraordinary combination of **soluble and insoluble fiber**, which helps lower **blood sugar** levels, cleanse the **intestines**, and feed **good gut bacteria**.

WHAT IS IT GOOD FOR?

ANTIDIABETIC A rich source of many nutrients, including fiber, vitamin B_6, and folate. B vitamins slow the progress of diabetic neuropathy and reduce levels of homocysteine, a risk factor for this disease. The soluble fiber also helps to stabilize blood sugar levels.

BRILLIANT DETOX Abundant in both soluble and insoluble fiber. Soluble fiber absorbs water and helps bulk up stools, and helps lower "unhealthy" (LDL) cholesterol in the blood. Insoluble fiber helps keep the intestinal tract healthy, binding to toxins and aiding their removal. This decreases the risk of some forms of cancer, especially colorectal cancer.

PROTECTING VISION In addition to having good amounts of beta-carotene, it contains zeaxanthin and lutein. These compounds are essential for maintaining good vision.

FOLATE-RICH Okra is a good source of folate, a nutrient that enriches red blood cells, protects the heart, and lowers the risk of birth defects in babies.

HOW DO I GET THE BEST FROM IT?

LEAVE IT WHOLE The more you slice okra, the more it exudes a gelatinous substance, which some people find off-putting. Avoid this by trimming just the ends without puncturing the inner pod, and don't overcook it.

HOW TO COOK IT Cook lightly and quickly by steaming, grilling, or adding to a stir-fry to preserve its essential nutrients.

HOW DO I USE IT?

ADD TO A SALAD If you are tired of the same lettuce, tomato, and cucumber salad, try slicing whole grilled okra into a salad and drizzle with a chile and lime dressing.

ADD TO STEWS Use in soups and stews and curries as a thickener.

GREEN OKRA
Okra is high in fiber in the form of mucilaginous gums and pectins. If you find purple okra it will have the additional cancer-protective antioxidant anthocyanin.

......... Seeds
Oil pressed from okra seeds is rich in heart-friendly polyunsaturated fats and is often used in African cooking

GREEN BEANS

 PROVIDES CELLULAR ENERGY

 STRENGTHENS CONNECTIVE TISSUE

 HELPS BUILD STRONG BONES

 PROTECTS AGAINST FREE-RADICAL DAMAGE

Fresh green beans, which are the same species as the dried versions we use in chili con carne and baked beans, are edible pods picked early in the plant's growth cycle; as they mature, the pods become tough, fibrous, and inedible. The beans are a **good source of vitamin C** and folate, and have useful amounts of **calcium** and **protein**. This makes them **heart-protective** and **anti-inflammatory**.

GREEN BEANS
Contain a wide spectrum of carotenoids and flavonoids, which pack an antioxidant punch.

PURPLE BEANS
Purple pod beans can be eaten raw and add tremendous color to fresh salads; the pods turn green when cooked.

RUNNER BEANS
Mature plants produce a pink/deep purple edible bean similar in flavor to a lima bean. Runner beans aid water balance through their strong diuretic properties.

FAVA BEANS
Fava beans are rich in isoflavones—plant hormones with heart-protective and anticancer properties.

WHAT IS IT GOOD FOR?

ENERGY BOOSTING Contains twice the amount of iron as spinach, so it's a good way to make up iron loss during menstruation. Iron is a component of red blood cells that transport oxygen from the lungs to cells throughout the body. It is also is a key element in making energy and the body's metabolism.

SKIN, HAIR, AND NAILS Provides an easily absorbed type of silicon, important for the formation of healthy connective tissues and strengthening nails.

BONE HEALTH Abundant in vitamin K, which activates osteocalcin, the main noncollagen protein found in bones that locks calcium molecules together inside the bone.

FIGHTS FREE RADICALS Levels of the antioxidants lutein, beta-carotene, violaxanthin, and neoxanthin are comparable to those in carotenoid-rich vegetables, such as carrots.

DETOX Beans have strong diuretic properties and help to speed the elimination of toxins from the body.

HOW DO I GET THE BEST FROM IT?

DON'T CUT THEM Where you can, just trim the beans and cook them whole to preserve their nutrients.

HOW TO COOK THEM Cook until "al dente" (slightly crunchy), or steam briefly to ensure their vitamin C content is retained.

HOW DO I USE IT?

VERSATILE Add to salads, soups, and stews, or serve as a side dish. Pair tender varieties with lighter meats, such as poultry, and more robust, coarser varieties, such as runner beans, with red meats.

GET BEYOND BUTTER Serve with a dressing of olive oil, lemon, and garlic to bring out their flavor and boost their nutritional value.

CHICORY

 PROMOTES A HEALTHY DIGESTIVE TRACT

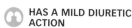 **HAS A MILD DIURETIC ACTION**

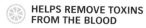 **HELPS REMOVE TOXINS FROM THE BLOOD**

 HAS NATURAL SEDATIVE PROPERTIES

Blanched white chicory (Belgian endive), green-leaf chicory, and red-leaf varieties (radicchios), are the most familiar types of this bitter leaf. Grown in the dark, the popular white chicory lacks the usual array of vitamins, but it retains the **volatile oils** and other substances that **aid digestion,** and acts as a **detoxifier** and a mild diuretic. Chicory contains natural sedative compounds to **ease stress and pain**.

WHAT IS IT GOOD FOR?

INTESTINAL HEALTH Rich in mucilaginous (gumlike) fiber, which helps lubricate the intestines and soften stools.

BETTER DIGESTION Its bitter constituents stimulate bile production, increase appetite, and aid digestion. Chicory can also help combat excessive wind and indigestion.

AIDS DETOXIFICATION It is a natural diuretic and mildly laxative. As a good source of dietary fiber, it helps removes toxins from the blood and tissues.

MILD SEDATIVE Both chicory and radicchio contain the substance lactucopicrin, which contributes to their bitter taste and has sedative and analgesic properties.

ANTIOXIDANT Although it lacks most other vitamins, chicory is rich in the useful antioxidant beta-carotene, which can help protect against cancer.

HOW DO I GET THE BEST FROM IT?

EAT IT RAW While it can be eaten lightly braised, you will receive more of chicory's vitamin C, folate, and beta-carotene content if you eat it raw.

EAT IT FRESH Both chicory and radicchio are relatively fragile and only keep for a few days in the refrigerator crisper before wilting.

HOW DO I USE IT?

A NATURAL SCOOP Use the leaves of the witloof chicory, also known as Belgian endive, which have a naturally curved shape, as crudités to serve with a variety of dips, or fill the leaves with different toppings or a stuffing made of rice and vegetables and serve them as a finger food or an appetizer.

ENLIVEN STIR-FRIES AND SALADS The mildly bitter flavor of chicory and radicchio gives a pleasant edge to salads and stir-fries.

WHITE CHICORY (WITLOOF OR BELGIAN ENDIVE
The thick leaves and delicate white flesh are a source of folate, beta-carotene, and vitamin K, and also contain traces of calcium and magnesium. Green-leaf chicory has similar nutrients.

RED-LEAF CHICORY (RADICCHIO)
Contains higher levels of the antioxidant anthocyanin and volatile oils that aid digestion.

NETTLES

 **HAS A POWERFUL
DIURETIC ACTION**

 **HELPS REDUCE AN
ENLARGED PROSTATE**

 **BOOSTS IRON STORES
TO COMBAT FATIGUE**

 **HELPS BALANCE BLOOD
SUGAR LEVELS**

Many gardeners consider stinging nettles to be a weed, but they have long been used to **treat painful muscles** and joints, eczema, **arthritis**, gout, and **anemia**. Today, they are used to benefit the blood, treat **urinary tract infections**, urinary problems during the early stages of an **enlarged prostate**, hay fever, or in compresses or creams to treat joint pain, sprains and strains, tendonitis, and **insect bites**.

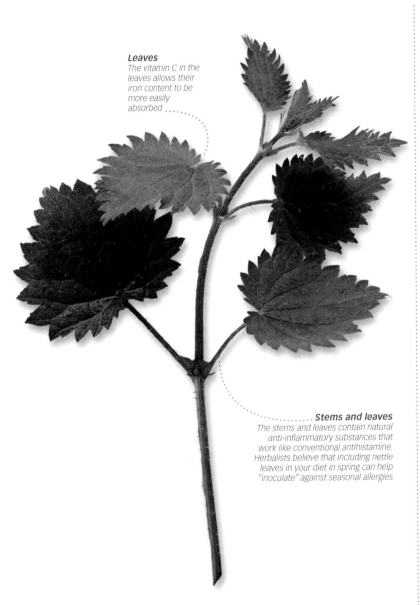

Leaves
The vitamin C in the leaves allows their iron content to be more easily absorbed

Stems and leaves
The stems and leaves contain natural anti-inflammatory substances that work like conventional antihistamine. Herbalists believe that including nettle leaves in your diet in spring can help "inoculate" against seasonal allergies

WHAT IS IT GOOD FOR?

DIURETIC It keeps water flowing through the kidneys and bladder, washing bacteria away and stopping urine crystals from developing into kidney stones.

HEALTHY PROSTATE Nettles are comparable to finasteride (a commonly prescribed medication) for reducing the symptoms of prostate enlargement. Unlike finasteride, it doesn't decrease prostate size, but does improve urinary flow, and reduce post-urination dripping and the urge to urinate.

BLOOD BUILDER Its iron content makes it a wonderful blood builder, and its vitamin C ensures better iron absorption. It is also a good source of vitamin K, which aids clotting.

DIABETIC CONDITIONS Nettle tea can help balance blood sugar levels.

RHEUMATIC CONDITIONS It can eliminate uric acid from joints. Studies suggest that nettle extract can help those with rheumatoid arthritis to lower their NSAID (nonsteroidal anti-inflammatory drug) use.

HOW DO I GET THE BEST FROM IT?

PICK FRESH PLANTS Avoid nettles treated with pesticides. Young nettle tops are full of nutrients and have a mild, pleasant flavor.

AS A TEA Steep fresh or dried nettles in hot water for 10–15 minutes for a detoxifying, diuretic tea. For prostate health, drink several cups of nettle root tea a day.

HOW DO I USE IT?

SPRING DETOX SOUP Sauté nettles, onion, leeks, and celery in butter, purée in a blender or food processor with stock and a little yogurt, and season to taste to serve.

YOUNG NETTLE PESTO Substitute basil leaves with nettles in any pesto recipe. Young spring leaves are more palatable and more potent.

DANDELION

 SUPPORTS HEALTHY LIVER FUNCTION

 HAS A MILD DIURETIC ACTION

 HELPS BOOST IMMUNITY

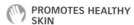 **PROMOTES HEALTHY SKIN**

Think of the dandelion as a superfood rather than a weed: it is a **nutritional powerhouse**, and can be used as a **diuretic** and **liver cleanser**. Every part can be used. Collect the leaves before the familiar yellow flowers emerge to ensure the least bitter taste, and gather the flowers once they turn yellow. Never collect wild plants from chemically treated lawns or gardens.

WHAT IS IT GOOD FOR?

LIVER CLEANSER Helps clear inflammation and congestion of the liver and gallbladder.

DIURETIC A natural source of potassium, making it a safe, gentle diuretic.

IMMUNE SUPPORT Rich in antioxidants that help fight infection and speed wound healing.

HEALTHY SKIN A good source of vitamin C, which supports collagen formation—the foundation of youthful skin and healthy gums.

HOW DO I GET THE BEST FROM IT?

LEAVES These supply all the major antioxidant vitamins, including vitamins C and E.

FLOWERS Dandelion flowers contain useful amounts of beta-carotene, vitamin C, iron, and other nutrients. The colorful petals contain antioxidant flavonoids, which help lower blood pressure and boost immunity.

ROOTS The root, which can be dried and used as a caffeine-free coffee substitute, has a mild laxative and diuretic effect. It also has antiviral properties and contains inulin, a prebiotic that encourages healthy gut flora.

HOW DO I USE IT?

MAKE A PESTO Use the leaves on their own, or combine with nettles, and blend to a paste in a food processor with pine nuts, garlic, Parmesan cheese, and olive oil to make a springtime alternative to classic pesto.

DANDELION TEA Fresh or dried, all parts of the plant can be brewed into a refreshing tea that has diuretic properties.

ADD TO SALADS AND STIR-FRIES Add the yellow flower petals to salads and stir-fries, or pickle the flower heads in vinegar to preserve their nutritional benefits beyond the period they are in season.

ROAST THE ROOTS Cook like parsnips. They taste sweetest from fall to early spring.

Flower
Contains flavonoids and coumaric acid derivatives that can help lower blood pressure

Leaf
Traditionally used to help remove excess water and toxins from the body

Root
Rich in choline, a B vitamin that supports heart health and is also antidiabetic

ARUGULA

 SUPPORTS HEALTHY LIVER FUNCTION

 HELPS PROTECT AGAINST INFECTIONS

 HELPS PROTECT EYE HEALTH

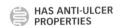 **HAS ANTI-ULCER PROPERTIES**

Once used mainly for its **energizing** medicinal qualities in stimulating **digestion** and protecting against **stomach ulcers**, arugula is now prized as a unique, peppery, **low-calorie**, **detoxifying** salad ingredient. The arugula plant is a relative of broccoli and cabbage and has many of the same benefits, including boosting the **immune system** and maintaining **eye and skin health**.

Leaves
A stimulating salad leaf that aids digestion and strengthens the liver.

WHAT IS IT GOOD FOR?

DETOX Sulfurous chemicals in arugula stimulate circulation, strengthen the liver, and have mild diuretic and laxative properties.

IMMUNE HEALTH Arugula contains very high levels of vitamin C and beta-carotene. These nutrients have proven immunity-boosting properties and help the body defend itself against infections. During digestion arugula releases isothiocyanates, which are protective against cancer.

HEALTHY EYES Arugula contains large quantities of eye-healthy lutein and zeaxanthin. Including these nutrients in your diet can reduce the risk of age-related macular degeneration (loss of vision).

DIGESTIVE HEALTH Studies show arugula can stimulate digestion and also help protect against stomach ulcers.

HOW DO I GET THE BEST FROM IT?

REPLACE OTHER SALAD LEAVES Unlike spinach, its iron and calcium levels are highly available because of its low levels of oxalate.

EAT RAW AND FRESH Arugula begins to lose its nutrients soon after picking. Heat can further degrade its nutritional value. For this reason it is best to buy it fresh and use it as quickly as possible after purchase.

HOW DO I USE IT?

ARUGULA PESTO Blend 4 generous handfuls of arugula, 3 crushed cloves of garlic, 3 tbsp pine nuts, and ¼ cup olive oil in a blender. Gradually add 1½oz (45g) pecorino cheese. Blend until smooth, then stir through hot pasta or mix with hot new potatoes.

SUPER SIMPLE SALAD Arugula is best eaten fresh and raw, so use it as the base of a salad. Combine with lycopene-rich tomatoes and dress the salad with a simple olive oil dressing for an antioxidant-rich meal.

MUSTARD GREENS

 HELPS REMOVE TOXINS FROM THE BODY

 CONTAINS ANTICANCER SUBSTANCES

 HELPS LOWER CHOLESTEROL

 HELPS FIGHT INFLAMMATION

Pungent, peppery mustard greens are the leaves of a mustard plant. They range from bright green to deep purple and are high in **antioxidants** and **anti-inflammatory** properties, and can help **detoxify** the body and lower "unhealthy" (LDL) **cholesterol**. The plant also produces hot, bitter-tasting brown seeds that are used to make Dijon mustard, and which are frequently used in Indian cooking.

WHAT IS IT GOOD FOR?

DETOX The antioxidant beta-carotene and vitamins C and K help neutralize toxins and remove them from the body, providing effective detox support.

CANCER PREVENTION A combination of antioxidant, detoxification, and anti-inflammatory properties contribute to cancer prevention. Mustard greens are also rich in sulfurous chemicals, called glucosinolates, which break down into cancer-fighting isothiocyanates. Studies have linked the leaves to the prevention of bladder, colon, breast, lung, prostate, and ovarian cancers.

LOWERS CHOLESTEROL Rich in natural substances called sulforaphanes. These help remove the "unhealthy" (LDL) cholesterol that increases the risk of heart disease.

BROAD SPECTRUM ANTIOXIDANT Contains key antioxidants including hydroxycinnamic acid, quercetin, isorhamnetin, and kaempferol, which help lower the risk of inflammation and oxidative stress caused by free radicals in the body.

HOW DO I GET THE BEST FROM IT?

HOW TO COOK IT Cooking decreases the availability of its anticancer properties so add raw to salads. However, light steaming boosts its cholesterol-lowering properties.

SPROUT THE SEEDS The seeds, rich in volatile oils, can be sprouted. Add to salads or soups.

HOW DO I USE IT?

HEALTHY SAUTÉ Sauté chopped onions and garlic until tender in a few tablespoons of broth or stock. Add roughly chopped mustard greens and cook until just wilted. Toss with sesame oil and season to taste before serving.

PASTA SAUCE Chop tomatoes and mustard greens and mix with pine nuts, goat cheese, and a little olive oil. Stir through hot pasta.

DEEP GREEN
Sulfurous chemicals support the heart and tissues, and aid detoxification.

PURPLE LEAF
Has the same nutritional value as green leaves, but also contains extra antioxidant pigments.

MIZUNA
These spidery leaves can be grown in the garden or bought at farmers' markets.

WATERCRESS

 CONTAINS ANTICANCER SUBSTANCES

 PROMOTES CLEAR SKIN

 AIDS OPTIMAL DIGESTION

 HAS A DIURETIC ACTION

This salad leaf is a member of the cruciferous vegetable family, which includes cabbage and broccoli. Its numerous health benefits include reducing the risk of certain **cancers**, aiding **digestion**, maintaining the body's **water balance**, and acting as a **natural antibiotic** to **boost immunity**. It doesn't have a particular growing season and so can be grown and harvested all year round.

Leaves
Contain digestive enzymes and are rich in vitamins C and K, iron, beta-carotene, and B vitamins

WHAT IS IT GOOD FOR?

REDUCED CANCER RISK A great source of the antioxidants vitamin C and beta-carotene, which help fight free radicals. Studies have found that regularly eating cruciferous vegetables can help reduce the risk of cancers of the colon, rectum, and bladder.

SKIN DETOX Rich in sulfur, which aids protein absorption, blood purification, and cell building, and promotes healthy skin and hair.

DIGESTIVE AID The chlorophyll that gives watercress its green color is rich in digestive enzymes that help the body fully utilize the nutrients in any meal.

MAINTAINS WATER BALANCE It is rich in potassium, so is natural diuretic and diet aid.

FIGHTS COLDS AND FLU The volatile oils that give it its peppery taste are a good remedy for coughs, colds, flu, and bronchial ailments.

HOW DO I GET THE BEST FROM IT?

JUICE A natural antibiotic. Add to freshly prepared juices to detox and boost clear skin.

BUY ORGANIC If watercress is not grown in controlled conditions, it runs the risk of being contaminated with harmful bacteria. Buying organic means it will contain neither the bacteria nor any pesticides.

EAT FRESH Watercress quickly loses its nutrients. Consume within 5 days of buying.

HOW DO I USE IT?

WATERCRESS SOUP A traditional remedy for inflammatory conditions including achy joints, swollen gums, and mouth ulcers. Simmer ½lb (225g) each of watercress and sliced carrots in water or vegetable stock until the watercress reduces to one-third in volume. Blend and season to taste before serving.

SALAD INGREDIENT The perfect base to any salad; use instead of, or with, lettuce.

SPINACH

 HELPS STRENGTHEN BONES

 CONTAINS ANTICANCER PROPERTIES

HELPS FIGHT INFLAMMATION

HELPS PREVENT ATHEROSCLEROSIS

Packed with **vitamins** and **minerals**, spinach contains more than a dozen different **antioxidant** flavonoid compounds that have **anti-inflammation properties** that protect against **heart disease** and help to **neutralize the free radicals** that compromise the immune system and are linked to cancer. Its considerable vitamin K content also helps to **protect bones**.

WHAT IS IT GOOD FOR?

BONE HEALTH A single serving provides more than twice the daily recommended intake of vitamin K, which is important for maintaining healthy bones. It is especially good at protecting the elderly from bone fractures.

REDUCED CANCER RISK Studies have shown it can help to reduce the risk of certain cancers. Specifically, the antioxidant kaempferol appears to be protective against prostate and ovarian cancer risk.

ANTI-INFLAMMATORY Its high levels of antioxidants, particularly neoxanthin and violaxanthin, have anti-inflammatory effects.

HEART HEALTH Its vitamin C and beta-carotene work together to prevent the oxidization of "unhealthy" (LDL) cholesterol, which can lead to hardening of the arteries.

HOW DO I GET THE BEST FROM IT?

COOKED VS. RAW While raw spinach is nutritious, cooked spinach is even more so. Its iron content is more available and it provides considerably larger amounts of beta-carotene, lutein, vitamins, and minerals.

SERVE WITH CITRUS FRUITS Contains oxalic acid, which prevents us from absorbing all its iron and calcium. If eating raw, serve with a lemon dressing or a glass of orange juice to increase absorption of these vital minerals.

HOW DO I USE IT?

CITRUS SPINACH SALAD Toss 2 generous handfuls of spinach leaves, ½ finely chopped red onion, 1 orange, peeled and separated into segments, and 2 tbsp toasted pine nuts in a bowl. For the dressing, mix 2 tbsp each of orange juice, white vinegar, olive oil, honey, and Dijon mustard with 1 tbsp chopped fresh cilantro. Season and serve.

SPINACH PESTO Substitute basil leaves with spinach in any pesto recipe.

SPINACH
Among the many nutrients in spinach, the carotenoids lutein and zeaxanthin can help to protect the eyes.

MICROGREENS
These contain more antioxidants and other nutrients than the mature leaves.

LETTUCE

 HAS NATURAL SEDATIVE PROPERTIES

 HELPS EASE BLOATING AND DISCOMFORT

 STRENGTHENS HEART AND BLOOD VESSELS

We may think of lettuce as simply a base for more flavorful foods, but it is a useful source of **folate** and **soluble fiber** in the form of pectin. How rich it is in other nutrients depends on the variety—deeply colored lettuces have greater stores of **beta-carotene**. It is also considered to be **cooling, diuretic,** and **calming** for the nerves. The milky juice in darker, bitter varieties contains a **sedative**, lactucarium.

RED LETTUCES (RED OAKLEAF)
The deep color signals the presence of extra beneficial antioxidants, such as carotenes and anthocyanins.

LEAF LETTUCE (ROMAINE)
Darker, more bitter leaves aid digestion and contain substances that calm the nerves.

HEAD LETTUCE
These generally thick leaves contain mostly water, but their minerals are easily assimilated by the body.

WHAT IS IT GOOD FOR?

SEDATIVE Wild lettuce is a traditional herbal sedative. The dark, bitter lettuces contain lactucarium, which can relax nerves, reduce palpitations, and induce sleep.

DIGESTIVE AID AND DIURETIC Contains useful amounts of fiber and can help soothe gassy or griping pains. The watery nature of lettuce also helps to flush toxins from the body.

HEALING HEMORRHOIDS The astringent nature of lettuce can help strengthen blood vessels and may help treat hemorrhoids.

HOW DO I GET THE BEST FROM IT?

CHOOSE LARGE LEAVES Large, loose lettuce leaves are richer in essential nutrients, especially chlorophyll, iron, beta-carotene, and vitamin C, than paler, tightly packed head lettuces, such as iceberg (mostly water).

BEYOND GREEN Ancient lettuce varieties were a rich array of colors. Red lettuces contain extra antioxidant pigments that enhance your daily intake of nutrients.

FRESH AND CRISP Its nutritional value depends on the variety, time of year, and how long it has been stored. To get the best out of lettuce and other salad leaves, buy what is in season and always choose fresh heads, leaves, or "living salad" leaves and not prewashed, bagged varieties of lettuce.

HOW DO I USE IT?

MIX IT UP Its watery texture and neutral, refreshing taste makes lettuce a good partner for fresh fruit.

MAKE A CALMING TEA Tea brewed from lettuce leaves is a useful nighttime sedative. Simmer 3–4 large, deeply colored lettuce leaves with 1 or 2 mint leaves in 1¼ cups water for 15 minutes. Remove from the heat, strain, and drink.

TOMATOES

 HELPS REMOVE TOXINS FROM THE BODY

 HELPS KEEP BLOOD VESSELS SUPPLE

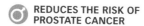 **REDUCES THE RISK OF PROSTATE CANCER**

Although strictly a fruit, tomatoes are widely used as a vegetable in savory dishes. They are rich in **beta-carotene**, vitamin C, and **lycopene**—a superstar of medicinal food substances and the source of their vibrant red color. Lycopene has been found to reduce the risk of **prostate** and **breast cancer**, lower **cholesterol**, protect **eyes and skin**, and boost **immunity**.

WHAT IS IT GOOD FOR?

DETOX Tomatoes are abundant in potassium, which reduces water retention. They are also a good source of glutathione, which helps the body remove fat-soluble toxins.

HEART HEALTH Contains large amounts of vitamins C and E and beta-carotene, all of which support heart health. However, lycopene is most important—it helps strengthen the walls of blood vessels and remove cholesterol from the blood.

PROSTATE CANCER Many cancers are linked with oxidative stress caused by free radicals in the body, and antioxidant foods, such as tomatoes, are known to be preventive. Research into prostate cancer shows that regularly eating raw or cooked tomatoes can reduce the development and spread of cancer.

HOW DO I GET THE BEST FROM IT?

JUICE One glass of tomato juice can contain 74 percent of your recommended daily vitamin C intake, other key vitamins, such as K, B_1, B_2, B_3, B_5, and B_6, and minerals, such as potassium, manganese, and iron.

COOKED When cooked, the lycopene content in tomatoes increases by 5 or 6 times.

KEEP THE SKIN ON The highest concentration of carotenoids is found in the skin.

HOW DO I USE IT?

SALSA Finely chop 2–3 medium tomatoes, 1 small onion, and 2 chiles. Add some finely chopped fresh cilantro, lime juice, 1 tsp water, and salt to taste. Mix well before serving.

HOMEMADE TOMATO JUICE Put 3¼lb (1.5kg) tomatoes, roughly chopped, in a saucepan. Add 1 chopped onion and 1 chopped celery stick, 2 tbsp sugar, and 1 tsp salt. Add some black pepper and, if you like, a few drops of chili sauce. Cook gently over low heat until souplike. Strain and chill before drinking.

GREEN TOMATOES
Low in lycopene, but contain beta-carotene in amounts comparable to red tomatoes.

RED TOMATOES
Contain all four major carotenoids: alpha- and beta-carotene, lutein, and lycopene.

PURPLE TOMATOES
Scientists boast of "creating" purple tomatoes by genetic modification, but these anthocyanin-rich fruits already exist in nature.

YELLOW TOMATOES
Low in lycopene, but they contain more niacin and folate than red tomatoes.

EGGPLANTS

 PROTECTS THE HEART AND BLOOD VESSELS

 HELPS BALANCE BLOOD SUGAR LEVELS

 HELPS REMOVE TOXINS FROM THE BODY

Eggplants, which grow on vines, are part of the same nightshade family that includes peppers and potatoes, and there are several varieties ranging in size, shape, and color. They all contain beneficial amounts of **antioxidants** as well as potassium, folate, magnesium, **beta-carotene**, and **fiber**, while their medicinal properties include balancing **blood sugar** levels and boosting **gut health**.

PURPLE EGGPLANT
Contains fiber that benefits digestion, and antioxidants that prevent cell damage.

BABY EGGPLANT
Has all the same benefits as the classic purple variety.

WHITE EGGPLANT
Lacks the protective dark pigments, but still contains heart-healthy chlorogenic acid.

WHAT IS IT GOOD FOR?

HEART HEALTH Dark purple varieties are particularly rich in the antioxidant polyphenol, chlorogenic acid, as well as caffeic acid and flavonoids, such as nasunin, which protect the heart from oxidative stress caused by free radicals in the body.

BALANCES BLOOD SUGAR LEVELS The antioxidant chlorogenic acid also helps slow the release of glucose into the bloodstream after a meal.

DETOX Beyond promoting bowel regularity and water balance, some studies have shown that eggplant can help remove harmful chemical substances from the body.

HOW DO I GET THE BEST FROM IT?

CHOOSE CAREFULLY Eggplant spoils fairly quickly so choose firm, glossy examples. Ideally, eat within a day of purchase.

LEAVE THE SKIN ON Eggplant's antioxidants concentrate in the skin, which tenderizes as you cook it. Some white varieties have a tougher skin that may need to be peeled before cooking.

HOW TO COOK IT Bake, roast, or fry. When fried, its spongy texture will soak up large amounts of oil; to prevent this, first sprinkle eggplant slices with salt and leave in a colander to drain. Rinse well, press firmly to remove excess water, and cook.

HOW DO I USE IT?

BABA GANOUSH This classic dish is made from eggplant fried or baked until soft, and puréed with lemon juice, garlic, and olive oil. Spread on bread or use as a vegetable dip.

STUFFED EGGPLANT For a satisfying main meal, slice an eggplant in half lengthwise, hollow out, and stuff with a mixture of healthy grains, such as quinoa, wild rice, or bulgur, and vegetables.

Toning, strengthening artichokes are best served simply. Cut away the spiky top and tough outer leaves, and boil or steam until just tender. Marinate in olive oil, lemon slices, parsley, freshly ground black pepper, and salt.

ARTICHOKE

 HELPS BALANCE BLOOD SUGAR LEVELS

 HELPS LOWER CHOLESTEROL

 AIDS THE DIGESTION OF FAT

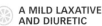 **A MILD LAXATIVE AND DIURETIC**

This edible member of the thistle family is among the top 10 highest **antioxidant-rich** foods. It is high in **dietary fiber**, and was traditionally eaten by the Greeks and Romans to maintain a **healthy gut**, promote **bowel regularity**, and **alleviate upset stomachs**. It also has a reputation for "cleaning the blood" by **detoxifying** the liver and gallbladder, reducing **cholesterol**, and balancing **blood sugars**.

Leaf
Stimulates the flow of bile and can ease constipation, diarrhea, and bloating

Heart
Contains inulin to keep blood sugar levels in balance

WHAT IS IT GOOD FOR?

BALANCES BLOOD SUGAR LEVELS The leaves and heart contain plant fibers including inulin (a prebiotic that feeds healthy gut flora), which helps maintain steady blood sugar levels.

REDUCES CHOLESTEROL The antioxidant flavonoid silymarin helps reduce "unhealthy" (LDL) cholesterol and raise "healthy" (HDL) cholesterol levels. It also protects the liver.

EASES INDIGESTION The leaves and hearts contain cynarine, a phytochemical that stimulates bile, helps digest fat, and prevents indigestion. May be particularly useful in cases of irritable bowel syndrome.

AIDS DETOXIFICATION A mild laxative and diuretic that supports kidney and liver health.

ENCOURAGES HEALTHY GUT Acts as a prebiotic food that encourages the growth of bifidobacteria in the gut.

HOW DO I GET THE BEST FROM IT?

LEAVES AND HEARTS Easy to digest, both leaves and hearts have similar nutritional and medicinal properties that benefit the liver.

MAKE A TEA Boil the fresh or dried leaves to make an antioxidant-rich, heart-healthy tea with a clean, slightly sweet taste.

HOW DO I USE IT?

CHOOSE SMALLER PRODUCE Look for smaller globes with dark, thick, fleshy leaves. Larger vegetables can be tough and tasteless.

HOW TO COOK IT Cook by boiling until tender. Dip the leaves into melted butter (or an olive oil and lemon dressing) and pull off the flesh at the base of the leaves with your teeth. Gently clear away the prickly thistle to reach the tender edible heart at the center.

MARINATED HEARTS Artichoke hearts marinated in healthy olive oil are delicious in salads, as part of a dip, or by themselves.

CORN

◉ **FIGHTS AGE-RELATED VISION LOSS** ◉ **HELPS REDUCE AN ENLARGED PROSTATE** ▤ **PROMOTES A HEALTHY DIGESTIVE TRACT**

Much corn is now genetically modified, and modern yellow varieties are bred for their high sugar content. However, heirloom varieties, particularly blue corn, have a **high nutritional value** that can balance **blood sugars**, boost **eye health**, soothe the **urinary tract**, and are available as organic and GM-free. Yellow corns contain more **beta-carotene**, while red and blue contain more **anthocyanins**.

WHAT IS IT GOOD FOR?

EYE HEALTH Carotenoids, such as zeaxanthin and lutein support eye health and prevent age-related macular degeneration.

PROSTATE HEALTH Partly due to its significant potassium content, corn silk can soothe urinary tract irritation, is a useful diuretic, and can treat an enlarged prostate.

DIGESTIVE HEALTH Corn contains soluble dietary fiber that regulates the flow of waste material through the digestive tract. Soluble fiber also helps to control blood sugar levels.

HOW DO I GET THE BEST FROM IT?

POPCORN Without added butter, sugar, and salt, popcorn is a great high-fiber, low-calorie food. Try using organic blue and multi-colored heirloom corn for extra benefits.

CORNMEAL Ground from dried corn, cornmeal is available in fine to coarse grades. Drying the corn improves the availability of B vitamins such as niacin, thiamine, pantothenic acid, and folate. Stoneground varieties are higher in nutrients and flavor.

EAT RAW OR LIGHTLY COOKED Add baby corn or raw kernels to salads or stir-fries.

HOW DO I USE IT?

MAKE A TEA Make a medicinal tea by steeping ¼ cup fresh corn silk in boiling water for 5 minutes. Strain and drink as a mild diuretic.

POLENTA Boil ground cornmeal in water or stock until thick. Let cool and firm up, and then bake in the oven at 350°F (180°C) or slice and broil it.

MAKE A CORN CHOWDER Strip the kernels from 6 cobs and simmer in boiling water until tender. Sauté some onions and garlic, put them in a blender with the kernels and some of the broth, and purée until smooth. Serve topped with fresh corn kernels and cilantro leaves.

Corn silk
The silky threads inside the husk are a useful diuretic and can relieve prostate enlargement

Fresh corn on the cob
Good source of skin- and eye-healthy beta-carotene and lutein

BLUE CORN
Contains 30 percent more protein than yellow corn. Beneficial antioxidants include protocatechuic acid (which gives green tea its healthy properties).

BABY CORN
Harvesting corn while young means the cob, with its beneficial soluble fiber, can be eaten.

ZUCCHINI

 HELPS MAINTAIN WATER BALANCE

 HELPS REDUCE AN ENLARGED PROSTATE

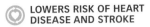 **LOWERS RISK OF HEART DISEASE AND STROKE**

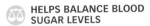 **HELPS BALANCE BLOOD SUGAR LEVELS**

Related to melons, cucumbers, and other squash, zucchini are a light, cleansing food. They contain a high volume of **water**, are **low in calories**, and can **ease prostate conditions** in men. Their **vitamin C** and potassium levels are higher than in other squash, and they also contain **beta-carotene**, phosphorus, and folate.

GREEN ZUCCHINI
Nutrients, such as folate and vitamin C, are concentrated in the skin.

Squash blossoms
The edible flower is high in folate and potassium

YELLOW SUMMER SQUASH
Particularly rich in antioxidant carotenes, such as lutein and zeaxanthin.

WHAT IS IT GOOD FOR?

DIURETIC AND LAXATIVE Phytonutrients in zucchini promote bowel regularity and aid water balance.

PROSTATE HEALTH Helps ease the symptoms of enlarged prostate, including frequent and painful urination, and increased risk of urinary tract infections (UTIs).

HEART HEALTH Contains magnesium, a mineral proven to reduce the risk of heart attack and stroke. Also contains folate, which breaks down homocysteine, a substance that raises the risk of heart attacks and stroke.

METABOLIC BALANCE Fiber, vitamin C, and beta-carotene help regulate blood sugar levels. Amounts of manganese can help the body metabolize protein and carbohydrates, digest fat, contribute to sex hormone production, and lower blood pressure.

HOW DO I GET THE BEST FROM IT?

EAT THE WHOLE PLANT From their skins to their seeds, zucchini and other summer squash are almost entirely edible. As cooling, sedative foods, they are useful for treating tired adrenals and frayed nerves. They can't be stored for long, so eat quickly while fresh.

EAT THE SKIN Important nutrients—including lutein and zeaxanthin, which promote healthy eyes—are concentrated in their skins.

JUICE THEM Their water content is highly mineralized and bioavailable (easily absorbed). Juice for a quick mineral boost.

HOW DO I USE IT?

TRY IT RAW Try adding julienne strips to your regular salad, or eat as crudités with dips.

STUFFED SQUASH Slice the squash in half lengthwise, remove the seeds, and fill with grains, lentils, and/or vegetables. Bake in the oven at 400°F (200°C), or until tender.

WINTER SQUASHES

 HELPS FIGHT INFLAMMATION

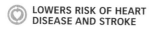 **LOWERS RISK OF HEART DISEASE AND STROKE**

 PROMOTES BOWEL REGULARITY

 SUPPORTS A HEALTHY PREGNANCY

Their bright orange flesh signals that all squashes have similar nutritional and medicinal benefits. They are good sources of healthy **carbohydrate**, **magnesium**, and antioxidant **carotenoids**, and are known to improve **cardiovascular health**, **digestion**, and benefit **pregnant women**. Unlike watery summer squashes, these squashes (which store well through winter) usually have tough rinds.

WHAT IS IT GOOD FOR?

HEALTHY CARBOHYDRATE About half its carbohydrate content is in the form of complex carbohydrates, or polysaccharides (including pectin). This makes it anti-inflammatory and antioxidant. It also has insulin-regulating properties.

CARDIOVASCULAR HEALTH Its wide range of nutrients, such as alpha- and beta-carotene, vitamin C, manganese, and magnesium, are all heart-healthy, helping protect against stroke and normalize blood pressure. Its folate content reduces homocysteine levels which, when too high, are a risk factor for heart disease.

BOWEL HEALTH Squashes are high in fiber, which promotes bowel regularity.

PREGNANCY Contains large amounts of folate, so it is a good food choice during pregnancy. While folate deficiency isn't the sole cause of birth defects, adequate levels of this B vitamin can help protect against neural tube defects.

HOW DO I GET THE BEST FROM IT?

SEEDS All squash seeds are edible and contain healthy fats, protein, and fiber. The seeds have long been used in traditional medicine for prostate and urinary problems, and their high-fat, low-carbohydrate content is useful for heart health.

EAT THE RIND Choose varieties with a thin rind, such as butternut. Cook with the rind on to make the most of the nutrients it contains.

BUY ORGANIC Squashes absorb heavy metals and other toxins from the soil, so buy organic.

HOW DO I USE IT?

ROASTED SEEDS Place rinsed seeds on a baking sheet. Bake for 15 minutes at 300°F (150°C) to preserve their beneficial fatty acids.

BAKED SQUASH Cube, toss in olive oil, season, and bake at 350°F (180°C) for 35–40 minutes.

BUTTERNUT SQUASH
This is a creamy squash with a thin, edible rind.

PUMPKIN
This squash is high in fiber and tastes sweeter than other varieties.

ACORN SQUASH
Small and round, this squash has a firm texture and slightly sweet taste.

CUCUMBERS

 DETERS ESTROGEN-BASED CANCERS

 HAS A DIURETIC ACTION

 PROMOTES A HEALTHY DIGESTIVE TRACT

 HELPS LOWER CHOLESTEROL

The watery composition of this member of the gourd family is packed with bioavailable (easily absorbed) **minerals**, **vitamins**, and **electrolytes**, making it an ideal way to increase your daily nutrients. Cucumber also contains **phytoestrogens** and digestive enzymes that **benefit the gut**. It is known for being a classic cooling food, helping to maintain the body's **water balance** on hot days.

CUCUMBERS
Keep the skin on to retain all the beneficial nutrients.

ENGLISH CUCUMBERS
Although 98 percent water, cucumber contains a highly available mix of vitamins and minerals.

WHAT IS IT GOOD FOR?

HELPFUL PHYTOESTROGENS Contains lariciresinol, secoisolariciresinol, and pinoresinol—three lignans (plant hormones) that help reduce the risk of cardiovascular disease and several types of cancer including breast, uterine, ovarian, and prostate.

MAINTAINS WATER BALANCE Its ability to balance water in the body makes cucumber important for heart and kidney problems. It also has a mild diuretic action and can help prevent constipation.

SUPPORTS URINARY FUNCTION The caffeic acid in cucumber helps prevent water retention. Other nutrients it contains help dissolve uric acid accumulations and can aid in the treatment of kidney and bladder stones.

PROMOTES A HEALTHY GUT Contains erepsin, a digestive enzyme that helps break down protein. It also acts as an antiparasitic and helps cleanse and tone the intestines.

LOWERS CHOLESTEROL Contains beneficial plant sterols that can help lower "unhealthy" (LDL) cholesterol levels.

HOW DO I GET THE BEST FROM IT?

EAT THE SEEDS The seeds have diuretic properties and so are worth consuming.

EAT THE SKIN The skin is a good source of silicon, chlorophyll, and bitter chemicals that aid digestion. It also contains the highest concentration of cholesterol-lowering sterols.

HOW DO I USE IT?

MAKE A COOLING DIP Grate a cucumber and mix with Greek yogurt, minced garlic, lemon juice, olive oil, and fresh mint for a tzatziki, or spices and natural yogurt for an Indian raita.

DRINK IT Juice with other vegetables, add slices to a cold pitcher of water, or brew the skin as a tea to ease swollen hands and feet.

Whichever jewel-colored chile variety you select, the heat and beneficial capsaicin is concentrated in the seeds and white membrane inside.

CHILES

 HELPS REMOVE TOXINS FROM THE BODY

 HELPS LOWER CHOLESTEROL

 CAN REDUCE APPETITE AND CRAVINGS

 HELPS CLEAR CONGESTION

The chile pepper, the hottest member of the capsicum family, is a fruit pod from the plant belonging to the nightshade family. Its volatile oils, particularly capsaicin, account for its strong, spicy, pungent character and **antioxidant** and **anti-inflammatory** effects, which give chile its **cholesterol-lowering**, **blood-sugar balancing**, and **appetite-suppressing** properties. Capsaicin can also aid **detoxification**.

Piri piri
Hot

FRESH CHILES
Some varieties are hotter than others, but the heat can vary enormously even between peppers of the same variety.

Jalapeño
Mild

Scotch bonnet
Super hot

DRIED CHILES
The dried seeds and flakes make a useful seasoning. The seeds contain the highest amounts of capsaicin.

CAYENNE POWDER
Unlike standard chili powder, which can be a mixture of spices, ground cayenne comprises pure hot chiles.

WHAT IS IT GOOD FOR?

DETOX The heat in capsaicin can help remove toxins by promoting increased sweating.

KEEPS ARTERIES CLEAR Studies show that capsaicin can help reduce "unhealthy" (LDL) cholesterol levels in obese individuals.

WEIGHT MANAGEMENT Hot chiles in quantities normally used for seasoning can stimulate digestion, reduce hunger and cravings, and boost metabolism.

CLEARS CONGESTION Hot chiles increase mucus secretion in the lungs and nose.

ANTIDIABETIC There is evidence that hot chiles can help regulate blood sugar levels.

HOW DO I GET THE BEST FROM IT?

AS HOT AS YOU DARE For an occasional spicy meal, use the hottest chiles you can tolerate to get the most from their capsaicin content.

DRIED SEEDS Most of us throw the seeds away, yet they contain the most capsaicin. Dry the seeds, combine with seasonings, such as salt and garlic, and grind to a coarse powder to add a quick zing to any savory dish.

CONTROL THE HEAT The heat of fresh chiles can vary. If you want to control how much heat you include in a dish, try using dried hot cayenne or milder chili powder blends instead, which are still rich in capsaicin.

HOW DO I USE IT?

AS A THERAPY FOR COLDS Add chile pepper and garlic to chicken soup as a therapeutic meal for colds, sinusitis, and bronchitis.

AS A MEDICINAL KICK IN DISHES Add chili and cayenne powders to salsas, chutneys, marinades, and rubs for an additional kick.

PICK THE FRESHEST PRODUCE Choose fresh chiles with bright, deep colors and glossy, firm, taut skins. Buy only as many as you need and use them up quickly.

SWEET PEPPERS

 PROMOTES COLLAGEN SYNTHESIS

 HELPS PROTECT AGAINST CATARACTS

 MAINTAINS HEALTHY BLOOD VESSELS

 CONTAINS ANTICANCER SUBSTANCES

Part of the nightshade family, which includes tomatoes, potatoes, and eggplant, peppers are rich in **antioxidants** to benefit **heart** and **eye health**. Their vitamin C content boosts **collagen** levels and they may also help to prevent **lung cancer**. They don't contain the beneficial compound capsaicin found in chiles, but weight-for-weight they contain more essential nutrients, because you can eat more of them.

WHAT IS IT GOOD FOR?

SKIN AND BONES Contains vitamin C, necessary for the synthesis of collagen, the main structural protein in the body that maintains the integrity of blood vessels, skin, and bones.

EYE HEALTH Possibly due to a combination of beta-carotene, vitamin C, lutein, and zeaxanthin, peppers have been shown to be protective against cataracts and age-related macular degeneration (loss of vision).

HEART HEALTH Antioxidant levels, including beta-carotene, capsanthin, quercetin, and luteolin, may vary between varieties, but all have been shown to prevent the oxidization of cholesterol, the cause of free-radical damage to the heart and blood vessels. Diets high in antioxidants can also help prevent blood clot formation and reduce the risk of stroke.

LUNG CANCER Beta-cryptoxanthin, found mostly in red peppers, may help prevent lung cancer in those at risk.

HOW DO I GET THE BEST FROM IT?

RED BENEFITS Red peppers have significantly higher nutrient levels than green, including lycopene, which helps to protect against cancer of the prostate, cervix, bladder, and pancreas, and lowers the risk of heart disease.

COOK THE RIGHT COLOR Cooking lowers vitamin C levels in green peppers, but increases their beta-carotene content; in red peppers it increases vitamin C levels and lowers its beta-carotene. Yellow peppers are high in vitamin C, so may be the best choice if you want more of this vitamin, but overall, cooked red peppers are more nutritious.

HOW DO I USE IT?

EAT RAW Slice and use as crudités with dips or salsas, or simply add to fresh salads.

STUFFED PEPPERS Fill with rice, mushrooms, other vegetables, and fresh herbs.

GREEN PEPPERS
This immature fruit eventually ripens to a bright red color. Even at this stage, it contains twice as much vitamin C as an orange.

RED PEPPERS
Red peppers, including romano peppers, offer superior quantities of nutrients and antioxidants to other colored peppers.

YELLOW PEPPERS
Yellow and red peppers contain 3 times as much vitamin C as an orange.

HORSERADISH

 ANTIBIOTIC AND ANTIBACTERIAL

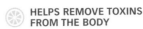 **HELPS REMOVE TOXINS FROM THE BODY**

 HAS A DIURETIC ACTION **HELPS CLEAR CONGESTION**

This pungent root contains an array of nutrients in small amounts, but its volatile oils are responsible for the **medicinal** effects of horseradish. Its potent oil, allyl isothiocyanate, boosts **metabolism** and gives it **antibiotic** and **antibacterial** properties against food-borne pathogens. This is why, in the days before refrigeration, horseradish was eaten with fish or meats as a kind of insurance policy.

HORSERADISH ROOT
Its volatile oils can fight food-borne pathogens, such as *listeria* and *E. coli.*

HORSERADISH LEAVES
The young leaves, which can be eaten raw, contain oils that aid digestion.

WASABI
Sometimes called Japanese horseradish, wasabi is not true horseradish but a root with similar properties.

WHAT IS IT GOOD FOR?

ANTIBIOTIC AND INSECTICIDAL Laboratory tests have shown horseradish to be active against a variety of harmful bacteria, such as *listeria*, *E. coli*, and *staphylococcus*. Allyl isothiocyanate is also effective against intestinal worms.

DETOX As a stimulating food it can aid digestion, boost circulation, and help lower fevers by promoting perspiration.

BENEFITS THE URINARY SYSTEM Traditionally, it has been used to help treat water retention, urinary infections, and kidney stones.

COMBATS SINUS INFECTIONS Stimulates the flow of mucus, and opens and cleanses the sinuses in much the same way as chile peppers. Try taking horseradish at the first signs of cold, flu, or coughs.

HOW DO I GET THE BEST FROM IT?

FRESH AND RAW If grated and left to stand too long, or cooked for long periods, it loses its potency, so eat horseradish fresh and raw.

EAT THE LEAVES The small tender leaves have a pleasant flavor with just enough "bite" to lift an everyday salad. The older leaves can be cooked and used as you would spinach or kale.

SERVE WITH VEGETABLES Studies show that serving vegetables, such as broccoli, with a little horseradish or wasabi can increase the amount of nutrients absorbed by the body.

HOW DO I USE IT?

ADD TO CONDIMENTS Freshly grated, it mixes well with mayonnaise, sour cream, yogurt, or cream cheese with fresh herbs and seasoning.

FOR HOARSENESS Infuse 2 tbsp grated horseradish root and 1 tbsp apple cider vinegar in ⅓ cup boiling water for 1 hour. Strain and add 1¼ cups honey. Take 1 tbsp hourly until the condition eases.

KALE

 HELPS STRENGTHEN BONES

 HELPS FIGHT INFLAMMATION

 HELPS LOWER CHOLESTEROL

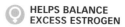 **HELPS BALANCE EXCESS ESTROGEN**

Science has revealed kale to be rich in beta-carotene, **vitamins C** and **K**, and **folate**, causing its popularity to grow in recent years. It is an exceptional source of **chlorophyll**, and its calcium and iron content are highly bioavailable (easily absorbed). It helps balance **hormones** and lower **cholesterol**, and its **antioxidants** and omega-3 fatty acids give kale strong **anti-inflammatory** properties.

WHAT IS IT GOOD FOR?

BONE BUILDING Its high calcium, magnesium, and vitamin K content helps strengthen bones, benefitting those with osteoporosis.

ANTIOXIDANT BOOST Contains multiple antioxidants, including kaempferol and quercetin, which are responsible for anti-inflammatory benefits in diseases, such as diabetes, arthritis, stroke, and heart disease.

LOWERS CHOLESTEROL Its fiber binds with cholesterol to remove it from the blood, lowering the risk of heart disease and stroke.

HORMONE BALANCING Contains indoles, natural substances that boost DNA repair and have an antiestrogen effect that can protect against and arrest the spread of estrogen-dependent cancers, such as breast cancer.

HEALING ULCERS The juice is rich in sulfur, which can aid the healing of stomach and duodenal ulcers.

DIGESTIVE STIMULANT Its bitter flavor aids digestion and eases lung congestion.

HOW DO I GET THE BEST FROM IT?

ADD LEMON Serving kale with a lemon dressing or another acidic citrus fruit as part of a meal boosts the absorption of its iron and calcium content.

COOK BRIEFLY The less you cook kale, the more nutrients you retain. Cooking lightly also leaves the plant's cholesterol-lowering properties intact.

HOW DO I USE IT?

ADD TO JUICES Blend kale juice with spicy ginger and apple juice, or try a cleansing mixture of celery, kale, and coconut water.

KALE PESTO Replace the basil and pine nuts in a pesto recipe with 1lb (450g) kale leaves, ribs removed, and 2½ cups toasted walnuts. Add to soups, stews, hot pasta, or dressings.

CURLY KALE
The antioxidants kaempferol and quercetin, which help fight inflammation, top the list of kale's beneficial properties.

CAVOLO NERO
This deep blue-green variety is rich in chlorophyll and folate.

PURPLE KALE
Purple varieties contain more anthocyanins—antioxidant red pigments—than green.

CABBAGE

 HELPS HEAL ULCERS

 SUPPORTS HEALTHY LIVER FUNCTION

 FIGHTS FREE-RADICAL DAMAGE TO SKIN

Many people don't consider cabbage a "love to eat" vegetable nowadays, but before we lost the habit of eating bitter foods it was revered as a warming, calming, **balancing**, and grounding food. It is now known to **clear the blood**, boost **skin health**, and is a remarkable remedy for **ulcers**. Its bitterness stimulates gastric juices to digest food more effectively, and it is also a mild **diuretic**.

GREEN CABBAGE
Contains a broad spectrum of nutrients including vitamin U—a potent ulcer remedy.

RED CABBAGE
Contains 2–8 times more vitamin C than other cabbages, and is rich in additional antioxidant anthocyanins.

BRUSSELS SPROUTS
These sprouts are higher in anticancer glucosinolates than other cabbages.

BOK CHOY
A good source of beta-carotene and vitamins C and B₆.

WHAT IS IT GOOD FOR?

HEALS ULCERS Contains ample amounts of vitamin U, or S-methylmethionine. Vitamin U heals stomach and duodenal ulcers quickly.

SUPPORTS LIVER FUNCTION It stimulates the production of glutathione, the body's most important internally produced antioxidant, which plays a role in liver detoxification.

HEALTHY SKIN Contains vitamins C and K, and antioxidants that protect skin from free-radical damage. Its sulfur content may be useful in healing acne and eczema.

ANTIPARASITIC Its high sulfur content helps maintain a gut free from parasites. It is also fiber-rich and promotes bowel regularity.

HOW DO I GET THE BEST FROM IT?

COOK IT LIGHTLY Cabbage retains more of its nutritional and medicinal benefits if lightly cooked or eaten raw.

TRY BOK CHOY Lighter in texture and taste, bok choy is also rich in vitamins A, B₆, and C, beta-carotene, calcium, potassium, and fiber.

GET COLORFUL Purple cabbage has more vitamin C and antioxidant anthocyanins, which help lower the risk of heart disease, diabetes, and certain types of cancer.

USE THE OUTER LEAVES The outer leaves have more vitamin E and contain about 30 percent more calcium than the inner leaves.

HOW DO I USE IT?

WRAPS The large leaves make ideal wraps. Use like tortillas and fill with ingredients, such as rice, beans, and different vegetables.

JUICE IT The juice is especially good for skin and ulcers. If you find the taste too strong, try mixing it with celery juice.

FERMENT IT Eating sauerkraut is a great way to cleanse the digestive tract and encourage healthy gut flora.

BROCCOLI

 PROMOTES PROSTATE HEALTH

 PROMOTES COLLAGEN SYNTHESIS

 HELPS STRENGTHEN THE IMMUNE SYSTEM

HELPS PROTECT EYE HEALTH

This cruciferous vegetable has been widely studied for its medicinal properties, which include antibacterial and **immunity-boosting** activities. It is rich in **vitamin C** and **fiber** and has the highest level of **carotenoids**—particularly eye-healthy lutein—of all brassicas. It is also an excellent source of indole-3-carbinol, a chemical that boosts **DNA repair** in cells and appears to block the growth of cancer cells.

WHAT IS IT GOOD FOR?

PROSTATE HEALTH Diets high in broccoli are associated with a lower risk of aggressive prostate cancer.

SKIN FOOD Contains abundant pantothenic acid, beta-carotene, and sulfur compounds, all of which encourage great skin. It is also rich in vitamin C, which aids the formation of collagen and helps to repair damaged tissue.

IMMUNITY BOOST Higher in vitamin C than many citrus fruits, and rich in beta-carotene antioxidants, broccoli is an ideal food to eat to maintain a healthy immune system.

EYE HEALTH Has a useful amount of lutein, an antioxidant that promotes eye health and may also benefit the heart and circulation.

HOW DO I GET THE BEST FROM IT?

STEAM IT Eat raw or steam lightly to retain its vitamin C, iron, and chlorophyll content.

TRY A CHANGE OF COLOR Purple sprouting broccoli generally contains more antioxidants and more of the phytochemical sulforaphane, which gives broccoli its detoxifying and anticancer reputation.

SPROUT THE SEEDS The sprouts are lower in nutrients than the vegetable, but higher in sulforaphane, thought to help prevent cancer.

HOW DO I USE IT?

HEART-HEALTHY MEAL Stir-fry with soba (buckwheat) noodles. The rutin content of buckwheat, the vitamin C in broccoli, and the healthy fats in olive oil together can lower cholesterol levels.

SALAD BOOSTER The raw leaves and sprouts can add a serious nutritional boost to salads.

ADD TOMATOES Eating broccoli together with tomatoes can slow the growth of prostate cancer more effectively than eating either vegetable on its own.

PURPLE BROCCOLI RABE
Contains more antioxidants than green varieties, but is more prone to nutrient loss when cooked.

GREEN BROCCOLI
Higher in vitamin C than many citrus fruits.

BROCCOLI SPROUTS
Higher than mature broccoli in the anticancer antioxidant sulforaphane.

Leaves
These contain more beta-carotene than the flower or stalks

AVOCADO

 HELPS KEEP JOINTS SUPPLE

 HELPS LOWER BLOOD PRESSURE

 HELPS IMPROVE FERTILITY

The avocado has the distinction of being the fruit with the highest fat content. This may sound unhealthy, but its **beneficial monounsaturated oils**, which can lower blood pressure and lubricate joints, have earned it the title "the olive oil of the Americas." The flesh and oil contain **antioxidants** and are **anti-inflammatory**, helping to lower the risk of diseases, such as **arthritis,** and boost women's fertility.

AVOCADO
The flesh contains a favorable balance of potassium and sodium that can help lower blood pressure.

AVOCADO OIL
The oil is pressed from the flesh of the avocado, not the seed, and is known for its ability to protect the heart and fight free-radical damage.

WHAT IS IT GOOD FOR?

ANTI-INFLAMMATORY The fats of this fruit are unique. They include phytosterols, plant hormones, such as campesterol, beta-sitosterol, and stigmasterol, that help to keep inflammation under control. It also contains polyhydroxylated fatty alcohols (PFAs), which are anti-inflammatory. Also a source of omega-3 fatty acids, which help lubricate joints and reduce arthritic symptoms.

LOWERING BLOOD PRESSURE A good source of potassium and low in sodium. As a result, it can reduce the risk of high blood pressure and stroke. Also very rich in antioxidants and monounsaturated fats, which offer protection from heart disease and stroke.

FERTILITY BOOST The healthy fats have been shown to dramatically boost fertility and increase the success of IVF treatment.

HOW DO I GET THE BEST FROM IT?

PEEL WITH CARE The majority of the avocado's nutrients concentrate in the dark green flesh near the skin. Quick or careless peeling means you lose these benefits. Cut the fruit lengthwise into quarters and peel off the skin in sections as you would a banana.

A RICH OIL The oil makes an excellent base for salad dressings and marinades, and can be used in sautés and as a dipping oil.

HOW DO I USE IT?

A COLORFUL SALAD Add avocado to a salad to increase the absorption of key fat-soluble antioxidants, such as lycopene and beta-carotene, in the other vegetables.

GUACAMOLE This classic Mexican dip is quick and easy to make, and is also great as a healthy accompaniment to fish dishes. Mash 1 avocado, a couple of diced tomatoes, and a squeeze of lime juice into a paste, and add chopped fresh cilantro to taste.

COCONUT

 FIGHTS BACTERIA, VIRUSES, AND FUNGI

 ENHANCES METABOLISM

 PROVIDES ENERGY FOR THE BRAIN

 INCREASES "HEALTHY" (HDL) CHOLESTEROL

We may think of coconut as a nut, but it is a fruit, or drupe, similar to peaches and plums. It is native to the Indo-Pacific region, where it is called the "tree of life." Its medicinal properties, which benefit, among others, the heart, brain, and stomach, stem from its unique **healthy fat content**, antibacterial effects, and **balance of sugar**, **dietary fiber**, proteins, antioxidants, **vitamins**, and minerals.

WHAT IS IT GOOD FOR?

A NATURAL ANTIBIOTIC Lauric acid—a fatty acid in coconuts—helps the body combat a wide spectrum of bacteria and viruses that cause colds, flu, herpes, gum disease, ulcers, and urinary tract infections, among others. The fruit also contains caprylic acid, found to be a potent antifungal that can fight disorders, such as candidiasis, thrush, and athlete's foot.

METABOLIC BALANCE The oil is high in medium-chain triglycerides (MCTs), healthy fats that help lower the risk of heart disease. MCTs can help with weight management by reducing appetite, boosting metabolism, and increasing the activity of fat-burning cells.

FEEDING THE BRAIN Studies show that the brains of Alzheimer's sufferers can utilize the ketones produced when MCTs are metabolized as an alternative energy source. This may help ameliorate some symptoms of the disease.

IMPROVING CHOLESTEROL RATIOS MCTs increase "healthy" (HDL) cholesterol without raising "unhealthy" (LDL) cholesterol levels.

HOW DO I GET THE BEST FROM IT?

CHOOSE THE RIGHT OIL Virgin coconut oil is not chemically treated (refined, bleached, and deodorized), so MCT content remains intact.

IN YOUR COOKING Coconut oil is very heat stable so use for roasts and in savory dishes.

HOW DO I USE IT?

AN ALTERNATIVE TO SPORTS DRINKS Hydrating coconut water from the immature fruit is a superior drink for restoring electrolyte balance during and after sports.

NOURISHING SALAD DRESSING Coconut oil, which is solid at room temperature, enhances the absorption of fat-soluble nutrients, such as carotenoids. Blend with other more "liquid" ingredients, such as vinegar, honey, or thinner oils, to make an excellent dressing.

COCONUT FRUIT
Contains less fat than many seeds and nuts, such as almonds, and less sugar and more protein than popular fruits, such as bananas, apples, and oranges.

Coconut water
A pure and perfect balance of electrolytes, it was given intravenously to soldiers during the Second World War when regular IV saline solution ran out

COCONUT OIL
Coconut oil is high in healthy fats that help lower the risk of heart disease.

COCONUT MILK
Coconut milk, obtained primarily by extracting the juice from the white kernel, is rich in beneficial fats.

PINEAPPLE

 EASES SYMPTOMS OF INFLAMMATORY BOWEL

 ENHANCES SPERM QUALITY

 SPEEDS RECOVERY FROM SPORTS INJURIES

Thirst-quenching and cooling, pineapple is a good source of **manganese**, which can boost men's fertility, and contains significant amounts of **vitamin C**. The core contains the proteolytic enzyme bromelain, a powerful **anti-inflammatory** used to treat bowel and joint problems. Its anti-inflammatory and **astringent** quality makes it a good choice for **treating sore throats**.

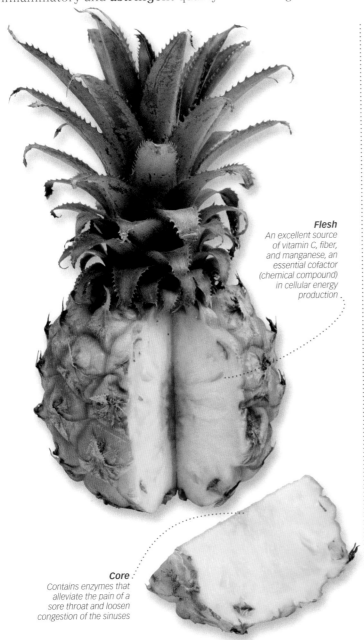

Flesh
An excellent source of vitamin C, fiber, and manganese, an essential cofactor (chemical compound) in cellular energy production

Core
Contains enzymes that alleviate the pain of a sore throat and loosen congestion of the sinuses

WHAT IS IT GOOD FOR?

INFLAMMATORY BOWEL The juice can ease the symptoms of colitis, an inflammatory bowel condition marked by abdominal pain and bloating, diarrhea, wind, and dehydration. Most bromelain is concentrated in the core and stem. However, researchers have found that the juice provides enough of the enzyme to have a medicinal effect.

MEN'S FERTILITY Its high manganese content helps restore vitality and can help boost fertility by improving sperm motility.

STAYING FLEXIBLE Bromelain has shown promise in treating and preventing inflammatory conditions, such as arthritis, and may facilitate recovery after sports injuries.

DIGESTION Bromelain extract is an effective digestive aid, while using the juice as a marinade for meat dishes helps tenderize them, making them more easily digestible.

HOW DO I GET THE BEST FROM IT?

FRESH IS BEST The nutrients and enzymes disappear quickly once cut or cooked. When ripe, almost to the point of spoilage, the fruit's antioxidant levels are at their highest.

EAT THE CORE Bromelain concentrates in the fibrous core of the fruit.

JUICE IT The juice can help lower fever, ease sore throats, and acts as a natural expectorant.

HOW DO I USE IT?

A TANGY SORBET Juice 1 large pineapple, pour 1 cup into a large pan, and add ⅔ cup superfine sugar. Boil to a syrup. Allow to cool. Add the pineapple pulp from the juicer and the juice of 3 large oranges. Pour into a plastic container. Freeze, removing it occasionally to give the sorbet a stir.

SALSA Dice and combine pineapple, chile, red onion, garlic, fresh cilantro, and lime juice.

*A **drizzle of** pomegranate molasses brings a tangy, sweet-sour flavor and an antioxidant boost to a simple salad dressing of olive oil, lemon, and black pepper.*

POMEGRANATE

 REDUCES THE RISK OF PROSTATE CANCER

 HELPS KEEP BLOOD VESSELS SUPPLE

 BLOCKS ENZYMES THAT DESTROY CARTILAGE

 PROVIDES ANTIVIRAL PROTECTION

Native to modern-day Iran and Iraq, pomegranate has been used as a folk medicine for thousands of years. The juice contains substances that support a **healthy prostate** and **antioxidants** to maintain the elasticity of the **arteries**. All parts of the plant are used as medicine in the Ayurvedic traditions; in the West, the arils (seeds) and their juice are most valued for their **antiviral** and **antibacterial** properties.

Seeds
Oil from the seeds contains isoflavones similar to those found in soy

Rind
Pomegranate rind is used in many medicinal traditions for making teas and gargles. Recent studies show it contains chemicals that are antibiotic and have cancer-fighting properties

WHAT IS IT GOOD FOR?

MEN'S HEALTH Drinking a glass of the juice every day has been shown to lower levels of prostate-specific antigen (PSA) in men. (The higher a man's PSA level is, the greater his risk of death from prostate cancer.)

HEART PROTECTIVE Its polyphenol compounds keep arteries elastic and so help lower blood pressure and the risk of heart disease and stroke. It also stops free radicals from oxidizing "unhealthy" (LDL) cholesterol in the blood and causing plaque to build up on artery walls (atherosclerosis).

JOINT HEALTH Antioxidant flavonols have been shown to significantly reduce the activity of proteins that cause inflammatory conditions, such as arthritis. Preliminary studies show that pomegranate extract (equivalent to one glass of juice) can block the production of an enzyme that destroys cartilage in the body.

FIGHTS INFECTION The juice has antiviral properties, and studies show that extracts of the fruit are effective against dental plaque.

HOW DO I GET THE BEST FROM IT?

EAT THE SEEDS The fruit is a high-fiber food, but only if you eat the seeds, which also contain unsaturated fats, beneficial isoflavones (plant hormones similar to those found in soy), and other micronutrients.

POMEGRANATE MOLASSES This concentrated form of the syrup contains all the nutritional values of pomegranate.

HOW DO I USE IT?

AS A "VINEGAR" Pomegranate molasses is a delicious substitute for balsamic vinegar in dressings, marinades, and glazes.

SUPERFRUIT SALAD Combine pomegranate seeds with pear, pineapple, and orange segments, chopped fresh mint, and lettuce. Drizzle with a honey-sweetened dressing.

PAPAYA

 CONTAINS NATURAL DIGESTIVE ENZYMES

 HELPS FIGHT INFECTIONS

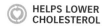 **HELPS LOWER CHOLESTEROL**

REDUCES CATARACT AND GLAUCOMA RISK

Also called paw paw or tree melon, papaya has become a commercial crop that is now widely available. It is known to have **antibacterial** properties and promotes good **digestion**, and almost every part of the plant can be used. In the West, we tend to focus only on its brightly colored orange flesh, which is a good source of **antioxidant** carotenoids, such as **beta-carotene**, that protect **eyesight**.

WHAT IS IT GOOD FOR?

DIGESTION Contains the enzymes papain and chymonpapain. Both have been shown to aid digestion, prevent constipation, and, in combination with the fruit's natural fiber, cleanse the colon. Papain is also helpful in healing and preventing stomach ulcers.

FIGHTS "BUGS" The seeds are effective against salmonella, *E. coli*, and staphylococcus infections. They can be used to support liver function and have an antiparasitic function, which helps rid the body of intestinal parasites.

HEALTHY FIBER Its natural fiber helps control blood pressure and regulate levels of "unhealthy" (LDL) cholesterol in the blood. Its dietary fiber is also important in preventing diseases, such as bowel cancer.

EYE HEALTH The beta-carotene and vitamins C and E in papaya help reduce the risk of cataracts, glaucoma, and age-related macular degeneration (loss of vision).

HOW DO I GET THE BEST FROM IT?

DON'T THROW THE SEEDS AWAY The seeds are edible either fresh or dried. They have a peppery flavor and can be used in cooking.

JUICE IT Papaya juice helps restore the good bacteria in the stomach, which is especially important after an illness or taking antibiotics.

GO GREEN Papain, a beneficial digestive enzyme, is found in greatest abundance in green, unripe papayas.

HOW DO I USE IT?

MAKE A CHUTNEY To benefit from the high concentration of papain in unripe papaya, make a spicy chutney for meats and cheeses.

SHRIMP AND PAPAYA Arrange cooked large shrimp and papaya slices on a bed of lettuce. Drizzle with a dressing of walnut oil, lime juice, Dijon mustard, honey, salt, and pepper.

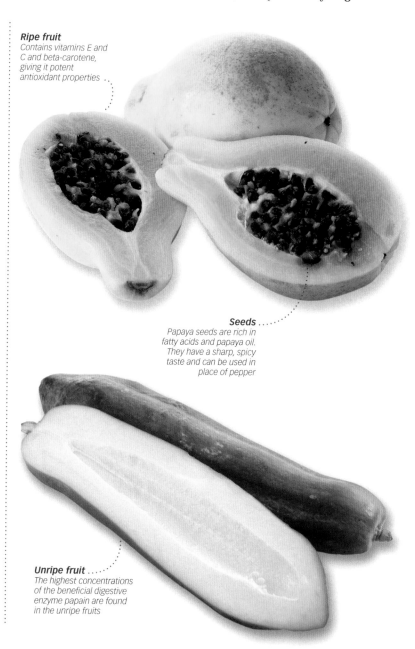

Ripe fruit
Contains vitamins E and C and beta-carotene, giving it potent antioxidant properties

Seeds
Papaya seeds are rich in fatty acids and papaya oil. They have a sharp, spicy taste and can be used in place of pepper

Unripe fruit
The highest concentrations of the beneficial digestive enzyme papain are found in the unripe fruits

MELONS

⊙ **HELPS PROTECT EYE HEALTH**

♡ **HELPS KEEP BLOOD VESSELS SUPPLE**

✋ **HELPS SPEED WOUND HEALING**

Aromatic melons are, perhaps surprisingly, members of the gourd family, which includes cucumber and squash. They were first cultivated in Persia and northern Africa nearly 4,000 years ago, and later by ancient Greeks and Romans. Rich in **beta-carotene**, **vitamin C**, and assorted **antioxidants**, they are good for **immune support**. They also contain potassium, which normalizes **blood pressure**.

HONEYDEW
It has the highest sugar content of any melon, but also contains vitamin C, folate, and potassium.

WATERMELON
Red-fleshed watermelon is a rich source of the plant pigment lycopene, which helps lower the risk of heart disease.

CANTALOUPE
This is the most nutrient-dense melon: a single serving provides around half your daily vitamin C and A needs.

WHAT IS IT GOOD FOR?

EYESIGHT Melons derive their bright color from the antioxidant beta-carotene, important for skin and bone health and for preventing age-related macular degeneration (loss of vision). Cantaloupes also contain lutein and zeaxanthin, which are good for eye health.

BLOOD FLOW Citrulline, an amino acid in the rind and flesh of watermelon, can stimulate the production of nitric oxide, which relaxes and expands blood vessels, lowering blood pressure and enhancing blood flow.

BLOOD PRESSURE Contains a useful amount of potassium, a natural diuretic that helps to normalize blood pressure. Watermelons are rich in lycopene, which helps lower the risk of heart disease.

WOUND HEALING The citrulline in watermelon plays a role in the production of the amino acid arginine, which boosts immune function and speeds wound healing.

HOW DO I GET THE BEST FROM IT?

DETOX Melons are an excellent food for light detox days. Their water content (around 95 percent) is highly mineralized, and has an alkalizing and diuretic effect.

GENTLE ON YOUR TUMMY Easy to digest, it also provides useful carbohydrates for energy.

EAT THE SEEDS The dried seeds contain healthy unsaturated fats and fiber, and make a nutritious addition to savory dishes.

HOW DO I USE IT?

SPICE UP YOUR CANTALOUPE Sprinkle a little freshly ground black pepper onto cantaloupe slices to enhance their flavor.

RAINBOW SALAD Slice watermelon, kiwi, and soft goat cheese into cubes, serve on bed of arugula or watercress, dress with balsamic vinegar, and scatter with sesame seeds.

MANGOES

 FEEDS GOOD BACTERIA IN THE GUT

 CONTAINS ANTICANCER SUBSTANCES

 HELPS PROTECT EYE HEALTH

 PROTECTS AGAINST COLDS AND FLU

Throughout Asia, the mango has both spiritual and medicinal significance. It is the national fruit of India, Pakistan, and the Philippines, and the national tree of Bangladesh. Mangoes are high in the antioxidants **beta-carotene** and **vitamin C**, and so are good for boosting the **immune system**, protecting **eyesight**, and aiding **digestion**. They also help neutralize **free-radical damage** in the body.

WHAT IS IT GOOD FOR?

DIGESTION Contains enzymes that aid the breakdown and digestion of protein, and also fiber, which keeps the digestive tract working efficiently. Dietary fiber has more long-term benefits as well, lowering the risk of developing colon cancer, heart disease, type-2 diabetes, and diverticular disease.

ANTICANCER EFFECTS Laboratory tests show the triterpene compound, lupeol, a kind of plant hormone found in mangoes, is effective against both prostate and skin cancers.

EYE HEALTH Rich in beta-carotene, a powerful antioxidant that helps reduce the effects of free-radical damage in the body, including the skin and eyes. It also helps prevent age-related macular degeneration (loss of vision).

IMMUNITY An average-sized mango contains up to two-thirds of the daily recommended intake of vitamin C, which plays a key role in boosting the immune system and so helps reduce the incidence of colds and flu.

HOW DO I GET THE BEST FROM IT?

KEEP IT FRESH Eat as fresh as possible. Mangoes bruise easily, so unless you are using them immediately, buy hard fruits and let them ripen at home. When you can't find fresh, dried mango is a good substitute.

ADD DAIRY Studies suggest the bioavailability of beta-carotene in the fruit improves by 19–38 percent if combined with a little dairy.

HOW DO I USE IT?

QUICK MANGO SMOOTHIE Blend 2 peeled, chopped mangoes, 1 cup cold milk or yogurt, and 1½ tbsp honey, until smooth.

MANGO SALSA Dice and mix 1 ripe mango, ½ red onion, ½ sweet red bell pepper, 1 small cucumber, 1 small finely chopped jalapeño chile, and 3 tbsp each lime juice and chopped fresh cilantro. Season and serve with fish.

Mango flesh
Contains prebiotic dietary fiber, which helps feed good bacteria in the gut

Green mango
In Southeast Asia, green mango is used shredded in salads. Green mangoes have more vitamin C and more pectin than ripe mangoes, but have a very sour taste

DATES

 PROMOTES BOWEL REGULARITY

 CONTAINS SLOW-RELEASE SUGARS

HELPS MAINTAIN A REGULAR HEARTBEAT

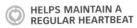 **SOOTHES COUGHS AND SORE THROATS**

The date palm, one of the oldest trees cultivated by man, has its origins in the desert around the Persian Gulf. **Immunity-boosting** dates are high in **potassium**, supply **slow-release sugars**, and provide a range of other **essential nutrients**, for example, they are a **good source of fiber**, **protein**, **minerals** including magnesium, manganese, selenium, and zinc, and trace elements, such as boron.

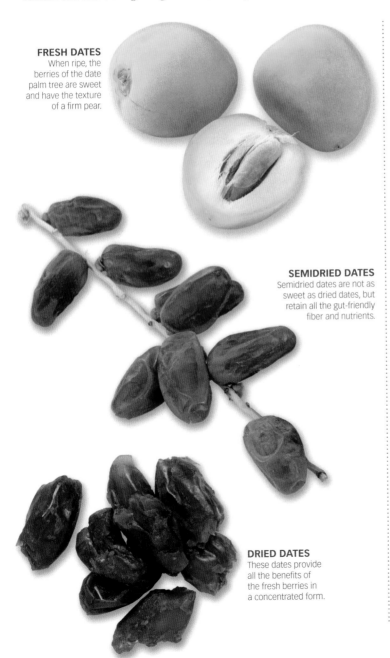

FRESH DATES
When ripe, the berries of the date palm tree are sweet and have the texture of a firm pear.

SEMIDRIED DATES
Semidried dates are not as sweet as dried dates, but retain all the gut-friendly fiber and nutrients.

DRIED DATES
These dates provide all the benefits of the fresh berries in a concentrated form.

WHAT IS IT GOOD FOR?

SUPPORTING DIGESTION A great source of soluble and insoluble fiber, aiding digestion and promoting bowel regularity. Also contains tannins, which have an astringent quality that is useful for treating stomach upsets and intestinal troubles.

BALANCING BLOOD SUGAR High in sugar, dates still defy the dogma that all sugar is bad. Their sugar is released slowly, so they benefit blood sugar control. Their soluble fiber content also aids blood glucose regulation.

HEART HEALTHY A very good source of potassium, an essential mineral that maintains proper muscle contractions, including those of the heart. Potassium also promotes a healthy nervous system and efficient metabolism by the body. The soluble fiber in dates also helps to lower "unhealthy" (LDL) cholesterol levels in blood.

COLDS AND FLU As an infusion, extract, syrup, or paste, dates are a traditional remedy for sore throats, colds, and bronchial catarrh.

HOW DO I GET THE BEST FROM IT?

DRIED The drying process concentrates all the nutrients so just a few dates will supply good amounts of nutrients and fiber. Look for dates that have not been treated with sulfites.

FRESH Fresh dates are usually only available for a few weeks in late summer, often from specialty supermarkets. They contain much more vitamin C than the dried fruit.

HOW DO I USE IT?

IN CEREALS AND BREADS Adding chopped dates to granola makes a great healthy breakfast. Dates are also a staple ingredient of sweet loaves, such as date and nut bread.

A SWEET SUBSTITUTE Dates are a delicious, sweet yet healthy snack, and can be eaten as a replacement for candy or chocolate.

BANANAS

 HELPS STRENGTHEN BONES

 PROTECTS AGAINST ULCERS

 CONTAINS SLOW-RELEASE SUGARS

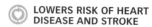 **LOWERS RISK OF HEART DISEASE AND STROKE**

Bananas are an extremely versatile and healthy fruit. They are **rich in potassium**, which is essential for **maintaining blood pressure** at healthy levels, and are **natural antacids**, which makes them a soothing and healing choice for **upset stomachs** and **ulcers**. The ripe fruit consists of nearly 90 percent natural **slow-release sugars**—ideal for athletes and busy people alike.

WHAT IS IT GOOD FOR?

BONE HEALTH Its potassium content slows the urinary calcium loss associated with a modern diet that is high in salt. Also contains prebiotic compounds that feed good bacteria in the gut. A healthy gut increases the body's ability to absorb key nutrients such as calcium, which is crucial for bone health.

SOOTHING THE STOMACH Has antacid effects that protect the stomach from ulcers. Also helps activate cells that build the stomach lining, and eliminates the bacteria that cause stomach ulcers. These antacid effects are also good for easing heartburn.

ENERGY BOOSTER The fruit contains both quick-release glucose and slow-release fructose, so it supplies energy in 2 ways.

CARDIOVASCULAR HEALTH An extremely good source of potassium and fiber. Studies show that potassium- and fiber-rich diets reduce the risk of stroke and heart disease. Potassium is also essential for the maintenance of a healthy level of blood pressure.

FOR CONSTIPATION Its high fiber content helps bowel regularity and eases constipation.

HOW DO I GET THE BEST FROM IT?

EAT RIPE FRUIT To get the most antioxidants, eat when the skin is yellow with a few brown or black spots, and the flesh is ripe, almost to the point of spoilage.

HOW DO I USE IT?

IN THE BLENDER Banana works well with many flavors and helps to thicken the texture, so it is a good base for a fruit smoothie.

TO SWEETEN CEREALS Add to your cereal or oatmeal as a natural sweetener and as an extra source of fiber.

A FROZEN TREAT Bananas can be frozen and eaten as an alternative to ice pops, or puréed and served as an alternative to ice cream.

FRUIT
The potassium in bananas lowers blood pressure and insures against brittle bones.

Heart
Like an artichoke, the outer bracts (leaves) and flowers are removed to reveal a pale, edible heart .

FLOWER
In some Asian cuisines, the flower (or inflorescence) is eaten both cooked and raw. It is high in vitamin C and beta-carotene and is a traditional remedy for menstrual cramps.

CITRUS FRUITS

 HELPS PREVENT KIDNEY STONES

 HELPS LOWER CHOLESTEROL

 AIDS HEALTHY DIGESTION

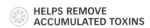 **HELPS REMOVE ACCUMULATED TOXINS**

This family of juicy fruits not only includes lemons, limes, oranges, and grapefruit, but also tangerines, mandarins, and less widely eaten fruits, such as pomellos and kumquats. Their **vitamin C** content is legendary, and regular consumption can help reduce the risk of **heart disease**, **kidney stones**, and **infections** of all kinds. They also boost **good digestion** and have alkalizing and **detoxifying** properties.

LEMONS
Lemons have antibacterial properties proven to fight the Vibrio species of bacteria, responsible for cholera.

LIMES
The vitamin K in limes is essential for healthy blood clotting.

ORANGES
Orange juice may help prevent kidney stones (calcium oxalate stone formation).

GRAPEFRUITS
High in vitamin C, these fruits can help reduce the severity of inflammatory conditions, such as asthma.

WHAT IS IT GOOD FOR?

KIDNEY STONES Lemons have the highest concentration of citrate; consuming dilute lemon juice or unsweetened lemonade daily has been shown to decrease the rate of stone formation. Orange juice may also help.

HEART HEALTH Contain hesperidin, which can reduce symptoms of hypertension, and pectin (fiber) and limonoid compounds, which can slow atherosclerosis (hardening of the arteries) and reduce "unhealthy" (LDL) cholesterol in the blood. Antioxidant flavones can also lower the risk of strokes in women.

RELIEVES INDIGESTION Mixed with hot water, lemon juice can relieve heartburn, nausea, acid indigestion, and stomach aches. It may also have an antiparasitic effect.

ALKALIZING AND DETOXIFYING Lemons are a natural diuretic and can help reduce swelling, inflammation, and edema (water retention). Also antibacterial, they flush out the bacteria that cause urinary tract infections (UTIs).

HOW DO I GET THE BEST FROM IT?

USE THE PEEL Citrus peel is full of beneficial antioxidants and has a high concentration of the fruit's limonoids. Modern science shows citrus peel fights free radicals, balances blood sugar levels, and supports thyroid health.

FOOD SYNERGY The vitamin C in citrus fruits helps the body absorb non-heme iron, a form of iron from plant sources, such as vegetables.

HOW DO I USE IT?

A JEWELED SALAD Chop the fruit of 5 large peeled oranges and place in a bowl. Add the seeds of 1 pomegranate and its juice. Add the juice of 1 orange, 3 tbsp olive oil, chopped fresh mint, and pepper, and mix gently.

MIX WITH WATER Start the day with a glass of warm water and lemon juice to alkalize and cleanse your system.

STRAWBERRIES

 HELPS PREVENT BLOOD VESSEL DAMAGE

SOOTHES UPSET STOMACHS

CONTAINS ANTICANCER SUBSTANCES

Fresh strawberries are a high **antioxidant** food. As well as being a rich source of **vitamin C**, they contain manganese, folate, potassium, B vitamins, and the beneficial **flavonoids**, quercetin and kaempferol. In addition, they have **heart-healthy** properties, benefit the **digestive system**, and are the only fruit to have seeds—a source of small amounts of omega-3 fatty acids—on their exterior.

WHAT IS IT GOOD FOR?

HEART HEALTH Apart from vitamin C, the berries are rich in quercetin and kaempferol, both of which can prevent "unhealthy" (LDL) cholesterol in the blood from oxidizing and damaging artery walls (atherosclerosis).

DIGESTION A tea made from the leaves is a traditional remedy to soothe acid indigestion. Fiber in the fruit can aid a sluggish bowel.

ANTICANCER Contains the antioxidant compound ellagic acid that scavenges for, binds to, and helps neutralize cancer-causing chemicals in the body.

HOW DO I GET THE BEST FROM IT?

EAT SEASONALLY Strawberries are grown all over the world and are available through the year, but they do not store well and quickly lose their nutrients once picked. They are most delicious and nutritious when eaten fresh in season.

GO ORGANIC Most strawberries are treated with high amounts of pesticides and fungicides. Eating organic is the only way to avoid this chemical contamination.

HOW DO I USE IT?

STRAWBERRY AND CUCUMBER SALAD Try this unusual and detoxifying combination: hull and halve 1lb (450g) strawberries and cut 1 cucumber into thin slices. Toss in a bowl and season with freshly ground black pepper (which brings out the flavor of the strawberries). Blueberries make a nice additional ingredient so add a few, if you like.

MAKE A TEA Stomach-soothing strawberry tea is best made from just-picked young strawberry leaves. Place a handful of fresh leaves in a teapot. Cover with boiling water and allow to steep for 5 minutes. Add honey, if you like, strain, and serve. If fresh leaves aren't available, use dried.

Leaves
Fresh or dried strawberry leaves can be used to make a tea that can soothe upset stomachs

Berries
Nutrients in strawberries help prevent cholesterol from damaging artery walls

RASPBERRIES

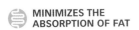 **MINIMIZES THE ABSORPTION OF FAT**

 HELPS TONE THE UTERUS

 CONTAINS CANCER-FIGHTING SUBSTANCES

Recent studies confirm that raspberries contain a vast array of **antioxidants** with a host of potential benefits in **regulating metabolism** and **fighting diseases**. One of these antioxidants is the anti-inflammatory compound, ellagic acid, which is **cancer-protective**. The leaves can be used medicinally as a **tonic in pregnancy**, and in particular, preparing the uterus for a birth.

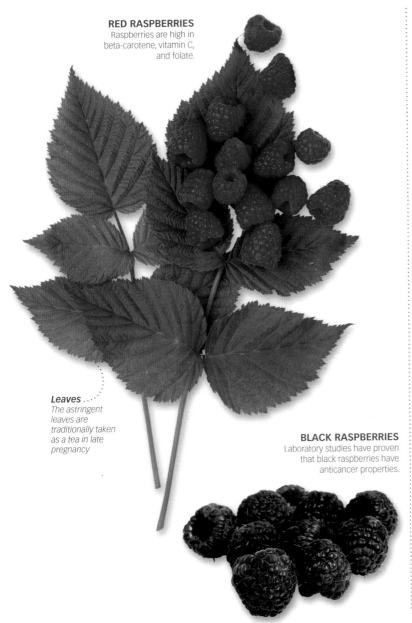

RED RASPBERRIES
Raspberries are high in beta-carotene, vitamin C, and folate.

Leaves
The astringent leaves are traditionally taken as a tea in late pregnancy

BLACK RASPBERRIES
Laboratory studies have proven that black raspberries have anticancer properties.

WHAT IS IT GOOD FOR?

METABOLIC AID Preliminary research suggests rheosmin, a phenolic compound, can suppress the digestion and absorption of fat, and stimulate the metabolism. Another compound, tiliroside, has a similar action, and may also help regulate blood sugar levels.

PREGNANCY AID The leaves are rich in tannins that may help tone and strengthen the uterus. However, only drink raspberry leaf tea during the last two months of pregnancy.

CANCER FIGHTER Phytonutrients in red and black berries may inhibit the development of certain cancers. Particular studies have focused on the potential of black raspberries to protect against DNA mutations and inhibit the growth of tumors. In laboratory tests, black raspberries have halted the development of esophageal and colon cancer. The anti-inflammatory compound, ellagic acid, which is cancer-protective, may also help with bowel conditions.

HOW DO I GET THE BEST FROM IT?

EAT ORGANIC Recent research on organic raspberries has shown the organic fruits to be significantly higher in their total antioxidant capacity than nonorganic berries.

MAKE SURE THEY ARE RIPE Studies show that fully ripe raspberries contain significantly more antioxidants than unripe fruits.

HOW DO I USE IT?

MAKE A JAM Extend the short season of raspberries by preserving them as jam.

MAKE A LEAF TEA Put 1 tsp dried leaves (or 2 tsp fresh) per ⅔ cup water in a teapot, cover with boiling water, leave to infuse for 10 minutes, strain, and drink as required. Raspberry leaf tea should only be drunk in the last 2 months of pregnancy; avoid it completely in the first 2 trimesters.

MULBERRIES

 HELPS RESTORE VITALITY

 RELIEVES TIRED EYES

 SOOTHES NERVES, PROMOTES SLEEP

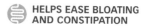 **HELPS EASE BLOATING AND CONSTIPATION**

Mulberries are an ancient fruit with a long tradition of use as a medicine, including as a **tonic** for the whole body. All parts of the plant, from root to tip, can be used medicinally, though these days we tend to concentrate only on the fruit and leaves, which are high in **antioxidant** anthocyanins and **cancer-fighting** resveratrol and vitamin C. They also protect against **eye damage** and act as a **sedative**.

WHAT IS IT GOOD FOR?

STRENGTHENING TONIC Can be used as a general tonic to restore vitality. The berries contain a useful amount of iron to benefit the kidneys, liver, and blood, and also resveratrol (also found in grape seeds), which has anticancer properties. Their high antioxidant content helps prevent heart disease and diseases associated with chronic inflammation.

EYE HEALTH The fruit and leaves contain zeaxanthin, which helps protect eyesight. Traditionally, mulberry was used to combat "dry conditions," such as dry skin and eczema, and a dry mouth and throat; its moistening properties can ease dry, strained eyes.

SEDATIVE A tea made from the fresh fruit or a teaspoon of the fruit preserve steeped in water is a traditional remedy for insomnia.

DIGESTIVE HEALTH Strengthens the digestive tract and can ease bloating and constipation.

LOWERS FEVERS A cooling food, it can be useful for treating fevers and heatstroke.

HOW DO I GET THE BEST FROM IT?

EAT DRIED Fresh mulberries don't store well, so enjoy their benefits in dried form—a good substitute for raisins.

MAKE A TEA FROM THE LEAVES The leaves, harvested after the first frosts of the fall season, have antibacterial properties.

BE GENTLE Picked fresh from the tree, the berries are a healthful treat, but they are more fragile than other berries so pick carefully.

HOW DO I USE IT?

ADD THE LEAVES TO A SALAD The young, tender leaves can be eaten raw in salads.

MAKE A JAM The berries are high in pectin and so make an excellent jam.

A NATURAL SWEETENER Add dried berries to regular or green tea to gain extra nutrients.

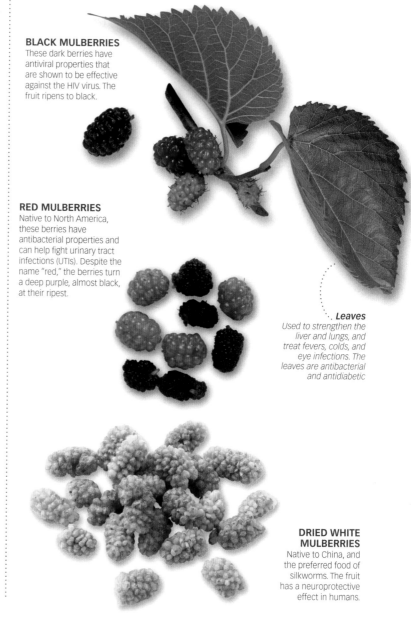

BLACK MULBERRIES
These dark berries have antiviral properties that are shown to be effective against the HIV virus. The fruit ripens to black.

RED MULBERRIES
Native to North America, these berries have antibacterial properties and can help fight urinary tract infections (UTIs). Despite the name "red," the berries turn a deep purple, almost black, at their ripest.

Leaves
Used to strengthen the liver and lungs, and treat fevers, colds, and eye infections. The leaves are antibacterial and antidiabetic

DRIED WHITE MULBERRIES
Native to China, and the preferred food of silkworms. The fruit has a neuroprotective effect in humans.

Goji Berries

 HELPS MAINTAIN MUSCLE STRENGTH

 SUPPLIES OXYGEN TO CELLS

 HELPS PROMOTE PEACEFUL SLEEP

 PROTECTS EYES FROM FREE-RADICAL DAMAGE

These berries belong to the broader nightshade family that includes chile peppers and tomatoes. Also called wolfberries, they are rich in a combination of **antioxidant** nutrients that benefit **cardiovascular health**, muscle health, and vision. They also contain a variety of **carotenoids**, including beta-carotene, known to boost **metabolic processes** and promote **good sleep** and **memory**.

FRESH WOLFBERRIES
Wolfberries don't store or travel well, which is why they are eaten dried as goji berries.

DRIED GOJI BERRIES
The antiaging effects attributed to goji berries are due to their high antioxidant capacity.

What Is It Good For?

MUSCLE HEALTH Contains betaine, a nutrient that helps build muscle, and beta-sitosterol, which helps prevent the inflammation that causes sore muscles.

METABOLIC SUPPORT Pyridoxine (vitamin B_6) is involved in numerous metabolic processes, aids the production of energy, and boosts the oxygen-carrying capacity of red blood cells. One serving of the berries contains nearly half the daily requirement of pyridoxine.

NEUROLOGICAL SUPPORT Betaine, used by the liver to produce choline, helps to soothe nerves, promote restful sleep, and has a role to play in enhancing memory.

VISION Abundant in lutein and zeaxanthin, antioxidants that have a proven ability to protect and maintain eye health.

ANTIOXIDANT BOOST Contains around 10 times the antioxidant capacity of blueberries, contributing to cardiovascular- and immune-system health. It may also protect against degenerative and inflammatory diseases, such as diabetes and arthritis. Its high antioxidant levels also mean it is a healthy skin food.

How Do I Get The Best From It?

DRIED Wolfberries deteriorate quickly once harvested. Dehydrating them preserves their nutritional benefits. Choose sulfite-free organic varieties to ensure a low toxic load.

JUICE Choose goji berry juice if you don't enjoy the dried fruit: it contains all the health benefits of the dried fruit except the fiber.

How Do I Use It?

AS THEY ARE Eat as a snack during the day to boost energy or satisfy cravings.

BREAKFAST FRUIT Soak in water and add to granola, oatmeal, fruit, yogurt, and smoothies, or add to home-baked breakfast bars.

ELDERBERRIES

 HELPS FIGHT COLDS AND THE FLU

HAS A MILD DIURETIC ACTION

Elderberries are the fruit of a woodland tree common throughout Europe, North America, and Asia. It was once regarded as a **complete medicine chest** because all parts of the plant can be used medicinally. The fruits and flowers, most commonly consumed today, have **immunity-boosting** and **diuretic effects**. The raw berries are an acquired taste, but cooking makes them more palatable.

WHAT IS IT GOOD FOR?

STRENGTHENING IMMUNITY The flowers are a traditional remedy for relieving lung congestion. They promote sweating and can cool fevers, and are also anti-inflammatory. Syrup made from the berries is a well-proven way to boost immunity at any time, but especially in winter against colds and flu.

DETOX The fruits are known to have a mild diuretic and laxative action.

HOW DO I GET THE BEST FROM IT?

PRESERVE THE FRUITS Raw elderberries are too sour for some tastes. Turning them into jams, preserves, compotes, and syrups is the best way to get the most benefit from them.

FLOWERS The flowers can be used to make everything from a lightly sparkling elderflower "champagne" to a useful gargle to soothe sore throats. Chemicals in the flowers may also help to reduce swelling in mucous membranes in the sinuses.

HOW DO I USE IT?

A HEALING SYRUP Add 2 cups strained juice from the berries to 1 cup honey and mix together well. For colds and flu, take 2 tsp as needed.

ELDERFLOWER TEA Add 2–4 fresh flower heads (or 2 tsp dried herb per cup) to a teapot, add boiling water, leave to infuse for a few minutes, strain, and drink as a tea to fight coughs and congestion.

MAKE A CORDIAL Place 2lb (900g) berries in a pan with 1 cup water. Simmer over low heat until the berries release their juice. Crush and strain, reserve the juice, and return to the pan with 1 cup superfine sugar and a 1in (2.5cm) piece of fresh ginger, grated (optional). Simmer for 1 hour. Strain and store in a tightly sealed sterilized bottle and chill. Use within 3 months. To drink, dilute to taste.

BERRIES
Elderberries get their color from antioxidant flavonoids that help prevent damage to the body's cells.

FLOWERS
The flowers (and berries) may help relieve nasal congestion.

CRANBERRIES

 FIGHTS URINARY TRACT INFECTIONS

 HELPS FIGHT GUM DISEASE

 HELPS ALLEVIATE HEAVY PERIODS

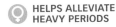 **HELPS PREVENT STOMACH ULCERS**

Native to North America, these rather sour red berries are packed with **antioxidants** and have a number of health benefits. They are both **astringent** and **antibacterial**, helping, among other things, to promote good **gum health**. Beyond that they contain a unique substance that helps prevent infections from taking hold in the urinary tract, kidney, and bladder.

Fruit
Cranberries were used by Native American People to treat bladder and kidney infections

Juice
To get the best from cranberry juice, look for brands low in sugar

Dried cranberries
Adding the dried fruit to cereals and granola is a simple way to include more antioxidants in your diet

WHAT IS IT GOOD FOR?

URINARY TRACT INFECTIONS Contains nondialyzable material (NDM) that prevents infections of the urinary tract (UTIs), bladder, and even kidneys.

PROTECTING TEETH The antioxidant proanthocyanidin, which gives the berries their bright red color, can inhibit enzymes associated with the buildup of plaque, acid formation in teeth, and receding gums.

TONING AND ASTRINGENT Its astringent and slightly antiseptic nature helps alleviate heavy periods, diarrhea, upset stomachs, sore throats, and laryngitis.

DIGESTION Preliminary research suggests that NDM may also prevent *Helicobacter pylori* bacteria from attaching to stomach walls, giving it a useful role in preventing ulcers.

HEALTHY HEART Its high vitamin C and anti-inflammatory antioxidant content can protect against inflammation and heart disease by reducing oxidative stress caused by free radicals in the body.

HOW DO I GET THE BEST FROM IT?

JUICE Fresh cranberry juice gives you the overall benefits of the fruit. Sugar feeds bacteria that can cause urinary tract infections in the first place, so look for unsweetened, varieties. Better yet, juice the berries yourself.

DRIED Eat the dried berries to enjoy most of the fruit's benefits throughout the year. Only the vitamin C content is heavily diminished.

HOW DO I USE IT?

MAKE A TEA Add 1 heaped tsp dried berries to 2 cups water in a pan. Simmer over low heat for 10–15 minutes, strain, and drink.

IN BETWEEN BRUSHING Chew dried berries thoroughly to release their gum-protecting properties and to give gums a gentle massage.

To freeze blueberries, spread them in a single layer on a large baking pan, and place in the freezer overnight. When completely frozen, transfer the berries to a freezer bag; force as much air out of the bag as possible. Return to the freezer for storage.

BLUEBERRIES

 SLOWS THE GROWTH OF PROSTATE CANCER

 HELPS PREVENT COGNITIVE DECLINE

 EFFECTIVE AGAINST GASTROENTERITIS

 HELPS PROTECT EYE HEALTH

Native to North America, blueberries have long been valued for their nutritional and medicinal properties. They contain **antibacterial** compounds that fight off stomach bugs and **antioxidants** to **prevent eye damage** and improve both **eyesight** and **memory**. They also promote **prostate health**. Much sweeter than many small berries, they can be eaten fresh on their own to reap all the benefits.

Berries
Studies show that blueberries have some of the highest levels of active antioxidants per serving of any food

Leaves
Tea made from the leaves can be used to prevent urinary tract infections and regulate blood sugar levels

WHAT IS IT GOOD FOR?

PROSTATE HEALTH A rich source of concentrated proanthocyanidin compounds, which can slow the growth and spread of various cancers. Recent laboratory studies show that blueberry extract also significantly slows the growth of prostate-cancer cells.

IMPROVED MEMORY It may have a positive effect on the nervous system. Also studies show it can increase levels of dopamine—a vital neurotransmitter—thus improving memory. May also alleviate cognitive decline.

HEALTHY GUT Contains anthocyanins, antibacterial antioxidants effective against causes of gastroenteritis, such as *E. coli*. Also combats the bacteria that cause diarrhea.

SUPPORTING VISION Anthocyanins can help improve eye health by protecting against retinal degeneration. They may also help prevent the eye condition glaucoma because of their collagen-enhancing properties.

URINARY TRACT INFECTIONS Recent studies confirm its usefulness in treating urinary tract infections (UTIs).

HOW DO I GET THE BEST FROM IT?

BUY ORGANIC Blueberries belong to a "dirty dozen" list of fruits that generally have the most pesticide residues. Eating organic is the only way to avoid chemical contamination.

LEAVES The leaves contain similar levels of antioxidants to that of the fruit. Use to prevent UTIs and regulate blood sugar levels.

HOW DO I USE IT?

FOR BREAKFAST Add to cereal or yogurt, or freeze to preserve them for longer and include them in a breakfast shake or smoothie.

LEAF TEA Pour boiling water on the leaves, infuse, strain, and drink as a tea that contains antibacterial and hypoglycemic properties.

BLACKCURRANTS

 HELPS REGULATE BLOOD PRESSURE

 PROTECTS AGAINST NEURODEGENERATION

 HELPS PROTECT AGAINST CATARACTS

 FIGHTS URINARY TRACT INFECTIONS

High in vitamin C, with useful levels of **potassium** and phosphorus, blackcurrants also contain a range of different anthocyanins, **antioxidants** that protect against **heart disease**, cancer, and neurological disorders, such as **Alzheimer's disease**. The fruits also have antibacterial properties and promote **better vision**. Too sour to eat fresh on their own, they make good cordials, syrups, and jams.

WHAT IS IT GOOD FOR?

HEART HEALTH Its potassium content helps maintain a regular heartbeat, and acts as a diuretic and blood-pressure regulator. Its antioxidants also help prevent damage to blood vessel walls, which can lead to atherosclerosis (hardening of the arteries).

BRAIN FOOD Anthocyanins, which give the berries their color, help protect the brain from the free-radical damage associated with dementia and Alzheimer's disease.

BETTER NIGHT VISION Antioxidants in the fruit have been shown to improve night vision, relieve eyestrain, and help prevent cataracts.

URINARY TRACT INFECTIONS Has a similar antibacterial action to cranberries: regular consumption of the juice can help fight urinary tract infections (UTIs).

IMMUNITY-BOOSTING TONIC Its mixture of vitamin C and antioxidants is good as a general tonic to help protect and boost immunity, and heal wounds more quickly.

HOW DO I GET THE BEST FROM IT?

ADD SUGAR Turn into preserves or add the fresh fruits to other sweeter fruits in desserts.

A HEALTHY SEED OIL The oil is rich in vitamin E and several unsaturated fatty acids, such as alpha-linolenic acid and gamma-linolenic acid. Regular consumption may help skin conditions, such as eczema and dermatitis.

USE THE LEAVES A tea made from the leaves can be used to treat coughs and sore throats.

HOW DO I USE IT?

SYRUP Turn the fruit into a sweet syrup or cordial, which retains its antioxidants and other immunity-boosting phytochemicals.

TEA Add a small handful of leaves to a teapot, cover with boiling water, leave to infuse for a few minutes, strain, and drink as required.

Fruit
Weight-for-weight, blackcurrants contain three times as much vitamin C as oranges. Too sour to eat raw, make them into sweetened cordials to enjoy their benefits

Leaves
Add the leaves to boiling water to make a tea that can help treat coughs and sore throats

BLACKBERRIES

 HELPS REPAIR SUN-DAMAGED SKIN

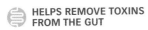 **HELPS REMOVE TOXINS FROM THE GUT**

 HELPS LOWER BLOOD PRESSURE

 CONTAINS ANTICANCER SUBSTANCES

Blackberries are high in antioxidants, of which anthocyanins are responsible for their deep purple color. Anthocyanins also fight **free-radical damage** in the body and address a range of modern conditions including **hypertension**, diabetes, cancer, vision loss, poor liver function, and **declining mental faculties**. The berries also have detoxifying properties and promote gut health.

Fruit
These berries are a source of salicylic acid, which helps lower blood pressure

Leaves
Reserve the leaves and brew as a tea to treat an upset stomach and boost mouth health

WHAT IS IT GOOD FOR?

SKIN HEALTH The berries are a great source of the antioxidant ellagic acid, which can help reduce damage done to skin from over-exposure to sun. Ellagic acid also prevents the breakdown of collagen, the "scaffolding" that supports firm skin and prevents inflammation.

HEALTHY GUT Contains both insoluble and soluble fiber, helpful for bowel regularity and removing toxins from the gut.

HEART PROTECTIVE Blackberries contain salicylic acid, a compound with properties similar to aspirin (also known as acetylsalicylic acid), which could help protect against heart disease and lower blood pressure.

ANTICANCER PROPERTIES Ellagic acid has been shown to stop the growth of cancer cells in laboratory tests.

HOW DO I GET THE BEST FROM IT?

FRESH IS BEST The nutrients deteriorate quickly so eat freshly picked or within a few days of purchase. Eat at room temperature.

LEAVES The leaves contain tannin and gallic acid, a natural antibiotic. Brewed in a tea, they are a traditional remedy for acute diarrhea, mouth ulcers, and bleeding gums.

HOW DO I USE IT?

ADD TO A CRISP Add to an apple crisp for added flavor and antioxidant benefits.

MAKE A VINEGAR Blackberry vinegar adds a real lift to salad dressings and marinades. Mixed with a little water, the vinegar is also a useful remedy for sore throats and a fever. Cover fresh blackberries in white wine or apple cider vinegar. Store in a cool dark place for 3 weeks. Strain the vinegar into a pan, add 2 cups superfine sugar for every 2 cups strained liquid, and boil gently for 5 minutes. Decant into sterilized, tightly sealed bottles and use within a year.

GRAPES

 HELPS REDUCE THE RISK OF CANCER

 HELPS PREVENT HARDENED ARTERIES

 HAS A MILD DIURETIC ACTION

 HELPS BALANCE BLOOD SUGAR LEVELS

For thousands of years every part of the grape plant, including the sap in the vines, has been used as medicine. Grapes, a **natural diuretic**, contain a variety of **antioxidants**, especially oligomeric proanthocyanidin complexes (OPCs), which contribute to everything from **glowing skin** to protection from **heart disease** and **free-radical damage**. OPCs are especially concentrated in grape seeds.

WHAT IS IT GOOD FOR?

ANTICANCER The high levels of flavonoids, anthocyanins, stilbenes, and many other antioxidants, especially in dark-skinned grapes, have been found to reduce the risk of cancers of the breast and prostate caused by free-radical damage. Grape antioxidant dietary fiber (GADF) also helps lower the risk of colon cancer. The seeds, in particular, are high in the antioxidant resveratrol, which has anticancer and antiaging properties.

CARDIOVASCULAR HEALTH Contains a wealth of antioxidants shown to prevent and reverse the effects of atherosclerosis (hardening of arteries). Red wine and grape juice are also high in resveratrol, which protects the heart.

DETOX AND WATER BALANCE Contains high levels of potassium and very little sodium, which encourages the body to flush out excess water and toxins.

STEADYING BLOOD SUGAR LEVELS Contains slow-release carbohydrates that assist with blood glucose control. Its antioxidant and fiber mix can also help reduce the threat of metabolic syndrome (a group of risk factors that can lead to diabetes and heart disease).

HOW DO I GET THE BEST FROM IT?

CRUNCH THE SEEDS Choose seeded varieties and eat the seeds—where OPCs, vitamin E, and linolenic acid all concentrate.

DRIED FRUIT When dried, fructose converts into a soluble fiber, fructan, which absorbs and removes cholesterol from the blood, and helps feed good bacteria in the gut.

HOW DO I USE IT?

IN A RICE DISH OR SALAD Raisins add flavor and nutrition to a rice dish, while grapes add a touch of sweetness to a green salad.

FREEZE THEM A cooling snack, frozen grapes have the same nutritional benefits as fresh.

RED GRAPES
Anthocyanins are the most abundant antioxidant in red and black grapes. They protect the heart and have anticancer properties.

Leaves
The leaves are rich in antioxidant polyphenols, beta-carotene, and vitamin K, and are a traditional remedy for pain and inflammation

WHITE GRAPES
Flavonoid antioxidants known as catechins, which also give cocoa its medicinal power, are most abundant in white varieties.

RAISINS
Dried white grapes are an effective prebiotic, feeding good bacteria in the gut.

CHERRIES

 HELPS PROMOTE SLEEP

 HELPS INCREASE INSULIN PRODUCTION

 REDUCES POST-EXERCISE INFLAMMATION

 CAN HELP PREVENT GOUT

Cherries—if you pick the correct kind—can rightly be called one of today's superfoods. Montmorency cherries have the highest medicinal value because they are rich in **antioxidants**, are a good **anti-inflammatory**, and are useful in the prevention and **treatment of gout**. They are also one of very few fruits to contain melatonin, which can help treat insomnia and jetlag and can **encourage good sleep**.

DARK RED CHERRIES
Sweet cherries contain a significant amount of perillyl alcohol (POH), a chemical that may help slow or halt certain cancers.

MONTMORENCY CHERRIES
Studies show this sour, bright red variety is around 10 times more active at relieving pain than aspirin.

YELLOW AND RED CHERRIES
A very sweet variety with useful levels of vitamin C and the antioxidant beta-carotene.

WHAT IS IT GOOD FOR?

A GOOD NIGHT'S SLEEP Sour cherries are one of the few foods to contain significant amounts of melatonin, a hormone produced naturally by the body as part of our sleep–wake cycle. Studies show that a glass of sour cherry juice before bedtime can promote sound sleep.

ANTIDIABETIC Tart cherries may be useful in treating diabetes. Their abundant antioxidant anthocyanins can increase insulin production, helping regulate blood sugar levels.

ANTI-INFLAMMATORY Rich in potent antioxidants that can help fight inflammation. Drinking tart cherry juice has been shown to reduce post-exercise pain and inflammation in athletes and long-distance runners.

ARTHRITIC CONDITIONS Gout, an inflammatory condition related to arthritis, is caused by an excess accumulation of uric acid in the blood. Both sour and sweet cherries have been found to lower levels of urates in the blood, and to reduce the risk of contracting gout.

HOW DO I GET THE BEST FROM IT?

CHOOSE FRESH IN SEASON Buy organic, in season, and as local as possible for the highest nutrient content. Alternatively, pit and freeze the fresh fruits to use through the year, or choose cherry concentrates and extracts.

PICK SOUR OVER SWEET Sour cherries have higher antioxidant levels than other cherries.

HOW DO I USE IT?

DRIED CHERRIES Dried cherries can be added to cereals and yogurts.

MAKE A CHERRY PIE Cherries don't lose their medicinal value when cooked. This makes them an ideal ingredient for preserves and pies, strudels, and other desserts.

ADD TO SMOOTHIES Sweet, pitted cherries are a great addition to a fruit smoothie.

QUINCE

SOOTHES STOMACH UPSETS

CONTAINS ANTICANCER SUBSTANCES

FIGHTS INFLAMMATION AND INFECTION

HELPS MAINTAIN HEALTHY ARTERIES

Quince is an ancient fruit native to the Middle East that is slowly finding its place again in the modern world. It boosts the **immune system** and benefits **heart health**, while its juice is used to treat diarrhea and as a mouthwash and gargle to maintain **gum health** and treat **mouth ulcers**. This deeply fragrant fruit is too sour to be eaten raw, but cooking helps bring out its flavor and nutritional benefits.

WHAT IS IT GOOD FOR?

STOMACH SOOTHER Has an astringent quality that makes it a good general tonic for the digestive system. It is also mildly diuretic.

ANTICANCER Laboratory studies have shown the leaf and fruit contain substances that inhibit the growth of colon and kidney cancer cells.

FIGHTS FREE RADICALS Rich in antioxidant vitamins A, C, and E and unique phytonutrients, shown to have strong free-radical scavenging properties (free radicals are implicated in heart disease, diabetes, inflammatory conditions, and cancer).

HEART HEALTH Rich in potassium, which promotes a regular heartbeat and helps remove excess water from the body. Its fiber and antioxidants can contribute to healthy arteries and the regeneration of arterial walls.

HOW DO I GET THE BEST FROM IT?

BUY IN SEASON From September to November look for large firm fruits with a yellow skin. Paradoxically, for such a hard fruit, quinces can bruise easily so avoid any fruits with signs of damage or decay. Don't store for long periods, and enjoy the fragrance they impart while it lasts.

MIX WITH WATER Several laboratory studies have shown that quince steeped in hot water has an immunity-boosting effect, and may help ease symptoms of allergic dermatitis.

HOW DO I USE IT?

GOES WELL WITH APPLES Add chunks of tart quince to apple crisp, apple sauce, or apple pies to lift their texture, flavor, and aroma.

SWEETEN YOUR TEA Add a spoonful of quince jelly or preserve to green tea to sweeten, add scent, and further boost its antioxidant effect.

A VERSATILE PRESERVE Quinces are high in pectin so they make wonderful preserves.

Seeds
An extraction of the seeds produces a viscous substance, which is a traditional Middle Eastern remedy for sore throats and coughs

Leaves
Studies have shown that the leaves and fruit contain properties that can inhibit the growth of certain cancer cells

Fruit
An astringent fruit that has a general tonic effects, quince juice can be used to treat diarrhea and even as a mouthwash and gargle to maintain gum health and treat mouth ulcers

FIGS

 REGULATES HEART RATE AND BLOOD PRESSURE

 HELPS STRENGTHEN BONES

 PROMOTES BOWEL REGULARITY

Figs are a lovely, sweet, seasonal fruit, generally available from July to September, and can be enjoyed fresh or dried. Although each has its own benefits, both fresh and dried figs are beneficial foods for **blood pressure** thanks to their high potassium levels, and are also beneficial for maintaining a good **digestive system** and improving **bone health**.

PURPLE FIGS
These figs are a good source of fiber, helping promote bowel regularity and reducing the risk of bowel cancer.

WHITE FIGS
Like purple figs, this white variety is a rich source of fiber, as well as calcium, potassium, and other trace elements.

DRIED FIGS
Dried figs retain and concentrate all the nutritional benefits of the fresh fruit, although they are lower in beta-carotene.

WHAT IS IT GOOD FOR?

BLOOD PRESSURE Fresh and dried figs contain large amounts of potassium, which is crucial for the smooth functioning of muscles and nerves, balancing fluid levels in the body, and regulating the heart rate and water balance. Figs are an ideal healthy food to eat if you have high blood pressure.

BONE HEALTH A good source of calcium, with one serving providing 10 percent of the daily recommended amount. Calcium is important in promoting the health and growth of bones. The potassium content of figs also helps reduce calcium lost through urine, meaning the body is able to absorb more calcium.

DIGESTION AND CONSTIPATION A fantastic source of fiber. Regularly including fiber in your diet is vital for maintaining a healthy digestive system, which in turn reduces the chances of constipation.

HOW DO I GET THE BEST FROM IT?

FRESH Compared to their dried counterparts, fresh figs are lower in calories and sugar. They are also higher in beta-carotene, which converts to vitamin A in the body.

DRIED Dried figs are available all year round. Compared to fresh figs, they contain more fiber, protein, calcium, potassium, magnesium, and phosphorus. They are also a great source of pectin, a form of soluble fiber, which is good for reducing blood sugar levels. They are, however, higher in calories and sugar.

HOW DO I USE IT?

AS THEY ARE Dried figs make a great sweet snack. Eat them instead of candy or chocolate, especially if you are trying to lose weight.

WITH CEREAL The health benefits of figs make them a fantastic addition to your breakfast. Adding chopped figs to granola or oatmeal is a tasty way to include them in your diet.

KIWI FRUIT

 PROMOTES COLLAGEN SYNTHESIS

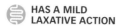 **HAS A MILD LAXATIVE ACTION**

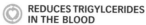 **REDUCES TRIGLYCERIDES IN THE BLOOD**

 PROTECTS AGAINST COLDS AND FLU

Native to China, and sometimes called a Chinese gooseberry, this unusual-looking fruit is now grown all over the world in sunny climates. There are some nutritional differences between the two varieties, green and gold, but both are good for **digestion** and **heart health.** Their high vitamin C content also promotes **skin health** and boosts the **immune system,** fighting off any inflammation.

WHAT IS IT GOOD FOR?

GREAT SKIN Vitamin C contributes to the formation of collagen and hastening the repair from sun and wind damage.

HEALTHY DIGESTION Its mild laxative effect is linked to its fiber content. Two kiwis provide 20 percent of the daily recommended amount of fiber, and can aid digestion and maintain colon health. Also contains actinidin, an enzyme that aids the digestion of protein.

HEART DISEASE Studies show that the high levels of flavonoids and vitamins C and E in kiwis can reduce triglycerides (a type of fat) in the blood and the buildup of plaque in the arteries (atherosclerosis). The tiny black seeds contain vitamin E and omega-3 fatty acids, which act as natural blood thinners.

IMMUNITY Vitamin C boosts immunity, fights off colds and flu, and combats inflammation.

HOW DO I GET THE BEST FROM IT?

EAT RAW ON ITS OWN Eat with a spoon, as you would a hard-cooked egg. The actinidin in green, but not gold, kiwis makes them incompatible with some foods, such as dairy produce, which they cause to curdle.

GET COLORFUL Green kiwis contain larger amounts of fiber, while gold kiwis contain higher levels of vitamin C and potassium.

HOW DO I USE IT?

A SUMMERY SMOOTHIE Blend the flesh (seeds removed) of ¼ watermelon, 2 peeled kiwi fruit, and a peeled banana in a blender.

DETOX SOUP For a cold soup for 2, blend until smooth the flesh of 1 galia or honeydew melon, halved, (reserve the shells to serve the soup in), 1 kiwi fruit, and 1 ripe pear (seeded), a handful of green grapes, grated fresh ginger (optional), and ¾ cup aloe vera juice. Chill, pour into the melon shells, and garnish with chopped kiwi and fresh mint to serve.

GREEN KIWI
Contains significantly more fiber than gold kiwi fruit.

GOLD KIWI
Gold kiwi contains large amounts of vitamin C, vital for boosting immunity.

PLUMS

 HELPS PROTECT EYE HEALTH

 HAS A LAXATIVE ACTION

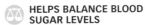 **HELPS BALANCE BLOOD SUGAR LEVELS**

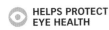 **SUPPORTS HEALTHY LIVER FUNCTION**

Plums, or gages, are members of the rose family and there are more than 2,000 varieties, including the greengage, Mirabelle, and damson. Plums have good **antioxidant** and **detoxifying** properties, are a **metabolic stimulant**, and contain chromium, potassium, selenium, and other minerals, as well as **vitamin C** and **beta-carotene**. Dried plums, or prunes, are a traditional treatment for constipation.

PURPLE PLUMS
Dark-skinned varieties with a red flesh are richer in beneficial antioxidants called anthocyanins than other varieties.

GREENGAGES
Like all plums, greengages are rich in potassium, beta-carotene, and fiber.

VICTORIA PLUMS
The antioxidants in these and other plums aid skin health.

PRUNES
Dried plums can help ease constipation.

WHAT IS IT GOOD FOR?

PROTECTS EYESIGHT Its antioxidants can help prevent age-related macular degeneration (a major cause of loss of vision).

CONSTIPATION Rich in stool-bulking fibers, especially pectin, fructose, and sulfur, which help food to move effectively through the colon. Together with substances, such as sorbitol and isatin, these fibers are responsible for the fruit's well-known laxative effect.

METABOLIC STIMULANT Contains useful amounts of calcium, potassium, magnesium, and the antioxidant beta-carotene. These nutrients help regulate heart rate, blood pressure, blood sugar levels, and water balance. Damsons in particular, are noted for their ability to stimulate appetite and digestion if eaten before a meal.

DETOX Can initiate detoxification and help improve liver function. As well as improving internal health, its detoxifying properties can help promote healthy skin.

HOW DO I GET THE BEST FROM IT?

DRIED FRUIT Prunes are a good way to reap the benefits of plums all year round. They contain both soluble and insoluble fiber, which help promote bowel regularity and balance blood sugar levels.

KEEP THE SKIN ON The skin is where most of its beneficial antioxidants concentrate.

HOW DO I USE IT?

BAKE THEM Slice some plums in half, remove the pits, and bake in an oven preheated to 350°F (180°C) until they are wrinkled. Eat them plain, or drizzle with a little yogurt sweetened with honey before serving.

SWEETEN A RICE SALAD Add chopped plums and pistachio nuts to a cold brown-rice salad. Dress with extra virgin olive oil and a fruit vinegar, such as blackberry or raspberry.

PEARS

 LOW-ALLERGY FOOD

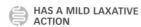 **HAS A MILD LAXATIVE ACTION**

 HELPS CALM THE NERVES

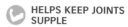 **HELPS KEEP JOINTS SUPPLE**

Dozens of different varieties of pear are now available; most have paper-thin skins and a similar shape, although some, such as the Asian pear, look a little different. A cooling, uplifting, low-allergy fruit and an excellent source of **water-soluble fiber**, pears also contain useful amounts of **beta-carotene** and B vitamins, as well as traces of copper, phosphorus, potassium, and other essential elements.

WHAT IS IT GOOD FOR?

ALLERGY RELIEF Low in salicylates and benzoates, pears are less allergenic than many other fruits, and are often recommended in exclusion diets for allergy sufferers. Pear juice is often introduced as a first juice to infants. Also good for recuperation after illness.

CONSTIPATION Most of its fiber is insoluble, making it a good bulking laxative.

NERVOUS EXHAUSTION Considered to be a cooling and soothing food. Vitamin C also triggers the production of norepinephrine and serotonin, neurotransmitters that can help lift mood.

RHEUMATIC CONDITIONS Contains a combination of potassium, pectin, and tannins that help dissolve uric acid, making it ideal for those with rheumatic conditions, such as gout and arthritis.

HOW DO I GET THE BEST FROM IT?

KEEP THE SKIN ON Most of its vitamin C and dietary fiber is contained within its thin skin.

RIPEN AT HOME Pears bruise easily when ripe. Buy them slightly underripe and let them ripen at home.

DRIED Like most dried fruits, pears are high in sugar but are a good source of natural fiber. Eat just a few for a sustained energy lift.

JUICE THEM Fresh pear juice is cooling and uplifting if you are feeling hot and anxious.

HOW DO I USE IT?

UPLIFTING DRINK Boil dried pears in water for 15 minutes. Strain and reserve the hot liquid, allow to cool, then drink to relieve nervous exhaustion and symptoms of PMS.

POACH THEM Cook fresh pears gently in a light sugar syrup or wine; add a little grated ginger or cinnamon, if you like. Serve while warm, sprinkled with toasted almonds.

CONFERENCE PEAR
Fresh pears like these have higher levels of fructose, glucose, and levulose—the sweetest of all natural sugars—in them than any other fruit.

RED ANJOU PEAR
Red-hued pears, such as Red Anjou and Red Bartlett, have more antioxidant anthocyanins than green, yellow, and brown varieties.

ASIAN PEAR
These pears may sound exotic but there is no nutritional difference between these and regular varieties.

PEACHES AND NECTARINES

 **HELPS PREVENT
METABOLIC SYNDROME**

 **FIGHTS FREE-RADICAL
DAMAGE TO SKIN**

 **HELPS EXPEL
EXCESS WATER**

Peaches originate from China, where they are considered an **uplifting**, **rejuvenating** fruit. Like other stone fruits, peaches and nectarines (a close relative) contain a balance of phenolic compounds—anthocyanins, chlorogenic acids, quercetin derivatives, and catechins—that work synergistically to **combat metabolic syndrome** (a group of risk factors that can lead to diabetes and heart disease).

PEACHES
These contain beta-carotene, lycopene, and lutein, which protect the heart and eyes.

NECTARINES
They have red, yellow, or white flesh and are a source of vitamins A and C and beta-carotene.

WHAT IS IT GOOD FOR?

WEIGHT MANAGEMENT Their phenolic compounds are known to have antiobesity, anti-inflammatory, and antidiabetic properties, and regular consumption of both can help prevent metabolic syndrome.

SKIN HEALTH Both are good sources of vitamin C, an essential component in the body's production of collagen. They are also a good source of the antioxidant lutein, which helps fight free-radical damage and supports healthy skin (and eyes).

DIURETIC Rich in potassium, phosphorus, and magnesium, peaches and nectarines are an antidote to a high-sodium diet and can help remove excess water from the body. They are also mildly laxative.

ANTICANCER Laboratory tests show that breast-cancer cells—even the most aggressive type—died after exposure to peach extract.

HOW DO I GET THE BEST FROM IT?

EAT IN SEASON Eat ripe stone fruits as soon as possible after buying; they can quickly become overripe and lose their nutritional benefits, and tend to bruise easily.

PRESERVE FOR LATER Both peaches and nectarines make delicious jams and preserves.

HOW DO I USE IT?

ANTIOXIDANT ICED TEA Slice 2 ripe peaches into a pan, add 2 cups water, and bring to a boil. Remove from the heat, add 8 green tea bags, and steep for 5 minutes. Gently squeeze the teabags as you remove them. Add a further 1 cup water and a little honey to sweeten, if you like. When cool, serve over ice with a mint garnish.

BREAKFAST BAGEL Top a toasted bagel with soft goat or kefir cheese and nectarine slices. A little freshly ground black pepper on top will bring out the sweetness of the fruit.

APRICOTS

 PROMOTES CLEAR SKIN

 HELPS PROTECT EYE HEALTH

PROMOTES BOWEL REGULARITY

 PROTECTS AGAINST FREE-RADICAL DAMAGE

Native to eastern Asia, apricots were cultivated by the Chinese for thousands of years before they reached the rest of the world. Low in calories yet **high in fiber** and many key vitamins, apricots can be eaten fresh or dried, and the leaves and kernels can all be used. Medicinally, they can help **improve digestion**, promote **clear skin**, and protect **vision**.

WHAT IS IT GOOD FOR?

EYE AND SKIN HEALTH Its high beta-carotene content is beneficial for aging eyes. Studies also show a regular high intake of nutrients such as vitamins C and E, zinc, and copper—all found in apricots—can reduce the risk of macular degeneration by 25 percent. They are also good for maintaining healthy skin.

DIGESTIVE HEALTH Its high fiber content aids bowel regularity, which can help prevent constipation and even bowel cancer.

ANTICANCER EFFECTS Its antioxidants can protect against free-radical damage linked to cancer and other diseases. The kernels also contain vitamin B_{17} (laetrile), shown in laboratory studies to kill cancer cells.

HOW DO I GET THE BEST FROM IT?

EAT FRESH AND DRIED Both are rich in fiber, vitamins A, C, and E, and other key nutrients. Buy dried apricots without added sulfites.

APRICOT KERNEL The seed inside the stone is edible. As well as its anticancer properties, it helps remove toxins and strengthens the body's defenses against disease.

KERNEL OIL Use the oil, which is rich in monounsaturated fats and vitamins A, C, and E, for cooking and salad dressings.

HOW DO I USE IT?

TO COUNTERBALANCE FATTY MEATS Pair with rich duck or goose meat, or include the dried fruits in stuffings or chopped into lamb stews.

LIGHTLY POACHED Poach fresh apricots in a light syrup of 1 part honey and 3 parts water. Add 6 crushed cardamom pods and ½ vanilla bean, and simmer until just tender.

PICKLED APRICOTS Japanese umeboshi, or pickled plums, are actually apricots. Eaten with rice, they stimulate digestion and prevent nausea, including nausea from hangovers.

Flesh
The very high levels of vitamin A in apricot promote healthy eyes and skin

Kernel
The kernel inside the stone is a source of a healthy oil rich in vitamin B_{17} (laetrile), known for its cancer-fighting properties

APPLES

 HELPS BALANCE BLOOD SUGAR LEVELS

 TACKLES DIARRHEA AND CONSTIPATION

 HELPS STRENGTHEN BONES

 HELPS LOWER CHOLESTEROL

Available in many varieties, juicy, crunchy apples have been celebrated since antiquity for their health benefits. They are **high in pectin**, a fiber, and **slow-release sugars** that help to improve **heart health** and regulate the body's **blood sugar levels**. They also contain many important vitamins and minerals, and substances that promote, among other things, strong, healthy bones.

GREEN APPLES
Like other apples, green apples contain malic acid, a useful digestive aid.

RED APPLES
Antioxidants, which can protect against neurological damage associated with conditions, such as Alzheimer's disease, are higher in red apples than in some other varieties.

YELLOW APPLES
The pectin in yellow and all other apples helps lower the body's absorption of excess dietary fats.

WHAT IS IT GOOD FOR?

BLOOD SUGAR REGULATION Fructose and antioxidant polyphenols in apples improve the metabolic balance and slow the rate at which sugar is absorbed into the bloodstream.

CONSTIPATION AND DIARRHEA Pectin has an amphoteric action. Paradoxically, it can provide relief from both constipation and diarrhea, depending on the body's needs.

PROTECTING BONES The flavonoid phlorizin, found in apple skin, may help prevent bone loss associated with menopause, because it fights the inflammation and free-radical production that lead to bone loss.

REDUCES CHOLESTEROL Pectin and other constituents, such as antioxidant polyphenols, reduce levels of "unhealthy" (LDL) cholesterol, and slow down its oxidation—a risk factor for atherosclerosis (hardening of the arteries). Polyphenols also prevent free radicals from damaging heart muscles and blood vessels.

HOW DO I GET THE BEST FROM IT?

THE WHOLE FRUIT Every part is edible. Supermarkets coat apples with wax to give a shine and keep them fresh over long periods, so always wash these apples before eating.

GO ORGANIC AND LOCAL Buy organic, and from sources as local as possible, for the freshest fruit without chemical contamination.

KEEP THE SKIN ON Peeling can remove more than half an apple's fiber, vitamin C, and iron.

HOW DO I USE IT?

A SIMPLE FOOD FOR RECUPERATION Grate 1 apple and allow to brown slightly to release the juices, making it easier to digest. Take 1–2 large spoonfuls every hour or as needed.

BAKED APPLES Core large apples, stuff with nuts, dried fruit, and spices, such as cinnamon, and bake at 350°F (180°C) until soft.

FOODS THAT HEAL

TAKE ADVANTAGE OF THE ENORMOUS **VARIETY** OF FOODS THAT HAVE INCREDIBLE **HEALTH** **BENEFITS** AND STAND AS A TESTIMONY TO "LET FOOD BE THY **MEDICINE**."

SUPPLEMENTS

A balanced diet is where health begins, but there are times when your diet may not provide all the nutrients you need. A Western diet and lifestyle can also leave us vulnerable to nutritional deficiencies including iron, calcium, magnesium, folic acid, vitamins B_6, B_{12}, C, and D. Most governments produce scientifically developed recommended dietary allowances (RDAs) to cover broadly healthy people of any age or gender. These are the basis for the Reference Daily Intake (RDI) values, which regulators use to create Daily Value (DV) packaging labels. RDAs are based on the lowest levels of nutrients required to prevent deficiency diseases, such as scurvy and rickets, and do not, as our tables on pages 338–41 illustrate, reflect the higher levels required for optimum health. This is why supplement nutrient levels are often much higher than RDA levels.

Who will benefit most from supplements?

Even in healthy people, multivitamins and other supplements may help to prevent vitamin and mineral deficiencies. They also provide more nutrients than diet can alone, so they may help to protect against, or manage, certain diseases. However, the following categories highlight those people who can most benefit from taking daily supplements:

- People who have lost weight, who may be deficient in a wide range of vitamins and minerals.

- Vegetarians, who are more likely to be deficient in vitamin B_{12}, iron, vitamin D, zinc, iodine, riboflavin, calcium, and selenium.

- Vegans, who are even more likely than vegetarians to be low in protein, selenium, and B_{12}.

- People living a typical "student lifestyle" and anyone not eating a balanced diet is likely to benefit from a multivitamin supplement.

- Elderly people living in their own homes, who are often deficient in vitamin D, vitamin A, vitamin E, calcium, and zinc, and occasionally vitamin B_1 and vitamin B_2.

- Smokers, who are most likely to be deficient in vitamin C and zinc.

- Premenopausal women, who have often been found to consume low amounts of calcium, iron, vitamin A, and vitamin C.

- Pregnant women are often advised to take a folic acid supplement, and studies have shown that taking a multivitamin supplement before and during pregnancy leads to a healthier pregnancy and a healthier baby.

- Anyone living in a colder climate who does not get regular sun exposure is likely to be deficient in vitamin D, which can lead to, among other problems, an increased incidence of breast cancer, bowel cancer, depression, osteoporosis, Parkinson's and heart disease.

- Anyone who is under stress is likely to benefit from taking additional B vitamins.

- Many men and women experiencing problems with low fertility are deficient in zinc.

Are supplements safe?

Generally speaking, taking nutritional supplements from reputable companies is extremely safe, but this doesn't mean all supplements are appropriate for everyone. It is worth doing some research to find out about the potential benefits and risks of taking a supplement. There are many sources of information available to help you become well informed. If you are suffering from a specific disease, it is advisable to talk to a knowledgeable healthcare professional before taking a supplement. If you are pregnant or breastfeeding, only take those supplements specifically recommended for you to take during this time.

While many vitamins, minerals, and herbs are known to safely prevent or treat a variety of diseases, they work by altering your body chemistry—just like any medicine. So before you take a supplement, make sure you know about how it might interact with any medications you may be already taking.

Before you turn to supplements, bear in mind that using the information in this book may help you to replace depleted nutrients by eating more of a certain food. For example, if you need to replace lost potassium, you may choose to eat more bananas or drink coconut water, or eat more fresh berries to increase your vitamin C intake.

LET FOOD BE YOUR MEDICINE

Food is the bedrock upon which a healthy life is based, and is the body's buffer against the stresses, strains, and the onslaughts of an increasingly toxic environment. Science has consistently shown that food can be used to support long-term heath as well as treat acute conditions. Ginger, for example, is a traditional remedy for nausea, honey can be as effective as conventional medicines at soothing nighttime coughs, saffron contains antioxidants that protect against age-related vision loss, garlic helps thin the blood, thus lowering the risk of stroke, and a diet rich in tree nuts can support heart health and even men's fertility. As the cost, and acknowledged side effects, of conventional medical treatments rise exponentially, we owe it to ourselves to eat the most nutritionally dense, best-quality foods. Good food is everybody's right, and in our view the best way to democratize good food is through the widespread use of organic farming and a greater attention to the concepts of local and seasonal. In reestablishing the fundamental link between food and health and exploring the benefits of traditional diets we are not looking backward, rather we are taking the best of our inherited knowledge about food and farming and applying it to a modern future.

For example, Chinese and Ayurvedic traditions have for thousands of years followed the concept that different foods have specific, healthy properties. Some foods, such as quail eggs, are considered energizing and full of concentrated life force while others, such as barley, are more soothing to the energies of the body. Traditional approaches to food also acknowledge the seasons: of recommending warming foods like oats and spices like cinnamon in winter; cleansing foods such as nettle or dandelion in spring; cooling foods like lettuce and cucumber in summer; and sustaining foods such as pumpkin and carrots in fall.

The first half of this book will help you to identify foods that have both stood the test of time as healing foods and are shown by modern research as being particularly relevant for helping to improve a health issue. The second half contains recipes, inspired by traditional cultural practices, that benefit various parts of the body or internal systems. We hope that this information will both encourage and help you affirm the connection between food and health and make food choices for yourself and your family that lead to lifelong optimal health.

Food as medicine

NAUSEA

GINGER
has a recognized ability to quell feelings of nausea.

COUGHS

HONEY
is an ancient remedy for soothing coughs and other throat complaints.

HEART

GARLIC
can help your body to fight free radicals and lower blood pressure.

LIVER

BRUSSELS SPROUTS
are a good source of sulfur, which enhances liver function.

MEMORY

BERRIES
contain antioxidants, which can help to stave off mental decline

CHOLESTEROL

NUTS & SEEDS
contain unsaturated fats, which can lower cholesterol.

whose organs are developing fast. Although most countries now set safety levels for pesticide residues in food, these are based on individual chemicals, and don't take into account the cocktail effect of several pesticides, which are known to be more damaging in combination. Many food additives common in processed foods are also banned from organic food products; monosodium glutamate (MSG), Brilliant Blue, aspartame, and tartrazine, for example, are now being linked to health issues and behavioral problems in children. Organic standards also insist that animals are given plenty of space and fresh air to thrive and grow, guaranteeing that they are reared humanely and not routinely fed antibiotics to suppress disease or promote growth.

Organic is kinder to the environment, too. Organic farming works with nature, not against it, and research shows that it's better for birds, butterflies, and other wildlife. Organic farms are havens for wildlife and provide homes for bees, birds, and butterflies. In fact, plant, insect, and bird life is up to 50 percent greater on organic farms. Biodiversity is something to encourage both in our environment and on our plate.

HOW ABOUT GM FOOD?

Genetically modified (GM) crops provide another potential health hazard. GM foods, which have had their genetic material (DNA) altered to achieve desired changes in their characteristics, have been developed by seed and chemical companies as one means of responding to climate change and a growing global population, although GM technologies have consistently underperformed. There is legitimate concern about how carelessly GM foods have been assessed for safety, and evidence that they may have risks to human health and wildlife. In a recent French study in 2012, rats fed a lifelong diet of a bestselling strain of genetically modified corn developed more and bigger breast tumors, and experienced kidney and liver dysfunction. In the USA, GM foods don't have to be labeled, in spite of overwhelming public support for such a requirement in a country where GM-adulterated food is so prevalent. In most countries in Europe, farm animals are fed GM foodstuff, but actual GM foods for human consumption are not yet accepted. Examples of GM foods include soybeans, corn, white rice, tomatoes, and Brazil nuts.

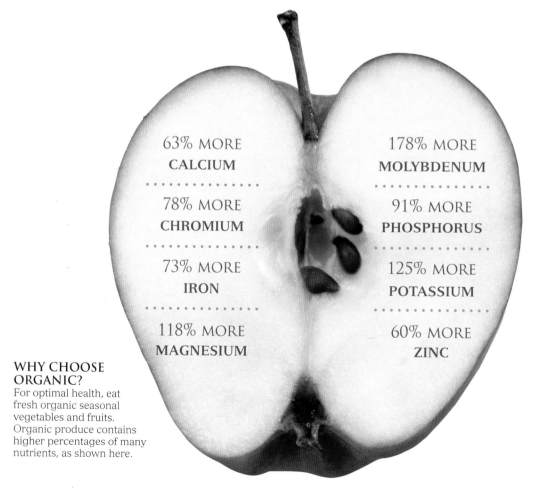

63% MORE
CALCIUM

178% MORE
MOLYBDENUM

78% MORE
CHROMIUM

91% MORE
PHOSPHORUS

73% MORE
IRON

125% MORE
POTASSIUM

118% MORE
MAGNESIUM

60% MORE
ZINC

WHY CHOOSE ORGANIC?
For optimal health, eat fresh organic seasonal vegetables and fruits. Organic produce contains higher percentages of many nutrients, as shown here.

As Nature Intended

The success of traditional diets, such as the Mediterranean and Inuit diets, in sustaining good health and well-being (p11) lies in the fact that they each contain a carefully balanced range of seasonal nutrient-rich foods that are available from local sources. To get the very best from locally grown fresh produce, however, it is worth considering buying organic, because foods that are produced this way contain more of the nutrients that make these seasonal foods so beneficial to our health.

LOCAL AND SEASONAL

Adjusting your diet with the seasons can mean that, as well as being beneficial for your body's "energies," you will eat more fresh foods that can be locally sourced. Choosing local and seasonal should also encourage you to make healthier choices, and can increase your general feeling of well-being as you become more in tune with the cycles of nature. This doesn't mean that you need to become rigid or obsessive about what you eat and when; some foods, such as avocados or bananas, may simply not grow where you live. It is the principles you base your dietary habits on that is key. The 80:20 rule—eating 80 percent of local, seasonal, unprocessed foods and 20 percent of more exotic foods, or "treats"—is probably a good guideline. When people switch to more local, seasonal food, many find they become more adventurous in their cooking and eating habits. If you unpack a CSA (Community Supported Agriculture) box, for example, you may find an unrecognized vegetable or fruit that you have to discover the best way to prepare, and hopefully you will look forward to preparing and eating it again next time it is in season. Or, you may become interested in learning how to preserve them—a more traditional and low-impact way of extending the natural season of foods throughout the year.

ORGANIC BENEFITS

Organic food is produced using environmentally and animal-friendly farming methods on organic farms. These methods are now legally defined in most countries of the world and any food that is sold as organic must be strictly regulated. Organic farming recognizes the direct connection between our health and how the food we eat is produced. Artificial fertilizers are banned and farmers develop fertile soil by rotating crops and using compost, manure, and clover in order. In contrast, modern intensive agricultural practices have led to the reduction of many minerals and vitamins in the food we eat; official food composition tables in the USA and UK have shown that fruits, vegetables, meat, and dairy products all

> "IT IS NOT JUST WHAT ORGANIC FOOD CONTAINS, IT IS ALSO WHAT IT DOES NOT CONTAIN THAT IS IMPORTANT."

contain fewer minerals than they did in the past. As soils become depleted of minerals, such as magnesium and zinc, for example, there is less for plants grown in this soil to draw up, and therefore less for us to absorb. Minerals that are particularly affected by these intensive farming methods are iron, zinc, copper, magnesium, and selenium, and their levels of depletion can be very significant. An early study in the Journal of Applied Nutrition in 1993 reported that organically and conventionally grown apples, potatoes, pears, wheat, and corn in a suburban area of the USA were analyzed and compared for mineral content. On a per-weight basis, average levels of essential minerals were much higher in the organically grown produce than in the conventionally grown foods. The organic produce was, on average, 63 percent higher in calcium, 78 percent higher in chromium, 73 percent higher in iron, 118 percent higher in magnesium, 178 percent higher in molybdenum, 91 percent higher in phosphorus, 125 percent higher in potassium, and 60 percent higher in zinc. More recent studies have confirmed this finding and interestingly, according to population studies, many people in the western world are becoming increasingly deficient in these same minerals, leading to problems such as anemia, fatigue, subfertility, and poor immunity. Organic farming can help to halt this decline in mineral content. Levels of vitamin C, phenolic acids, and antioxidants also tend to be 60–80 percent higher in organic produce. Just as important from a health point of view is the markedly more benign balance of omega-6 and -3 fatty acids in organic meat and dairy produce as compared to conventionally produced foods.

It is not just what organic food contains, it is what it does not contain that is important. Some synthetic chemicals commonly used in nonorganic agriculture are now known to potentially disrupt the nervous, circulatory, endocrine, and reproductive systems of humans. This may be even more of a problem in babies and children,

VARIETY IS THE SPICE OF LIFE

The good news is that if you currently eat a modern Western diet, you can easily adapt your eating habits to dramatically improve your health. Including a variety of nutrient-rich, low-energy foods, such as vegetables and fruit, in your diet both helps with weight control and can have a positive effect on your health. Eating a varied diet ensures we get a steady supply of highly bioavailable nutrients that help reduce the likelihood of conditions such as Alzheimer's disease, dementia, anxiety, depression, arthritis, some types of cancer (including breast and bowel cancer), and heart and circulatory disease.

DIETARY DIVERSITY

No single food or food group can supply all the nutrients we need, which is why a diverse diet is so important. Research consistently shows that dietary diversity protects against the onset of type 2 diabetes, for example, by balancing out blood sugar levels and protecting against blood vessel damage. A varied, seasonal diet rich in plant foods can also lower your total risk of cancer and has been shown to protect against some very specific cancers of the digestive tract. To improve the balance and variety of your diet, choose foods like multigrain breads and granola that have variety "built in," and eat side dishes and condiments, such as fruit and vegetable salads, sprouted seeds, fresh salsas, pickles, and chutneys. Stir-fries, casseroles, and soups with many ingredients are another easy way to increase diversity in your diet. Or, when grocery shopping, regularly buy a fruit or vegetable that is not familiar to you to prepare and eat. Following a varied diet also tends to be more satisfying and so reduces your sugar, salt, and saturated fat consumption—all risk factors for heart disease. Including more spices and herbs in your food can also boost its flavor and nutritional density: adding a handful of chopped fresh herbs to lettuce in a salad, for example, can add up to 75 percent extra antioxidants to the food.

Vary your diet

TYPICAL DIET	DIVERSE DIET
BREAKFAST Wheat bran cereal with milk, sugar and banana; orange juice; tea with milk	**BREAKFAST** Oatmeal made with milk, sprinkled with dried fruit, sunflower and pumpkin seeds, and seasoned with cinnamon and maple syrup; rosehip and hibiscus tea
LUNCH Wheat bread, ham, cheese, and lettuce sandwich with mayonnaise for spread; a piece of fruit	**LUNCH** Lentil soup (p212) made with ginger, turmeric, shallots, garlic and chile; served with slice of rye bread (p328) spread with butter; a piece of fruit
DINNER Chicken (or other meat) served with a vegetable and rice	**DINNER** Salmon with dill and tamari sauce (p268) served with an adzuki and mung bean salad (p226) with tomatoes and a mixed citrus and herb dressing
SNACK Potato chips	**SNACK** Multiseed crackers (e.g. wheat, pumpkin seed, flaxseed, poppy seed) spread with Hummus (p196) made with chickpeas, tahini, coriander seeds, paprika
TOTAL OF 13 FOODS	**TOTAL OF 35 FOODS**

Soughdough rye bread p328

Hummus with coriander p196

THE WESTERN DIET

By contrast, the modern Western diet, also called the Western pattern diet, is characterized by high intakes of red meat, sugar and artificial sweeteners, high-fat foods, salt, and refined grains. It also typically contains hydrogenated and transfats, high-sugar drinks, and higher intakes of processed meat. This diet, based on studies of western populations, is associated with an elevated incidence of obesity, death from heart disease, cancer (especially colon cancer), and other western-pattern diet-related diseases. The high consumption of grains—as breakfast cereals, breads, cakes, cookies, pasta, and so on—means that grain has become a significant source of carbohydrate-energy, minerals, and, in the case of whole grains, of fiber and B vitamins. However, it is now thought that this reliance on cereals may come at a high cost to our health. Modern strains of high-gluten cereals, combined with an over-reliance on wheat-based products and an industrial approach to the processing of grain-based foods, can place a strain on our digestive systems and nutrient balance. For example, an increasing number of people have developed gluten intolerance, or gluten sensitivity, which can vary from celiac disease to feeling bloated if they eat too many cereal-based foods in a day. Cereals contain what have been termed "antinutrients," which may prevent the digestive system from absorbing several essential nutrients. The most researched antinutrients are the phytates found in the bran or outer hull of most grains, and which is part of a seed's system of preservation—it prevents the seed from sprouting until conditions are right. The phytate known as phytic acid can block the absorption of essential minerals such as calcium, magnesium, copper, iron, and especially zinc, in the gut. This may be why a diet high in improperly prepared whole grains may lead to serious mineral deficiencies and bone loss, and why consuming large amounts of unprocessed bran often initially improves bowel regularity, but may lead to irritable bowel syndrome and, in the long term, other adverse effects.

> "IT IS NOW THOUGHT THAT RELIANCE ON CEREALS MAY COME AT A HIGH COST TO OUR HEALTH."

So although cereals can be a useful part of a diet, they do require careful preparation because of their antinutrient properties. Many cultures throughout the world have developed ways of preparing types of grain for human consumption. Soaking, sprouting, and souring are very common aids for grain preparation, and ensure the neutralization of phytates, enzyme-inhibitors, and other antinutrients with which seeds are naturally endowed. Some traditional preparation methods involve complex, comparatively labor-intensive steps that produce what are now considered unusual foods from common grains, but which were once part of common dietary practices. The traditional sourdough method of preparing rye bread, for example, once widespread throughout eastern Europe, helps to make rye flour far more digestible.

Modern diets in general also tend to include a larger number of dried beans, and, more recently, soy derivatives. Although including beans in your diet can be a useful source of fiber and protein, these foods also contain phytates. The phytate in soybeans, for example, means they are low in calcium and one reason why they are less healthy than you might think, though fermenting helps to make soy a more nutritious food. It is interesting to note that the traditional Japanese diet includes a lot of soy, but it is usually fermented in the form of tempeh or miso. In addition, Japanese preparation techniques eliminate most of the antinutrients in other dried beans and in grains. Soymilk is not fermented and so can be a cause of digestive problems and calcium depletion, as well as being a fairly potent phytoestrogen—potentially useful for reducing hot flashes in menopausal women, but not so suitable for children or everyone else.

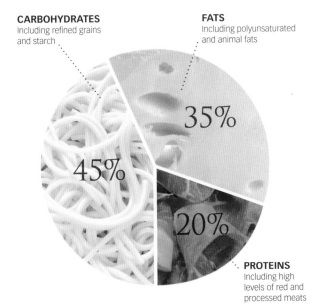

CARBOHYDRATES
Including refined grains and starch

FATS
Including polyunsaturated and animal fats

35%

45%

20%

PROTEINS
Including high levels of red and processed meats

WESTERN DIET FIGURES

In a Western diet, the main nutritional building blocks of fats, carbohydrates, and protein are often processed, nutrient-poor foods high in sugar, refined grains, and saturated fats.

DIFFERENT DIETARY PATTERNS

While we would not advocate a rigid approach to a particular diet, there are things that can be gained and adopted from traditional diets. Humans are very adaptable and it is interesting to see the ways in which different cultures have adjusted their diets to remain healthy in widely different environments.

TRADITIONAL DIETS

INUIT

The Inuit people of the Arctic have traditionally had very little access to cereals or fresh fruit and vegetables, but the manner in which they hunt and eat their mostly fish- and meat-based diet meets their nutritional needs. For example, vitamins and minerals that are derived from plant sources in other areas of the world are also present in most Inuit diets: vitamins A and D are present in the oils and livers of coldwater fishes and mammals, for instance, while vitamin C is obtained through sources such as caribou liver, kelp, whale skin, and seal offal. Because these foods are typically eaten raw or frozen, the vitamin C they contain—which would be destroyed by cooking—is instead preserved.

MEDITERRANEAN

Another traditional diet that has received publicity in recent years is the Mediterranean diet. This diet is based mainly on fresh vegetables and fruit with some whole grains, healthier oils like olive oil and those from fresh fish, red wine, and smaller quantities of meat. Studies throughout the world have shown that following a strict Mediterranean diet offers substantial protection against heart disease, cancer, and Parkinson's and Alzheimer's diseases. The biggest study into this diet has shown that it can reduce the number of deaths from these diseases; it also found that people who follow this diet show significant improvements in health, and are nine percent less likely to die young.

JAPANESE

Traditional Japanese cuisine is rich in fat-soluble vitamins from seafood and organ meats and minerals from fish broth, and contains plenty of beneficial lactofermented foods, such as tempeh and miso. Although portions tend to be relatively small, they are both filling and very nutrient-dense. In fact, Japanese people who follow this traditional diet tend to be some of the healthiest, least obese, and longest-lived people in the world.

ANCESTRAL/PALEOLITHIC

Also referred to as the caveman or hunter-gatherer diet, this modern nutritional plan is based on an ancient diet of wild plants and meat that early humans were likely to have habitually eaten during the Paleolithic era—a period of about 2.5 million years that ended around 10,000 years ago with the development of agriculture. Early humans were foragers who would have grazed opportunistically on seasonally available plants and not made the, often arbitrary, distinctions we do between weeds and crops and medicinal and culinary herbs. Although the hunter-gatherer diet comprises commonly available modern foods—mainly fish, grass-fed, pasture-raised meats, vegetables, fruit, fungi, roots, and nuts—it largely excludes dried beans, dairy products, grains, salt, refined sugar, and processed oils, which define the Western diet (overleaf). Studies of the Paleolithic diet in humans have shown improved health and fewer incidences of diseases, such as diabetes, cancer, obesity, dementia, and heart disease.

WHAT MANY OF THESE DIETS have in common is that they are plant-based, with meat reserved for feast days and occasional treats. They include plenty of oily fish so are rich in the omega-3 fatty acid DHA. Their overall balance of essential fatty acids is healthier (i.e. higher in omega 3 than 6, unlike modern diets), and they are high in antioxidants. People who follow these diets rely on seasonal fresh food produced without industrial chemicals, which means they eat a wide variety of nutrient-dense foods necessary for optimal heath throughout the year. They tend to eat sensible portions and rarely "snack" between meals.

THE PROTECTIVE POWER OF FOOD

Nutritional science has shed much light on the importance of "whole food": we now understand that nutrients in our food work synergistically to promote health—and that processed food, denuded of many of its intrinsic nutrients, can promote disease. We also know of 50 or so essential vitamins, amino acids, minerals, and essential fatty acids that we need to get on a regular basis from our diet, and more than 1,200 phytonutrients found in fruits, vegetables, beans, grains, and animal products.

A RAINBOW OF PHYTONUTRIENTS

Phytonutrients are the bioactive compounds in plants ("phyto" means plant) that supply their color and flavor. Although not essential to life in the way that vitamins and minerals are, they support health in a variety of ways.

Antioxidants, for example, protect the body from free radicals, the unstable molecules that are produced through metabolism of and exposure to pollution, and which cause disease by damaging vital tissues and organs.

Antioxidants by color

COLOR	PHYTONUTRIENT	BENEFITS	FOUND IN
	Green		
	Lutein	Protects eyes; boosts immunity; and supports healthy tissues, skin, and blood	Kale, collard greens, cucumber, zucchini, peas, avocado, asparagus, green beans
	Chlorophyll	Detoxifying; helps build red blood cells and collagen; boosts energy and well-being	All leafy green vegetables, sprouted grasses, and microalgae
	Indoles	Has anticancer properties; supports healthy hormone balance	Brussels sprouts, broccoli, bok choy, cabbage, and turnips
	Orange/yellow		
	Carotenes (incl. alpha-, beta-, and delta-carotene)	Source of vitamin A; has anticancer and heart-protective properties; protects mucous membranes	Orange and yellow fruits and vegetables (peppers, squashes, carrots, apricots, mangoes, oranges, grapefruit)
	Xanthophylls (incl. zeaxanthin and astaxanthin)	Source of vitamin A; has anticancer properties; protects eyes and brain; strengthens the immune system	Red fish (e.g. salmon), eggs, most orange and yellow fruits and vegetables
	Red		
	Lycopene	Protects against heart disease, cancer (especially prostate), and vision loss	Fresh and cooked tomatoes, watermelon, goji berries, papaya, and rosehips
	Anthocyanins	Can help reduce the risk of heart disease, cancer, and neurodegenerative diseases	Cranberries, strawberries, raspberries, cherries, and red cabbage
	Blue/purple		
	Anthocyanins	Fights free radicals; has anticancer properties; supports healthy aging	Blueberries, eggplant, grapes, grape juice, raisins, and red wine
	Resveratrol	Has anticancer properties; helps balance hormone levels	Grapes, grape juice, red wine, mulberries, and cocoa
	White		
	Allyl sulfides	Boosts immunity; has anticancer and anti-inflammatory properties	Onions, garlic, scallions, and chives
	Anthoxanthins	Helps lower cholesterol and blood pressure; helps reduce the risk of certain cancers and heart disease	Bananas, cauliflower, mushrooms, onions, parsnips, potatoes, garlic, ginger, and turnips

INTRODUCTION

"LET FOOD BE THY MEDICINE
AND MEDICINE BE THY FOOD"

HIPPOCRATES

THE FOOD WE EAT HAS AN OVERREACHING EFFECT ON OUR HEALTH AND **WELL-BEING**, WHETHER WE ARE CONSCIOUS OF IT OR NOT. BECOMING MORE AWARE OF YOUR DIET AND THE **HEALING PROPERTIES** OF FOOD WILL HELP YOU TO MAKE NECESSARY ADJUSTMENTS TO MEET THE NEEDS OF **YOUR BODY**—AND IT WILL DO AN ENORMOUS AMOUNT TO MAINTAIN AND IMPROVE YOUR **HEALTH**.

KEY TO ICONS

These icons are used throughout to signpost you to dietary benefits for different health areas.

 HEART AND CIRCULATION

 ENERGY BOOST

 DIGESTION

 MUSCLES AND JOINTS

 URINARY

 SKIN AND HAIR

 RESPIRATORY

 MIND AND EMOTIONS

 DETOX

 EYE HEALTH

 METABOLIC BALANCE

 MEN'S HEALTH

IMMUNE SUPPORT

WOMEN'S HEALTH

ABOUT THE AUTHORS

Susan Curtis has practiced as a homoeopath and naturopath since the mid-1980s and is the Director for Natural Health for Neal's Yard Remedies. She is the author of several books, including *Essential Oils*, and co-author of *Natural Healing for Women*. Susan has two grown-up children and is passionate about helping people to eat well and live a more natural and healthy lifestyle.

Pat Thomas is a journalist, campaigner, broadcaster, and passionate cook. She is the author of several books on health and environment, and has worked with leading campaign organizations to outline sensible strategies for healthy and sustainable eating. She is a former editor of *The Ecologist* magazine and was the director of Paul McCartney's "Meat Free Monday" campaign in the UK. She currently sits on the Council of Trustees of the Soil Association—the UK's premier organic certification body —and is the editor of Neal's Yard Remedies' natural health website, *NYR Natural News*.

Dragana Vilinac, medical herbalist, comes from a family with a long lineage of traditional herbalists. Her life's purpose is the exploration of the healing dynamics between plants, the planet, and people, and educating others in the subject. She has worked in the field of western, Chinese, and traditional Tibetan (Bhutanese) medicines since the 1980s, and has been a consultant on international development projects related to herbal medicines in Europe and Asia. She has co-authored books with the theme of plants as food and medicine. Dragana is the Chief Herbalist for Neal's Yard Remedies.

CULINARY HERBS *100*
Basil
Cilantro
Parsley
Rosemary
Sage
Thyme
Dill
Mint
Oregano

CEREALS AND GRAINS *104*
Amaranth
Quinoa
Spelt
Rice
Bulgur wheat
Oats
Rye
Millet
Barley
Buckwheat

DRIED BEANS *114*
Adzuki beans
Black beans
Butter beans
Chickpeas
Kidney beans
Lentils
Mung beans

SPICES *116*
Cardamom
Cinnamon
Coriander
Cumin
Fenugreek
Juniper
Licorice
Nutmeg
Pepper
Saffron
Star anise

FATS AND OILS *120*
Butter and Ghee
Olive oil
Sunflower oil
Flaxseed oil
Hemp seed oil
Black seed oil

FERMENTED FOODS *122*
Sauerkraut
Kimchi
Soy sauce
Miso
Tempeh

MEATS *124*
Chicken
Beef
Lamb
Pork
Turkey
Venison
Quail
Squab
Waterfowl
Liver
Kidneys

OILY FISH *128*
Salmon
Herring
Mackerel
Sardines
Trout
Sea bass
Tuna

OTHER FOODS *130*
Algae
Seaweeds
Aloe vera
Wheatgrass
Honey
Stevia
Maple syrup
Blackstrap molasses
Chocolate
Milk
Yogurt
Kefir
Eggs
Tea
Rose

RECIPES THAT HEAL *146*

A Day of ... Heart Health *148*
A Day of ... Good Digestion *150*
A Day of ... Liver Health *152*
A Day of ... Skin Health *154*
A Day of ... Healthy Joints *156*
A Day of ... Boosted Energy *158*
A Day of ... Stress Relief *160*
A Day of ... Men's Health *162*
A Day of ... Women's Health *164*
A Day of ... Healthy Pregnancy *166*

RECIPE CHOOSER *168*

BREAKFAST *176*

SNACKS *194*

SOUPS *208*

LIGHT MEALS AND SALADS *222*

MAIN MEALS *244*

SWEET TREATS *284*

DRINKS *304*

OILS, DRESSINGS, AND EXTRAS *326*

SUPPLEMENTS *338*

INDEX BY HEALTH AREA *342*

INDEX AND ACKNOWLEDGMENTS *346*

CONTENTS

INTRODUCTION 8

FOODS THAT HEAL 18

FRUITS 20
Orchard Fruits 20
Apples
Apricots
Peaches and Nectarines
Pears
Plums
Kiwi fruit
Figs
Quince
Cherries

Vine Fruits 29
Grapes

Berries and Currants 30
Blackberries
Blackcurrants
Blueberries
Cranberries
Elderberries
Goji berries
Mulberries
Raspberries
Strawberries

Citrus Fruits 40
Lemon
Lime
Orange
Grapefruit

Tropical Fruits 41
Bananas
Dates
Mangoes
Melons
Papaya
Pomegranate
Pineapple

Coconut
Avocado

VEGETABLES 51
Brassicas 51
Broccoli
Cabbage
Kale
Horseradish

Fruiting and Flowering Vegetables 55
Sweet peppers
Chiles
Cucumbers
Winter squashes
Zucchini
Corn
Artichoke
Eggplant
Tomatoes

Leafy and Salad Vegetables 66
Lettuce
Spinach
Watercress
Mustard greens
Arugula
Dandelion
Nettles
Chicory (Belgian endive)

Podded Vegetables 74
Green beans
Okra
Peas

Bulbs and Stems 77
Asparagus
Celery and Celeriac
Fennel
Rhubarb

Onion Family
Garlic

Roots, Tubers, and Rhizomes 83
Beets
Carrots
Radishes
Potatoes
Sweet potatoes
Turmeric
Ginger

Fungi 91
Mushrooms

NUTS 92
Almonds
Cashews
Chestnuts
Hazelnuts
Pine nuts
Pistachio nuts
Walnuts

SEEDS AND SPROUTS 94
Sesame seeds
Sunflower seeds
Pumpkin seeds
Flaxseeds
Poppy seeds
Hemp seeds
Alfalfa seeds
Chia Seeds
Red clover seeds

MEDICINAL HERBS 98
Astragalus
Valerian root
Chamomile
Schisandra
Marshmallow root
Milk thistle
St. John's wort

LONDON, NEW YORK, MELBOURNE,
MUNICH, AND DELHI

US Consultant Kate Curnes Ramos
US Editor Constance Novis
US Senior Editor Rebecca Warren

DK UK
Editor Susannah Steel

Project Editor Shashwati Tia Sarkar
Senior Art Editor Tessa Bindloss
Editorial Assistant Christopher Mooney
Managing Editor Dawn Henderson
Managing Art Editor Christine Keilty
Senior Jacket Creative Nicola Powling
Jacket Design Assistant Rosie Levine
Producer, Pre-Production Raymond Williams
Senior Producer Jen Scothern
Art Director Peter Luff
Publisher Peggy Vance

DK INDIA
Senior Editor Chitra Subramanyam
Senior Art Editor Balwant Singh
Editor Ligi John
Art Editor Prashant Kumar
Assistant Art Editor Tanya Mehrotra
Managing Art Editor Navidita Thapa
DTP/CTS Manager Sunil Sharma
DTP Designer Anurag Trivedi
Photo Research Aditya Katyal

First American Edition, 2013

Published in the United States by DK Publishing,
375 Hudson Street, New York, New York 10014

13 14 15 16 10 9 8 7 6 5 4 3 2 1

001—187277—May/2013

DISCLAIMER See page 352

A catalog record for this book is available from the Library
of Congress.

ISBN 978-1-4654-0853-2

DK books are available at special discounts when purchased in
bulk for sales promotions, premiums, fund-raising, or
educational use. For details, contact: DK Publishing Special
Markets, 375 Hudson Street, New York, New York 10014 or
SpecialSales@dk.com

Color reproduction by Opus Multimedia Services, India
Printed and bound in China by South China (DK)

Discover more at **www.dk.com**

Healing Foods

Eat your way to a healthier life

Healing Foods

2 planning your all-time best party
 appetizers by the numbers
 stocking a party pantry
3 assembling a menu
 last-minute appetizers
4 menu starter kit
5 crudités done right
6 all about cheese
8 anatomy of a cheese plate
9 buying beer
10 which wine?
11 bar stocking and cocktail basics

planning your all-time best party

stocking a party pantry

Host a last-minute party anytime with help from these staples.

puff pastry Frozen puff pastry is a real workhorse; it's one of the easiest shortcuts to elegant hors d'oeuvres, from tarts to wrapped bites. Some of our favorite puff pastry recipes are Asparagus Puffs (page 35), Tomato and Mozzarella Tart (page 80), and Ham and Cheese Palmiers (page 127).

prosciutto Add prosciutto to cheese or antipasto platters. It also pairs well with sweet ingredients (see Prosciutto-Wrapped Figs with Gorgonzola, page 23). Unopened packs keep in the fridge for months.

olives Olives are a classic party snack. You can make your own Marinated Olives (page 50), but jarred olives are handy in a pinch.

roasted red peppers Pick a jar packed in a simple salt and water brine. Blend into a dip (like our Roasted Red Pepper Hummus, page 113) or slice on top of a tart.

jam/preserves A jar of jam in an interesting flavor is a great addition to a cheese plate, simple canapé, or baked Brie recipe.

whole nuts Plain or spiced nuts (like our recipes on page 53) are an easy way to add substance and flavor to your menu. Store in the freezer to avoid rancidity.

crackers Crackers are a necessary pairing with cheese and can also form the base of a quick canapé.

While the quality of the company is the number-one most important element of a successful party, we think that the quality (and quantity) of the food is not far behind. The goal is to choose a menu that will leave your guests satisfied and impressed and that also allows you to relax and enjoy your get-together. We've put together this book to help guarantee you success. Almost every recipe has instructions about how to make all or part of the dish ahead of time to minimize the amount of work you have to do as your guests are arriving. We've also organized the chapters to make it super-simple to assemble a menu; just pick one recipe from each chapter for a great variety of foods and flavors. (See page 4 for some themed menu suggestions built using this structure.) Of course you don't have to use these guidelines; if you want to, you can pick your menu entirely from a single chapter—an all-dips party could be a lot of fun (just stock up on chips). In the end, your party should be a reflection of your style in and out of the kitchen; these tips and recommendations are offered to help you get there with as little stress and fuss as possible.

appetizers by the numbers

One frequently asked question when it comes to appetizers concerns quantity: How many types of appetizers and how many pieces should you have? The answer depends on how long you plan to serve the appetizers and what follows. If you're having a short cocktail hour followed by a meal, you will want to serve just one or two appetizers. (If you are expecting a large crowd, you might consider making three.) Plan on three to four pieces per person for 1 hour or less of cocktails. For more than 1 hour, make at least two appetizers and plan on four to six pieces per person.

A true cocktail party (with no dinner to follow) requires more types of appetizers and more pieces. In many cases, guests are imbibing for several hours and some may even make a meal out of the appetizers. (Don't forget that alcohol can function as an appetite stimulant.) In this case, you want to serve at least five or six appetizers and should plan on at least 10 to 12 pieces per person. Dips can be used to supplement these recommendations. You also need to take into account how heavy and filling the appetizers you have chosen are. Guests are likely to be satisfied by one or two pieces of a filling tart but might want three or four shrimp with cocktail sauce.

assembling a menu

There are no hard-and-fast rules for putting together a menu for your gathering—the most important thing is choosing recipes that you and your guests will enjoy. However, we have come up with a few guidelines that can help if you feel like you don't know where to start:

snack by the season Keep the time of year in mind; serve lighter food in the summer and heavier fare in the winter.

consider the setting Figure out where you plan to serve the appetizers. If guests will be seated and can hold forks, knives, and plates, you can serve different appetizers than if everyone will be standing and juggling drinks, napkins, and food.

stick with a theme If you're serving a full meal, plan that first and then choose appetizers that complement the menu in some way. For instance, if your dinner will include *boeuf bourguignon*, you may want to offer a simple pâté, an array of French cheeses, and thinly sliced baguette.

it's okay to keep it simple If you are putting a lot of effort into an elaborate or multicourse meal, it's okay to serve very simple appetizers, such as nuts, olives, and an interesting spread with crackers.

pair with care If you're serving more than one or two appetizers, choose dishes that will complement each other. It's fine to have one rich appetizer full of cheese, but you probably shouldn't serve several cheese-heavy recipes. (Unless your whole party is cheese-themed, of course.)

take the temperature Try to pick a mix of hot and cold (or room-temperature) appetizers. This will help minimize the amount of work and worry involved at the last minute and also create a more interesting menu.

make it ahead Look for recipes that can be prepared in part or in whole ahead of time (which includes about 75% of the recipes in this book). You'll still have to do some last-minute work to bring everything together and take care of any recipes that must be made the day they're being served, but finding recipes that you can get a jumpstart on days or even weeks ahead of time will make your party prep much more manageable.

appetizers for all Pick at least one or two vegetarian options (or more, depending on the size of your menu and the makeup of your guest list). You may also want to consider including gluten-free, dairy-free, and vegan options. See pages 174–175 for lists of all the recipes in the book that fit those categories. Don't feel like you have to accommodate every possible dietary restriction, but it's always a nice gesture to include as many people as possible and doing so can also help you assemble a more diverse, flavorful menu.

last-minute appetizers
When you need something ASAP.

stuffed cherry tomatoes
Cut ¼-inch slices off tops of 1 pint cherry tomatoes and gently scoop out seeds. Stir 4 ounces goat cheese and 2 tablespoons olive tapenade together in bowl until smooth. Transfer cheese mixture to small zipper-lock bag and press cheese into one corner. Twist bag tightly, squeezing out as much air as possible. Snip off corner of bag, insert tip into each tomato, and squeeze to fill. Garnish with parsley and serve.

prosciutto-wrapped melon
Trim rind from 1 medium cantaloupe, cut melon in half, and scoop out seeds with spoon. Cut each half into eight ½-inch-wide crescents. Cut each crescent in half crosswise. Cut 16 thin slices prosciutto (8 ounces) in half lengthwise and wrap 1 piece around each melon slice. Serve.

edamame with sea salt
Bring 4 quarts water to boil in large pot. Add 1 pound frozen edamame in pods and 1 tablespoon salt and cook until just tender, 3 to 5 minutes. Drain and toss with 2 teaspoons salt. Serve warm.

boursin–cheddar cheese spread
Process softened 5.2-ounce package of Boursin Garlic and Fine Herbs spread with 1 cup shredded extra-sharp cheddar cheese, 2 tablespoons mayonnaise, ½ tablespoon Worcestershire sauce, and pinch cayenne pepper in food processor until smooth, scraping down sides as needed, about 1 minute. Transfer to serving bowl, sprinkle with 2 tablespoons minced chives, and serve with crackers or thinly sliced baguette.

menu starter kit

These menus are designed for a party where appetizers are the only food being served. Each of these lists will serve 6 to 8 people. You can also scale down by picking just 2 or 3 appetizers from a particular menu or scale up by making multiple batches or more than one flavor variation of a single appetizer. *(Note: See pages 174–175 for lists of all the gluten-free, dairy-free, vegetarian, and vegan recipes in this book.)*

antipasto
- prosciutto-wrapped figs with gorgonzola (23)
- marinated olives (50)
- bruschetta with artichoke and parmesan topping (71)
- rosemary and garlic white bean dip (110)
- broiled shrimp cocktail with creamy tarragon sauce (159)

quick-prep
- marinated artichoke hearts and stuffed pickled sweet peppers (16)
- parmesan-pepper popcorn (56)
- naan tarts with ricotta and sun-dried tomatoes, and olive tapenade (79)
- pan-fried halloumi with garlic-parsley sauce (139)
- easy crab rangoon (152)

game day
- stuffed mushrooms with bacon and blue cheese (18)
- cajun-spiced popcorn (56)
- blt canapés with basil mayonnaise (73)
- ultimate smoky seven-layer dip (104)
- oven-fried chicken wings with buffalo wing sauce (168)

cheese, please
- stuffed mushrooms with cheddar, fennel, and sage (18)
- cheddar cheese coins (61)
- naan tarts with artichokes, pesto, and goat cheese (79)
- baked brie with honeyed apricots (108)
- green chile cheeseburger sliders (132)

gluten-free
- stuffed mushrooms with chorizo and manchego (18)
- kale chips (54)
- crispy polenta squares with olive tapenade (88)
- spinach dip with feta, lemon, and oregano (97)
- spanish-style garlic shrimp (160)

tapas
- easy mini chicken empanadas (38)
- homemade cheese straws (62)
- serrano and manchego crostini with orange honey (74)
- cilantro-lime spinach dip (97)
- spanish tortilla with garlic mayonnaise (141)

french flavors
- bacon and chive deviled eggs (15)
- gruyère, mustard, and caraway cheese coins (61)
- caramelized onion, pear, and bacon tart (86)
- chicken liver pâté (123)
- gougères (128)

seafood
- bacon-wrapped scallops (26)
- fisherman's friend party mix (59)
- smoked salmon and leek tart (85)
- caesar dip with parmesan and anchovies (93)
- fried calamari (155)

summer picnic
- curry deviled eggs (15)
- barbecue party mix (59)
- bruschetta with grape tomato, white bean puree, and rosemary topping (71)
- ultimate seven-layer dip (104)
- korean fried chicken wings (171)

vegetarian
- asparagus puffs (35)
- crispy spiced chickpeas (49)
- fennel, olive, and goat cheese tarts (82)
- roasted artichoke dip (100)
- mini cheese quiches (136)

meze
- spanakopita (32)
- olive oil–sea salt pita chips (65)
- tomato and mozzarella tart (80)
- spicy whipped feta (107)
- lamb meatballs with yogurt sauce (167)

tea party
- shrimp salad on endive (30)
- cinnamon-spiced nuts (53)
- homemade gravlax on pumpernickel with crème fraîche (77)
- easy mushroom pâté (120)
- blini (147)

crudités done right

A well-assembled platter of crudités and a dip or two gives you a fresh and healthy appetizer. Not only is it cheaper to prepare your own, but it also guarantees fresher crudités and lets you serve a wider variety of vegetables. You can prepare crudités up to two days in advance. Keep fresh vegetables wrapped in damp paper towels in a zipper-lock bag in the refrigerator. Store blanched vegetables in an airtight container. You can also give celery and carrot sticks extra freshness by standing them in a glass with a few ice cubes in the bottom.

to blanch Some vegetables need to be blanched and shocked in ice water to help preserve their color and crisp texture. Bring 6 quarts water and 2 tablespoons salt to a boil in a large pot over high heat. Cook the vegetables, one type at a time, until slightly softened but still crunchy at the core, following the times below. Transfer the blanched vegetables immediately to a bowl of ice water until completely cool, then drain and pat dry.

bell peppers Slice off top and bottom of pepper and remove seeds and stem. Slice down through side of pepper, unroll it so that it lies flat, then slice into ½-inch-wide strips.

carrots and celery Slice both celery and peeled carrots lengthwise into long, elegant lengths rather than short, stumpy pieces.

radishes Choose radishes with green tops still attached so each half has leafy handle for grasping and dipping. Trim each radish and slice in half through stem.

broccoli and cauliflower Place head of broccoli or cauliflower upside down on cutting board and use chef's knife to trim off florets close to heads. Cut larger florets into bite-size pieces by slicing down through stem. Blanch broccoli and cauliflower (separately) for 1 to 1½ minutes.

green beans Line beans up in row on cutting board and trim off inedible stem ends with one slice. Blanch beans for 1 minute.

snow and snap peas Use paring knife to snip off tip of pod and pull along flat side to remove tough, fibrous string that runs along straight side of snow and snap peas. Blanch snow and snap peas separately for 15 seconds.

all about cheese

There is a bewildering variety of American and European cheeses, both in specialty cheese shops and at the supermarket. The selection listed here includes some of the more popular and widely available cheeses, with descriptions of their flavors and textures to help you put together a balanced cheese plate. For long-term storage in the refrigerator, we find that cheeses are best wrapped in parchment paper and then in aluminum foil. The paper allows the cheese to breathe, while the foil keeps out off-flavors from the refrigerator and prevents the cheese from drying out.

asiago
This cow's-milk cheese is sold at various ages. Fresh Asiago is firm like cheddar and the flavor is fairly mild. Aged Asiago is drier and has a much sharper, saltier flavor.

cheddar
The American versions of this cow's-milk cheese are softer in texture, with a tangy sharpness, whereas British cheddars are drier, with a nutty sharpness. Older farmhouse cheddar is best eaten by itself. Cheddar can also be found smoked.

feta
A fresh cheese made from cow's, goat's, or sheep's milk (or a combination thereof), feta is a staple in many Mediterranean countries. It is made in a variety of styles, from dry and crumbly to soft and creamy; flavors range from mild to tangy and salty.

brie
A popular soft cow's-milk cheese from France, Brie is creamy with a slight mushroom flavor, subtle nuttiness, and an edible rind. It is a classic choice for a cheese tray.

colby
Colby is a semisoft cow's-milk cheese from the United States that is very mild in flavor. One of only a few cheeses that have true American roots, Colby is a wonderful melting cheese.

fontina
Fontina is a semisoft cow's-milk cheese from Italy with an earthy flavor. The domestic variety (with its bright red coating) is buttery and melts well but lacks the complex flavor of the Italian original.

camembert
Camembert is a soft cow's-milk cheese from France with an edible rind. Similar to Brie in texture, Camembert is more pungent, with a stronger flavor.

emmentaler
This semifirm cow's-milk cheese from Switzerland and France is a classic Swiss-style cheese. It has a fruity flavor with a sweet, buttery nuttiness.

goat cheese
Goat cheeses range from creamy, tangy fresh cheeses to firm, pungent aged cheeses. French goat cheeses (called *chèvres*) are typically more complex than their American counterparts.

gorgonzola
Gorgonzola can be aged and crumbly or young and creamy. In general, we like young Gorgonzola, often called Gorgonzola dolce; its flavor is less overwhelming.

jarlsberg
Jarlsberg is a Swiss-style cow's-milk cheese from Norway that has a waxy texture and a straightforward Swiss cheese flavor, with a hint of fruitiness.

pecorino romano
Pecorino Romano has an intense peppery flavor and a strong sheepy quality. Like Parmesan, Pecorino Romano is designed for grating, but it has a much saltier and more pungent flavor.

gouda
Gouda is a semifirm to firm cow's-milk cheese from Denmark. Young gouda is mild and slightly sweet, whereas aged gouda is dry and crumbly, with deep caramel flavors and a sharp zing.

manchego
Manchego is a semifirm to firm sheep's-milk cheese from Spain that is nutty, salty, and acidic. Serve it with crackers and fresh fruit.

provolone
Provolone, a cow's-milk cheese from Italy, is made in two styles. The semifirm mild version is widely available and is usually sold sliced. There is also a firm, aged style that is salty, nutty, and sweet. It makes a nice addition to any cheese platter.

gruyère
Gruyère is a semifirm cow's-milk cheese from France and Switzerland that is strong, fruity, and earthy in flavor, with a hint of honey-flavored sweetness.

mozzarella
This cow's- or water buffalo's–milk cheese from Italy is available fresh or semisoft. The semisoft version is mild in flavor and is usually melted. Fresh mozzarella is richer and sweeter. It is sold in balls of various sizes and usually served on its own.

ricotta salata
Fresh ricotta cheese is salted and pressed to make this firm but crumbly cheese with a texture that is similar to feta but has a flavor that is milder and far less salty.

havarti
This semisoft cow's-milk cheese from Denmark is often flavored with herbs or caraway seeds due to its mild flavor.

parmesan
Parmesan is a hard, grainy cow's milk cheese. We like authentic Italian Parmigiano-Reggiano, which has an unmistakable fruity, nutty flavor. Parmesan is excellent served with fresh fruit.

roquefort
Roquefort is a blue-veined sheep's-milk cheese from France. Aged in specially designated caves, it's probably the oldest known cheese variety. Roquefort's flavor is bold but not overpowering, and salty with a slight mineral tinge.

anatomy of a cheese plate

Pair different flavors (mild to strong), textures (soft, semisoft, semifirm, and hard), and types of cheeses (such as goat's milk and cow's milk) to make the platter interesting.

For cheese accompaniments, either go complementary, like zesty onion relish and tangy goat cheese, or contrasting, like sweet fig jam and a sharp, bracing blue cheese.

Remove cheeses from the refrigerator 1 to 2 hours before serving and keep them wrapped until serving time to prevent them from drying out.

For portion size, figure on 2 to 3 ounces of cheese per person.

Choose mild-flavored bread and crackers that don't overshadow the cheese.

Think about texture: Crunchy nuts and crisp apples can add contrast to soft cheeses.

Fresh and dried fruit, chutneys and jams, nuts, honey, and olives are all good additions.

buying beer

In recent years, beer has come into its own as a partner for food. The beer on the market today has all the variety of aromas and flavors that we associate with wine, with the advantage of being easier on the wallet. These developments in the world of beer can make it harder to pick a single type of beer to serve. A person who loves wheat beers may not have any taste for stouts, so you will probably want to choose a few different options to have on hand for beer-drinkers at your party. Here are a few common styles to be aware of.

india pale ale
IPAs are known for their very pronounced hoppy flavors, which can be bitter, floral, or piney depending on the variety of hops used. Be aware: the hoppier the beer, the higher the alcohol content by volume (ABV).

pilsner
Though it's brewed like lager, pilsner is lighter in color and body and has a floral, slightly spicy finish. True pilsners often have a high level of carbonation due to months of aging.

wheat beer
Wheat beers have a hazy, unfiltered look, and taste of clove, banana, and citrus. Brewers rely on warm fermentation and a particular strain of yeast to produce the yeasty, spicy flavor of these beers.

saison
Saisons are yeasty, hoppy European ales made from mixed grains and noble hops. Saisons pair very well with food, especially cheese. American beers brewed in the same style are often labeled "farmhouse" ales.

porter
Relatively low-alcohol porters are known for their chocolate, toffee, and toasty flavors, which come from the malts used to make them—these dark malts are also what make porter so dark.

cider
Hard cider is an alcoholic beverage made from fermented apple juice. Ciders are available in a variety of styles and flavors from sweet to dry. We recommend ciders with a high sugar content, which contributes to stronger apple flavor.

lager
Unlike ales, which ferment at high temperatures for more yeast activity and flavor, lagers ferment at cool temperatures before aging to develop more subtle, crisp flavors. Lagers tend to be light- to medium-bodied.

stout
This dark brew uses toasted malts, giving stouts roasted, sometimes bitter coffee-like notes. Since sugars are cooked off during roasting, the resulting stouts are usually lower in alcohol (and calories) than you'd expect.

session
Session beers were invented as a response to ever-increasing alcohol percentages in craft beers such as India Pale Ales. Session beers are brewed with the same care for flavor as craft beers, but with an alcohol content usually between 4 and 5 percent.

which wine?

wine, open and shut

Our favorite way to open a bottle of wine is with a sturdy, easy-to-use waiter's corkscrew. Look for one with an ergonomically curved body and a hinged fulcrum that makes it easy to lever out the cork. Our winning model, **Pulltap's Classic Evolution Corkscrew by Pulltex**, also has a Teflon-coated worm, which reduces the friction as you twist it into the cork. If you're looking for an even easier option, we like the **Waring Pro Professional Cordless Wine Opener** for an electronic assist.

Once your bottle is open, if it's a red wine, you might want to aerate it to soften the tannins and balance the flavors. While we've found that this can be achieved by simply pouring the wine back and forth between two pitchers about 15 times, you can also use a gadget like the **Nuance Wine Finer**, a tube-like aerator that slides right into the neck of your bottle leaving only a pouring spout, for neat hands-free aerating. You may also want to preserve the remains of an opened bottle of wine. For that, you need a way to eliminate all the air in the bottle. Many gadgets exist that can keep an open bottle drinkable for up to a month. We like **The Wine Preserver** from **Air Cork**, which uses a balloon to seal off the air in the bottle.

Wine can be one of the easiest things to serve at a party, but it can also be intimidating to choose the right kind. Stephen Meuse, our guru for all things wine, suggests thinking about it in terms of the following five basic categories of wine that should take care of most of your party needs. Discussion with the staff at your local wine shop can help you figure out which specific bottles to buy that fit into these categories. If you're serving wine as the main option at your party, you should plan on about one bottle for every two guests. Feel free to mix varieties of wine based on your tastes and your menu.

aperitifs Wines in this category are the perfect complement to simple hors d'oeuvres or small plates served before dinner. Choose an inexpensive sparkling wine, such as a pink, lightly fizzy, fully dry Lambrusco. This category is great with salty bites and cured meats.

fruity whites To pair with lighter menus, choose a white wine with a fruity profile. This might mean an aromatic white such as a Sauvignon Blanc or Riesling, or a nonaromatic white like a Chardonnay, depending on your taste. Keep in mind that the more aromatic the wine, the harder it is to successfully pair it with a variety of foods.

savory whites A savory white is one that is less fruity and has more earthy or mineral flavors. This profile makes these wines easier to pair with foods than their fruitier counterparts. Look for wines from Central Italy, such as a Verdicchio. Savory whites can be a good choice even when you think the food might call for something red.

light-bodied, fruity, chillable reds Light, chilled reds are bright, juicy, and great to pair with snacks like chicken wings or taquitos. Cooling light-bodied wines down to around 50 degrees highlights their innate freshness. Wines in this category include Beaujolais and Pinot Noir.

full-bodied, savory reds This category includes standard-body, nicely textured reds with lots of earthy character that pair best with savory, meaty foods. Try a Cabernet Sauvignon or similarly full-bodied varietal.

bar stocking and cocktail basics

You don't have to stock your liquor cabinet like a professional bartender in order to show your guests a good time. A simple setup that allows guests to make a few basic drinks is a great option, or you can choose a few signature cocktails ahead of time and stock up with those specifically in mind. If you're going for a more general setup, here are some tips:

just the basics Stock one or two more neutral spirits like vodka or light rum as well as some with a stronger profile, such as gin or whiskey.

easy upgrades The addition of a sweet liqueur like Grand Marnier or a bitter liqueur like Campari helps diversify the number of drinks you can make. Dry and sweet vermouth are similarly useful building blocks. Vermouth and liqueurs can also serve as aperitifs or digestifs on their own.

better with bitters Another ingredient that makes a huge impact even in tiny amounts is cocktail bitters. Stock a few different types and your flavor options will increase exponentially.

simply sweet Sugar syrup (also called simple syrup) is an essential ingredient in many cocktails. Make your own by combining 1 cup water and 1 cup granulated sugar in a small saucepan over medium-high heat until the sugar dissolves, about 5 minutes. Let cool to room temperature before using. The syrup can be kept in the refrigerator for one week. For more flavor, simmer one of these ingredients with the water and sugar (strain the flavorings out once the syrup cools): 1 tablespoon citrus zest; 1 cinnamon stick; one 2-inch piece fresh ginger, cut into four coins; 3 ounces fresh berries; or 3 tablespoons packed mint leaves.

a cherry on top Stock a variety of citrus fruits and juices: These are basic cocktail ingredients and you'll also want the peels for garnishing drinks. Other common garnishes are maraschino cherries and olives.

beyond booze The most useful nonalcoholic mixers are club soda and tonic water. You may also want to have cranberry juice and some kind of soft drink like ginger ale or cola. You should always have a nonalcoholic option available for your guests.

mix it up A cocktail shaker is an important component of every home bar. There are two basic types of cocktail shakers: Boston shakers and cobbler shakers. If you're new to cocktail making, a cobbler shaker is a good choice, as it comes with a built-in strainer—all you have to do is fit the parts together and shake. We like the **Tovolo Stainless Steel 4-in-1 Cocktail Shaker**, which is a breeze to use and to clean. More experienced cocktail makers might want to try a Boston shaker. While Boston shakers require a separate strainer and take practice to use correctly, they offer more speed, control, and security during use—and they're less likely than cobblers to leak or fall apart. We recommend **The Boston Shaker's Professional Boston Shaker, Weighted**.

with a twist

There are three common citrus garnishes for cocktails. The first is a "twist," a simple disk of citrus peel that is squeezed over the drink, then rubbed around the rim of the glass and discarded.

The second is a "flamed twist," in which a flame is held between the drink and the peel so that when the peel is squeezed, its oils ignite briefly.

The third type is a "swath," a band of zest with a little pith attached that is twirled and placed in the drink. We made all three types of garnishes with orange peel and tasted each in a Negroni. The twist contributed bright orange notes that enlivened the drink. The flamed twist offered sulfurous undertones. The swath added citrus notes along with mild bitterness from the pith.

In sum, fancy citrus garnishes are more than just ornamental: Your choice should hinge on the flavor profile you're trying to create.

wrapped and stuffed

15 curry deviled eggs
 bacon and chive deviled eggs
16 marinated artichoke hearts and stuffed pickled sweet peppers
18 stuffed mushrooms with parmesan and thyme
 with cheddar, fennel, and sage
 with olives and goat cheese
 with chorizo and manchego
 with bacon and blue cheese
21 stuffed jalapeños
23 prosciutto-wrapped figs with gorgonzola
24 prosciutto-wrapped asparagus
26 broiled bacon-wrapped sea scallops
 broiled bacon-wrapped shrimp
29 chinese chicken lettuce wraps
30 shrimp salad on endive
32 spanakopita
35 asparagus puffs
37 beef and bean taquitos with avocado sauce
38 easy mini chicken empanadas
40 potstickers with scallion dipping sauce
42 steamed chinese dumplings (shu mai)
45 fresh vegetable spring rolls

curry deviled eggs

why this recipe works The best deviled eggs start with the best hard-cooked eggs. Conventional wisdom insists that older eggs peel more easily than fresh eggs but we wanted to be able to start with eggs of any age and still end up with flawlessly smooth peeled results. Instead of using a cold-water start, we placed cold eggs directly into hot steam, which rapidly denatured the outermost egg white proteins, causing them to shrink and pull away from the shell membrane. We could then slip the eggshells off easily to reveal smooth, unblemished hard-cooked eggs. Fresh herbs, curry powder, and cayenne elevated the filling, and we also created a variation with bacon and chives. Be sure to use large, cold eggs that have no cracks. If you don't have a steamer basket, use a spoon or tongs to gently place the eggs in the water. It doesn't matter if the eggs are above the water or partially submerged. You can double this recipe as long as you use a pot and steamer basket large enough to hold the eggs in a single layer. If you prefer, use a pastry bag fitted with a large plain or star tip to fill the egg halves.

serves 4 to 6

6 eggs

3 tablespoons mayonnaise

1 tablespoon minced fresh parsley, plus 12 small whole parsley leaves for garnishing

1½ teaspoons lemon juice

1 teaspoon Dijon mustard

1 teaspoon curry powder

Pinch cayenne pepper

1. Bring 1 inch water to rolling boil in medium saucepan over high heat. Place eggs in steamer basket. Transfer basket to saucepan. Cover, reduce heat to medium-low, and cook eggs for 13 minutes.

2. When eggs are almost finished cooking, fill large bowl halfway with ice and water. Using tongs or spoon, transfer eggs to ice bath; let sit for 15 minutes. Peel eggs.

3. Slice each egg in half lengthwise with paring knife. Transfer yolks to bowl; arrange whites on serving platter. Mash yolks with fork until no large lumps remain. Add mayonnaise and use rubber spatula to smear mixture against side of bowl until thick, smooth paste forms, 1 to 2 minutes. Add minced parsley, lemon juice, mustard, curry powder, and cayenne and mix until fully incorporated.

4. Transfer yolk mixture to small, heavy-duty plastic bag. Press mixture into 1 corner and twist top of bag. Using scissors, snip ½ inch off filled corner. Squeezing bag, distribute yolk mixture evenly among egg white halves. Garnish each egg half with parsley leaf and serve.

variation

bacon and chive deviled eggs
Cook 2 slices bacon, chopped fine, in 10-inch skillet over medium heat until crispy, 5 to 7 minutes. Using slotted spoon, transfer bacon to paper towel–lined plate. Reserve 1 tablespoon fat. Cook and peel 6 eggs as directed in steps 1 and 2. Slice each egg in half lengthwise with paring knife. Transfer yolks to bowl; arrange whites on serving platter. Mash yolks with fork until no large lumps remain. Add 2 tablespoons mayonnaise and 1 teaspoon Dijon mustard and use rubber spatula to smear mixture against side of bowl until thick, smooth paste forms, 1 to 2 minutes. Add reserved bacon fat, 1 tablespoon minced fresh chives, 2 teaspoons distilled white vinegar, ⅛ teaspoon salt, and pinch cayenne and mix until fully incorporated. Stir in three-quarters of bacon. Fill whites as directed in step 4. Sprinkle each egg half with remaining bacon and serve.

to make ahead
Unpeeled hard-cooked eggs can be refrigerated for up to 1 week. Filled deviled eggs can be refrigerated in airtight container for up to 24 hours before serving. If making ahead, reserve garnish and add just before serving.

marinated artichoke hearts and stuffed pickled sweet peppers

why this recipe works The very best appetizer doesn't always have to be the one with the fanciest preparation. Stuffed peppers are a mainstay in the Italian antipasto tradition, and with good reason. They offer a bold flavor combination of salty, savory, and spicy; plus, they come together in a snap. For our take on stuffed peppers, we decided to add sweetness to the mix by using jarred sweet cherry peppers. Tasters liked the combination of subtly tangy fontina and rich prosciutto for the filling. Pairing these peppers with the bright acidity and bite of artichoke hearts marinated with herbs and aromatics made for an easy appetizer that was wonderfully complex in its flavors. Make sure to dry the artichokes thoroughly before tossing them with the marinade or they will be watery. Sweet cherry peppers are sold in jars and at the deli counter alongside the olives. If placing the peppers on a platter, help them stand upright by using a paring knife to trim the bottom of the peppers level. Serve with thin breadsticks.

serves 8

¼ cup minced fresh parsley or basil

1 shallot, minced

¾ teaspoon grated lemon zest plus 2 tablespoons juice

1 garlic clove, minced

Salt and pepper

¾ cup extra-virgin olive oil

18 ounces frozen artichoke hearts, thawed, patted dry, and quartered if whole

16 ounces pickled sweet cherry peppers (25 peppers)

6 ounces fontina cheese, cut into ½-inch cubes

7 ounces thinly sliced prosciutto, cut in half lengthwise

1. Whisk parsley, shallot, lemon zest and juice, garlic, ¼ teaspoon salt, and ⅛ teaspoon pepper together in small bowl. Whisking constantly, drizzle in olive oil. Measure out 2 tablespoons dressing and set aside for stuffed peppers. Gently fold artichoke hearts into remaining dressing, cover, and refrigerate until flavors meld, at least 3 hours.

2. Meanwhile, remove stem and core of peppers with paring knife. Rinse peppers well and pat dry with paper towels. Roll each piece of cheese inside 1 piece prosciutto and stuff inside cored peppers.

3. To serve, transfer artichoke hearts to serving bowl and season with salt and pepper to taste. Whisk reserved dressing to re-emulsify, then drizzle over peppers.

to make ahead
Marinated artichokes can be refrigerated for up to 24 hours before serving. Peppers can be assembled, covered, and refrigerated for up to 24 hours. Bring to room temperature and drizzle with reserved dressing before serving.

stuffed mushrooms with parmesan and thyme

why this recipe works Forget about leathery, dried-out stuffed mushrooms with bland, watery filling; these are meaty bites full of great savory flavor. To get rid of excess moisture before stuffing, we roasted the mushrooms gill side up until their juice was released and they were browned; we then flipped them gill side down to let the liquid evaporate. To create the filling, we chopped the mushroom stems in the food processor and sautéed them with garlic and wine. Cheese bound the filling together, and a final hit of acid brightened the earthy, savory flavor. Once you know how easy it is to make great stuffed mushrooms, you'll want to try all our savory flavor variations.

serves 4 to 6

24 large white mushrooms
(1¾ to 2 inches in diameter),
stems removed and reserved

¼ cup olive oil

Salt and pepper

1 small shallot, minced

2 garlic cloves, minced

¼ cup dry white wine

1 ounce Parmesan cheese, grated
(½ cup)

1 teaspoon minced fresh thyme

1 teaspoon lemon juice

1. Adjust oven rack to middle position and heat oven to 425 degrees. Line rimmed baking sheet with aluminum foil. Toss mushroom caps with 2 tablespoons oil, ¼ teaspoon salt, and ⅛ teaspoon pepper in large bowl. Arrange caps gill side up on prepared sheet and roast until juice is released, about 20 minutes. Flip caps and roast until well browned, about 10 minutes; set aside.

2. Meanwhile, pulse reserved stems, shallot, garlic, and ⅛ teaspoon pepper in food processor until finely chopped, 10 to 14 pulses. Heat remaining 2 tablespoons oil in 8-inch nonstick skillet over medium heat until shimmering. Add stem mixture to skillet and cook until golden brown and moisture has evaporated, about 5 minutes. Add wine and cook until nearly evaporated and mixture thickens slightly, about 1 minute. Transfer to bowl and let cool slightly, about 5 minutes. Stir in Parmesan, thyme, and lemon juice. Season with salt and pepper to taste.

3. Flip caps gill side up. Divide stuffing evenly among caps. Return caps to oven and bake until stuffing is heated through, 5 to 7 minutes. Serve.

variations

stuffed mushrooms with cheddar, fennel, and sage
Substitute ¼ cup shredded sharp cheddar cheese for Parmesan, ½ teaspoon fennel seeds and ½ teaspoon dried sage for thyme, and malt vinegar for lemon juice. Add ¼ teaspoon red pepper flakes to cooked stuffing.

stuffed mushrooms with olives and goat cheese
Substitute ¼ cup crumbled goat cheese for Parmesan, 1 teaspoon chopped fresh oregano for thyme, and red wine vinegar for lemon juice. Add 3 tablespoons chopped pitted kalamata olives to cooked stuffing.

stuffed mushrooms with chorizo and manchego
In step 2, before adding stem mixture, cook 1½ ounces Spanish-style chorizo sausage, cut into ¼-inch pieces, in skillet until lightly browned, about 2 minutes. Proceed with remainder of step 2, substituting ¼ cup shredded Manchego cheese for Parmesan, 2 tablespoons chopped fresh parsley for thyme, and sherry vinegar for lemon juice. Add ½ teaspoon paprika to cooked stuffing.

stuffed mushrooms with bacon and blue cheese
In step 2, omit oil and cook 2 slices finely chopped bacon in skillet (before adding stem mixture) until crispy, about 5 minutes. Proceed with remainder of step 2, substituting ¼ cup crumbled blue cheese for Parmesan, 2 tablespoons chopped fresh chives for thyme, and cider vinegar for lemon juice.

to make ahead
Stuffed caps can be refrigerated for 24 hours before baking. Increase baking time to 10 to 15 minutes.

stuffed jalapeños

why this recipe works Crispy, creamy, and spicy, stuffed jalapeños are a classic crowd-pleaser. But between the stuffing and traditional deep frying, making them is usually a pain, and all too often the first bite leaves you holding an empty batter shell while you struggle to eat the entire jalapeño. To make these appetizers easier to prepare (and eat), we swapped the deep-fried batter for a crunchy bread-crumb topping and baked them open-faced. For the creamy filling, we blended together cheddar for its bold flavor and cream cheese for its silkiness. Scallions and chili powder added complexity and a little heat, and a bit of lime juice contributed brightness. To ensure that the topping stayed crisp, we used extra-crunchy panko bread crumbs and toasted them in a skillet before sprinkling them over the filling. To make the peppers spicier, reserve and add the jalapeño seeds to the filling.

½ cup panko bread crumbs

1 tablespoon vegetable oil

12 medium jalapeño chiles, preferably with stems

6 ounces cheddar cheese, shredded (1½ cups)

4 ounces cream cheese, softened

2 scallions, chopped fine

2 teaspoons lime juice

1 teaspoon chili powder

½ teaspoon salt

Vegetable oil spray

1. Adjust oven rack to middle position and heat oven to 350 degrees. Line rimmed baking sheet with aluminum foil. Toss panko with oil and toast in 12-inch nonstick skillet over medium-high heat, stirring often, until well browned, 5 to 10 minutes.

2. Cut each jalapeño in half lengthwise through stem, then remove ribs and seeds. Combine cheddar, cream cheese, scallions, lime juice, chili powder, and salt in bowl. Spoon cheese mixture evenly into jalapeños and transfer to prepared sheet. Top with toasted panko and spray lightly with oil spray. Bake until hot, 15 to 20 minutes. Serve.

seeding jalapeños

To remove ribs and seeds from jalapeño, cut pepper in half lengthwise, then use melon baller to scoop down inside of each half.

prosciutto-wrapped figs with gorgonzola

why this recipe works Few food pairings are more perfect than savory, salty prosciutto and sweet fresh figs. To add another level of sweet-salty complexity and textural interest to this appetizer, we also incorporated bold, pungent blue cheese and golden honey into the mix. We started by halving the figs to make them easier to eat. For the cheese, tasters preferred creamy, assertive Gorgonzola. Small mounds of the cheese, placed in the center of each fig before adding the honey, offered a rich, bold counterpoint to the figs' tender flesh and sweet flavor. Briefly microwaving the honey ensured that it was easy to drizzle over the cheese-stuffed figs. Finally, we wrapped the whole thing in thin slices of prosciutto. To guarantee the ham stayed put, we stuck a toothpick through the center of each fig. Be sure to choose ripe figs for this recipe. They not only taste best, but also yield easily when mounding the blue cheese gently into the centers.

serves 8 to 10

2 ounces Gorgonzola cheese

16 fresh figs, stemmed and halved lengthwise

1 tablespoon honey

16 thin slices prosciutto (8 ounces), cut in half lengthwise

Mound 1 teaspoon Gorgonzola into center of each fig half. Microwave honey in bowl to loosen, about 10 seconds, then drizzle over cheese. Wrap prosciutto securely around figs, leaving fig ends uncovered. Secure prosciutto with toothpick and serve.

to make ahead
Wrapped figs can be refrigerated for up to 8 hours; bring to room temperature before serving.

notes from the test kitchen
buying prosciutto
Not too long ago, the only way to buy prosciutto was to find an Italian market and wait while someone sliced an imported ham by hand. But since domestic producers have gotten into the game, many supermarkets now carry this cured pork product in grab-and-go packages. Look for a brand that's aged at least 12 months for complex flavor and sliced paper-thin to avoid chewiness. The ingredients list should include just pork and salt. Our winning brand is tender, buttery **Volpi Traditional Prosciutto**. Another advantage to presliced prosciutto is that the sealed packages can keep for several months, making them easy to keep on hand.

prosciutto-wrapped asparagus

why this recipe works While you certainly can't go wrong when wrapping anything in prosciutto, asparagus makes a particularly attractive subject. The contrasting textures of the tender spears and the buttery prosciutto give this simple preparation subtle depth. We found that a few minutes of broiling was a fast and unfussy method for parcooking the asparagus, rendering it tender but allowing it to remain crisp and brightly colored. A pat of spreadable Boursin cheese provided tang and a welcome herbal note and also served as a handy paste to hold the prosciutto around the spears. Do not introduce any additional salt to this recipe because the prosciutto is already very salty. If necessary, you can substitute thin asparagus for thick: Just roll two thin spears into each bundle. Don't overcook the asparagus in step 3 or the prosciutto will turn tough and leathery; the spears should just be warmed through before serving.

serves 6 to 8

2 pounds thick asparagus, trimmed

2 teaspoons extra-virgin olive oil

1 (5.2-ounce) package Boursin Garlic & Fine Herbs cheese, room temperature

16 thin slices prosciutto (8 ounces), cut in half crosswise

1. Adjust oven rack 3 inches from broiler element and heat broiler. Toss asparagus with oil and lay in single layer on rimmed baking sheet. Broil until asparagus is crisp-tender, about 5 minutes, tossing halfway through broiling. Let asparagus cool slightly.

2. Spread Boursin evenly over each piece of prosciutto. Roll prosciutto around center of each asparagus spear and transfer to clean rimmed baking sheet.

3. Adjust oven rack to middle position and heat oven to 450 degrees. Bake prosciutto-wrapped asparagus until just warmed through, about 5 minutes. Serve warm.

to make ahead
Wrapped asparagus on baking sheet can be covered loosely in plastic wrap and stored at room temperature for up to 4 hours before baking.

trimming asparagus

1. Remove 1 stalk of asparagus from bunch and bend it at thicker end until it snaps.

2. With broken asparagus as guide, trim tough ends from remaining asparagus bunch.

broiled bacon-wrapped sea scallops

why this recipe works Bacon-wrapped anything is always a party hit, but its smoky flavor pairs especially well with briny scallops for a simple yet impressive appetizer. The problem is making sure the bacon is crisp but still pliable enough to wrap around the scallops and that the balance between bacon and scallop is right. We found that a whole slice of bacon was too much for one scallop—the smoky flavor was overwhelming and it also turned the appetizer unappealingly greasy. Smaller strips of bacon worked much better. As for broiling the scallops, we found that they finished cooking before the bacon had time to brown and crisp. To even out the timing, we parcooked the bacon in the microwave. This had the added benefit of rendering some of the bacon fat ahead of time for less-greasy results. From there it was a cinch to wrap the parcooked bacon around the scallops and pop the whole thing under the broiler. When buying scallops, be sure to buy large sea scallops rather than the small bay scallops and dry scallops rather than wet scallops (wet scallops are treated with preservatives that dull the scallops' flavor and ruin their texture).

serves 6 to 8

4 slices bacon

¼ teaspoon salt

⅛ teaspoon ground pepper

Pinch cayenne pepper

1 pound large sea scallops (about 24 scallops), tendons removed

2 tablespoons minced fresh chives

1. Adjust oven rack 6 inches from broiler element and heat broiler. Line broiler-pan bottom with foil and top with slotted broiler-pan top.

2. Slice each piece of bacon lengthwise into 2 long, thin strips, then cut each strip into 3 short pieces (total of 24 bacon pieces). Spread bacon pieces out over 4 layers of paper towels on microwave-safe plate, then cover with 2 more layers of paper towels. Microwave on high until bacon fat begins to render but bacon is still pliable, 1 to 2 minutes.

3. Meanwhile, place scallops in medium bowl. Sprinkle salt, pepper, and cayenne over scallops and toss to coat.

4. Wrap piece of microwaved bacon around center of each scallop and place on broiler-pan top, pinning bacon ends underneath the scallop. Broil until sides of scallops are firm and edges of bacon are brown, rotating broiler

pan halfway through cooking, 3 to 4 minutes. Skewer scallop with toothpicks, transfer to serving platter, and sprinkle with chives. Serve immediately.

variation

broiled bacon-wrapped shrimp
Replace scallops with 1 pound extra-large shrimp (21 to 25 per pound), peeled and deveined.

prepping scallops

Use your fingers to peel away small, crescent-shaped muscle that is sometimes attached to scallops, as this tendon becomes incredibly tough when cooked.

chinese chicken lettuce wraps

why this recipe works There aren't many chain restaurant appetizers worth making at home, but Chinese chicken lettuce wraps are an exception. Unfortunately, most recipes for this easy, refreshing dish suffer from stringy meat drowned in bland sauce. To remedy this, we started with chicken thighs and marinated them in soy sauce and rice wine. We also tossed the meat in a cornstarch slurry, which helped it retain moisture. A savory sauce added at the very end melded all the ingredients together.

serves 6

chicken
1 pound boneless, skinless chicken thighs, trimmed and cut into 1-inch pieces

2 teaspoons Chinese rice wine or dry sherry

2 teaspoons soy sauce

2 teaspoons toasted sesame oil

2 teaspoons cornstarch

sauce
3 tablespoons oyster sauce

1 tablespoon Chinese rice wine or dry sherry

2 teaspoons soy sauce

2 teaspoons toasted sesame oil

1/2 teaspoon sugar

1/4 teaspoon red pepper flakes

stir-fry
2 tablespoons vegetable oil

2 celery ribs, cut into 1/4-inch pieces

6 ounces shiitake mushrooms, stemmed and sliced thin

1/2 cup water chestnuts, cut into 1/4-inch pieces

2 scallions, white parts minced, green parts sliced thin

2 garlic cloves, minced

1 head Bibb lettuce (8 ounces), washed and dried, leaves separated and left whole

Hoisin sauce

1. for the chicken Place chicken pieces on large plate in single layer. Freeze meat until firm and starting to harden around edges, about 20 minutes.

2. Whisk rice wine, soy sauce, oil, and cornstarch together in bowl. Pulse half of meat in food processor until coarsely chopped into 1/4- to 1/8-inch pieces, about 10 pulses. Transfer meat to bowl with rice wine mixture and repeat with remaining chunks. Toss chicken to coat and refrigerate for 15 minutes.

3. for the sauce Whisk all ingredients together in bowl; set aside.

4. for the stir-fry Heat 1 tablespoon oil in 12-inch nonstick skillet over high heat until smoking. Add chicken and cook, stirring constantly, until opaque, 3 to 4 minutes. Transfer to bowl and wipe out skillet.

5. Heat remaining 1 tablespoon oil in now-empty skillet over high heat until smoking. Add celery and mushrooms; cook, stirring constantly, until mushrooms have reduced in size by half and celery is crisp-tender, 3 to 4 minutes. Add water chestnuts, scallion whites, and garlic; cook, stirring constantly, until fragrant, about 1 minute. Whisk sauce to recombine. Return chicken to skillet; add sauce and toss to combine. Spoon into lettuce leaves and sprinkle with scallion greens. Serve, passing hoisin sauce separately.

shrimp salad on endive

why this recipe works This classic, elegant appetizer doesn't have to be dull or fussy. A good shrimp salad starts with tender, well-seasoned shrimp. We placed the shrimp in a cold court bouillon (a flavorful liquid of lemon juice, herbs, spices, and water) and then slowly heated them over medium heat. This gentle cooking method enabled the shrimp to draw more flavor from the poaching liquid and kept them moist and tender. A modest amount of mayonnaise added moisture and richness to the salad. Light, fresh herbs (parsley and tarragon) and lemon juice perked up and rounded out the flavors. Chopped apple added sweet crunch and leaves of endive made an ideal vessel; crisp and a little bitter, they contrasted nicely with the creamy dressing and sweet shrimp. If your shrimp are smaller than 21 to 25 per pound, the cooking time will be slightly shorter.

serves 8 to 10

1½ pounds extra-large shrimp (21 to 25 per pound), peeled, deveined, and tails removed

6 tablespoons lemon juice (2 lemons), spent lemon halves reserved

8 sprigs fresh parsley, plus 1 tablespoon minced

6 sprigs fresh tarragon, plus 1 tablespoon minced

1 tablespoon sugar

1 teaspoon black peppercorns

Salt and pepper

⅔ cup mayonnaise

1 shallot, minced

1 Granny Smith apple, peeled, cored, halved, and chopped fine

4 large heads Belgian endive (1½ pounds), leaves separated

1. Combine 3 cups cold water, shrimp, ¼ cup lemon juice, spent lemon halves, parsley sprigs, tarragon sprigs, sugar, peppercorns, and 1 teaspoon salt in medium saucepan. Place saucepan over medium heat and cook, stirring often, until shrimp are firm, pink, and opaque throughout, 8 to 10 minutes. Off heat, cover and let shrimp sit for 2 minutes.

2. Meanwhile, fill large bowl halfway with ice and water. Drain shrimp, discarding aromatics, then plunge immediately into ice bath to chill, about 3 minutes. Drain shrimp well, discarding any ice, and dry thoroughly with paper towels. Chop shrimp into small pieces.

3. Whisk mayonnaise, shallot, minced parsley, minced tarragon, and remaining 2 tablespoons lemon juice together in medium bowl. Stir in shrimp and apple and season with salt and pepper to taste. Cover bowl with plastic wrap and refrigerate for at least 2 hours.

4. When ready to serve, lay endive leaves on large serving platter. Divide shrimp salad evenly among stem ends of leaves and serve.

to make ahead
Shrimp salad can be refrigerated for up to 24 hours before serving.

removing endive leaves

Gently pull off endive leaves one at a time, continuing to trim root end as you work your way toward heart of endive.

spanakopita

why this recipe works Spanakopita, or spinach and feta pie, is one of Greece's most popular culinary exports. To translate this dish into a finger-friendly appetizer, we turned the large-format pie into individual phyllo triangles. Frozen spinach was much more convenient than fresh without any loss of flavor. To ensure even distribution of the cheese in our filling, we mixed crumbled feta into the eggs before adding the spinach. We also added ricotta cheese to give the filling creaminess. Phyllo dough is also available in larger 18 by 14-inch sheets; if using, cut them in half to make 14 by 9-inch sheets. A 1-pound package of phyllo dough contains two rolls; you will need only one roll for this recipe. Keep the second roll in the freezer for another use. Don't thaw the phyllo in the microwave; let it sit in the refrigerator overnight or on the counter for 4 to 5 hours.

serves 8 to 10

filling
8 ounces feta cheese, crumbled fine (2 cups)

6 ounces (3/4 cup) whole-milk ricotta cheese

2 large eggs, lightly beaten

4 scallions, sliced thin

3 tablespoons minced fresh dill

1 1/2 tablespoons lemon juice

1 garlic clove, minced

1/2 teaspoon ground nutmeg

Pinch pepper

15 ounces frozen chopped spinach, thawed and squeezed dry

phyllo layers
8 ounces (14 by 9-inch) phyllo, thawed

3/4 cup olive oil

1. for the filling Mix feta, ricotta, eggs, scallions, dill, lemon juice, garlic, nutmeg, and pepper together in large bowl. Stir in spinach until mixture is uniform.

2. for the phyllo layers Line 2 rimmed baking sheets with parchment paper. Lay 1 phyllo sheet on counter with short end near you. Brush sheet with oil, then top with second phyllo sheet and brush with oil. Cut sheets lengthwise into three 3-inch strips. Place 1 tablespoon filling on bottom left-hand corner of each strip. Fold up phyllo to form right-angle triangle. Continue to fold up and over to end of strip. Brush triangle with oil and place seam side down on prepared baking sheet. Repeat with remaining phyllo sheets and filling.

3. Adjust oven racks to upper-middle and lower-middle positions and heat oven to 375 degrees. Bake until golden, about 20 minutes, switching and rotating baking sheets halfway through baking. Serve warm.

to make ahead
Filling can be refrigerated for up to 24 hours. Baking sheets of filled phyllo triangles can also be wrapped in plastic and frozen. Once the triangles are frozen, the spanakopita can be stored in the freezer for up to 1 month. Increase baking time for frozen triangles to about 25 minutes.

folding phyllo triangles

1. After cutting phyllo sheets into 3 strips, place 1 tablespoon of filling on bottom left-hand corner of each strip.

2. Fold phyllo over filling to form right-angle triangle. Continue to fold up and over until you reach end of strip.

asparagus puffs

why this recipe works Things-wrapped-in-puff-pastry is a genre of appetizers all on its own, but all too often these bites bake up doughy, with undeveloped layers. We solved this problem by rolling out the pastry sheets to create a thinner wrapper. For a filling that could hold its own, we blanched asparagus for just 1 minute and then shocked it in an ice bath to immediately stop the cooking for perfectly cooked asparagus in the finished puffs. We first tried pairing it with ricotta, but its milky flavor lacked pizzazz. Creamy, tangy goat cheese, further brightened by a squeeze of lemon juice and a dash of lemon zest, was the perfect complement to the fresh asparagus. To thaw frozen puff pastry, let it sit either in the refrigerator for 24 hours or on the counter for 30 minutes to 1 hour.

serves 6 to 8

12 ounces asparagus, trimmed

Salt and pepper

4 ounces goat cheese, room temperature

2 ounces Parmesan cheese, grated (1 cup)

¼ cup minced fresh chives

1 teaspoon grated lemon zest plus 2 teaspoons juice

2 (9½ by 9-inch) sheets puff pastry, thawed

2 large eggs

1. Adjust oven racks to upper-middle and lower-middle positions and heat oven to 375 degrees. Line 2 baking sheets with parchment paper. Bring 2½ quarts water to boil in large saucepan over high heat. Add asparagus and 1 teaspoon salt and cook until asparagus is bright green and still crisp, about 1 minute. Meanwhile, fill large bowl halfway with ice and water. Drain asparagus, then transfer immediately to ice bath. Let asparagus cool completely, about 5 minutes, then drain, pat dry with paper towels, and chop fine. Combine goat cheese, ¾ cup Parmesan, chives, lemon zest and juice, and asparagus in bowl and season with salt and pepper to taste.

2. Unfold both sheets puff pastry onto lightly floured counter and roll to flatten bumps or creases. Roll each pastry sheet into 12-inch square. Using 3-inch round cutter, cut out 32 circles. Beat 1 egg lightly in small bowl. Brush circles with egg. Place 2 teaspoons filling slightly off center on each circle. Fold circle over filling and crimp edges with fork to seal. Place puffs on prepared baking sheets.

3. Beat remaining 1 egg lightly in small bowl. Brush puffs with egg, sprinkle with remaining ¼ cup Parmesan, sprinkle with salt to taste, and bake until puffed and golden brown, about 20 minutes. Let puffs cool on sheets for 5 minutes and serve warm.

to make ahead
Baking sheets with prepared puffs can be tightly wrapped in plastic wrap and frozen. Frozen puffs can be transferred to zipper-lock bag and stored in freezer for up to 1 month. Let frozen puffs sit at room temperature on prepared baking sheet for 45 minutes before baking. Increase baking time for frozen puffs to 25 minutes.

beef and bean taquitos with avocado sauce

why this recipe works Making crunchy, golden taquitos is easy for restaurant cooks with access to a deep-fryer; our goal was to make them foolproof for home cooks, too. Adding mashed pinto beans to a seasoned ground beef filling and rolling the taquitos tightly helped the filling hold together. Sealing the edge with egg wash offered extra insurance, and frying in a mere cup of oil prevented the taquitos from unrolling as they cooked.

serves 4 to 6

taquitos

1 cup plus 4 teaspoons vegetable oil

8 ounces 90 percent lean ground beef

1 cup canned pinto beans, rinsed

1 onion, halved and sliced thin

2 jalapeño chiles, stemmed, seeded, and minced

3 garlic cloves, minced

1 teaspoon ground cumin

1 teaspoon chili powder

1 (8-ounce) can tomato sauce

1/2 cup water

3 tablespoons minced fresh cilantro

Salt and pepper

12 (6-inch) corn tortillas

1 large egg, lightly beaten

avocado sauce

2 avocados, halved, pitted, and chopped coarse

1/2 cup sour cream

1/4 cup water

3 tablespoons lime juice (2 limes)

2 tablespoons minced fresh cilantro

Salt and pepper

1. for the taquitos Heat 1 teaspoon oil in 12-inch nonstick skillet over medium-high heat until just smoking. Add beef and cook, breaking up pieces with spoon, until no longer pink, about 5 minutes. Drain beef in colander; set aside. Mash beans to paste with potato masher or fork; set aside.

2. Heat 1 tablespoon oil in now-empty skillet over medium heat until shimmering. Add onion and cook until lightly browned, about 5 minutes. Stir in jalapeños, garlic, cumin, and chili powder and cook until fragrant, about 30 seconds. Stir in mashed beans, tomato sauce, water, cilantro, 1/2 teaspoon salt, and 1/2 teaspoon pepper. Stir in drained beef and cook, stirring occasionally, until mixture has thickened and begins to sizzle, about 10 minutes. Season with salt and pepper to taste. Transfer to bowl; set aside to cool, about 20 minutes.

3. Line rimmed baking sheet with parchment paper. Set wire rack in second rimmed baking sheet. Wrap 6 tortillas in clean, damp kitchen towel; place on plate; and cover plate tightly with plastic wrap. Microwave until hot and pliable, about 90 seconds. Working with 1 tortilla at a time, brush edges of top half with egg. Place row of 3 level tablespoons filling across lower half of tortilla. Fold bottom of tortilla up and over filling, then pull back on tortilla to tighten it around filling. Roll tightly and place seam side down on lined baking sheet. Cover with second clean damp towel. Microwave remaining 6 tortillas and repeat with remaining filling.

4. Adjust oven rack to middle position and heat oven to 200 degrees. Heat remaining 1 cup oil in clean, dry 12-inch nonstick skillet over medium-high heat until 350 degrees. Using tongs, place 6 taquitos, seam side down, in oil and fry until golden, about 5 minutes. Flip and fry until second side is golden, about 3 minutes longer. Transfer to wire rack and place in oven to keep warm. Repeat with remaining 6 taquitos.

5. for the avocado sauce Meanwhile, combine avocados, sour cream, water, lime juice, and cilantro in bowl and mash with potato masher or fork until smooth. Season with salt and pepper to taste. Cover with plastic until ready to serve. Serve taquitos with sauce.

to make ahead
Taquitos can be covered with a damp towel, wrapped tightly in plastic, and refrigerated for up to 24 hours before frying.

easy mini chicken empanadas

why this recipe works Making empanadas is a labor of love. Our bite-size version streamlines the process by using store-bought pie dough, and can also be assembled ahead of time and baked just before serving. The filling requires no cooking other than the chicken. The remaining ingredients—sharp cheddar cheese, lime juice, cilantro, chipotle, and green olives—don't require a lot of coaxing either. For a finishing touch, we used the food processor to create a vibrant salsa that came together in minutes. To make this dish spicier, reserve the jalapeño seeds and add them with the jalapeño. Our favorite store-bought pie dough is **Wholly Wholesome 9" Certified Organic Traditional Bake at Home Rolled Pie Dough.**

serves 6 to 8

empanadas
1 (6- to 8-ounce) boneless, skinless chicken breast, trimmed

Salt and pepper

1 tablespoon vegetable oil

4 ounces sharp cheddar cheese, shredded (1 cup)

1/2 cup pitted green olives, chopped fine

1/4 cup minced fresh cilantro

2 teaspoons lime juice

1 teaspoon minced canned chipotle chile in adobo sauce

2 packages store-bought pie dough

salsa
1 small onion, quartered

1 green bell pepper, stemmed, seeded, and quartered

1 jalapeño chile, stemmed, seeded, and minced

2 tablespoons fresh cilantro leaves

1/2 teaspoon salt

2 tomatoes, cored and chopped coarse

1/3 cup white wine vinegar

3 tablespoons extra-virgin olive oil

1. for the empanadas Adjust oven rack to middle position and heat oven to 425 degrees. Pat chicken dry with paper towels and season with salt and pepper. Heat oil in 12-inch nonstick skillet over medium-high heat until just smoking. Add chicken and cook until browned on 1 side, about 3 minutes. Flip chicken over, add 1/2 cup water, and cover. Reduce heat to medium and continue to cook until thickest part of breast registers 160 degrees, 5 to 7 minutes longer. Transfer chicken to carving board. When cool enough to handle, shred chicken into bite-size pieces.

2. Combine shredded chicken, cheddar, olives, cilantro, lime juice, and chipotle in bowl. Season with salt and pepper to taste. Cover bowl with plastic wrap and refrigerate until needed.

3. Line rimmed baking sheet with parchment paper. Using 3 1/2-inch round cutter, cut circles out of dough rounds (6 circles per round); discard scraps.

4. Working with half of dough circles at a time, place 2 teaspoons empanada filling in center of each. Moisten edges of dough circles with water, then fold dough over filling into half-moon shape. Pinch edges to seal, then crimp with fork to secure. Arrange empanadas on prepared sheet.

5. for the salsa Pulse onion, bell pepper, jalapeño, cilantro, and salt in food processor until minced, about 10 pulses, scraping down sides of bowl as needed. Add tomatoes and pulse until chopped, about 2 pulses. Transfer to serving bowl and stir in vinegar and oil. Let salsa sit at room temperature until flavors meld, about 30 minutes.

6. Bake empanadas until golden, 23 to 28 minutes, rotating sheet halfway through baking. Let cool for 5 minutes, then serve with salsa.

to make ahead
Baking sheets of prepared empanadas can be wrapped in plastic wrap and refrigerated for up to 3 days. Chopped vegetables for salsa can be refrigerated for up to 3 days before adding vinegar and oil.

potstickers with scallion dipping sauce

serves 6 to 8

why this recipe works These crispy potstickers are filled with tender ground pork and crunchy cabbage and spiked with garlic, ginger, and soy sauce. Salting the cabbage kept the filling from getting soggy. The secret to perfectly browned potstickers was a three-step cooking technique: first we pan-fried them; next we added liquid and let them steam; and finally we uncovered them and cooked until they crisped up again. Serving these potstickers with a sweet and savory dipping sauce made them irresistible. Store-bought round dumpling wrappers are convenient and offer a nice, chewy texture.

potstickers

3 cups minced napa cabbage

¾ teaspoon salt

12 ounces ground pork

4 scallions, minced

2 large egg whites, lightly beaten

4 teaspoons soy sauce

1½ teaspoons grated fresh ginger

1 garlic clove, minced

⅛ teaspoon pepper

24 round Asian dumpling wrappers

4 teaspoons vegetable oil

scallion dipping sauce

¼ cup soy sauce

2 tablespoons rice vinegar

2 tablespoons mirin

2 tablespoons water

1 scallion, minced

1 teaspoon chili oil (optional)

½ teaspoon toasted sesame oil

1. for the potstickers Toss cabbage with salt in colander and let drain for 20 minutes; press gently to squeeze out moisture. Combine drained cabbage, pork, scallions, egg whites, soy sauce, ginger, garlic, and pepper in bowl. Cover bowl with plastic wrap and refrigerate until chilled, at least 30 minutes or up to 24 hours.

2. Working with 4 wrappers at a time (cover others with damp paper towel), place 1 tablespoon filling in center of each wrapper, brush edges with water, fold wrapper in half, and pinch dumpling closed, pressing out any air pockets. Place dumpling on 1 side and gently flatten bottom. Transfer to baking sheet and cover with clean, damp dish towel. Repeat with remaining wrappers and filling.

3. for the scallion dipping sauce Combine all ingredients in bowl.

4. Line large plate with double layer of paper towels. Brush 2 teaspoons oil over bottom of 12-inch nonstick skillet and arrange half of dumplings in skillet, flat side down (overlapping just slightly if necessary). Place skillet over medium-high heat and cook dumplings, without moving, until golden brown on bottom, about 5 minutes.

5. Reduce heat to low, add ½ cup water, and cover immediately. Continue to cook, covered, until most of water is absorbed and wrappers are slightly translucent, about 10 minutes. Uncover skillet, increase heat to medium-high, and continue to cook, without stirring, until dumpling bottoms are well browned and crisp, 3 to 4 minutes more. Slide dumplings onto paper towel–lined plate, browned side facing down, and let drain briefly. Transfer dumplings to serving platter and serve with scallion dipping sauce. Let skillet cool until just warm, then wipe out with paper towels and repeat steps 4 and 5 with remaining dumplings, oil, and water.

to make ahead
Uncooked dumplings can be placed on plate, wrapped tightly with plastic wrap, and refrigerated for 24 hours, or frozen for 1 month. Once frozen, dumplings can be transferred to zipper-lock bag to save space in freezer; do not thaw before cooking.

steamed chinese dumplings (shu mai)

why this recipe works Flavor-packed, bite-size dumplings are an irresistible appetizer. For tender filling, we ground half of the meat to a fine consistency. The smaller pieces helped hold the dumplings together. Powdered gelatin and cornstarch kept the filling moist. Do not trim the excess fat from the ribs. Use any size shrimp except popcorn shrimp; there's no need to halve shrimp smaller than 26 to 30 per pound. Serve with chili oil.

serves 8 to 10

2 tablespoons soy sauce

½ teaspoon unflavored gelatin

1 pound boneless country-style pork ribs, cut into 1-inch pieces

8 ounces shrimp, peeled, tails removed, halved lengthwise

¼ cup chopped water chestnuts

4 dried shiitake mushroom caps (about ¾ ounce), soaked in hot water 30 minutes, squeezed dry, and chopped fine

2 tablespoons cornstarch

2 tablespoons minced fresh cilantro

1 tablespoon toasted sesame oil

1 tablespoon Chinese rice wine or dry sherry

1 tablespoon rice vinegar

2 teaspoons sugar

2 teaspoons grated fresh ginger

½ teaspoon salt

½ teaspoon pepper

1 (1-pound) package 5½-inch square egg roll wrappers

¼ cup finely grated carrot (optional)

1. Combine soy sauce and gelatin in small bowl. Set aside to allow gelatin to bloom, about 5 minutes.

2. Meanwhile, place half of pork in food processor and pulse until coarsely ground into ⅛-inch pieces, about 10 pulses; transfer to large bowl. Add shrimp and remaining pork to food processor and pulse until coarsely chopped into ¼-inch pieces, about 5 pulses. Add to more finely ground pork. Stir in soy sauce mixture, water chestnuts, mushrooms, cornstarch, cilantro, sesame oil, wine, vinegar, sugar, ginger, salt, and pepper.

3. Divide egg roll wrappers into 3 stacks. Using 3-inch biscuit cutter, cut two 3-inch rounds from each stack. Cover with moist paper towels to prevent drying.

4. Working with 6 rounds at a time, brush edges of each round lightly with water. Place heaping tablespoon of filling in center of each round. Form dumplings by pinching opposing sides of wrapper with your fingers until you have 8 equidistant pinches. Gather up sides of dumpling and squeeze gently to create "waist." Hold dumpling in your hand and gently but firmly pack down filling with butter knife. Transfer to parchment-lined baking sheet, cover with damp kitchen towel, and repeat with remaining wrappers and filling. Top center of each dumpling with pinch of grated carrot, if using.

5. Cut piece of parchment paper slightly smaller than diameter of steamer basket and place in basket. Poke about 20 small holes in parchment and lightly coat with vegetable oil spray. Place batches of dumplings on parchment, making sure they are not touching. Set steamer over simmering water and cook, covered, until no longer pink, 8 to 10 minutes. Serve immediately.

to make ahead
Dumplings can be frozen for up to 3 months. Do not thaw before cooking; increase cooking time by about 5 minutes.

shaping chinese dumplings

1. Pinch 2 opposing sides of wrapper with your fingers. Rotate dumpling 90 degrees and repeat pinching. Continue until you have 8 equidistant pinches.

2. Gather up sides of dumpling and squeeze gently to create "waist."

fresh vegetable spring rolls

why this recipe works As an appetizer, spring rolls are an appealing fresh option that offers a pleasing combination of textures and flavors. Marinating the noodle and vegetable filling ingredients gave our rolls superior flavor. If you can't find Thai basil, do not substitute regular basil; its flavor is too mild. Mint makes a better substitute. For a vegetarian fish sauce substitute, use an equal amount of rice vinegar plus 1/4 teaspoon salt. Spring rolls are best eaten immediately, but they can be held for up to 4 hours in the refrigerator, covered with a clean, damp dish towel.

serves 6 to 8

peanut dipping sauce

1/4 cup creamy peanut butter

1/4 cup hoisin sauce

1/4 cup water

2 tablespoons tomato paste

1 teaspoon Asian chili-garlic sauce

2 teaspoons vegetable oil

2 garlic cloves, minced

1 teaspoon red pepper flakes

spring rolls

2 1/2 tablespoons lime juice (2 limes)

1 1/2 tablespoons fish sauce

1 teaspoon sugar

3 ounces rice vermicelli

1 teaspoon salt

1 large carrot, peeled and shredded (about 1/2 cup)

1/3 cup chopped unsalted roasted peanuts

1 medium jalapeño chile or 2 Thai chiles, stemmed, seeded, and minced, or 1/2 teaspoon red pepper flakes

1 large cucumber (about 12 ounces), peeled and cut into matchsticks

4 leaves red leaf lettuce or Boston lettuce, halved lengthwise

8 (8-inch) round rice paper wrappers

1/2 cup fresh Thai basil leaves, small leaves left whole, medium and large leaves torn into 1/2-inch pieces

1/2 cup fresh cilantro leaves

1. for the peanut dipping sauce Whisk peanut butter, hoisin, water, tomato paste, and chili-garlic sauce, if using, together in bowl. Heat oil, garlic, and pepper flakes in small saucepan over medium heat until fragrant, 1 to 2 minutes. Stir in peanut butter mixture and bring to simmer. Reduce heat to medium-low and cook, stirring occasionally, until flavors meld, about 3 minutes. Transfer sauce to bowl and let cool to room temperature.

2. for the spring rolls Combine lime juice, fish sauce, and sugar in small bowl; set aside.

3. Bring 2 quarts water to boil in medium saucepan. Stir in rice vermicelli and salt. Cook until noodles are tender but not mushy, 3 to 4 minutes. Drain noodles and rinse under cold running water until cool. Drain again and transfer to medium bowl; toss 2 tablespoons fish sauce mixture with noodles and set aside.

4. Combine carrot, peanuts, and jalapeño in small bowl. Add 1 tablespoon fish sauce mixture; toss to combine. Toss cucumber in remaining 1 tablespoon fish sauce mixture.

5. Arrange lettuce on platter. Spread clean, damp dish towel on counter. Fill 9-inch pie plate with 1 inch room-temperature water. Submerge each wrapper in water until just pliable, about 2 minutes; lay softened wrapper on towel. Scatter about 6 basil leaves and 6 cilantro leaves over wrapper. Arrange 5 cucumber sticks horizontally on wrapper, leaving 2-inch border at bottom. Top with 1 tablespoon carrot mixture, then arrange about 2 1/2 tablespoons noodles on top of carrot mixture. Fold bottom of wrapper up over filling. Fold sides of wrapper over filling, then roll wrapper up into tight spring roll. Set spring roll on 1 lettuce piece on platter. Cover with second damp dish towel. Repeat with remaining wrappers and filling. Serve with peanut dipping sauce, wrapping lettuce around exterior of each roll.

to make ahead
Peanut dipping sauce can be refrigerated for up to 3 days. Bring to room temperature before serving.

snacks in bowls

49 crispy spiced chickpeas
50 marinated olives
 with feta
 with baby mozzarella
53 spiced nuts
 curry-spiced nuts
 cinnamon-spiced nuts
54 kale chips
 ranch-style kale chips
 spicy sesame-ginger kale chips
56 perfect popcorn
 garlic and herb popcorn
 parmesan-pepper popcorn
 cajun-spiced popcorn
 hot and sweet popcorn
59 barbecue party mix
 fisherman's friend party mix
 asian firecracker party mix
61 cheddar cheese coins
 parmesan and rosemary cheese coins
 gruyère, mustard, and caraway cheese coins
 blue cheese and celery seed cheese coins
62 homemade cheese straws
65 olive oil–sea salt pita chips
 rosemary-parmesan pita chips
 chili-spiced pita chips
 buttermilk-ranch pita chips
 cinnamon-sugar pita chips
66 kettle chips

crispy spiced chickpeas

why this recipe works Chickpeas aren't just for salads and curries anymore. Tossed in oil and roasted, these beans become ultracrisp and deeply nutty in flavor—the perfect cocktail snack. Most recipes call for roasting chickpeas in the oven, but we found they never became crisp enough. Switching to the stovetop and frying the chickpeas in olive oil gave us the big crunch factor we were seeking. A quick toss in a sweet and savory mixture of sugar and smoked paprika made our chickpeas incredibly addictive. Make sure to dry the chickpeas thoroughly with paper towels before placing them in the oil. In order to get crisp chickpeas, it is important to keep the heat high enough to ensure the oil is simmering the entire time. After about 12 minutes, test for doneness by removing a few chickpeas and placing them on a paper towel to cool slightly before tasting. If they are not quite crisp yet, continue to cook 2 to 3 minutes longer, checking occasionally for doneness.

serves 6

1 teaspoon smoked paprika

1 teaspoon sugar

1/2 teaspoon salt

1/4 teaspoon pepper

1 cup extra-virgin olive oil

2 (15-ounce) cans chickpeas, rinsed and patted dry

Combine paprika, sugar, salt, and pepper in large bowl. Line rimmed baking sheet with paper towels. Heat oil in Dutch oven over high heat until just smoking. Add chickpeas to oil and cook, stirring occasionally, until deep golden brown and crisp, 12 to 15 minutes. Using slotted spoon, transfer chickpeas to prepared baking sheet to drain briefly, then toss with spices. Serve.

to make ahead
Chickpeas can be stored at room temperature for up to 24 hours.

frying chickpeas

1. Rinse chickpeas, then pat dry with paper towels.

2. Fry chickpeas in hot oil until deep golden brown and very crisp, 12 to 15 minutes.

marinated olives

why this recipe works Making your own marinated olives may not seem like the best use of your energy, especially when you can buy a wide variety of prepared olive products at the supermarket, but with just a little effort you can put together a snack with way more flavor and freshness than anything store-bought. The most important step when making marinated olives is to start with good olives and good olive oil. We used olives with pits (pitted olives tend to have less flavor), packed in brine, not oil. To give the dish more variety, we chose a combination of green and black olives. On top of the usual aromatics—garlic, thyme, and red pepper flakes—we added sliced shallots, fresh oregano, and grated lemon zest for a bright citrus note. Our simple variations add cheese and mix up the flavors for easy ways to change the profile of the dish. Make sure to bring the mixture to room temperature before serving or the oil will look cloudy and congealed. Serve with toothpicks and a thinly sliced baguette or crackers.

1 cup brine-cured green olives with pits

1 cup brine-cured black olives with pits

¾ cup extra-virgin olive oil

1 shallot, minced

2 teaspoons grated lemon zest

2 teaspoons minced fresh thyme

2 teaspoons minced fresh oregano

1 garlic clove, minced

½ teaspoon red pepper flakes

½ teaspoon salt

Rinse olives thoroughly, then drain and pat dry with paper towels. Toss olives with oil, shallot, lemon zest, thyme, oregano, garlic, pepper flakes, and salt in bowl, cover, and refrigerate for at least 4 hours. Let sit at room temperature for at least 30 minutes before serving.

variations

marinated olives with feta
Omit black olives and thyme. Substitute orange zest for lemon zest. Add 8 ounces feta cheese, cut into ½-inch cubes (2 cups) to olive mixture.

marinated olives with baby mozzarella
Reduce black and green olives to ½ cup each. Substitute 1 tablespoon chopped fresh basil for oregano. Add 8 ounces fresh mozzarella balls (bocconcini), cut into ½-inch pieces (2 cups) to olive mixture.

to make ahead
Olive mixture can be refrigerated for up to 4 days before serving.

spiced nuts

why this recipe works Salty spiced nuts are a deceptively easy and unassuming appetizer. Done correctly, however, they pack a double punch of flavor and protein that makes a perfect addition to your party snacks. Most recipes are made with a heavily sugared syrup that causes the nuts to clump awkwardly and leaves your hands a sticky mess. We wanted to develop a recipe that was both tasty and neat. Tossing the nuts in a mixture of egg white, water, and salt gave them a nice crunch when baked and helped the spices adhere. Using that basic technique, you can vary the spices for a mix that fits your menu. If you can't find superfine sugar, process granulated sugar in a food processor for 1 minute. If desired, you can use a mixture of the recommended nuts equaling 1 pound instead of 1 pound of a single type of nut.

serves 8 to 10

1 large egg white

1 tablespoon water

1 teaspoon salt

1 pound pecans, cashews, walnuts, or whole unblanched almonds

2/3 cup superfine sugar

2 teaspoons cumin

1 teaspoon cayenne pepper

1 teaspoon paprika

1. Adjust oven racks to upper-middle and lower-middle positions and heat oven to 275 degrees. Line 2 rimmed baking sheets with parchment paper. Whisk egg white, water, and salt together in medium bowl. Add nuts and toss to coat. Let nuts drain in colander for 5 minutes.

2. Mix sugar, cumin, cayenne, and paprika together in clean medium bowl. Add drained nuts and toss to coat. Spread nuts evenly over prepared baking sheets. Bake until nuts are dry and crisp, about 50 minutes, stirring occasionally.

3. Let nuts cool completely on baking sheets, about 30 minutes. Break nuts apart and serve.

variations

curry-spiced nuts
Reduce cumin to 1 teaspoon and substitute 1 teaspoon curry powder for cayenne.

cinnamon-spiced nuts
Substitute 2 teaspoons ground cinnamon, 1 teaspoon ground ginger, and 1 teaspoon ground coriander for cumin, cayenne, and paprika.

to make ahead
Nuts can be stored at room temperature for up to 1 week.

kale chips

why this recipe works Kale chips offer a healthier alternative to the usual potato or tortilla chip options, but you don't have to buy a prepackaged version full of unnecessary ingredients and crumbly leaves; making your own is a simple process and produces much better results. Kale chips should boast a crisp texture and earthy flavor, but often they just don't stay crispy. We found there were three key steps to getting kale chips with the perfect texture. First, we made sure that we started with completely dry leaves—we spun them dry using a salad spinner and then blotted them between two dish towels to make sure no water was left clinging. Using a very low oven ensured that the kale dried out but didn't burn, and we baked the chips for an hour or more to ensure that all of the moisture evaporated. Finally, baking on a wire rack allowed the oven air to circulate above and beneath the kale. We prefer to use Lacinato (Tuscan) kale in this recipe, but curly-leaf kale can be substituted; chips made with curly-leaf kale will taste a bit chewy at the edges and won't hold together as well.

serves 4

12 ounces Lacinato kale, stemmed and torn into 3-inch pieces

1 tablespoon extra-virgin olive oil

1 teaspoon kosher salt

1. Adjust oven racks to upper-middle and lower-middle positions and heat oven to 200 degrees. Set wire racks in 2 rimmed baking sheets. Dry kale thoroughly between clean dish towels, transfer to large bowl, and toss with oil.

2. Arrange kale evenly on prepared racks, making sure leaves overlap as little as possible. Sprinkle kale with salt and bake until very crisp, 1 to 1¼ hours, switching and rotating sheets halfway through baking.

3. Let chips cool completely on racks, about 10 minutes. Serve.

variations

ranch-style kale chips
Combine 2 teaspoons dried dill, 1 teaspoon garlic powder, and 1 teaspoon onion powder with salt before sprinkling over kale.

spicy sesame-ginger kale chips
Substitute 1 tablespoon sesame oil for olive oil. Combine 2 teaspoons toasted sesame seeds, 1 teaspoon ground ginger, and ¼ teaspoon cayenne pepper with salt before sprinkling over kale.

to make ahead
Kale chips can be stored in paper towel–lined airtight container for up to 24 hours.

making kale chips

1. Stem kale, then tear leaves into rough 3-inch pieces.

2. Wash and dry kale using salad spinner, then dry it thoroughly between dish towels. Transfer to large bowl and toss with oil.

3. Bake on prepared racks until very crisp, 1 to 1¼ hours, switching and rotating sheets halfway through baking.

perfect popcorn

why this recipe works Most of us reach for those preseasoned, microwavable bags when we're in the mood for popcorn, but once you discover how easy it is to pop your own, you'll never go back to the microwave, and you may find that homemade popcorn becomes a new mainstay at your gatherings. The key to this recipe is making the popcorn in a big, heavy-bottomed Dutch oven. The Dutch oven does the best job of heating the oil evenly, which ensures that the kernels heat and pop at the same rate, giving you few unpopped kernels and less risk of burning. Once we had the technique down, we came up with lots of flavorful variations to dress up the light, fluffy popcorn. You'll want a good-size Dutch oven to make the popcorn— at least 5 or 6 quarts. Be sure to shake the pot vigorously when cooking to prevent the popcorn from scorching.

serves 6 to 8

3 tablespoons unsalted butter

2 tablespoons vegetable oil

1/2 cup popcorn kernels

Salt

Microwave butter in bowl on 50 percent power until just melted, 1 to 3 minutes. Combine oil and popcorn in large Dutch oven. Cover and place over medium-high heat, shaking occasionally, until first few kernels begin to pop. Continue to cook, shaking pot vigorously, until popping has mostly stopped. Transfer to large bowl, toss with melted butter, and season with salt to taste. Serve.

variations

garlic and herb popcorn
Add 2 minced garlic cloves and 1 tablespoon minced fresh or 1 teaspoon dried rosemary, thyme, or dill to butter before melting.

parmesan-pepper popcorn
Add 1/2 teaspoon pepper to butter before melting. Add 1/2 cup grated Parmesan to popcorn when tossing with butter.

cajun-spiced popcorn
Add 1 teaspoon red pepper flakes, 1 teaspoon minced fresh thyme (or 1/2 teaspoon dried), 3/4 teaspoon hot sauce, 1/2 teaspoon garlic powder, 1/2 teaspoon paprika, and 1/4 teaspoon onion powder to butter before melting.

hot and sweet popcorn
Add 2 tablespoons sugar, 1 teaspoon ground cinnamon, and 1/2 teaspoon chili powder to butter before melting.

barbecue party mix

why this recipe works Crunchy, salty, and addictive, this homemade snack mix outshines anything you can buy prepackaged at the store. For our upgrade on back-of-the-box recipes, tasters preferred the nutty sweetness of melted butter to margarine or olive oil, both of which left a greasy finish. Instead of relying on an excess of salt like packaged versions do, we chose a bold barbecue angle and seasonings that held their flavor through baking. The flavors can easily be tweaked for different options like our variations.

serves 10 to 12

5 cups Corn Chex cereal

2 cups corn chips

1 cup Melba toast rounds, lightly crushed

1 cup pretzel sticks

1 cup smoked almonds

6 tablespoons unsalted butter, melted

¼ cup barbecue sauce

1 teaspoon chili powder

½ teaspoon dried oregano

¼ teaspoon cayenne pepper

1. Adjust oven rack to middle position and heat oven to 250 degrees. Combine cereal, corn chips, Melba toast, pretzels, and almonds in large bowl. Whisk melted butter and barbecue sauce together in separate bowl, then drizzle over cereal mixture. Sprinkle with chili powder, oregano, and cayenne and toss until well combined.

2. Spread mixture over rimmed baking sheet and bake, stirring every 15 minutes, until golden and crisp, about 45 minutes. Let cool to room temperature. Serve.

variations

fisherman's friend party mix
Combine 5 cups Corn Chex or Rice Chex cereal, 2 cups oyster crackers, 1 cup Pepperidge Farm Cheddar Goldfish, 1 cup Pepperidge Farm Pretzel Goldfish, and 1 cup Melba toast rounds, lightly crushed, in large bowl. Whisk 6 tablespoons melted butter, 2 tablespoons hot sauce, and 1 tablespoon lemon juice together in separate bowl, then drizzle over cereal mixture. Sprinkle with 1 tablespoon Old Bay seasoning and toss until well combined. Bake as instructed in step 2.

asian firecracker party mix
Combine 5 cups Rice Chex cereal, 2 cups sesame sticks, 1 cup wasabi peas, 1 cup chow mein noodles, and 1 cup honey-roasted peanuts in large bowl. Whisk 6 tablespoons melted butter and 2 tablespoons soy sauce together in separate bowl, then drizzle over cereal mixture. Sprinkle with 1 teaspoon ground ginger, ¾ teaspoon garlic powder, and ¼ teaspoon cayenne pepper and toss until well combined. Bake as instructed in step 2.

to make ahead
Mix can be stored at room temperature for up to 1 week.

cheddar cheese coins

why this recipe works When it comes to homemade crackers, you need a recipe that's easy, versatile, and packs a huge flavor punch. We wanted to come up with a simple, foolproof version that would be cheesy, buttery, and just a little spicy. We started with a full 8 ounces of cheese and a touch of salt, cayenne, and paprika. We used the food processor to combine the dry ingredients and the shredded cheese, which helped to keep the coins tender by limiting the handling of the dough. Adding a little cornstarch with the flour further ensured that the coins baked up flaky and buttery. We processed the dry ingredients with chilled butter until the mixture resembled wet sand, added water, and processed until the dough came together. Next, we rolled the dough into logs, refrigerated them until firm, and then sliced them into thin coins before baking until lightly golden and perfectly crisp. With this simple technique, it's easy to vary the cheese and flavorings used to suit any taste.

serves 10 to 12

8 ounces extra-sharp cheddar cheese, shredded (2 cups)

1½ cups (7½ ounces) all-purpose flour

1 tablespoon cornstarch

½ teaspoon salt

¼ teaspoon cayenne pepper

¼ teaspoon paprika

8 tablespoons unsalted butter, cut into 8 pieces and chilled

3 tablespoons water

1. Process cheddar, flour, cornstarch, salt, cayenne, and paprika in food processor until combined, about 30 seconds. Scatter butter pieces over top and process until mixture resembles wet sand, about 20 seconds. Add water and process until dough forms ball, about 10 seconds. Transfer dough to counter and divide in half. Roll each half into 10-inch log, wrap in plastic wrap, and refrigerate until firm, at least 1 hour.

2. Adjust oven racks to upper-middle and lower-middle positions and heat oven to 350 degrees. Line 2 rimmed baking sheets with parchment paper. Unwrap logs and slice into ¼-inch-thick coins, giving dough quarter turn after each slice to keep log round. Place coins on prepared sheets, spaced ½ inch apart.

3. Bake until light golden around edges, 22 to 28 minutes, switching and rotating sheets halfway through baking. Let coins cool completely on sheets before serving.

variations

parmesan and rosemary cheese coins
Substitute 8 ounces finely grated Parmesan for cheddar, black pepper for cayenne, and 1 teaspoon minced fresh rosemary for paprika.

gruyère, mustard, and caraway cheese coins
Substitute Gruyère for cheddar. Add 1 teaspoon caraway seeds to food processor with spices. Substitute 4 tablespoons whole-grain mustard for water.

blue cheese and celery seed cheese coins
Substitute 1 cup crumbled blue cheese for 1 cup cheddar. Increase paprika to 2 teaspoons and cayenne to ½ teaspoon. Add 1 teaspoon celery seeds to food processor with spices. Omit water.

to make ahead
Unbaked dough can be refrigerated for up to 3 days or frozen for up to 1 month; thaw completely before slicing and baking. Baked coins can be stored at room temperature for up to 3 days.

homemade cheese straws

why this recipe works Cheese straws are always fast to disappear from a party platter, especially when they're homemade. Ours are also a cinch to make. We kept things simple by using frozen puff pastry, which bakes up buttery and flaky. We wanted our straws to boast bold cheese flavor, and potent Parmesan gave us a big bang for our buck. (Aged Asiago also works well.) To ensure that the cheese adhered to the pastry, we used a rolling pin to press it, along with a smattering of chopped parsley for vibrancy, into the pastry before slicing and shaping the straws. Be sure to allow enough time to defrost the puff pastry. To thaw frozen puff pastry, let it sit either in the refrigerator for 24 hours or on the counter for 30 minutes to 1 hour.

serves 4 to 6

1 (9½ by 9-inch) sheet puff pastry, thawed

2 ounces Parmesan or aged Asiago cheese, grated (1 cup)

1 tablespoon minced fresh parsley

¼ teaspoon salt

⅛ teaspoon pepper

1. Adjust oven rack to middle position and heat oven to 425 degrees. Line rimmed baking sheet with parchment paper.

2. Lay puff pastry on second sheet of parchment and sprinkle with Parmesan, parsley, salt, and pepper. Top with third sheet of parchment. Using rolling pin, press cheese mixture into pastry, then roll pastry into 10-inch square.

3. Remove top sheet of parchment and cut pastry into thirteen ¾-inch-wide strips with sharp knife or pizza wheel. Gently twist each strip of pastry and space about ½ inch apart on prepared baking sheet.

4. Bake until cheese straws are fully puffed and golden brown, 10 to 15 minutes. Let cheese straws cool completely on baking sheet.

to make ahead
Cheese straws can be wrapped in plastic wrap and stored at room temperature for up to 24 hours before serving.

shaping cheese straws

Hold each end of 1 strip of dough. Gently twist ends in opposite directions to form corkscrew shape.

olive oil–sea salt pita chips

why this recipe works Homemade pita chips are surprisingly easy to make and taste much better than store-bought; plus, making your own means you can customize the flavors to suit the needs of your menu. We started by separating the two layers of each pita to get thinner, crispier chips. Next, we brushed each round with plenty of oil (we chose extra-virgin olive oil for its robust flavor) and sprinkled them with coarse salt. To quickly cut the rounds into wedges, we stacked them up and then sliced the stacked rounds into eight wedges all at once. This method also meant that we needed to oil and season the rounds only on one side, because the unseasoned sides of the stacked pita rounds absorbed the seasoned oil from the adjacent rounds. Finally, we arranged the wedges on two rimmed baking sheets in a single layer to ensure that they baked evenly. We tried flipping the chips halfway through baking, but we found that it wasn't worth the hassle—even without flipping, the bottom side of the chips browned nicely from contact with the baking sheet. Both white and whole-wheat pita breads will work well here. We prefer the larger crystal size of kosher or sea salt here; if using table salt, reduce the amount of salt by half.

serves 8

4 (8-inch) pita breads

1/2 cup extra-virgin olive oil

1 teaspoon sea salt or kosher salt

1. Adjust oven racks to upper-middle and lower-middle positions and heat oven to 350 degrees. Using kitchen shears, cut around perimeter of each pita and separate into 2 thin rounds.

2. Working with 1 round at a time, brush rough side generously with oil and sprinkle with salt. Stack rounds on top of one another, rough side up, as you go. Using chef's knife, cut pita stack into 8 wedges. Spread wedges, rough side up and in single layer, on 2 rimmed baking sheets. Bake until wedges are golden brown and crisp, about 15 minutes, rotating and switching sheets halfway through baking. Let cool before serving.

to make ahead
Pita chips can be stored at room temperature for up to 3 days.

variations

rosemary-parmesan pita chips
Reduce salt to 1/2 teaspoon and toss with 1/2 cup grated Parmesan and 2 tablespoons minced fresh rosemary before sprinkling over pitas.

chili-spiced pita chips
Mix 1 tablespoon chili powder, 1/2 teaspoon garlic powder, and pinch cayenne pepper with salt before sprinkling over pitas.

buttermilk-ranch pita chips
Mix 1 tablespoon buttermilk powder, 2 teaspoons dried dill, 1/4 teaspoon garlic powder, and 1/4 teaspoon onion powder with salt before sprinkling over pitas.

cinnamon-sugar pita chips
Substitute 8 tablespoons melted unsalted butter for oil. Reduce salt to 1/4 teaspoon. Mix 3 tablespoons sugar and 1 tablespoon cinnamon with salt before sprinkling over pitas.

kettle chips

why this recipe works Whether thick-cut, crinkle, plain, or flavored, potato chips are one of America's most beloved snack foods. Our favorites are small-batch kettle-style chips, which cook up thicker and sturdier than regular potato chips, with a distinctive caramelized flavor. Store-bought versions tend to be greasy and oversalted, but making a perfect batch at home is actually pretty simple. The first trick is getting the potatoes to the perfect thickness. Thicker chips never get properly crisp, while those that are too thin fry up as light as confetti. We found the sweet spot at $1/16$ inch for thin but substantial, crisp chips. A mandoline made easy work of this potentially tedious task. Next, we tackled the frying step. Frying at too low a temperature made the chips soggy and greasy, but when we increased the heat, they burned. Realizing that the potatoes' starch was the source of our troubles, we finally landed on a method of rinsing, parboiling, and then frying. Rinsing washed away the exterior starch while parboiling jump-started the cooking and further reduced the amount of starch in the potatoes. It was a bit of work, but the reward of fresh, golden home-made potato chips was well worth it. You will need a mandoline for this recipe. These chips are best enjoyed the day they are made.

1 pound medium Yukon Gold potatoes, sliced $1/16$ inch thick on mandoline

2 quarts vegetable oil

Fine sea salt

1. Line rimmed baking sheet with clean dish towel. Set wire rack in second rimmed baking sheet and line with triple layer of paper towels; set both sheets aside. Place potato slices in large bowl and cover with cold water. Gently swirl potatoes to release starch. Drain potatoes and return to bowl. Repeat rinsing step until water no longer turns cloudy, about 5 rinses.

2. Bring 2 quarts water to boil in large saucepan over high heat. Add potatoes, return to gentle boil, and cook until just beginning to soften, 2 to 3 minutes. Drain potatoes well, then spread out over dish towel–lined sheet and thoroughly pat dry.

3. Meanwhile, heat oil in Dutch oven over medium-high heat to 325 degrees. Carefully place one-quarter of potato slices in oil. Fry, stirring frequently with wire skimmer or slotted spoon, until oil stops bubbling and chips turn golden and crisp, 3 to 4 minutes. Adjust burner, if necessary, to maintain oil temperature around 325 degrees. As soon as chips finish frying (some chips may cook slightly faster than others), transfer to prepared wire rack using skimmer or slotted spoon. Season with salt to taste.

4. Return oil to 325 degrees and repeat with remaining potato slices in 3 more batches. Let cool to room temperature before serving.

making kettle chips

1. Rinse thinly sliced potatoes in cold water until water runs clean.

2. Parboil potatoes until they just start to soften, 2 to 3 minutes.

3. Fry in batches. Remove chips when they turn golden brown and stop bubbling in oil.

sliced
and
stacked

71 bruschetta
black olive pesto, ricotta, and basil topping
grape tomato, white bean puree, and rosemary topping
artichoke and parmesan topping
73 blt canapés with basil mayonnaise
74 serrano and manchego crostini with orange honey
77 homemade gravlax on pumpernickel with crème fraîche
79 naan tarts with fig jam, blue cheese, and prosciutto
with ricotta and sun-dried tomato–olive tapenade
with artichokes, pesto, and goat cheese
80 tomato and mozzarella tart
82 fennel, olive, and goat cheese tarts
85 smoked salmon and leek tart
86 caramelized onion, pear, and bacon tarts
classic pizza dough
88 crispy polenta squares with olive tapenade

bruschetta

serves 8 to 10

why this recipe works Bruschetta might seem too simple to be the star of the show, but with the right toppings and presentation, this classic Italian antipasto can go way beyond chopped tomatoes and basil and bring a huge spectrum of flavors to the table. Classic bruschetta starts with slices of simple toasted garlic bread. One problem that consistently plagues many bruschetta recipes is soggy bread, especially once you add substantial toppings. Bread choice is key to fixing this—we used a crusty loaf of country-style bread with a tight crumb so the toppings wouldn't fall through and we cut the bread into thick slices for maximum support. Presented here are a few of our favorite takes on bright, flavorful toppings for this infinitely customizable appetizer. Toast the bread just before assembling the bruschetta.

1 loaf country bread, ends discarded, sliced crosswise into ³/₄-inch-thick pieces

¹/₂ garlic clove, peeled

Extra-virgin olive oil

Salt

Adjust oven rack 4 inches from broiler element and heat broiler. Place bread on aluminum foil–lined baking sheet. Broil until bread is deep golden on both sides, 1 to 2 minutes per side. Lightly rub 1 side of each slice with garlic and brush with oil. Season with salt to taste.

black olive pesto, ricotta, and basil topping
Process ¹/₂ cup pitted kalamata olives, 1 minced small shallot, 2 tablespoons extra-virgin olive oil, 1¹/₂ teaspoons lemon juice, and 1 minced garlic clove in food processor until uniform paste forms, about 10 seconds. Season 12 ounces whole-milk ricotta cheese with salt and pepper to taste. Spread olive pesto evenly on toasts. Carefully spread ricotta over pesto. Drizzle with additional extra-virgin olive oil to taste, sprinkle with 2 tablespoons shredded fresh basil, and serve.

grape tomato, white bean puree, and rosemary topping
Combine 12 ounces grape tomatoes, quartered; ¹/₂ teaspoon salt; and ¹/₄ teaspoon sugar in bowl and let sit for 30 minutes. Spin tomatoes in salad spinner until excess liquid has been removed, 45 to 60 seconds, redistributing tomatoes several times during spinning. Return to bowl and toss with 3 tablespoons extra-virgin olive oil, 1 tablespoon red wine vinegar, and ¹/₄ teaspoon pepper. Process 1 (15-ounce) can cannellini beans, rinsed, with 2 tablespoons water, ¹/₂ teaspoon salt, and ¹/₄ teaspoon pepper in food processor until smooth, about 1 minute. With processor running, slowly add 3 tablespoons extra-virgin olive oil until incorporated. Spread bean mixture evenly on toasts. Top with tomatoes and 1 ounce Parmesan cheese, shaved, and sprinkle with 2 teaspoons minced fresh rosemary. Serve.

artichoke and parmesan topping
Use artichoke hearts packed in water.

Pulse 1 (14-ounce) can artichoke hearts, rinsed and patted dry; 2 tablespoons extra-virgin olive oil; 2 tablespoons chopped fresh basil; 2 teaspoons lemon juice; 1 minced garlic clove; ¹/₄ teaspoon salt; and ¹/₄ teaspoon pepper in food processor until coarsely pureed, about 6 pulses, scraping down bowl once during pulsing. Add ¹/₂ cup finely grated Parmesan cheese and pulse to combine, about 2 pulses. Spread artichoke mixture evenly on toasts. Top toasts with 1 ounce Parmesan cheese, shaved, season with pepper to taste, and drizzle with additional extra-virgin olive oil to taste. Serve.

blt canapés with basil mayonnaise

why this recipe works Some of the best appetizers take familiar foods and translate them into a new, unexpected form. A bright basil mayonnaise enhanced with a spritz of lemon and a couple of garlic cloves helps turn the classic BLT sandwich into a fresh bite-size snack. We kept the prep easy, pureeing lots of fresh basil leaves with store-bought mayonnaise for the spread and cooking the bacon in the oven, which was less messy and more hands-off than cooking it in a skillet. The toasts, which are merely rounds punched with a biscuit cutter from store-bought sandwich bread, are broiled in one batch. Even in the summer, supermarket tomatoes can be unreliable, but cherry tomatoes are always sweet and they scale perfectly for a pint-size appetizer.

serves 8 to 10

2 cups fresh basil leaves, plus ¼ cup chopped fresh basil

⅔ cup mayonnaise

4 teaspoons lemon juice

2 garlic cloves, minced

Salt and pepper

11 slices hearty white sandwich bread

Vegetable oil spray

11 slices bacon

6 ounces cherry tomatoes

1. Process basil leaves, mayonnaise, lemon juice, garlic, and ¼ teaspoon salt in food processor until smooth, about 1 minute, scraping down sides of bowl as needed. Transfer to bowl and season with salt to taste.

2. Adjust 1 oven rack to middle position and second rack 6 inches from broiler element and heat broiler. Using 2-inch round cutter, cut rounds out of bread slices (3 rounds per slice), avoiding crust. Spray both sides of bread rounds with oil spray and arrange on rimmed baking sheet. Broil until golden brown on both sides, about 5 minutes, flipping bread rounds halfway through broiling. Let toasts cool completely.

3. Heat oven to 400 degrees. Arrange bacon in single layer on rimmed baking sheet. Bake until crispy and brown, 10 to 12 minutes, rotating sheet halfway through baking. Transfer bacon to paper towel–lined plate and let cool completely. Break each bacon slice evenly into 3 short pieces.

4. Cut tomatoes into ⅓-inch-thick slices. Season tomato slices with salt and pepper to taste. Spread basil mayonnaise evenly over 1 side of each toast, then top with 1 piece bacon and 1 slice tomato. Sprinkle with chopped basil. Serve.

to make ahead
Basil mayonnaise can be refrigerated for up to 4 days. Broiled toasts can be held at room temperature for up to 6 hours before topping. Bacon pieces can be held at room temperature for up to 1 hour. Assembled canapés can be held at room temperature for up to 1 hour before serving.

notes from the test kitchen
mayonnaise
You can make mayonnaise yourself, but doing so requires careful technique, and the shelf life of homemade mayo is short. Luckily, a good supermarket product can rival homemade. The best-tasting brands have the fewest ingredients and no add-ins like dried garlic or onion. Our top-rated brand, **Blue Plate Real Mayonnaise**, doesn't even include lemon juice or mustard, which are more common additions. It does, however, use all egg yolks (no whites) and contain plenty of salt for rich, deep flavor.

serrano and manchego crostini with orange honey

why this recipe works There's more to making great crostini than just putting cheese on toast. The right combination of ingredients can take this deceptively simple appetizer to a whole other level. In our version, Serrano ham, Manchego cheese, and artisanal bread come together to form an elegant yet stress-free Spanish-inspired starter. For the bread, we preferred a nutty artisanal loaf such as walnut or pecan with dried fruit to complement the cheese. Toasting the bread intensified its nutty flavor. Assembling the crostini was as easy as topping the bread with the ham and cheese and drizzling each toast with a mixture of honey, orange marmalade, and fresh thyme for a sweet-salty flavor contrast. The key to this recipe is using high-quality ingredients; be sure to use authentic Spanish Serrano ham and Manchego cheese. If you can't find walnut or pecan bread, any variety of hearty artisanal-style nut and fruit bread would work here.

serves 8

1 loaf artisanal-style walnut or pecan bread

¼ cup honey

1 tablespoon orange marmalade

½ teaspoon minced fresh thyme

8 ounces thinly sliced Serrano ham

4 ounces thinly sliced Manchego cheese

1. Adjust oven rack 6 inches from broiler element and heat broiler. Slice bread into ¼-inch-thick pieces; cut larger pieces in half if necessary. Lay bread on 2 rimmed baking sheets. Broil bread, 1 baking sheet at a time, until golden brown on both sides, about 2 minutes per side.

2. Combine honey, marmalade, and thyme. Top toasts with ham and Manchego, then drizzle with honey mixture. Serve.

to make ahead
Toasted bread can be stored in airtight container for up to 24 hours. Assembled crostini should be eaten within several hours.

notes from the test kitchen
shopping for honey
Traditional honey is usually heated and strained to removed pollen and give the honey a clear appearance. Raw honey is treated more gently and retains most of its pollen. We prefer raw honey for its complexity and balanced sweetness. Look for the word "raw" on the label and choose a product that comes from bees with a varied diet (rather than solely clover). Our winning brand is **Nature Nate's 100% Raw and Unfiltered Honey**. Honey never spoils and can be stored indefinitely in the pantry.

homemade gravlax on pumpernickel with crème fraîche

why this recipe works Homemade gravlax sounds like it would require an extravagant time commitment and specialty tools and ingredients, but in fact it's a super easy and fun project. Served with thin slices of pumpernickel and a creamy sauce, this cured fish makes a rich, elegant appetizer. For gravlax that was evenly moist, tender, and consistently salted, we soaked the fish in brandy, coated it in brown sugar, salt, and dill, and then pressed and refrigerated it. The salt drew liquid from the fish and cured it, while the brown sugar countered the harshness of the salt and added deep flavor. The brandy helped the rub adhere and added flavor. We basted the fish just once a day to keep it moist. Once it was finished, all we had to do was slice the salmon as thin as possible and layer it on pumpernickel toasts with a tangy sauce for a sophisticated and flavorful canapé. The homemade gravlax has to cure for three days. The gravlax is ready when the fish is no longer translucent and its flesh is firm, with no give.

serves 8 to 10

salmon
⅓ cup packed light brown sugar

¼ cup kosher salt

1 (1-pound) skin-on salmon fillet

3 tablespoons brandy

1 cup coarsely chopped fresh dill

canapés
1 (1-pound) loaf pumpernickel cocktail bread

Olive oil spray

1 cup crème fraîche

1 shallot, minced

3 tablespoons capers, rinsed, patted dry, and minced

¼ teaspoon grated lemon zest

⅛ teaspoon pepper

2 tablespoons minced fresh chives

1. for the salmon Combine sugar and salt. Place salmon, skin side down, in 13 by 9-inch glass baking dish. Drizzle with brandy, making sure to cover entire surface. Rub salmon evenly with sugar mixture, pressing firmly on mixture to adhere. Cover with dill, pressing firmly to adhere.

2. Cover salmon loosely with plastic wrap, top with square baking dish, and weight down with several large, heavy cans. Refrigerate until salmon feels firm, about 3 days, basting salmon with liquid released into baking dish once a day.

3. Scrape dill off salmon. Remove fillet from dish and pat dry with paper towels. Slice salmon cross-wise on bias into very thin pieces. Trim away skin and cut larger pieces in half.

4. for the canapés Adjust oven racks to upper-middle and lower-middle positions and heat oven to 350 degrees. Cut bread slices in half on diagonal into triangles and spread out onto 2 rimmed baking sheets. Spray both sides of bread liberally with olive oil spray. Bake bread until lightly toasted, about 15 minutes, switching and rotating halfway through baking; let cool.

5. Mix crème fraîche, shallot, capers, lemon zest, and pepper together in bowl. Spread half of crème fraîche over toasts and top attractively with salmon. Dollop with remaining crème fraîche, sprinkle with chives, and serve.

to make ahead
Gravlax can be wrapped tightly in plastic and refrigerated for up to 1 week.

slicing gravlax

Using sharp slicing knife, slice salmon thinly, crosswise, on bias.

naan tarts with fig jam, blue cheese, and prosciutto

why this recipe works Naan (Indian flatbread) makes a great prebaked crust for a quick and easy savory appetizer pizza. For a simple but irresistible topping, we combined the assertive flavors of salty prosciutto and bold blue cheese against a backdrop of sweet fig jam. The toppings needed only a brief stint in the oven to warm through, so we brushed the baking sheet with olive oil and baked the tart on the lowest rack to help the naan crisp up during the short baking time. Our variations use a variety of simple ingredients in creative combinations for two additional easy savory options. If fig jam is not available, you can substitute caramelized onion or apricot jam. Also, 1 tablespoon minced fresh parsley can be substituted for the scallions.

serves 6

1 tablespoon olive oil

2 (8-inch) naan breads

¼ cup fig jam

1 teaspoon water

⅛ teaspoon pepper

2 ounces blue cheese, crumbled (½ cup)

2 ounces thinly sliced prosciutto, cut into 1-inch strips

¼ teaspoon fresh thyme leaves

2 scallions, sliced thin

1. Adjust oven rack to lowest position and heat oven to 500 degrees. Brush baking sheet with oil and lay naan on sheet. Whisk fig jam, water, and pepper in bowl to loosen, then spread evenly over each naan, leaving ½-inch border around edge. Sprinkle blue cheese, prosciutto, and thyme evenly over top.

2. Bake until naan are golden brown around edges, 8 to 10 minutes, rotating sheet halfway through baking. Sprinkle with scallions, cut each tart into 6 pieces, and serve.

variations

naan tarts with ricotta and sun-dried tomato–olive tapenade
Use either whole-milk or part-skim ricotta here.

Combine 4 ounces ricotta cheese, ¼ cup grated Parmesan cheese, 1 tablespoon olive oil, 1¼ teaspoons lemon juice, 1 minced garlic clove, ¼ teaspoon salt, and ⅛ teaspoon pepper in bowl. In separate bowl, combine 3 tablespoons sun-dried tomatoes, rinsed, patted, dry, and chopped fine; 3 tablespoons finely chopped pitted kalamata olives; 1½ tablespoons pine nuts; and 2 tablespoons olive oil. Substitute ricotta mixture for fig jam mixture. Omit pepper, blue cheese, prosciutto, and thyme. Scatter tomato-olive mixture evenly over top of each naan before baking.

naan tarts with artichokes, pesto, and goat cheese
We prefer to use jarred marinated artichoke hearts here rather than artichokes canned in water because they have more flavor. Either store-bought or homemade pesto will work fine here.

Combine ¾ cup crumbled goat cheese, ½ cup basil pesto, and 1 tablespoon water in bowl. Substitute goat cheese mixture for fig jam mixture. Omit pepper, blue cheese, prosciutto, and thyme. Scatter ½ cup marinated artichokes, drained and patted dry, evenly over top of naan before baking. Substitute 1 tablespoon fresh parsley leaves for scallions.

tomato and mozzarella tart

why this recipe works This crowd-pleasing tart combines the richness of a quiche with the convenience of a pizza. Ready-made dough and minimal ingredients keep the preparation brief for a simple appetizer whose great vine-ripened flavor and good looks belie its simplicity. However, this dish also has its challenges. The main issue is that the moisture in the tomatoes almost guarantees a soggy crust. We set out to develop a recipe that could easily be made at home with a solid bottom crust that almost miraculously stayed firm even after topping with tomatoes. The best results came from using a two-step baking method—we parbaked the unfilled crust until golden and then baked it again once the topping had been added. "Waterproofing" the crust with egg wash and using two kinds of cheese in layers further protected against sogginess. To remove moisture from the sliced tomatoes, we salted them for 30 minutes, then gently pressed them with paper towels to sop up excess juice. To thaw frozen puff pastry, let it sit either in the refrigerator for 24 hours or on the counter for 30 minutes to 1 hour. Be sure to use low-moisture supermarket mozzarella sold in block form, not fresh water-packed mozzarella.

serves 4 to 6

to make ahead
Tart shell can be prebaked through step 1, cooled to room temperature, wrapped in plastic wrap, and kept at room temperature for up to 2 days before being topped and baked with mozzarella and tomatoes.

1 (9½ by 9-inch) sheet frozen puff pastry, thawed

1 large egg, lightly beaten

1 ounce Parmesan cheese, grated (½ cup)

2 plum tomatoes, cored and sliced ¼ inch thick

½ teaspoon salt

4 ounces mozzarella cheese, shredded (1 cup)

2 tablespoons extra-virgin olive oil

1 garlic clove, minced

2 tablespoons chopped fresh basil

1. Adjust oven rack to lower-middle position and heat oven to 425 degrees. Line rimmed baking sheet with parchment paper. Lay puff pastry in center of parchment and fold over edges of pastry to form ½-inch-wide crust. Using paring knife, cut through folded edge and corners. Brush edges with egg. Sprinkle Parmesan evenly over crust bottom, then poke uniformly with fork. Bake until crust is golden brown and crisp, 15 to 20 minutes. Let cool on wire rack.

2. Meanwhile, spread tomatoes over several layers of paper towels. Sprinkle with salt and let drain for 30 minutes.

3. Sprinkle mozzarella evenly over cooled crust bottom. Press excess moisture from tomatoes using additional paper towels. Shingle tomatoes evenly over mozzarella. Whisk olive oil and garlic together, then drizzle over tomatoes. Bake until cheese has melted and shell is deep golden, 10 to 15 minutes.

4. Let cool on wire rack for 5 minutes. Gently slide tart onto cutting board, sprinkle with basil, and slice into pieces. Serve.

forming pastry shell

1. Fold short edges of pastry over by ½ inch. Repeat with long edges.

2. Using paring knife, cut through folded edges and corners of tart shell.

fennel, olive, and goat cheese tarts

why this recipe works Savory tarts offer a more substantial addition to a party spread and can be the vehicle for a wide variety of flavor combinations. For this version, we used a fresh and sophisticated mixture of sautéed fennel and garlic along with briny olives and tangy goat cheese spiked with fresh basil and lemon. We based our tart on convenient store-bought puff pastry, which we parbaked. Once the pastry puffed up in the oven, we cut through some of the layers to create a smaller inner rectangle that served as a bed for our fresh and flavorful filling. This technique allowed us to add more filling than we normally could on top of a flat pastry base for an especially hearty tart. To thaw frozen puff pastry, let it sit either in the refrigerator for 24 hours or on the counter for 30 minutes to 1 hour.

serves 4

1 (9½ by 9-inch) sheet puff pastry, thawed and cut in half

3 tablespoons extra-virgin olive oil

1 large fennel bulb, stalks discarded, bulb halved, cored, and sliced thin

3 garlic cloves, minced

½ cup dry white wine

½ cup pitted oil-cured black olives, chopped

1 teaspoon grated lemon zest plus 1 tablespoon juice

Salt and pepper

8 ounces goat cheese, softened

5 tablespoons chopped fresh basil

1. Adjust oven rack to middle position and heat oven to 425 degrees. Lay puff pastry on parchment paper–lined baking sheet and poke all over with fork. Bake pastry until puffed and golden brown, about 15 minutes, rotating sheet halfway through baking. Using tip of paring knife, cut ½-inch-wide border around top edge of each pastry, then press centers down with your fingertips.

2. Meanwhile, heat 1 tablespoon oil in 12-inch skillet over medium-high heat until shimmering. Add fennel and cook until softened and browned, about 10 minutes. Stir in garlic and cook until fragrant, 30 seconds. Add wine, cover, and cook for 5 minutes. Uncover and cook until liquid has evaporated and fennel is very soft, 3 to 5 minutes. Off heat, stir in olives and lemon juice and season with salt and pepper to taste.

3. Mix goat cheese, ¼ cup basil, remaining 2 tablespoons oil, lemon zest, and ¼ teaspoon pepper together in bowl, then spread evenly over center of pastry shells. Spoon fennel mixture over top.

4. Bake tarts until cheese is heated through and crust is deep golden, 5 to 7 minutes. Sprinkle with remaining 1 tablespoon basil. Serve.

to make ahead
Tarts can be held at room temperature for up to 2 hours before baking.

making a puff pastry tart shell

1. Lay pastry rectangles on parchment-lined baking sheet and poke all over with fork. Bake pastry until puffed and golden, about 15 minutes.

2. Using tip of paring knife, cut ½-inch border around top edge of each baked shell and press center down with your fingertips to create bed for filling.

smoked salmon and leek tart

why this recipe works Unexpected and elegant, each bite of this savory tart contains a trio of flavors and textures: flaky pastry, creamy custard, and briny, smoky salmon. Using half-and-half in the leek and custard filling added flavor and richness. Chopping up the salmon made the tart easier to both slice and eat. You will need a 9-inch fluted tart pan with a removable bottom for this recipe. Buy smoked salmon that looks bright and glossy. Serve chilled or at room temperature, with lemon wedges.

serves 8

crust

1¼ cups (6¼ ounces) all-purpose flour

1 tablespoon sugar

½ teaspoon salt

8 tablespoons unsalted butter, cut into ½-inch cubes and chilled

3 tablespoons ice water

filling

1 tablespoon unsalted butter

1 pound leeks, white and light green parts only, halved lengthwise, sliced thin, and washed thoroughly

Salt and pepper

2 large eggs

½ cup half-and-half

1 tablespoon minced fresh dill

6 ounces thinly sliced smoked salmon, cut into ¼-inch pieces

1 tablespoon extra-virgin olive oil

1 tablespoon minced fresh chives

1. for the crust Spray 9-inch tart pan with removable bottom with vegetable oil spray; set aside. Pulse flour, sugar, and salt in food processor until combined, about 4 pulses. Scatter butter pieces over flour mixture and pulse until mixture resembles coarse sand, about 15 pulses. Add 2 tablespoons ice water and continue to process until large clumps of dough form and no powdery bits remain, about 5 seconds. If dough doesn't clump, add remaining tablespoon water and pulse to incorporate, about 4 pulses.

2. Tear dough into walnut-sized pieces, then pat into prepared tart pan. Lay plastic wrap over dough and smooth out any bumps or shallow areas using your fingertips. Place tart shell on large plate and freeze until firm, about 30 minutes. Meanwhile, adjust oven rack to middle position and heat oven to 375 degrees.

3. Place frozen tart shell on baking sheet. Gently press piece of extra-wide heavy-duty aluminum foil that has been sprayed with oil spray against dough and over edges of tart pan. Fill shell with pie weights and bake until top edge of dough just starts to color and surface of dough under foil no longer looks wet, about 30 minutes.

4. Remove shell from oven and carefully remove foil and weights. Return baking sheet with tart shell to oven and continue to bake, uncovered, until golden brown, 5 to 10 minutes. Set baking sheet with tart shell on wire rack to cool while making filling. (Do not turn off oven.)

5. for the filling While crust is baking, melt butter in 10-inch skillet over medium heat. Add leeks and ½ teaspoon salt and cook, covered, stirring occasionally, until leeks are softened, about 10 minutes. Remove pan from heat, remove lid, and let leeks cool for 5 minutes.

6. Whisk eggs, half-and-half, dill, and ¼ teaspoon pepper together in large bowl. Stir in leeks until just incorporated. Spread leek mixture over bottom of baked crust. Bake tart on baking sheet until filling has set and center feels firm to touch, 20 to 25 minutes. Set baking sheet with tart shell on wire rack and let cool to room temperature, about 2 hours.

7. Toss salmon with olive oil and chives and season with salt and pepper to taste. Sprinkle salmon evenly over cooled tart. Slice and serve.

caramelized onion, pear, and bacon tarts

why this recipe works Ready-made pizza dough is a great shortcut to a quick appetizer, but it's not as simple as just throwing on the toppings. For a truly great appetizer tart, you need a crisp crust, the right balance of ingredients, and a flavor profile to please a wide variety of palates. Our secret weapon for this tart is a cast-iron skillet, which retains heat like a pizza stone with the functionality of a skillet, making it the perfect tool for a quick and easy tart. We topped ours with bacon, which also helped grease the pan, and onions that we caramelized in the bacon fat. To ensure that this tart had broad appeal, we mixed in pear and goat cheese to balance the savory-sweet flavor profile. We like the convenience of using ready-made pizza dough here; however, you can also use our Classic Pizza Dough.

serves 8 to 10

8 slices bacon, chopped fine

2 pounds onions, halved and sliced ¼ inch thick

1 teaspoon minced fresh thyme or ¼ teaspoon dried

1½ teaspoons packed brown sugar

Salt and pepper

2 tablespoons balsamic vinegar

1 pound pizza dough

1 Bosc pear, quartered, cored, and sliced ¼ inch thick

4 ounces goat cheese, crumbled (1 cup)

2 tablespoons minced fresh chives

1. Adjust oven rack to upper-middle position and heat oven to 500 degrees. Cook bacon in 12-inch cast-iron skillet over medium heat until crisp, 7 to 9 minutes. Using slotted spoon, transfer bacon to bowl. Measure out and reserve ¼ cup fat; discard remaining fat.

2. Add 2 tablespoons reserved fat, onions, thyme, sugar, and ¾ teaspoon salt to now-empty skillet. Cover and cook, stirring occasionally, until onions are softened, 8 to 10 minutes. Uncover and continue to cook, stirring occasionally, until onions are deep golden brown, about 10 minutes. Stir in vinegar and cook until almost completely evaporated, about 2 minutes; transfer to bowl.

3. Wipe skillet clean with paper towels, then grease with 1 tablespoon reserved fat. Place dough on lightly floured counter, divide in half, and cover with greased plastic wrap. Press and roll 1 piece of dough (keeping remaining dough covered) into 11-inch round. Transfer dough to prepared skillet and gently push it to corners of pan. Spread half of onion mixture over dough, leaving ½-inch border around edge. Scatter half of pear, half of crisp bacon, and ½ cup goat cheese evenly over top.

4. Set skillet over medium-high heat and cook until edge of dough is set, tart is lightly puffed, and bottom crust is spotty brown when gently lifted with spatula, 2 to 4 minutes. Transfer skillet to oven and bake until edge of tart is golden brown, 7 to 10 minutes.

5. Using potholders, remove skillet from oven and slide tart onto wire rack; let cool slightly. Being careful of hot skillet handle, repeat with remaining 1 tablespoon reserved fat, dough, and toppings. Sprinkle tarts with chives and cut into wedges. Serve.

classic pizza dough
makes 1 pound

Pulse 2 cups plus 2 tablespoons bread flour, 1⅛ teaspoons instant or rapid-rise yeast, and ¾ teaspoon salt in food processor to combine, about 5 pulses. With processor running, add 1 tablespoon olive oil, then ¾ cup warm water (110 degrees), and process until rough ball forms, 30 to 40 seconds. Let dough rest for 2 minutes, then process for 30 seconds longer. (If after 30 seconds dough is very sticky and clings to blade, add extra flour as needed.) Transfer dough to lightly floured counter and knead by hand to form smooth, round ball, about 1 minute. Place dough in large, lightly greased bowl, cover tightly with greased plastic wrap, and let rise until doubled in size, 1 to 1½ hours.

to make ahead
Pizza dough can be refrigerated for at least 8 hours or up to 16 hours after being made.

crispy polenta squares with olive tapenade

why this recipe works With their crispy crust and creamy interior, these bite-size polenta squares serve as a perfect base for a hearty appetizer that goes beyond the usual things-on-bread recipes. We poured the polenta into a loaf pan and let it firm up in the refrigerator. Once firm, it was easy to slice into bite-size squares. Broiling the polenta on a preheated baking sheet proved to be the best (and most hands-off) method for achieving a nicely browned exterior. We topped the crispy squares with a briny, bold tapenade made with black and green olives. Be sure to buy instant polenta, which has a much shorter cooking time than regular polenta. Don't process the green and kalamata olives together or the tapenade will look muddy.

serves 8 to 10

tapenade
3/4 cup pitted green olives

3/4 cup pitted kalamata olives

1/4 cup chopped fresh basil

3 tablespoons extra-virgin olive oil

4 anchovy fillets, rinsed, patted dry, and minced

1 tablespoon capers, rinsed and minced

polenta
3 tablespoons olive oil

6 garlic cloves, minced

1 teaspoon minced fresh rosemary

4 cups water

Salt and pepper

1 cup instant polenta

1/4 cup vegetable oil

1. for the tapenade Pulse green olives in food processor until finely chopped, about 10 pulses; transfer to bowl. Pulse kalamata olives, basil, oil, anchovies, and capers until finely chopped, about 8 pulses, then stir into green olives until well combined.

2. for the polenta Line 8 1/2 by 4 1/2-inch loaf pan with parchment paper and coat lightly with vegetable oil spray. Cook olive oil and garlic in 8-inch nonstick skillet over low heat, stirring often, until garlic is golden and fragrant, about 10 minutes. Off heat, stir in rosemary; set aside.

3. Meanwhile, bring water to boil, covered, in large saucepan over high heat. Reduce heat to low and stir in 3/4 teaspoon salt. Slowly add polenta while whisking constantly in circular motion to prevent clumping. Continue to cook uncovered, stirring often, until polenta is soft and smooth, 3 to 5 minutes. Off heat, stir in oil-garlic mixture and season with pepper to taste.

4. Pour polenta into prepared pan, smooth top, and let cool completely. Wrap pan tightly in plastic wrap and refrigerate until polenta is very firm, at least 2 hours or up to 24 hours.

5. Run small knife around edge of polenta, then flip onto cutting board and remove parchment. Trim 1/4 inch off both ends of loaf and discard. Slice polenta crosswise into 1/4-inch-thick slabs. Stack about 6 slabs on top of one another, trim edges, then cut in half to make 1 1/2-inch squares. (You should have 50 squares total.)

6. Adjust oven rack 3 inches from broiler element. (If necessary, set overturned rimmed baking sheet on oven rack to get closer to broiler element.) Place rimmed baking sheet on rack and heat broiler for 10 minutes. Carefully remove sheet from oven. Working quickly, drizzle vegetable oil evenly on hot sheet and arrange polenta squares in single layer. Broil polenta squares until spotty brown and crispy, 8 to 10 minutes. Transfer polenta squares to serving platter, top each square with tapenade, and serve.

to make ahead
Tapenade can be refrigerated for up to 3 days. Sliced polenta squares can be refrigerated in airtight container for up to 24 hours before broiling.

spread
and
dipped

93 four creamy dips
caesar dip with parmesan and anchovies
chipotle-lime dip with scallions
creamy horseradish dip
green goddess dip
94 bacon, scallion, and caramelized onion dip
97 herbed spinach dip
with blue cheese and bacon
with feta, lemon, and oregano
cilantro-lime spinach dip
99 whipped cashew nut dip with roasted red peppers and olives
with chipotle and lime
with sun-dried tomatoes and rosemary
100 roasted artichoke dip
103 baked crab dip with crostini
104 ultimate seven-layer dip
ultimate smoky seven-layer dip
107 spicy whipped feta
108 baked brie with honeyed apricots
110 rosemary and garlic white bean dip
caper and tarragon white bean dip
goat cheese and lemon white bean dip
green chile and cilantro white bean dip
sun-dried tomato and feta white bean dip
113 classic hummus
artichoke-lemon hummus
roasted red pepper hummus
roasted garlic hummus
114 sweet potato hummus
117 baba ghanoush
118 guacamole
bacon and tomato guacamole
chipotle and pepita guacamole
feta and arugula guacamole
habanero and mango guacamole
120 easy mushroom pâté
123 chicken liver pâté

four creamy dips

why this recipe works For creamy dips that draw a crowd, you need a rich but well-balanced base matched with fresh and assertive flavorings. These dips are almost as easy as store-bought options, but with way more flavor. For our base, we tested mayonnaise, sour cream, yogurt, buttermilk, heavy cream, cottage cheese, and cream cheese in all possible combinations. Mayonnaise and sour cream made the strongest pairing. The mayonnaise contributed the body, richness, and velvety texture we wanted in a creamy dip, while sour cream heightened the flavor. Adding a few flavor-charged ingredients let us take the dips in different directions without making the process too complicated.

serves 4 to 6

caesar dip with parmesan and anchovies
1 cup mayonnaise

½ cup sour cream

¼ cup grated Parmesan cheese

1 tablespoon lemon juice

1 tablespoon minced fresh parsley

2 garlic cloves, minced

2 anchovy fillets, rinsed and minced

⅛ teaspoon pepper

creamy horseradish dip
¾ cup mayonnaise

¾ cup sour cream

2 scallions, sliced thin

¼ cup prepared horseradish, squeezed of excess liquid

1 tablespoon minced fresh parsley

⅛ teaspoon pepper

Combine all ingredients in medium bowl until smooth and creamy. Transfer dip to serving bowl, cover with plastic wrap, and refrigerate until flavors are blended, at least 1 hour.

to make ahead
Dips can be refrigerated for up to 2 days.

chipotle-lime dip with scallions
1 cup mayonnaise

½ cup sour cream

3 scallions, sliced thin

2 garlic cloves, minced

1 tablespoon minced canned chipotle chile in adobo sauce plus ½ teaspoon adobo sauce

1 teaspoon grated lime zest plus 1 tablespoon juice

green goddess dip
¾ cup mayonnaise

¾ cup sour cream

¼ cup minced fresh parsley

¼ cup minced fresh chives

2 tablespoons minced fresh tarragon

1 tablespoon lemon juice

2 garlic cloves, minced

⅛ teaspoon salt

⅛ teaspoon pepper

bacon, scallion, and caramelized onion dip

why this recipe works For a more modern, grown-up take on onion dip, we started with caramelized onions, which gave our dip a sweet, complex flavor. We discovered several keys to making caramelized onions that weren't burnt, gummy, bland, or greasy. First, we sautéed the onions in a nonstick pan in butter and oil over high heat to quickly release their moisture and then we turned down the heat to medium until they were cooked through. This ensured clear onion flavor and a yielding yet firm texture. Adding light brown sugar to the pan helped bring out their sweetness and complemented their caramel-like flavor. Bacon added a smokiness that perfectly balanced the sweet onions, while fresh minced scallions reinforced the onion flavor and added a touch of color.

serves 4 to 6

½ tablespoon unsalted butter

1½ teaspoons vegetable oil

½ teaspoon light brown sugar

Salt and pepper

1 pound onions, halved through root end, trimmed, peeled, and sliced ¼ inch thick across grain

1½ teaspoons water

3 slices bacon, cut into ¼-inch pieces

¾ cup sour cream

2 scallions, minced

½ teaspoon cider vinegar

1. Heat butter and oil in 12-inch nonstick skillet over high heat; stir in sugar and ¼ teaspoon salt. Add onions and stir to coat; cook, stirring occasionally, until onions begin to soften and release some moisture, about 5 minutes. Reduce heat to medium and cook, stirring frequently, until onions are deeply browned and slightly sticky, about 40 minutes longer. (If onions are sizzling or scorching, reduce heat. If onions are not browning after 15 to 20 minutes, raise heat.) Off heat, stir in water and season with pepper to taste.

2. Cook bacon in 8-inch skillet over medium heat until crispy, 5 to 7 minutes; using slotted spoon, transfer to paper towel–lined plate.

3. Combine sour cream, scallions, vinegar, caramelized onions, and bacon in medium bowl. Season with salt and pepper to taste and serve.

to make ahead
Caramelized onions can be refrigerated in airtight container for up to 1 week. Finished dip can be refrigerated in airtight container for up to 3 days.

slicing onions

Trim onion and halve through root end. Peel onion and then slice ¼ inch thick across grain.

herbed spinach dip

why this recipe works Spinach dip can feel like the responsible, healthy choice on an appetizer buffet but that doesn't mean it has to be bland or boring. For a spinach dip to really taste good, we found that both the ingredients and the method were key. We packed tons of flavor into our spinach dip with herbs, red bell pepper, scallions, garlic, and even a little kick of hot sauce. For the mixing method, we used the food processor to help distribute the spinach evenly throughout the dip. This method also made it easy to add other flavors to the dip for our creative variations. The garlic must be minced or pressed before going into the food processor or the dip will contain large chunks of garlic. Serve with crudités.

10 ounces frozen chopped spinach, thawed and squeezed dry

½ red bell pepper, chopped fine

½ cup sour cream

½ cup mayonnaise

½ cup fresh parsley leaves

3 scallions, sliced thin

1 tablespoon fresh dill or 1 teaspoon dried

1 garlic clove, minced

¼ teaspoon hot sauce

Salt and pepper

Process all ingredients with ½ teaspoon salt and ¼ teaspoon pepper in food processor until well combined, about 1 minute. Transfer to serving bowl, cover, and refrigerate until flavors have blended, at least 1 hour. Season with salt and pepper to taste before serving.

variations

spinach dip with blue cheese and bacon
Omit bell pepper, dill, hot sauce, and salt. Add ⅓ cup crumbled blue cheese to food processor with spinach. Sprinkle with 2 slices cooked, crumbled bacon before serving.

spinach dip with feta, lemon, and oregano
Omit bell pepper, dill, and salt. Add ½ cup crumbled feta cheese, 2 tablespoons fresh oregano, 1 teaspoon grated lemon zest, and 1 tablespoon lemon juice to food processor with spinach. Season with salt to taste before serving.

cilantro-lime spinach dip
Omit bell pepper, dill, and hot sauce. Add ¼ cup fresh cilantro leaves, 1 tablespoon chopped canned chipotle chile in adobo sauce, ½ teaspoon grated lime zest, 1 tablespoon lime juice, ½ teaspoon light brown sugar, and ⅛ teaspoon ground cumin to food processor with spinach.

to make ahead
Dip can be refrigerated for up to 24 hours.

whipped cashew nut dip with roasted red peppers and olives

why this recipe works We were seeking a way to create a creamy dairy-free dip when we learned about a technique that used soaked raw cashews. We were skeptical, but once we tried it, we were so impressed that this flavorful, foolproof recipe became one of our all-time favorite dips. When soaked and pureed, the cashews took on a creamy texture that made a perfect neutral-flavored base for our dip. We used a variety of simple ingredients to amp up the flavor. Tasters liked the mildly smoky flavor of roasted red peppers with the briny, salty depth of chopped kalamata olives. A bit of olive oil and lemon juice boosted the flavor further and thinned the dip to a perfect spreadable consistency. Some parsley, stirred in with the olives after processing, provided welcome freshness. Two other flavorful variations turn to smoky chipotle, tangy lime juice, and fresh cilantro; and sweet sun-dried tomatoes and earthy rosemary. You can substitute an equal amount of slivered almonds for the cashews; however, the dip will have a slightly coarser consistency. Soak the raw cashews for at least 12 hours; any less, and the dip will turn out grainy. Serve with crudités.

serves 6 to 8

1½ cups raw cashews

½ cup jarred roasted red peppers, rinsed, patted dry, and chopped

3 tablespoons extra-virgin olive oil

3 tablespoons lemon juice

Kosher salt and pepper

1 garlic clove, minced

½ cup minced fresh parsley

½ cup pitted kalamata olives, chopped

1. Place cashews in bowl and add cold water to cover by 1 inch. Soak cashews at room temperature for at least 12 hours or up to 24 hours. Drain and rinse well.

2. Process soaked cashews, red peppers, 3 tablespoons water, oil, lemon juice, 1½ teaspoons salt, ½ teaspoon pepper, and garlic in food processor until smooth, about 2 minutes, scraping down sides of bowl as needed.

3. Transfer cashew mixture to serving bowl and stir in parsley and olives. Season with salt and pepper to taste. Cover with plastic wrap and let sit at room temperature until flavors meld, about 30 minutes. Serve.

variations

whipped cashew nut dip with chipotle and lime
Omit red peppers and olives. Add ½ teaspoon chipotle chile powder and ½ teaspoon ground cumin to processor with soaked cashews and increase water to 6 tablespoons in step 2. Substitute ¼ cup lime juice (2 limes) for lemon juice and ⅓ cup minced fresh cilantro for parsley.

whipped cashew nut dip with sun-dried tomatoes and rosemary
Omit red peppers and parsley. Add 2 teaspoons minced fresh rosemary to processor with soaked cashews and increase water to 6 tablespoons in step 2. Substitute ½ cup finely chopped oil-packed sun-dried tomatoes for olives.

to make ahead
Dip can be refrigerated for up to 5 days; if necessary, stir in 1 tablespoon warm water to loosen dip consistency before serving.

roasted artichoke dip

why this recipe works A staple of party buffets in the 1970s, hot artichoke dip is still a crowd-pleaser. For our version of this retro favorite, we rejected convenience products and focused on packing in tons of great artichoke flavor under a golden, crispy crust. We replaced tinny canned artichokes with the cleaner taste of frozen artichokes, which we roasted with olive oil, salt, and pepper to intensify their flavor. For the perfect creamy texture and rich flavor, we used a combination of mayonnaise and cream cheese as the base for the dip. Finally, we added some grated Parmesan to the bread-crumb topping to kick it up a notch. Do not thaw the frozen artichoke hearts. This dip is best served warm. Serve with crackers or a thinly sliced baguette.

serves 8 to 10

topping

2 slices hearty white sandwich bread, torn into quarters

2 tablespoons grated Parmesan cheese

1 tablespoon unsalted butter, melted

dip

18 ounces frozen artichokes

2 tablespoons olive oil

Salt and pepper

1 onion, chopped fine

2 garlic cloves, minced

1 cup mayonnaise

4 ounces cream cheese, softened

1 ounce Parmesan cheese, grated (½ cup)

2 tablespoons lemon juice

1 tablespoon minced fresh thyme

Pinch cayenne pepper

1. for the topping Pulse bread in food processor until coarsely ground, about 12 pulses. Toss bread crumbs with Parmesan and melted butter; set aside.

2. for the dip Adjust oven rack to middle position and heat oven to 450 degrees. Line rimmed baking sheet with aluminum foil. Toss artichokes with 1 tablespoon oil, ½ teaspoon salt, and ¼ teaspoon pepper on prepared sheet. Roast artichokes, stirring occasionally, until browned at edges, about 25 minutes. When cool enough to handle, chop artichokes coarse. Reduce oven temperature to 400 degrees.

3. Meanwhile, heat remaining 1 tablespoon oil in 10-inch skillet over medium-high heat until just shimmering. Add onion and cook until softened, 5 to 7 minutes. Stir in garlic and cook until fragrant, about 30 seconds. Transfer onion mixture to large bowl.

4. Stir mayonnaise, cream cheese, Parmesan, lemon juice, thyme, and cayenne into onion mixture until uniform, smearing any lumps of cream cheese against side of bowl with rubber spatula. Gently fold in artichokes and season with salt and pepper to taste. Transfer mixture to 1-quart baking dish and smooth top. Sprinkle topping evenly over dip.

5. Bake dip until hot throughout and topping is golden brown, 20 to 25 minutes. Let dip cool for 5 minutes before serving.

to make ahead
Unbaked dip can be covered tightly with plastic wrap and refrigerated for up to 3 days.

baked crab dip with crostini

why this recipe works In its ideal form, crab dip is a warm, decadent party pleaser full of creamy, meaty seafood and savory spices. Unlike other versions of this popular appetizer, ours has a high ratio of crab to cheese, allowing the sweet crab flavor to come through. To make it even more party-friendly, we used a cast-iron skillet as an oven-to-table cooking vessel, which ensures that your guests will enjoy the dip while it's hot. For a serving option that was sturdy enough to scoop into the rich dip without any need for a spoon, we made a quick batch of crostini from sliced baguettes. To make a savory base for the crab dip, we first cooked onion in the skillet, adding just a bit of Old Bay seasoning and coriander. We then removed the sautéed onions from the skillet and combined them with cream cheese, mayonnaise, and parsley. After gently folding the crabmeat into the mixture, we put the whole thing back in the skillet and baked it until it was warm and bubbly, with the crostini fanned around the perimeter. Do not substitute imitation crabmeat here. To soften the cream cheese quickly, microwave it for 20 to 30 seconds.

serves 8 to 10

2 (12-inch) baguettes, sliced ¼ inch thick on bias

¼ cup extra-virgin olive oil

Salt and pepper

1 onion, chopped fine

1 teaspoon Old Bay seasoning

1 teaspoon ground coriander

8 ounces cream cheese, cut into 8 pieces and softened

½ cup mayonnaise

4 teaspoons minced fresh parsley

12 ounces lump crabmeat, picked over for shells and pressed dry between paper towels

1. Adjust oven racks to upper-middle and lower-middle positions and heat oven to 400 degrees. Arrange bread slices in even layer on 2 rimmed baking sheets and bake until dry and crisp, about 10 minutes, rotating sheets and flipping slices halfway through baking. Brush crostini with 2 tablespoons oil and season with salt and pepper; set aside.

2. Heat 10-inch cast-iron skillet over medium heat for 3 minutes. Add remaining 2 tablespoons oil and heat until shimmering. Add onion and cook until softened, about 5 minutes. Stir in Old Bay and coriander and cook until fragrant, about 30 seconds; transfer to large bowl. Stir cream cheese, mayonnaise, 1 tablespoon parsley, ¼ teaspoon salt, and ¼ teaspoon pepper into onion mixture until thoroughly combined. Gently fold in crabmeat.

3. Spread dip evenly in now-empty skillet, then shingle crostini around edge, submerging narrow ends in crab mixture. Transfer skillet to oven and bake until dip is heated through and crostini are golden brown, about 10 minutes. Sprinkle with remaining 1 teaspoon parsley. Serve.

assembling crab dip

Shingle crostini around edge of skillet, submerging narrow ends in crab mixture.

ultimate seven-layer dip

why this recipe works To create the ultimate version of this appealing dip with bold Southwestern flavors and a simple, no-fuss technique, we distilled every layer down to its essential flavors and designed our recipe to emphasize those elements. We replaced the usual refried beans with canned black beans that we processed with garlic, chili powder, and lime juice. To keep the sour cream layer from watering down our dip, we combined it with cheese to give it more structure. We made the salsa and guacamole layers quick and simple to ensure that they would come together easily and stay fresh and vibrant. This recipe is usually served in a clear dish so you can see the layers. For a crowd, double the recipe and serve in a 13 by 9-inch glass baking dish. If you don't have time to make fresh guacamole as called for, simply mash three avocados with 3 tablespoons lime juice and 1/2 teaspoon salt. Serve with tortilla chips.

serves 8 to 10

4 large tomatoes, cored, seeded, and chopped fine

2 jalapeño chiles, stemmed, seeded, and minced

3 tablespoons minced fresh cilantro

6 scallions (2 minced; 4, green parts only, sliced thin)

2 tablespoons plus 2 teaspoons lime juice (2 limes)

Salt

1 (15-ounce) can black beans, drained but not rinsed

2 garlic cloves, minced

3/4 teaspoon chili powder

1 1/2 cups sour cream

1 pound pepper Jack cheese, shredded (4 cups)

1 recipe (3 cups) Guacamole (page 118)

1. Toss tomatoes, jalapeños, cilantro, minced scallions, 2 tablespoons lime juice, and 1/8 teaspoon salt in bowl. Let stand until tomatoes begin to soften, about 30 minutes. Strain through fine-mesh strainer, discard liquid, and return to bowl.

2. Meanwhile, pulse black beans, garlic, remaining 2 teaspoons lime juice, chili powder, and 1/8 teaspoon salt in food processor until mixture resembles chunky paste, about 15 pulses. Spread bean mixture evenly over bottom of 8-inch square baking dish or 1-quart glass bowl.

3. Wipe out food processor, add sour cream and 2 1/2 cups pepper Jack, and pulse until smooth, about 15 pulses. Spread sour cream mixture evenly over bean layer. Top evenly with remaining 1 1/2 cups pepper Jack, followed by guacamole and, finally, drained tomato mixture. Sprinkle with sliced scallion greens before serving.

variation

ultimate smoky seven-layer dip
Add 1 to 3 teaspoons minced canned chipotle chile in adobo sauce to food processor with black beans. Sprinkle with 4 slices cooked, crumbled bacon before serving.

to make ahead
Dip can be refrigerated for up to 24 hours; bring to room temperature and sprinkle with sliced scallion greens before serving.

spicy whipped feta

why this recipe works The return on investment is huge with this Greek meze classic; you simply process tangy, salty feta to a smooth consistency with a few simple flavors to get a rich yet light, cheesy dip. We found that rinsing the feta was the key to preventing an overly salty dip. To allow the flavor of the feta to take center stage, we kept the other flavorings minimal. A dose of cayenne pepper gave the dip a subtle background heat. Olive oil imparted fruity notes and some richness, and bright lemon juice balanced the saltiness of the cheese. While a pound of feta may seem like a lot, its volume will condense dramatically when processed. This dip is fairly spicy; to make it less spicy, reduce the amount of cayenne to ¼ teaspoon. Serve with Olive Oil–Sea Salt Pita Chips (page 65) or pita wedges.

serves 8

1 pound feta cheese, crumbled (4 cups)

⅓ cup extra-virgin olive oil, plus extra for drizzling

1 tablespoon lemon juice

½ teaspoon cayenne pepper

½ teaspoon pepper

Rinse feta under cold running water and pat dry with paper towels. Process feta, oil, lemon juice, cayenne, and pepper in food processor until smooth, about 20 seconds. Transfer mixture to serving bowl, drizzle with additional oil to taste, and serve.

to make ahead
Processed feta can be refrigerated for up to 2 days; bring to room temperature before serving.

notes from the test kitchen
feta facts
In Greece, feta is still made with methods dating back to the Trojan War. According to European regulations, only cheese made in Greece that contains at least 70 percent sheep's milk can rightfully bear the label "feta." Sheep's milk gives the cheese the funky, grassy tang that most people associate with good feta. For these reasons, we prefer imported feta cheese over domestic versions, which are usually made with 100 percent cow's milk. Our winning brand is **Mt. Vikos Traditional Feta**, which contains 80 percent sheep's milk, hails from the mother country, and balances plenty of tang with just enough salt. When buying block feta, make sure it's packaged in brine. Store the cheese in the brine it is packed in. It's a good idea to rinse feta packed in brine just before serving to remove excess salt. We do not recommend buying precrumbled "dry" feta.

baked brie with honeyed apricots

why this recipe works Baked Brie topped with jam or fruit is popular for good reason. When the cheese is warmed, it becomes rich and gooey, and pairing it with sweet fruit brings out the savory notes in the cheese. For sweet and creamy flavor in every bite, we reengineered the traditional whole wheel of baked Brie by trimming off the rind (which doesn't melt that well) and slicing the cheese into cubes. This allowed our honey-apricot mixture to be evenly distributed throughout this deconstructed version of the dish, not just spooned on top. Baking the cheese in a cast-iron skillet seemed like a no-brainer; since the skillet holds on to heat so well, it keeps the cheese in the ideal luscious, fluid state. We finished the dish with an extra drizzle of honey and some minced chives to reinforce the sweet-savory flavor profile. Be sure to use a firm, fairly unripe Brie for this recipe. Serve with crackers or Melba toast.

serves 8 to 10

¼ cup chopped dried apricots

¼ cup honey

1 teaspoon minced fresh rosemary

¼ teaspoon salt

¼ teaspoon pepper

2 (8-ounce) wheels firm Brie cheese, rind removed, cheese cut into 1-inch pieces

1 tablespoon minced fresh chives

1. Adjust oven rack to middle position and heat oven to 400 degrees. Microwave apricots, 2 tablespoons honey, rosemary, salt, and pepper in medium bowl until apricots are softened and mixture is fragrant, about 1 minute, stirring halfway through microwaving. Add Brie and toss to combine.

2. Transfer mixture to 10-inch cast-iron skillet and bake until cheese is melted, 10 to 15 minutes. Drizzle with remaining 2 tablespoons honey and sprinkle with chives. Serve.

cutting rind off brie

1. Using serrated knife, carefully slice top and bottom rind off wheel of Brie.

2. Trim rind from sides.

rosemary and garlic white bean dip

why this recipe works White bean dip is a secret weapon for your party menu: It's creamy but not too rich, it's built on just a few simple ingredients, and the mild beans make the perfect canvas for highlighting fresh, assertive flavors (as our variations show). To add appealingly chunky texture to our variation, we reserved a handful of beans and pulsed them in at the end. Serve with crackers, Olive Oil–Sea Salt Pita Chips (page 65), or crudités.

serves 8 to 10

2 (15-ounce) cans cannellini beans, rinsed

½ cup extra-virgin olive oil

¼ cup water

2 tablespoons lemon juice

2 garlic cloves, minced

½ teaspoon chopped fresh rosemary

Salt and pepper

1. Process two-thirds of beans, 6 tablespoons oil, water, lemon juice, garlic, and rosemary in food processor until smooth, about 10 seconds; scrape down bowl. Add remaining beans and pulse to incorporate (do not puree smooth), about 5 pulses.

2. Transfer to serving bowl, cover, and let sit at room temperature until flavors have blended, at least 30 minutes. Before serving, season with salt and pepper to taste, make small well in center of dip, and pour remaining 2 tablespoons oil into well.

to make ahead
Dip can be refrigerated for up to 2 days.

variations

caper and tarragon
white bean dip
Substitute 4 teaspoons minced fresh tarragon for rosemary, omit salt, and add 6 tablespoons rinsed capers to food processor with first two-thirds of beans.

goat cheese and lemon
white bean dip
Substitute 2 teaspoons minced fresh thyme for rosemary and add 2 cups crumbled goat cheese and 4 teaspoons grated lemon zest to food processor with first two-thirds of beans.

green chile and cilantro
white bean dip
Omit water. Substitute 6 tablespoons minced fresh cilantro for rosemary. Add 1 cup patted dry canned green chiles and 4 tablespoons sour cream to food processor with first two-thirds of beans.

sun-dried tomato and feta
white bean dip
Increase water to ½ cup, substitute 2 teaspoons minced fresh oregano for rosemary, omit salt, and add 1 cup crumbled feta cheese and ½ cup oil-packed sun-dried tomatoes to food processor with first two-thirds of beans.

classic hummus

why this recipe works For a light, silky-smooth hummus with flavors that put supermarket versions to shame, we started with canned chickpeas. We used the food processor to simplify the preparation for this recipe; instead of laboring over the fussy job of removing the chickpeas' tough skins, we simply pureed the unskinned chickpeas into a velvety emulsion with olive oil and tahini for the perfect texture. From there it was easy to mix up the flavors for a set of hummus options to suit any partygoer's palate.

serves 6 to 8

¼ cup water

3 tablespoons lemon juice

6 tablespoons tahini

2 tablespoons extra-virgin olive oil, plus extra for drizzling

1 (15-ounce) can chickpeas, rinsed

1 small garlic clove, minced

½ teaspoon salt

¼ teaspoon ground cumin

Pinch cayenne pepper

1 tablespoon minced fresh cilantro or parsley

1. Combine water and lemon juice in small bowl. In separate bowl, whisk tahini and oil together. Set aside 2 tablespoons of chickpeas for garnish.

2. Process remaining chickpeas, garlic, salt, cumin, and cayenne in food processor until almost fully ground, about 15 seconds. Scrape down bowl with rubber spatula. With processor running, add lemon juice mixture in steady stream. Scrape down bowl and continue to process for 1 minute. With processor running, add tahini mixture in steady stream and process until hummus is smooth and creamy, about 15 seconds, scraping down bowl as needed.

3. Transfer hummus to serving bowl, cover with plastic wrap, and let sit at room temperature until flavors meld, about 30 minutes. Sprinkle with reserved chickpeas and cilantro, drizzle with additional oil to taste, and serve.

variations

artichoke-lemon hummus
Rinse 1 cup drained canned artichoke hearts and pat dry with paper towels. Chop ¼ cup artichoke hearts and set aside for garnish. Increase lemon juice to 4 tablespoons (2 lemons) and omit cumin. Process entire can of chickpeas (do not reserve 2 tablespoons) along with remaining ¾ cup artichokes and ¼ teaspoon grated lemon zest. Omit cilantro. Garnish hummus with reserved artichokes, 2 teaspoons minced fresh parsley or mint, and olive oil.

roasted red pepper hummus
Omit water and cumin. Process entire can of chickpeas (do not reserve 2 tablespoons) with ¼ cup jarred roasted red peppers that have been rinsed and thoroughly patted dry with paper towels. Omit cilantro. Garnish hummus with 2 tablespoons toasted sliced almonds, 2 teaspoons minced fresh parsley, and olive oil.

roasted garlic hummus
Remove outer papery skins from 2 heads garlic; cut top quarters off heads and discard. Wrap garlic in foil and roast in 350-degree oven until browned and very tender, about 1 hour. Meanwhile, heat 2 tablespoons extra-virgin olive oil and 2 thinly sliced garlic cloves in 8-inch skillet over medium-low heat. Cook, stirring occasionally, until garlic is golden brown, about 15 minutes. Using slotted spoon, transfer garlic slices to paper towel–lined plate and set aside; reserve oil. Once roasted garlic is cool, squeeze cloves from their skins. Substitute garlic cooking oil for olive oil in step 1 and omit cumin. Process entire can of chickpeas (do not reserve 2 tablespoons) along with roasted garlic puree. Garnish hummus with toasted garlic slices, 2 teaspoons fresh parsley, and olive oil.

to make ahead
Hummus can be refrigerated for up to 5 days; refrigerate garnishes separately. Before serving, stir in 1 tablespoon warm water to loosen hummus texture if necessary.

sweet potato hummus

why this recipe works Hummus doesn't have to mean just plain chickpea dip. Our new take on this dish brings in the earthy, vibrant flavors of sweet potato to share the stage with the traditional legumes. The trick to this rendition was finding the right balance of ingredients and bringing out the best in the sweet potato's subtle flavor. We started with our recipe for Classic Hummus and added varying amounts of tender sweet potato pulp. One large sweet potato (about 1 pound) gave us just the right balance. We found that microwaving the sweet potato resulted in flavor that was nearly as intense as when we roasted it, and was far faster and easier, which was important for such a simple dish. Tasters preferred less tahini here than in the plain hummus, so we reduced it to ¼ cup. To play up the sweet potato's flavor, we used complementary warm spices: sweet paprika, coriander, cinnamon, and cumin. A dash of cayenne pepper and a single clove of garlic cut the sweetness and accented the spices well.

serves 6 to 8

1 large sweet potato (about 1 pound), unpeeled

¾ cup water

¼ cup lemon juice (2 lemons)

¼ cup tahini

2 tablespoons extra-virgin olive oil, plus extra for drizzling

1 (15-ounce) can chickpeas, rinsed

1 small garlic clove, minced

1 teaspoon paprika

1 teaspoon salt

½ teaspoon ground coriander

¼ teaspoon ground cumin

⅛ teaspoon ground cinnamon

⅛ teaspoon cayenne pepper

1. Prick sweet potato several times with fork, place on plate, and microwave until very soft, about 12 minutes, flipping half-way through microwaving. Slice potato in half lengthwise, let cool, then scrape sweet potato flesh from skin; discard skin.

2. Combine water and lemon juice in small bowl. In separate bowl, whisk tahini and oil together.

3. Process sweet potato, chickpeas, garlic, paprika, salt, coriander, cumin, cinnamon, and cayenne in food processor until almost fully ground, about 15 seconds. Scrape down bowl with rubber spatula. With processor running, add lemon juice mixture in steady stream. Scrape down bowl and continue to process for 1 minute. With processor running, add tahini mixture in steady stream and process until hummus is smooth and creamy, about 15 seconds, scraping down bowl as needed.

4. Transfer hummus to serving bowl. Cover with plastic wrap and let sit at room temperature until flavors meld, about 30 minutes. Drizzle with additional oil to taste and serve.

to make ahead
Hummus can be refrigerated for up to 5 days; before serving, stir in 1 tablespoon warm water to loosen hummus texture if necessary.

baba ghanoush

why this recipe works This version of the staple Mediterranean appetizer has great eggplant presence and a smooth, not-at-all watery texture. We found that it was critical to start with fresh eggplant and cook it until the flesh was almost sloshy; undercooked eggplant, while misleadingly soft to the touch, tastes spongy and raw in the finished dish. It can take anywhere from 40 minutes to an hour to cook the eggplant fully, depending on how much moisture the eggplant has. To avoid a watery texture, we drained the cooked eggplant before processing it along with the classic flavors of tahini, lemon juice, garlic, and parsley. Pricking the eggplant all over with a fork before roasting also helped it release moisture. Look for eggplants with shiny, taut, and unbruised skins and an even shape (eggplants with a bulbous shape won't cook evenly). We prefer to serve baba ghanoush only lightly chilled; if cold, let it stand at room temperature for about 20 minutes before serving. Serve with Olive Oil–Sea Salt Pita Chips (page 65), pita wedges, tomato wedges, or cucumber slices.

serves 4 to 6

2 pounds eggplant, pricked all over with fork

2 tablespoons tahini

2 tablespoons extra-virgin olive oil, plus extra for drizzling

4 teaspoons lemon juice

1 small garlic clove, minced

Salt and pepper

2 teaspoons chopped fresh parsley

1. Adjust oven rack to middle position and heat oven to 500 degrees. Place eggplants on aluminum foil–lined rimmed baking sheet and roast, turning eggplants every 15 minutes, until uniformly soft when pressed with tongs, 40 minutes to 1 hour. Let eggplants cool for 5 minutes on baking sheet.

2. Set colander over bowl. Trim top and bottom off each eggplant. Slit eggplants lengthwise and use spoon to scoop hot pulp from skins. Place pulp in colander (you should have about 2 cups packed pulp); discard skins. Let pulp drain for 3 minutes.

3. Transfer pulp to food processor. Add tahini, oil, lemon juice, garlic, ¾ teaspoon salt, and ¼ teaspoon pepper. Process mixture into coarse puree, about 8 pulses. Season with salt and pepper to taste. Transfer to serving bowl, cover with plastic wrap flush with surface of dip, and refrigerate until chilled, about 1 hour. Drizzle with additional oil to taste, sprinkle with parsley, and serve.

to make ahead
Dip can be refrigerated for up to 24 hours; let sit at room temperature for 30 minutes and season with extra lemon juice and salt to taste before drizzling with extra olive oil, sprinkling with parsley, and serving.

guacamole

why this recipe works Our guacamole is all about bold flavor and great texture; no pasty, bland guac here. For the base, we mashed one avocado and then gently folded in two diced avocados to keep the mixture nice and chunky. We flavored our guacamole with onion, fresh herbs, spices, and a few other add-ins to keep it interesting. The flavors and textures of the base recipe lent themselves easily to creative variations for a variety of fresh takes on this party favorite.

serves 4 to 6

3 ripe avocados

¼ cup chopped fresh cilantro

1 jalapeño chile, stemmed, seeded, and minced

2 tablespoons finely chopped onion

2 tablespoons lime juice

2 garlic cloves, minced

Salt

½ teaspoon ground cumin

1. Halve 1 avocado, remove pit, and scoop flesh into medium bowl. Add cilantro, jalapeño, onion, lime juice, garlic, ¾ teaspoon salt, and cumin and mash with potato masher (or fork) until mostly smooth.

2. Halve and pit remaining 2 avocados. Carefully make ½-inch crosshatch incisions in flesh with butter knife, cutting down to but not through skin. Insert spoon between skin and flesh, gently scoop out avocado cubes, and add to mashed mixture. Gently mash until mixture is well combined but still coarse. Season with salt to taste. Serve.

variations

bacon and tomato guacamole
Add 6 slices chopped and cooked bacon and 1 tomato, cored and cut into ¼-inch pieces, with avocados in step 2.

chipotle and pepita guacamole
Substitute 1 tablespoon minced canned chipotle chile in adobo sauce for jalapeño in step 1. Add ¼ cup toasted pepitas with avocados in step 2.

feta and arugula guacamole
Substitute ½ cup chopped baby arugula for cilantro in step 1. Add 1 cup crumbled feta cheese with avocados in step 2.

habanero and mango guacamole
Substitute 1 stemmed, seeded, and minced habanero chile for jalapeño in step 1. Add ½ mango, peeled and cut into ¼-inch pieces, with avocados in step 2.

to make ahead
Guacamole can be stored for up to 24 hours by pressing plastic wrap directly against its surface before refrigerating.

preparing avocados

1. After slicing avocado in half around pit, lodge edge of knife blade into pit and twist to remove. Use large wooden spoon to pry pit safely off knife.

2. Use dish towel to hold avocado steady. Make ½-inch crosshatch incisions in flesh of each avocado half with knife, cutting down to but not through skin.

3. Separate flesh from skin with soupspoon inserted between skin and flesh, scooping out cubes.

easy mushroom pâté

why this recipe works To achieve a mushroom pâté full of heady, earthy mushroom flavor without foraging the forests for wild specimens, we supplemented everyday white mushrooms with dried porcini, which are intensely flavored but widely available year-round. We found we got the best results when we pulsed the mushrooms in the food processor until still slightly chunky rather than aiming for a perfectly smooth texture. Processing the mushrooms before cooking rather than after also helped them retain more texture. After rehydrating the dried porcini we reserved some of the potent soaking liquid and added it in later to give the pâté even more mushroom flavor. Cream cheese and a couple of tablespoons of heavy cream provided a rich, creamy base while sautéed shallots, thyme, and garlic contributed deep flavor. Lemon juice and parsley offset the earthy flavors with some brightness. Serve with crackers or a thinly sliced baguette.

serves 8

1 ounce dried porcini mushrooms, rinsed

1 pound white mushrooms, trimmed and halved

3 tablespoons unsalted butter

2 large shallots, minced

Salt and pepper

3 garlic cloves, minced

1½ teaspoons minced fresh thyme

2 ounces cream cheese

2 tablespoons heavy cream

1 tablespoon minced fresh parsley

1½ teaspoons lemon juice

1. Microwave 1 cup water and porcini mushrooms in covered bowl until steaming, about 1 minute. Let sit until softened, about 5 minutes. Drain porcini in fine-mesh strainer lined with coffee filter set over bowl. Reserve ⅓ cup liquid. Pulse porcini and white mushrooms in food processor until finely chopped and all pieces are pea-size or smaller, about 10 pulses, scraping down bowl as needed.

2. Melt butter in 12-inch skillet over medium heat. Add shallots and ¾ teaspoon salt and cook until shallots are softened, 3 to 5 minutes. Stir in garlic and thyme and cook until fragrant, 30 seconds. Stir in processed mushrooms and cook, stirring occasionally, until liquid released from mushrooms evaporates and mushrooms begin to brown, 10 to 12 minutes.

3. Stir in reserved porcini liquid and cook until nearly evaporated, about 1 minute. Off heat, stir in cream cheese, cream, parsley, and lemon juice, and season with salt and pepper to taste. Transfer to serving bowl and smooth top. Press plastic wrap flush to surface of pâté and refrigerate until firm, at least 2 hours. Before serving, bring pâté to room temperature to soften.

to make ahead
Pâté can be refrigerated for up to 3 days.

notes from the test kitchen
choosing dried mushrooms
We love to add dried mushrooms to recipes; even a small amount can pack a huge flavor punch and add intense flavor to a variety of dishes. They can be expensive, though, so make sure you choose carefully: Avoid packages with lots of dust and crumbled bits or those labeled "wild mushroom mix," as these are often older and of lesser quality. Dried mushrooms should have an earthy (not musty or stale) aroma. Store dried mushrooms in an airtight container in a cool, dry place for up to one year.

chicken liver pâté

why this recipe works This smooth, buttery pâté is irresistibly rich and very easy to make. We started by sautéing sweet shallots in butter with fresh thyme and vermouth to provide an aromatic base. We first seared the livers to develop their flavor and then gently poached them to ensure a moist pâté. A bit of brandy unified the pâté's flavors. Pressing plastic wrap against the surface of the pâté before refrigerating it minimized any discoloration due to oxidation. Buy the freshest livers possible and make sure to trim them well of fat and connective tissues. Serve with toast points, baguette, or crackers, and cornichons.

serves 6 to 8

8 tablespoons unsalted butter

3 large shallots, sliced thin

1 tablespoon minced fresh thyme

Salt and pepper

1 pound chicken livers, rinsed, patted dry, and trimmed of fat and connective tissue

¾ cup dry vermouth

2 teaspoons brandy

1. Melt butter in 12-inch skillet over medium-high heat. Add shallots, thyme, and ¼ teaspoon salt and cook until shallots are lightly browned, 3 to 5 minutes. Add chicken livers and cook, stirring constantly, about 1 minute. Add vermouth and simmer until livers have rosy interior, 4 to 6 minutes.

2. Using slotted spoon, transfer livers to food processor. Continue to simmer vermouth until slightly syrupy, 2 minutes.

3. Add vermouth mixture and brandy to processor. Process mixture until very smooth, about 2 minutes, scraping down bowl as needed. Season with salt and pepper to taste. Transfer to small serving bowl, smooth top, press plastic wrap flush to surface of pâté, and refrigerate until firm, at least 6 hours.

4. Before serving, bring to room temperature to soften, and scrape off any discolored pâté on top.

to make ahead
Pâté can be refrigerated for up to 3 days.

passed and plattered

127 ham and cheese palmiers
128 gougères
131 hushpuppies with chipotle aïoli
132 green chile cheeseburger sliders
135 chicken and avocado arepa bites
136 mini cheese quiches
139 pan-fried halloumi
 with garlic-parsley sauce
141 spanish tortilla with garlic mayonnaise
142 bacon-cheddar potato skins
144 latkes
147 blini
149 scallion pancakes
151 cocktail crab cakes with chipotle mayonnaise
152 easy crab rangoon
155 fried calamari with tartar sauce
156 classic shrimp cocktail with horseradish cocktail sauce
159 broiled shrimp cocktail with creamy tarragon sauce
160 spanish-style garlic shrimp
163 chicken satay with spicy peanut dipping sauce
 beef satay with spicy peanut dipping sauce
164 cocktail meatballs in tomato-saffron sauce
167 lamb meatballs with yogurt sauce
168 oven-fried chicken wings
 buffalo wing sauce
 smoky barbecue wing sauce
 sweet and spicy thai wing sauce
171 korean fried chicken wings

ham and cheese palmiers

why this recipe works French *palmiers* are made from puff pastry that has been rolled up and sliced into thin pieces that are said to resemble palm leaves, elephant ears, or butterflies. We retooled this typically sweet pastry into an elegant but easy savory appetizer. We brushed store-bought puff pastry with Dijon mustard, sprinkled it with minced thyme, layered it with thinly sliced ham and Parmesan cheese, and rolled it into a log. To finish the pastries, we simply sliced the log and baked the palmiers until they were golden brown and crispy. To thaw frozen puff pastry, let it sit either in the refrigerator for 24 hours or on the counter for 30 minutes to 1 hour. If the dough becomes too warm and sticky to work with, cover it with plastic wrap and chill it in the refrigerator until firm. To round out this appetizer, consider serving it with farmhouse cheddar cheese and sliced apples.

serves 6 to 8

1 (9½ by 9-inch) sheet puff pastry, thawed

2 tablespoons Dijon mustard

2 teaspoons minced fresh thyme

4 ounces thinly sliced deli ham

2 ounces Parmesan cheese, grated (1 cup)

1. Roll puff pastry into 12-inch square on lightly floured counter. Brush evenly with mustard, sprinkle with thyme, lay ham evenly over top (to edge), and sprinkle with Parmesan. Roll up both sides of pastry until they meet in middle. Wrap pastry log in plastic wrap and refrigerate until firm, about 1 hour.

2. Adjust oven rack to middle position and heat oven to 400 degrees. Line rimmed baking sheet with parchment paper. Using sharp knife, trim ends of log, then slice into ⅓-inch-thick pieces and space them about 1 inch apart on prepared baking sheet.

3. Bake until golden brown and crispy, about 25 minutes, rotating baking sheet halfway through baking. Transfer palmiers to wire rack and let cool completely. Palmiers can be held at room temperature for up to 6 hours before serving.

to make ahead
Rolled pastry log can be refrigerated for up to 2 days before slicing and baking.

shaping palmiers

1. After layering mustard, thyme, ham, and Parmesan on pastry sheet, tightly roll up pastry from opposite sides until they meet in middle.

2. Once pastry is chilled, slice it into ⅓-inch-thick pieces.

gougères

why this recipe works Cheese puffs, or *gougères*, hail from the Burgundy province of France and are the ideal hors d'oeuvre to pair with a glass of red wine like the ones made famous by that region. Made from the French pastry dough *pâte à choux* enriched with cheese, a perfect gougère has a crispy, caramel-colored exterior that yields to a tender, slightly moist interior. After discovering that small variations in oven temperature led to wildly different results, we settled on a combination method: 425 degrees for 15 minutes and 375 degrees for about 12 minutes delivered crispy results. Then, to keep our puffs from becoming soggy, we slit each one with a paring knife to release trapped steam and returned them to a turned-off oven for 45 minutes. If Gruyère is unavailable, Swiss or Emmentaler cheese will work. Coating the pan with vegetable oil spray ensures that the parchment will stay in place when you pipe out the sticky dough.

serves 4 to 6

2 large eggs plus 1 large egg white

6 tablespoons water

5 tablespoons unsalted butter, cut into ½-inch pieces

2 tablespoons whole milk

¼ teaspoon salt

½ cup (2½ ounces) all-purpose flour

3 ounces Gruyère cheese, shredded (¾ cup)

Pinch cayenne pepper

1. Adjust oven rack to middle position and heat oven to 425 degrees. Spray baking sheet with vegetable oil spray and line with parchment paper. Fit large pastry bag with ½-inch plain tip. Beat eggs and white together with fork in liquid measuring cup; you should have ½ cup eggs. Discard any excess. Set aside eggs.

2. Bring water, butter, milk, and salt to boil in small saucepan over medium heat, stirring occasionally, until butter is melted. Off heat, stir in flour until mixture forms dough that clears sides of pan, about 45 seconds. Return pan to low heat and cook, stirring constantly, until mixture looks like wet sand and registers 175 to 180 degrees, about 3 minutes. Immediately transfer mixture to food processor and process until fully incorporated, about 10 seconds. With processor running, gradually add eggs in steady stream. Scrape down sides of bowl, add Gruyère and cayenne, and continue to process until sticky paste forms, about 30 seconds.

3. Fill prepared pastry bag with paste and pipe sixteen 2-inch mounds, spaced about 1 inch apart, onto prepared sheet. Use back of teaspoon dipped in bowl of cold water to even out shape and smooth surface of piped mounds.

4. Bake for 15 minutes, then reduce oven temperature to 375 degrees and, without opening oven door, continue to bake until mounds are fairly firm and golden brown, 12 to 14 minutes longer. Remove sheet from oven. Using paring knife, cut ¾-inch slit in side of each puff. Return puffs to oven, turn off oven, and prop open oven door with handle of wooden spoon. After 10 minutes, transfer puffs to wire rack. Serve warm or at room temperature.

to make ahead
Gougères can be cooled completely and stored at room temperature for up to 24 hours or frozen in zipper-lock plastic bag for up to 1 month. Before serving, crisp room-temperature gougères in 300-degree oven for 5 to 8 minutes; crisp frozen gougères for 8 to 10 minutes.

hushpuppies with chipotle aïoli

why this recipe works Hushpuppies are fried cornmeal dumplings with crispy outsides, fluffy insides, and big corn flavor. They are a classic Southern side dish, but we are on a campaign to get them wider recognition as an appetizer pick. With all the appeal of golden-brown cornbread in a perfectly fried mouthful, it's easy to see why these should be the star of your next party. For truly delicate interiors, we strayed from tradition and lightened the cornmeal batter with a little all-purpose flour. We returned to tradition by using buttermilk as our liquid, which not only added a nice tang but also let us incorporate baking soda, which reacted with the acidic buttermilk and created carbon dioxide bubbles that further lightened the batter. We also added a little baking powder, which was activated when the batter was dropped into the hot oil, causing the dumplings to expand slightly and open up their interior crumb. To jazz up the hushpuppies, we added cayenne pepper, scallions, and Dijon mustard to the batter and paired them with a quick chipotle aïoli dipping sauce. Do not use stone-ground cornmeal in this recipe; it will make the texture of the hushpuppies too gritty. You will need a 12-inch cast-iron skillet with at least 2-inch sides for this recipe.

serves 8

½ cup mayonnaise

5 teaspoons minced canned chipotle chile in adobo sauce

1 teaspoon lime juice

¾ cup (3¾ ounces) cornmeal

½ cup (2½ ounces) all-purpose flour

1½ teaspoons baking powder

½ teaspoon baking soda

¼ teaspoon salt

¼ teaspoon cayenne pepper

¾ cup buttermilk

2 large eggs

2 scallions, sliced thin

2 tablespoons Dijon mustard

1 quart peanut or vegetable oil

1. Adjust oven rack to middle position and heat oven to 200 degrees. Whisk mayonnaise, chipotle, and lime juice together in bowl; set aside for serving.

2. Whisk cornmeal, flour, baking powder, baking soda, salt, and cayenne together in large bowl. In separate bowl, whisk buttermilk, eggs, scallions, and mustard together until well combined. Stir buttermilk mixture into cornmeal mixture with rubber spatula until just combined. Let batter sit at room temperature for 10 minutes.

3. Set wire rack in rimmed baking sheet and line with triple layer of paper towels. Add oil to 12-inch cast-iron skillet until it measures about ¾ inch deep and heat over medium-high heat to 375 degrees.

4. Carefully drop one-third of batter, 1 tablespoon at a time, into oil. Fry until deep golden brown, 2 to 4 minutes, flipping hushpuppies halfway through frying. Adjust burner, if necessary, to maintain oil temperature between 350 and 375 degrees. Transfer hushpuppies to prepared rack and keep warm in oven. (Hushpuppies can be kept warm in oven for up to 30 minutes.)

5. Return oil to 375 degrees and repeat with remaining batter in 2 batches. Serve with chipotle aïoli.

green chile cheeseburger sliders

why this recipe works No appetizer book would be complete without a slider recipe. For our version, we wanted all the great char and juicy meat of a full-size burger stuffed into a diminutive package. To create a flavorful crust on a small burger while retaining a moist interior, you need a real blast of heat that can char the outside quickly, so we used a cast-iron skillet. To take the flavor to the next level, we added a double dose of green chiles, both in the meat and on top of the burgers. We sautéed onion, garlic, and canned green chiles, then pureed part of that mixture and added it to the ground beef. Refrigerating the burgers for half an hour ensured that the thin, delicate patties were easy to handle. For the topping, we reserved ½ cup of the unpureed sautéed green chile mixture and combined it with mayonnaise, lime juice, and salt for a spread that added moisture and extra flavor to the sliders. Using shredded pepper Jack helped ensure that the cheese melted evenly on the burgers. Form the patties ½ inch wider than the slider buns; after the patties shrink during cooking, they will be the perfect size. We found Martin's 12 Sliced Potato Rolls to be a great slider bun. When flipping these thin, moist patties, it's helpful to use two spatulas.

serves 10 to 12

5 tablespoons vegetable oil

1 onion, chopped fine

1½ cups canned chopped green chiles, rinsed and patted dry

1 garlic clove, minced

¼ cup mayonnaise

1 tablespoon lime juice

Salt and pepper

1 pound 85 percent lean ground beef

4 ounces pepper Jack cheese, shredded (1 cup)

12 soft white dinner rolls, sliced and toasted

1. Heat 12-inch cast-iron skillet over medium heat for 3 minutes. Add 2 tablespoons oil and heat until shimmering. Add onion and cook until softened, about 5 minutes. Stir in chiles and garlic and cook until fragrant, about 1 minute. Transfer mixture to food processor and process to smooth paste, about 1 minute, scraping down sides of bowl as needed. Combine ½ cup processed chile paste, mayonnaise, lime juice, and ¼ teaspoon salt in bowl; set aside for serving.

2. Add remaining chile paste, beef, ½ teaspoon salt, and ¼ teaspoon pepper to large bowl and knead with your hands until uniformly combined. Divide meat mixture into 12 lightly packed balls, then flatten into ¼-inch-thick patties. Transfer patties to platter and refrigerate until chilled, about 30 minutes.

3. Wipe now-empty skillet clean with paper towels and heat over medium heat for 5 minutes. Add 1 tablespoon oil and heat until just smoking. Place 4 burgers in skillet and cook, without moving, until well browned on first side, about 2 minutes. Flip burgers and top with 1 heaping tablespoon pepper Jack. Cover and continue to cook until well browned on second side and cheese is melted, about 2 minutes.

4. Repeat with remaining 2 tablespoons oil, burgers, and pepper Jack in 2 batches. Serve burgers with buns and chile sauce.

to make ahead
Patties can be refrigerated for up to 24 hours before cooking in step 3.

chicken and avocado arepa bites

why this recipe works An *arepa* is a type of corn cake that is super-popular in Colombia and Venezuela, where they are often split open and stuffed with savory fillings. We thought this hearty dish would translate perfectly to an appetizer, so we deconstructed the classic arepa into a bite-size morsel with all the flavor of a full-size sandwich. To make our mini corn cakes, we combined a type of corn flour called *masarepa* with water, salt, and, for lightness, a little baking powder (which is untraditional); formed the mixture into cakes; and then browned the cakes in a skillet before baking them. To assemble the bites, we simply topped them with a traditional shredded chicken and avocado mixture and a dollop of lime *crema*.

serves 10 to 12

crema
1/2 cup sour cream

1/2 teaspoon finely grated lime zest plus 2 teaspoons juice

Salt

topping
2 (6- to 8- ounce) boneless, skinless chicken breasts, trimmed

Salt and pepper

1 tablespoon vegetable oil

2 avocados, halved and pitted

3 scallions, sliced thin

2 tablespoons lime juice

2 tablespoons minced fresh cilantro

1/2 teaspoon chili powder

corn cakes
2 cups (10 ounces) masarepa blanca

1 teaspoon salt

1 teaspoon baking powder

2 1/2 cups warm tap water

1/2 cup vegetable oil

1. for the crema Mix sour cream and lime zest and juice together in small bowl. Season with salt to taste, cover bowl with plastic, and refrigerate until needed.

2. for the topping Pat chicken dry with paper towels and season with salt and pepper. Heat vegetable oil in 12-inch nonstick skillet over medium-high heat until just smoking. Add chicken and cook until browned on 1 side, about 3 minutes. Flip chicken over, add 1/2 cup water, and cover. Reduce heat to medium and continue to cook until thickest part of breasts registers 160 degrees, 5 to 7 minutes longer. Transfer chicken to carving board. When cool enough to handle, shred chicken into bite-size pieces.

3. Scoop avocado flesh into bowl. Mash flesh with scallions, lime juice, cilantro, and chili powder. Season with salt and pepper to taste. Gently fold in chicken. Press plastic against surface of topping and refrigerate until needed, up to 6 hours.

4. for the corn cakes Adjust oven racks to upper-middle and lower-middle positions and heat oven to 400 degrees. Line 2 baking sheets with parchment paper.

Whisk masarepa, salt, and baking powder together in medium bowl. Gradually stir in warm tap water to form dough. Working with 1 tablespoon dough at a time, shape into 1 1/2-inch-diameter patties about 1/4 inch thick and space them evenly on prepared sheets.

5. Heat 2 tablespoons oil in 12-inch nonstick skillet over medium-high heat until shimmering. Using flat metal spatula, carefully place one-quarter of patties in skillet and cook until golden on both sides, about 4 minutes per side. Place parcooked corn cakes back on prepared sheets. Repeat with remaining oil and remaining patties.

6. Bake corn cakes until they sound hollow when tapped on bottom, about 10 minutes, switching and rotating sheets halfway through baking. Divide topping evenly among corn cakes. Top with crema and serve.

to make ahead
Baked and cooled corn cakes can be frozen for up to 1 month. If using frozen corn cakes, bake for 20 minutes in step 6. Crema can be refrigerated for up to 3 days.

mini cheese quiches

why this recipe works A perfect quiche should have flaky crust, rich flavor, and velvety smooth filling. Achieving all those goals in a full-size quiche is hard enough, but when you shrink this classic dish down to finger-food size, it gets even harder. We wanted all the flavor and velvety texture of a standard-size quiche encased in an elegant handheld appetizer. We kept it simple by going with a basic cheese filling and using frozen pie dough for the crust. For a medium-rich custard that worked in this miniature format, we combined three eggs and 1 cup of half-and-half. We parbaked our pastry shells at 375 degrees and then decreased the oven temperature to 350 degrees, which was low enough to set the custard gently without overbaking the crust. Use two pie dough rounds to make 24 mini quiches. Our favorite store-bought pie dough is **Wholly Wholesome 9″ Certified Organic Traditional Bake at Home Rolled Pie Dough**.

serves 8 to 10

1 package store-bought
pie dough

1 cup half-and-half

3 large eggs

¼ teaspoon salt

⅛ teaspoon pepper

2 ounces cheddar cheese,
shredded (½ cup)

1 teaspoon minced fresh chives

1. Adjust oven rack to middle position and heat oven to 375 degrees. Spray one 24-cup or two 12-cup mini muffin tin(s) with vegetable oil spray. Working with 1 dough round at a time, roll out dough to ⅛-inch thickness on lightly floured counter. Using 3-inch round cutter, cut 12 circles out of dough round (reroll scraps if necessary); discard scraps. Fit each circle into cup of prepared mini muffin tin, pressing dough into corners (dough should stick up just over rim). Repeat with remaining dough. Bake shells until dough is partially cooked and rims look opaque, 12 to 15 minutes. Let partially baked shells cool slightly. Reduce oven temperature to 350 degrees.

2. Whisk half-and-half, eggs, salt, and pepper together in medium bowl until no streaks of egg remain and transfer to 2-cup liquid measuring cup. Place shells, still in muffin tin(s), on baking sheet. Sprinkle cheddar and chives evenly over bottoms of shells. Carefully pour egg mixture into shells until it reaches about ⅛ inch from top edge of crust (you may have extra egg mixture). Carefully transfer sheet to oven and bake quiches until center is set but soft, 14 to 18 minutes. Serve warm or at room temperature.

to make ahead
Quiches can be stored in the refrigerator. Let quiches cool completely in muffin tin(s) on wire rack. Transfer quiches to airtight container and refrigerate for up to 3 days. When ready to serve, heat oven to 350 degrees. Arrange quiches on sheet and heat until just warmed through, about 10 minutes (do not overbake).

making mini quiches

1. Fit dough circles into cups of mini muffin tin, pressing dough into corners. Parbake shells.

2. Fill parbaked shells with custard to within ⅛ inch of top edge of crust and bake.

pan-fried halloumi

why this recipe works Halloumi is a firm, brined cheese popular in Greece, Cyprus, and Turkey. It is made from goat's or sheep's milk (or a combination of both) and when pan-seared, it makes a fresh, modern, incredibly simple cheese appetizer. The salty, creamy, chewy pan-fried cheese is so good, all it needs is a squeeze of bright lemon juice. To get a crisp, browned crust that would offer a satisfying contrast to the chewy cheese, we tried pan-frying the halloumi both plain and dusted with flour, bread crumbs, and cornmeal. A combination of cornmeal and a little all-purpose flour provided just the right golden-brown, textured coating. For a slightly more dressed-up version, you can make a quick butter sauce with thinly sliced garlic, fresh parsley, and red pepper flakes to drizzle over the top of the pan-fried cheese. It also tastes great with a drizzle of honey.

serves 4

2 tablespoons cornmeal

1 tablespoon all-purpose flour

1 (8-ounce) block halloumi cheese

2 tablespoons extra-virgin olive oil

Lemon wedges

1. Combine cornmeal and flour in shallow dish. Slice block of cheese crosswise into ½-inch-thick slabs. Working with 1 slab at a time, coat both wide sides in cornmeal mixture, pressing to help coating adhere; transfer to plate.

2. Heat oil in 12-inch nonstick skillet over medium heat until shimmering. Arrange halloumi in even layer in skillet and cook until golden brown on both sides, 2 to 4 minutes per side. Transfer to platter and serve with lemon wedges.

variation

pan-fried halloumi with garlic-parsley sauce
After frying halloumi, discard oil left in skillet and wipe out skillet with paper towels. Add 2 tablespoons unsalted butter to now-empty skillet and melt over medium heat. Add 1 thinly sliced garlic clove, 2 tablespoons chopped fresh parsley, and ¼ teaspoon red pepper flakes and cook until garlic is golden brown and fragrant, about 1 minute. Drizzle butter mixture over pan-fried halloumi and serve with lemon wedges.

spanish tortilla with garlic mayonnaise

why this recipe works This savory, velvety potato and egg cake is perhaps Spain's ultimate tapa. Slathered with a homemade garlic mayonnaise, this appetizer becomes irresistible. We parcooked the potatoes before combining them with the eggs and other flavorings to ensure that they were cooked through. Flipping the tortilla over halfway through cooking ensured that it was evenly cooked through on both sides. Traditional recipes instruct the cook to "flip" the tortilla up in the air, but we found that using two plates to flip it over was much more foolproof. When making the garlic mayonnaise, we whisked in the extra-virgin olive oil by hand to protect its delicate flavor. We like to cut the tortilla into bite-size squares measuring about 1¼ inches. Note that this will result in a few small, misshapen pieces around the edges of the circle—treats for the cook. You can also cut the tortilla into wedges for more substantial servings.

serves 10 to 12

garlic mayonnaise
2 large egg yolks

2 teaspoons Dijon mustard

2 teaspoons lemon juice

1 garlic clove, minced

¾ cup vegetable oil

1 tablespoon water

½ teaspoon salt

¼ teaspoon pepper

¼ cup extra-virgin olive oil

tortilla
1½ pounds Yukon Gold potatoes, peeled, quartered lengthwise, and sliced crosswise ⅛ inch thick

1 small onion, halved and sliced thin

6 tablespoons plus 1 teaspoon extra-virgin olive oil

Salt and pepper

8 large eggs

½ cup jarred roasted red peppers, rinsed, patted dry, and cut into ½-inch pieces

½ cup frozen peas, thawed

1. for the garlic mayonnaise Process egg yolks, mustard, lemon juice, and garlic in food processor until combined, about 10 seconds. With processor running, slowly drizzle in vegetable oil, about 1 minute. Transfer mixture to medium bowl and whisk in water, salt, and pepper. Whisking constantly, slowly drizzle in olive oil.

2. for the tortilla Toss potatoes, onion, ¼ cup oil, ½ teaspoon salt, and ¼ teaspoon pepper in large bowl. Heat 2 tablespoons oil in 10-inch nonstick skillet over medium-high heat until shimmering. Add potato mixture, reduce heat to medium-low, and set aside bowl. Cover potato mixture and cook, stirring occasionally, until potatoes are tender, 22 to 28 minutes.

3. Meanwhile, whisk eggs and ½ teaspoon salt in now-empty bowl until just combined. Fold in hot potato mixture, red peppers, and peas.

4. Heat remaining 1 teaspoon oil in now-empty skillet over medium-high heat until just smoking. Add egg-potato mixture and cook, shaking pan and folding mixture constantly, for 15 seconds. Smooth top of mixture and reduce heat to medium. Cover and cook, gently shaking pan every 30 seconds, until bottom is golden brown and top is lightly set, about 2 minutes.

5. Using rubber spatula, loosen tortilla from pan. Shake pan gently until tortilla slides around freely, then slide tortilla onto large plate. Invert tortilla onto second large plate, then slide back into skillet, browned side up. Tuck in tortilla edges and continue to cook over medium heat, gently shaking often, until second side is golden brown, about 2 minutes. Slide tortilla onto plate and let cool completely.

6. Transfer tortilla to cutting board. Cut into 42 squares and serve with garlic mayonnaise.

to make ahead
Garlic mayonnaise can be refrigerated for up to 4 days. After cooling completely, tortilla can be wrapped in plastic and refrigerated for up to 24 hours. Let stand at room temperature for 30 minutes before slicing and serving.

bacon-cheddar potato skins

why this recipe works With tasty hits of salt, cheese, and bacon, it's easy to understand the appeal of potato skins. But if your house isn't a restaurant or sports bar with a deep-fat fryer at the ready, it can be hard to get them perfectly crisp. Most recipes instruct the home cook to bake the potatoes, scoop out the flesh, top the shells with cheese and bacon, and then bake again, but we found that these failed to produce a satisfying crunch. We prepared our version with a combination cooking method: We started in the microwave, then finished in the oven. Cooked this way, our potato skins took a fraction of the time of potatoes cooked straight through in the oven. For extra flavor and crispness, we brushed the skin side of the shells with rendered bacon fat. Cutting the skins in quarters before baking increased the surfaces that touched the hot baking sheet and made for more crispy bits. Taking a cue from our twice-baked potato recipe, we baked the shells before filling them to avoid excess moisture. After the initial baking, we filled the shells and then returned them to the oven to melt the cheese. Serve with sour cream and sliced scallions.

serves 4 to 6

4 russet potatoes, scrubbed

6 slices bacon, chopped

Salt and pepper

4 ounces sharp cheddar cheese, shredded (1 cup)

4 ounces Monterey Jack cheese, shredded (1 cup)

1 tablespoon cornstarch

1. Adjust oven rack to middle position, place rimmed baking sheet on rack, and heat oven to 475 degrees. Prick potatoes all over with fork, place on paper towel, and microwave until tender, 10 to 15 minutes, turning potatoes over after 5 minutes.

2. Cook bacon in large skillet over medium heat until crisp, about 8 minutes. Reserve 2 teaspoons bacon fat, then transfer bacon to paper towel-lined plate. Blot bacon with paper towels to remove excess grease.

3. Quarter potatoes lengthwise, let cool for 5 minutes, and then scoop out most of flesh (reserve for another use), leaving ¼-inch layer of potato flesh. Brush exterior of potatoes with reserved bacon fat and season with salt and pepper. Transfer potatoes, skin side down, to preheated baking sheet and bake until golden brown and crisp, 15 to 20 minutes.

4. Combine cheeses, cornstarch, half of bacon, ½ teaspoon salt, and ¼ teaspoon pepper in bowl. Remove potato shells from oven and top with cheese mixture. Return to oven and bake until cheese melts, 2 to 4 minutes. Transfer skins to paper towel-lined plate and sprinkle with remaining bacon. Serve.

to make ahead
Potatoes can be cooked, scooped, and refrigerated in airtight container for 2 days before proceeding with recipe.

latkes

why this recipe works These perfectly crispy potato pancakes are the ideal vehicle for all manner of toppings, making them a super-versatile appetizer pick. We kept our latkes light and crisp by removing as much water as possible from the shredded potatoes. First we wrung them out in a dish towel and then we microwaved the shreds, which caused the starches in the potatoes to form a gel. This took care of any remaining water. This also meant that our latkes absorbed minimal oil, so they didn't get greasy. We prefer shredding the potatoes on the large holes of a box grater, but you can also use the large shredding disk of a food processor; cut the potatoes into 2-inch lengths first so you are left with short shreds. Serve with applesauce, sour cream, smoked salmon, or caviar.

serves 4 to 6

2 pounds russet potatoes, unpeeled, scrubbed, and shredded

½ cup grated onion

Salt and pepper

2 large eggs, lightly beaten

2 teaspoons minced fresh parsley

Vegetable oil

1. Adjust oven rack to middle position, place rimmed baking sheet on rack, and heat oven to 200 degrees. Toss potatoes, onion, and 1 teaspoon salt in bowl. Place half of mixture in center of dish towel. Gather ends together and twist tightly to drain as much liquid as possible, reserving liquid in liquid measuring cup. Transfer drained mixture to second bowl and repeat process with remaining mixture. Set potato liquid aside and let stand so starch settles to bottom, at least 5 minutes.

2. Cover mixture and microwave until just warmed through but not hot, 1 to 2 minutes, stirring with fork every 30 seconds. Spread mixture evenly over second rimmed baking sheet and let cool for 10 minutes. Don't wash bowl.

3. Pour off water from reserved potato liquid, leaving potato starch in measuring cup. Add eggs and stir until smooth. Return cooled potato mixture to bowl. Add parsley, ¼ teaspoon pepper, and potato starch mixture and toss until evenly combined.

4. Set wire rack in clean rimmed baking sheet and line with triple layer of paper towels. Add oil to 12-inch skillet until it measures about ¼ inch deep and heat over medium-high heat until shimmering but not smoking (350 degrees). Place ¼-cup mound of potato mixture in oil and press with nonstick spatula into ⅓-inch-thick disk. Repeat until 5 latkes are in pan. Cook, adjusting heat so fat bubbles around latke edges, until golden brown on bottom, about 3 minutes. Turn and continue cooking until golden brown on second side, about 3 minutes longer. Drain on paper towels and transfer to baking sheet in oven. Repeat with remaining potato mixture, adding oil to maintain ¼-inch depth and returning oil to 350 degrees between batches. Season with salt and pepper to taste, and serve immediately.

to make ahead
Cooled latkes can be covered loosely with plastic wrap and held at room temperature for up to 4 hours, or frozen on baking sheet until firm, transferred to zipper-lock bag, and frozen for up to 1 month. Reheat latkes in 375-degree oven until crisp and hot, 3 minutes per side for room-temperature and 6 minutes per side for frozen.

blini

why this recipe works Blini are hearty but elegant traditional Russian buckwheat crêpes that are usually spread with a variety of rich and flavorful fillings (such as jam, caviar, smoked fish, or sour cream), rolled up, and served. For our appetizer version, we focused on silver dollar–sized blini, called *oladi*. The small pancakes are topped with a spoonful of the same fillings and make an excellent hors d'oeuvre. While many blini are yeasted, we wanted a less time-consuming version so our recipe uses baking powder and baking soda. These were also favored by our tasters for their slightly sweet, less sour taste. We developed our recipe with a combination of buckwheat and all-purpose flours for the best flavor and texture. A note about buckwheat: it isn't actually wheat at all, but an herb, whose seeds are ground to make flour. Buckwheat flour can be found in natural foods stores and some well-stocked supermarkets.

serves 10 to 12

1/2 cup (2 1/2 ounces) unbleached all-purpose flour

1/2 cup (2 1/2 ounces) buckwheat flour

1 tablespoon sugar

1/2 teaspoon salt

1/2 teaspoon baking powder

1/4 teaspoon baking soda

3/4 cup buttermilk

1/2 cup whole milk

1 large egg

2 tablespoons unsalted butter, melted and cooled, plus extra for cooking the blini

1. Adjust oven rack to middle position and heat oven to 200 degrees. Line rimmed baking sheet with foil, top with wire rack, and spray rack with vegetable oil spray; set aside.

2. Whisk flours, sugar, salt, baking powder, and baking soda together in medium bowl and set aside. In separate bowl, whisk buttermilk, milk, egg, and melted butter together. Whisk buttermilk mixture into flour mixture until just combined (do not overmix).

3. Using pastry brush, brush bottom and sides of 12-inch nonstick skillet very lightly with melted butter; heat skillet over medium heat. When butter stops sizzling, add batter in spots to skillet using 1 scant tablespoon of batter per pancake (6 to 8 pancakes will fit at a time). Cook until large bubbles begin to appear, 1 1/2 to 2 minutes. Flip pancakes over and cook until golden on second side, about 1 1/2 minutes longer.

4. Transfer pancakes to prepared wire rack and keep warm, uncovered, in oven. Repeat with additional butter and remaining batter. Let cool slightly before topping and serving.

to make ahead
Blini can be frozen to for up to 1 week; let them cool to room temperature, wrap them in plastic wrap, and freeze. Thaw frozen pancakes in refrigerator for 24 hours, then spread out over baking sheet and warm in 350-degree oven for about 5 minutes before serving.

scallion pancakes

why this recipe works Despite their simple appearance, scallion pancakes are full of rich flavor and flaky, golden brown layers. The secret to these hidden depths is all in the method. We made ours with boiling water, which helped keep the pancake dough firmer and less sticky. This makes it much easier to complete the multistep rolling, coiling, and rerolling process required to shape the pancakes. Then we cooked the pancakes in a hot skillet, first covered to cook the pancake through and then uncovered to crisp up the exterior. A simple slit cut in the center of each pancake allowed steam to escape and gave us more even browning and better crisping. The finishing touch was a quick sweet-salty dipping sauce. We strongly recommend weighing the flour for the pancakes. For this recipe we prefer the steady, consistent heat of a cast-iron skillet.

dipping sauce
1 scallion, sliced thin

2 tablespoons soy sauce

1 tablespoon water

2 teaspoons rice vinegar

1 teaspoon honey

1 teaspoon toasted sesame oil

1 pinch red pepper flakes

pancakes
1½ cups (7½ ounces) plus 1 tablespoon all-purpose flour

¾ cup boiling water

7 tablespoons vegetable oil

1 tablespoon toasted sesame oil

1 teaspoon kosher salt

4 scallions, sliced thin

1. **for the dipping sauce** Whisk all ingredients together in small bowl; set aside.

2. **for the pancakes** Using wooden spoon, mix 1½ cups flour and boiling water in bowl to form rough dough. When cool enough to handle, transfer dough to lightly floured surface and knead until it forms ball that is tacky but no longer sticky, about 4 minutes (dough will not be perfectly smooth). Cover loosely with plastic wrap and let rest for 30 minutes.

3. While dough is resting, stir together remaining 1 tablespoon flour, 1 tablespoon vegetable oil, and sesame oil. Set aside.

4. Place 12-inch cast-iron skillet over low heat. Divide dough in half. Cover one half of dough with plastic wrap and set aside. Roll remaining dough into 12-inch round. Drizzle 1 tablespoon oil-flour mixture over surface and then use pastry brush to spread evenly over entire surface. Sprinkle with ½ teaspoon salt and half of scallions. Roll dough into cylinder. Coil cylinder into spiral, tuck end underneath, and flatten spiral with your palm. Cover with plastic wrap and repeat with remaining dough, oil-flour mixture, salt, and scallions.

5. Place 2 tablespoons oil in skillet and increase heat to medium-low. Roll first pancake into 9-inch round. Cut ½-inch slit in center of pancake. Place pancake in pan (oil should sizzle). Cover and cook until pancake is slightly puffy and deep golden brown on underside, 1 to 1½ minutes. (If underside is not browned after 1 minute, turn heat up slightly. If it is browning too quickly, turn heat down slightly.) Drizzle 1 tablespoon oil over pancake. Use pastry brush to distribute oil over entire surface. Carefully flip pancake. Cover and cook until second side is deep golden brown, 1 to 1½ minutes. Uncover skillet and flip pancake. Cook uncovered until very deep golden brown and crispy on underside, 30 to 60 seconds. Flip and cook second side until very deep golden brown and crispy, 30 to 60 seconds. Transfer to wire rack. Repeat with remaining oil and pancake. Cut each pancake into 8 wedges and serve with dipping sauce on side.

to make ahead
Stack uncooked pancakes between layers of parchment, wrap tightly in plastic wrap and refrigerate for up to 24 hours, or freeze for up to 1 month. If frozen, thaw in single layer for 15 minutes before cooking.

cocktail crab cakes with chipotle mayonnaise

why this recipe works You'd be hard-pressed to taste the crab in most crab cakes, especially the ones in miniature hors d'oeuvre form. They usually have way more binder than meat, making them closer to dough balls than seafood specialties. Our version is different: We kept both binder and seasonings to a minimum to let the sweet crab flavor really sing. For the binder we used fine dry bread crumbs that didn't overwhelm the crab. We also included mayonnaise and an egg to keep the crabmeat moist and help hold everything together. To further ensure they held their shape, we chilled the cakes briefly before pan-frying them. Great crab cakes begin with top-quality crabmeat. Look for fresh jumbo lump, which indicates the largest pieces and highest grade. The amount of bread crumbs you add will depend on the juiciness of the crabmeat. If the cakes won't hold together once you have added the egg, add more bread crumbs, 1 tablespoon at a time.

serves 6 to 8

crab cakes
1 pound jumbo lump crabmeat, picked over for shells

4 scallions, green parts only, minced

1 tablespoon chopped fresh parsley

1 1/2 teaspoons Old Bay seasoning

2–4 tablespoons fine dry bread crumbs

1/4 cup mayonnaise

Salt and ground white pepper

1 large egg

1/2 cup all-purpose flour

6 tablespoons vegetable oil

chipotle mayonnaise
1/4 cup mayonnaise

1/4 cup sour cream

2 teaspoons minced canned chipotle chile in adobo sauce

1 small garlic clove, minced

2 teaspoons minced fresh cilantro

1 teaspoon lime juice

1. for the crab cakes Gently mix crabmeat, scallions, parsley, Old Bay, 2 tablespoons bread crumbs, and mayonnaise in medium bowl, being careful not to break up crab lumps. Season with salt and white pepper to taste. Carefully fold in egg with rubber spatula until mixture just clings together. Add more crumbs if necessary.

2. Line rimmed baking sheet with parchment paper. Using generous tablespoon, form mixture into 24 cakes, each 1 1/2 inches in diameter and 1/2 inch thick. Place each finished cake on baking sheet. Cover with plastic wrap and chill at least 30 minutes.

3. for the chipotle mayonnaise While cakes are chilling, combine all ingredients in small bowl. Cover and refrigerate for at least 30 minutes.

4. to finish the crab cakes Adjust oven rack to middle position and heat oven to 200 degrees. Line baking sheet with double layer of paper towels. Put flour in shallow bowl or pie dish. Lightly dredge half of the crab cakes, knocking off excess flour.

5. Meanwhile, heat 3 tablespoons oil in 12-inch nonstick skillet over medium-high heat until hot but not smoking. Gently place floured crab cakes in skillet; pan fry until outside is crisp and brown, 1 to 2 minutes. (Flour remaining cakes while first batch is browning.) Using spatula, turn cakes. Pan fry until second side is crisp and brown, 1 to 2 minutes. Transfer finished cakes to paper towel-lined baking sheet and place sheet in oven.

6. Pour off fat from hot skillet and wipe clean with paper towels. Return skillet to heat, add remaining 3 tablespoons oil, and heat 1 minute. Repeat pan-frying with remaining cakes. Serve hot with chipotle mayonnaise.

to make ahead
Chipotle mayonnaise can be refrigerated for up to 2 days. Crab cakes can be refrigerated for up to 24 hours before frying.

easy crab rangoon

why this recipe works This retro classic is now a staple on American Chinese restaurant menus but crab rangoon first became famous at the Polynesian-style restaurant Trader Vic's in San Francisco. While the culinary roots of this dish might be unclear, we think the more important question is why it never actually tastes like crab; most restaurant versions are greasy, heavy lumps full of bland cream cheese. To give this popular fried bite an upgrade, we switched up the usual proportions and packed our version with sweet, delicate crabmeat and a lesser amount of cream cheese. For a crispy shell, we turned to the oven instead of deep frying. To dramatically simplify the shaping process, we made wonton "cups" that we baked in a mini muffin tin before filling them with our cream cheese and crab mixture. Sprinkled with sliced scallion greens, our open-faced crab rangoon are a fresher take on this tempting appetizer. To soften cream cheese quickly, microwave it for 20 to 30 seconds.

serves 4 to 6

Vegetable oil spray

16 wonton wrappers

4 ounces lump crabmeat, picked over for shells

3 ounces cream cheese, softened

1 scallion, white part sliced thin, green part sliced thin on bias

1 teaspoon grated fresh ginger

¾ teaspoon soy sauce

1. Adjust oven rack to middle position and heat oven to 350 degrees. Spray mini muffin tin with oil spray. Gently press wonton wrappers into tin cups, making sure bottoms and sides are flush with tin; let edges of wrappers extend out of cups. Lightly spray wrappers with oil spray and bake until lightly browned, 6 to 9 minutes; let cool slightly.

2. Combine crabmeat, cream cheese, scallion whites, ginger, and soy sauce in bowl. Using small spoon, fill each wonton cup with 2 teaspoons filling. Bake until filling is heated through, 6 to 8 minutes. Sprinkle with scallion greens. Serve warm.

making wonton cups

Gently press each wonton wrapper into greased mini muffin tin cup; press out air bubbles and folds. Lightly spray wonton cups with vegetable oil spray and bake until lightly browned.

fried calamari with tartar sauce

serves 6 to 8

why this recipe works We wanted to develop a foolproof way to make this perennial seafood favorite at home. If you're going to go through the work of deep-frying, you want to make sure the results are worth the effort. Without the advantage of a restaurant-grade deep-fryer, it can be tricky to get both the squid and the breading to finish cooking at the same time. In our tests, by the time the squid was perfectly cooked, the breading was only light brown, not the golden-brown we were looking for. Boosting the oil temperature improved browning, but the rings were still on the pale side. To improve the coating's color, we added cornmeal to the flour. Although cornmeal is not a traditional Italian ingredient in fried calamari recipes, we liked the color, flavor, and crunch it contributed. Cayenne pepper also helped, and the spiciness sharpened the squid's mild flavor. This recipe still yields calamari that is slightly lighter in color than most restaurant versions, so keep that in mind when frying. Follow the cooking time, not the color, and you will have perfectly cooked squid. Before slicing the squid, check the bodies for beaks the fishmonger might have missed. They look and feel like pieces of transparent plastic. Use a Dutch oven that holds 6 quarts or more for this recipe. For the best results, clip a candy/deep-fry thermometer to the side of the saucepan to monitor the temperature of the oil. Do not use stone-ground cornmeal in this recipe; it will make the texture too gritty. Serve with tartar sauce or lemon wedges.

1¼ cups unbleached all-purpose flour

¼ cup cornmeal

Salt and pepper

½ teaspoon cayenne pepper

2 large egg whites

1 pound squid, bodies sliced crosswise into ½-inch-thick rings, tentacles left whole

1 quart vegetable oil

1. Thoroughly combine flour, cornmeal, ½ teaspoon salt, ½ teaspoon pepper, and cayenne in medium bowl. In second medium bowl, beat egg whites with fork until frothy, about 10 seconds. Add half of squid to bowl with egg whites, toss to coat, and remove with slotted spoon or your hands, allowing excess whites to drip back into bowl. Add squid to bowl with seasoned flour and, using your hands or large rubber spatula, toss to coat. Place coated squid in single layer on wire rack set in rimmed baking sheet, allowing excess flour to fall free of squid. Repeat with remaining squid.

2. Meanwhile, add oil to large Dutch oven until it measures about ¾ inch deep and heat over medium-high heat to 400 degrees. Carefully add one-quarter of squid and fry until light golden (do not let coating turn golden brown, or squid will toughen), about 1½ minutes, adjusting heat as necessary to maintain temperature of 380 to 400 degrees. With slotted spoon or mesh skimmer, transfer fried squid to paper towel-lined plate. Fry remaining batches of squid and add them to plate. Season with salt to taste and serve immediately.

tartar sauce
makes about 1 cup

Combine ¾ cup mayonnaise, ½ minced small shallot, 2 tablespoons rinsed and drained capers, 2 tablespoons sweet pickle relish, 1½ teaspoons white vinegar, and ½ teaspoon Worcestershire sauce in small bowl, let sit for 15 minutes, and season with salt and pepper to taste. Stir again before serving.

to make ahead
Tartar sauce can be refrigerated for up to 5 days.

classic shrimp cocktail with horseradish cocktail sauce

why this recipe works Our take on this party staple boasts tender, sweet shrimp and a lively, well-seasoned cocktail sauce. Rather than simply boiling the shrimp, we cooked them in a simple mixture of water and seasonings to infuse the shrimp with as much flavor as possible. Old Bay seasoning contributed a perceptible depth of flavor to the shrimp. To avoid overcooking, we brought the water and aromatics to a boil, took the pot off the heat, and then added the shrimp, leaving them to poach for 7 minutes. This method delivered perfectly tender, not rubbery, shrimp every time. Buy refrigerated prepared horseradish, not the shelf-stable kind, which contains preservatives and additives.

serves 6

shrimp
2 teaspoons lemon juice

2 bay leaves

1 teaspoon salt

1 teaspoon black peppercorns

1 teaspoon Old Bay seasoning

1 pound extra-large shrimp (21 to 25 per pound), peeled and deveined (see page 159)

horseradish cocktail sauce
1 cup ketchup

2 tablespoons lemon juice

2 tablespoons prepared horseradish, plus extra for seasoning

2 teaspoons hot sauce, plus extra for seasoning

⅛ teaspoon salt

⅛ teaspoon pepper

1. for the shrimp Bring lemon juice, bay leaves, salt, peppercorns, Old Bay, and 4 cups water to boil in medium saucepan for 2 minutes. Remove pan from heat and add shrimp. Cover and steep off heat until shrimp are firm and pink, about 7 minutes. Meanwhile, fill large bowl with ice water. Drain shrimp and plunge immediately into ice water to stop cooking; let sit until cool, about 2 minutes. Drain shrimp and transfer to bowl. Cover and refrigerate until thoroughly chilled, at least 1 hour.

2. for the horseradish cocktail sauce Stir all ingredients together in small bowl and season with additional horseradish and hot sauce as desired. Arrange shrimp and sauce on serving platter or in individual dishes and serve.

to make ahead
Shrimp can be chilled for up to 24 hours after ice bath. Cocktail sauce can be refrigerated for up to 24 hours.

broiled shrimp cocktail with creamy tarragon sauce

why this recipe works When you're willing to splurge on shrimp to serve a crowd, this recipe cannot be beat. It's easy to make (you just toss the shrimp with spices and sugar before broiling them) and different enough to elicit rave reviews from your guests. Our simple rub got a huge boost from a little sugar. The sugar caramelized quickly under the broiler, adding a nice sear on the outside of the shrimp and helping to bring out the fresh, sweet shrimp flavor. A creamy herb and lemon dipping sauce was the perfect balance to the broiled shrimp. It's important to dry the shrimp thoroughly before cooking. Other fresh herbs, such as dill, basil, cilantro, or mint, can be substituted for the tarragon. We prefer to use jumbo shrimp here, but extra-large shrimp (21 to 25 per pound) can be substituted; if using smaller shrimp, reduce the broiling time by about 2 minutes.

serves 12

creamy tarragon sauce
1 cup mayonnaise

¼ cup lemon juice (2 lemons)

3 scallions, minced

3 tablespoons minced fresh tarragon

½ teaspoon salt

¼ teaspoon pepper

shrimp
1 teaspoon salt

1 teaspoon ground coriander

½ teaspoon pepper

½ teaspoon sugar

⅛ teaspoon cayenne pepper

3 pounds jumbo shrimp (16 to 20 per pound), peeled and deveined

3 tablespoons olive oil

1. for the creamy tarragon sauce Stir all ingredients together in serving bowl. Cover and refrigerate until flavors have blended, at least 30 minutes or up to 24 hours.

2. for the shrimp Adjust oven rack 3 inches from broiler element and heat broiler. (If necessary, set upside-down rimmed baking sheet on oven rack to get closer to broiler element.) Combine salt, coriander, pepper, sugar, and cayenne in small bowl. Pat shrimp dry with paper towels, then toss with oil and spice mixture in large bowl.

3. Spread half of shrimp in single layer on rimmed baking sheet. Broil shrimp until opaque and edges begin to brown, about 6 minutes. Transfer shrimp to serving platter and cover to keep warm. Repeat with remaining shrimp; transfer to platter. Serve with sauce.

peeling and deveining shrimp

1. Break shell under swimming legs, which will come off as shell is removed. Leave tail intact if desired, or tug tail to remove shell.

2. Use paring knife to make shallow cut along back to expose vein. Use tip of knife to lift out vein. Discard vein by wiping blade against paper towel.

spanish-style garlic shrimp

why this recipe works Sometimes you want to think outside the traditional shrimp cocktail box. This Spanish tapas classic is a double threat that is packed with powerful garlic kick not only in the shrimp themselves but also in the intensely flavorful garlic oil that is created during cooking. To get good garlic flavor in our recipe, we added garlic in three ways: as minced cloves in a marinade, as smashed whole cloves browned in and removed from the oil before the shrimp are added, and as slices added to the oil before the shrimp are cooked. Be sure to serve this dish with crusty bread for dipping in the richly flavored olive oil. The dish can be served directly from the skillet (make sure to use a trivet) or, for a sizzling effect, transferred to an 8-inch cast-iron skillet that's been heated for 2 minutes over medium-high heat. We prefer the slightly sweet flavor of dried chiles in this recipe, but ¼ teaspoon sweet paprika can be substituted. If sherry vinegar is unavailable, use 2 teaspoons dry sherry and 1 teaspoon white vinegar.

serves 6

14 garlic cloves, peeled

1 pound large shrimp (26 to 30 per pound), peeled, deveined, and tails removed (see page 159)

½ cup olive oil

½ teaspoon salt

1 bay leaf

½ dried New Mexico chile, stemmed, seeds reserved, torn into ½-inch pieces

1½ teaspoons sherry vinegar

1 tablespoon chopped fresh parsley

1. Mince 2 garlic cloves with chef's knife or garlic press. Toss minced garlic with shrimp, 2 tablespoons olive oil, and salt in medium bowl. Let shrimp marinate at room temperature for 30 minutes.

2. Meanwhile, using flat side of chef's knife, smash 4 garlic cloves. Heat smashed garlic with remaining 6 tablespoons olive oil in 12-inch skillet over medium-low heat, stirring occasionally, until garlic is light golden brown, 4 to 7 minutes. Remove pan from heat and let oil cool to room temperature. Using slotted spoon, remove smashed garlic from skillet and discard.

3. Slice remaining 8 garlic cloves thin. Return skillet to low heat and add sliced garlic, bay leaf, and chile. Cook, stirring occasionally, until garlic is tender but not browned, 4 to 7 minutes. (If garlic has not begun to sizzle after 3 minutes, increase heat to medium-low.) Increase heat to medium-low; add shrimp with marinade to pan in single layer. Cook shrimp, undisturbed, until oil starts to gently bubble, about 2 minutes. Using tongs, flip shrimp and continue to cook until almost cooked through, about 2 minutes longer. Increase heat to high and add vinegar and parsley. Cook, stirring constantly, until shrimp are cooked through and oil is bubbling vigorously, 15 to 20 seconds. Serve immediately.

chicken satay with spicy peanut dipping sauce

why this recipe works Any dish that comes with its own handle is bound to be an appetizer favorite, and this Southeast Asian dish of marinated, grilled meat has deep flavor to match its convenient format. We set out to bring this dish indoors for a simple but satisfying appetizer. A marinade of brown sugar, soy sauce, ketchup, and hot sauce guaranteed moist, full-flavored meat. The intense, direct heat of the broiler approximated a grill. Our peanut dipping sauce has sweet, tart, and spicy elements that echo the marinade for a fresh, bright finish. Covering the exposed ends of the skewers with aluminum foil protects them from burning. Freezing the chicken for 30 minutes will make it easier to slice into strips.

serves 10 to 15

skewers
2 pounds boneless, skinless chicken breasts, trimmed and sliced diagonally into ¹/₄-inch thick strips

¹/₄ cup soy sauce

¹/₄ cup vegetable oil

¹/₄ cup packed dark brown sugar

¹/₄ cup minced fresh cilantro

3 tablespoons ketchup

2 garlic cloves, minced

1 teaspoon hot sauce

4 scallions, sliced thin

30 (6-inch) wooden skewers

spicy peanut dipping sauce
¹/₂ cup peanut butter, creamy or chunky

¹/₄ cup hot water

3 tablespoons lime juice (2 limes)

2 tablespoons ketchup

1 tablespoon soy sauce

1 tablespoon packed dark brown sugar

1 tablespoon minced fresh cilantro

2 scallions, sliced thin

1¹/₂ teaspoons hot sauce

1 garlic clove, minced

1. for the skewers Place chicken in bowl. Combine soy sauce, vegetable oil, brown sugar, cilantro, ketchup, garlic, hot sauce, and scallions and pour over chicken. Refrigerate for 30 minutes to 1 hour.

2. for the spicy peanut dipping sauce Meanwhile, whisk peanut butter and hot water together in medium bowl. Stir in lime juice, ketchup, soy sauce, sugar, cilantro, scallions, hot sauce, and garlic. Transfer to serving bowl.

3. Adjust oven rack 6 inches from broiler element and heat broiler. Line broiler-pan bottom with foil and cover with slotted broiler-pan top. Weave chicken onto skewers, lay skewers on broiler-pan top, and cover skewer ends with foil. Broil until fully cooked, about 8 minutes, flipping skewers halfway through broiling. Serve, passing peanut sauce separately.

variation
beef satay with spicy peanut dipping sauce
To make the beef easier to slice, freeze it for 15 minutes.

Replace chicken with 2 pounds flank steak. Cut flank steak in half lengthwise and freeze for 30 minutes. Slice each piece across grain into ¹/₄-inch-thick strips.

to make ahead
Marinade and meat can be prepared (but not combined) and refrigerated, wrapped tightly in plastic wrap, for up to 24 hours. Sauce can be refrigerated, wrapped tightly in plastic wrap, for up to 2 days. Bring to room temperature, season with additional lime juice to taste, and adjust consistency with water before serving.

skewering satay

Weave meat back and forth on skewer until entire strip is firmly on skewer.

cocktail meatballs in tomato-saffron sauce

why this recipe works This traditional Spanish tapas dish features a luxurious saffron-scented sauce that ensures every bite is packed with flavor. For super-tender meatballs, we used a panade (a mixture of bread and milk) and a combination of ground beef and pork. Browning the meatballs before making the sauce helped build flavor and kept the meatballs intact during simmering. Raw garlic and chopped almonds added classic flavor and helped thicken the sauce. Serve with toothpicks or cocktail forks.

serves 8 to 10

meatballs
2 slices hearty white sandwich bread, torn into 1-inch pieces

⅓ cup whole milk

8 ounces 85 percent lean ground beef

8 ounces ground pork

¼ cup grated Manchego or Parmesan cheese

2 tablespoons minced fresh parsley

1 large egg yolk

1 garlic clove, minced

¾ teaspoon salt

⅛ teaspoon pepper

2 tablespoons olive oil

tomato-saffron sauce
1 small onion, chopped fine

1 small tomato, cored, seeded, and chopped

¼ teaspoon saffron threads, crumbled

¼ teaspoon paprika

1 cup chicken broth

½ cup dry white wine

1 tablespoon minced fresh parsley

1 tablespoon finely chopped almonds

2 garlic cloves, minced

⅛ teaspoon salt

Pinch pepper

1. for the meatballs Mash bread and milk together in large bowl to form smooth paste. Add beef, pork, Manchego, parsley, egg yolk, garlic, salt, and pepper and mix with your hands until uniform. Pinch off and roll mixture into forty 1-inch meatballs, about 1 tablespoon each, and transfer to baking sheet.

2. Heat oil in 12-inch nonstick skillet over medium-high heat until shimmering. Add half of meatballs and brown on all sides, 8 to 10 minutes; transfer to paper towel–lined plate. Repeat with remaining meatballs; transfer to plate.

3. for the tomato-saffron sauce Pour off all but 1 tablespoon fat left in skillet. Add onion and cook over medium heat, scraping up any browned bits, until very soft and lightly browned, 6 to 9 minutes. Stir in tomato, saffron, and paprika and cook for 1 minute. Stir in broth and wine.

4. Carefully return meatballs to skillet, cover, and simmer until just cooked through, 10 to 12 minutes. Combine parsley, almonds, garlic, salt, and pepper in bowl. Gently stir parsley mixture into skillet. Transfer meatballs and sauce to dish and serve.

to make ahead
Meatballs and broth mixture can be stored in separate airtight containers and refrigerated for up to 2 days.

notes from the test kitchen
shopping for saffron
Saffron is a delicate red thread harvested by hand from the crocus flower. Because each flower yields only a tiny amount of saffron, it can take up to 200 hours to collect just 1 pound—thus explaining why it is the most expensive spice in the world. Saffron is available in two forms: threads and powder. While we generally prefer the flavor of saffron threads, powdered saffron can be a decent option when substituted correctly. If substituting powdered saffron for threads, reduce the amount by a generous half.

lamb meatballs with yogurt sauce

why this recipe works For a new flavor twist on the cocktail meatball, we looked to the heavily spiced lamb patties known as *kofte* that are a popular street food in the Middle East. In most authentic recipes, ground lamb is charred over an outdoor grill; we achieved that charred flavor by swapping out a fiery grill for a smoking-hot cast-iron skillet. To translate kofte into meatballs, we seasoned ground lamb with fresh mint, cumin, garlic, cinnamon, and cloves. For our binder we stuck with a standard egg yolk, but instead of a traditional panade of bread and milk to help bind the meat and ensure moistness, we used Greek yogurt and crushed saltines. The yogurt added a welcome tang to our meatballs that fit nicely within the flavor profile, and saltines ensured that our meatballs held their shape but weren't too moist. We browned the meatballs in just one batch; it took only a few minutes in the hot cast-iron skillet to create a perfectly seared exterior. A tangy and refreshing Greek yogurt sauce provided the perfect pairing for these tasty morsels. To crush the saltines quickly and easily, place them in a zipper-lock bag and use a rolling pin to smash them.

serves 8 to 10

1 cup plain Greek yogurt

3 tablespoons minced fresh mint

2 tablespoons extra-virgin olive oil

1 garlic clove, minced

½ teaspoon grated lemon zest plus ½ teaspoon juice

Salt and pepper

6 square or 7 round saltines, crushed (3 tablespoons)

2 tablespoons water

1 pound ground lamb

1 large egg yolk

1 teaspoon ground cumin

¾ teaspoon ground cinnamon

⅛ teaspoon ground cloves

1. Combine ⅔ cup yogurt, 1 tablespoon mint, 1 tablespoon oil, half of garlic, lemon zest and juice, and ¼ teaspoon salt in bowl. Season with salt and pepper to taste. Cover and refrigerate until ready to serve.

2. Mash remaining ⅓ cup yogurt, crushed saltines, and water together with fork in large bowl to form paste. Add ground lamb, egg yolk, cumin, cinnamon, cloves, ¾ teaspoon salt, ⅛ teaspoon pepper, remaining 2 tablespoons mint, and remaining garlic and knead with your hands until uniformly combined. Pinch off and roll mixture into 1-inch meatballs (about 35 meatballs).

3. Heat 12-inch cast-iron skillet over medium heat for 5 minutes. Add remaining 1 tablespoon oil and heat until just smoking. Brown meatballs on all sides, 5 to 8 minutes; using slotted spoon, transfer to serving platter. Serve with yogurt sauce.

oven-fried chicken wings

why this recipe works These are the perfect chicken wings; crispy without requiring messy, time-consuming deep frying. To achieve this feat, we had to find a way to dry out the skin. Baking powder is our secret weapon; it helps break down the proteins within the skin and also aids in browning. After we tossed them with baking powder and salt, we started the wings in a low oven—on a wire rack for better air circulation—to fully dry the skin and begin rendering the fat. Then we cranked the oven to finish roasting the wings and crisping the skin. A coating of flavorful sauce and these wings were ready to be devoured.

serves 4 to 6

4 pounds chicken wings, cut at joints, wingtips discarded

2 tablespoons baking powder

¾ teaspoon salt

1 recipe wing sauce (recipes follow)

1. Adjust oven racks to upper-middle and lower-middle positions and heat oven to 250 degrees. Set wire rack in aluminum foil–lined rimmed baking sheet. Pat wings dry with paper towels and transfer to 1-gallon zipper-lock bag. Combine baking powder and salt, add to wings, seal bag, and toss to evenly coat.

2. Arrange wings, skin side up, in single layer on prepared wire rack. Bake wings on lower-middle oven rack for 30 minutes. Move wings to upper-middle rack, increase oven temperature to 425 degrees, and roast until wings are golden brown and crispy, 40 to 50 minutes longer, rotating sheet halfway through baking. Remove sheet from oven and let stand for 5 minutes. Transfer wings to bowl with wing sauce of your choice, toss to coat, and serve.

buffalo wing sauce
Classic Buffalo sauce is made with Frank's RedHot Original Cayenne Pepper Sauce

Combine ½ cup hot sauce, 1 tablespoon molasses, and 4 tablespoons unsalted butter, melted in large bowl.

smoky barbecue wing sauce
Combine ¼ cup chicken broth, ¼ cup ketchup, 1 tablespoon molasses, 1 tablespoon cider vinegar, 1 tablespoon minced canned chipotle chile in adobo sauce, and ¼ teaspoon liquid smoke in large bowl.

sweet and spicy thai wing sauce
Combine ½ cup packed brown sugar, ¼ cup lime juice (2 limes), 1 tablespoon toasted sesame oil, 1 teaspoon red pepper flakes, and 1 minced garlic clove in small saucepan; bring to simmer over medium heat. Cook until slightly thickened, about 5 minutes. Off heat, stir in 2 tablespoons fish sauce. Transfer to large bowl.

korean fried chicken wings

why this recipe works One bite of this exceptionally crunchy, sweet-spicy style of fried chicken and you'll be hooked. To get the ideal crispy exterior even under a layer of wet sauce, we followed tradition and double-fried the wings. Our sauce mixes spicy, sweet, and savory for the perfect balance of flavors. We tried different types of coating for our chicken—a simple dusting of cornstarch, a light batter of cornstarch and water, and a heavy batter of eggs, cornstarch, and water. We preferred the middle ground—the cornstarch and water batter—which yielded a light, crisp crust, especially if we let the excess batter drip off before frying. A rasp-style grater makes quick work of turning the garlic into a paste. Gochujang, Korean hot red chili paste, can be found in Asian markets and some supermarkets. Tailor the heat level of your wings by adjusting how much of it you use. If you can't find gochujang, substitute an equal amount of Sriracha sauce and add only 2 tablespoons of water to the sauce.

serves 8 to 10

1 tablespoon toasted sesame oil

1 teaspoon garlic, minced to paste

1 teaspoon grated fresh ginger

1¾ cups water

3 tablespoons sugar

2–3 tablespoons gochujang

1 tablespoon soy sauce

2 quarts vegetable oil

1 cup all-purpose flour

3 tablespoons cornstarch

3 pounds chicken wings, cut at joints, wingtips discarded

1. Combine sesame oil, garlic, and ginger in large bowl and microwave until mixture is bubbly and fragrant but not browned, 40 to 60 seconds. Whisk in ¼ cup water, sugar, gochujang, and soy sauce until smooth and set aside.

2. Heat oil in large Dutch oven over medium-high heat to 350 degrees. While oil heats, whisk flour, cornstarch, and remaining 1½ cups water in second large bowl until smooth. Set wire rack in rimmed baking sheet and set aside.

3. Place half of wings in batter and stir to coat. Using tongs, remove wings from batter one at a time, allowing any excess batter to drip back into bowl, and add to hot oil. Increase heat to high and cook, stirring occasionally to prevent wings from sticking, until coating is light golden and beginning to crisp, about 7 minutes. (Oil temperature will drop sharply after adding chicken.) Transfer wings to prepared rack. Return oil to 350 degrees and repeat with remaining wings. Reduce heat to medium and let second batch of chicken rest for 5 minutes.

4. Return oil to 375 degrees. Carefully return all chicken to oil and cook, stirring occasionally, until exterior is deep golden brown and very crispy, about 7 minutes. Transfer to rack and let stand for 2 minutes. Add chicken to reserved sauce and toss until coated. Return chicken to rack and let stand for 2 minutes to allow surface to set. Transfer to platter and serve.

preparing chicken wings

Using kitchen shears or sharp chef's knife, cut through wing at joints and discard wingtip.

conversions and equivalents

Some say cooking is a science and an art. We would say that geography has a hand in it, too. Flours and sugars manufactured in the United Kingdom and elsewhere will feel and taste different from those manufactured in the United States. So we cannot promise that the pie crust you bake in Canada or England will taste the same as a pie crust baked in the States, but we can offer guidelines for converting weights and measures. We also recommend that you rely on your instincts when making our recipes. Refer to the visual cues provided. If the pie dough hasn't "come together," as described, you may need to add more water—even if the recipe doesn't tell you to. You be the judge.

The recipes in this book were developed using standard U.S. measures following U.S. government guidelines. The charts below offer equivalents for U.S. and metric measures. All conversions are approximate and have been rounded up or down to the nearest whole number. For example:

1 teaspoon = 4.9292 milliliters, rounded up to 5 milliliters
1 ounce = 28.3495 grams, rounded down to 28 grams

volume conversions

U.S.	metric
1 teaspoon	5 milliliters
2 teaspoons	10 milliliters
1 tablespoon	15 milliliters
2 tablespoons	30 milliliters
$1/4$ cup	59 milliliters
$1/3$ cup	79 milliliters
$1/2$ cup	118 milliliters
$3/4$ cup	177 milliliters
1 cup	237 milliliters
$1 1/4$ cups	296 milliliters
$1 1/2$ cups	355 milliliters
2 cups (1 pint)	473 milliliters
$2 1/2$ cups	591 milliliters
3 cups	710 milliliters
4 cups (1 quart)	0.946 liter
1.06 quarts	1 liter
4 quarts (1 gallon)	3.8 liters

weight conversions

ounces	grams
$1/2$	14
$3/4$	21
1	28
$1 1/2$	43
2	57
$2 1/2$	71
3	85
$3 1/2$	99
4	113
$4 1/2$	128
5	142
6	170
7	198
8	227
9	255
10	283
12	340
16 (1 pound)	454

conversion for common baking ingredients

Baking is an exacting science. Because measuring by weight is far more accurate than measuring by volume, and thus more likely to produce reliable results, in our recipes we provide ounce measures in addition to cup measures for many ingredients. Refer to the chart below to convert these measures into grams.

ingredient	ounces	grams
Flour		
1 cup all-purpose flour*	5	142
1 cup cake flour	4	113
1 cup whole-wheat flour	5½	156
Sugar		
1 cup granulated (white) sugar	7	198
1 cup packed brown sugar (light or dark)	7	198
1 cup confectioners' sugar	4	113
Cocoa Powder		
1 cup cocoa powder	3	85
Butter†		
4 tablespoons (½ stick, or ¼ cup)	2	57
8 tablespoons (1 stick, or ½ cup)	4	113
16 tablespoons (2 sticks, or 1 cup)	8	227

* *U.S. all-purpose flour, the most frequently used flour in this book, does not contain leaveners, as some European flours do. These leavened flours are called self-rising or self-raising. If you are using self-rising flour, take this into consideration before adding leavening to a recipe.*

† *In the United States, butter is sold both salted and unsalted. We generally recommend unsalted butter. If you are using salted butter, take this into consideration before adding salt to a recipe.*

oven temperatures

fahrenheit	celsius	gas mark
225	105	¼
250	120	½
275	135	1
300	150	2
325	165	3
350	180	4
375	190	5
400	200	6
425	220	7
450	230	8
475	245	9

converting temperatures from an instant-read thermometer

We include doneness temperatures in many of the recipes in this book. We recommend an instant-read thermometer for the job. Refer to the table at left to convert Fahrenheit degrees to Celsius. Or, for temperatures not represented in the chart, use this simple formula:

Subtract 32 degrees from the Fahrenheit reading, then divide the result by 1.8 to find the Celsius reading. For example: "Roast chicken until thighs register 175 degrees."

To convert

175°F − 32 = 143°

143° ÷ 1.8 = 79.44°C, rounded down to 79°C

recipes by dietary category

vegetarian

Curry Deviled Eggs, 15

Stuffed Mushrooms with Parmesan and Thyme, 18

Stuffed Mushrooms with Cheddar, Fennel, and Sage, 18

Stuffed Mushrooms with Olives and Goat Cheese, 18

Stuffed Jalapeños, 21

Spanakopita, 32

Asparagus Puffs, 35

Crispy Spiced Chickpeas*, 49

Marinated Olives*, 50

Marinated Olives with Feta, 50

Marinated Olives with Baby Mozzarella, 50

Spiced Nuts, 53

Curry-Spiced Nuts, 53

Cinnamon-Spiced Nuts, 53

Kale Chips*, 54

Ranch-Style Kale Chips*, 54

Spicy Sesame-Ginger Kale Chips*, 54

Perfect Popcorn, 56

Garlic and Herb Popcorn, 56

Parmesan-Pepper Popcorn, 56

Cajun-Spiced Popcorn, 56

Hot and Sweet Popcorn, 56

Barbecue Party Mix, 59

Fisherman's Friend Party Mix, 59

Asian Firecracker Party Mix, 59

Cheddar Cheese Coins, 61

Parmesan and Rosemary Cheese Coins, 61

Gruyère, Mustard, and Caraway Cheese Coins, 61

Blue Cheese and Celery Seed Cheese Coins, 61

Homemade Cheese Straws, 62

Olive Oil–Sea Salt Pita Chips*, 65

Rosemary-Parmesan Pita Chips, 65

Chili-Spiced Pita Chips*, 65

Buttermilk-Ranch Pita Chips, 65

Cinnamon-Sugar Pita Chips, 65

Kettle Chips*, 66

Bruschetta with Black Olive Pesto, Ricotta, and Basil Topping, 71

Bruschetta with Grape Tomato, White Bean Puree, and Rosemary Topping, 71

Bruschetta with Artichoke and Parmesan Topping, 71

Naan Tarts with Ricotta and Sun-Dried Tomato–Olive Tapenade, 79

Naan Tarts with Artichokes, Pesto, and Goat Cheese, 79

Tomato and Mozzarella Tart, 80

Fennel, Olive, and Goat Cheese Tarts, 82

Chipotle-Lime Dip with Scallions, 93

Creamy Horseradish Dip, 93

Green Goddess Dip, 93

Herbed Spinach Dip, 97

Spinach Dip with Feta, Lemon, and Oregano, 97

Cilantro-Lime Spinach Dip, 97

Whipped Cashew Nut Dip with Roasted Red Peppers and Olives*, 99

Whipped Cashew Nut Dip with Chipotle and Lime*, 99

Whipped Cashew Nut Dip with Sun-Dried Tomatoes and Rosemary*, 99

Roasted Artichoke Dip, 100

Ultimate Seven-Layer Dip, 104

Spicy Whipped Feta, 107

Baked Brie with Honeyed Apricots, 108

Rosemary and Garlic White Bean Dip*, 110

Caper and Tarragon White Bean Dip*, 110

Goat Cheese and Lemon White Bean Dip, 110

Green Chile and Cilantro White Bean Dip, 110

Sun-Dried Tomato and Feta White Bean Dip, 110

Classic Hummus*, 113

Artichoke-Lemon Hummus*, 113

Roasted Red Pepper Hummus*, 113

Roasted Garlic Hummus*, 113

Sweet Potato Hummus*, 114

Baba Ghanoush*, 117

Guacamole*, 118

Chipotle and Pepita Guacamole*, 118

Feta and Arugula Guacamole, 118

Habanero and Mango Guacamole*, 118

Easy Mushroom Pâté, 120

Gougères, 128

Hushpuppies with Chipotle Aïoli, 131

Mini Cheese Quiches, 136

Pan-Fried Halloumi, 139

Pan-Fried Halloumi with Garlic-Parsley Sauce, 139

Spanish Tortilla with Garlic Mayonnaise, 141

Latkes, 144

Blini, 147

Scallion Pancakes, 149

* = vegan

gluten-free

Curry Deviled Eggs, 15

Bacon and Chive Deviled Eggs, 15

Marinated Artichoke Hearts and Stuffed Pickled Sweet Peppers, 16

Stuffed Mushrooms with Parmesan and Thyme, 18

Stuffed Mushrooms with Cheddar, Fennel, and Sage, 18

Stuffed Mushrooms with Olives and Goat Cheese, 18

Stuffed Mushrooms with Chorizo and Manchego, 18

Stuffed Mushrooms with Bacon and Blue Cheese, 18

Prosciutto-Wrapped Figs with Gorgonzola, 23

Prosciutto-Wrapped Asparagus, 24

Broiled Bacon-Wrapped Sea Scallops, 26

Broiled Bacon-Wrapped Shrimp, 26

Shrimp Salad on Endive, 30

Crispy Spiced Chickpeas, 49

Marinated Olives, 50

Marinated Olives with Feta, 50

Marinated Olives with Baby Mozzarella, 50

Spiced Nuts, 53

Curry-Spiced Nuts, 53

Cinnamon-Spiced Nuts, 53

Kale Chips, 54

Ranch-Style Kale Chips, 54

Spicy Sesame-Ginger Kale Chips, 54

Perfect Popcorn, 56

Garlic and Herb Popcorn, 56

Parmesan-Pepper Popcorn, 56

Cajun-Spiced Popcorn, 56

Hot and Sweet Popcorn, 56

Kettle Chips, 66

Crispy Polenta Squares with
Olive Tapenade, 88

Caesar Dip with Parmesan and
Anchovies, 93

Chipotle-Lime Dip with Scallions, 93

Creamy Horseradish Dip, 93

Green Goddess Dip, 93

Bacon, Scallion, and Caramelized
Onion Dip, 94

Herbed Spinach Dip, 97

Spinach Dip with Blue Cheese
and Bacon, 97

Spinach Dip with Feta, Lemon,
and Oregano, 97

Cilantro-Lime Spinach Dip, 97

Whipped Cashew Nut Dip with
Roasted Red Peppers and Olives, 99

Whipped Cashew Nut Dip with
Chipotle and Lime, 99

Whipped Cashew Nut Dip with
Sun-Dried Tomatoes and Rosemary, 99

Ultimate Seven-Layer Dip, 104

Ultimate Smoky Seven-Layer Dip, 104

Spicy Whipped Feta, 107

Baked Brie with Honeyed Apricots, 108

Rosemary and Garlic White Bean Dip, 110

Caper and Tarragon White Bean Dip, 110

Goat Cheese and Lemon White
Bean Dip, 110

Green Chile and Cilantro White
Bean Dip, 110

Sun-Dried Tomato and Feta White
Bean Dip, 110

Classic Hummus, 113

Artichoke-Lemon Hummus, 113

Roasted Red Pepper Hummus, 113

Roasted Garlic Hummus, 113

Sweet Potato Hummus, 114

Baba Ghanoush, 117

Guacamole, 118

Bacon and Tomato Guacamole, 118

Chipotle and Pepita Guacamole, 118

Feta and Arugula Guacamole, 118

Habanero and Mango Guacamole, 118

Easy Mushroom Pâté, 120

Chicken Liver Pâté, 123

Chicken and Avocado Arepa Bites, 135

Spanish Tortilla with Garlic
Mayonnaise, 141

Bacon-Cheddar Potato Skins, 142

Latkes, 144

Classic Shrimp Cocktail with
Horseradish Cocktail Sauce, 156

Broiled Shrimp Cocktail with Creamy
Tarragon Sauce, 159

Spanish-Style Garlic Shrimp, 160

Oven-Fried Chicken Wings with Buffalo
Wing Sauce, 168

Oven-Fried Chicken Wings with Smoky
Barbecue Wing Sauce, 168

Oven-Fried Chicken Wings with Sweet
and Spicy Thai Wing Sauce, 168

dairy-free

Curry Deviled Eggs, 15

Bacon and Chive Deviled Eggs, 15

Broiled Bacon-Wrapped Sea
Scallops, 26

Broiled Bacon-Wrapped Shrimp, 26

Chinese Chicken Lettuce Wraps, 29

Shrimp Salad on Endive, 30

Potstickers with Scallion Dipping
Sauce, 40

Steamed Chinese Dumplings, 42

Fresh Vegetable Spring Rolls, 45

Crispy Spiced Chickpeas, 49

Marinated Olives, 50

Spiced Nuts, 53

Curry-Spiced Nuts, 53

Cinnamon-Spiced Nuts, 53

Kale Chips, 54

Ranch-Style Kale Chips, 54

Spicy Sesame-Ginger Kale Chips, 54

Olive Oil–Sea Salt Pita Chips, 65

Chili-Spiced Pita Chips, 65

Kettle Chips, 66

BLT Canapés with Basil Mayonnaise, 73

Crispy Polenta Squares with Olive
Tapenade, 88

Whipped Cashew Nut Dip with
Roasted Red Peppers and Olives, 99

Whipped Cashew Nut Dip with
Chipotle and Lime, 99

Whipped Cashew Nut Dip with
Sun-Dried Tomatoes and Rosemary, 99

Rosemary and Garlic White Bean Dip, 110

Caper and Tarragon White Bean Dip, 110

Classic Hummus, 113

Artichoke-Lemon Hummus, 113

Roasted Red Pepper Hummus, 113

Roasted Garlic Hummus, 113

Sweet Potato Hummus, 114

Baba Ghanoush, 117

Guacamole, 118

Bacon and Tomato Guacamole, 118

Chipotle and Pepita Guacamole, 118

Habanero and Mango Guacamole, 118

Spanish Tortilla with Garlic
Mayonnaise, 141

Latkes, 144

Scallion Pancakes, 149

Fried Calamari with Tartar Sauce, 155

Classic Shrimp Cocktail with
Horseradish Cocktail Sauce, 156

Broiled Shrimp Cocktail with Creamy
Tarragon Sauce, 159

Spanish-Style Garlic Shrimp, 160

Chicken Satay with Spicy Peanut
Dipping Sauce, 163

Beef Satay with Spicy Peanut
Dipping Sauce, 163

Oven-Fried Chicken Wings with Buffalo
Wing Sauce, 168

Oven-Fried Chicken Wings with Smoky
Barbecue Wing Sauce, 168

Oven-Fried Chicken Wings with Sweet
and Spicy Thai Wing Sauce, 168

Korean Fried Chicken Wings, 171

index

NOTE: Page references in *italics* indicate photographs.

A

Anchovies
Crispy Polenta Squares with Olive Tapenade, 88, *89*
and Parmesan, Caesar Dip with, *92*, 93
Appetizers
assembling menu of, 3
calculating quantity needed, 2
last-minute, pantry staples for, 2
last-minute, suggestions for, 3
menu ideas, 4
preparing crudités, 5
Apricots, Honeyed, Baked Brie with, 108, *109*
Arepa Bites, Chicken and Avocado, *134*, 135
Artichoke(s)
Hearts, Marinated, and Stuffed Pickled Sweet Peppers, 16, *17*
-Lemon Hummus, 113
and Parmesan Bruschetta Topping, 71
Pesto, and Goat Cheese, Naan Tarts with, 79
Roasted, Dip, 100, *101*
Arugula and Feta Guacamole, 118
Asiago
about, 6
Homemade Cheese Straws, 62, *63*
Asian Firecracker Party Mix, *58*, 59
Asparagus
Prosciutto-Wrapped, 24, *25*
Puffs, *34*, 35
trimming ends of, 24
Avocado(s)
and Chicken Arepa Bites, *134*, 135
Guacamole, 118, *119*
Bacon and Tomato, 118
Chipotle and Pepita, 118
Feta and Arugula, 118
Habanero and Mango, 118
preparing, 118
Sauce, Beef and Bean Taquitos with, *36*, 37
Ultimate Seven-Layer Dip, 104, *105*
Ultimate Smoky Seven-Layer Dip, 104

B

Baba Ghanoush, *116*, 117
Bacon
BLT Canapés with Basil Mayonnaise, *72*, 73
and Blue Cheese, Spinach Dip with, 97
and Blue Cheese, Stuffed Mushrooms with, 18, *19*
Caramelized Onion, and Pear Tarts, 86, *87*

Bacon *(cont.)*
-Cheddar Potato Skins, 142, *143*
and Chive Deviled Eggs, 15
Scallion, and Caramelized Onion Dip, 94, *95*
and Tomato Guacamole, 118
Ultimate Smoky Seven-Layer Dip, 104
-Wrapped Sea Scallops, Broiled, 26, *27*
-Wrapped Shrimp, Broiled, 26
Baked Brie with Honeyed Apricots, 108, *109*
Baked Crab Dip with Crostini, *102*, 103
Barbecue Party Mix, 59
Bar setups, 11
Basil
Black Olive Pesto, and Ricotta Bruschetta Topping, *70*, 71
Fresh Vegetable Spring Rolls, *44*, 45
Mayonnaise, BLT Canapés with, *72*, 73
Naan Tarts with Artichokes, Pesto, and Goat Cheese, 79
Bean(s)
and Beef Taquitos with Avocado Sauce, *36*, 37
Crispy Spiced Chickpeas, *48*, 49
Edamame with Sea Salt, 3
green, preparing, for crudités, 5
Hummus
Artichoke-Lemon, 113
Classic, 113
Roasted Garlic, *112*, 113
Roasted Red Pepper, 113
Sweet Potato, 114, *115*
Ultimate Seven-Layer Dip, 104, *105*
Ultimate Smoky Seven-Layer Dip, 104
White, Dip
Caper and Tarragon, 110
Goat Cheese and Lemon, 110
Green Chile and Cilantro, 110
Rosemary and Garlic, 110, *111*
Sun-Dried Tomato and Feta, 110
White, Puree, Grape Tomato, and Rosemary Bruschetta Topping, *70*, 71
Beef
and Bean Taquitos with Avocado Sauce, *36*, 37
Cocktail Meatballs in Tomato-Saffron Sauce, 164, *165*
Green Chile Cheeseburger Sliders, 132, *133*
Satay with Spicy Peanut Dipping Sauce, 163
Beer, common styles of, 9
Black Olive Pesto, Ricotta, and Basil Bruschetta Topping, *70*, 71

Blini, *146*, 147
BLT Canapés with Basil Mayonnaise, *72*, 73
Blue Cheese
and Bacon, Spinach Dip with, 97
and Bacon, Stuffed Mushrooms with, 18, *19*
and Celery Seed Cheese Coins, 61
Fig Jam, and Prosciutto, Naan Tarts with, *78*, 79
Gorgonzola, about, 7
Prosciutto-Wrapped Figs with Gorgonzola, 22, 23
Roquefort, about, 7
Boursin
-Cheddar Cheese Spread, 3
Prosciutto-Wrapped Asparagus, 24, *25*
Breads. *See* **Bruschetta; Canapés; Crostini; Naan; Pita Chips**
Brie
about, 6
Baked, with Honeyed Apricots, 108, *109*
removing rind from, 108
Broccoli, preparing, for crudités, 5
Broiled Bacon-Wrapped Sea Scallops, 26, *27*
Broiled Bacon-Wrapped Shrimp, 26
Broiled Shrimp Cocktail with Creamy Tarragon Sauce, *158*, 159
Bruschetta, *70*, 71
Buffalo Wing Sauce, 168, *169*
Buttermilk-Ranch Pita Chips, 65

C

Cabbage
Potstickers with Scallion Dipping Sauce, 40, *41*
Caesar Dip with Parmesan and Anchovies, *92*, 93
Cajun-Spiced Popcorn, 56
Calamari, Fried, with Tartar Sauce, *154*, 155
Camembert, about, 6
Canapés
BLT, with Basil Mayonnaise, *72*, 73
Homemade Gravlax on Pumpernickel with Crème Fraîche, *76*, 77
Caper and Tarragon White Bean Dip, 110
Caramelized Onion, Pear, and Bacon Tarts, 86, *87*
Carrots
Fresh Vegetable Spring Rolls, *44*, 45
preparing, for crudités, 5

Cashew Nut Dip, Whipped
with Chipotle and Lime, *98*, *99*
with Roasted Red Peppers and
Olives, *98, 99*
with Sun-Dried Tomatoes and
Rosemary, *98, 99*
Cauliflower, preparing, for crudités, 5
Celery, preparing, for crudités, 5
Cheddar (Cheese)
about, 6
-Bacon Potato Skins, 142, *143*
–Boursin Spread, 3
Coins, *60*, 61
Easy Mini Chicken Empanadas, 38, *39*
Fennel, and Sage, Stuffed
Mushrooms with, 18, *19*
Mini Cheese Quiches, 136, *137*
Stuffed Jalapeños, *20*, 21
Cheese
Asiago, about, 6
Baked Brie with Honeyed Apricots,
108, *109*
Black Olive Pesto, Ricotta, and Basil
Bruschetta Topping, *70*, 71
Blue, and Bacon, Spinach Dip with, 97
Blue, and Bacon, Stuffed Mushrooms
with, 18, *19*
Blue, and Celery Seed Cheese
Coins, 61
Blue, Fig Jam, and Prosciutto, Naan
Tarts with, *78*, 79
Boursin–Cheddar Cheese Spread, 3
Brie, about, 6
Brie, cutting rind off, 108
Camembert, about, 6
Coins
Blue Cheese and Celery Seed, 61
Cheddar, *60*, 61
Gruyère, Mustard, and Caraway, 61
Parmesan and Rosemary, 61
Colby, about, 6
Emmentaler, about, 6
fontina, about, 6
Gorgonzola, about, 7
gouda, about, 7
Gougères, 128, *129*
Green Chile Cheeseburger Sliders,
132, *133*
Gruyère, about, 7
and Ham Palmiers, *126*, 127
Havarti, about, 7
Jarlsberg, about, 7
Manchego, about, 7
Marinated Artichoke Hearts and
Stuffed Pickled Sweet Peppers,
16, *17*
Marinated Olives with Baby
Mozzarella, 50
mozzarella, about, 7
Naan Tarts with Ricotta and Sun-
Dried Tomato–Olive Tapenade, 79

Cheese *(cont.)*
Pan-Fried Halloumi, 139
Pan-Fried Halloumi with Garlic-
Parsley Sauce, *138*, 139
Pecorino Romano, about, 7
plates, assembling, 8
Prosciutto-Wrapped Asparagus, 24, *25*
Prosciutto-Wrapped Figs with
Gorgonzola, *22*, 23
provolone, about, 7
Quiches, Mini, 136, *137*
ricotta salata, about, 7
Roquefort, about, 7
Serrano and Manchego Crostini with
Orange Honey, 74, *75*
serving temperature, 8
Spanakopita, 32, *33*
storing, 6
Straws, Homemade, 62, *63*
Stuffed Mushrooms with Chorizo
and Manchego, 18
Tomato and Mozzarella Tart, 80, *81*
types of, 6–7
Ultimate Seven-Layer Dip, 104, *105*
Ultimate Smoky Seven-Layer Dip, 104
see also Cheddar (Cheese); Feta; Goat
Cheese; Parmesan
Cherries, maraschino, for drinks, 11
Chex cereal
Asian Firecracker Party Mix, *58*, 59
Barbecue Party Mix, 59
·Fisherman's Friend Party Mix, 59
Chicken
and Avocado Arepa Bites, *134*, 135
Empanadas, Easy Mini, 38, *39*
Lettuce Wraps, Chinese, *28*, 29
Liver Pâté, *122*, 123
Satay with Spicy Peanut Dipping
Sauce, *162*, 163
Wings
Korean Fried, *170*, 171
Oven-Fried, 168, *169*
preparing, 171
Chile(s)
Chipotle-Lime Dip with
Scallions, *92*, 93
Chipotle Mayonnaise, *150*, 151
Cilantro-Lime Spinach Dip, 97
Green, and Cilantro White Bean
Dip, 110
Green, Cheeseburger Sliders, 132, *133*
Guacamole, 118, *119*
Bacon and Tomato, 118
Chipotle and Pepita, 118
Feta and Arugula, 118
Habanero and Mango, 118
Hushpuppies with Chipotle
Aïoli, *130*, 131
jalapeño, seeding, 21
Salsa, 38, *39*
Smoky Barbecue Wing Sauce, 168, *169*
Spanish-Style Garlic Shrimp, 160, *161*
Stuffed Jalapeños, *20*, 21

Chile(s) *(cont.)*
Ultimate Seven-Layer Dip, 104, *105*
Ultimate Smoky Seven-Layer Dip, 104
Whipped Cashew Nut Dip with
Chipotle and Lime, *98*, 99
Chili-Spiced Pita Chips, 65
Chinese Chicken Lettuce Wraps, *28*, 29
Chipotle
-Lime Dip with Scallions, *92*, 93
Mayonnaise, *150*, 151
and Pepita Guacamole, 118
Chips, Kale, 54, *55*
Ranch-Style, 54
Spicy Sesame-Ginger, 54
Chips, Kettle, 66, *67*
Chips, Pita
Buttermilk-Ranch, 65
Chili-Spiced, 65
Cinnamon-Sugar, 65
Olive Oil–Sea Salt, 65
Rosemary-Parmesan, *64*, 65
Chive(s)
and Bacon Deviled Eggs, 15
Green Goddess Dip, *92*, 93
Chorizo and Manchego, Stuffed
Mushrooms with, 18, *19*
Cider, hard, about, 9
Cilantro
Fresh Vegetable Spring Rolls, *44*, 45
and Green Chile White Bean Dip, 110
Guacamole, 118, *119*
Bacon and Tomato, 118
Chipotle and Pepita, 118
Feta and Arugula, 118
Habanero and Mango, 118
-Lime Spinach Dip, 97
Whipped Cashew Nut Dip with
Chipotle and Lime, 99
Cinnamon
-Spiced Nuts, 53
-Sugar Pita Chips, 65
Citrus garnishes, 11
Classic Hummus, 113
Classic Pizza Dough, 86
Classic Shrimp Cocktail with
Horseradish Cocktail Sauce,
156, *157*
Cocktail basics, 11
Cocktail bitters, 11
Cocktail Crab Cakes with Chipotle
Mayonnaise, *150*, 151
Cocktail Meatballs in Tomato-Saffron
Sauce, 164, *165*
Cocktail Sauce, Horseradish, 156, *157*
Cocktail shakers, 11
Colby cheese, about, 6
Corkscrews, 10
Cornmeal
Hushpuppies with Chipotle
Aïoli, *130*, 131

Crab
Cakes, Chipotle, with Chipotle Mayonnaise, *150*, 151
Rangoon, Easy, 152, *153*
Crackers, 2
Blue Cheese and Celery Seed Cheese Coins, 61
Cheddar Cheese Coins, *60*, 61
for cheese plates, 8
Gruyère, Mustard, and Caraway Cheese Coins, 61
Parmesan and Rosemary Cheese Coins, 61
Creamy Horseradish Dip, *92*, 93
Crema, *134*, 135
Crème Fraîche, Homemade Gravlax on Pumpernickel with, *76*, 77
Crispy Polenta Squares with Olive Tapenade, 88, *89*
Crispy Spiced Chickpeas, *48*, 49
Crostini
Baked Crab Dip with, *102*, 103
Serrano and Manchego, with Orange Honey, 74, *75*
Crudités, preparing, 5
Cucumbers
Fresh Vegetable Spring Rolls, 44, 45
Curry
Deviled Eggs, *14*, 15
-Spiced Nuts, 53

D

Dill
Buttermilk-Ranch Pita Chips, 65
Herbed Spinach Dip, *96*, 97
Homemade Gravlax on Pumpernickel with Crème Fraîche, *76*, 77
Ranch-Style Kale Chips, 54
Dips
Baba Ghanoush, *116*, 117
Bacon, Scallion, and Caramelized Onion, 94, *95*
Baked Brie with Honeyed Apricots, 108, *109*
Baked Crab, with Crostini, *102*, 103
Caesar, with Parmesan and Anchovies, *92*, 93
Chipotle Aïoli, *130*, 131
Chipotle-Lime, with Scallions, *92*, 93
Green Goddess, *92*, 93
Guacamole, 118, *119*
Bacon and Tomato, 118
Chipotle and Pepita, 118
Feta and Arugula, 118
Habanero and Mango, 118
Horseradish, Creamy, *92*, 93
Hummus
Artichoke-Lemon, 113
Classic, 113
Roasted Garlic, *112*, 113
Roasted Red Pepper, 113
Sweet Potato, 114, *115*
Roasted Artichoke, 100, *101*

Dips *(cont.)*
Spicy Whipped Feta, *106*, 107
Spinach
with Blue Cheese and Bacon, 97
Cilantro-Lime, 97
with Feta, Lemon, and Oregano, 97
Herbed, *96*, 97
Ultimate Seven-Layer, 104, *105*
Ultimate Smoky Seven-Layer, 104
Whipped Cashew Nut
with Chipotle and Lime, 98, 99
with Roasted Red Peppers and Olives, 98, 99
with Sun-Dried Tomatoes and Rosemary, 98, 99
White Bean
Caper and Tarragon, 110
Goat Cheese and Lemon, 110
Green Chile and Cilantro, 110
Rosemary and Garlic, 110, *111*
Sun-Dried Tomato and Feta, 110
see also Mayonnaise; Sauces
Dumplings
Potstickers with Scallion Dipping Sauce, 40, *41*
Steamed Chinese, (Shu Mai), 42, *43*

E

Easy Crab Rangoon, 152, *153*
Easy Mini Chicken Empanadas, 38, *39*
Easy Mushroom Pâté, 120, *121*
Edamame with Sea Salt, 3
Eggplant
Baba Ghanoush, *116*, 117
Eggs
Bacon and Chive Deviled, 15
Curry Deviled, *14*, 15
Spanish Tortilla with Garlic Mayonnaise, *140*, 141
Emmentaler cheese, about, 6
Empanadas, Easy Mini Chicken, 38, *39*
Endive
leaves, removing, 30
Shrimp Salad on, 30, *31*

F

Fennel, Olive, and Goat Cheese Tarts, 82, *83*
Feta
about, 6
and Arugula Guacamole, 118
buying and storing, 107
Lemon, and Oregano, Spinach Dip with, 97
made in Greece, 107
Marinated Olives with, 50
Spanakopita, 32, *33*
Spicy Whipped, *106*, 107
and Sun-Dried Tomato White Bean Dip, 110
winning brand, 107
Fig Jam, Blue Cheese, and Prosciutto, Naan Tarts with, *78*, 79

Figs, Prosciutto-Wrapped, with Gorgonzola, *22*, 23
Fish. *See* Anchovies; Salmon
Fisherman's Friend Party Mix, 59
Fontina cheese
about, 6
Marinated Artichoke Hearts and Stuffed Pickled Sweet Peppers, 16, *17*
Four Creamy Dips, *92*, 93
Fresh Vegetable Spring Rolls, 44, 45
Fried Calamari with Tartar Sauce, *154*, 155
Fruit
for cheese plates, 8
see also specific fruits

G

Garlic
and Herb Popcorn, 56
Mayonnaise, *140*, 141
-Parsley Sauce, Pan-Fried Halloumi with, *138*, 139
Roasted, Hummus, *112*, 113
and Rosemary White Bean Dip, 110, *111*
Shrimp, Spanish-Style, 160, *161*
Garnishes, citrus, 11
Ginger-Sesame Kale Chips, Spicy, 54
Goat Cheese
about, 6
Artichokes, and Pesto, Naan Tarts with, 79
Asparagus Puffs, *34*, 35
Caramelized Onion, Pear, and Bacon Tarts, 86, *87*
Fennel, and Olive Tarts, 82, *83*
and Lemon White Bean Dip, 110
and Olives, Stuffed Mushrooms with, 18
Stuffed Cherry Tomatoes, 3
Gorgonzola
about, 7
Prosciutto-Wrapped Figs with, *22*, 23
Gouda cheese, about, 7
Gougères, 128, *129*
Grape Tomato, White Bean Puree, and Rosemary Bruschetta Topping, *70*, 71
Gravlax, Homemade, on Pumpernickel with Crème Fraîche, *76*, 77
Green beans, preparing, for crudités, 5
Green Chile and Cilantro White Bean Dip, 110
Green Chile Cheeseburger Sliders, 132, *133*
Green Goddess Dip, *92*, 93
Gruyère
about, 7
Gougères, 128, *129*
Mustard, and Caraway Cheese Coins, 61

Guacamole, 118, *119*
 Bacon and Tomato, 118
 Chipotle and Pepita, 118
 Feta and Arugula, 118
 Habanero and Mango, 118

H

Habanero and Mango Guacamole, 118
Halloumi
 Pan-Fried, 139
 Pan-Fried, with Garlic-Parsley
 Sauce, *138,* 139
Ham
 and Cheese Palmiers, *126,* 127
 Serrano and Manchego Crostini with
 Orange Honey, 74, *75*
 see also Prosciutto
Havarti cheese, about, 7
Herb(ed)
 and Garlic Popcorn, 56
 Spinach Dip, *96,* 97
 see also specific herbs
Homemade Cheese Straws, 62, *63*
Homemade Gravlax on Pumpernickel
 with Crème Fraîche, *76,* 77
Honey
 Baked Brie with Honeyed
 Apricots, 108, *109*
 for cheese plates, 8
 Orange, Serrano and Manchego
 Crostini with, 74, *75*
 raw, about, 74
 shopping for, 74
 winning brand, 74
Horseradish
 Cocktail Sauce, 156, *157*
 Dip, Creamy, *92,* 93
Hot and Sweet Popcorn, 56
Hummus
 Artichoke-Lemon, 113
 Classic, 113
 Roasted Garlic, *112,* 113
 Roasted Red Pepper, 113
 Sweet Potato, 114, *115*
Hushpuppies with Chipotle
 Aïoli, *130,* 131

I

India pale ales (IPAs), about, 9

J

Jams
 appetizer ideas with, 2
 for cheese plates, 8
Jarlsberg cheese, about, 7
Jiggers, 11

K

Kale Chips, 54, *55*
 Ranch-Style, 54
 Spicy Sesame-Ginger, 54
Kettle Chips, 66, *67*
Korean Fried Chicken Wings, *170,* 171

L

Lagers, about, 9
Lamb Meatballs with Yogurt
 Sauce, *166,* 167
Latkes, 144, *145*
Leek and Smoked Salmon Tart, *84,* 85
Lemon
 -Artichoke Hummus, 113
 Feta, and Oregano, Spinach Dip
 with, 97
 and Goat Cheese White Bean Dip, 110
Lettuce
 Fresh Vegetable Spring Rolls, *44,* 45
 Wraps, Chinese Chicken, *28,* 29
Lime
 and Chipotle, Whipped Cashew Nut
 Dip with, 99
 -Chipotle Dip with Scallions, *92,* 93
 -Cilantro Spinach Dip, 97
 Crema, *134,* 135
 Sweet and Spicy Thai Wing
 Sauce, 168, *169*
Liquor cabinet, stocking, 11
Liver, Chicken, Pâté, *122,* 123

M

Manchego
 about, 7
 and Chorizo, Stuffed Mushrooms
 with, 18
 and Serrano Crostini with Orange
 Honey, 74, *75*
Mango and Habanero Guacamole, 118
Marinated Artichoke Hearts and
 Stuffed Pickled Sweet
 Peppers, 16, *17*
Marinated Olives, 50, *51*
 with Baby Mozzarella, 50
 with Feta, 50
Mayonnaise
 Basil, BLT Canapés with, *72,* 73
 Chipotle, *150,* 151
 Garlic, *140,* 141
 top-rated brand, 73
Meatballs
 Cocktail, in Tomato-Saffron
 Sauce, 164, *165*
 Lamb, with Yogurt Sauce, *166,* 167
Melon, Prosciutto-Wrapped, 3
Mini Cheese Quiches, 136, *137*
Monterey Jack cheese
 Bacon-Cheddar Potato Skins, 142, *143*
Mozzarella
 about, 7
 Baby, Marinated Olives with, 50
 and Tomato Tart, 80, *81*
Mushroom(s)
 Chinese Chicken Lettuce Wraps, *28,* 29
 dried, choosing and storing, 120
 Pâté, Easy, 120, *121*
 Steamed Chinese Dumplings (Shu
 Mai), 42, *43*

Mushroom(s) *(cont.)*
 Stuffed
 with Bacon and Blue Cheese, 18, *19*
 with Cheddar, Fennel, and
 Sage, 18, *19*
 with Chorizo and Manchego, 18, *19*
 with Olives and Goat Cheese, 18, *19*
 with Parmesan and Thyme, 18, *19*

N

Naan Tarts
 with Artichokes, Pesto, and Goat
 Cheese, 79
 with Fig Jam, Blue Cheese, and
 Prosciutto, *78,* 79
 with Ricotta and Sun-Dried Tomato–
 Olive Tapenade, 79
Nonalcoholic drinks, 11
Noodles
 Fresh Vegetable Spring Rolls, *44,* 45
Nuts
 Cashew, Dip, Whipped
 with Chipotle and Lime, *98,* 99
 with Roasted Red Peppers and
 Olives, *98,* 99
 with Sun-Dried Tomatoes and
 Rosemary, *98,* 99
 for cheese plates, 8
 Cinnamon-Spiced, 53
 Curry-Spiced, 53
 Fresh Vegetable Spring Rolls, *44,* 45
 Spiced, *52,* 53
 storing, 2

O

Olive Oil–Sea Salt Pita Chips, 65
Olive(s), 2
 Black, Pesto, Ricotta, and Basil
 Bruschetta Topping, *70,* 71
 for cheese plates, 8
 Easy Mini Chicken Empanadas, 38, *39*
 Fennel, and Goat Cheese Tarts, 82, *83*
 and Goat Cheese, Stuffed
 Mushrooms with, 18, *19*
 Marinated, 50, *51*
 Marinated, with Baby Mozzarella, 50
 Marinated, with Feta, 50
 and Roasted Red Peppers, Whipped
 Cashew Nut Dip with, *98,* 99
 –Sun-Dried Tomato Tapenade and
 Ricotta, Naan Tarts with, 79
 Tapenade, Crispy Polenta Squares
 with, 88, *89*
Onion(s)
 Caramelized, Bacon, and Scallion
 Dip, 94, *95*
 Caramelized, Pear, and Bacon
 Tarts, 86, *87*
 slicing, 94
Orange(s)
 garnishes made with, 11
 Honey, Serrano and Manchego
 Crostini with, 74, *75*

Oregano, Feta, and Lemon, Spinach
Dip with, 97
Oven-Fried Chicken Wings, 168, *169*

P

Palmiers, Ham and Cheese, *126, 127*
Pancakes
Blini, *146,* 147
Scallion, *148,* 149
Pan-Fried Halloumi, 139
Pan-Fried Halloumi with Garlic-
Parsley Sauce, *138,* 139
Parmesan
about, 7
and Artichoke Bruschetta Topping, 71
Asparagus Puffs, *34,* 35
Ham and Cheese Palmiers, *126,* 127
Homemade Cheese Straws, 62, *63*
-Pepper Popcorn, 56
Roasted Artichoke Dip, 100, *101*
and Rosemary Cheese Coins, 61
-Rosemary Pita Chips, *64,* 65
and Thyme, Stuffed Mushrooms
with, 18, *19*
Tomato and Mozzarella Tart, 80, *81*
Parsley
-Garlic Sauce, Pan-Fried Halloumi
with, *138,* 139
Green Goddess Dip, *92, 93*
Herbed Spinach Dip, *96,* 97
Whipped Cashew Nut Dip with
Roasted Red Peppers and
Olives, *98,* 99
Party Mixes
Asian Firecracker, *58,* 59
Barbecue, 59
Fisherman's Friend, 59
Passed and plattered
Bacon-Cheddar Potato Skins, 142, *143*
Beef Satay with Spicy Peanut
Dipping Sauce, 163
Blini, *146,* 147
Broiled Shrimp Cocktail with
Creamy Tarragon Sauce, *158,* 159
Chicken and Avocado Arepa
Bites, *134,* 135
Chicken Satay with Spicy Peanut
Dipping Sauce, *162,* 163
Classic Shrimp Cocktail with
Horseradish Cocktail
Sauce, 156, *157*
Cocktail Crab Cakes with Chipotle
Mayonnaise, *150,* 151
Cocktail Meatballs in Tomato-
Saffron Sauce, 164, *165*
Easy Crab Rangoon, 152, *153*
Fried Calamari with Tartar
Sauce, *154,* 155
Gougères, 128, *129*
Green Chile Cheeseburger Sliders,
132, *133*
Ham and Cheese Palmiers, *126,* 127

Passed and plattered *(cont.)*
Hushpuppies with Chipotle
Aïoli, *130,* 131
Korean Fried Chicken Wings, *170,* 171
Lamb Meatballs with Yogurt
Sauce, *166,* 167
Latkes, 144, *145*
Mini Cheese Quiches, 136, *137*
Oven-Fried Chicken Wings, 168, *169*
Pan-Fried Halloumi, 139
Pan-Fried Halloumi with Garlic-
Parsley Sauce, *138,* 139
Scallion Pancakes, *148,* 149
Spanish-Style Garlic Shrimp, 160, *161*
Spanish Tortilla with Garlic
Mayonnaise, *140,* 141
Pâtés
Chicken Liver, *122,* 123
Mushroom, Easy, 120, *121*
Peanut(s)
Dipping Sauce, *44,* 45
Dipping Sauce, Spicy, *162,* 163
Fresh Vegetable Spring Rolls, *44,* 45
Pear, Caramelized Onion, and Bacon
Tarts, 86, *87*
Peas
snow and snap, preparing for
crudités, 5
Spanish Tortilla with Garlic
Mayonnaise, *140,* 141
Pecorino Romano cheese, about, 7
Pepita and Chipotle Guacamole, 118
Pepper Jack cheese
Green Chile Cheeseburger
Sliders, 132, *133*
Ultimate Seven-Layer Dip, 104, *105*
Ultimate Smoky Seven-Layer Dip, 104
Pepper(s)
Herbed Spinach Dip, *96,* 97
preparing, for crudités, 5
Roasted Red, and Olives, Whipped
Cashew Nut Dip with, *98,* 99
Roasted Red, Hummus, 113
roasted red, jarred, 2
Salsa, 38, *39*
Spanish Tortilla with Garlic
Mayonnaise, *140,* 141
Stuffed Pickled Sweet, and
Marinated Artichoke
Hearts, 16, *17*
see also Chile(s)
Perfect Popcorn, 56, *57*
Pesto
Artichokes, and Goat Cheese, Naan
Tarts with, 79
Black Olive, Ricotta, and Basil
Bruschetta Topping, *70,* 71
Phyllo dough
folding into triangles, 32
Spanakopita, 32, *33*
Pilsners, about, 9

Pita Chips
Buttermilk-Ranch, 65
Chili-Spiced, 65
Cinnamon-Sugar, 65
Olive Oil–Sea Salt, 65
Rosemary-Parmesan, *64,* 65
Pizza Dough, Classic, 86
Polenta Squares, Crispy, with Olive
Tapenade, 88, *89*
Popcorn, Perfect, 56, *57*
Cajun-Spiced, 56
Garlic and Herb, 56
Hot and Sweet, 56
Parmesan-Pepper, 56
Pork
Cocktail Meatballs in Tomato-
Saffron Sauce, 164, *165*
Potstickers with Scallion Dipping
Sauce, 40, *41*
Steamed Chinese Dumplings
(Shu Mai), 42, *43*
Stuffed Mushrooms with Chorizo
and Manchego, 18, *19*
see also Bacon; Ham
Porters, about, 9
Potato(es)
Kettle Chips, 66, *67*
Latkes, 144, *145*
Skins, Bacon-Cheddar, 142, *143*
Spanish Tortilla with Garlic
Mayonnaise, *140,* 141
Sweet, Hummus, 114, *115*
Potstickers with Scallion Dipping
Sauce, 40, *41*
Prosciutto, 2
buying, 23
Fig Jam, and Blue Cheese, Naan
Tarts with, *78,* 79
Marinated Artichoke Hearts and
Stuffed Pickled Sweet
Peppers, 16, *17*
winning brand, 23
-Wrapped Asparagus, 24, *25*
-Wrapped Figs with Gorgonzola,
22, 23
-Wrapped Melon, 3
Provolone cheese, about, 7
Puff pastry, 2
Asparagus Puffs, *34,* 35
Fennel, Olive, and Goat Cheese
Tarts, 82, *83*
Ham and Cheese Palmiers, *126,* 127
Homemade Cheese Straws, 62, *63*
Tomato and Mozzarella Tart, 80, *81*

Q

Quiches, Mini Cheese, 136, *137*

R

Radishes, preparing, for crudités, 5
Ranch-Style Kale Chips, 54
Rangoon, Easy Crab, 152, *153*
Ricotta
 Black Olive Pesto, and Basil
 Bruschetta Topping, *70,* 71
 Spanakopita, 32, *33*
 and Sun-Dried Tomato–Olive
 Tapenade, Naan Tarts with, 79
Ricotta salata, about, 7
Roasted Artichoke Dip, 100, *101*
Roasted Garlic Hummus, *112,* 113
Roasted Red Pepper Hummus, 113
Roquefort, about, 7
Rosemary
 and Garlic White Bean Dip, 110, *111*
 Grape Tomato, and White Bean Puree
 Bruschetta Topping, *70,* 71
 -Parmesan Pita Chips, *64,* 65
 and Sun-Dried Tomatoes, Whipped
 Cashew Nut Dip with, *98,* 99

S

Saffron
 shopping for, 164
 -Tomato Sauce, Cocktail Meatballs
 in, 164, *165*
Saison ales, about, 9
Salmon
 Homemade Gravlax on Pumpernickel
 with Crème Fraîche, *76,* 77
 Smoked, and Leek Tart, *84,* 85
Salsa, 38, *39*
Satay
 Beef, with Spicy Peanut Dipping
 Sauce, 163
 Chicken, with Spicy Peanut Dipping
 Sauce, *162,* 163
Sauces
 Avocado, *36,* 37
 Buffalo Wing, 168, *169*
 Dipping, for Scallion Pancakes, *148,* 149
 Garlic-Parsley, Pan-Fried Halloumi
 with, *138,* 139
 Horseradish Cocktail, 156, *157*
 Peanut Dipping, *44,* 45
 Peanut Dipping, Spicy, *162,* 163
 Scallion Dipping, 40, *41*
 Smoky Barbecue Wing, 168, *169*
 Sweet and Spicy Thai Wing, 168, *169*
 Tarragon, Creamy, *158,* 159
 Tartar, 155
 Yogurt, *166,* 167
Sausages. *See* Chorizo
Scallion(s)
 Bacon, and Caramelized Onion Dip,
 94, *95*
 Chipotle-Lime Dip with, *92,* 93
 Dipping Sauce, *148,* 149
 Dipping Sauce, Potstickers with, 40, *41*
 Pancakes, *148,* 149

Scallops
 preparing, 26
 Sea, Broiled Bacon-Wrapped, 26, *27*
Seafood
 Baked Crab Dip with Crostini, *102,* 103
 Broiled Bacon-Wrapped Sea
 Scallops, 26, *27*
 Cocktail Crab Cakes with Chipotle
 Mayonnaise, *150,* 151
 Easy Crab Rangoon, 152, *153*
 Fried Calamari with Tartar
 Sauce, *154,* 155
 Homemade Gravlax on Pumpernickel
 with Crème Fraîche, *76,* 77
 scallops, preparing, 26
 Smoked Salmon and Leek Tart, *84,* 85
 see also Anchovies; Shrimp
Serrano and Manchego Crostini with
 Orange Honey, *74, 75*
Sesame-Ginger Kale Chips, Spicy, 54
Session beers, about, 9
Shot glasses, 11
Shrimp
 Broiled Bacon-Wrapped, 26
 Cocktail, Broiled. with Creamy
 Tarragon Sauce, *158,* 159
 Cocktail, Classic, with Horseradish
 Cocktail Sauce, 156, *157*
 Garlic, Spanish-Style, 160, *161*
 peeling and deveining, 159
 Salad on Endive, 30, *31*
 Steamed Chinese Dumplings
 (Shu Mai), 42, *43*
Shu Mai (Steamed Chinese
 Dumplings), 42, *43*
Sliced and stacked
 BLT Canapés with Basil
 Mayonnaise, *72,* 73
 Bruschetta, *70,* 71
 with Artichoke and Parmesan
 Topping, 71
 with Black Olive Pesto, Ricotta,
 and Basil Topping, *70,* 71
 with Grape Tomato, White Bean
 Puree, and Rosemary
 Topping, *70,* 71
 Caramelized Onion, Pear, and Bacon
 Tarts, 86, *87*
 Crispy Polenta Squares with Olive
 Tapenade, 88, *89*
 Fennel, Olive, and Goat Cheese
 Tarts, 82, *83*
 Homemade Gravlax on Pumpernickel
 with Crème Fraîche, *76,* 77
 Naan Tarts
 with Artichokes, Pesto, and Goat
 Cheese, 79
 with Fig Jam, Blue Cheese, and
 Prosciutto, *78,* 79
 with Ricotta and Sun-Dried
 Tomato–Olive Tapenade, 79

Sliced and stacked *(cont.)*
 Serrano and Manchego Crostini with
 Orange Honey, *74, 75*
 Smoked Salmon and Leek Tart, *84,* 85
 Tomato and Mozzarella Tart, 80, *81*
Sliders, Green Chile Cheeseburger,
 132, *133*
Smoked Salmon and Leek Tart, *84,* 85
Smoky Barbecue Wing Sauce, 168, *169*
Snacks in bowls
 Cheese Coins
 Blue Cheese and Celery Seed, 61
 Cheddar, *60,* 61
 Gruyère, Mustard, and Caraway, 61
 Parmesan and Rosemary, 61
 Crispy Spiced Chickpeas, *48,* 49
 Homemade Cheese Straws, 62, *63*
 Kale Chips, 54, *55*
 Ranch-Style, 54
 Spicy Sesame-Ginger, 54
 Kettle Chips, 66, *67*
 Marinated Olives, 50, *51*
 with Baby Mozzarella, 50
 with Feta, 50
 Party Mixes
 Asian Firecracker, *58,* 59
 Barbecue, 59
 Fisherman's Friend, 59
 Perfect Popcorn, 56, *57*
 Cajun-Spiced, 56
 Garlic and Herb, 56
 Hot and Sweet, 56 Parmesan-
 Pepper, 56
 Pita Chips
 Buttermilk-Ranch, 65
 Chili-Spiced, 65
 Cinnamon-Sugar, 65
 Olive Oil–Sea Salt, 65
 Rosemary-Parmesan, *64,* 65
 Spiced Nuts, *52,* 53
 Cinnamon-, 53
 Curry-, 53
Spanakopita, 32, *33*
Spanish-Style Garlic Shrimp, 160, *161*
Spanish Tortilla with Garlic
 Mayonnaise, *140,* 141
Spiced Nuts, *52, 53*
Spicy Sesame-Ginger Kale Chips, 54
Spicy Whipped Feta, *106,* 107
Spinach
 Dip
 with Blue Cheese and Bacon, 97
 Cilantro-Lime, 97
 with Feta, Lemon, and Oregano, 97
 Herbed, *96,* 97
 Spanakopita, 32, *33*
Spreads
 Boursin–Cheddar Cheese, 3
 Chicken Liver Pâté, *122,* 123
 Easy Mushroom Pâté, 120, *121*
 Olive Tapenade, 88, *89*

index **181**

Spring Rolls, Fresh Vegetable, *44,* 45
Steamed Chinese Dumplings
 (Shu Mai), 42, *43*
Stout, about, 9
Stuffed Cherry Tomatoes, 3
Stuffed Jalapeños, *20,* 21
Stuffed Mushrooms
 with Bacon and Blue Cheese, 18, *19*
 with Cheddar, Fennel, and Sage, 18, *19*
 with Chorizo and Manchego, 18, *19*
 with Olives and Goat Cheese, 18, *19*
 with Parmesan and Thyme, 18, *19*
Sugar syrup, preparing, 11
Sun-Dried Tomato and Feta White
 Bean Dip, 110
Sweet and Spicy Thai Wing
 Sauce, 168, *169*
Sweet Potato Hummus, 114, *115*

T

Tahini
 Artichoke-Lemon Hummus, 113
 Baba Ghanoush, *116,* 117
 Classic Hummus, 113
 Roasted Garlic Hummus, *112,* 113
 Roasted Red Pepper Hummus, 113
 Sweet Potato Hummus, 114, *115*
Tapenade
 Olive, Crispy Polenta Squares
 with, 88, *89*
 Sun-Dried Tomato–Olive, and
 Ricotta, Naan Tarts with, 79
Taquitos, Beef and Bean, with
 Avocado Sauce, *36,* 37
Tarragon
 and Caper White Bean Dip, 110
 Green Goddess Dip, *92,* 93
 Sauce, Creamy, *158,* 159
Tartar Sauce, 155
Tarts
 Caramelized Onion, Pear, and
 Bacon, 86, *87*
 Fennel, Olive, and Goat Cheese, 82, *83*
 Naan
 with Artichokes, Pesto, and Goat
 Cheese, 79
 with Fig Jam, Blue Cheese, and
 Prosciutto, *78,* 79
 with Ricotta and Sun-Dried
 Tomato–Olive Tapenade, 79
 Smoked Salmon and Leek, *84,* 85
 Tomato and Mozzarella, 80, *81*

Tomato(es)
 and Bacon Guacamole, 118
 BLT Canapés with Basil
 Mayonnaise, *72,* 73
 Cherry, Stuffed, 3
 Grape, White Bean Puree, and
 Rosemary Bruschetta
 Topping, *70,* 71
 and Mozzarella Tart, 80, *81*
 -Saffron Sauce, Cocktail Meatballs
 in, 164, *165*
 Salsa, 38, *39*
 Sun-Dried, and Feta White Bean
 Dip, 110
 Sun-Dried, and Rosemary, Whipped
 Cashew Nut Dip with, 99
 Sun-Dried, –Olive Tapenade and
 Ricotta, Naan Tarts with, 79
 Ultimate Seven-Layer Dip, 104, *105*
 Ultimate Smoky Seven-Layer Dip, 104

U

Ultimate Seven-Layer Dip, 104, *105*
Ultimate Smoky Seven-Layer Dip, 104

V

Vegetable(s)
 crudités, preparing, 5
 Fresh, Spring Rolls, *44,* 45
 see also specific vegetables

W

Wheat beer, about, 9
Whipped Cashew Nut Dip
 with Chipotle and Lime, *98,* 99
 with Roasted Red Peppers and
 Olives, *98,* 99
 with Sun-Dried Tomatoes and
 Rosemary, *98,* 99
Wine
 aerating, 10
 for aperitifs, 10
 buying and serving, 10
 estimating amount to serve, 10
 fruity whites, 10
 full-bodied reds, 10
 leftover, preserving, 10
 light-bodied reds, 10
 opening, corkscrews for, 10
 savory whites, 10
Wine openers, electronic, 10
Wine preservers, 10

Wrapped and stuffed
 Asparagus Puffs, *34,* 35
 Bacon and Chive Deviled Eggs, 15
 Beef and Bean Taquitos with
 Avocado Sauce, *36,* 37
 Broiled Bacon-Wrapped Sea
 Scallops, 26, *27*
 Broiled Bacon-Wrapped Shrimp, 26
 Chinese Chicken Lettuce Wraps, *28,* 29
 Curry Deviled Eggs, *14,* 15
 Easy Mini Chicken Empanadas,
 38, *39*
 Fresh Vegetable Spring Rolls, *44,* 45
 Marinated Artichoke Hearts and
 Stuffed Pickled Sweet
 Peppers, 16, *17*
 Potstickers with Scallion Dipping
 Sauce, 40, *41*
 Prosciutto-Wrapped Asparagus, 24, *25*
 Prosciutto-Wrapped Figs with
 Gorgonzola, *22,* 23
 Shrimp Salad on Endive, 30, *31*
 Spanakopita, 32, *33*
 Steamed Chinese Dumplings (Shu
 Mai), 42, *43*
 Stuffed Jalapeños, *20,* 21
 Stuffed Mushrooms
 with Bacon and Blue Cheese, 18, *19*
 with Cheddar, Fennel, and
 Sage, 18, *19*
 with Chorizo and Manchego, 18, *19*
 with Olives and Goat Cheese, 18, *19*
 with Parmesan and Thyme, 18, *19*

Y

Yogurt Sauce, Lamb Meatballs with,
 166, 167